American Visual Cultures

American Visual Cultures

Edited by David Holloway and John Beck

continuum
LONDON • NEW YORK

CONTINUUM
The Tower Building
11 York Road
London SE1 7NX

15 East 26th Street
New York
NY 10010

British Library Cataloguing-in-Publication Data
A catalogue record for this book is available from the British Library.

ISBN: 0-8264-6484-X (hardback)
 0-8264-6485-8 (paperback)

Library of Congress Cataloging-in-Publication Data
American visual cultures / edited by David Holloway and John Beck.
 p. cm.
 Includes bibliographical references and index.
 ISBN 0-8264-6484-X — ISBN 0-8264-6485-8 (pbk)
 1. Arts and society — United States. 2. Arts, American — 19th century.
 3. Arts, American — 20th century. I. Holloway, David, 1967–
 II. Beck, John, 1963–

NX180.S6A437 2005
700'.973—dc22

 2004061827

Typeset by Servis Filmsetting Ltd, Manchester
Printed and bound in Great Britain by Antony Rowe, Chippenham, Wiltshire

Contents

List of Figures ix

Notes on Contributors xii

Acknowledgements xvi

General Introduction 1
Towards a Social Theory of American Visual Cultures
David Holloway and John Beck

PART 1: 1861–1929

Introduction to Part 1 13
David Holloway and John Beck

Manifest Destiny and Visual Culture 21
Photographing American Indians: Repression and Revision
Mick Gidley

Visualizing Women in the Civil War 31
*Unsexed Amazons and Desperadoes: Imaging Public War Women and Imagining
Female Warriors in the American Civil War*
Cynthia Wiedemann Empen

Renegotiating Masculinity after the Civil War 39
*Absent Fathers and Women with Beards: Religion and Gender in Popular Imagery
of the Nineteenth Century*
David Morgan

Visualizing 'America' as 'Progress' at the end of the Western Frontier 48
Painting the Nation: American Art at the White City
Christopher Gair

Alternative Racial Gazes in American Silent Cinema 56
Visualizing Racial Politics in the Films of D.W. Griffith and Oscar Micheaux
Charlene Regester

Contents

Visualizing Dissent in World War 1 63
Modernism, and the End of 'Liberal' Progressivism, in Art from The Masses
(1911–1917)
David Holloway

The Avant-Garde and the Market 73
Debating Modernism: Art and American Advertising in the 1920s
Don McComb

PART 2: 1929–1963

Introduction to Part 2 83
David Holloway and John Beck

The New Deal and Film 89
Debating the New Deal: Gold Diggers of 1933 *and* My Man Godfrey
Michael Ryan

Painting and the New Deal 98
Art and Work on the WPA
Joan Saab

The New Deal and Photography 107
*Liberal Documentary Goes to School: Farm Security Administration Photographs
of Students, Teachers and Schools*
Eric Margolis

Supporting Dictatorship in World War 2 News 116
'Flash From Brazil' – 1940s' Newsreels Present Latin America
Pennee Bender

The Emergence of TV as a New Mass Medium 125
The Birth of American Televisual Spectatorship
Cat Celebrezze

Negotiating the Cold War in Film 133
The Other Side of Hollywood's Cold War: Images of Dissent in the 1950s
Tony Shaw

Cold War 'Containment Culture' and Photography 142
Robert Frank's The Americans *and the 1950s*
Neil Campbell

Reading Abstract Expressionist Art 150
Aesthetics, Politics and 'Cultural Theory': Barnet Newman's Utopian Painting
David A. Wragg

PART 3: 1963–1980

Introduction to Part 3 161
David Holloway and John Beck

Visualizing Political Struggle 166
Civil Rights-era Photography
Deborah Willis

Towards Postmodernism 174
Post-World War 2 Photography in America: From Committed to Solipsistic Art
Jean Kempf and Bruno Chalifour

Visual Violence in History and Art 183
Zapruder, Warhol, and the Accident of Images
John Beck

New Modes of Dissent in Art of the 1960s and 1970s 190
Visual Culture and Strategies of Resistance: from Semina *to* Heresies
Francis Frascina

Photographing the Vietnam War 199
Democratic Accountability and Liberal Representation in American Iconic
Photography: the Image of 'Accidental Napalm'
Robert Hariman and John Louis Lucaites

'Commodity Feminism' in 1960s' Visual Culture 209
Sex, Style and Single Girls
Bill Osgerby

New Genre Forms in 'New Hollywood' Film 216
Partly Truth and Partly Fiction: The Western, the City Movie and the American 1970s
Linnie Blake

PART 4: 1980–2001

Introduction to Part 4 227
David Holloway and John Beck

Marketing 'Post-Fordism' 232
Advertising the Global Economy
Katherine Johnson

Commodifying Latin America in NAFTA-era Film 241
The World According to Miramax: Chocolate, Poetry and Neoliberal Aesthetics
Sophia A. McClennen

Visualizing 'Memory' in the Age of Global Capital 249
A Taste for Black and White: Visuality, Digital Culture and the Anxieties of the Global
Paul Grainge

Remembering Vietnam in the 1980s 257
White Skin, White Masks: Vietnam War Films and the Racialized Gaze
LeiLani Nishime

Contents

'Queer' Photography and the 'Culture Wars' 265
Robert Mapplethorpe's Queer Aesthetic of the Pair
Denis Flannery

Transnationalism in Contemporary African American Photography 274
Memory, History and 'Universal' Narrative in the Work of Carrie Mae Weems
Maren Stange

Anthropology at the Movies 284
Jerry Maguire *as 'Expeditionary Discourse'*
Jonathan Gayles and S. Elizabeth Bird

Negotiating Feminism in Contemporary TV 291
'What's Sex Got To Do With It?': Signifying Post-Feminism in Sex and the City
Anna Gough-Yates

Constructing History in TV News from Clinton to 9/11 299
Flashframes of History – American Visual Memories
Andrew Hoskins

Bibliography 306

Index 338

List of Figures

Fig. 1. A poster advertising Westward Ho tobacco (1868). (Photo by MPI/Getty Images.) Courtesy of Getty Images. 14

Fig. 2. *American Progress*, John Gast. Oil on canvas, 1872. Courtesy of the Museum of the American West collection, Autry National Center. 15

Fig. 3. William Henry Jackson. *US Geological Survey pack train on trail along the Yellowstone River* (1871). Library of Congress, Prints and Photographs Division, LC-USZ62-20198 DLC. 16

Fig. 4. William Henry Jackson. *Crater of the Castle Geyser* [Yellowstone] (1871). Library of Congress, Prints and Photographs Division, LC-USZ62-27952 DLC. 17

Fig. 5. William Henry Jackson. *Scenery of the Yellowstone National Park – Mammoth Hot Springs, lower basins, looking up* (1872). Library of Congress, Prints and Photographs Division, LC-USZ62-44164 DLC. 17

Fig. 6. William Henry Jackson. *Great Falls of the Yellowstone River* (1872). Library of Congress, Prints and Photographs Division, LC-USZ62-16709 DLC. 18

Fig. 7. 1899: American guide, army scout and showman William Frederick Cody (1846–1917), nicknamed Buffalo Bill, plays the part of himself in a melodrama by novelist Ned Buntline. (Photo by MPI/Getty Images.) Courtesy of Getty Images. 23

Fig. 8. *The Spirit of the Past*, by Edward S. Curtis, c. 1905 (copy print, author's collection, from a photogravure in *The North American Indian*). The very title of this image indicates that it depicts a reconstruction, in that on the Crow Reservation where and when it was made war parties were definitely a thing of the 'past'. 25

Fig. 9. *He Dog, Brulé Sioux*, by John Alvin Anderson, c. 1910 (copy print, author's collection, courtesy of the Barbican Gallery, London). He Dog (1836–1927), though a witness to his people's subjection, registers in this portrait a powerful sense of his enduring individual and cultural identity. 29

Fig. 10. 'Train up a child in the way he should go'. Courtesy of the Billy Graham Center Museum, Wheaton, IL. 40

Fig. 11. From *The Well-Spring*, 21 June, 1861. Courtesy of the Billy Graham Center Museum, Wheaton, IL. 44

Fig. 12. Illinois WPA Art Project poster, promoting workers' education (1941). Library of Congress, Prints and Photographs Division, WPA Poster Collection, LC-USZC2-5209 DLC. 84

Fig. 13. Federal Art Project poster by John Buczak, promoting careers in business and finance (1936–9). Library of Congress, Prints and Photographs Division, WPA Poster Collection, LC-USZC2-808 DLC. 85

Fig. 14. A billboard in Dubuque, Iowa, paid for by the National Association of Manufacturers (1940). (Photo by John Vachon/Library Of Congress/Getty Images.) Courtesy of Getty Images. 86

Fig. 15. Patriotic WPA poster during wartime (1941–3). Library of Congress, Prints and Photographs Division, WPA Poster Collection, LC-USZ62-91022. 87

Fig. 16. An advertisement for a Motorola television set (1950). (Photo by MPI/Getty Images.) Courtesy of Getty Images. 88

Fig. 17. Embedding art in community life during the New Deal (1936–9). Library of Congress, Prints and Photographs Division, WPA Poster Collection, LC-USZC2-870 DLC. 100

Fig. 18. Poster from the WPA Adult Education programme of the Chicago Board of Education, announcing free neighbourhood art classes (1936–7). Library of Congress, Prints and Photographs Division, WPA Poster Collection, LC-USZC2-5167 DLC. 100

Fig. 19. Joseph Janoskowsky, in a pinstripe suit, displays leather straps used in dungeon floggings, during State Civil Service Commission hearings, State Industrial School (name changed in 1961 to Lookout Mountain School for Boys), Golden, Jefferson County, Colorado. Date: January 1941. Photographer Rocky Mountain News. Courtesy of Denver Public Library, Western History Collection, Call Number X-10085. 112

Fig. 20. *Children on porch*, probably in Colorado (1930–40). Photographer Harry Mellon Rhoads. Courtesy of Denver Public Library, Western History Collection, Call Number Rh-5387. 113

Fig. 21. Republican politician and anti-communist Joseph McCarthy (1908–57), after the Senate censured him for financial irregularities in 1954. (Photo by MPI/Getty Images.) Courtesy of Getty Images. 130

Fig. 22. A spoof Anti-Vietnam war poster (1968) advertising an Eastern Theatre Production of a film, *Vietnam*, which is 'Filmed in Real Blood'n Guts Colour' and states, 'Price of Admission: Your Son plus Taxes'. A smiling President Lyndon Johnson lounges in the foreground. (Photo by MPI/Getty Images.) Courtesy of Getty Images. 161

Fig. 23. A poster commemorating the massacre of Wounded Knee (March 1973). (Photo by MPI/Getty Images.) Courtesy of Getty Images. 162

Fig. 24. A poster (1980) depicting Ronald Reagan bottle feeding a chimp in his 1951

film, *Bedtime for Bonzo*, is held aloft at a Democratic Convention in New York.
(Photo by Luiz Alberto/Keystone Features/Getty Images.) Courtesy of Getty Images. 165

Fig. 25. Protesters at March on Washington. c. 1963. Photograph by Jack T. Franklin.
Courtesy of the African American Museum in Philadelphia. 168

Fig. 26. View of Washington Monument and Protesters at March on Washington.
c. 1963. Photograph by Jack T. Franklin. Courtesy of the African American Museum
in Philadelphia. 169

Fig. 27. James Baldwin, Harry and Julie Belafonte, at March on Washington. c. 1963.
Photograph by Jack T. Franklin. Courtesy of the African American Museum in
Philadelphia. 170

Fig. 28. Jackie Robinson, Sidney Poitier and Sammy Davis, Jr. at March on Washington.
c. 1963. Photograph by Jack T. Franklin. Courtesy of the African American Museum in
Philadelphia. 171

Fig. 29. Photograph by Nick Ut. Reprinted by permission of AP/Worldwide. 200

Fig. 30. Photography by Joe McNally. Reprinted by permission of *Life*/Joe McNally. 207

Fig. 31. *Mom at Work*. From Carrie Mae Weems's Family Pictures and Stories series.
Courtesy of the artist and PPOW Gallery, NY. 276

Fig. 32. From Carrie Mae Weems's *Sea Island Series*. Courtesy of the artist and PPOW
Gallery, NY. 279

Fig. 33. From Carrie Mae Weems's *The Hampton Project*. Courtesy of the artist and
PPOW Gallery, NY. 282

Notes on Contributors

John Beck
John Beck teaches American literature and culture in the School of English at the University of Newcastle upon Tyne. He is author of *Writing the Radical Center: William Carlos Williams, John Dewey, and American Cultural Politics*. He has written for journals that include the *European Journal of American Culture, Nepantla: Views from South*, and *Southwestern American Literature*.

Pennee Bender
Pennee Bender is the Associate Director and Media Director of the American Social History Project at the Graduate Center of the City University of New York. Her PhD was on the government use of film in its policy with Latin America during World War 2.

S. Elizabeth Bird
S. Elizabeth Bird is Professor of Anthropology at the University of South Florida. Her publications include, as author, *The Audience in Everyday Life: Living in a Media World* and *For Enquiring Minds: A Cultural Study of Supermarket Tabloids*, and, as editor, *Dressing in Feathers: The Construction of the Indian in American Popular Culture*.

Linnie Blake
Linnie Blake teaches Film at Manchester Metropolitan University. Her research is predominantly concerned with the politics of horror cinema, and her publications include essays on Jorg Buttgereit, George A. Romero, and the serial killer in American popular culture.

Neil Campbell
Neil Campbell is head of American Studies at the University of Derby. He is author of *The Cultures of the American New West*, co-author of *American Cultural Studies: An Introduction to American Culture*, editor of *American Youth Cultures*, and co-editor of *Issues in Americanisation and Culture*. He is curator of the touring exhibition, *States of America: the Photographs of Michael Ormerod*.

Cat Celebrezze
Cat Celebrezze has a PhD from the New School for Social Research, and is the Associate Director of Dunvagen Music Publishers in New York City.

Bruno Chalifour
Bruno Chalifour is a photographer, photo historian and critic. He has taught and lectured on

photography in various schools and institutions in France and in the US. He is the editor of *Afterimage* magazine.

Cynthia Wiedemann Empen
Cynthia Wiedemann Empen received her PhD in American Art History from Indiana University, Bloomington. She is Director of the Staelens Art History Slide Library at Augustana College, Rock Island, Illinois.

Denis Flannery
Denis Flannery is Lecturer in American and English Literature at the University of Leeds. He is author of *Henry James: A Certain Illusion*, and is writing a book on the relationship between sibling love and queer attachment in American writing.

Francis Frascina
Francis Frascina is John Raven Professor of Visual Arts in the School of American Studies at Keele University. His books include *Art, Politics and Dissent: Aspects of the Art Left in Sixties America*, as co-author *Modernism in Dispute: Art Since the Forties*, as editor *Pollock and After: the Critical Debate*, and as co-editor *Art in Modern Culture: An Anthology of Critical Texts*.

Christopher Gair
Christopher Gair teaches American Studies at Birmingham University. He is the author of *Complicity and Resistance in Jack London's Novels* and *The American Counterculture* (forthcoming). He has also edited editions of Stephen Crane's *Maggie: A Girl of the Streets* (2000) and Jack London's *South Sea Tales* (2001).

Jonathan Gayles
Jonathan Gayles is Assistant Professor of African American Studies at Georgia State University. His research interests include the cultural meaning of educational achievement among African-American males, and the role of the media in enculturation.

Mick Gidley
Mick Gidley is Professor of American Literature at the University of Leeds. His most recent books are *Edward S. Curtis and the North American Indian, Incorporated*, and, as editor, *Modern American Culture: An Introduction* and *Edward S. Curtis and the North American Indian Project in the Field*.

Anna Gough-Yates
Anna Gough-Yates is Academic Leader in Media, Culture and Communications at London Metropolitan University. She is the author of *Magazines* and *Understanding Women's Magazines: Publishers, Markets and Readerships*, and co-editor of *Action TV: Tough Guys, Smooth Operators and Foxy Chicks*.

Paul Grainge
Paul Grainge is Lecturer in Film Studies at the University of Nottingham. He is the author of *Monochrome Memories: Nostalgia and Style in Retro America* and the editor of *Memory and Popular Film*. He has written for journals including *Cultural Studies*, *International Journal of Cultural Studies*, *Journal of American Studies*, *American Studies*, *Journal of American and Comparative Cultures*, and *American Studies International*.

Robert Hariman
Robert Hariman is Professor of Communication Studies at Northwestern University. His books include *Political Style: The Artistry of Power*, as editor *The Discourses of Prudence*, and as co-editor *Post-Realism: The Rhetorical Turn in International Relations*.

David Holloway

David Holloway teaches American Studies at the University of Derby. He is author of *The Late Modernism of Cormac McCarthy*, and editor of an independently published series, *Polemics: Essays in American Literary and Cultural Criticism*. He has written for journals that include *The Southern Quarterly* and the *European Journal of American Culture*.

Andrew Hoskins

Andrew Hoskins is Director of Undergraduate Studies in the Department of Media and Communication Studies at the University of Swansea. He is author of *Televising War: From Vietnam to Iraq*, and has written for journals including *Time & Society* and *The Historical Journal of Film, Radio and Television*.

Katherine Johnson

Katherine Johnson is Assistant Professor of Communication at St John's University in College-ville, Minnesota. Her essay is based on her doctoral work at the University of Minnesota.

Jean Kempf

Jean Kempf is Professor of American Studies at the University of Lyons. He writes about the history of American photography, particularly of the twentieth century, and American memory.

John Louis Lucaites

John Louis Lucaites is Associate Professor of Communication and Culture and American Studies at Indiana University. His publications include, as co-author, *Crafting Equality: America's Anglo-African Word*, as editor *Martin Luther King, Jr. and The Sermonic Power of Public Discourse*, and as co-editor *Contemporary Rhetorical Theory: A Reader*.

Eric Margolis

Eric Margolis is a sociologist and Associate Professor in the Division of Educational Leadership and Policy Studies, at Arizona State University's College of Education. He is editor of *The Hidden Curriculum in Higher Education*, and has produced a number of documentary projects including photo exhibits, slide/tape and multimedia programmes, and video programmes. His study of coal miners was broadcast as *Out of the Depths – The Miners' Story*, in the PBS series *A Walk Through the 20th Century with Bill Moyers*.

Sophia A. McClennen

Sophia A. McClennen is Associate Professor of Comparative Literature and Spanish, and Co-Director of the Graduate Program in Comparative Literature at Pennsylvania State University. She is author of *The Dialectics of Exile: Nation, Time, Language, and Space in Hispanic Literatures*, and co-editor of *Comparative Cultural Studies and Latin America*.

Don McComb

Don McComb is Associate Professor of Graphic Design at Upper Iowa University.

David Morgan

David Morgan is Duesenberg Professor in Christianity and the Arts at Valparaiso University (Indiana). Among his books are *Visual Piety: A History and Theory of Popular Religious Images*, and *Protestants and Pictures: Religion, Visual Culture, and the Age of American Mass Production*. He is editor of *Icons of American Protestantism: The Art of Warner Sallman*, co-author of *Exhibiting the Visual Culture of American Religions*, and co-editor of *The Visual Culture of American Religions*.

LeiLani Nishime

LeiLani Nishime is an Assistant Professor of American Multicultural Studies at Sonoma State

University. Her work has appeared in the journals *Amerasia*, *MELUS*, and *Cinema Journal*. She is editing an anthology, *Asian American Popular Culture*.

Bill Osgerby
Bill Osgerby is Senior Lecturer in Cultural Studies at the University of North London, and Pathway Leader for Mass Communications and Cultural Studies. He is author of *Youth in Britain Since 1945* and *Playboys in Paradise: Masculinity, Youth and Leisure-Style in Modern America*, and co-editor of *Action TV: Tough Guys, Smooth Operators and Foxy Chicks*.

Charlene Regester
Charlene Regester is an Adjunct Assistant Professor in the Department of African and Afro-American Studies at the University of North Carolina at Chapel Hill. She has published numerous essays on early black film stars and filmmakers in journals including *Film Literature Quarterly*, *Popular Culture Review*, *Western Journal of Black Studies*, *Studies in American Culture*, *Film History*, *Journal of Film and Video*. She co-edits the Oscar Micheaux Society Newsletter.

Michael Ryan
Michael Ryan teaches American film and culture, as well as courses in composition and criticism, at Northeastern University in Boston. His books include *Marxism and Deconstruction*, *Camera Politica: The Politics and Ideology of Contemporary Hollywood Film*, *Politics and Culture*, *Literary Theory: An Anthology*, *Literary Theory: A Practical Introduction*, and *Film Interpretation: An Introduction*.

Joan Saab
Joan Saab received her PhD from New York University in 1999, and is Assistant Professor of American Studies, and Assistant Professor of Visual and Cultural Studies, at the University of Rochester. She is the author of *For the Millions: American Art and Culture between the Wars*.

Tony Shaw
Tony Shaw is Senior Lecturer in History at the University of Hertfordshire. His publications include *Eden, Suez and the Mass Media: Propaganda and Persuasion during the Suez Crisis*, and *British Cinema and the Cold War: The State, Propaganda and Consensus*.

Maren Stange
Maren Stange is Associate Professor at The Cooper Union for the Advancement of Science and Art, in New York City. Widely published on American photography, Stange is the author of *Symbols of Ideal Life: Social Documentary Photography in America, 1890–1950*, co-editor of *Paul Strand: Essays on his Work and Life*, and co-author of *Official Images: New Deal Photography*.

Deborah Willis
Deborah Willis is a MacArthur Fellow and Professor of Photography and Imaging in the Tisch School of the Arts at New York University. Her books include *Black: A Celebration of a Culture*, *Reflections in Black: A History of Black Photographers 1840 to the Present*, and, as co-author, *The Black Female Body: A Photographic History*.

David A. Wragg
David Wragg teaches in the School of Cultural Studies at University College Northampton. His publications include essays on Wyndham Lewis and Frank Zappa. He is writing a book on Wyndham Lewis.

Acknowledgements

A number of people gave invaluable assistance, in various ways, in the preparation of this book. The editors would like to thank, particularly, Annie Bautz, Neil Campbell, John Cox, Sophie Cox, Paul Grainge, Martin Halliwell, Nick Heffernan, Alasdair Kean, Tristan Palmer, Simon Philo, Jenny Robinson, and Douglas Tallack. David Holloway would also like to thank the Arts and Humanities Research Board (AHRB) for the award of a 'Small Grant in the Creative and Performing Arts', which assisted in the preparation of the manuscript.

General Introduction

Towards a Social Theory of American Visual Cultures

DAVID HOLLOWAY AND JOHN BECK

When his ego disperses into the particles of the universe at the conclusion of the first chapter of 'Nature', the great nineteenth-century American mystic Ralph Waldo Emerson famously becomes a 'transparent eyeball': 'I am nothing; I see all' (Emerson 1982: 39). Emerson's choice of sight as the privileged organ for reception of the cosmos is unremarkable enough, given the conventional notion of the eye as the window to the soul, and what Chris Jenks refers to as the 'ocularcentrism' of modernity generally (Jenks 1995: 3) – its 'tendency to picture or visualize existence' (Mirzoeff 1998: 6). But the notion of a sight that renders the subject to nothingness is provocative, if the problem at hand is the formation of what we will call, following Jenks, a 'social theory' of American visual cultures (Jenks 1995: 1–25). For while Emerson is concerned with the raptures of immanent transcendence, the prospect of a seeing that annihilates the subject also provides one way of conceiving the limitations of agency achieved by the hypersocializations of 'spectacular' late capitalism, even as it provides (for some) a brilliant, perhaps even sublime and incandescent pleasure.

Where Emerson's transparent eyeball proposed a mystical oneness of all things united by their embeddedness in 'nature' and 'instinct', its twenty-first-century equivalent would likely posit an annihilation of the viewing self in rather different terms (today's avowedly material selfhood being no longer thinkable as the product of anything but culture, and thus, put differently, of history). To appropriate Emerson in this fashion in a twenty-first-century book about American visual cultures – and as Marx once did to Hegel, to stand him on his head – is therefore to raise particular pedagogical problems and possibilities. In the first instance it reminds us that the meanings of acts of looking (including our own acts of looking as editors of this book) are always overdetermined, and therefore 'strategically contained' (see Jameson 1989) by the socialized ground on which looking takes place. In the second instance it then allows us to locate acts of looking within an expansive social and historical frame, or totality – what Emerson called the 'oversoul', and what we will refer to here, rather more prosaically, as the material and ideological hegemony of capitalist-democratic social formation in the history of the modern United States.

The idea that anything so unified as 'America' actually exists is of course an ideological fiction, albeit a powerful one that can motivate as profoundly an 'anti-American' sentiment as it can a sense of unified patriotic endeavour. In proposing a social theory of American visual cultures by talking first about the history of a capitalist-democratic hegemony, and thence about the provisional 'totality' of American experience, we do not therefore propose a new mysticism to take the place of Emerson's old one. 'What we need', as W. J. T. Mitchell once put it, 'is a critique of visual culture that is alert to the power of images for good and evil and that is capable of discriminating the variety and historical specificity of their uses' (Mitchell 1994: 2–3). *American Visual Cultures* shares this desire for a nuanced and flexible critique, and our figuring

of modern American experience as the history of a 'capitalist-democratic totality' is intended to recognize this. First, in the acknowledgement that the capitalist history of the US is about rather more than the history of American capitalism. And second, in the recognition that the *material* organization of American social life is constituted in part by the *abstract* rhetorics of democratic entitlement and mutual recognition – and the frustration and contesting of these rhetorics across the social spectrum – that structure the ideological life of the 'nation' (and vice versa).

We should also note at the outset that the social theory of American visual cultures we propose is motivated in part by what we, along with many others around the world, consider to be a renewed historical transparency in the operating of American power-elites on the global stage. In the world order that is being consolidated and modified in the War on Terror, where the ability of US elites to intervene in global affairs (if not always monolithically) in pursuit of their own interests has been dramatically reconfirmed, there is, we feel, a renewed need to refocus critical attention on the continuities – not just the discontinuities – linking the diversity of constituencies who have not historically identified their own interests with those of US elites. Although today's social realm is conflicted and appears dispersed, it is also 'unified' by the fact that we are all conditioned by our structural position within the US-led global market, and hence by our class. Just as, in the era of 'multiple concurrent theatres of war', National Missile Defense, and what the Pentagon refers to as 'full spectrum dominance', we are also once again all either menaced, 'protected' or otherwise touched by American military power, and by the elites in whose interests that power operates.

Concurrently, of course, the social realm is also 'unified' in that we are all conditioned by constructed discourses of race, ethnicity, gender, sexuality, and by other embedded relationships of social power. The social realm of late American capitalist-democracy is thus stratified and contested, but it is not intrinsically atomized, any more than it could be described as a seamless historical unity. With a view to the construction of a social theory of American visual cultures, one that might stand as a strategic re-routing of that outlined by Jenks (where the social is cast as determinedly plural but is also diffuse and resolutely opaque), we might say instead that today's social realm may be viewed as a totality in so far as it is constituted by a multiplicity of overlapping power-relations in which we are differentiated, synchronically, as subjects, citizens and 'consumers'.

As the development of a 'transnational' American Studies in the 1990s suggests, the contexts in which these differentiations take shape are global as well as American. Indeed, one of the functions of transnationalist critical discourse has been to jeopardize further the old idea of 'American exceptionalism', the phrase coined by Alexis de Tocqueville in the 1830s to connote the existence of a unique, distinctive or 'exceptional' social order in the United States (Tocqueville 1966). But the global reach of US elites at the dawn of the new American century means that 'American*ism*' – 'an ism or ideology', as Seymour Martin Lipset once put it, 'in the same way that communism or fascism or liberalism are isms' (Lipset 1991: 16) – remains the most powerful nationalist discourse the world has ever known. This may be due, at least in part, to the opportunity US elites have historically had to articulate their own interests within more populist (but also bourgeois) conceptions of egalitarianism, democracy and republican self-government. 'A Coke is a Coke', Andy Warhol once wrote, for example, 'and no amount of money can get you a better Coke than the one the bum on the corner is drinking' (Warhol 1975: 101). We are asked to understand, here, that American democratic ideology is embedded in the machinery of mass consumption. Alternatively, it is also the case that the capitalist model of mass consumption is impossible to achieve without some form of liberal democracy to produce and protect the 'freedom' to buy the same thing as everyone else: needless to say, Warhol's aphorism also requires the structural presence of the bum on the corner in order to celebrate the 'classlessness' of both the product and the act of consumption. But the real democracy posited in Warhol's pictures of Coke bottles, and in the advertising images on which he drew, is one of objects rather than of social relations. When we are told in the advertising slogan that 'Coke is it', this is literally so. Coke is materially 'it', a thing among things, the reified democracy of American matter reanimated by the signs and surfaces of a commercial visual culture

that adds social, political and 'surplus' value to the commodity, whose only tangible value otherwise derives only from the acts of labour lodged within it. Coke's Coke and Warhol's Coke is therefore also 'it' in the sense that it is the supreme icon of American capitalism's fetishizing of commodities, its production and visual dissemination of a complexly layered national imaginary that can sell sugar water as the stuff – the 'it' – of liberty. And in this regard Coke is also 'it' because the visual culture constituting the meanings of Coke (in this instance Warhol's 'factory' images and the marketing discourses they encompass) *is* a piece of American capitalist-democracy, not merely an outgrowth from or representation of it.

In other words, and as Warhol clearly understood, the functioning of normalizing visual codes cannot now be seen as 'superstructural' excrescences of capitalist-democratic practices, but as integral to their very dynamism, their legitimation, and in these respects at least, their continued success. In a diverse, polyglot society that has been constantly remade by generations of immigrants, visual communication has often been a vital instrument for the inculcation (and unsettling) of dominant political and moral values, and for the transmission (and contesting) of normative patterns of behaviour and habit. The early implementation of sophisticated visual codes in republican portrait painting and in landscape art and photography, in advertising and other commercial promotion, in advice literature and political tracts, and later in mass forms of visual entertainment, knowledge and display (particularly film and TV), have been an essential part of the architecture of the American capitalist-democratic polis, and also a complexly undecidable product of it. Today, the proliferation of American visual cultural forms 'produces' the everyday lived environment of cities through the street furniture of hoardings, billboards, signs and notices. American print culture, too, is itself a largely visual culture. Newspapers, periodicals, comic books, postcards, pornography, advertising brochures, mail order catalogues, mission statements, university prospectuses, maps, train timetables, postage stamps, candy wrappers, milk cartons, websites and wanted posters all vie for attention in the field of vision. The ubiquity of visual culture today, and the circulation of capital as visual information and entertainment, mean that visual culture can no longer be construed, if indeed it ever could be, as a simple 'reflection' of historical experience, or as a 'distortion,' something added onto the 'real' to ameliorate and contain, or divert us from, its contradictions. 'In this swirl of imagery', if we might rework Nicholas Mirzoeff's observation, 'seeing is much more than believing. It is not just a part of everyday [capitalist-democratic] life, it is everyday [capitalist-democratic] life' (Mirzoeff 1999: 1).

A number of issues arising from this recognition recur throughout this book. In the first place, the everyday-ness of many visual cultural forms, and their immediate, language-blind impact, has historically caused concern among commentators fearful of what we might refer to, these days, as 'dumbing down' (see ibid.: 9–13). The paradox here is that the elite interests invested in disseminating the 'itness' of Coke are also responsible for the slow collapse of elite taste regimes and systems of 'high' cultural value. This is a disaster, if elite, 'highbrow' cultural practices are thought to embody the promise of resistance to commodification by virtue of art's intrinsic non-instrumentality (see, for example, Adorno 2003). On the other hand, from an avant-gardist position that seeks to rid culture of the fetish for auratic art, the demise of 'serious' cultural values might not be such a bad thing, even if they are destroyed at the hands of a corporate-cultural matrix characterized by class domination, oligarchic market share, the pseudo-sensual vibrancy of commodity culture and the 'itness' of Coke. In part this is because the battle for the preservation of a 'high' visual culture never really came to much in the US anyway. As a number of the essays in this collection demonstrate, much American art in the modern era has often sought to democratize its subject matter, as well as its forms, by drawing on mass cultural and vernacular forms. When Marcel Duchamp wrote in 1917 that the 'only works of art America has given are her plumbing and her bridges', this was not intended as a sleight, but as a recognition that capitalist-democracy must, of necessity, transform the very conception of the relation between art and life (Duchamp 1992: 248). Even more contemporary artists positioned in an overtly critical relationship to mass consumption – for example, Richard Prince, Jenny Holzer, or Sherrie Levine – tread a fine line between subversive appropriation and celebration.

What is at issue today, we suggest, indeed what has always been at issue in the United States, is not the erosion of the timeless value of the 'best' or most moral products of a civilization by the 'massification' of culture. The real concern (which itself derives in part from the contradictions between capitalist domination and rhetorics of egalitarian entitlement and republican responsibility) is how the modalities of visual culture inevitably work both with and against normative values at the same time. The construction of a modern fine art commensurate with 'American' values, for example, has in large part involved a (not uncontested) capitulation to the tropes of a bourgeois capitalist realism that sees the avant garde as, in Thomas Crow's terms, 'a kind of research and development arm of the culture industry' (Crow 1996: 35). By the same token, however, American visual cultures can hardly be inured against the contradictions of the social order in which they are constituted – contradictions that enable resistant counter-readings, creative reappropriations, and cultural embodiments of the commodity form that are not, somehow, simply acts of commodification. What is clear in many of the essays collected in this volume is that even when the production of visual information appears to be at its most affirmative, it may also contain a turbulent undertow that throws into question the validity of the meanings or the social relations it affirms. Likewise, it is equally evident that critical or subversive tendencies in American visual cultures, and in the acts of looking by which we engage them, tend to find themselves compromised and implicated in the machineries of domination they may seek to expose and overthrow. One conclusion that can again be drawn from these dialectical frustrations is that any visual code is always imbricated in the broader contradictions upon which the modern capitalist-democratic social formation is built. Another is that no affirmative message completely meets its target, just as no act of resistance ever fully extricates itself from dominant ideologies. The modern mass media of cinema, television, and print journalism control their own respective means of production, and police their content, as rigorously and systematically as 'high' art institutions have sought to maintain economic and cultural power through the regulation of taste, distinction, and value. This broad process of containment has not, of course, eliminated dissent. But as many of the essays in this collection imply, criticism today must often work in the cracks, disjunctions, and inconsistencies within dominant practices and ideologies. Taken collectively, the essays in this volume recognize this awkward and complex relationship between resistance and consent, and seek to explore some of the contours of that complexity.

In the contexts of institutional academia, considering the visual mediation of social life has meant confronting the role of culture in general in the reproduction of the world, and in the histories that have provided the condition for the emergence of the contemporary over time. In this respect, an interest in the social and political effects of mass culture in its various 'spectacular' modalities has provided one characteristic focus for commentators, whether it be the radical situationist interventionism of Guy Debord in the 1960s or the concerned citizens who organize to protect society from the 'corrupting' influence of movies, MTV, porn and the internet. Wherever this criticism comes from politically, a shared (and sometimes patronizing) assumption has often been the impressionable malleability of a mass cultural audience constituted by socially or politically marginalized groups – immigrants, workers, women, and/or children.

In responding to and qualifying this legacy, the canonical criticism of visual culture studies has come to embrace a set of assumptions drawn from the institutionalizing of poststructual and postmodern methodologies within cultural studies and social theory. In part this has led to the pluralizing of the critical discourses through which culture can now be studied, and to a critical expansion of the social terrain in which it might be said to operate. In particular, the stress on the function of the audience as an active, participatory presence in the production of a text's meaning has transformed the way in which cultural studies now works, and has become a critical orthodoxy in the emergent field of interdisciplinary visual culture studies. Stuart Hall, for example, echoes many other visual culture critics when he writes that 'The power or capacity of the visual sign to convey meanings is only "virtual" or potential until those meanings have been realized in use. Their realization requires, at the other end of the meaning chain, the cul-

tural practices of looking and interpretation, the subjective capacities of the viewer to make images signify' (Evans and Hall 1999: 310).

That the meaning of the 'text' is multiple, that its 'truths' are contingent upon the relative social, economic and political location of the reader or reading group, has been the greatest and most enduring lesson of contemporary theory, and has substantially informed the field of visual culture studies. Indeed, one persuasive signifier of the extent to which interdisciplinary visual culture studies has emerged as a more or less full-formed 'postmodern' discourse – unlike the older monodisciplinary contexts of film or photography studies, for example – has been its inversion of the old binary that privileged the interrogation of the text's production over the circumstances in which it is received. This inversion is visible in the language as much as in the methodologies that critics of visual culture have used to delineate the field. To do visual culture studies, Nicholas Mirzoeff's *An Introduction to Visual Culture* suggests, is 'to study the genealogy, definition and functions of postmodern everyday life from the point of the *consumer*, rather than the producer' (Mirzoeff 1999: 3, emphasis added). Similarly, Marita Sturken and Lisa Cartwright's *Practices of Looking: An Introduction to Visual Culture* argues that 'meaning does not reside within images, but is produced at the moment that they are consumed by and circulate among viewers' (Sturken and Cartwright 2001: 7).

The early critical work of interdisciplinary visual culture studies, then, stresses the contextual positioning of acts of looking, arguing that images are produced and consumed in a social realm of constructed and contested social and political power and knowledge. To this extent, visual culture studies does not exclusively interrogate visuality in terms of acts of looking, or acts of 'consumption' alone. Yet there is a sense that, due to its own self-consciously postmodern historical construction as a discipline, visual culture studies has privileged a methodology that is less interested in historicizing culture than in what we might call the culturalizing (or better, the acculturation) of history. At times, indeed, visual culture studies can look like a set of methodologies that positions cultural 'consumption' as the motor force and meaning behind the construction of history itself. Through systems of representation like visual images, write Sturken and Cartwright, 'we actually construct the meaning of the material world' (ibid.: 13). While for Mirzoeff, the ability 'to absorb and interpret visual information' is nothing less than '*the basis of industrial society*', with visual culture thus accorded 'a determining role . . . in the wider culture to which it belongs' (Mirzoeff 1999: 5, 4, emphasis added).

Though statements like these may be intended to collapse the 'production' and 'consumption' binary, and to recognize the constant and mutual mediation of each sphere by the other, what really seems to be effected is the relegation of cultural 'production' – as the hopelessly opaque, unknowable historical absent – in favour of the 'consumption' of images. If the act of looking is to be conceived as 'the basis of industrial society', then it is granted a privileged and determining role in the shaping of the history of capitalist-democratic social relations. History is not said to create culture; culture, in individual acts of looking, is said to constitute history. Through this veiling of the history of production, visual culture studies repositions the truths constructed by the individual 'consumer' of images, or by different, relatively-placed 'consumer' groups, as transcendent. The transparent eyeball of the late capitalist 'consumer' is nothing but sees all, for there is no identity or history, no mode of socialization or production, accessible beyond the reified act of looking.

Moreover, while it is one thing to suggest that history is made up of everyday experience as it is actually lived and understood by human beings, it is another thing entirely to imply, as visual culture studies has sometimes done, that it is only everyday experience that constructs history, or that our everyday experience of the world around us is identical with the way that history works. The viewer and the viewed may be 'mutually constitutive' (Evans and Hall 1999: 310), but in a world where power is distributed unevenly, and where social relations are both the source and the everyday form taken by this inequality, viewer and viewed are not necessarily 'mutual' in the sense that they are always *equally* constitutive. The meanings of a US energy company's logo displayed on a billboard in Kabul or Baghdad may be determined subjectively in any number of ways by the gaze of the indigenous 'consumer' of images. But none of the

meanings she might construct or derive from the image on display would necessarily trouble or dislodge the historical meaning of that image as an emblem of US corporate power, whose flowing across international borders as both capital and military violence provides the empirical conditions in which display and consumption of the image is made possible.[1]

This is perhaps one of the unspoken meanings we might derive from Stuart Hall's observation that 'cultural effects have to be seen in terms of how meaningful discourses construct what is held to be "normative", which of course regulates conduct, but in ways which cannot be reduced to or empirically measured as a behavioural impulse' (ibid.: 311). To extrapolate an example of what we take to be Hall's intended meaning, while Classical Hollywood narrative may project a set of codes constitutive of what is considered 'normal' femininity, this in no way means that female or male viewers of Classical Hollywood films necessarily act out these prescriptions in their everyday life. Cultural effects do not come with predetermined meanings that are absorbed and reproduced by passive audiences. At the same time, however, Hall's observation also alerts us to the historical limitations that impose themselves on the looker as the act of looking takes place. The Afghan or Iraqi viewer of the oil company's billboard may respond with resentment to the brand logo and the values it seeks to define as normative. But until the accumulation of such acts of looking forces a 'behavioural impulse' – in, for example, a restructuring of the hierarchies in which Iraqi/Afghan citizens and US elites are, to say the least, differentially placed – the critical act of looking cannot be said to have effected any tangible 'empowerment' of the looker. The act of looking, we might infer from Hall, does not necessarily translate into practical, transformative action, or the meaningful empowerment of exploited or marginalized constituencies. To assume otherwise, we suggest, is to embrace an idealist or utopian intellectual premise that may have a certain strategic or gestural value, but which is ultimately predicated upon little more than the putative creative freedom of insightful looking.

As editors we believe that the freedom to produce and consume one's 'own' meanings in the reception of a given visual text can only exist, in any meaningful sense, when the historical domination of certain social groups over others, and the capacity of some to shape the world ideologically in their own image, is no longer a social, political and economic reality. Of course, reciprocal relations exist between objects/images and their audiences. But to assume that the act of looking is always formed in a mutually 'powerful' relationship with the other variegated contexts in which visual forms and practices are produced, is to risk reintroducing, albeit in damaged form, the kind of antiquated (and ideological) assumptions about the instrumentality of the 'centred' bourgeois self which contemporary social theory and cultural studies have worked so hard to undermine.

Here we might add that the fact that visual culture studies has tended to conceive the viewing subject as a 'consumer' of images (rather than as a 'citizen', say, who is a 'participant observer') suggests that the dominant critical paradigm of the field accepts the logic of the late capitalist market-place as a historical given, rather than as something that has been contested, or that *can* be contested, and whose development over time has taken place at the exclusion of other possible modes of securing our material life.

This naturalizing of market ideologies in the vocabulary assigned to the critical interrogation of marketplace visuality seems buttressed by the operating of a further contradiction in visual culture studies. To describe the world, as visual culture studies has done, as a nexus of social and political power-relations in which collective groups seek and wield influence over others, but at the same time to describe our negotiations with visual culture as essentially individualistic acts analogous or identical to individualized acts of commodity consumption, may be to risk leaving the collective character of historical power (and the collectives who wield it) more or less untouched by the critical act. That this atomization can also be enabled by various forms of mass visual experience – the darkened hall of the cinema or the domestic incarceration of the television viewer, for example – reminds us again that the contexts in which individuals consume images are also material and institutional contexts in which the notional empowerment of the viewer is always circumscribed by powers that emanate from sources beyond the self.

As proponents of a social theory of American visuality we therefore assume that the kinds of visual culture a society produces, and the meanings assigned to images during their moment of 'consumption', depend upon the kind of society, and hence the historically specific social relations, in which the production and consumption of visual culture takes place. We also assume that historical social relations may be said *figuratively* to pre-exist – though they are also modified and mediated by – the cultures that arise within them. In suggesting this, we do not seek to return to what some critics of visual culture have referred to as an outmoded 'productionist' model, in which the possible meanings of discrete visual artefacts are thought to inhere within themselves, aside and apart from the institutional contexts and acts of looking (i.e. audiences) in which they are constituted as meaningful objects or forms. And such an approach need not stress, as Jenks would have it, a 'deskilling' of the capacity of 'everyday members of the culture' to function as 'interpretive beings' (Jenks 1995: 14). Rather, we maintain that visual artefacts are first and foremost historical products, and that the particular groups or gazes whose experience is enacted and mediated by those artefacts are themselves produced by the larger historical processes in which they seek, as human actors, to intervene. Such an approach does not seek to withdraw or compromise the capacity of individual 'consumers' to construct their own meanings from visual images or acts of looking. But it does emphasize the extent to which normative codes and ways of seeing – according to their very status *as* norms that persist and are reconstituted over time – constantly reimpose themselves upon and re-contain the acts of interpretive looking brought to bear upon (or within) them.

Our suggestion that the historical production of social relations (and hence power) should be seen to precede, figuratively, the production of visual culture, rests on our assumption that whereas power can exist without a dependence on culture to transmit and negotiate it, culture cannot exist without power, because culture is itself a set of transmissions and negotiations with power. As it is exercised in post/modernity power may have become 'cultural', in the sense that it is reproduced not simply through the application of material or physical force, or through the embodiment of this in law, but also, and perhaps primarily, through the practices of everyday labour and leisure. Modern power, as Jenks notes (following Foucault), 'has the deft touch of a "look" in interaction. It no longer requires the hard-edge and the explicit realisation of the *ancien régime*. The "gaze" and the conscious manipulation of images are the dual instruments in the exercise and function of modern systems of power and social control' (ibid.: 15). But they are not the only instruments, or sources, of power. And unless power is to be defined as nothing more than a social bonding agent or glue that sticks accidentally to some more than it does to others, its functioning must also be described as the expression of dominant points of view – which in practice may mean the expression of power*ful* elite interests, or of resistances that have developed to an extent that elite discourses are driven into, as it were, a process of negotiation, compromise or retreat. Power always has an object on which it operates. But it must also have a historical/social subject from which it emanates, and from which it derives its being and its consequences (even if the subject is multiple, the distinction between subject and object is not necessarily clear, and the consequences are not as intended). This does not mean that we view visual culture as a secondary or parasitical presence that derives its every detail from a primary or originary historical ground, or that we see American visual artefacts and modes as mere 'reflections' of a single underlying truth about life as it is lived in the United States. But implied within the editorial contributions to this book there is an assumption that the act of looking, which constitutes the otherwise inert object as a meaningful visual text, is itself a historically produced procedure; that looking – and the meanings that looking decodes from the visual objects upon which it rests, and from the modes in which it operates – is thus also an act that is 'produced' by and within the material realities of the histories in which looking takes place.

This volume engages primarily with film, television, photography, painting, graphic illustration, advertising and visual news media. We hope this will not be taken as an attempt to delimit the field of visual culture studies by excluding, say, architecture, or other aspects of material culture, or, for that matter, any other 'form of apparatus designed either to be looked at or to enhance

natural vision' (Mirzoeff 1999: 3). On the contrary, one of the real strengths of the emerging field of visual culture studies, we believe, is its commitment to doing *interdisciplinary* work. This commitment acknowledges the saturation of our current historical moment in a plurality of visual media, and thus grapples with visual culture as it finds it historically, rather than as it might wish it to be. In its acceptance that culture is created within a plastic (because infinite) totality of overlapping historical contexts, interdisciplinarity also has a further value, we will suggest, in that it helps create the hermeneutic and pedagogical conditions for a truly social theory of visuality.

The interdisciplinarity of visual culture studies may be described in two broad ways. It is interdisciplinary in the sense that it brings together and juxtaposes the study of discrete 'disciplines' – film studies, art history, TV studies and so on, each of which is constituted as a plurality of practices and forms. It is also interdisciplinary in that it recognizes the intensive cross-fertilization and hybridizing of images and their meanings that is characteristic of mass media and late capitalist commodity-culture generally. Think only, as Sturken and Cartwright note, of the endless reproducibility, in multiple different contexts, of iconic images of Marilyn Monroe, or John F. Kennedy, or of paintings such as the *Mona Lisa*, or Edvard Munch's *The Scream* (the latter having been reproduced not only on posters and postcards but having also proliferated 'as a kind of kitsch object – an inflatable figure, a birthday card, a key chain, a refrigerator magnet . . . a reference in the 1996 film *Scream*, in which the killer wears a *Scream*-inspired mask' [Sturken and Cartwright 2001: 125]). In this respect, visual culture studies may again be seen as symptomatic of the historical period in which it has emerged as an academic discourse, its emphasis on exploring the cross-fertilization of visual images across different cultural modes paying fidelity to the intensive commodifying and hybridizing of culture in our time.

Interdisciplinary approaches to the study of culture and society remain surprisingly controversial, often regarded within higher education institutions as practices that – by challenging the extant division of academic labour into discrete specialisms and localized disciplinary fields – must weaken our understanding of the distinctive phenomenological properties of discrete cultural forms and practices. In contrast, we assume that by expanding and multiplying the contexts in which the peculiar formal organization and discrete historical significance of particular cultural modes might be seen to operate, interdisciplinary approaches to the study of culture tend to enhance rather than diminish our understanding of how specific cultural forms and practices have functioned, aesthetically, socially and politically, over time.

In the field of American Studies, there has also been a debate about the tendency of interdisciplinary enquiry to invoke what Paul Giles has referred to as 'the illusion of synchronicity, or the synecdochic fallacy', by which he means a suspicion that interdisciplinarity simply provides 'discourses which turn into mirror images of each other, where a line of extension is drawn between text and context as though they fitted together through the organicist trope of synecdoche' (Giles 2000: 14). As we understand it, however, there is nothing intrinsic to interdisciplinary visual culture studies, or to interdisciplinary cultural studies in general, that leads necessarily to the kind of foreclosing or unifying of critical practice that worries Giles. As we use the term here, the interdisciplinary study of culture rests finally on the assumption that the production and 'consumption' of specific cultural artefacts takes place within an expansive totality of other social practices, experiences and forms, and that specific cultural encounters are merely localized instances of historical experience in a broader sense. If culture is irreducibly historical, and history itself can be said to acquire its momentum from the conflicts and antagonisms (just as much as the consensuses) out of which it is made, then the interdisciplinary study of culture is as likely to reflect upon rifts, tensions and discontinuities, as it is to assemble them into new ironclad unities or crude 'mirror images of each other'.

There is no reason, therefore, to assume that interdisciplinary approaches to the study of history/culture must necessarily invoke a 'synecdochic fallacy', or must close down in whatever other way the terms upon which critical engagement with history/culture might take place. Interdisciplinary criticism, to us, means a methodology that recognizes not only the plurality of the social realm, but which also stresses the interlinking of multiple social, cultural and histor-

ical contexts in a totality that is itself always provisional, in the sense that it expands or contracts, becoming plastic or porous, according to the diversity of social and historical experience in which the interests of students, teachers and critics are formed. Unlike Jenks, our social theory of visuality does not therefore assume that 'All concepts of totalities are merely glosses of an unattainable unity' (Jenks 1995: 8). In its interdisciplinarity, it places an emphasis on the building and continuous rebuilding of expansive historical totalities in which visuality might be situated, and it connotes a process of coming to 'know' the visual through the historical social relations in which the visual is produced. But it also defines 'knowledge' and historical 'totality' provisionally, as plastic multiplicities constituted by the overlapping social relations and cultural forms characteristic of particular periods of historical and cultural production.

In the editorial structuring of the book into a set of more or less chronological narratives from the US Civil War to the US War on Terror, we have not aimed, as editors, to present an exhaustive account of modern American history. Nor would we claim to have assembled a comprehensive taxonomy of American visual cultures, or of the possible approaches to visual culture criticism. Our intention is not to form new historical or cultural canons. Contributors to *American Visual Cultures* vary widely in the particular political commitments they articulate or do not articulate, and they draw, in sum, on a range of the critical paradigms that have informed visual culture studies during its emergence as an interdisciplinary field. While we do not necessarily agree, as editors, about where such a social theory of the visual might lead (just as we would not expect individual contributors to agree either with us or with each other), in the Introductions to each of the four separate Parts of the book we have outlined a range of issues that seem to us to have had a decisive influence, in one way or another, on the construction of US social life and the historicity of American visual culture in the particular period at hand. Throughout the book, a number of narratives recur, illustrating the intersections of visual culture with key domestic and foreign policy issues of the nineteenth and twentieth centuries. Among these are the construction and reproduction of elite military, economic and 'political' power at home and abroad, the development of feminism and the women's movements, and the establishment and contesting of racial, ethnic, sexual and class hierarchies. Certain essays also trace historical factors that have informed the technological, institutional and aesthetic development of different visual forms and practices across time. In the interplay between the diverse issues and events covered by individual contributors, our own contributions as editors, and the extant canon of visual culture criticism, our aim has been to provide students and teachers of US visual culture with a resource that exemplifies the historicity of at least some of the visual practices and acts of looking that have become established as core elements within the emerging field of interdisciplinary visual culture studies.

Note

1. The logo of the Unocal Corporation, say, whose attempt to build a gas pipeline from the petroleum rich Caspian Sea through Turkmenistan, Afghanistan and Pakistan was thwarted by the Taliban, and on whose behalf the Bush administration had been pressurizing the Taliban leadership in Kabul in the months prior to 9/11. Hamid Karzai, appointed leader of the US-controlled interim Afghan administration in December 2001, formerly worked as a Unocal consultant, as did Zalmay Khalilzad, who was appointed US special envoy to Afghanistan at the same time as Karzai.

Part 1: 1861–1929

Introduction to Part 1

DAVID HOLLOWAY AND JOHN BECK

US history between the late antebellum period and the Wall Street Crash is constituted by the stories of many American ages. It contains contested ages of imperial war, civil war and world war, industrialization, urbanization and early 'Fordism'. It encompasses the age of Reconstruction, the Gilded Age, the Progressive Age, the Machine Age, the age of suffrage and mass politics, one of several ages of mass migration from the South to the North, the age of nativism, several different cyclical ages of capitalist boom, stagnation and bust, and many other synchronic and diachronic ages besides. The essays collected in Part 1 of this collection demonstrate the intersection of US visual cultures with at least some of these contested American ages. Collectively they address a number of visual mediations that occurred during the 'modernizing' of victorian American sensibilities, and within the unifying articulations of 'nationhood' that flowed out of and beyond the age of heroic bourgeois expansion in the United States.

During the middle decades of the nineteenth century, either side of the Civil War, the culmination of the long bourgeois revolution in the US brought capitalist-democracy to the American South, the Southwest and West, and by the turn of the twentieth century the reach of US capitalist-democratic elites extended beyond American borders into the Pacific Ocean and Caribbean Sea. Capitalist-democratic ideologies of nationhood formed part of the public discourse of the mid-late-nineteenth-century US, and to this extent they frequently functioned, as they do today, as powerful tools for the legitimation and reproduction of elite agendas and imperial initiatives. Most famously, in 1845 the editor John Louis O'Sullivan announced that it was America's 'manifest destiny to overspread the continent allotted by Providence for the free development of our yearly multiplying millions'. O'Sullivan's coining of 'manifest destiny' as a trope for US nationhood was timely. Between 1846 and 1848 the US fought a war of plunder against Mexico, during which American troops occupied Mexico City. At the end of the Mexican War large areas of the Southwest – including the modern states of California, Nevada, New Mexico, and parts of what would become Utah, Arizona and Colorado – were ceded to the United States. By the time that historian Frederick Jackson Turner announced the Western frontier closed in 1893, formative attempts at controlling the northern Pacific coastline, with a view to controlling access to markets in Asia, had taken manifest destiny out into the world. In 1898 the Spanish-American War confirmed the ambitions of Anglo-American elites in the Caribbean, leading to the annexation of the Philippines from Spain.

From the 1820s through the 1870s, ideologies of 'national' identity were visualized most emphatically by landscape painters (and patrons) of the Hudson River school, a loosely affiliated group based predominantly in the Northeast, and whose gaze after the Civil War was fixed firmly on the West. From the 1820s the plurality of styles associated with Hudson River painting evoked interlinking, but often conflicted narratives, stressing the pursuit of 'national' distinctiveness, moral law and capitalist enterprise in Nature. In 1836 the man sometimes referred

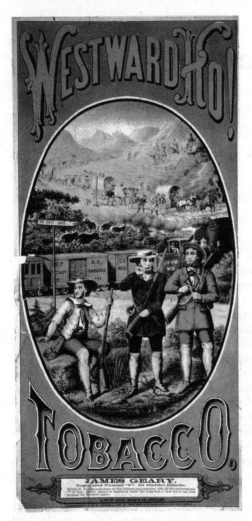

Fig. 1. A poster advertising Westward Ho tobacco (1868). (Photo by MPI/Getty Images.) Courtesy of Getty Images.

to as the 'founding father' of Hudson River style, the patrician Thomas Cole, wrote to his patron Luman Reed 'they are cutting down all the trees in the beautiful valley on which I have looked so often with a loving eye', asking that Reed encourage Cole's Hudson River compatriot Asher Durand to 'join with me in maledictions on all dollar-godded utilitarians' (Noble 1964: 160–61). The aspiring aristocrat Cole had as his early patrons 'rich Federalist families, landowners, merchants, and lawyer-politicians with long roots, [who] had aristocratic pretensions and formed a kind of American squirearchy: men like Stephen Van Rensselaer III, America's biggest landlord in the 1820s, and the merchant Philip Hone' (Hughes 1997: 141). But the class to which Cole aspired was a decaying class, one whose ascendancy had gone, and his preference for a pastoral republic governed by virtuous aristocratic elites at times assumed overtly polemical form – particularly so in his middle period, in paintings such as the famous *Course of Empire* series (1836), where Cole's class-conscious eye contrasted the moral perpetuity of nature with the, as he saw it, vulgar decadence of bourgeois Jacksonianism. Pitched into the depredations of his age, which for Cole meant the shifting axis of class power and the nascent hegemony of the market economy, his aesthetic took solace in the divinity of American nature (the 'American sublime'), and in the degree of moral, if not social, elevation that accompanied its rendering in paint.

At the same time as the West was reinvented nostalgically, in the later nineteenth century, as the primal ground of a pioneering democratic mythos, and as an environment in which masculine individualism might flourish unbound by external restraint, by 1891 '365,000,000 acres of land [in the West] or an area ten times the size of Illinois were not open to homesteading and an additional 50,000,000 acres had passed into the hands of speculators' (Gates 1989: 154). The postbellum commodifications of Western wilderness, and the complementary association of Westward 'expansion' with the freedoms of Anglo-American 'progress', saturate late-nineteenth-century US visual culture, from commercial advertising images such as Figure 1, all the way to the 'high' art of an iconic painting such as John Gast's *American Progress* ([1872], Figure 2).

Considered retrospectively, within a future lineage incorporating Westward Ho tobacco and Gast's *American Progress*, other Hudson River landscapes seem more sanguine than Thomas Cole about the quotidian surge of the market in the second quarter of the century. The conjunction of God and nature, and the ease with which the viewing eye is sucked into a distant vanishing point (crossing land, water and space to get there) in an early Hudson River painting such as Thomas Doughty's *In Nature's Wonderland* (1835), anticipates the 'imperial gaze' that would characterize later outgrowths of Hudson River style – particularly the 'Rocky Mountain school' work of painters such as Albert Bierstadt and Thomas Moran (see Boime 1991; Kinsey

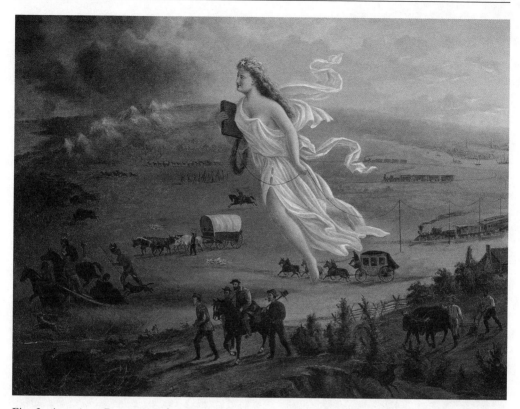

Fig. 2. *American Progress*, John Gast. Oil on canvas, 1872. Courtesy of the Museum of the American West collection, Autry National Center.

1992; Miller 1993; Novak 1995). By the turn of the century, the paintings Moran made of the Great Geyser Basin and surrounding areas of Yellowstone would be recycled and (re)commodified as images in railroad advertising. But when Moran and the photographer William Henry Jackson accompanied Ferdinand Vandiveer Hayden (Director of the Geological and Geographical Survey of the Territories) on the third major expedition to Yellowstone in 1871, the iconic nationalism of the images they made there was already an explicitly class-intervention. The company's patron on the Yellowstone trip was Jay Cooke and Company, financiers of the Northern Pacific Railroad, whose corporate strategy included plans to establish a 'tourist mecca' (Nash 1982: 111) in Yellowstone, to be served exclusively by the Northern Pacific. While Hayden acted as Cooke's representative, lobbying congressmen to sponsor the project by designating Yellowstone a National Park, Moran's paintings and Jackson's photographs (Figures 3 to 6) were shown around the corridors of the Capitol, advertising (already) the wonders of the West (Kinsey 1992: 53–64).

The therapeutic flooding of colour across Moran's Yellowstone pictures, their Ruskinian melding of nature, religion and private moral vision, their patronage, and their assertion that the West was already (in advance) a distinctively 'American' terrain, make them exemplary documents of bourgeois expansionism in the mid-nineteenth-century US. But if, like the earlier Hudson River work of Thomas Cole, the Western landscapes of Thomas Moran or Albert Bierstadt are therefore exemplary in part because of the class interests they embody, they are also exemplary in their articulation of the conflicts and contradictions such interests entail. Moran was the son of an immigrant handweaver from Lancashire in England, his family displaced by the mechanization of labour in the Industrial Revolution. The extent to which he was aware of the corporate agenda of the 1871 Yellowstone expedition is unclear. And, just as Albert

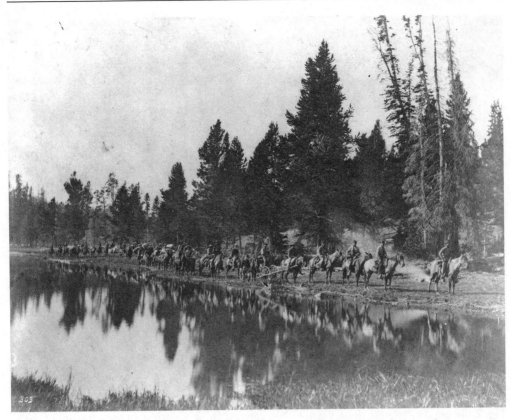

Fig. 3. William Henry Jackson. *US Geological Survey pack train on trail along the Yellowstone River* (1871). Library of Congress, Prints and Photographs Division, LC-USZ62-20198 DLC.

Bierstadt's shimmering Western edens sometimes look too delicate, their sheets of light so translucent that they might dissolve or fade under too insistent an 'imperial gaze', so too the fallen boulders that litter Moran's paintings, balanced precariously on slivers of rock too fragile to bear their weight, evoke a wilderness vulnerable to bourgeois conquest and commodification.

Moran's work may also be viewed as an exemplary late-nineteenth-century American visual culture because of its 'undecidable' imbrication in the variety of other conflicted contexts in which manifest destiny was set. The bringing of capitalist-democracy to the South and West, for example, was also a gendered process, its popular iconography, and until recently its institutional history, being overwhelmingly masculine – and overtly masculin*ist* – in content. And as Mick Gidley illustrates in the opening essay of this collection, manifest destiny was also an explicitly racial programme that legitimized the 'imperial' act by visualizing non-Anglo identities and precapitalist-democratic societies as historical contingencies or mistakes.

As Gidley suggests, the conquest and settling of the lands west of the Mississippi was accomplished not just by force, but also on a cultural and ideological level, where the doctrine of manifest destiny and the racial hierarchies it erected were circulated, legitimized and reproduced in the daily experience of American citizens. Gidley discusses some of the roles played by photography and photographers in this process, emphasizing both the visual construction of American Indians as a savage and thus 'vanishing' race, and later, when land clearances were complete, the emergence of an anthropological photography that fetishized the notion of a pure and vanishing Indianness in images that would 'float free of the particular historical circumstances' on which they reflected. While Gidley thus views contemporary photography as a visual corollary

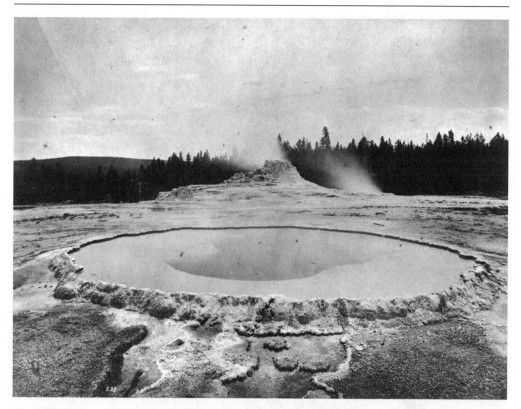

Fig. 4. William Henry Jackson. *Crater of the Castle Geyser* [Yellowstone] (1871). Library of Congress, Prints and Photographs Division, LC-USZ62-27952 DLC.

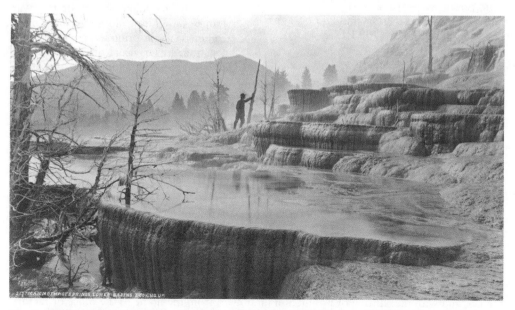

Fig. 5. William Henry Jackson. *Scenery of the Yellowstone National Park – Mammoth Hot Springs, lower basins, looking up* (1872). Library of Congress, Prints and Photographs Division, LC-USZ62-44164 DLC.

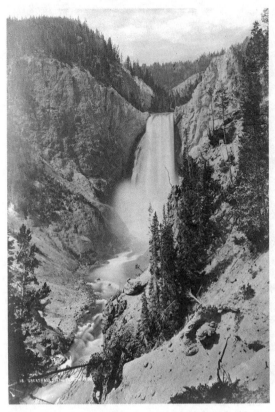

Fig. 6. William Henry Jackson. *Great Falls of the Yellowstone River* (1872).
Library of Congress, Prints and Photographs Division, LC-USZ62-16709 DLC.

and ideological prop to the expropriation of American Indian land and 'fully part of the process of conquest', he also comments on images in which Indian subjects themselves clearly sought to undermine the dominant stories told about them by photographers. In the closing part of the essay Gidley borrows from postcolonial theory to comment on the development of these acts of subversion into a revisionist tradition of 'photographing back', in which twentieth-century American Indian photographers have sought to reclaim, and literally re-vision, the histories occluded by the doctrine of manifest destiny and by US 'imperialism' across the contiguous continent.

The long bourgeois revolution in the United States was also fought (and resisted) in the slave-South, as the rapid development of capitalism in the second quarter of the nineteenth century led to a divergence of elite Southern and Northern class-interests and Civil War (Ashworth 1995). As Cynthia Wiedemann Empen notes in her essay, throughout the conflict the immanent harmony of imagined nationhood was further destabilized by the entrance of women into the public and primarily masculine sphere of the War. Empen shows how illustrated journalism, commercial art prints and photography functioned as a visual field in which the antebellum cult of female domesticity – which defined bourgeois and middle-class women as moral guardians within the home – was both troubled and reinforced by contending positions on the gendering of political rights and the place of women within the public sphere. As Empen demonstrates, Civil War visual culture embodied a conflicted ideology of 'wartime womanhood' that conceived the existence of 'unruly' women as emblems of the broader national crisis represented by the secession of the South.

David Morgan's essay argues that protestant visual culture of the postbellum period functioned as a medium through which masculine authority sought to re-contain the transgressive gender dynamics Empen sees at work during the Civil War. Where an antebellum 'feminizing' of Christ legitimated the doctrine of separate spheres by depicting female domesticity as divine, a visual re-masculinizing of Christ in the postwar era sought to keep women in the home by reconfiguring Him as a righteous warrior protector – a revisualizing of masculinity that found expression, later in the century, in what Morgan calls 'a truculent call to dominate the cultural means of display, a mobilization of suitably masculine visual representation as the instrument of influence'. As Morgan notes, the gendering of home and work was also an economic formulation, whose historical development was congruent with the rooting of industrial capitalism in the US, and with the shifting of production (and men) from the home to the office or factory. The figure of the republican mother, as Morgan suggests, 'was a symbol of the [white] bourgeoisie', and of 'the middle class'. While Morgan's essay is concerned with the visual gendering of domestic and 'public' space, it therefore also raises other issues – among them the impact of

industrial capitalism on the protestant imaginary, and the reciprocal role of protestant visual culture in the policing of the industrial as well as the sexual division of labour.

This 'undecidable' embedding of visuality in multiple flows of social power is reiterated in Chris Gair's essay. As Gair illustrates, the racialized rhetorics of 'progress' that legitimized the westward expansion of the bourgeois revolution were reciprocally enabled by class and ethnic tensions in the industrial cities to the East, where from the 1870s the sources of mass immigration had shifted to Southern and Eastern Europe. Gair discusses how paintings in the Fine Arts Building at the Chicago World's Fair of 1893 managed the multiple contradictions of industrialization and empire in gendered terms too, encoding nationhood in therapeutic visual codes that stressed the unifying discourse of American 'progress'. In order to achieve this, however, Gair notes that the exhibition had to sublimate anxieties about contemporary American life that would contradict the imagination of harmonious nationhood, anxieties which then reappeared elsewhere in the paintings, subjecting normative ideologies 'to considerable pressures from within'.

In the closing years of the nineteenth century and the first two decades of the twentieth, those pressures intensified and spilled out into a diverse network of social struggles and reformist initiatives. The Progressive Era – broadly speaking the period between the agrarian revolts of the 1890s and the end of World War 1 – was characterized in part by revolts against (and reassertions of) the normative cultures of the Gilded Age, and partly by what the historian Robert Wiebe influentially called a 'search for order' (Wiebe 1967), a broad-based series of initiatives that sought to contain the frequently chaotic milieux of late-nineteenth-century American capitalism and the structural fissures and contradictions thrown up by the long bourgeois revolution.

In the late Progressive Era those contradictions took diffuse forms, some of them, as Charlene Regester's essay on the cultural politics of the contemporary silent cinema attests, explicitly racial in orientation. In the South, the conjunction of a depressed agricultural economy, rising white violence against African Americans, and the demand for new sources of labour in the North, prompted a 'Great Migration' of Southern blacks into northern cities that would continue into the 1920s. The late Progressive years also saw the rebirth (in 1915, the same year as D. W. Griffith's 'white supremacist' movie *The Birth of a Nation*) of the Ku Klux Klan. After the War the new Klan blended the two major nativist traditions of the early twentieth century – Anglo Saxon supremacism and anti-catholicism – into a new 'comprehensive nativism' (Higham 1992: 266) that spread with astonishing speed, particularly in the South and Mid-West. By 1923 the KKK had a membership of around two and a half million (Jones 1992: 236), and in 1925 drew 40,000 demonstrators to a parade in Washington D.C., where white-hooded Klan members carried the Stars and Stripes down Pennsylvania Avenue.

As Regester's commentary on *The Birth of a Nation* (1915) and the work of black movie director Oscar Micheaux suggests, the racialized conflicts of the late Progressive Era were also fought in the contemporary silent cinema. Exemplifying the more pluralistic and politicized character of American film production in the days before the Studio System, Regester shows how Micheaux's deconstructions of racialized identity responded to contemporary doctrines of white supremacy circulating in popular cultural artefacts such as *The Birth of a Nation*, encouraging both black and white audiences to confront and reconfigure normative (that is, 'white') encodings of race.

Regester's discussion of Griffith and Micheaux alerts us not only to the contested – and overtly politicized – character of silent American cinema, but also to the complex and contradictory historical tendencies marking the Progressive Era in general. Progressivism comprised campaigns for agrarian reform and women's suffrage, attempts to improve public sanitation and reform urban politics and social services, tentative measures aimed at regulating the influence of finance houses and big city banks, and a host of other 'liberal' reform initiatives. But Progressivism was also driven in large part by middle-class agendas (moves to outlaw child labour, for example, were particularly unpopular in some working-class communities), and by owners and employers who sought to introduce more 'efficient' technologies and working practices to the workplace. The passing of the nineteenth amendment in 1920 granting women the

right to vote, secured the previous year by a bare two thirds majority in the Senate, was the high point of 'liberal' Progressivism. But by the end of World War 1, David Holloway's essay notes, 'liberal' reform was in retreat.

It is possible to overstate the importance of WW1 as a moment of historical rupture in the United States. Many of the underlying tendencies that would shape the '20s were already well developed before the War. But, as Holloway suggests, WW1 certainly accelerated their fuller development, as business and political elites embedded their own variants of managerial administration in the mobilizations that characterized both the periods of war 'preparedness' and formal US intervention. Holloway's essay on the wartime artwork and graphics of the socialist magazine *The Masses* characterizes *Masses* art as a series of visual forms in which the cultural Left began experimenting with modernist conventions as one component of the magazine's resistance to new patterns of 'Fordist' regulation in American social life (aspects of which were themselves energized by Progressivist emphases on the bureaucratic administration of capitalist-democratic social relations).[1]

In many respects the War was a catastrophe for the American Left, setting a climate of 'acceptable' political repression that would spill over into the Red Scare of 1919–21 and beyond. But for groups who would identify their interests closely with the emergent 'Fordist' political economy of the postwar era, US intervention was a boon. The production of wartime propaganda to support enlistment drives, food and fuel conservation, the various Liberty Loan campaigns and civilian service initiatives, for example, became 'the chief proving ground for the advertising strategies that after the war would encourage and guide the growth of American consumerism' (Van Wienen 1997: 142). As the advertising trade journal *Printers' Ink* would later note, reviewing the impact of the War on the development of new advertising techniques in the '20s, wartime campaigns had shown that 'it is possible to sway the minds of whole populations, change their habits of life, create belief, practically universal, in any policy or idea' (cited in Marchand 1985: 6; see also Lears 1994: 219). Holloway's suggestion that *The Masses* recognized, if not yet theoretically, the socialist resonance of modernist form, is thrown into poignant relief by Don McComb, whose essay describes how modernism was debated in advertising-industry trade journals, and both utilized and rejected in advertising practice, during the 1920s. Drawing attention particularly to the qualities advertisers anticipated abstract form would bring to the promotion of mass-produced commodities, McComb reminds us of the ease with which avant-garde visual practices have been routinely assimilated and reproduced within elite capitalist-democratic discourse in the United States. McComb notes that the goals of advertisers constituted desired outcomes and relations, rather than ones that were necessarily achieved. And he also shows that the advertising discourse on modernism was itself conflicted. But in juxtaposition with Holloway's essay on the possibilities abstract form had earlier appeared to offer the Left, McComb also reminds us just how far the cultural climate shifted in the US, with the decline of 'liberal' progressivism after WW1 and the emergence of the early-Fordist business hegemony of the 1920s.

Note

1. 'Fordism is to be understood in the first instance as a system of mass-production involving the standardization of products; the large-scale use of dedicated machinery suitable only for a particular model; the Taylorist "scientific management" of labour; and flowline assembly of products. The high fixed costs involved required guaranteed mass markets. Consequently Fordism is characterized, secondly, by the articulation of mass production and mass consumption: the use of advertising etc. to encourage consumers to purchase standardized products; the formation of protected national markets; and the intervention of the state, employing techniques such as Keynesian demand management and transfer payments, to prevent catastrophic falls in demand. The crisis of the late 1960s and the 1970s represented the collapse of Fordism. In its place a new variant of capitalism, called . . . post-Fordism, is taking shape' (Callinicos 1989: 134). See also Aglietta 1979; Lipietz 1986; 1987.

Manifest Destiny and Visual Culture

Photographing American Indians: Repression and Revision

MICK GIDLEY

This essay is about the representation – more specifically the photographic representation – of Native Americans who lived west of the Mississippi river during the period that this vast territory was being, as American commentators claimed at the time, 'opened up' to settlement by non-Indians, most of whom, whether already established as United States citizens or new immigrants, were white. It is concerned with the emergence of Indians as subject matter for photography, and their subsequent depiction as the medium developed through the nineteenth century and into the twentieth century. This era of expansion – extending from fairly soon after Thomas Jefferson sent out the trend-setting Lewis and Clark expedition to explore his Louisiana Purchase in 1804–1806 – roughly corresponds to the first hundred years of the new medium, initially patented by Louis Mandé Daguerre and William Henry Fox Talbot in 1839, with all its technological and aesthetic changes.

My concentration is on how photography not only depicted Native Americans but also helped to *define* them. That is, photography was one among a battery of powerful technologies ranged against indigenous peoples struggling for survival in a landscape that was frequently rich in natural resources, often beautiful, and always contested. Photography itself was, of course, the first of the mass media, and, as such, it prepared the way for cinema and television; with respect to Indians, we might say that photography established tropes of representation that would be followed, sometimes more influentially, by these later forms of communication. At the same time – despite oft-repeated assertions that, as photography is a mechanistic medium, made possible by an automatic reaction between rays of light and chemicals, it is a form somehow less subject to human intervention and, therefore, human subjectivity – we cannot assume that the story of the photography of Indians is merely one of changing technologies. As the following sections of this essay show, specific images reveal the determining influence of ideologies, government policies and aesthetic conventions. In the final parts of the essay, however, I also hope to show that, in this very uneven photographic struggle between the dominant culture and indigenous peoples, Native Americans were not only or merely victims. I therefore conclude by offering just a few instances in which present-day Indian photographers have turned the tables, as it were, sometimes by revisioning and revising specific images created during the era of white westward expansion.

The Puritans, as is well known, rarely acknowledged the humanity of the indigenous peoples they encountered on their landfall in the New World. They saw an 'emptie land', and were embarked on a divinely ordained 'errand into the wilderness' (see Miller 1956). Such notions had a very long life, leading to almost total blindness towards the Native presence in the land. The artist Thomas Cole, inaugural figure in the Hudson River School of painting, was all too typical when – in his influential 'Essay on American Scenery' (1836), in which he laid out what he saw as the

21

special features of American landscapes, as against those of Europe – he wrote as if the land itself was wild, and nothing but wild, however much grandeur it possessed: 'He who stands on Mont Albano and looks down on ancient Rome, has his mind peopled with the gigantic associations of the storied past; but he who stands on the mounds of the West, the most venerable remains of American antiquity, *may* experience the emotion of the sublime, but it is the sublimity of a shoreless ocean un-islanded by the recorded deeds of man' (Cole 1974: 577). 'American associations', he continued, 'are not so much of the past as of the present and the future', so that 'where the wolf roams, the plough shall glisten' and 'mighty deeds', as he called them, would occur in what was then merely 'pathless wilderness' (ibid.: 578; see also Fender 1989). Despite the fact that it was Native American peoples who had constructed the great 'mounds' Cole mentioned – probably during the period of Temple Mound culture which had dominated the Mississippi valley for centuries, achieving its peak between AD 1300 to 1500 – and that remnants of this culture had survived into the period of white incursions, Cole saw *only* 'wilderness'.

Such a vision met the dictates of the doctrine of 'manifest destiny', so vociferously propounded in nineteenth-century America, that the United States would move ever westwards across the continent 'alloted [sic] by Providence', occupying, settling, controlling and, crucially, 'civilizing' the land (quoted, among many other places, in Milner *et al.* 1994: 166; Horsman 1981 is a full study of the doctrine). Since 'the United States' meant, on the frontier, Euro-Americans, the faith in manifest destiny was readily buttressed by a set of almost equally unquestioned assumptions about the supposed inferiority of Indians. These beliefs, codified as 'savagism' by Roy Harvey Pearce (1965), Robert Sayre (1977), and other intellectual historians, envisaged Indians as hunters, rather than farmers, *by nature* (see Berkhofer 1978). Virtually everything they did was said to be determined by ancestral custom and tradition, so that they were not readily open to any of the 'improvements' offered by civilization. They were, moreover, childlike innocents – except, significantly, in their cruelty and cunning – and, as such, were readily corruptible by the vices of civilization, especially alcohol. That is, mostly because of their tribal superstitions and pagan practices, they seemed immune to the virtues of civilization, such as Christianity, thrift and technology, and were thus doomed to extinction.

Such ideological assumptions found expression in the policy of Indian Removal. First enacted in the Southeast, against such Indian nations as the Creeks and the Cherokees, who were transported west of the Mississippi, to 'Indian Territory' (later to become Oklahoma and part of Kansas), the policy was to remove peoples from some or all of their traditional land-base and to relocate them, in the charge of an agent appointed by the Bureau of Indian Affairs (BIA), onto a designated reservation. Sometimes the result desired by the government was achieved through treaty negotiation alone, that is, peacefully, but more often than not, especially on the Plains, it entailed at least an element of force. Sometimes white incursions ahead of treaty agreements resulted in attacks on whites by Indian war parties, often acting independently of the tribal leadership, and some of these were notable for their ferocity. As the Euro-American population grew, and as demand for land or mineral resources and the like became louder and more insistent, Native people after Native people, across the trans-Mississippi West, found itself struggling to retain its ancestral homeland, and then for survival wherever it washed up.[1]

This removal policy – in implementation, if not by intent – amounted to genocide. Government action often involved the military, sometimes led to the outbreak of violent hostilities, and the resulting full-blown wars were also the occasion for much vehemently aggressive public rhetoric against Native peoples – such as General Sheridan's famous sneer that the 'only good Indian I ever saw was dead' (quoted in Brown 1971: 170). And, as must now be admitted, whole villages, including women and children, were massacred – as happened to the Southern Cheyennes at Sand Creek, Colorado, in 1864.

Nevertheless, it has proved hard for American culture – with its pride in its largely democratic government system, its valorization of 'liberty', and its faith in the United States as a land of 'opportunity' – to acknowledge the scale and significance of this tragic aspect of its history. Very near to the time, for example in Buffalo Bill Cody's 'Wild West Show' (Figure 7), it was sometimes utterly trivialized: when Sitting Bull, holy man of the Sioux in 1876 at the time of

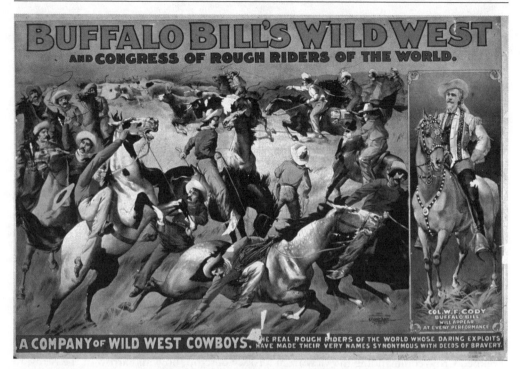

Fig. 7. 1899: American guide, army scout and showman William Frederick Cody (1846–1917), nicknamed Buffalo Bill, plays the part of himself in a melodrama by novelist Ned Buntline. (Photo by MPI/Getty Images.) Courtesy of Getty Images.

the Indian victory at the Little Big Horn and the subsequent devastating Indian defeats, joined the Show, Cody even issued publicity photographs of himself, imperious and overbearing, with the chief diminished in stature, if not in poise, beside him; they carried the caption 'Foes in '76, Friends in '85' (reproduced, though without the original caption, in Taylor with Sturtevant 1991: 94), as if everything in the preceding conflict had been resolved and almost forgotten. It was as if inter-communal life had been quickly normalized, when in fact the Sioux were starving, Sitting Bull himself would soon be murdered, and the 1890 massacre at Wounded Knee would climax a pattern of continuing unrest (see Brown 1971: 415–46; for photographs, see, for example, Fleming and Luskey 1986: 62–9, and Hiesinger 1994: 108–21 and 131).

Once Native Americans were largely settled on reservations and the era of overt violence was ended, a new policy – basically, one of assimilation – began to be enacted (for fuller treatment, see Hoxie 1989). It was decided that everything that could be done to reduce a sense of tribal or collective identity would be done. The clearest manifestation of such collectivism was the communal stewardship of land – and for most peoples it was stewardship rather than 'ownership' in the way that Euro-Americans understood it. The General Allotment Act, or Dawes Act, of 1887 was intended to break forever any communal title by allotting reservation land in small, family-sized farms to named Indian individuals, some of whom were to be rewarded with individual certificates of US citizenship. The 'surplus' land was then to be opened up to white settlement (the tribe concerned receiving a token payment for the 'surplus' land). Needless to say, as allotment was enacted on reservation after reservation, thousands of acres were transferred from Indian to white hands and, since many of the brand-new Indian farmers created by the policy could not make a living, their land, too, often passed out of Indian control. Alongside the Dawes Act, the BIA introduced other assimilationist policies. Specifically 'Indian' practices, such as the almost universal use of the sweat bath for the cleansing of the body and the purification

of the mind, were frowned upon, sometimes banned. There was particular opposition to Native shamans or, as the BIA termed them, 'medicine men'. Indian children were dragooned into local reservation schools – or, more controversially, distant boarding schools – to be cut off from their birth languages and taught 'white' ways. Many tribal communities cracked under such pressure, with some folk opting for the new ways in the belief that it was their only chance of survival, while others totally resisted all BIA initiatives. A prominent Hopi pueblo became so fractured that one faction left to build a new village; Kate Cory, an amateur photographer resident among the Hopi, photographed the intra-communal violence (reproduced in Wright *et al.* 1986: plate 46).[2]

Frances Benjamin Johnston, one of the earliest successful women commercial photographers, created in 1899 an image that evokes more of the pathos of assimilation than she could have realized. Titled 'Class in American History', it depicts a lone Plains Indian – a student at the Hampton Institute in Virginia, which trained the children of former slaves and newly 'resettled' Indians. He stands at the head of the room, alongside such 'teaching aids' as an American eagle, to display full feathered regalia under the gaze of other students, both Indian and African-American, who wear the Institute's military uniform. It is a rich image, and much has been written about it (see, for example, reproductions and discussions in Gidley 1998b: 163; Davidov 1998: 167–72 and Wexler 2000: 167–71). I wish to draw attention to the empty desks, which seem to urge us, as spectators, to enter physically *into* the picture, actively to decode its ambiguous 'lesson'. As they do in Johnston's photograph, features of savagism, especially the suggestion that Indians were a 'vanishing race', persisted in Indian imagery well beyond the era of removal, and they were inflected by notions associated with the policy of assimilation. Edward S. Curtis, for example, long after war parties had ceased, produced a photograph of a mounted Crow commanding the view from a rocky outcrop, bow and arrow at the ready, to which he gave the telling title 'The Spirit of the Past' (1905 [Figure 8]). In painting, an art much less subject than photography to claims of 'objectivity' and verisimilitude, there were numerous instances. Two typical ones were produced by Henry Farny and Frederic S. Remington. Farny exhibited in 1912 *The Happy Days of Long Ago*, an evocative view of a Plains encampment from former times (reproduced in Truettner 1991: 314), and the more celebrated Remington, in *Twilight of the Indian* (1897; reproduced in Parry 1974), depicted a lone Native figure uncomfortably wrestling a plough across an allotted square of land. (Remington and Charles M. Russell, as is well documented, were heavily responsible for the prolific illustration and widespread publication of this kind of imagery; see Truettner 1991.)

As befits the coincidence of chronology mentioned at the outset of this essay, photographers were employed in all but the very earliest phases of white westward expansion, from exploration to the official geological and other surveys, from army excursions and fort-building to free-range ranching and the building of the railroad, from town settlement to the initiation of Western tourism. Whether a photographer was engaged by John Wesley Powell on his exploratory descent of the Colorado (as happened to Jack Hillers) or by one of the great railroad companies laying track across the continent (as was the case for William Henry Jackson), or even freelanced as an entrepreneurial studio owner in a new town (which was the situation for John Grabill in Deadwood, South Dakota), he (or, very occasionally, she) was fully *part* of the process of conquest. Indeed, the pictures made in the course of this process were often, in turn, used to boost it (see Current and Current 1978). Jackson's famous views of Yellowstone (see Figures 3 to 6), to give but one example, were circulated in the East through official exploration reports, through magazine engravings, and through his own sales of prints and postcards (see Sandweiss 2002: 199–201).

This means that the photographs of Indians produced during and by this westering process should be seen for what they were: images of conquest and dispossession. It is interesting to note that the Native figures in such photographs were often actually of second order importance, akin to flora and fauna, and sometimes they were physically peripheral. In 1868, for instance, Eadweard Muybridge took a view which, despite being titled 'Indian Village, Fort Wrangle, Alaska', seems now to be more focused on the grasses and flowers in one half of it

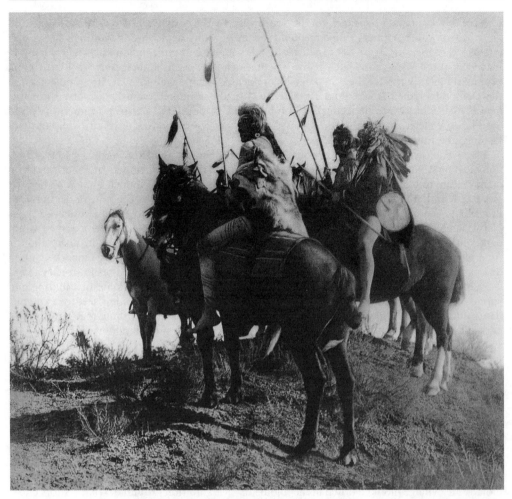

Fig. 8. *The Spirit of the Past*, by Edward S. Curtis, c. 1905 (copy print, author's collection, from a photogravure in *The North American Indian*). The very title of this image indicates that it depicts a reconstruction, in that on the Crow Reservation where and when it was made war parties were definitely a thing of the 'past'.

than on the Native figures and the village dwellings in the other half (reproduced, with other examples, in Gidley 1989: 200). Later, in 1903, Edward S. Curtis made a famous image of 'Mosa', a young Mojave woman, and described her as akin to 'a fawn of the forest' (reproduced, with further commentary, in Gidley 2004). At the same time – when, for example, a tribe constituted a notable obstacle to expansion – the Indian subject inevitably became a prime topic (or target). There was thus a ready market for Camillus S. Flye's 1886 pictures of the captured Geronimo after General Crook had put down the Chiricuaha Apache uprising (reproduced in Fleming and Luskey 1986: 60–61) – and Geronimo's notoriety meant that later photographers, such as Curtis in 1904, were willing to pay him for sittings.

In fact, once Native peoples were considered thoroughly subjugated, their presence could even lend attraction – history, romance, exotic colour – to the land, and photography, like larger forces at work in society, was prepared to exploit them. A small galaxy of photographers, for example, lent their talents to the Santa Fé Railroad when it gathered images of the spectacular Hopi Snake Dance and other Indian scenes for publication in a booklet (Dorsey 1903) produced

to extol the beauty and pageantry of the Southwest. By the early twentieth century, many individual town photographers supplemented their incomes by deploying Indian imagery as part and parcel of their locale's tourist industry. G. H. Bennett was typical: best known for his enticing views of the Wisconsin Dells, he also spent much time creating images of local Ho-Chunk people, frequently posing them in story-like tableaux against well-known sites (and sights) in the Dells (Hoelscher 2002). And Roland Reed made some spectacular, if overly dramatic, images of Blackfoot people, bedecked in full regalia, standing tall on steep promontories and the like in Glacier National Park, situated near their reservation in northern Montana (see Fleming and Luskey 1993: 118–25).

Indian subject matter became a profitable sideline for some, and led towards serious anthropological photography of Native peoples, helping more receptive members of America's dominant culture to realize the striking *variety* of indigenous life-ways – in fact, images by Bennett and Reed, and others like them, were commissioned or purchased by the Bureau of American Ethnology. From the 1890s on, as Native populations continued to decline numerically, as Native languages increasingly died out, and as assimilation to 'white' ways seemed to be ascendant, anthropologists – perhaps most influentially Franz Boas of Columbia University and the American Museum of Natural History – increasingly saw themselves as embarked upon 'salvage' missions. They themselves took photographs and they employed professional camera workers to record what they feared were disappearing customs, from domestic, hunting and agricultural activities to healing rites and elaborate community ceremonies (see, for example, Banta and Hinsley 1986). In this era of Indians as an oft-invoked 'vanishing race', anthropologists also fetishized notions of 'pure' Indianness, which fed the pursuit of portrayals of 'types', so that we find many images, especially profile views, with such titles as 'Cheyenne Type', 'A Pure Mandan', and the like.

This was a climate in which William Henry Jackson could be asked to make a thorough national catalogue of all extant photographs of Indians, and it proved a fraught and fascinating enterprise (see Sandweiss 2002: 203–50). It was a climate in which, a little later, specialist photographic chroniclers of Native Americans could arise, and Paula Richardson Fleming has dubbed their efforts to capture aboriginal life as 'grand endeavors' (Fleming and Luskey 1993). But it was also a climate in which photography as such, because its power was recognized, could not escape use and regulation by the BIA. On the one hand, at the time of the great World's Fair in Chicago in 1893 the BIA was only too ready to cooperate in the presentation of 'living Indians' in a village plonked down in the middle of the exhibition grounds so that visitors could assess how these 'primitives' compared with the strides towards technological and other sorts of progress on display in the rest of the fair. They were virtually offered up to the intrusive gaze – and cameras – of untold numbers of onlookers. Similarly, at the Omaha World's Fair of 1898, bands of Indians were organized to mount mock battles for visitors' cameras. On the other hand, by 1917, BIA policy was that allowing Indians to participate in the 'westerns' then being produced by an emergent Hollywood only encouraged them to hold onto their unwanted warrior ways. And the BIA soon also forbade the photography of Indian religious rites, such as those of the Pueblos, just as – declaring them 'obscene' or a diversion from productive labour – it attempted to ban the ceremonies themselves.

But we should ourselves be wary of crediting photography as such with too much power. One of the key insights of the recent sophisticated history by Martha Sandweiss, *Print the Legend: Photography and the American West* (2002), is that *words* are the most potent legend-makers, and that other forms of visual communication, such as painting and engraving, have created the majority of the most enduring visual tropes by which we recognize the West, including Indians. It was the painters George Catlin, Karl Bodmer and Alfred Jacob Miller who set up a tension between the impulse towards 'documentary' and, on the one hand, spectacle, and, on the other, narrative that was to characterize the 'western' image (see extended discussions in Truettner 1991). I will elaborate what I mean by these juxtapositions by relating them to particular photographs as we look at photographic enterprises specifically mounted to represent Native peoples.

Edward S. Curtis embarked upon the grandest endeavour of them all: a long-term study, to be published in twenty volumes of illustrated text and twenty portfolios of large-size photogravures, treating all the peoples of the trans-Mississippi West who, as he put it, 'still retained some semblance of their traditional ways of life' (Curtis 1907–1930, vol.1: Preface). As it happened, he himself wrote only a minority of the massive text of *The North American Indian*, but he did take virtually all of the thousands of photographs for it and, despite the limited, expensive, subscription-only basis upon which the volumes themselves were sold, he managed to get numerous images from it into general circulation – in periodicals, as postcards, in popular books, in parallel movie footage, and through exhibitions. It would be reductive to claim any one or two images as representative of such a monumental enterprise. What is most important to realize is that while he claimed predominantly to be making a bare 'record', he was actually creating a dream of 'the North American Indian' that would float free of the particular historical circumstances in which he found his subjects (see Gidley 1998a).

In certain respects, the ambitions of Joseph Kossuth Dixon, if not his achievements, exceeded even those of Curtis – and became, indeed, grandiose (see Trachtenberg 1998 and, for pictorial examples, Fleming and Luskey 1993: 134–47). More insistently than Curtis – who almost despite himself often captured the depth of a specific person's abiding *presence* in his haunting Indian portraits (see Gidley 2003) – he, too, believed that his subjects were a 'vanishing race' and, with a plangent sentimentality largely absent from Curtis's images, he strove, visually, to register their going. (With his patron, the department store tycoon Rodman Wanamaker, he also planned a gigantic Indian statue at the entrance to New York harbour, opposite Liberty, as a monument to vanished huddled masses of Indians). By contrast, certain endeavours were wholesomely less than 'grand'. For example, such feminist critics as Judith Fryer Davidov (1998) and Laura Wexler (2000) have argued that Gertrude Käsebier, the leading woman exponent of Pictorialism as a photographic style, brought a humanizing warmth and specificity to her portraits of Iron Tail and other off-duty Sioux members of Buffalo Bill's Wild West Show that contrasted with the studied likenesses of Curtis and his ilk. This may be true, but the resulting images failed to achieve the circulation granted the bigger projects.

What is likely is that Käsebier's alternative approach had an effect on the later Indian work of at least two significant female figures. The first was the writer on Nativist themes, Mary Austin: after producing a range of work, including what she called 'Re-expressions', in free verse, of traditional 'Amerind' poems – songs, prayers, aphorisms, and the like (Austin 1923) – she decided to cooperate with Ansel Adams, then (as a founding member of the f.64 group) on his way to becoming a 'straight' photographer of note, in the making of his first book, *Taos Pueblo* (1930). In sharply-focused depictions of such characteristic Taos activities as the winnowing of corn and the baking of bread in exterior mud-walled ovens, the book above all represents the inhabitants of the northern New Mexico pueblo as deeply at one with their habitat, both their multi-story adobe buildings and their ancestral arid, mountain land (see Austin and Adams 1977 [1930] and Trachtenberg 2004). The second was Laura Gilpin: though initially trained as a Pictorialist, she came to produce a photographic study, *The Enduring Navajo* (1968), consisting of quiet portraits, some of them in colour, so arranged – among landscapes and, crucially, with ethnographically sound text – as to testify to the range of qualities signified by the book's title and narrativized by its verbal text (Gilpin 1968; see also Davidov 1998: 135–54).

Except for occasional hints of something else – a restiveness, say, in the pose – the images produced by mainstream (usually white) photographers during the period so far discussed, including those embarked upon specialist 'grand endeavours', mostly support the dominant culture's view of Indians. But this was not universally the case. Even as late as Curtis's time, when all the conventions had been long codified, not everyone everywhere observed them. Curtis himself recalled an incident in which a Hopi man had snatched up a shield that was not ethnographically characteristic of his people and insisted on brandishing it for the camera (Gidley 1998a: 100). Curtis told the story to illustrate the childishness of his subjects, and their lack of understanding of the demands of his project, but the episode could be seen quite

differently. It could be that this Hopi man knew what he was doing, and that his actions were subversive of the larger narrative being told about him and his people. The essays *by* Native Americans devoted to a range of historical photographs collected by Lucy Lippard in *Partial Recall* (1992) argue, indeed demonstrate, that many different stories can be told.

Certainly, once we are prepared to look, we can find many instances where Indian subjects seem to be at least inflecting, and sometimes positively undermining, the dominant story. Elsewhere (in Gidley 2000: 262–3), I have tried to set down the ambiguities of a seemingly straightforward image of 'Long Wolf and his Family' (1886). While on the one hand it appears to be an archetypal image of the hostile Indian with a gun, when we wonder what might have been going through Long Wolf's own mind – the mind of someone used to *performing* in Cody's show – the photograph, with its painted backdrop and other props, begins to seem more like an elaborate parody of such conventional images. Not surprisingly, in the most searching chapter of *Print the Legend*, Sandweiss suggests several other ways in which we may register a full Native presence in historical photographs; she shows that sometimes such subjects exerted sufficient agency in and through their portrayal to force viewers today to speculate upon their motivations (Sandweiss 2002: 207–74). Paradoxically, there is a sense in which perhaps the most effective subversion of all occurred when Native figures gave themselves so fully to the camera (if not to its operative) – that is, to the *photograph* – that when we look at their images now, their presence makes a claim upon us – even if, as is sometimes the case, we do not so much as know their names. Witness the face of He Dog as represented by John Alvin Anderson early in the twentieth century (Figure 9). He wears his headdress, his finely finished shirt, and his peace medal with pride; yet he also looks 'away', as if in introspection, and we cannot 'know' him. He dresses, even perhaps performs, for the camera – but not *only* for the camera: that is, He Dog's act of subversion was truly to be himself, for himself.

Once Indians themselves became photographers, it was probably easier for their Native subjects to be themselves when they sat for photographic portraits. The evidence provided by the pictures produced by such Indian photographers as Horace Poolaw (Kiowa), and Lee Marmon (Laguna Pueblo) points that way (see Alison 1998 for many reproductions). Photographs bequeathed by the Hopi photographer Owen Seumptewa, taken from the 1940s onwards, seem particularly pertinent, in that they contrast so markedly with Hopi views by such earlier white camera workers as Ben Wittick, Adam Clark Vroman and Curtis. Whereas each of the white men mostly went for rituals, or for what they presented (by their deliberate positioning of their subjects) as the peculiarities of unmarried young women's 'squash blossom' hairstyles, or for the sheer otherness of Hopi habitations on their arid mesa tops, Seumptewa's subjects seem relaxed, dressed in their 'ordinary' clothes, and have composed themselves just sitting by the stove or the like, their everyday rooms open around them. When Seumptewa does tackle a ceremonial scene, as in his untitled depiction of a painted boy clown, he goes for the 'off duty' moment, the figure composed yet alert, and ahead of the day's high drama (reproduced in Masayesva and Younger 1983: 56).

It is obvious that we now reside in a postcolonial world. Speaking of literary production, Salman Rushdie, in theorizing postcolonial expression, played on the popular *Star Wars* films to coin the phrase 'the Empire Writes Back': using the very language of the oppressor, the Native writer represents and creates his or her own different and autonomous cultural experience (for elaboration, see Ashcroft *et al.* 1989). I have wondered if, applying the phrase to our topic, we might equally well conceive of Native Americans 'photographing back'. In fact, my argument is that 'photographing back' could take – and has taken – many forms. We could call one impulse – with its invocation of the tradition of the photograph as unadorned record – 'documentary'. Needless to say, perhaps, this part of the documentary tradition is not quite as straightforward as it might first appear. For example, when a collection of historical photographs built up by the National Museum of the American Indian was published to herald the opening of the Museum in 1999, the editor also included present-day images of Native American high school pupils taken by Dorothy Grandbois (Turtle Mountain Chippewa), as if to counteract the humiliations of the past by stressing current 'advances' among the country's

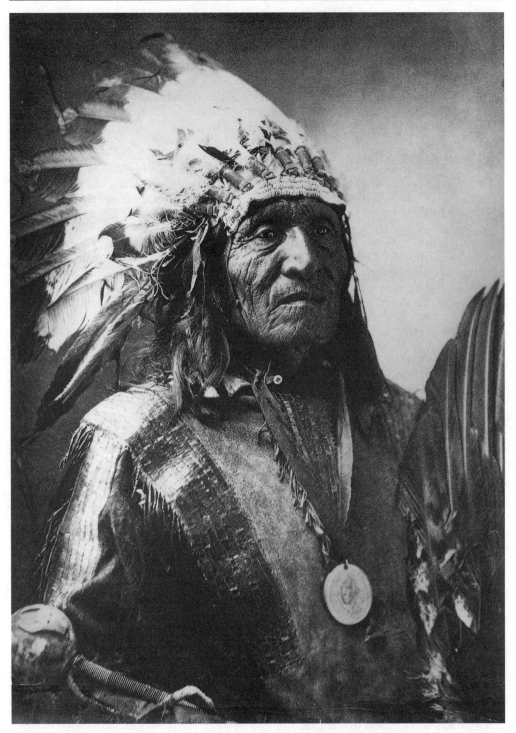

Fig. 9. *He Dog, Brulé Sioux*, by John Alvin Anderson, c. 1910 (copy print, author's collection, courtesy of the Barbican Gallery, London). He Dog (1836–1927), though a witness to his people's subjection, registers in this portrait a powerful sense of his enduring individual and cultural identity.

tribes, traditionally a group with a very marked school drop-out rate (Johnson 1998: 107–11). At the same time, Grandbois' shots – including ones of girls braiding each other's hair, as if for a tribal ritual – could be read as a very subtle satirization of the conventionalized use of documentary in high school yearbook imagery. Richard Ray Whitman went a little further in his documentary series of 'street chiefs' (actually Indian down-and-outs), deploying, like Dorothea Lange before him, 'internal captions' – signs found within the selected frame of the photograph – to point up society's, the state's, responsibility towards such folk (see the example reproduced in Lippard 2000: 216 and commentary in Gidley 2004).

In 1989, David Avalos, who is of Mexican *mestizo* descent and a co-founder of the Border Art Workshop in San Diego, produced a form of 'photographing back' that might well be termed 'interpretative revision': In 'Wilderness', an installation eight feet long, he superimposed the word 'wilderness', letter by letter, onto the faces – or, more accurately, the photographed faces – of ten of the original inhabitants of the continent (see reproduction as a two-page spread in Lippard 2000: 174–5). The faces were sequenced to alternate between female and male and to 'represent' most of the aboriginal culture areas of North America – *if* you recognize them. They are all, in fact, Curtis photographs, and one of them is 'Mosa'. Avalos also incorporated into the installation the dictionary definition of 'wilderness' – 'a tract or region uncultivated or uninhabited by human beings', 'an area essentially undisturbed by human activity', and so on, but also ending on 'a bewildering situation' – to recall the dominant culture's frequent evaluation (evoked, for example, by Thomas Cole) of the continent's aboriginal people's status as 'wild' as the land. Avalos's new work is creative precisely in the way it calls attention to, and revises, past imagery.

In fact, such 'photographing back' seems to be a marked feature of present-day Indian art photography. Witness the work of Shelley Nero (Mohawk), Hulleah Tsinhnahjinnie (Creek/Seminole/Navajo) and Jolene Rickard (Tuscarora Turtle Clan) as reproduced in such significant collections as *Native Nations: Journeys in American Photography* (Alison 1998): each of them deploys historical photographs within her work, and recontextualizes them. Tsinhnahjinnie, in particular, has produced a body of funny yet hard-hitting sequences, and the very title of her 'Photographic Memoirs of an Aboriginal Savant (living on occupied land)' (1994) declares its reflexive, revisionist stance. We, in turn, reflect upon the traditions involved in the photography of Native Americans and realize that from it we may learn at least as much about the dominant culture of the United States as we can learn about Indians. But we *do*, also, learn much about Indians: it is not that photography as a medium grants the immediate, transparent access to them (or any subject matter) that its early proponents believed, but that it registers, in detail, and sometimes in beauty, their enduring presence and their capacity to act.

Notes

1. Of the numerous accounts of this process, which was far more varied and complicated than can readily be conveyed in short compass, perhaps the most graphic remains Brown 1971.
2. In 1924, with muted fanfare, all Indians were granted the mixed blessing of US citizenship. With some respite during Franklin Delano Roosevelt's presidency, which saw the implementation of certain more tradition-enhancing proposals by Commissioner John Collier, assimilationist goals, applied in varying degrees of ferocity, have governed BIA policy down to the present. Though this policy was actually just as dangerous to Native tribal life as the earlier inexorable removals – in effect, threatening to extinguish Indian ethnic identity as such – it has proved even more difficult for mainstream American culture to understand how harmful it has been. Basically, the dominant culture, as represented by specific administrations of either leading party, has stressed Indian access to 'equal rights', when – as members of tribal nations with whom treaties were made – Indians themselves have sought 'different rights'. The mainstream culture has tended to believe that Native Americans – especially in comparison with immigrant groups – have been trying to gain 'special' privileges.

Visualizing Women in the Civil War

Unsexed Amazons and Desperadoes: Imaging Public War Women and Imagining Female Warriors in the American Civil War

CYNTHIA WIEDEMANN EMPEN

In the context of mid-nineteenth-century American civil upheaval, visual culture of the tumultuous war years distinctly embodied the Civil War as a gendering activity, and particularly the gender-role transformation of women and the masculinization of the female body in and at war. The Civil War was inherently fought over embodiment and body regulation – how to forge a single united body politic from sectional conflict between states and also how to bring freedom to enslaved bodies. Popular print images, newspaper cartoons and wood-engraved book illustrations also portrayed a gendered Civil War, caricatured public war women, or imagined the Female Warrior type, revealing both cultural tensions and imagined fantasies concerning the entrance of women into the public and primarily masculine sphere of war. Such imagery forms an intriguing visual and cultural record dealing with the volatile issues of public womanhood, transvestism, and deviant bodies, and reflects a profound visual reorganization and altered vision of the female social body in mid-nineteenth-century American culture.

As war broke out on the 12th of April in 1861, calling hundreds of thousands of men to volunteer during the four-year conflict, questions soon developed regarding women's roles in the absence of a significant portion of the male populace. Whether or not the Civil War visibly or physically altered women's personal lives, it did push many women beyond the popular antebellum image of middle-class women as sentimental and domestic 'angels' of the house. The martial imagery of this great conflict, particularly the visual image of the male body as a uniformed soldier, deeply affected female experience in the public affairs of a national war. Personally reflecting upon the initial eagerness and pageantry of war, Lucy Larcom of Massachusetts noted in her diary, after watching troop preparations in April 1861, that she 'felt a soldier-spirit rising' within her when she saw her townsmen 'armed and going to risk their lives for their country's sake' (Addison 1970: 89). Elizabeth Van Lew, an ardent abolitionist and Union spy living in the Confederate capital of Richmond, expressed similar sentiments in her Civil War journal upon witnessing soldiers engaged in battle. She called the exhilarating spectacle of men riding horses and bursting ammunition observed during an evening ride 'thrilling' and 'wonderful' (Van Lew 1996: 44).

Wartime activities visualized as spectacles and pageants appeared immediately in popular American illustrated picture weeklies and in separate-sheet prints. A *Harper's Weekly* illustration, 'Great Sumter Meeting in Union Square, New York, April 11', from 25 April, 1863, particularly exemplifies the notion of war as a public spectacle for women's viewing (*Harper's Weekly*, 25 April, 1863, p. 260).[1] Marginal figures at the right edge, the three women sequestered high upon a balcony appear as the most prominent and delineated figures beside a grand swirling Union flag. Visually and physically segregated and enclosed upon the rooftop, these women stand as patriotic spectators of war gazing upon the grand panorama of the army review parading below. Describing the scene with equal patriotic fervour and gendered rhetoric, the accompanying text

stated that 'Handkerchiefs and flags were waved by the fair hands of ladies who filled doorways, windows, and balconies that border the square . . .' (quoted from the *Tribune* in *Harper's Weekly*, 25 April, 1863, p. 270).[2] The rhetoric of doorways, windows and balconies further frames women's contained place as spectators in the public sphere of war.

Northern imagery of Union women formed important subjects of patriotic discourse symbolizing public unity on the home front in such spectacle images of war. Indeed the first major war battle began as a 'picnic war', with spectators on a picnic excursion across the Potomac River to Manassas, Virginia on 21st July 1861 witnessing the North suffer a humiliating defeat at Bull Run.[3] With the advent of illustrated journalism, such war-related newsworthy events along with featured wood-engraved portraits and cartoons accompanied extensive coverage of the national battle in the relatively new genre of pictorial newspapers and weeklies including *Harper's Weekly* and *Frank Leslie's Illustrated Newspaper*. Soon the heroic postures and romantic chauvinism of traditional battle art became nearly obsolete as illustrated journalism, commercial art prints and photography brought a new modern vision of a soldiers' war to main street shops and pushcarts that permeated domestic parlours and later led to the Civil War's description as the first 'living-room war' (Grover 1984: 8–11).

Numerous artist-correspondents contributed war images to the illustrated press, including Winslow Homer, the 'special artist' for *Harper's Weekly*. Winslow Homer's 'News from the War' from 14 June, 1862, provides a visual code that combines wartime themes and organizing principles of gender segregation and news circulation, perpetuating the gendered myth that war was constituted by the separate public and private spheres of men/battle and women/home-front respectively (Tatham 1979: 86–7). Rigid rectilinear borders separate and sequester the woman in the central vignette within a closed domestic space, segregating her from the flowing open scenes that depict the unbordered masculine spaces of the war front, spaces that also produced and controlled the circulating news. The visual divide of bordered spheres delineating the feminine/home front from masculine/battle front realms became a stock device in popular prints that depicted the conventional but equally potent political image of women as sentimental and domestic, waving goodbye to loved ones, weeping, writing letters to soldiers, or in volunteer roles as ministering angels to the injured body politic. Further examples of this iconographic device include portrayals of organized and controlled female volunteerism that presented images of a mobilized home front with women in auxiliary roles performing unpaid war work in specific gendered arenas, but depicted in the form of a constructed fantasy of sentimental femininity. Graphic images like Winslow Homer's 'Our Women And War' and Thomas Nast's 'Our Heroines', both printed in *Harper's Weekly*, pictured women's obligation to the nation in wartime as ministering, benevolent and domestic, based upon visions of war women as icons of an idealized femininity and antebellum gender ideologies of the sentimental lady.[4]

Sexual politics formed an integral part of the national ideological strategy of war; thus, all war roles assigned to women – aiding and sustaining soldiers and maintaining morale at the home front – became political. As army enlistment was not an open option for women, many women deliberated over their individual service to the war cause. Almost immediately, out of necessity and desire, numerous women utilized new 'public' skills to sustain the Union and Confederate home fronts by running households and businesses, gathering at public assemblages, and forming so-called 'bonnet brigades', or benevolent organizations and money-making enterprises, while male relatives and friends responded to the call of the country and left for the battle front. As Jeanie Attie describes in her book *Patriotic Toil: Northern Women and the American Civil War*, the Civil War tested the ideological separation of men's and women's domains and the gendering of political rights (Attie 1998: 16. See also Ryan 1990: 141–55).

Visual culture echoed this ideological separation and pictured the gendered domains of male and female public work and influence. While Winslow Homer imaged the familiar theme of women 'left behind' in the domestic realm – sewing, reading letters from loved ones, welcoming soldiers home – he also created and documented visions of women engaged in alternative public roles within the war effort.[5] The wood-engraved illustration 'Filling Cartridges at the United States Arsenal, at Watertown, Massachusetts', from the *Harper's Weekly* cover of 20

July, 1861, portrays the opportunity for women to demonstrate political loyalty and their skills in public employment during wartime labour shortages. The top vignette of the image depicts government work at an arsenal where, as *Harper's* describes, 'at least seventy girls and women are kept constantly employed' inserting bullets into cartridges ('Filling Cartridges' 1861, p. 450). While the image's main intention served to exhibit the abundance of war supplies and the logistical advantage of Union forces, it also pictures women engaged in the industry of war. Yet wartime industry's implementation of organized segregation is also shown, with the muskets providing a central visual divide separating women's work from men's as pictured in the bottom vignette. This rare instance of female industrial employment and public visibility did not associate public femininity with disrepute nor appear to threaten the sexual status quo, but rather displayed women's useful wartime employment as part of Union propaganda.[6] Serving in various public capacities and even in non-traditional roles, most women, however, maintained a 'feminine' persona, retaining their female identities while working in public as clerks, nurses, munitions workers and daughters of regiments, performing duties that upheld the maternal or domestic nature of their proper gender role.[7] As the rebellion drew on, causing increasing war weariness, it became apparent that some women actually became dissatisfied with simply being left behind to sew uniforms and tend the home fires.

With the social fabric of a nation torn and manpower shortages in the face of war, everything from the political order to the cultural identity of the social body – male and female – was called into question and reordered. Consequently, the social and political effects of wartime put stresses on the established gender system, as women engaged in new roles in public contexts, interrupting such exclusive male domains as the military hospital and battlefield.[8] In picturing women who demonstrated a new sense of public responsibility and a masculine ethos of self-reliance and physical strength, crossing traditional gender lines, Civil War visual culture both embodied and helped to create, while also denigrating, an emergent ideology of wartime womanhood. A dichotomy in print imagery quickly developed, with images that promoted a gendered vision of women's public work and influence as segregated or domestic conflicting with those images that envisioned an unusual alternative image of the public war woman.

As certain women disregarded prescribed behaviours and dress, wartime visual culture satirized the concern over women disrupting and crossing the social order of the gendered body. Graphic humorists who portrayed changing sentiments and satirized gender ideologies brought temporary relief from daily anxieties to war-weary Americans, as comic drawings and writings, primarily Northern, continued to appear as regular features in weeklies and dailies alongside the detailed progress of war. Unlike popular separate-sheet prints whose purpose served mainly as reassurance, patriotism or decoration, the weeklies' cartoons focused upon sensationalism and social criticism of both their Southern enemy and Northern women.[9] A more imaginative vision of the female body in war imagery, which manifested the tensions, anxieties and fears regarding public womanhood, appeared in the cartoons of pictorial weeklies. In one such image, *Harper's* cartoonist William Newman (later an artist for *Leslie's*) offered humorous solutions on 'How to Deal with Female Traitors' in his sketches that pictured various punishments for female espionage. Central to Newman's graphic humour and design is a vision of the deviant and public female body. One might recognize the female type Newman envisions as a war traitor – she is thin and bony with angular features, resembling the so-called 'strong-minded' female or 'women's rights' stereotypes caricatured before the war (Empen 2003). In separate vignettes, Newman imagines punishments that focus upon conceptions of the female body, including forcing the female war traitor to wear ridiculous fashions, denying her the latest in fashionable-styled clothing and enforcing subservient lower-class labour as a domestic servant and nursemaid ('How to Deal with Female Traitors' 1861, p. 656).[10]

Cartoons such as 'The Recruiting Question – A Hint to Railcar Companies' from *Frank Leslie's Illustrated Newspaper* also exemplify the war's influence upon the perception of women's new 'masculine' assertion at the moment of national crisis. This cartoon from 1862 depicts a surprised male passenger about to board a city railcar managed by a 'fascinating conductress' dressed in the bloomer outfit made infamous in the 1850s. The scene presents a mildly

amusing message regarding women's new roles and the controversial wartime proposal of putting women to work in public. It also portrays fascination with a woman posing in a man's role and wearing the ultimate symbol of maleness – trousers. Alluding to the problematic short-age of male wage earners so soon into the war, the caption explains the conductress' new unusual, elevated and somewhat authoritative (but polite) position as she states: (to a surprised passenger) – 'Yes! You see, my good man has gone to the war, and as the Company continue half his wages, I've come along to earn the other half – hurry up, sir, if you please.'[11] The social realities of warfare inherently disrupted the sexual division of labour, thrusting resourceful women into such dangerous public spaces as urban labour and transportation (see Cohen 1992: 109–22). While the public vehemently rejected bloomers as street clothing in the 1850s, the emancipating dress seemed appropriate garb for the cartoonist to include as the uniform of a conductress, signifying the wearing-the-pants figure that has appeared as a recurrent motif in visual culture during periods of social unrest (Davis 1978: 147–90. See also Faust 1996: 220–33). Cartoonists and caricaturists effectively utilized the language of clothing to express the thrilling and frightening possibilities of altered roles during wartime, with cultural imagery picturing the masculinization of women in public.

Other treatments of women who were found actively participating in the war, most fre-quently in the guise of soldier's clothing or other masculine garb, also appear to signify the uncertain reaction to the public war woman, particularly the so-called 'unsexed' woman.[12] Under such headlines as 'A New York Heroine', 'Female Soldiers', and 'The Romance of War', reports in newspapers and the illustrated penny weeklies quickly recorded and publicized women's active participation in the war as soldiers and spies.[13] For the most part, these stories indicated the danger of exposure in dressing as a man and the treasonous criminality of spying during the war. In addition to such written accounts, illustrators and cartoonists portrayed vign-ettes of women's public war activities, continually publicizing their unusual and criminal exploits during the war. The perception of women who dared to assert themselves and violate gender codes by adopting masculine traits and behaviour presented another image of wartime womanhood, that of the female Amazon warrior type. On 5 November, 1861, the *New York Herald* reported that 'a very short time ago, there was no end to the clamorous caterwauling of the would-be heroic females, some of them in short dresses and long pantaloons . . . What has become of them all? Where have they gone to? Why do they not form themselves into a great Amazonian brigade, and bear their part in the fatigue and toils of the present war?' (cited in Schultz 1989: 266). The caricature 'General Stuart's New Aid' echoed the *Herald*, imagining the new 'Major' on General J. E. B. Stuart's Confederate cavalry, a jaunty rebel female spy with a short skirt, spurs and masculine-styled bobbed hair riding astride a galloping horse. Despite such an unconventional vision of wartime womanhood, this *Harper's* cartoon reacted with only a light sneer to the embarrassing federal defeat aided by this female enemy whose espionage led to the capture of Union troops in Virginia (*Harper's Weekly*, 4 April, 1863, p. 211).[14] Earlier in the war, the relatively new satirical picture weekly *Vanity Fair* printed a cartoon titled 'GOV. MORTON LEADING ON HIS GALLANT LAWRENCEBURG (IND.) BRIGADE' in 1861. Depicting an all women Amazonian brigade much like the one proposed by the *New York Herald*, the cartoon imagines and ridicules a troop of armed women dressed in soldier's garb and charging forward into battle. Reacting to certain men's unresponsiveness to the call of war duty, the cartoon visualizes one suggested solution for women's participation in the war effort (reproduced in Franzen and Ethiel 1988: 125).

In addition to pictorial press imagery, the figure of the unsexed female Amazon appeared as a heroicized adventurer and Female Warrior type in the nineteenth-century American literary imagination. Female warrior narratives published during and after the Civil War fostered the reappearance of the cross-dressed fe/male or 'half-soldier heroine' as a central motif and image of female autonomy and military heroism in mid-nineteenth-century American culture (Brockett and Vaughan 1867: 773).[15] In 1864, Canadian immigrant Sarah Edmonds wrote an account of her war experience as a Union male nurse and spy under the enlisted alias 'Franklin Thompson' in the illustrated spy narrative titled *Unsexed: or, The Female Soldier*. Subsequent editions were

published as the best-selling *Nurse and Spy* in English (and later in German), selling over 175,000 copies through nine editions. Describing her enlistment, Edmonds reported she was 'to go to the front and participate in all the excitement of the battle scenes, or in other words be a "FIELD NURSE"' (Edmonds 1865: 19). A field nurse would be Edmonds's initial role in the war, but during her war adventures she also took on the parts of civilian, spy, federal and rebel soldier, female and male black contrabands, and an Irish immigrant domestic.[16] The continual blurring of identities along with the various guises and gender masquerades of the principal heroine in Sarah Edmonds's exploits as a male nurse and spy form the basis of the book's plot, characterizations and illustrations. Following the title page to *Nurse and Spy*, the flourishing title of 'EMBELLISHMENTS' heads the list of the twelve wood-engraved 'Disguises and other Scenes' illustrated and the steel-engraved frontispiece portrait of Edmonds. The engraved illustrations or pictorial 'embellishments', which accompanied the printed text, portray a crafted and imaginative image of the Civil War Female Warrior type in titillating incidents of transvestism and in romantic, adventurous exploits of espionage as a heroic rebel Amazon warrior.[17]

The frontispiece illustration to the 1865 edition of *Nurse and Spy* bears a portrait engraved on steel by George E. Perine of Edmonds dressed in a traditional dark-coloured women's side-saddle riding costume with a plumed hat.[18] She stands in profile beside a horse with her head turned fully towards the viewer and her right hand grasping the reins, and she holds a riding crop in her left hand. While no specific description of Edmonds wearing such a costume exists in her narrative, it does resemble the pseudo-military dress worn by Edmonds's companion in *Nurse and Spy*, Mrs B, who is described as wearing a 'narrow brimmed leghorn hat, [and] black cloth riding habit, shortened to walking length' (Edmonds 1865: 39). Considered within the visual tradition of romantic cavalier and heroic warrior equestrian portraiture that pictured swarthy young men mounted on graceful steeds, what then are the gendered meanings inherent in picturing Edmonds as a horsewoman?[19]

Edmonds's portrait does not reveal her cross-dressed masculine identity, diverging from the popular visual tradition depicting trouser-wearing women in Female Warrior narratives.[20] Rather, the portrait of Edmonds as a horsewoman presents an understated but specific visual allusion to her status as a modern Amazon. Ancient tales largely coloured by Greek myth created the allegorical representation of bare-breasted untamed female warriors or horse-women, known as Amazons. The wild Amazon warrior remained a popular figure in nineteenth-century American culture, as seen in the Currier and Ives lithograph 'Queen of the Amazons Attacked by a Lion', an image that continued the centuries-long tradition of associating strong erotic connotations with the Amazon type.[21] In the nineteenth century, the figure of the Amazon woman also signified the type of the unwomanly or unsexed woman, and Edmonds's wearing of a riding habit provides the strongest link in her association as an Amazon woman. A short comic barb in the *Harper's Weekly* 'Humors of the Day' section from 28 August, 1863, reveals the contemporary mid-nineteenth-century association between the female riding dress fashion and the epithet 'Amazon'. It reads: '"Take off your hat, man," cried a judge to an Amazon in a riding-dress. "I'm a lady," was the reply; "I'm not a man." – "Then," said his lordship, "I'm not a judge"' (*Harper's Weekly*, 29 August, 1863, p. 558). More popular pamphlet adventure novels like *Dora, The Heroine of The Cumberland; or, The American Amazon* (Anon. 1864), whose cover image depicts Dora as an adventurous wild horsewoman above the subtitle 'The Western Amazon', further reinforce the link between female Civil War spies and soldiers and the fantasy image of the Amazon warrior.[22] Presenting an updated and modern image of the American Amazon warrior as the female crossed-dressed spy and soldier, Edmonds's equestrian portrait hides veiled allusions to both her unwomanly identity and her adventurous exploits as a horsewoman and male soldier in *Nurse and Spy*. The hybrid riding costume made a palatable and uncontroversial public portrait image into a compromise likeness that is neither overtly feminine nor revealing of Sarah Edmonds's masculine persona.

In *Nurse and Spy*, the Amazon archetype formed a highly mutable image, picturing Edmonds dressed in both feminine equestrian garb and as a cross-dressed Union spy and soldier in seven of the remaining twelve 'Disguises and other Scenes' drawn and engraved on wood that depict

Sarah masqueraded in soldier's garb while pursuing wild adventures on the battlefield.[23] Both types of image represent the dichotomy of the female Amazon warrior as an object of male fantasy and as a martial woman engaged in battle or violent acts with weapons rebelling against the patriarchal status quo. As a wild Amazonian warrior in action dodging dashing sabre strokes and engaging in 'hand-to-hand fight', Edmonds in male guise finds herself in the thick of battle in the illustration 'Acting Orderly' (Edmonds 1865: 178a), escaping on a stolen colt amongst a shower of Minnie balls from rebel soldiers as portrayed in 'Riding for Life' (ibid.: 216a), and shooting a rebel captain in the face while astride a horse in the action scene 'Paying a debt of gratitude' (ibid.: 316a). These illustrations, along with similar imagery from popular pamphlet Female Warrior narratives depict the war woman as powerful, wild and fully adapted to the rugged, masculine soldier lifestyle. Their open body contours and deviant behaviour, shooting or whipping men, broke all standards of feminine decorum and imagined unruly women as symbols of bodily disorder and, by extension, as icons of national social discord.

At the end of *Nurse and Spy*, Edmonds abandons her male costume and masculine persona as 'Frank' and resumes her 'proper' gender and female clothing.[24] Upon leaving the army and redonning her feminine facade, Edmonds wrote 'All my soldierly qualities seem to have fled, and I was again a poor, cowardly, nervous, whining woman . . . I procured female attire, and laid aside forever (perhaps) my military uniform; but I had become so accustomed to it that I parted with it with much reluctance' (Edmonds 1865: 359–60).

In reality, Edmonds likely deserted the Union army for fear of exposing her true sex. She willingly left the carnivalesque and public social space of the battlefield that enabled her gender inversion and provided an arena for her pursuit of a public life.[25] Based partly in fact and fantasy, *Nurse and Spy* presents an illustrated textual performance of Sarah Edmonds's war adventures in a masculine masquerade as a cross-dressed female soldier, evoking a potent image of wild and public womanhood at mid century.

What then were the implications of the Civil War crisis for public womanhood and the imaging of public women? It can be argued that women's altered wartime roles did not transform the American pre-war gender system but only defended and safeguarded a patriarchal society in crisis. Leaving for the battle front or involving themselves in the public business of supporting the war at home, war women who demonstrated masculine characteristics of self-reliance and strong-mindedness transgressed the Victorian gender system that most noticeably separated women's proper roles from those of men. As such, the Civil War generated imagery which editorialized upon women's changing public roles and demonstrated that the 'civil war' extended far beyond regional disputes fought on the battlefield. Popular print images that portrayed war women with aspirations of public service either tried to contain women's wartime endeavours under the guise of patriotic femininity or caricatured their over-zealous war spirit, documenting the various degrees of female civil disobedience through rebellious gestures and actions like spying and wearing trousers. Similarly shattering the image of war as a special and exclusive masculine sphere, and evoking a new vision of public womanhood, the reinvented fantasy image of the Female Warrior type in illustrated Civil War narratives such as Edmonds's *Nurse and Spy* presented a modern vision of the Amazon in the guise of the American female cross-dressed soldier and spy. Civil War visual culture, as a metaphor for the crisis in patriarchal definitions of femininity, demonstrates that the rhetoric of the body politic is never ungendered, with wartime imagery of gender disorder variously portraying the national body politic as feminized, masculinized, or unsexed and even transvestite. Such imagery entered the discourse that both encouraged and criticized new ambitions for public womanhood, and that depicted women's desire for public visibility in mid-nineteenth-century American society and culture.

Notes

1. Philip Beam attributes this image to Winslow Homer (Beam 1979: 124).
2. On handkerchief waving as a public feminine sign of allegiance and patriotic devotion, see Ryan 1990: 130–71.

3. A caricature lithograph portrays the picnic battle with Northern lady and gentleman spectators fleeing in the background: A. Pfott (lithographer), 'The Battle of Bull's Run', 1861, Library of Congress Prints and Photographs Division. See Neely and Holzer 2000: 83–4, 243, n.4. See also Thompson 1994: 37–47.

4. Winslow Homer [Block: unsigned], 'Our Women and War', Wood engraving, *Harper's Weekly*, 6 September, 1862, pp. 568–9; and Thomas Nast [Block B.R.: Th. Nast.], 'Our Heroines', Wood-engraved illustration, *Harper's Weekly*, 9 April, 1864, p. 229.

5. Winslow Homer [Block B.R.: HOMER], 'The War – Making Havelocks for the Volunteers', Wood engraving, *Harper's Weekly*, 29 June, 1861, Cover, p. 401, exemplifies the 'left behind' theme.

6. For a brief discussion of women in wartime reportorial illustration, see Thompson, who notes that artists and editors adhered to a double standard in images. Women maintained their femininity as pictured in appropriate feminine activities – sewing and charity – while the weeklies ignored thousands who worked in factories and on farms to supply weapons and food for the armies (Thompson 1994: 103). Portrayals of women near the army are rare and mostly show wives in camp or women viewing army reviews. For an image picturing two women in encampments, one selling products from a milk wagon and the other a Daughter of a Regiment, see 'Scenes About Camp', *Harper's Weekly*, 20 July, 1861, p. 453.

7. On public criticism and the propriety of new public roles for war women, see Faust 1996: 80–113. Mark Neely has pointed out that no popular separate-sheet prints depict war women on the job except images of nurses (Neely and Holzer 2000: 100).

8. The term 'gender system' is used by Julia Epstein and Kristina Straub 1991: 3, n.6; and Leonard 1994: xx–xxi, n.24, 209–10.

9. On the scarcity of graphic images with Southern imprints and Confederate illustrated papers during the war, see Neely *et al.* 1987: 3–9, 23–30; and Thompson 1994: 23.

10. Various criminal charges were applied to female spies. See Schultz 1989: 262–3; Leonard 1999a: 21–97.

11. Attributed to William Newman [Block B.L.: N], 'The Recruiting Question – A Hint to Railcar Companies', *Frank Leslie's Illustrated Newspaper* (23 August 1862: Indiana University Main Library, Research Collection, Bloomington).

12. Newspaper accounts used the contemporary term 'unsexed', as in the 1862 report 'Incidents of the War. A New York Heroine', in *Frank Leslie's Illustrated Newspaper* XIV (19 July, 1862, p. 355). The *Milledgeville Confederate Union* also expressed its concern about 'unsexed women' (*Milledgeville Confederate Union*, 17 January 1865, as cited in Faust 1996: 6).

13. See *Frank Leslie's Illustrated Newspaper*: 'Incidents of the War. A New York Heroine', p. 355; 'Female Soldiers', XIX, 17 December, 1864, p. 199; and 'The Romance of War', XII, 17 August, 1861, p. 211. The article 'A Company of Fair Rebels', in *Frank Leslie's Illustrated Newspaper*, XIV, 9 August, 1862, p. 318, which clearly speaks with Northern sentiment, also offered pen 'portraits of the three of the most celebrated of these feminine desperadoes', including one of the infamous Southern spy Belle Boyd.

14. The caricature caption, quoted from the *Daily Paper*, reads: 'The rebel cavalry leader, STUART, has appointed to a position on his staff, with the rank of Major, a young lady residing at Fairfax Court House [Virginia], who has been of great service to him in giving information, etc.' This image refers to the rebel spy Antonia J. Ford [born Fairfax Court House, 1838–1871] who Stuart made his aide-de-camp in October 1861. See Leonard 1999a: 45–50.

15. The Civil War nurse and sanitary-aid activist Mary Livermore also used the term 'half-soldier heroine' in her memoirs *My Story of the War* (1889: 119). On the lives of actual half-soldier heroines, see Leonard 1999a: 99–141. Of the few discussions devoted solely to war narratives concerning female authors and subjects, see Leonard 1999a: 179–81, 252–63; and Curtis Carroll Davis 1964: 385–400.

16. In a recent annotated version of *Nurse and Spy*, Elizabeth Leonard authenticates specific names and events in Edmonds's narrative and states the narrative is the only one verifiable female soldier memoir. See Leonard 1999b: xiii, xxi, 237–58.
17. A more in-depth examination of the pictorial embellishments in *Nurse and Spy* can be found in Empen 2003.
18. 'S.E.E. Edmonds' [sic], steel-engraved frontispiece portrait of Sarah Edmonds from *Nurse and Spy* (1865), Indiana University Main Library, Research Collection, Bloomington.
19. On stock print images of Civil War hero equestrian portraits, see Neely and Holzer 2000.
20. One example is the frontispiece to Maturin Murray Ballou's *Fanny Campbell, The Female Captain. A Tale of the Revolution* (1845). This romantic pamphlet novel inspired Edmonds to adopt a masculine identity. On Edmonds and Fanny Campbell, see Leonard 1999a: 248–50. See also Cohen 1997: 9.
21. 'Queen of the Amazons Attacked by a Lion', nineteenth-century (undated) black and white lithograph, published by Nathaniel Currier, reproduced as Fig. 11 in *Currier & Ives: A Catalogue Raisonné*, Vol. 1, 1984: xxxi.
22. Another frontispiece illustration from sensationalist pamphleteer Charles Wesley Alexander's *Pauline of the Potomac* (1862) also imagines the Amazon type in the figure of the calculating and bewitching heroine in disguise, Pauline D'Estraye, who as an excellent horsewoman and expert sharpshooter spied for Generals McClellan and Grant. On the stereotype of fictional female spies, see Leonard 1999a: 95–6.
23. The attribution of all twelve wood engravings to R. O'Brien of New York is somewhat uncertain as other engravers' names with 'Sc' [sculpsit] appear inscribed in some of the illustrations.
24. In *Nurse and Spy*, Sarah's horse is named 'Frank' (1865: 148), a vague allusion to Edmonds's own disguise as 'Frank', her actual male alias that remains veiled and never explicitly named throughout her memoir.
25. Schultz notes some scholars dismiss patriotism as a motivation and instead attribute nascent feminist motives for enlisted female soldiers (Schultz 1989: 32, 260, 270). Other cross-dressed female soldiers were condemned as prostitutes (see Leonard 1999a: 241–8).

Renegotiating Masculinity after the Civil War

Absent Fathers and Women with Beards: Religion and Gender in Popular Imagery of the Nineteenth Century

DAVID MORGAN

A generation of scholarship on the social history of the American family has developed a compelling narrative. With the rise of the industrial revolution in the early republic, the colonial paradigm of the patriarchal family was challenged by a new set of economic circumstances and social arrangements. Production during the colonial period had been centred in the home, with labourers and apprentices living under the same roof as the owner of the mill, farm, or shop, where the master craftsman and father-owner was the principal authority in family and workplace. With the rise of the factory and the expansion of wage-earning urban populations, the owners and managers relocated to quiet side streets and neighbourhoods near the business district while the labouring classes congregated in separate neighbourhoods. The *paterfamilias* spent more and more time away from home, working at the office or factory. Responsibility for domestic order, including religious formation, was therefore increasingly invested in the mother during the antebellum period.

This account, however, has recently been challenged for overlooking evidence of the anxieties of middle-class fathers regarding the lives of their children and the persistent involvement of many fathers in domestic concerns (see Johansen 2001: 17–44; Frank 1998). There was not, in fact, a wholesale exodus of middle-class fathers from the home. And many of the fathers who spent increasing amounts of time away from home suffered guilt and regret for doing so. Yet it remains the case that fathers in the antebellum period left the home for the workplace as American industry and finance expanded and the workforce moved from country to town and city.

One does well, therefore, to proceed mindful of the complexity of evidence when examining the wealth of visual materials illustrating the publications of antebellum Protestants who were concerned about the state of the American family in the period. Rather than 'snapshots' of family arrangements, the domestic images of mothers with children and paternal absence may be better understood as visualizations of ideological formations. The images, in other words, were designed to foster an ideal that responded *both* to the actual circumstances of mothers assuming greater responsibility in home life due to increased paternal absence *and* to the desire of Protestant men and women to resist the movement of women into social roles beyond the home. The new economic forces of factories and the growth of urban centres provided markets for female labour that drew heavily on the (frequently immigrant) lower classes (see Licht 1995: 27). Middle-class Protestants responded by underscoring class distinctions, clarifying the respective roles for both middle-class men and women. The proper sphere for middle-class Protestant women was the home. As Stephen Frank has pointed out in his fine study of nineteenth-century fatherhood, the working-class practice of sending children into the workplace, and valuing them for their economic potential, contrasted with the middle-class valuation of children. For bourgeois fathers who worked increasingly away from home, a new,

Fig. 10. 'Train up a child in the way he should go'. Courtesy of the Billy Graham Center Museum, Wheaton, IL.

sentimentalized understanding of children as the organic product of loving mothers at work in the domestic nest of the home contributed to an important social distinction between the classes and helped form middle-class consciousness (Frank 1998: 5). Hence the importance of middle-class mothers staying at home and the central role for advice literature (and fathers) to tutor and reinforce this view of maternity.

The image reproduced as Figure 10 illustrated a religious weekly of 1857, published in London but distributed in the United States, and shows the middle-class mother solemnly fulfilling her role in the home while the statuesque patriarchal 'head' of the household looks over, a small monument to his own absence.[1] The mother teaches her child the Proverbs, indeed, teaches him the importance of teaching him the Proverbs, in particular, Proverbs 22: 6: 'Train up a child in the way he should go'. The mother has called her son away from his playthings, which he has obediently left on the floor, in order to be instructed. Above the mother and to the left hangs an elaborately framed painting of an ancient mother instructing her son, arguing visually that the modern duty of mother teaching son was in fact an ancient one. We know from another antebellum image that the older woman is Lois and the younger, Eunice, the grandmother and the mother of Timothy, whom they teach (see *American Tract Magazine*, March, 1830, p. 1). If the marble bust atop a classically decorated parlour organ represents St Paul, as the bald head and toga may suggest, the irony is complete since it was Paul who, in his letter to the Ephesians (6: 4), directed fathers, not mothers, to rear their children 'in the discipline and instruction of the Lord'. Moreover, when Paul remembers Timothy's mother and grandmother in his second letter to Timothy, it was for their faith, not their pedagogical practice (2 Tim. 1: 5). Therefore, the image modifies the scriptural record to fit contemporary American domestic piety. The mute effigy of a brooding patriarch commands only a titular presence in this domestic cult of maternity.

As Figure 10 clearly suggests, the audience for admonitions to honour and practise republican motherhood was not working-class women, but those of the middle class, that is, not the women who were employed in factories or mills, but the wives of factory owners, mill operators, bankers, merchants, landowners, managers and entrepreneurs of the middle and upper-middle classes. These images and the literature they illustrated helped shape bourgeois self-consciousness and the emergence of a self-identifying middle class. The republican mother, in other words, was a symbol of the middle-class.

In 1820 more than half of the white American population was sixteen years old or younger (United States Bureau of the Census 1909: 103). Over half of these young people were single

and female among urban labouring classes and constituted a group whom Protestant educators and reformers sought to direct to the safety and propriety of the domestic sphere – where working-class women should aspire to middle-class status or serve the middle classes as respectable members of the subservient class. Teaching and benevolent work were among the few acceptable public roles for middle-class women in the national campaign to secure the Christian Republic of the United States, as Northern Whigs liked to imagine it. Literature produced by the American Tract Society sought to restrict women to the home sphere by reassuring them of its impact on all of society. A tract entitled 'Female Influence and Obligations', first circulated in 1836, cautioned women: 'It is not your province to fill the chair of state, to plan in the cabinet, or to execute in the field; but there is no department of human life, and no corner of the world, where your influence is not felt' ('Female Influence and Obligations' 1842: 392).[2] In fact, the tract goes on to suggest that if women withdrew from such public spaces as the ballroom, the soirée, theatre-going, and the stage, if women were to denounce duels and drunkard men, and if all women would revere the Sabbath by attending church, then nothing less than the millennial and 'blessed reign of Christ would be established on earth' (ibid.). But women were not strictly limited to the home as the image illustrating this tract demonstrates. The tract itself states that women were better able than men to minister to the children of the poor by gaining access to their homes and bringing them to Sabbath school. The tract urged women to serve as 'guardian angels' and 'throw yourselves between these little immortals and destruction!' (ibid.: 393). The woman's redemptive influence was likened to Christ's.

Primers, spellers, and readers were issued by religious and secular publishers alike in order to equip mothers with a pedagogy and curriculum that would instil an evangelical piety stressing duty, benevolence, self-denial, patriotism, and clearly defined gender roles. Mother was widely addressed and depicted in this literature as the child's best friend, teacher, and spiritual counsellor. As one tract put it, 'the wife and mother is a kind of presiding spirit in the sanctuary of domestic life' (ibid.: 391). Religious formation, in other words, was really about what mother instilled in her children since it was she who occupied the centre of their lives and father who was relegated to the margins. The emphasis on lived practice rather than written word or spoken sermonic discourse also alerts us to the rise of a devotional piety among nineteenth-century American Protestants who found an increasingly important place for visual images as suasive moral presences that were accorded by Horace Bushnell and other advocates of nurture, rather than catechetical indoctrination, a special power in the unconscious, unspoken influence of a child's moral development.

Christian advice literature contended that the effect mothers had on infants was unparalleled. Not only did advice authors emphasize the pre-eminence of mothers in the religious education of her flock at the fireside, they also spoke of the mother in the home as officiating in 'the sanctuary of religious instruction'. It was the mother, not the father, who 'must be the earnest and affectionate guide to the Saviour. She must take her little ones by the hand and lead them in the paths of piety' (Abbott 1833: 107–08). The formation of an infant's identity proceeded from a direct influx of maternal influence. A tract issued in the late 1840s stated that 'a mother should be what she wishes her children to become' and urged the use of illustrated Bibles and sacred histories as 'particularly serviceable in the instruction of the little ones who have not yet learned to read' ('Letters on Christian Education', 197, 1849: 11–18).

Viewing mother as Christ-like became a widespread practice. Tracts and advice books visualized the parallel of mother and Jesus most frequently by juxtaposing Christ blessing the children with a mother teaching her little ones.[3] The Christology visualized and promulgated by the American Tract Society and other benevolent groups such as the American Sunday School Union stressed the accessibility, sympathy, and benevolence of Jesus. The author of 'Letters on Christian Education' instructed Christian parents to acquaint their children with Christ's story, the following summary of which paints Jesus in the warm colours of the ideal of Mother that enraged later advocates of 'muscular Christianity' in the United States such as Bruce Barton. Children were to learn about Jesus

from his humble birth, through his life of sorrows, to his crucifixion, resurrection, and ascension into heaven. Tell them of the miracles he wrought, his continual acts of benevolence, his tender sympathy for the afflicted, his condescension to little children, his forbearance toward the wicked, his forgiveness of his enemies, and his meek endurance of suffering in the garden and on the cross . . . When you observe them tenderly affected by what they have heard from you, pray with them; minutely confessing their faults, and affectionately commending them to the mercy of this kind Saviour. ('Letters on Christian Education' 197, 1849: 32)

The visual piety of much nineteenth-century American Protestantism consisted of imaging in children a filial devotion in which self-denial was rewarded by the intimate friendship of a gentle saviour who was more like mother than he was like father, whose absence from the iconography of domestic nurture corresponded to his absence from the home. Perhaps the most familiar literary example of domestic matriarchy and the absent father was *Little Women*, published in 1868 by Louisa May Alcott, daughter of Unitarian Bronson Alcott.

The prominence of mother in popular imagery and literature contrasted though not necessarily conflicted with male assessments of youth culture and the perceived needs of boys and young men. Two Unitarian clergymen present the two dominant faces of American masculinity in the antebellum period and make an instructive comparison with the domestic culture of maternal influence. In an 1855 article on 'Gymnastics' in *The North American Review*, Unitarian clergyman A. A. Livermore summed up the host of causes widely identified by his contemporaries as threatening modern American well-being:

In the early history of this country, the Olympic games of our people were hunting, woodcraft, and Indian, French, and Revolutionary wars. The wild forests developed the muscles of our fathers, and cottage toil strengthened noble mothers of heroes and patriots. A hardy life in rural pursuits in the open air is still the mighty rampart of our nation against an army of diseases, and the effemination of a whole race of men. But, unfortunately, as our cities grow, as civilization waxes complex and luxurious, and the classes addicted to professional, mercantile, and sedentary life are multiplied, the physical stamina are in danger of succumbing . . . (Livermore 1855: 66–7)

Livermore discerned a declension of physical activity resulting from the rise of modern American society. Coupled with the growth of cities and the office culture of modern commerce, the expansion and sophistication of civilization, and the decline of warfare, inactivity had sapped Anglo peoples in North America. Livermore characterized this historical process as a national loss of masculinity. Men needed exercise in order to fight the onslaught of 'effemination'. Livermore strongly urged American educators to use athletics to infuse students – essentially boys and young men – with the vigorous health they lacked. He looked to the history of western civilization and found in it an abundance of physical culture abandoned by modernity. Exasperated as he was by the 'pallid effeminacy' of American youth, Livermore did not despair. Protestant America had something that ancient Greece and Rome did not: the adornment of 'Christian virtues never known to the Porch or the Academy'. Physical culture could redeem the bodies of young Americans and therefore place the nation and its religious faith on the throne of western civilization (ibid.: 69).

The absent father in literature and visual iconography generally cultivated a masculinity that stressed manliness rather than machismo. Unlike the aggressive, often jingoistic masculinity to come after the war, Christian manliness was less hostile towards women, even deferential to the pre-eminence of the female gender, though always in order to delineate the feminine sphere as properly domestic and non-public. Manliness was the Christian counterpart of the republican mother. The principal task of male formation in this ideology of manhood was character development: the young male needed to be formed by both mother and father, but finally by association with like-minded young men of one's own class. Organized athletics in college or sponsored by the YMCA were believed capable of developing the virtues of manliness. The ideal

of a 'sound mind in a sound body' served as a motto for the YMCA, where sport produced a rival to the insidious urban distractions of dancing, gambling, taverns, and circuses – alternative forms of association that not only harmed body and soul, but led to intermingling with lower classes.

The term 'muscular Christianity' was used already in the 1860s to signify this notion of masculinity and should not therefore be understood to designate only the machismo that arose in the final decades of the century. Thomas Hughes, British author of the enormously popular novel, *Tom Brown's School Days* (1856), spoke for many in the United States when, in 1861, he defined 'muscular Christianity' as 'the old chivalrous and Christian belief' that 'a man's body is given him to be trained and brought into subjection and then used for the protection of the weak, the advancement of all righteous causes, and the subduing of the earth which God has given to the children of men' (quoted in Rosen 1994: 36). Hughes's distinction of manliness and machismo underscored the virtuous understanding of character. Recalling Emerson's anthropology, the body was a wilful force, a base domain of passions that had to be subjected to the controlling power of the mind. The result, achieved through denial and mastery of the bodily urges, was good character. In this masculine regime, the formation of character began with mastering the unruly male body and its passions.

The effects of the war on conceptions of masculinity hearkened a decades-long shift in the popular understanding of masculinity. This change, which is manifold and by no means uniform, is evident in many familiar aspects of American culture during the final decades of the nineteenth century that made male segregation and affiliation vital issues in the cultural and social life of the nation. Scholars of American masculinity have rightly pointed to new male roles fostered by Teddy Roosevelt, who posed for a photographic portrait as a pioneer hunter, dressed in buckskin, evoking folkloric memories of Davy Crocket and Daniel Boone (the image is reproduced in Kimmel 1996). Another important mythographer in the Gilded Age was the painter and sculptor, Frederic Remington, who eulogized the heroics of Indian fighters, cowboys, and soldiers in order to assert the continental aspirations of American civilization in the face of savage resistance. Other manifestations of an increasingly self-conscious male culture in the later nineteenth century include the mushrooming of male-only fraternal organizations; the importance of sport among boys and men, including the organization of collegiate and professional sports teams; and a series of revivals dominated by male evangelicals such as Dwight L. Moody, who embraced the ideals of 'muscular Christianity' as taught by the Young Men's Christian Association (the first association in the United States was formed in Boston in 1851).

The Civil War helped intensify consciousness about male difference in American society. In the South, male honour in the cause of the Confederacy and in the North the integrity of the Union each evoked an appeal to manliness in the face of military aggression. The pivotal shift is evident in even a single illustration used by a Sunday school weekly, *The Well-Spring*, just before the war (Figure 11). The illustration presents a rashly disposed young boy brandishing a sword. The article, which the image illustrated, asked of young viewers: 'Is this the plan for life you would choose?' The emphatic answer in 1860 was no, but when the same children's newspaper reused the identical image a year later, after the Civil War had begun, it enquired: 'Who would not now encourage any one in becoming a solider in his country's cause?' ('What a Change' 1861: 95).[4] Framed in this manner, the gender differences could not be more starkly drawn in this illustration. What had been the image of a rude young boy before the war was transformed into 'the military spirit we are now willing to see in all, even the boys, – a spirit to stand by our country, – to defend our government against every foe'. 'Even affectionate mothers', the caption continued, 'urge their beloved sons . . . to go forth at their country's call.' The image was dramatically recoded to support the Union's campaign against the Confederacy by fostering a new understanding of the relation of sons and mothers. Mother is no longer the teacher, as she had been before the war, but the now passive admirer of her militant son. And the aggressive behaviour of sons is no longer to be subordinated to maternal authority, but nurtured as the proper 'military spirit'.

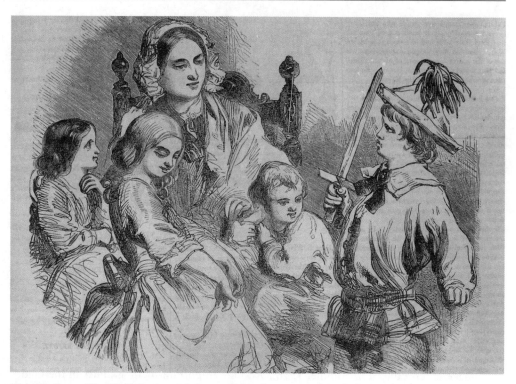

Fig. 11. From *The Well-Spring*, 21 June, 1861. Courtesy of the Billy Graham Center Museum, Wheaton, IL.

Following the Civil War, the rise of the American city, the mobilization of the populace, women's suffrage, the arrival of growing numbers of immigrants, and the longing for something to replace the militarism and male association of the Civil War also contributed to the emergence of a new kind of masculinity, one that found expression in rhetoric that lamented the softening of the American male and which tended to externalize the threat to self-mastery. The shift became evident in American sport: James Naismith, inventor of basketball in 1891, looked back upon the sport in 1914 and regretted the dominant ethos of winning at all costs, which eliminated the older ideal of character formation in boys and young men (Ladd and Mathisen 1999: 70). Such competition corrupted youth because it made cheating desirable in order to ensure winning. Sportsmanship and the honour it endorsed were old-fashioned. Competition ranked personal gain over collective development and regarded the opponent not as a manly fellow citizen, but merely as the external hindrance to personal benefit.

For some advocates of male rights and the new masculinity, the quest for masculine characteristics was coupled to a rising anxiety about the status of women. When he directed his attention to refuting women's suffrage in 1869, Horace Bushnell fixed on the physically distinguishing features of masculinity as emblems of men's authority over women (Bushnell 1978: 50). 'In physical strength,' he wrote, 'the man is greatly superior, and the base in his voice and the shag on his face, and the swing and sway of his shoulders, represent a personality in him that has some attribute of thunder. But there is no look of thunder in the woman.' Bushnell characterized Woman as softness, grace, and beauty and as utterly 'unOlympic', while Man's looks spoke 'Force, Authority, Decision, Self-asserting Counsel, Victory'. If men were warring sons of Zeus, women were normal mortals who belonged at home. Bushnell put it without subtlety: 'One is the forward, pioneering mastery, the out-door battleaxe of public war and family providence; the other is the indoor faculty, covert, as the law would say, and complementary, mistress and

dispenser of the enjoyabilities' (ibid.: 51). Bushnell objected to women's suffrage as an unwarranted claim to authority, a claim to the right to govern, which was properly reserved for the sex selected by nature for its assertive powers, marked by nature with the beard. For women to seek the right to vote, therefore, was the same as wanting to grow facial hair. 'The claim of a beard would not be a more radical revolt against nature,' Bushnell reasoned as he sought to lodge a biological wedge between the genders in order to secure male authority. Absent this difference, Bushnell feared, the ontological status of masculinity would be in doubt. According to him, 'Man' was the law and law was the basis of government. Were the masculine principle of law to fall 'into second place or equal place with anything else, it would lose the inherent sovereignty of its nature, when, of course, it would be law no longer' (ibid.: 56, 61). In other words, Man must remain superior to Woman in order to remain Man. Gender identity was premised entirely on sharp and clear difference. As Bushnell reasoned, man and woman are one species, 'but if they were two, they would be scarcely more unlike' (ibid.: 51). But Bushnell's urgency to keep the two separate implies that he knew very well such a separation was constructed and enforced, a policed and insecure boundary in the cultural politics of authority.

If the ideology of the republican mother, which was supposed to keep middle-class women at home engaged in childcare, helped feminize American Christianity, likening Jesus to mother, the Civil War militarized and masculinized sons for duty to country, seeing in masculine formation the necessary condition for life outside the home. Additionally, the rise of women's suffrage stiffened resistance among its opponents, who were inclined to deepen gender differences by fetishizing such biological features as the beard as signifiers of masculinity and its nature-sanctioned rights of pre-eminence. All of this exerted great influence among those Protestant moralists and intellectuals who envisioned Jesus as the embodiment of the new masculine ideal.

Concern for underscoring the masculinity of Jesus and the significance of the beard fuelled critical attacks on traditional portrayals of Jesus around the turn of the century. In 1903, William Barton decried the absence of virility in historical portrayals of Christ: 'it is often a womanly sweetness,' Barton complained,

> that shows in the face of the Christ of art. 'The masculine,' so the painters have seemed to say, 'is the gross, the sensual, the aggressive, the belligerent. We will make our Christ with a woman's face, and add a beard.' Popular thought is in accord with this conception. The newspapers have a standing word of reproach for any form of masculine or aggressive effort professedly Christian, and which they do not like. (Barton 1903: 504)

Barton's reference to the mass medium of newspapers suggests that the movement of muscular Christianity learned from the feminization of the church the concept of influence as a device of mass culture. What followed was a truculent call to dominate the cultural means of display, a mobilization of suitably masculine visual representation as the instrument of influence. Voices promoting virile influence arose and fastened onto mass-produced images as a way of shaping young men's souls. In his 1917 study entitled *Jesus, the Christ, In the Light of Psychology*, G. Stanley Hall called on modern artists to overwhelm viewers with portrayals of manly men. 'With its skill in depicting women,' Hall wrote, modern-day art 'should not lose its power to represent virile men. Its virgins should not be superior to its Christs, nor the latter be more effeminate or bisexual in appearance than masculine' (Hall 1917 [Vol. 1]: 27). Hall observed that modern religion was more affective because less dogmatic, and this threatened a physical and emotional refinement in boys that Hall found unacceptable. But the answer, according to the liberal Hall, was not to enhance the intellectual rigour of the faith, since Hall found the content less than persuasive, but to fix on the appropriately inspirational symbols of belief. Thus, he derided most nineteenth-century depictions of Christ as feminine, as evidenced by 'feminine features' and a scant beard that 'sometimes almost suggests a bearded lady' (p. 23).

Muscular Christianity of the aggressive sort appealed to conservative evangelical and to liberal Protestant alike. At the same time that G. Stanley Hall applied his psychology of adolescence to the use of images of Christ in religious formation, the evangelical revivalist Billy

Sunday, former professional baseball player, developed a hyper-masculine homiletic style. The manly charisma of his jingoistic gestures at the pulpit was captured in postcard photographs that were sold at his tent meetings (for further discussion of these images, see Morgan 2002: 37–56). In a manner of speaking, therefore, liberal and conservative Protestant men were in agreement on the emasculating influence of women. But was it, as Bruce Barton alleged, a war against fatuous, sentimental Sunday school teachers and the long strings of mother's apron?

Denunciations of visual images of Christ as a woman with a beard increased in volume following the turn of the century, suggesting that advocates of the new Christian masculinity knew they were fighting a more formidable opponent than mom. In fact, they were waging a losing battle. The last quarter of the nineteenth century witnessed the rise of female activism within American Protestantism. Women's suffrage attracted increasing attention, leading to the adoption of the Nineteenth Amendment to the Constitution in 1919. A leading activist in this cause, Elizabeth Cady Stanton, identified orthodox Christianity and its Bible as part of the problem, which she attempted to correct by issuing *The Woman's Bible* in 1895 (volume one) and 1898 (volume two). In this controversial publication Stanton challenged Holy Writ and Christian tradition for endorsing the suppression of women, which she considered nothing less than the 'slavery of women'.[5]

One international evangelical operation, the Salvation Army, even adopted some obvious aspects of the militarism favoured by advocates of muscular Christianity. Yet the Army distinguished itself notably by offering women a fundamental role in its enterprise. In fact, the leadership of the Army's American contingent for the first several decades was female, co-led from 1887 to 1896 by Maud and Ballington Booth, then from 1904 to 1934 by the daughter of the couple, Evangeline Booth. Whereas the tradition of revivals and tent meetings extending from Charles Grandison Finney to Dwight Moody, J. Wilbur Chapman, and Billy Sunday were conducted by men, the Salvation Army determined that these initiatives were aimed at the middle-class Christian and elected instead to place women on the front lines of evangelical outreach among the urban dispossessed (Gaustad 1990: 209). The American *War Cry* was the principal organ for the Army and carried both articles and images that presented the Army's conception of the female warrior for Christ.

The perception that women had a much more active and public role to play in the cause of moral reform and redemption is evident in a lithograph entitled 'Woman's Holy War: Grand Charge on the Enemy's Works'.[6] Issued by Currier & Ives in 1874, the year that the Woman's Christian Temperance Union was founded in Ohio, the image broadcast the sensation of the new activism (members of the WCTU had wielded axes to smash liquor casks). The WCTU urged women to take a more assertive and open opposition to the abuse of alcohol and even encouraged the political enfranchisement of women by endorsing the national Prohibition Party. As one scholar has argued, the WCTU offered middle-class women instruction in the rhetoric of public campaigning in the form of pamphlets, tracts, organizational literature, national reports, and guidelines on public speaking (Mattingly 1998: 58–72). Yet as progressive as Frances Willard sought to make the WCTU during her long tenure as president (1879 to 1898), the organization never moved beyond its bourgeois, Protestant base.

This moderate character is registered in the Currier & Ives print. A crusading woman on horseback, swinging a battleaxe, clad in armour and gauntlet, recalls contemporary iconography of Joan of Arc, an enormously popular heroine in nineteenth-century France. In the Currier & Ives print Joan is Americanized. The image still reflects the romanticized, idealized aesthetic of the pure and uncompromised woman, the Victorian notion of Woman as Redeemer, familiar in portrayals of Joan of Arc and part of American visual culture from the antebellum era, where Mother was portrayed as Christ-like. But now the feminine ideal is emboldened, activated as a dynamic public presence, a kind of apocalyptic Christ figure who means business. She marks a shift from Christ as pastoral saviour to Christ as furious and righteous judge. But she is also a nationalistic figure (bearing a shield with stars and stripes), modelled perhaps on Joan as a symbol of French nationalism and resistance to foreign invaders. As the totem of the WCTU's opposition to alcohol, this American Joan may represent the Protestant establish-

ment's abiding preoccupation with control in the face of an immigrant society in which the drinkers and the producers of drink were often not white bread Protestants, but Irish and European newcomers. The Prohibition Party, which the WCTU supported (though a faction split off over this support), sought enforcement of criminal codes against prostitutes, promoted the Comstock Law against obscenity in the mails, lobbied for a constitutional amendment to establish Christianity as the national religion, supported enactment of the national observance of the Christian Sabbath, and encouraged the use of the Bible as a textbook in public schools (Ginzberg 1990: 206).

If women secured a new voice and presence through the efforts of the WCTU, they did so clad in the confining garments of bourgeois Protestantism. Under the reassuring banner of moral purity, religious righteousness, and social order, women found their way into the public arena, transforming their image on the way from queen of the home to militant activist on the public battlefield. It was not a perfect revolution, but the measure of liberation it delivered was irreversible, the cant and volume of strident Protestant masculinists notwithstanding.

Notes

1. *The Sunday at Home* was published by the Religious Tract Society, London, from 1854 to 1894 as a weekly magazine for family reading on the Sabbath. Publications by the Religious Tract Society were widely used by such American antebellum organizations as the American Tract Society and the American Sunday School Union.
2. This tract first appeared as a separate publication by the American Tract Society in 1829.
3. See for example a version of 'Letters on Christian Education' earlier than the one reproduced here. The earlier version, illustrated by Alexander Anderson, included a cover showing a mother tending her four children and a tailpiece of Christ with four children ('Letters on Christian Education' 1842).
4. In a brief paragraph Clifford Putney asserts that the Civil War 'actually undermined muscular Christianity in America by certifying the manliness of innumerable men', since those who fought in battle considered they were not compelled to feel the need to exhibit their physical prowess on the sports field (Putney 2001: 23). He does not, however, cite any evidence in support of this vast claim, which suggests that it is motivated by a general definition of 'muscular Christianity' rather than particular historical evidence. Elsewhere in his study, Putney regards the Civil War as the demarcation of a major shift in Protestant notions of masculinity (ibid.: 75). In fact, as he himself points out, the Civil War established the heroic masculinity of an entire generation of American men so thoroughly that the next generation looked to other wars and a militarized ideal of the strenuous life in order to compare with the generation of their fathers.
5. See Stanton's letter to Susan B. Anthony, January 10, 1880: 'I accept no authority of either bibles or constitutions which tolerate the slavery of women' (Stanton and Blatch 1922 [Vol. 1]: 163–4. See also Stanton 1974).
6. A copy of the lithograph can be found in the prints and photographs collection of the Library of Congress. The image is reproduced in *Currier & Ives: A Catalogue Raisonné*, 2 vols (Detroit: Gale Research Company, 1984), Gale no. 7299, vol. 2, 737.

Visualizing 'America' as 'Progress' at the end of the Western Frontier

Painting the Nation: American Art at the White City

CHRISTOPHER GAIR

Writing for the *Cosmopolitan* in the guise of an 'Altrurian Traveller', the novelist and critic William Dean Howells published a series of letters harshly observant of modern American life. The one significant exemption from his criticism came in his account of the World's Columbian Exposition, contained in the second entry, written during a visit to Chicago in 1893. For Howells, echoing innumerable journalistic reports of the Fair, the White City is 'harmonized [in the Court of Honor] to one effect of beauty, as if in symbol of the concentrated impulses which had created it'. In what *could* be an example of a racially overdetermined view of the Fair, he talks of having 'caught a glimpse of the glorious capitals which will whiten the hills and shores of the east and the borderless plains of the west when the New York and the Newer York of today shall seem to all the future Americans as impossible as they would seem to any Altrurian now'. For Howells, however, unlike most commentators, this 'object lesson' is particularly *un*-American in its focus on education, beauty, and knowledge. Instead, it is the Midway Plaisance (a mile-long strip that led up to the White City, combining popular amusements, such as the Ferris wheel, with ethnological displays of other, explicitly 'primitive', cultures) that functions as the exemplification of the modern world, and illustrates the global influence of a very different kind of American identity:

> In the Fair [White] City, everything is free; in the Plaisance everything must be paid for. You strike at once here the hard level of the outside western world; and the Orient, which has mainly peopled the Plaisance, with its theatres and restaurants and shops, takes the tint of the ordinary American enterprise . . . but whether one visited the Samoan or Dahomeyan in his hut, the Bedouin and the Lap in their camps; the delicate Javanese in his bamboo cottage, or the American Indian in his tepee, one must be aware that the citizens of the Plaisance are not there for their health, as the Americans quaintly say, but for the money there is in it. (Howells 1961: 22, 20, 24–5)

For Howells, it is evident that American cultural imperialism is already in full stride. His pessimistic version of a contemporary America dominated by hustlers in it 'for the money', however, also reflects the extent to which urban identity was being defined (at least in the popular imagination) by a shift from a production-based work ethic to a performative culture (of 'theatres and restaurants and shops') within which status was acquired through the conspicuous display of consumer goods.

Commemorating the four hundredth anniversary of Columbus's arrival in the New World, the Exposition, or World's Fair, was held on a 686-acre site in Jackson Park, seven miles south of downtown Chicago, between May and October 1893. Visited by over twenty million people, it served to express dominant ideas about American and global cultures. As Howells's account

makes clear, exhibits were divided into two separate sections: unlike the multicultural and pop-ulist Midway Plaisance, the White City, a collection of neo-classically fronted buildings con-taining the 'best' of contemporary art and technology, displayed an official version of 'progress' and the limitless possibilities for material and spiritual improvement opened up by the emer-gence of the United States as a world power.

The dominant view at the time pictured the White City as representing the near-perfected state of current (white) American society contrasted with the other cultures that preceded it, and which were displayed outside its gates in a kind of evolutionary progression acted out in the present. Thus, the *New York Times*, reporting the opening ceremony, commenced with a brief account of the Presidential procession up the Midway, during which, 'Arabs, Egyptians, Javanese, Nubians, Cingalese, Soudanese, Moors, Chinese, and the inhabitants of every quarter of the globe were grouped on either side of the roadway, ready to do obedience to the ruler of the great American Nation.' It then moved on to observe that the White City 'was Athens and Venice and Naples in one, and all around on every pathway and road, swarming over the bridges, thronging the plazas and colonnades and terraces, 500,000 people were waiting breathlessly for the signal to shout the praises of Columbus, discoverer of the "land of the free and the home of the brave"' (*New York Times*, 2 May, 1893: 1–2).

In contrast, Howells, who by the 1890s was feeling increasingly desperate about the state of American life and what he saw as the negligible impression his moral realism had made on the reading public, visualizes the White City as an almost utopian alternative that counters human exhibits who are *already* modern and 'American' in their unrestrained pecuniary obsessions. Notwithstanding his remarks on American cultural imperialism, Howells's one cause for opti-mism is that, unlike his own fiction (with, as he thought, its limited market appeal), the White City would reach out to its twenty million visitors and, through its combination of education and entertainment, demonstrate the true capacities of humankind, and counter the commercial excesses of a commodified modern world.

It is unsurprising that such divergent interpretations existed at the time, and that the per-ceptive Howells should seem so pessimistic about the conditions of American life. In apparent tension with the splendours of the Exposition, 1893 also witnessed the most severe financial panic in the nation's history, as banks closed and the growing rifts between capital and labour erupted into waves of violent protest and retribution. In his hugely influential address (deliv-ered at the White City), the historian Frederick Jackson Turner interpreted the significance of the declaration in 1890, by the Bureau of the Census, that the frontier was 'closed'. The panic and the historian's thesis were not unrelated: according to Turner, the frontier had acted as a safety valve, preventing internal ethnic and racial conflict by reducing pressure on the United States as the nation pushed ever further west. Without that release, many people felt that increased tension was inevitable and that, as demonstrated in 1893, the city would become the new scene of conflict. Waves of non-English-speaking immigrants arrived in American cities (largely from Southern and Eastern Europe) during the 1880s and 1890s, calling into question just what it meant to be an 'American'. Post-Reconstruction, the Southern (and by the 1890s increasingly national) fear of miscegenation and the 'black rapist' would contribute to the Supreme Court's 'separate but equal' ruling in 1896, and to thousands of lynchings during the decade. With no more 'free land' at home, the debate between imperial and anti-imperial voices about the nation's role in global politics started to dominate the front pages of the popular press.

Located in the Fine Arts Building, the exhibition of American painting and sculpture at the White City was specifically designed to negate such discontents, and to illustrate the matur-ity of a nation able to compete with or surpass any other, not only in industry but also in the arts. In his magisterial *The Book of the Fair* (1893), the historian Hubert Howe Bancroft rec-ognized the importance of the display, claiming that, 'in this era of international expositions there is perhaps no department in which their stimulating influence has been more strongly felt than in the fine arts' (Bancroft 1893: 665). In a similar vein, the painter Will Low sug-gested (in 1910):

When the White City was built in 1893 art assumed a definite place in our national life. Then for the first time we awoke to a realization that art of the people, by the people, for the people had come to us. It came to this New World in the old historic way. From the seed sown in the Orient, through Greece, through Italy from Byzantium, wafted ever westward, its timid flowering from our Atlantic seaboard had been carried a thousand miles inland to find its first full eclosion; not as a single growth, but as the triple flower of architecture, painting, and sculpture. (Quoted in Carr and Gurney 1993: 13)

Low's comments are significant in at least two ways. First, there is an implicit assumption that the Americanization of art represents an incorporation of high culture into the republican process. Freedom of opportunity here includes not just the possibility of financial or practical self-improvement along the lines of the model advocated in Benjamin Franklin's *Autobiography*. Instead, in recognition of the gradual shift from a production to a consumption-based economy around the end of the nineteenth century, Low suggests that art is produced for a 'people' with the leisure time not only to visit exhibitions, but also to acquire the sensibilities necessary for understanding such works. As will become clear, this process functioned within a wider cultural logic in place at the White City and more widely in the United States in the 1890s, when (as Bill Brown has astutely summarized), the stress on visual representations participated in a complex 'amusement/knowledge system' (Brown 1996: 230). Like Howells, Low is aware of the educational value of the spectacle – in this case, the display in the Fine Arts Building – but where Howells sees the White City as representative of some future utopia, Low clearly believes that the impact was immediate. Thus, for him, the true significance of the display of American art is in its demonstration that the nation has transcended its stereotype as industrious but uncultured.

Second, it is notable that Low places this moment as the culmination of an evolutionary process marked by Westward migration. Drawing on the Victorian conviction that ideals of beauty and taste were shaped in ancient Greece and Italy (as the design of the White City illustrates) Low makes clear that mere imitation of the old world is not enough. Instead, it is only in Chicago that the potentialities present in classical art and architecture attain their full maturation. The combination of the two points suggests just how significant the Exposition was as a way to imagine new forms of American nationhood, coupling traditional stress on symbols such as the Frontier, with a newer sense of cultural maturity in a project that depended, above all, on the power of visual representations to convey meanings.

Not all interpreters of the art exhibition were quite as unqualified in their praise as Low. In his *Book of the Fair*, Bancroft noted:

While by no means 'the best display of art from any nation,' as the vainglorious among our countrymen would have us believe, the galleries devoted to domestic art contain much that is of value and interest, with more of promise yet to be fulfilled. By American visitors to the Fair none of its departments were inspected with closer scrutiny, with greater solicitude and curiosity, for never before had American art received adequate expression at an international exposition. That we could hold our own in the mechanic and liberal arts, in agriculture, mining, stock-raising, and other branches of industry was not for a moment doubted; but in pictorial and plastic art how would we compare with the painters and sculptors of European nations, their works evolved amid the fostering influences of a civilization compared with which our own is but of yesterday? (Bancroft 1893: 672)

Although Bancroft refuses to celebrate American art to quite the same extent as Low, he shares the sense not only that the United States is emerging as a significant producer of serious works, but also that its populace is now ready to appreciate the significance of these works in the process of nation building. And even his observation that American art does not yet match that of the old world is tempered by the suggestion that, given a national ability to triumph in all fields, it is only a matter of time until its 'promise' will be 'fulfilled'.

What is clear is that, for both critics, the art exhibition mirrors the wider ethnic and racial construction of the Columbian Exposition in the manner that it imagines relationships between self and other. Thus, the paintings and sculptures on show in the Fine Arts Building are overwhelmingly by white artists and depict comforting narratives of American exceptionalism, grounded in familiar mythologies. The 'people' for whom Low imagines this art are also implicitly white. Where other racial and ethnic groups are represented, they tend to assume stereotypical roles such as the 'primitive' Native American spectator in Edward Moran's *The First Ship Entering New York Harbor* (1892). The figure is near the centre of the canvas, but in a gesture that was widely reproduced in nineteenth-century American painting, his half-naked torso, his position peering out from behind a rock, and his simple weaponry all mark his status as member of a group destined to be pushed to the margins by the European newcomers, represented here through Henry Hudson's strikingly modern ship, the *Half Moon*. Given that White City was staged to celebrate the 400th anniversary of Columbus's arrival in the New World, it is clear that Moran's painting (part of a series depicting the maritime history of the United States) would be seen within the context of Columbus's arrival, and would be viewed as representing a founding moment in the creation of the United States. Implicit in a representation of an arrival on the East coast of North America is the whole history of Westward expansion and imperial ambition, and, as Turner's thesis suggests, even at this foundational moment, the ideological relationship between landscape and people is already in place.

Historian Robert W. Rydell has assessed the numerous ways in which the project of imagining a national identity functioned in the Fine Arts Building. First, alongside the American art, gallery space was reserved for other 'civilized' nations according to their position within an evolutionary hierarchy. In addition, the jury process whereby paintings were selected deployed specific criteria for their choices. As Rydell continues, most paintings and sculptures were works 'that encoded images of Anglo-Saxon supremacy . . . [or that] treated [women] as objects of male pleasure or, like many of the displays within the Women's Building, as antidotes to America's rampant commercialism'. The selection process also functioned 'through silences – for instance the relative absence of American paintings that addressed issues of immigration or labor conflict reflected the fact that these disruptive subjects were deemed unpaintable.' Rydell's observations echo Howells's more wide-ranging comments about the lack of overtly commercial activity throughout the White City. There were few paintings representing commercial activity, and Rydell's conclusion that the Art Palace 'occupied a privileged position at the World's Columbian Exposition . . . connecting the narratives of civilization in the White City to narratives of "otherness" along the Midway' (Rydell 1993: 52) points to the organizers' attempts to illustrate cultural differences in evolutionary, rather than economic terms.

There is much to be said for Rydell's argument. Indeed, I have written elsewhere of the manner in which the architecture of the White City constructed precisely such a connection (Gair 2000). The spatial arrangement of various national collections certainly does mirror the evolutionary hierarchies implicit in the layout of the Exposition as a whole. On the other hand, this does not tell the whole story. While many of the paintings, such as Moran's *The First Ship Entering New York Harbor* plainly do fit the pattern, there are also a striking number that are more problematic, and that are potentially subversive of this dominant narrative. In the remainder of this essay, I shall assess the extent to which this counter-narrative was present at the Fair through brief readings of key examples, in order to suggest that the unity of intent implicit in so much of the organizing committee's expressed ideology was subjected to considerable pressures from within. As such, neither Howells's sense of utopian, un-American space, nor the celebrations of a near-perfected contemporary United States articulated by the *New York Times* or William Low, serve as completely satisfactory accounts of the significance of the White City, and, more particularly, of the role played by art at the Fair.

In the context of what Rydell summarizes as an exhibition suggesting 'the idea of the nation's progress from simple, quaint beginnings to a level of supreme accomplishment in industry and the arts' (Rydell 1993: 124), a painting such as J. G. Brown's *The Stump Speech* is unusual in its relatively contemporary, urban setting, and in its themes. The painting represents a boy of

eleven or twelve standing on a soapbox and addressing an audience of other boys of similar age. Although the speaker is clearly the focus of the other boys' attention, and they are both attentive and amused by his performance, his position in the centre of the picture is also slightly deceptive. First, we only see his back – enough to suggest a parody of the district politicians of the age, given his jacketless attire and hands on hips pose, masking what he is doing to amuse his audience. In contrast, the focus on the other boys' faces, and the attention to detail in the representation of their dress, posture, and reactions suggests a democratic concern with the nuances of everyday city life that counters the predominance of portraits and rural scenes that constituted the American exhibition.

More problematically, the painting also serves as a reminder of the dramatic changes that had taken place in the decade between its composition in the early 1880s and its display in 1893. The assembly of amused, united faces is suggestive of less turbulent, and more innocent, times, before the massive unrest marked by waves of strikes during the 1880s and early 1890s, as well as incidents such as Chicago's Haymarket Square atrocity of 4 May 1886, as a result of which four well-known anarchists were (as Howells put it) 'civically murdered' in a highly public mis-carriage of justice (quoted in Tanner 1990: x). Likewise, in the light of Turner's thoughts about the ways in which the Frontier had served as a safety valve to preclude the kinds of urban unrest witnessed in Europe in the nineteenth century, the tightly assembled group could now be seen as a warning of the dangers awaiting a nation with 'no more free land'. Whereas the boys are united in their appreciation of the orator, and are all presumably English speakers, the urban proletariat of the 1890s was characterized in the popular imagination as fragmented along ethnic and linguistic lines, as well as divided within itself by its repeated battles with capital. Finally, the absence of any clue as to what the boy is saying reflects a further anxiety prevalent at the time, with the focus on performance over content echoing the fears (that the White City was in part designed to alleviate) about an increasingly manipulative and unscrupulous political machine.

Although *The Stump Speech* represents a common motif of nineteenth-century American art, its focus on an urban, political scene was unusual in the context of the Fine Arts Building. This becomes even more apparent when it is contrasted with works by Winslow Homer, the artist who, as Carolyn Kinder Carr has noted, was celebrated 'among the critics who championed a home-grown American art . . . [and who] was repeatedly complimented for merging technique with American subject matter' (Carr and Gurney 1993: 100). Although Homer's career began in earnest with his Civil War landscapes, his move from New York City to Prout's Neck, Maine in 1883 resulted in his most important legacy, a series of seascapes from the 1880s and 1890s. Homer's earlier works had been criticized for what Barbara Groseclose has summed up as 'lack of finish in surface and absence of refinement in touch', but these apparent defects now became the cause for celebration of Homer's ability to disregard European influences and match an American subject matter with an independent style.

Groseclose rightly identifies the manner in which Homer's 'near-perfect meshings of palette, light, and mood . . . underscores what is constant in nature: its terrible might and its oblivious-ness to man' (Groseclose 2000: 140–41). On the other hand, her (brief) reading misses the full impact of his subjects' struggles against that nature, and the manner in which the paintings were received at the time. Thus, *Herring Fishing* and *The Fog Warning* (both 1885), works prominently displayed at the White City, represent a refusal to be defeated by nature, as the fishermen battle against the elements to complete their catch. The men's actions not only epit-omize such ideologically dominant themes as Man's battle with Nature, and the virtues of hard work. They do so in a way that would also carry particular resonance in the 1890s. Fears about overcivilization reached their peak during the decade, and Homer's paintings of physical courage and mental fortitude in the face of overwhelming odds parallel Theodore Roosevelt's call for the 'strenuous life', a new passion for sport, and a revived interest in war as antidotes to the 'feminizing' qualities he perceived at the heart of middle-class American existence. In almost every instance, as is apparent from Homer's Prout's Neck paintings, these manifesta-tions of strenuosity combine the cult of Anglo-Saxon supremacism with this fear of modern

'softness'. Whereas *The Stump Speech* could remind spectators of what America had lost without offering an alternative, Homer's works tackle familiarly nationalistic themes as a means of regenerating an ideology that is threatened by the conflicts of contemporary life. Although Groseclose correctly identifies more recent readings of Homer's painting as displacements of an unstable and unpredictable commercial world onto nature (ibid.: 142–3), at the Columbian Exposition they were overwhelmingly applauded for their combination of masculinity and sensitivity to detail.

Homer's representations of masculine strenuosity in the paintings he displayed at the White City form one half of a gendered pairing of industriousness and leisure. As we have seen, Robert Rydell suggests that the one other primary subject for the art collection was the representation of women, treating them 'as objects of male pleasure or . . . as antidotes to America's rampant commercialism'. While the first part of this statement is undoubtedly true, it is highly questionable whether such representations served as 'antidotes' to the materialistic extremes of consumer capitalism that were emerging at the time. Unsurprisingly, given the sexual politics of the late-nineteenth century, the majority of pictures of contemporary white American women portray them as representatives of what Thorstein Veblen famously theorized as the 'leisure class'. Around this time the new woman became a public spectacle, subject to the scrutiny of press, acquaintances and fellow citizens, and compelled to demonstrate her non-productive role via her clothing and behaviour. As Veblen observed in 1899:

> It needs no argument to enforce the generalization that the more elegant styles of feminine bonnets go even further towards making work impossible than does the man's high hat. The woman's shoe adds the so-called French heel to the evidence of enforced leisure afforded by its polish; because this high heel obviously makes any, even the simplest and most necessary manual work extremely difficult. The like is true even in a higher degree of the skirt and the rest of the drapery which characterizes woman's dress. The substantial reason for our tenacious attachment to the skirt is just this: it is expensive and it hampers the wearer at every turn and incapacitates her for all useful exertion. The like is true of the feminine custom of wearing the hair excessively long.

For Veblen, and in marked contrast to the kinds of masculine productivity depicted in Homer's pictures, the leisure-class woman represents a combination of non-productivity – in addition to external symbols of leisure, the use of the corset '[lowers] the subject's vitality' – and wastefulness. Thus, she epitomizes the transformation from utility to the 'flux and change' of fashion as the economy shifts from producer to consumer capitalism, with the latter's success depending upon the generation of a limitless desire for newness in the form of commodities (Veblen 1953: 121–2). Whereas representations of the role of women in earlier American history, or in contemporary rural European life by artists such as Charles Sprague Pearce, Elizabeth Nourse, and Guy Rose depicted impoverished figures struggling to subsist in unfriendly environments, paintings by (among others) William Merritt Chase and Mary Fairchild MacMonnies epitomized the leisure-class womanhood described by Veblen.

Chase's exhibits are particularly significant, given his pre-eminent position within the American art world as both teacher and painter, helped in part by his self-promotion as a 'wholesome' Midwesterner whose good taste was untainted by European influenced art-for-art's sake aesthetes (Groseclose 2000: 29–32).[1] At one extreme, his *Portrait of Mrs. E.* (Lydia Field Emmet, 1893) imagines a place for affluent women beyond Veblen's leisure-class paradigm. Although the portrait does not acknowledge the fact that the subject is also an artist, she is clearly not a passive recipient of the male gaze. Barbara Groseclose's description of Chase's *Portrait of Miss Dora Wheeler* (1883) could also be aptly applied to this later work: '[The model's] eye contact . . . invites approach and . . . does so aggressively. The alert poise of her body hints at energy and strength' (ibid.: 56). Furthermore, the loose-fitting gown facilitates movement and contrasts markedly with the constrictive clothes described by Veblen. With her hair piled on top of her head, and with her lower arms free to move unrestrictedly, the subject

appears to be ready to act in the practical and productive manner suggested by the determined and possibly confrontational expression of her face.

In contrast, Chase's *Lady in Pink* (Mrs Leslie Cotton, c. 1888–9) and MacMonnies's *Tea al Fresco* (1891) conform closely to Veblen's leisure-class archetype. Like Wheeler, Cotton was a student of Chase's, but again there is no acknowledgement that the model is an artist, and in *Lady in Pink* the forms of self-authorization represented in *Portrait of Miss Dora Wheeler* are absent. Not only is Cotton sitting modestly, avoiding the viewer's gaze, she is also attired in such a manner as to confirm her passivity. The title of the painting directs the viewer to what the artist sees as truly significant, and the canvas is dominated by the impractical and multi-layered pink dress. Although the sitter does have freedom of movement for her arms, they are clutching a parasol; her corseted body and the way in which her legs are engulfed by sweeping layers of expensive fabric, suggests that she is a non-productive bearer of the wasteful symbols of affluence.

Mary Fairchild MacMonnies also disguises her own role as a professional artist in *Tea al Fresco*, a painting centrally placed within the exhibition of American Impressionism and much admired at the Fair. The work represents two leisure-class women taking afternoon tea on a veranda surrounded by a verdant garden. *Tea al Fresco* can best be understood within the double context of the Exposition as a whole, and as part of its exhibition of art. When we compare it to Hubert Howe Bancroft's description of the Soudanese and Dahomean villagers, it is not hard to identify its position within the evolutionary models of race implicit in the layout of the Fair. For Bancroft, in the Soudanese village, 'The dancing of girls and children, some of the latter little more than infants, is merely a series of writhings and contortions offensive to taste and disgusting to look upon.' Likewise, the Dahomeans are 'all supremely hideous . . . In their "war-dance", there is nothing of the graceful or sensuous, simply a contortion and quivering of limb and body, with swinging of weapons as though nothing would delight them more than to kill and destroy. It is in truth a barbaric spectacle' (Bancroft 1893: 868, 878). In contrast, MacMonnies's self-representation projects a combination of restraint, beauty, grace and taste. In this depiction of a highly cultured American ritual, the two women are absorbed within a reciprocal gaze, reflecting back upon each other and seeming to exclude even the possibility of knowing the kinds of otherness on display at the far end of the Midway Plaisance.

The painting is as much marked by norms of gender as by assumptions about race. As Carolyn Kinder Carr has observed, the 'ambiguous role of a professional woman artist at this time is expressed in the way MacMonnies represented herself in this painting – not as a working painter but as a fashionable woman participating in the social ritual of afternoon tea' (Carr and Gurney 1993: 189). The point becomes even clearer when we juxtapose the painting with Thomas Eakins's *The Gross Clinic* (also called *Portrait of Dr. Gross*, 1875), 'arguably', as Philip Fisher has suggested, 'the single most important American painting between the Civil War and the First World War' (Fisher 1999: 124), and a work that (in many ways) exemplifies the ideological strategies of a dominant American culture on display at the Chicago World's Fair, not least in the ways its presence can inform gender-specific reading of works exhibited alongside it, such as *Tea al Fresco*. *The Gross Clinic* had been painted for the art exhibition at the 1876 Centennial Exposition in Philadelphia, but as a result of its graphic treatment of the surgical process the art jury refused to allow it to be displayed. Following Dr Gross's personal intervention, the painting was hung in the medical section, where it was described as representing 'an operation for the removal of dead bone from the femur of a child'. Although even in 1893 there were still critics who felt that 'there can be little that is esthetic in representations of probing and dissecting', the art establishment was overwhelmingly supportive of Eakins's work (see Carr and Gurney 1993: 184). Whereas MacMonnies depicts herself at ease within her painting, Eakins calls attention to Dr Gross in a manner that is diametrically opposed to an emphasis on leisure-class inactivity. Thus, instead of the self-enclosed ritual of tea taking, Eakins transforms what could also be a private working space into public performance. In one way, this process *does* subvert the ideological premise of the Exposition: the urgency and skill with which the surgeon operates on the exposed body collapses the polarities of 'civilized' and 'prim-

itive', highlighting both the possibilities of advanced medical science and the vulnerability of a demystified body whose flesh and blood biological realities echo the staged 'writhings and contortions' of other races, and are in marked contrast to the ethereal beings displayed by MacMonnies. Nevertheless, observed by the medical students within the picture and by viewers of the painting, Dr Gross turns surgery into performance, in an exemplification of the combination of entertainment and education that served as the Exposition's *raison d'être*.

But this is not all. Fisher's exemplary reading of *The Gross Clinic* points to an identification between painter and subject in a manner that further develops our understanding of art at the Fair. For Fisher,

> We are witnesses to two superimposed demonstrations of mastery: that of the surgeon, Dr. Gross, and that of the painter, Thomas Eakins, both of whom work with an extended hand holding scalpel or brush covered with the brightest of crimsons, blood or paint. We, as the audience for two performers, have also before us an audience – the students – who instruct us in the intensity of attention that should be given to the scene, to surgery, and to painting . . . What we learn from them we apply to the (to us) equally visible skill of the painter, Eakins, who, although no longer standing there in front of the finished painting, is still visible in his surrogate, Dr. Gross. (Fisher 1999: 125)

Where J. G. Brown's *The Stump Speech* is unusual in its refusal to allow the painting's viewers many clues as to why the speaker has so transfixed the other boys, Eakins's work calls attention to the skill of both surgeon and artist. By doing so, it places art in tandem with science, a link mirroring the layout of the White City, where the neo-classically fronted buildings housed the latest technological wonders, as well as art and sculpture. The effect is to extend even what Winslow Homer achieved in his Prout's Neck paintings, since, though *The Gross Clinic* was first displayed in 1875, its pairing of artist and subject turns painting itself into the kind of 'manly' pursuit that will counter the fears of 'feminizing' overcivilization that were emerging by 1893. In addition, it suggests that this transformation exists in specifically American ways, since the public staging of the operation(s) locates them within the republican process.

There is no doubt that the World's Columbian Exposition raised the profile of American art both domestically and internationally. The detailed attention to the layout of the paintings and the juxtaposition of native and European art deliberately announced the arrival of an American culture to match anything produced by the old world. But, despite the efforts to construct a coherent narrative across the paintings, the contradictions inherent to the internal and international ambitions of the United States surface in numerous representations of American life. As the paintings examined here suggest, the tensions over urbanization, imperialism, gender, immigration, race and ethnicity that characterized political and popular debates in the 1890s were also present in the art that the nation exhibited to the world. While William Dean Howells was right to identify the propagandistic impulses inherent to the White City, and to point to the Americanization of the other cultures on show on the Midway Plaisance, he underplayed the significance of ruptures in the 'object lesson'. Although not immediately apparent, narratives of imperialism, class conflict, and commerce were present in the art exhibition, in a collapse of the apparent divide between the White City and the crisis torn nation that surrounded it.

Note

1. Chase was also a member of the Fair's International Committee of Judges.

Alternative Racial Gazes in American Silent Cinema

Visualizing Racial Politics in the Films of D. W. Griffith and Oscar Micheaux

CHARLENE REGESTER

American silent cinema is intricately interwoven with American history, and has much to say about the historical relationships between whites and blacks. In the early 1900s, during the period of the silent screen, cinematic representation of racial politics played a vital role in impacting the actions and reactions of American spectators, white and black, and also functioned archivally, portraying and reconstructing this period of United States history for future generations.

Before the advent of 'talkies', two important American filmmakers, in particular, created films directly engaging the issue of racial division in the United States. One, white filmmaker, D. W. Griffith, is often said to have inflamed racial tensions between black and white Americans in his *The Birth of a Nation* (1915), a film that endorsed a racial hegemony grounded in the notion of white supremacy, and that owed much to Thomas Dixon's racist novel *The Clansman* (1905). In *The Birth of a Nation* – known as an artistic masterpiece and as a film that polarized racial debates and provoked public protests at the time of its release – white male spectators were asked to identify with the film's white male heroes, who led valiant and vigilant struggles to hold on to or reclaim supremacy for the (white) South.[1] While *The Birth of a Nation* did not represent the views of all white Americans, it nonetheless had a powerful impact, not only during the silent-film period, but also as an archival document – a distillation of important struggles and social tensions from a particular moment in American history that speaks to us of that historical moment today.

The works of the African American filmmaker Oscar Micheaux provided alternative views on America's racial tensions during the days of the silent cinema, and, like Griffith's work, they have also had an important archival function. This essay examines how Micheaux resisted the racially infused representations promulgated by a film such as *The Birth of a Nation*, creating an alternative racial gaze to the white supremacism endorsed and disseminated by Griffith.

From its first showings, *The Birth of a Nation* provoked strong and often negative responses from the public, some of them violent, particularly in urban areas. According to the *Chicago Defender*, a 'race' newspaper, when *The Birth of a Nation* opened in Philadelphia:

> It was billed at the Forest Avenue Theater. When the doors were opened thousands of people crowded at the theater to see if the race really meant to show its backbone and resent the disgraceful play. Five thousand members of the race, old and young went to the theater and demanded that the play be stopped. Policemen were called and a riot call was sent to the nearest station. There was a general melee. Policemen beat women of the race who took part in the fight, and never before in the history of this city was there such a riot. ('*Birth of a Nation* Run Out of Philadelphia', *Chicago Defender*, 25 September, 1915, p. 1)

Black filmmakers responded to *The Birth of a Nation* by creating alternative representations of American racial politics and by confronting the film's most inflammatory content. Jane Gaines, for example, contends that Oscar Micheaux's *Within Our Gates* was a direct response to *The Birth of a Nation*. While Griffith's film posed the black male as a rapist who threatened white female sanctity during the postbellum period, Micheaux provided an alternative reading by suggesting that, historically, white males raped black women (some of whom were of their own bloodline as a result of miscegenation that had occurred during slavery). Moreover, as Gaines points out, while Griffith presents the Ku Klux Klan as the saviours of the (white) South, Micheaux portrays white vigilantes as responsible for the lynching of a (black) family wrongly accused of murder (Gaines 2001: 161–84). Two filmmakers, one white and one black, provide two vastly different versions of, and perspectives on, a shared American history.

Although *The Birth of a Nation* is not, strictly speaking, a horror film, Griffith utilized three narrative components that would later become known to film scholars as characteristics of the horror film genre – the female as victim, the black male as monster, the representation of terror and its inculcation in spectators. In *The Birth of a Nation*, the character Flora assumes the position of victimized female (the symbol of white innocence and purity). Flora resists the sexual lustfulness of her alleged black rapist, Gus, the monstrous beast who pursues her, and who is introduced in the film's title cards as 'Gus, the renegade, a product of the vicious doctrines spread by carpetbaggers'. By the time her brother Cameron realizes that his sister Flora is alone in the wilds, he rushes to reach her. But Flora has leapt to her death to escape her attacker. Cameron lifts his sister's limp body and wipes blood from her mouth.

The film's representation of black terror visited on southern whites is reciprocated – and developed, for Griffith, to its natural conclusion – by the vengeful white terror it summons in return. In one scene, two white children hide beneath a white sheet, and are observed by four black children, the visual reference to white hoods symbolically introducing the Ku Klux Klan. When the white children hiding behind the sheet move as though they are ghosts, the black children flee in terror. In a title card Griffith clarifies the message, introducing the KKK as 'The organization that saved the South from anarchy, but not without shedding more blood than was spilled at Gettysburg'. Having introduced the Ku Klux Klan, the film diverts to the terror the Klan is likely to inflict on blacks, noting, in an overtly threatening gesture, that some 400,000 Klan costumes were made by Southern women who were 'not betrayed'. The implication that Southern males viewed Klan violence as a badge of loyalty to white women, in a film where black men are rapists and white women their victims, embeds racial terror further into the heart of the film.

The principled visiting of white terror on a notional black terror is legitimized in a number of ways throughout the film; by its religious dimension, by its association with patriotism and nationhood, and by its explicit association with 'justice' and 'order'. As the black 'villain', Gus, kneels on the ground and looks up fearfully at the KKK, the victim of a Klan ritual that will end in his death, white power and therefore the 'natural' order are considered restored. Gus's body is then delivered to the steps of the Lieutenant Governor's house with a note attached from the Klan. Numerous critical accounts of *The Birth of a Nation* have suggested that the film's racial politics were indicative of Griffith's obsession to reclaim the white South lost in the Civil War. According to Peter Noble, at the end 'The Negroes have been depicted throughout the film's length in the worst possible light, [and so] the inevitable conclusion reached by cinema-goers is that their persecution by the Ku Klux Klan is only part of their just desserts' (Noble 1971: 128).

In reading *The Birth of a Nation* as a visualizing of white supremacist racial politics, however, it is also important to acknowledge the contradictions and inconsistencies on which Griffith's vision is built – contradictions and inconsistencies that enable oppositional or counter-ideological readings of both the film and the politics of terror it endorses. Russell Merritt, for example, refers to a scene where Gus attempts to victimize the white female, Flora. In this scene, Russell asks, 'Is Gus expressing animal-like rage at having missed his prey or is this a gesture

of fear turned to despair? To permit such alternative readings makes nonsense of the rest of the film. . . . But it suggests how Griffith is constantly tearing the fabric of his narrative with provocative nuances that suggest possibilities the director only dimly perceives and is unwilling or unable to pursue' (Merritt 1990: 228–9).

Some of these possibilities are explored by critics who have discussed Griffith's representation of miscegenation, Kim Magowan, for example, noting that Griffith's position begins to disintegrate when he invokes the issue. Magowan argues that the film's encodings of whiteness and masculinity are both compromised when we consider that fear of miscegenation implicitly acknowledges the always potential merging of races and genders, not the immutable or natural separations envisaged by Griffith and Thomas Dixon (see Magowan 1999). Similarly, Michael Rogin notes that the film's character, Stoneman (who resembles the Northern white abolitionist politician and Reconstruction activist Thaddeus Stevens, 1792–1868), has a club foot which becomes symbolic of a 'distended, sexualized, aggressive weapon' (Rogin 1994: 269), marking the white Stoneman with a conventional signifier of black masculinity. If such mergings of 'blackness' and 'whiteness' in *The Birth of a Nation* undermine the doctrine of racial separation the film endorses, it is also important to note, as Michele Wallace has done, that the inability to distinguish fully between blacks and whites was 'an important element in Dixon and Griffith's nightmare of race mixing and of mulattoes taking over the United States' (Wallace 2003: 97). The cross-racial transit of racial signifiers between black and white characters may undermine the separatism of white supremacist doctrine. But it also, in a direct sense, reaffirms it, and Griffith clearly argues that race mixing would result in the dissolution of racial purity and the destruction of white American society. As Rogin notes, 'Griffith and Dixon imagined a monstrous America of the future, peopled by mulattoes. Stopping black men from penetrating white women gave birth to a redeemed nation' (Rogin 1994: 279). Whatever the inconsistencies and contradictions in Griffith's vision, *The Birth of a Nation*, as Edward Guerrero attests, is a film that clearly glamorizes the Ku Klux Klan. As Guerrero notes, on Thanksgiving night 1915, in response to

the film's broad and vile influence . . . some twenty-five thousand Klansmen marched down Peachtree Avenue in full menacing regalia to celebrate the film's opening in Atlanta. So, considering the racism, discrimination, and brutality at large in that historical moment, African Americans had every reason to fear that what was depicted on the screen could easily be acted out against them in reality. (Guerrero 1993: 14)

Griffith's apparent endorsement of white supremacism in the South may have reflected and influenced the racialized discourses of the dominant white culture in America, but *The Birth of a Nation* was only one of several positions taken on race in film of the silent era. Filmed versions of Harriet Beecher Stowe's widely read novel *Uncle Tom's Cabin* (1852), for example, had a significant impact during the silent period (the film was first made in 1903, and was subsequently remade on several occasions – at least ten different versions had been filmed by 1927). On film *Uncle Tom's Cabin* was pivotal in providing an alternative visualization of the African American experience, just as the 'sentimental' novel had contributed to debates about the abolition of slavery before the Civil War. According to Linda Williams *Uncle Tom's Cabin* caused African Americans, 'whose primary depiction in American popular culture had previously been as objects of fun, suddenly [to] become, in and through this work, new objects of sympathy by whites' (Williams 2001: 48). She adds that with *Uncle Tom's Cabin* interracial violence, including black-on-white violence, was displayed on screen for the first time in American cinema (ibid.: 92). Affirming the power and impact of *Uncle Tom's Cabin*, Gerald Butters suggests that 'Uncle Tom is one of the rare "good niggers", whereas the majority of black men are [portrayed at the time as] shiftless, lazy, dancing fools, content to be sold into slavery' (Butters 2002: 55).

In most instances, African American men were not even [considered] worthy enough to play themselves on the screen; it was necessary for white men to depict them. Anyone watching a large body of early silent films would assume that all black men ate watermelon and stole

chickens and in their spare time played craps and danced; black babies were worthless, black women were wenches, and the black family was nonexistent. According to early silent film, the white master's family was the only family that African Americans had. Black men were shot at, hung, eaten by alligators, bucked by donkeys, and beaten. Black men were always afraid (except when saving white families) and black romance was simply a joke. (ibid.: 62)

Seen within such a context, the films of Oscar Micheaux cannot be considered exclusively as a response to Griffith, and in many ways the work of each director must be thought of separately. The conditions under which each of these men worked, for example, were very different. Griffith was a white citizen of reputation and position who enjoyed considerable financial backing; Micheaux, a son of former slaves, was a black man who was barely formally educated, and who was not welcomed by the contemporary film 'establishment'. But in a historicizing account of the silent-era film industry's intervention in contemporary racial politics, their pairing remains suggestive. Whereas *The Birth of a Nation* sought to 'save' America in the cause of white supremacy, Micheaux was devoted to elevating black Americans and guiding them into positions from which they could command respect both from their own people and from whites with whom they could coexist. To demonstrate how Micheaux both responded to the racial representations popularized by popular cultural artefacts such as *The Birth of a Nation* and helped revise the on-screen image of black Americans, I will examine three of his silent films (films that have survived and are available for viewing today) – *Within Our Gates* (1920), *Symbol of the Unconquered* (1920), and *Body and Soul* (1924).

As an independent black filmmaker, Micheaux worked in the margins of the mainstream industry to create films designed particularly for black film audiences that provided alternative (that is, non-'white') gazes on black life and contemporary racial politics. While Griffith promoted white supremacism in *The Birth of a Nation*, in *Within Our Gates*, *Symbol of the Unconquered*, and *Body and Soul* Micheaux forced spectators – blacks as well as whites – to re-examine conventionally racialized views. In *Within Our Gates*, subtitled *Black Male Lynching and the Liberation of the Black Female*, Micheaux astutely recognized that while white filmmakers had used cinema to *dis*empower African Americans, he could use cinema to *em*power them. To this end, *Within Our Gates* sought to re-politicize African Americans by confronting, and repositioning, the racial and sexual precepts characterizing a film such as *The Birth of a Nation*. Micheaux's film also sought to revise the image of African Americans in contemporary cinema, challenging both white and black spectators to redirect their gaze back onto – and thence to question – dominant white assumptions about the African American experience.

Within Our Gates depicts a black sharecropper's struggle to escape the debt-bondage system of sharecropping instituted by his white employer (Phillip Girdlestone). While the two engage in a dispute, the employer is murdered by a third party who seeks to take advantage of this situation, but it is the black sharecropper, Jasper Landry, who is accused of the murder. Jasper and his wife are lynched, while their young son manages to escape. Their adopted daughter, Sylvia, waylaid because she was being pursued by Jasper's employer's brother (Armand Girdlestone), also eludes the lynching. This plot is backgrounded by another narrative involving Sylvia's struggles to secure funding to keep the Piney Woods School for Negroes in the South open. Throughout this endeavour, she entangles or disentangles herself from the attentions of several suitors – some of whom, such as Dr Vivian (a physician) are presented as positive black role models, and others, like Larry, a character associated with the underworld and whose criminal behaviour results in his death, who are not so positive.

In this film, Micheaux tackled controversial and provocative themes – among others, white racism, stereotyping, lynching, rape, miscegenation, and incest. While many blacks agreed with his views privately, few dared to articulate them publicly. Strapped, as always, for cash, Micheaux 'hyped' his film's showings by strategically timing the film's release to coincide with African American newspapers' coverage of an actual lynching. For example, one week before *Within Our Gates* was released, the *Chicago Defender* reported that, 'Nine Ex-Soldiers [had been] lynched in the South'. Some two weeks following the film's premiere this same newspaper

reported that the 'Senate Drafts Bill to Halt Lynching'. Combining reports of lynching in the black press with his own visual representation of lynching as reconstructed in *Within Our Gates*, Micheaux sought to counter racial injustice. But he also sought to affirm a new self-consciousness and self-confidence among African Americans (an early marker of which was W. E. B. Du Bois's *The Souls of Black Folk* [1903]) that would be developed further in the 1920s in Alain Locke's influential essay 'The New Negro' (1925), and in the eclectic cultural and political initiatives associated with the Harlem Renaissance.

Within Our Gates foregrounded lynching as an aggressive act against black males, the nominal aim of which was the protection of white women. But the film also foregrounded African American women and their vulnerability to white rapists. While Gaines argues that the lynching in *Within Our Gates* becomes symbolic of the black response to the rape of a white female by a black male in *The Birth of a Nation* (Gaines 2001: 219–57), this essay takes a slightly different position; namely, that the lynching of the black family in *Within Our Gates* is answered in the film by the attempted rape of the black female, Sylvia, by a white male (a sequence that incidentally hints at incest, since it implies the rape of a daughter by her father). By inverting the terms of the dominant white discourse in which white women were raped and black men were rapists, Micheaux visualized the possibility of an alternative black history for black women (itself an act of revisionist empowerment). And by casting *white* men as both rapists and lynchers, Micheaux also revised the white screen image of black masculinity in a manoeuvre that collapsed, visually, the white folklore of black-on-white rape (and its legitimation of lynching), by removing the black male from the equation.

Just as lynching served as punishment for black males who exploited or violated white women, Micheaux thus visualized miscegenation strategically as a way of punishing white males for exploiting and violating black women, and as a way of reconstructing and re-empowering black manhood (see Gaines 2001: 165–76). By invoking the debates surrounding miscegenation, Micheaux used film to construct a visual diffusion and dilution of the power that white males wielded over black males. Whereas black male bodies were violated through the lynching process by white men who, because of their unique subject position, assumed positions of power and hence also the power to punish, *Within Our Gates* inverted the conventional ordering of the white/black binary, using miscegenation to punish the powerful, and to collapse the hierarchical matrix in which white power assumed the right to punish.

Off-screen, Micheaux had to contend with film censors. Prior to the release of *Within Our Gates*, the Chicago film censor-board halted public showing of the film because Micheaux featured a lynching on the screen – perhaps becoming the first African American filmmaker to do so. But the censors were not alone: even some African American leaders feared that the film's release would arouse racial resentment and unrest. In its depiction of lynching, miscegenation, the attempted rape of a black female by a white male and incest, *Within Our Gates* certainly forced both black *and* white spectators to rethink and publicly acknowledge their racialized positions. And in presenting visual images affirming that blacks were honest and upstanding citizens, *Within Our Gates* gave voice to sentiments that were rarely publicly shared and expressed in white American films of the time. Eventually the film was screened in Chicago (with around 1200 feet of original scenes cut), but it disappeared from the US for many years until it was discovered in an archive in Spain – where it was titled *La Negra* – and restored by the Library of Congress in 1993.

In his next film *Symbol of the Unconquered*, Micheaux again used racial tensions in the film's diegesis to confront – and to encourage his spectators to confront – racial tensions in the world beyond the film. In the filmic world, *Symbol of the Unconquered* focuses on the struggles of an African American woman, Eve, who travels to the Midwest to claim and retain valuable land she inherited from her grandfather. Although 'passing' as white, she is refused hotel accommodations by the hotel owner Driscoll, an African American male who himself is in denial of his race. Driscoll has recognized Eve's masquerade. The film presents spectators with a double-question. If Eve and Driscoll are both passing, who then is looking at whom (is black looking at white, or is white looking at black)? And if Driscoll can recognize that Eve is passing, with

whom do spectators both black and white identify? In *Symbol of the Unconquered*'s complex diegesis, where 'black' identity is also 'white' identity (and vice versa), crude racial distinctions such as 'black' and 'white' are themselves placed under erasure, and Micheaux again forces spectators to explore relations of looking as they intersect with the formation of social identities, both within the context of the film and in their personal lives.

In the film, Eve has been frightened by Driscoll, who revels in her agony. During a perilous escape through the wilds of the frontier, Eve luckily meets an upstanding African American male, Hugh Van Allen, who comes to her rescue, but mistakenly assumes that she is white, contributing further to the deconstruction of 'black' and 'white' posited in the film (Van Allen, who is black, is deceived by Eve's masquerade, while Driscoll, who is also masquerading, is not deceived). When Driscoll, advancing from being a hotel owner to becoming a real estate entrepreneur, stoops so low as to solicit the assistance of the Ku Klux Klan to help him extort land from Van Allen, Van Allen emerges victorious. He not only retains his valuable oil-producing land, he also holds onto Eve, the woman of his desire, who has meanwhile revealed that she is indeed black.

In *Symbol of the Unconquered*, Micheaux critiqued racial violence and the hatred (black as well as white) that motivates it (Bowser and Spence 2000: 160), and again encouraged his spectators to re-examine their pre-existing racialized views. At the same time, he also implied that African Americans responded to their marginalization in American society by internalizing their racial oppression – a theme explored particularly in the characterization of Driscoll, a black man so obsessed with being white that he resorts to assaulting his own mother and recruiting the Ku Klux Klan to exploit another African American male. In *Symbol of the Unconquered*, Micheaux clearly conveys to his black spectators how internalized racial oppression can lead to self-hate and the erosion of the moral fibre, and identity, of the black community.

With *Body and Soul* Micheaux again ran into difficulties with the censors, most famously this time in New York, as well as Chicago, and the film is considered among Micheaux's most controversial work for two reasons. First, it depicted the African American minister in a morally compromised position, whereas off-screen black ministers had always been revered. Second, the film featured Paul Robeson, an African American political leader marked by his own complexities and at times, contradictions. *Body and Soul* was one of several films Robeson appeared in that was notable for the interiority of his characterization on screen, where the roles he played were structured around 'inward' behaviour or psychological dilemma, and the film remains striking, today, for the relative complexity of its leading black character.

Robeson, in his first leading screen appearance, assumed the dual role of both the 'jack-leg' preacher and the preacher's righteous brother, Sylvester. Robeson, a convict, escapes as he is being extradited from Tatesville, Georgia, to England, to face a variety of criminal charges. Already laden with a variety of aliases, at this point he is masquerading as a minister. Posing as the Reverend Isiah Jenkins, he presents himself as a man of the cloth to his parishioners and, in particular, to Sister Martha Jane and her daughter, Isabelle. At the same time, he continues in his more sinister role of criminal, Jenkins. Muscling free liquor from a local club operator and threatening to expose the club owner's illegal operation, Jenkins also 'buys' silence from a former fellow prisoner by funding his gambling activities. Exerting brute force over Isabelle, Jenkins makes promises of marriage, and then forces her to steal money from her mother, Martha Jane. Jenkins's exploits also include siphoning money from church members, particularly from women who find this pseudo-Reverend appealing.

Jenkins commits murder, rape, and assaults that ultimately lead to his own demise. As the narrative unfolds through Sister Martha Jane's dream-like state, we meet Jenkins's brother Sylvester, a scientist (also played by Robeson) whose research into pesticide has allowed him to become well established and thereby eligible for marriage to Isabelle, who is also wooed in the film by Jenkins. Now we learn that Jenkins, ostensibly the corrupt brother of the righteous and admirable Sylvester, was only a figment of Sister Martha Jane's imagination. In *Body and Soul* Micheaux thus splits the protagonist into two parts, dually positioning Robeson on screen as (a) Sylvester, the morally righteous black man and (b) the Reverend Isiah, a fantasized figure

who should represent morality, but who actually represents its antithesis – evil, criminality, corruption and who engages in an internal struggle to locate the righteous side of his self. Throughout the film, the strong black female character, Martha Jane, becomes the mirror image by which the hypocritical black male examines his soul or inner self. In so doing she also becomes symbolic of the ability to assume a moral position. Developing the treatment of the character Driscoll in *Symbol of the Unconquered*, that position is arrived at in *Body and Soul* by Martha Jane's breaking out of a 'dream-like' state in which she associates her righteous black suitor, Sylvester, with desired racialized definitions of blackness – definitions that counter the evil criminality of Jenkins – common in contemporary white discourse, and exemplified in a film such as Griffith's *The Birth of a Nation*.[2]

American films of the silent era that portrayed racialized characters and themes played an important role in contemporary race relations, whipping up hysteria and fear, and engendering self-confidence and self-respect – visually empowering and disempowering both black and white constituencies. While a film such as *The Birth of a Nation* promoted white supremacy and the separation of the races, Micheaux responded to the reductive mythification inherent in Griffith's racialized views, constructing instead nuanced and overtly revisionist accounts of the African American experience. In *Body and Soul*, Micheaux presented spectators with a black pyschodrama which again raised tabooed issues, and which presented black subjectivity as complex, contradictory and constructed. As in *Within Our Gates* and *Symbol of the Unconquered*, Micheaux opposed the dominant racial conventions of the times, and did so with remarkable courage. In films that constructed the black male as victim rather than as villain, monster or rapist, films that positioned the black female as heroine rather than the white female, and that portrayed the Ku Klux Klan as a group that would embrace blacks for the sake of terrorizing other blacks by whatever means available, Micheaux forced black and white spectators to confront the racialized visions they brought with them into movie-theatres, and to re-examine those visions bravely and honestly.

Notes

1. Griffith has been thought of as a protégé of writer and dramatist Dixon, whose own work played upon the psychological constructions of race and sex in the white and black imagination. Thomas Cripps, for example, refers to Dixon as a 'fretful Negrophobe' (Cripps 1971: 111). *The Clansman* (1905) has been widely noted as an influence on *The Birth of a Nation*.
2. In positioning the principal characters in a world of dualities, Micheaux also presents Martha Jane's daughter, Isabelle – a moral character who is forced to become immoral when Jenkins coerces her into stealing money from her mother – as a character in which the binaries of 'good' and 'evil' collapse.

Visualizing Dissent in World War 1

Modernism, and the End of 'Liberal' Progressivism, in Art from The Masses *(1911–1917)*

DAVID HOLLOWAY

Before it was closed by the Attorney General in 1917 under the terms of the wartime Espionage Act (1917), the libertarian socialist magazine *The Masses* had established itself as an important cultural and intellectual hub of the bohemian American Left, publishing an eclectic assemblage of political journalism and commentary, artwork and graphics, prose fiction and poetry. Founded in 1911 by its first editor Piet Vlag, a Dutch émigré and New Yorker who used the magazine to promote the formation of worker-organized co-operatives in the United States, under its second editor Max Eastman (from 1912) *The Masses* reinvented itself as 'a revolutionary and not a reform magazine', and sought to integrate art more fully into the diverse socialist commitments to which many (though not all) *Masses* associates subscribed.

Rebecca Zurier's observation that when it came to art *The Masses* 'was contemporary but hardly modern – radical, perhaps, but not avant-garde' (Zurier 1988: 161) is characteristic of much *Masses* criticism, in which Eastman, and senior members of the magazine's editorial staff such as Floyd Dell and Art Young, have traditionally been seen as contradictory figures, political radicals with conservative cultural tastes who had little interest in, or understanding of, abstract or experimental art. As is often noted, during public controversy over the Armory Show in 1913 – the exhibition of mainly European, but also American contemporary art staged at New York's 69th Regiment Armory on Lexington Avenue in Manhattan – the magazine's overt engagement with the exhibition was limited to John Sloan's satirical piece 'A Slight Attack of Third Dimentia' (*Masses*, April, 1913, p. 12), a mock-cubist image that appeared dismissive, if not contemptuous, of the 'schizophrenia' evoked in cubist art.[1]

As might be expected, however, from the eclectic aesthetic tastes of *Masses* artists themselves, and from the diversity of 'Left' political commitments evinced in their work, the assumption that *Masses* artists and editors had no interest in modernism rests on a set of critical givens that has privileged certain aspects of the magazine's visual content while downplaying or ignoring others. Critical studies and anthologies have attributed to the magazine an authentic 'spirit', and an essential visual style, that was developed and consolidated during the 'May Days', the period of 'innocent rebellion' that flowered briefly before US intervention in WW1, notably in bohemian Greenwich Village, New York City, where *The Masses* maintained its offices. So, while Maik (1994) and Zurier (1988), for example, both acknowledge that *The Masses* regularly published abstract, figural and formalist artwork, particularly so during 1916 and 1917, this engagement with the avant-garde is read variously as an aberration – a dilution of the magazine's 'authentic' visual style following the departure of a number of the magazine's 'realist' artists (including John Sloan) from *The Masses* art-editorial board in 1916 – or as indicative, in its seeming drift from engagement with the 'real', of a 'pessimism' characterizing *Masses*' coverage of the War.

While it is certainly true that embittered coverage of the War dominated successive editions of the magazine during 1916 and 1917, the desire to equate an 'authentic' *Masses* with the

'innocent' bohemianism of May Days, and a diluted, deflated or aberrant *Masses* with the 'pessimism' of the Left during wartime, itself rests on the further assumption that the magazine's socialist analysis of the War and of contemporary American class-relations was misplaced or simplistic. As Maik notes, if *The Masses* 'began in innocence and ended in maturity, perhaps their beginning was marked more by naivete than by innocence, and the disillusionment that set in with their adulthood stemmed from the fatal flaw within themselves . . . Very simply, *The Masses* group had illusions, not dreams, and those illusions prevented them from coping with reality once they found themselves in an adult world' (Maik 1994: 173–4). Or as Zurier puts it, the socialists at *The Masses* were 'hopelessly naïve' (Zurier 1988: xviii).

The story of *Masses* art, that is, has been told by historians and art critics in highly selective ways that have sometimes seemed motivated as much by political as by aesthetic judgements. If we begin with a rather different historicizing of *The Masses* – and with a different version of Eastman, upon whose personal tastes *Masses* critics have placed particular weight – we may also see a rather different discursive response to modernism emerging in the magazine, particularly in its later editions.

The Masses is best remembered today for its trenchant criticism of Wilsonian war policy during the period of American 'preparedness' for War. The magazine's opposition to proposals for a compulsory military draft, in particular, was a key factor in the trial of seven *Masses* associates in April 1918 on conspiracy charges. Among the evidence of seditious intent cited in the two conspiracy trials during 1918 and 1919 – the first was declared a mistrial – were Henry Glintenkamp's drawings 'Conscription' (*Masses*, August, 1917, p. 9) and 'Physically Fit' (*Masses*, October, 1917, p. 9), the latter depicting a skeleton and a new conscript in the foreground, with a stack of coffins to the rear. The coffins vary in size. The skeleton is measuring the boy's height with a tailor's tape.

For Eastman, and for many *Masses* editors and contributors, however, the War was not an event that could be easily abstracted from the broader economic and class histories in which it was forged. 'The real War, of which this sudden outburst of death and destruction is only an incident, began long ago', John Reed wrote, in the September 1914 *Masses*. 'It has been raging for tens of years, but its battles have been so little advertised that they have been hardly noted. It is a war of Traders . . . a falling out among commercial rivals.' The war in Europe, he suggested, in what would soon be codified as the Leninist position on WW1, was a war fought between 'the ruling classes of competing imperial powers'. It was not, Reed insisted, 'our War' (*Masses*, September, 1914, reproduced in Reed [1966: 266–9]; see also Lenin 1996).

Despite the official neutrality of Wilsonian war policy before 1917, however, corporate initiatives in the US made WW1 an American war from an early stage. With huge loans flowing from Wall Street to support the Allied war effort, as well as shipments of armaments and other war supplies, industrialists and the directors of powerful financial houses effectively tied Wilsonian war policy to their own interests, and to the interests of the Allied powers. The appointment of corporate leaders to key positions within federal wartime agencies, and the favouring of large companies able to deliver speedily on war orders, brought the Wilson administration's tentative reforms of corporate power and the 'money trust' to an abrupt end.

In this respect the crisis in Europe was also a crisis in Wilsonian progressivism, as the contradictions of 'liberal' reform during the late Progressive Era unwound in the face of war. While it is often remembered today, as it was widely seen at the time, as a period of liberal optimism and social 'improvement', the Progressive Era preference for 'continuity and regularity, functionality and rationality, administration and management' (Wiebe 1967: 295) as 'efficient' solutions to social 'problems' also lent itself to the private interests of capital, and to attempts by elites to contain (while reproducing) the inequalities and contradictions structuring capitalist-democratic life in the United States. Indeed, throughout the Progressive Era, as Wiebe notes, 'the major corporations tended to move somewhat *ahead* of the reformers in attempts to extend the range and continuity of their power through bureaucratic means' (ibid.: 181, emphasis added).

As Wiebe implies, the merging of technical administration in the name of liberal reform with the construction of what I will refer to here as early 'Fordist' class discipline, was under way before the War, not least in the early corporate application of managerial techniques codified in Frederick Winslow Taylor's influential treatise *The Principles of Scientific Management* (1911) and the 'time and motion' studies of Frank and Lillian Gilbreth. In certain respects the war years accentuated contemporary struggles over the possible social legacies of progressivist administration, and might be read, schematically, as the historical hinge around which the capacity to define the appropriate usages of administrative technique passed substantively out of the hands of liberal reformers, and into the hands of social elites. As corporate leaders whose influence had been challenged by Wilsonian reform initiatives moved back into positions of influence at the heart of the war effort, bureaucratic 'efficiency' became the governing mode in key wartime agencies such as the War Industries Board, the Council of National Defense and the Naval Consulting Board (see Schaffer 1991: 40–45). Concurrently, while some organized workers wrested temporary concessions from wartime employers – the railways were nationalized, for example, and wages rose in certain sectors – others suffered in a climate of political repression that would spill over into the postwar years, and from which the American Left would not recover until the crises of the 1930s. Enabled by wartime conceptions of the 'public interest', inspired by federal legislation such as the Espionage Act and by national 'patriot' organizations like the American Protective League, 'acts of political repression and violence' against the Left, notably against the syndicalist Industrial Workers of the World, 'were committed in almost every region of the United States' (Knock 1992: 133).[2]

Citing Frederick Winslow Taylor, and identifying Taylor*ism* as a key 'discursive formation' (Foucault) in the bourgeois appropriation of Progressivist reform, has become a cliché, but one that remains instructive nonetheless, given Taylorism's multifaceted functioning as a synecdoche for the bleeding of Progressivist efficency discourses into the historical genesis of early Fordism. In order to achieve industrial and service sector 'efficiencies', Taylor argued, control over production had to pass in its entirety from workers to management. 'Efficient', 'scientifically' managed labour, he contended (i.e. labour subordinated most effectively to the interests and requirements of capital), was labour that could be reduced to a series of simple, repetitive procedures easily assimilated by unskilled (or deskilled) workers.[3] In its advocacy of a new disciplining of bodies to the productive capacities of mechanized 'monopoly' (or more properly, oligarchic) capitalism, Taylorism speaks of the intensive resocialization of capitalist labour relations required by the new technologies (and mass markets) of vertically integrated mass production. In its insistence that control over production should be transferred from workers with craft knowledge to managers with 'scientific' knowledge, Taylorism thus also articulates early Fordist assumptions about the need to administer, regulate and control the contradictory energies of labour necessary to the process of production, and acknowledges the structural dependence of early Fordist 'efficiency' on the technical expertise of an emergent 'professional-managerial class' positioned between capital and labour.

As a discursive formation embedded in the emergence of new techniques of commodification in wartime advertising, Taylorist 'efficiency' (if not Taylorism itself) also helped structure the field of consumption. During the War, advertisers played a central role in campaigns for food and fuel conservation, advertising the patriotic virtues of compulsory enlistment and the various 'Liberty Loan' drives by which US citizens contributed $17 billion to the war effort during 1917 and 1918 (in the purchase of state-issued bonds), and a further $4.5 billion in the Victory Loan drive of 1919 (Fearon 1987: 11). Energized, and newly institutionalized, by its influence during the War ('the first time that government policy itself had been systematically promoted through commercial techniques of mass persuasion' [Lears: 1994: 219]), the US advertising industry grew dramatically during wartime. Total advertising volume of $682 million in 1914 increased to $1,409 million by 1919, and then to $2,987 million by 1929, at the same time as prominent figures in the industry began appearing as consultants on corporate boards of directors (Marchand 1985: 6, 29). As Jackson Lears notes, during WW1 and the 1920s corporate advertising 'played a crucial role in promoting the ethos of management', collapsing the distinction

between the administered 'public' realm of commodity consumption and 'private' experience. Pioneering 'the statistical surveillance of private life, a practice that would become central to the maintenance of managerial cultural hegemony' in the 1920s, advertisers created 'powerful images of human subjectivity that embodied the values of the emergent social system. If any one value dominated all others, it was a new and more demanding notion of individual well-being that could be summarized as "personal efficiency"', a phrase signifying 'a tighter fit between the supposedly private realm of physical or emotional health and the public world of organized competition for success' (Lears 1994: 138).

Immersed in these shifting historical and cultural currents, many *Masses* contributors opposed US intervention in the War not because of antiwar sentiment *per se*, but because, like John Reed, they viewed the conflict as a working through of elite class agendas and initiatives on both sides of the Atlantic. For some, the socialization of the American people for war in Europe chimed perfectly with the broader restructuring and resocializing of class relations in the US during the late Progressive/early 'Fordist' era. As *Masses* patron Amos Pinchot saw it, the 'commercial policy of conscription' would cultivate 'not only unthinking physical obedience' to officers of the US military, 'but unthinking obedience in general . . . to . . . the employer, the boss, the politician, the state'. Behind the call for compulsory military service, Pinchot suggested, was a project 'to mould the United States into an efficient, orderly nation, economically and politically controlled by those who know what is good for the people'. In this newly 'efficient' America, he observed, 'the common man will gradually cease to be an American citizen and become an American subject' (Pinchot 1917: 6, 8).

Pinchot implies, problematically, a fully class-conscious motivation on the part of elite protagonists at all times, and a comprehensive (and undialectical) suppression of working-class class-consciousness that was rarely fully achieved, even in the 1920s. But the cross-identifications he makes between contemporary 'efficiency' cults, compulsory military enlistment and the resocializing of the working-class 'citizen' as working-class 'subject', is indicative of the extent to which *Masses* debates about war policy were imbricated in the conflicted vocabularies and class-agendas of late Progressive/early Fordist reform. Pinchot's emphasis on the training of bodies, in particular, tells us how sensitive the cultural Left had become to the *ideological* forms taken by contemporary Taylorist instrumentalities of 'efficiency' and 'scientific management'. In the July 1916 *Masses*, Pinchot's case was anticipated by a Robert Minor sketch picturing an Army medical examiner, hands clasped in admiration of what the caption calls 'a perfect soldier', a hugely proportioned musculature without a head, who towers, arms passively folded, above the medic. The drawing of the eye to the soldier's enormous (but passive) muscled torso, and its disciplined 'containment' by the process of medical inspection, allows the sketch to comment satirically on the military construction of the working-class citizen as 'subject'. But, like Pinchot, Minor's sketch also visualizes the extraordinary militarization of the body in wartime as the continuation and intensifying of everyday 'peace-time' socialization on the domestic front. Above the medic and to the left of the soldier hangs an army recruiting poster. The 'perfect soldier' in Minor's drawing, the disciplined body without a brain, is an American civilian who has yet to enlist.

Many of the more celebrated US visual modernisms before, during and after WW1 – work by Alfred Stieglitz, say, or by Georgia O'Keeffe, Paul Strand, Charles Sheeler, Charles Demuth, Joseph Stella, Marsden Hartley, or Stuart Davis – engaged more or less overtly with the new technologies and cultural/ideological sensibilities emergent in patterns of early Fordist socialization. Some of these painters and photographers attempted an ambiguous melding of their aesthetic with 'machine age' precepts and forms; others sought visually to check, or carve 'other' space within, the new technologies and ideological forms of early Fordist socialization. Max Eastman's own self-conscious attempts to codify a set of aesthetic principles in which *The Masses* might anchor itself visually as 'a revolutionary not a reform magazine', suggest that he too was touched by the emergent modernisms of the day to a greater degree than historians and art critics have generally supposed. And in the visual culture of *The Masses* there is certainly

evidence to support the assumption that, however outspoken they sometimes were about the limitations (as they saw it) of experimental art, Eastman and others on the editorial staff arrived at an intuitive, unspoken understanding of formalist art that harnessed modernism's pursuit of the essential, the experiential, and the untrammelled to a critique of early Fordist socialization.

In 'What Is the Matter with Magazine Art', a programmatic essay outlining criteria for a non-capitalist visual aesthetic, Eastman contrasted the commodified forms of what he called 'business art' – a profitable but 'drab and mediocre semblance of art . . . standard types, pictures of pictures of pictures of people' – with art that aims to achieve 'the beautiful, the real, the ideal, the characteristic, the perfect, the sublime, the ugly, the grotesque, the harmonious, the symmetrical, or any other of those ends that various schools of art and art criticism have with similar merit set before them' (Eastman 1915: 12). Eastman's separation of art into that which is standardized and commodified and that which is not, his privileging of form (the symmetrical, the harmonious, the ideal, the perfect) as the locus of artistic resistance to market-driven 'mechanical' art, and his valorizing of art as private, subjective experience, bring *The Masses* within touching distance of the contemporary avant-garde. 'The difference between drawing a man and drawing a perception of a man,' Eastman wrote, 'is akin to the difference between knowledge and experience. The thing an artist has to do is to transcend his knowledge and win his way back to experience.' By doing this, Eastman added, authentic art becomes 'free and independent of customary knowledge' (ibid.: 13), stripping layers of socialized 'artifice' from consciousness so as to place artist, artefact and audience beyond contamination by the degraded common sense of the 'customary'. As Zurier notes, *The Masses* came too early, historically, to embrace subsequent Marxian assumptions about art's capacity to estrange or alienate artists and audiences from the ideological norms administering everyday capitalist life (Zurier 1988: 161). But built into Eastman's definition of what a non-capitalist art might be there is a commitment, shared with many contemporary modernisms, to locating *formally* a 'space' or experience antithetical to the 'customary knowledge' of the prevailing social order.

The drawing Eastman chose to exemplify his criteria was Art Young's 'Nice Cool Sewer', published in the May 1913 *Masses*. In Young's drawing we see a man and a woman together in a barely furnished room. It is, at least for the man, the end of the working day. To the left of the frame he sits, slumped in a chair and hollow-eyed, a pair of oversized hands drooping from the armrests. To the right, and slightly in the foreground, a woman stands at a stove, cooking. She is half-turned towards him, and says 'YOU'RE tired! Here I be a-standin' over a hot stove all day, an' you workin' in a nice cool sewer!' Although the woman is foregrounded in the frame, Eastman's gaze is drawn first of all to the man's hands, which are drawn disproportionately large, their swollen backs and extended fingers pointing directly downward as if their weight might at any moment drag the man to the floor. The distortion of the hands is echoed in the man's face, much of which is filled with two large ovals Young has left unfilled around the eyes, marking the face with the same sagging weight of gravity as the hands. The hands in 'Nice Cool Sewer' are not, as Eastman notes, realistic hands, or 'objective hands . . . hands from a hand factory. They are a certain peculiar individual's perception of the hands of a certain peculiar man, a tired man, a man sunk onto a chair at the end of a dirty day's work, a man who feels bad and smells bad to himself, and wishes he were abed' (Eastman 1915: 12–13).

What Eastman values in 'Nice Cool Sewer', and what holds his gaze, is Young's formal distortion of the human body, and the way form conveys the subjective presence and singular point of view of an artist who – in responding subjectively, and in reconstructing that 'authentic' subjectivity on the page – has freed himself from 'customary knowledge' (meaning political 'knowledge' as well as aesthetic 'knowledge'), and who has consequently tapped into an essential but 'customarily' occluded truth about the capitalist organization of wage-labour and unwaged domestic labour. The formal distortion of the hands and eyes embodies in pencil the exhausting character of the man's work and the physical alienation of working-class bodies from the acts of labour they perform. In the woman's angry posture and the accompanying caption, the image also parallels the man's work with the woman's, and invites the viewer to consider the corrosive effects of the capitalist organization of work, both inside and outside the home, on

family relations. 'Nice Cool Sewer' is not by any means an abstract work. But in its expressive distortion of hands and eyes it is certainly a highly stylized rendition that could be viewed in a lineage of 'modernist realism' that would include some of the highly stylized paintings of, say, a post-*Masses* Sloan or Bellows, or the later 'psychological realism' of an Edward Hopper.

By the time that Eastman ceded control over the magazine's artistic content to art editors alone following the 'Artists' Strike' in 1916, *The Masses* was regularly printing abstract work – from contributors including Hugo Gellert, Arthur B. Davies, Jo Davidson, Maurice Stern, John Storrs, and, in April 1917, Pablo Picasso – whose experimentations with form went well beyond Art Young's 'Nice Cool Sewer'.[4] Under Eastman, *The Masses* became a truly hybrid magazine, whose combined parts created political meaning out of the juxtaposition and cross-fertilization of the various visual and written materials assembled alongside each other in each issue. Among the more revealing of these juxtapositions were the inclusion of abstract, and highly formalist artworks alongside explicatory poems whose own meanings were thrown into reciprocal relief by the visual images on which they appeared to comment. Beneath one of Arthur B. Davies's 'Melodies', an airy but austere series in which Davies sought to capture the essence of music in the graphic rendition of abstract nudes, a poem by Helen Hoyt ('In the Art Institute') contrasted the messiness and opacity of human relationships with the 'stern air', the 'High, rational' and 'impersonal' space of the gallery – where 'clean-edged' exhibits allow the speaker's mind 'to sharpen again/Out of its blur', as the voice reflects on the formal perfection, the 'fine symmetry of being', constructed in art (Hoyt 1916: 14). Earlier that summer, one of Hugo Gellert's untitled compositions, a figural rendering of two nudes against a flattened background of abstract foliage rising vertically through the centre of the frame, was reproduced above Charles Erskine Scott Wood's poem 'A Song of Beauty' (Wood 1916: 12). In the poem Wood defined beauty as nature, 'The madness of a wind-swept hilltop' that 'my soul keeps in its secret chamber'; with beauty/nature depicted thus as an authenticity or essence that might be figured momentarily in art – as it is, in Gellert's composition, in the conventional inscription of harmony in the nude and thus 'natural' human form – but which remains generally inaccessible within the administered and instrumentalized social relations of what Eastman called 'customary knowledge'.

The juxtapositions of visual images by Davies and Gellert with poetry by Hoyt and Wood resonates with a position invoked by other *Masses* contributors who sought, from an early stage in the magazine's history, to integrate aesthetic practice within the commitments of revolutionary socialism. In 'Art Impossible Under Capitalism' (March 1912) Marjorie Hood defined art as 'the expression of that sense of beauty which lies deep and purposeful in the human soul', but which is 'buried, crushed – by poverty, dirt, monotonous toil' and 'exploited by the impersonal, hurried, machine-like labor that goes into the making of everything about us – the clothes we wear, the houses we live in, our utensils, our public buildings, even our books and pictures and music' (Hood 1912: 18). A similar position had been taken earlier by Andre Tridon, in one of the later issues under Vlag's editorship. After capitalism, Tridon hoped, 'the great need of mankind will not be so much for the useful as for the purely beautiful'. When 'the food, clothes and shelter question is solved,' he suggested, 'there will be little besides Art and Beauty to occupy our minds' (Tridon 1911: 15).

Zurier reads *The Masses*' turn towards abstract art in 1916 and 1917 as a shift towards 'apolitical' and 'non-political' visual forms that expressed the growing pessimism of the cultural Left during wartime, and that exemplified the magazine's failure to integrate artistic vision with political commitment (Zurier 1988: 154–8; see also Maik 1994 and Fitzgerald 1973). But if the war years are re-historicized as a decisive period in the formation of the early Fordist business hegemony of the 1920s, the turn towards abstraction and formalism in some *Masses* art looks less like an aberration or a retreat from political engagement, and more like a logical extension of the magazine's commitment to a visual practice that would strive to negate and transcend both the new socializations characteristic of early Fordism, and the commodified 'business art' that spoke for them. Certainly, Davies's and Gellert's nudes, and their juxtaposition on the page with Hoyt's and Wood's poetry, provide a recognizable approxima-

tion of Eastman's prescriptions for a non-capitalist art in which formal qualities – the beautiful, the characteristic, the perfect, the sublime, the harmonious – might serve as a negation of the degraded 'customary' realm.

Abstraction was not the only mode pursued by *Masses* associates who made formal values central to their work. In Europe, where its use can be traced back to the mid-nineteenth-century cartoonist and lithographer Honore Daumier, the unfinished 'authenticity' of rough crayon line technique had been associated with working-class art, and with working-class issues and audiences. In the United States, the rough crayon line became associated with *The Masses*, where it appeared across a wide range of different styles published in the magazine, from the Ashcan Realism of Sloan and Bellows, to the sardonic political satire of Boardman Robinson, Robert Minor or Kenneth Russell Chamberlain, and the more overtly formalist experimentations of Maurice Becker.

As a self-consciously craft aesthetic, in which the influence of the artist is visible in the shaping of every line, the affected spontaneity of the rough crayon was offered in *The Masses* as a visual negation of the glossy finish and formulaic repetition of 'mechanical' 'business art'. But the 'craft' qualities of the rough crayon line had a further resonance for the cultural Left during the 1910s, when the socialization of Fordist 'efficiency' in the workplace meant, among other things, a systematic deskilling of craft labour by the introduction of mechanized plant and the imposition of 'Taylorist' techniques of 'scientific management'. In its formal emphasis on art as a process of *unmediated* craft production, the rough crayon line simulated an aesthetic space beyond the deskilling, surveillance and mechanization of labour characteristic of early Fordist production in the United States. The crayon line's evoking of the spontaneous, raw and 'unfinished', and its valorizing of the artist's presence, his private, subjective vision and felt experience, thus worked as a formal disavowal of the administered working-class 'subject' invoked by Amos Pinchot's essay on the 'commerical policy of conscription' and by Robert Minor's 'A Perfect Soldier', and as a formal repudiation of bureaucratic Fordist reform initiatives as such. 'There was a man', Boardman Robinson wrote of Daumier; 'His drawing came daily, directly, and hot off his mind.' It was impossible, Robinson added, to 'separate the man from his craft', there being 'no hiatus between his thought and his stone or canvas' (quoted in Christ-Janer 1946: 57–8).

Among the more ambitious exponents of the rough crayon line was Maurice Becker, whose work for *The Masses* at times achieved a startling fusion of the rough crayon's traditionally working-class cultural politics with more experimental, formalist, visual modes. Becker, who 'was at most one generation removed from eastern European Jewry' and who was therefore 'not trapped by American artistic traditions' (Fitzgerald 1973: 198, 209), had exhibited at the Armory Show and was visibly influenced by contemporary avant-garde formalism from Europe, particularly Cubism and Expressionism. In his best work, exemplified in a drawing such as 'Untitled (Woman Hurling Brick)' (1916), Becker harnessed the crayon line's formal immediacy, its evocation of the spontaneous and the authentic, to a rigorously formalis*tic* compositional technique, and to a visual emphasis on 'expressive distortion' (ibid.: 209) that enhanced and recharged the crayon form's conventional association with working-class experience.

In this regard Becker's 'Woman Hurling Brick' might best be considered as a visual negation of the same socializations – or Fordist discursive formations – satirized in Robert Minor's 'A Perfect Soldier'. In 'Woman Hurling Brick', the body in revolt is a body gripped by the rushing of an elemental political energy whose 'authentic' break with 'customary knowledge' is conveyed in the simulation of a raw, untrammelled momentum built up by the flowing of layered crayon lines, and by Becker's formal presentation of the body itself. In the upper half of the frame the woman is fashioned out of rapidly sketched lines running more or less horizontally across the page, which extend either side of the torso in a left arm that points forward out of the frame, and in a right arm that extends beyond the frame, opposite. Parallel lines marking out the woman's hair, eyeline, cheekbone, nostril and shawl, and in the middle and lower right of the frame her waistline and the curve of her shirt into her stomach, echo and re-emphasize the horizontality of the arms, and help ensure that whatever response the viewer may bring to

the image will be fashioned in large part out of engagement with the picture's highly formalistic rendition of the body in revolt. The layering of parallel lines running left to right resonates with the physical and political energy felt by the body (and its viewer) in the moment the brick is drawn back, while the reciprocal rushing of the lines right to left anticipates also the energetic forward motion of the right arm in the moment when the brick will be hurled. This formal rendition of the body in motion concentrates the eye not so much on the throwing of the brick as on the physical and political energies channelling the act, and on an experiential simulation of the moment when those energies are galvanized – a moment when the body sheds the socializations containing it within 'customary knowledge', the summoning of its own 'authentic' energies subverting its entrapment in the discursive formations of early Fordist class discipline.

The attention drawn to the authentic energy achieved by the body in revolt is accentuated further by Becker's framing of the drawing, the woman's body spilling out of the frame to the lower right (where she is cut off at the thighs), to the upper left and right (where her arms likewise extend beyond the frame), and to the top right (where the upper edge of the brick is clipped from view). The formal compression of the figure into the frame re-emphasizes both the dialectical eruption of the authenticated body as it rebounds against the forces which seek to discipline it (visually the frame itself, poetically the patterns of class domination in which the body remains normatively circumscribed), and the unrestrainability, as such, of a politicized working class.

The political claims made by Becker's drawing are also formally constructed around the repetition of perpendicular shapes that echo one another, in turn, across each of the four quadrants of the picture: the cocked right arm in the upper right; the head resting on the shoulder in the upper left; the juxtaposition of the left arm with the dangling shawl in the bottom left; Becker's contrasting of the outspread arms and shawl with the tightly flowing, vertically skewed lines of the skirt in the lower right. The angularity of the drawing, and the compositional quartering of the image, help encode the otherwise unruly eruption of physical force with order, symmetry, precision and balance, interpreting the act of throwing the brick as a moment of clarity, and of directed political activity – a rational moment, that is, of achieved class-consciousness, rather than, say, a moment of irrational thuggery. The 'symmetrical' balancing of the body in each of the image's four quadrants also invites the viewer to consider the perpendicular shapes made by the frame as an extension of the perpendicular shapes made within the picture, pulling both frame and picture together into a new, unified and harmonious visual 'whole'. Formally, the drawing therefore ascribes a tangible sense of harmony – and thus also a kind of perfection or 'universal' truthfulness – to the moment in which class consciousness, and the act of revolt flowing from it, are achieved.

The broader conflicts of capitalist-democratic history in which competing class-consciousnesses are formed and dissipated are not immediately present in this drawing. All we are shown is a woman preparing to hurl a brick. But the very narrowness of the visual field Becker constructs, focusing the viewing eye in close-up on the body, invites the viewer to situate the apparently reified act of revolt in events taking place out of our sight (but not out of the woman's sight), just as her body and her own gaze visually transgress the analytical context provided by the frame. If the framing of the figure in an uncomfortably narrow field of vision draws attention to what lies beyond the frame, and thus to the broader history in which the woman acts as a political agent, so too the *provisionality* of the rough crayon line (its rough, unfinished and 'spontaneous' qualities) depict the history in which she acts as open, unfinished, and susceptible to the political energies that would seek to transform it. Above all, it is the ragged, vital animus of the crayon line form that constructs formally the drawing's immediate, language-blind impact, the expressive rushing of rough, unfinished strokes across and beyond the frame evoking both the visceral experience of the act of hurling, and the 'authentic' (because desocialized and thus transgressive) political energies the act embodies.

Historians and critics of *Masses* art have stressed the expressiveness of the rough crayon line form rather than its Expression*ism*. And in obvious respects Becker's 'Untitled (Woman Hurling Brick)' has very little in common with the Expressionism of a Van Gogh, Munch or Matisse. But Expressionism was certainly in the air in bohemian Greenwich Village during the 1910s.

Like Becker, both Munch and Matisse had exhibited at the Armory Show (in the same gallery as *Masses* artist Stuart Davis). And in Becker's 'Woman Hurling Brick' there are certainly echoes of Van Gogh's famous dictum that art should harness *form* to 'express man's terrible passions', and more than a nod towards the vertiginous, elongated brush strokes of an Edvard Munch.

But where a painting such as Munch's *The Scream* evoked a generalized sense of existential 'alienation', in which the atomizations marking bourgeois modernity appear fully ontological (and therefore insurmountable), the 'alienation' posited in Becker's 'Woman Hurling Brick' is explained (and, in the drawing at least, is overcome) in collective and class terms. Effected in Becker's expressive formal distortions, then, as it was for Eastman in the hands holding his gaze in Art Young's 'Nice Cool Sewer', there is an appropriation of modernism's emphasis on the formal rendition of intensely felt, private emotion and experience in a baffling and fragmented universe, and a reinscription of these elements – now explained as collective experiences formed within the variegated contradictions of capitalist social relations – in service of socialist political struggle.

For *Masses* historian Richard Fitzgerald, Becker 'merged art and politics more fully and more successfully' than any other *Masses* artist, his dominant style of expressive distortion being 'within the medium of art per se' (Fitzgerald 1973: 214), its articulation of political vision and aesthetic formalism emphasizing, if anything, the absence of such representation in *The Masses* generally. To depict Becker as an aberration, though – much as Zurier reads the magazine's relative turn to abstraction after the Artists' Strike as an oddity, a departure from its authentic style – is to downplay the extent to which abstract and/or overtly formalist values informed, as we have seen, a range of different *Masses* art forms. Maik places Eastman in a native tradition taking in Thoreau, Whitman and Twain, ascribing to Eastman a peculiarly American radical sensibility. By the 1910s, however, Walt Whitman (for example) had been reinvented in artistic circles as the laureate not so much of republicanism or democracy, as of modernity. In Europe, as early as 1888, Van Gogh had written admiringly of Whitman in a letter to his sister, around the time that he was preparing to paint 'Sunflowers' (Van Gogh 1981: 445). In America, influential figures in the visual avant-garde such as Paul Strand, Charles Sheeler, Joseph Stella, and Marsden Hartley, would all invoke Whitman and transcendentalism as influences on their own work. In their short experimental film *Manhatta* (1920), Sheeler and Strand used lines from Whitman's poetry as inter-titles, cut between scenes displaying the vertiginous, technological spaces of modern(ist) New York City. Stella, who was as impressed by Whitman's treatments of New York as Sheeler and Strand had been, effectively paraphrased Whitman's 'Crossing Brooklyn Ferry' (1856), when describing Brooklyn Bridge as 'all the efforts of the new civilization of America, the eloquent meeting of all the forces arising in a superb assertion of their powers, in apotheosis' (quoted in, among others, Hughes 1997: 377). If Eastman sought to encompass within *Masses* socialism an aesthetic theory derived in part from Whitman and Thoreau, this was, at the time, a thoroughly modish, and indeed modernist move to make.

It is important not to overstate the presence of modernist stylings in *Masses* art, even in its later editions in 1916 and 1917. From the early Vlag issues through the period of Eastman's tenure, realism, caricature and satire predominate over the figural and the experimental. But the critical truism that senior *Masses* figures were implacably hostile to modernism in art, and that the magazine simply failed to integrate art and politics, has perhaps obscured somewhat the contributions made by 'experimental' modes to *Masses*' visual culture, and to *Masses*' cultural politics. The regular appearance of abstract art, the self-conscious formalism of the ubiquitous rough crayon line and the 'expressive distortions' of an Art Young or a Maurice Becker, as well as Eastman's own criteria for the construction of a non-capitalist visual culture, suggest that a number of *Masses* associates arrived, often in very different and unacknowledged ways, at an intuitive understanding of what modernist precepts might bring to the cultural Left. It is also, perhaps, instructive to note that *The Masses*' metaphorizing of the administered social realm of early Fordism as a militarizing of the body gave visual form to a discourse that can be seen at work quite widely in (more or less) contemporaneous cultures of the American Left – from critiques of the mechanization of labour and the impact of 'Taylorist' technique, through

Masses contributor John Reed's experimental 'filmic' evocations of revolutionary bodies as *de-socialized* bodies in *Ten Days that Shook the World* (1919), to the vivid literary impressionism of John Dos Passos in his early, neglected war-novels.[5] In a highly *politicized* period characterized by new patterns of bureaucratic administration and industrial 'efficiency', a new disciplining of both labour and leisure, and a broad resocialization of US class relations generally, the sometimes tentative and sometimes bold politicizing of visual formalism in a magazine that 'came to be known as one of the most dangerous in America' (Zurier 1988: 29) should, with hindsight, be one of the less surprising cultural developments of a turbulent decade. After all, as Maik notes, editorial for the very last edition in November–December 1917 promised *Masses* readers that the next issue would be 'the most vigorous *and beautiful* magazine you have seen' (*Masses*, November–December, 1917, p. 44; cited in Maik 1994: 198, emphasis added).

Notes

1. The full title of Sloan's sketch is 'A Slight Attack of Third Dimentia Brought on by Excessive Study of the Much-Talked-Of Cubist Pictures in the International Exhibition at New York'.
2. Howard Zinn notes that by June 1917 the APL 'had units in six hundred cities and towns, a membership of nearly 100,000. The press reported that their members were "the leading men in their communities . . . bankers . . . railroad men . . . hotel men." . . . The League claimed to have found three million cases of disloyalty' (Zinn 1980: 360).
3. For Marxian accounts of the structural function of Taylorism in the administration of 'monopoly' capitalism, see Braverman 1974; Aglietta 1979.
4. The 'Artists' Strike' was the culmination of a long-running disagreement over Eastman's captioning of artwork, which led to the departure of Sloan, Glenn Coleman, Stuart Davis and others from the magazine's art-editorial board.
5. See Dos Passos 1969 and 1990. See also Reitell 1964 [1924], for whom early Fordist mechanization wrought changes not only on workers' wages, but 'upon his mental actions and reactions, upon his physical being, and upon the whole social and industrial fabric of which he is a part' (Reitell 1964 [1924]: 181).

The Avant-Garde and the Market

Debating Modernism: Art and American Advertising in the 1920s

DON McCOMB

Many of the forms of visual expression familiar today had their origins in the social conditions of the early part of the twentieth century. Modern art movements of the 1920s gave graphic artists new forms of visual expression. It was an explosive period in which the advertising industry experimented with new forms and the revival of old styles, a time during which advertisers seized upon art and illustration to distinguish their products in a competitive consumer market. Advertisers used new approaches in graphic design influenced by modern art to differentiate products and breathe new life into old advertising formulas. Modern art was also thought to appeal to the emotional side of consumers who no longer were persuaded by rational, 'reason-why' copy.

According to Lorraine Wild (1989), the link between present-day graphic design and its modernist antecedents is so close that it is largely unquestioned. The contemporary definition of graphic design as a conceptual activity was largely shaped by the artists and designers of the European avant-garde who, in the years just before and after World War 1, challenged traditional notions of cultural and artistic production. During the 1920s, the elasticity of forms combined with the modern mechanical notions of interchangeability of parts (a quality appropriate to the Machine Age) allowed design to be seen as mechanical, manipulable and convenient. Modernist experiments and forms were thus simplified and adapted to meet the demands of mass reproduction and formulas for commercial success.

Influenced largely by the 1925 Paris International Exposition and later by the emigration of European designers, graphic design in America during the period reflected American fascination with European Art Deco (the name came from the title of the Paris show: *Exposition Internationale des Arts Décoratifs et Industriels Modernes*), which was a conservative rendition of a plurality of European styles. According to Ellen Lupton and J. Abbott Miller, 'The term aptly describes the way elements of avant-garde art – Futurism, Expressionism, Cubism and Constructivism – were used to inflect a mass, commercial style with an appealing, uncontroversial, modernity' (Lupton and Miller 1989: 43).

In America, popular awareness and growing acceptance of modernist styles was cultivated by publicity and news reports about the Paris Exposition. According to Lupton and Miller, 'In graphic design and illustration it [modernism] did not constitute a singular aesthetic but was rather a loose set of ideas and motifs, ranging from reductive geometry, elongated torsos, and a mannered angularity, to the repetition and regularity associated with the machine' (ibid.). While American interest in European fashion clearly predates the 1920s, the Paris Exposition served to bring the styles to the attention of a wider public.

The purpose of this study is to explore the contours of the advertising industry's discourse on modernism as revealed in the advertising trade journals of the 1920s. Specifically I want to discuss and analyse the discourse in *Printers' Ink* and *Printers' Ink Monthly*. The content of

these trade journals constitutes a social narrative of the advertising world. Like all social narratives, the advertising discourse mobilizes and reproduces assumptions about history, culture, society and technology. These assumptions play a large part in the constitution of real and imagined relations between people, material conditions and cultural production. My goal is to identify the dominant contours in this discourse, to locate and clarify the fundamental assumptions that operate within it, and to reassess the role of modernism in advertising in the 1920s.

T. J. Jackson Lears describes the contradictory conditions of work in the advertising world as 'the drive for personal creativity harnessed to an organizational ethos; the effort to capture reality by creating an ephemeral image-empire' (Lears 1984: 387). Taking this into account, this study considers advertising as a contradictory and constantly changing domain in which cultural forms struggle for dominance. The use of modern art in advertising in the 1920s was controversial. A systematic review of all editions (1919–29) of *Printers' Ink Monthly*, an advertising trade journal, reveals a protracted discussion and debate over the uses of modern art in advertisements. In the design of the publication itself, *Printers' Ink Monthly* greatly expands its own use of modern art, photography and colour through the 1920s as a proving ground for new ideas and technologies. It also cites the major influence of European design on American advertisements.

The primary source of this study is the discourse on advertising and art revealed in the trade press of the 1920s. While this source of material may tend to exaggerate the power and prestige of the advertising profession – indeed, Ewen (1976) has been taken to task for treating the puffery of industry insiders as proof of a co-ordinated conspiracy (Schudson 1984: 175; Jensen 1990: 43) – it is a bona fide method for exploring the attitudes of the practitioners. Furthermore, the trades offer a discourse that should be situated historically. As Lears notes, 'National advertising was not merely part of a diffuse popular culture; it was created by specific groups with needs and interests shaped by particular historical circumstances' (Lears 1984: 350).

Lears observes that although there was much discussion of artistic strategies in the trade press, the dilemmas of the visual artist in advertising – e.g. the tension between 'art' and commodification, and battles over artists' rights to sign their works – were virtually ignored. Much of the trade discourse on photographs and illustrations in advertisements focuses only on aspects of technical quality. The content of *Printers' Ink* and *Printers' Ink Monthly* constitutes a discourse in which advertising practitioners discussed strategies and the development of the field. But mostly the discourse reveals how they talked to each other and to clients. The pages of *Printers' Ink* and *Printers' Ink Monthly* are swollen with confidence about the progress and the future of advertising practice and the profession. It is a confession of the industry's own struggle for legitimation and power in both economic and cultural spheres. For the most part, it is an attempt by the industry to convince readers of its own importance. By focusing on the discourse of the trades, I am clearly exploring the producer aspects of advertising's relationship to larger issues and features of American culture. Indeed, the discourse will reveal how the advertising world collaborated to produce advertisements, as well as their hopes and expectations for advertising. In this sense it is a discourse on the dominant values of the industry and people in power. But it is only one of many institutional expressions of dominant values that ran concomitant, for example religion, education, literature and the arts.

In the 1920s, *Printers' Ink* was the recognized spokesman for advertising. *Printers' Ink* was founded in 1888 by George Presbury Rowell, an advertising agent, and was edited in the 1920s by John Irving Romer. With its slogan, 'The Little Schoolmaster of Advertising', *Printers' Ink* was the leading periodical devoted to the multiple phases of advertising during its first fifty years (Mott 1957). The weekly magazine was small in format, measuring only four-and-one-half by eight inches, but was comprised of nearly 200 pages per number. A larger format (eight-and-a-half by eleven inches) publication, *Printers' Ink Monthly*, premiered in December 1919. Unlike *Printers' Ink*, *Printers' Ink Monthly* was printed on coated stock (also known as glossy paper) to better reproduce illustrations with accuracy and detail. It averaged between 150 to 200 pages monthly.

It is important to note that the new technologies of advertising in this period, for example half-tone processes and colour separation, developed independently of the influence of modern art on graphic design. Technological developments, along with economic prosperity in 1920s' America, contributed to advertising's increased use of illustration, only a portion of which was influenced by modern art. It was not until August of 1927 that *Printers' Ink Monthly* used a colour illustration on its cover. Like *Printers' Ink*, it also reveals how the advertising industry was talking to and about itself. The two publications shared many of the same writers; however, they appear not to have published any duplicate articles. A systematic review of selected editions of *Printers' Ink Monthly* (December 1919–December 1929) reveals a protracted discussion and debate over the uses of modern art in advertisements. The discourse on modernism in *Printers' Ink Monthly* picks up momentum after 1926, and is by far the most prominent topic of *Printers' Ink Monthly* in 1929.

The general discussion of modernism in the trades notes that 'modernistic' art is better suited to the advertising of luxury articles. What is questionable is whether advertising is leading or following contemporary public acceptance of modernism. An answer in part falls along lines of class and age. As Milton Towne, President of the Joseph Richards Company wrote, it is essential to talk to the new generation in their own terms (Towne 1926: 128). Counter to the storytelling school of realism in advertising, modernism lent atmosphere to advertisements during a time when product illustration and product claims were not enough to sell commodities to the American public.

According to Hiram Blauvelt, writing in 1925 in *Printers' Ink Monthly*, there were two functions of art in advertising. 'Either it may actually sell by picture through the faithful portrayal of the product at rest or in use, or through its striking unusualness it may be used to attract the weary eye of the blasé prospect, vaguely suggesting the product and creating enough curiosity and interest in it to lead the reader on, so that he will read the copy' (Blauvelt 1925: 65).

For Blauvelt, modern art was better suited to luxury articles and products of a more unusual nature. 'After all, luxury is for the most part, a bizarre taste, and must be catered to in startling new ways' (ibid.). He also found that the modern style was particularly effective for small-space use, 'for it makes up in greater attention value what the advertisement loses through lack of space and expresses its message more tersely and with deadly surety' (ibid.: 66). He adds that the contemporary trend was for advertising to use modernist forms developed by 'pure art' even before they have been accepted by the public. 'In America, advertising has been one of the most refreshing stimulants to good taste and artistic appreciation among our peoples within the last ten years, and with the increasing competition of advertisements for attention it seems but a short time when advertising in its turn will be developing new modernistic forms which will do their business of successful selling' (ibid.).

In 1929 C. B. Larrabee said the overriding demand of modern American design would be that of utility. The office may not be so beautiful, but it would be more convenient, more comfortable and better suited to its purpose. Materials would be chosen because of their fitness for the work they were to do, with regard to economical upkeep and sanitation. 'Its decorative treatment, then has been dictated by the capabilities of the machine or process by which it is made' (Larrabee 1929: 138).

While advertising had gone over to Futurism, at least temporarily, W. Livingston Larned said there remained some caution in its use. 'Those who seek this type of art have found out one thing quite definitely: it requires a certain technique which is not easily imitated, and there is nothing quite so disappointing as near-futurism; a diluted attempt by an artist who does not think in the right terms' (Larned 1927b: 43). One of the first demands was to startle the eye. Futurism broke all compositional rules. But even those who did not care for Futurism admitted that they never overlooked such campaigns. Each season the advertiser had to look for fresh ways of injecting new atmosphere into campaigns. 'It's survival of the fittest and the – oddest.' Larned added that modern styles were 'an echo of the hour, of now. Advertising which is most remunerative keys in with this modernism' (ibid.: 44). Larned also noticed a growing tendency to create bizarre and European-flavoured effects as a protest against the old school. 'Whether

the advertisers like it or not, and whether it is wholly insane or not, the public invites a new angle, encourages it, and must be served' (Larned 1927c: 186, 188).

According to Abbott Kimball, New York Manager of Lyddon & Hanford Co., twentieth-century style was being proclaimed with the full force of twentieth-century publicity methods. 'Main Street wants not only smart hats, but smart ice-boxes – style not only in bracelets, but also in plumbing fixtures' (Kimball 1928: 17). The question was not whether to 'go modern' or 'not to go modern', but how far? According to Kimball, going modern began with style research to anticipate the demands of his customers. 'Style impulses come too thick and too fast. What style leaders demand today affects what the rest of the world will want tomorrow. For to be too far ahead with a style may be thought even more disastrous than being too far behind' (ibid.: 18–19). Kimball noted that it was important to be fashionable, not faddish. Could these ideas be made technically practical for mass production and everyday use?

> The modern eye with so much to see and so little time to grasp it, passes over the cluttered up advertisement. But [the client] is eventually convinced that the old generation is already sold. It is the new generation that matters. And this new crop of customers, coming up every year, have very little interest in his grandfather's business. Their sole concern lies in today – and tomorrow. (ibid.: 20)

An active debate on modernism and its appropriate use in advertising art took place in *Printers' Ink Monthly* beginning in September 1927 and continued through December 1929. Authors actively engaged each other, responding to articles and accusations. The favoured methods of representation in advertising art swayed between literal imitation and artistic expression. On the pragmatic side, modernism was said to attract attention and to guide the reader's eye through the advertisement and towards the written message. One author suggested that advertising art in America was not truly modernist; it was merely a simplification of representations of natural forms, rather than an attempt to visualize abstract qualities. Finally, it was noted that modernism had reached maturity when despite challenging formal conventions of art and composition, it had become too 'well groomed'.

'Modern art, when it gets too modern, ceases to be art, and becomes – well, if it must be said, comical' (Flagg 1927: 44). Thus, James Montgomery Flagg, a noted illustrator, fired off the first volley in the debate over modernism in the September 1927 *Printers' Ink Monthly*. Relating the 'grotesquery of today' to the 'happily dying Cubist-Futurist disease', Flag attacked some current trends in advertising art manifested mostly in fashion advertising (ibid.). He referred to certain representations of the allegedly divine human form as 'damnable nightmares – these dreadful china skeletons – some with necks like giraffes, mouths like murderers and figures like aspirin capsules'. Flagg signs off with, 'When the Ultra and the Smart preclude the Healthy and the Clean – Good evening!' (ibid.: 119).

Richard J. Walsh, President of The John Day Company, Inc., responded to Flagg in 'Must Advertising Go Back to Nature?' (Walsh 1927). Walsh admitted that modernism might be a form of madness, 'but isn't it captivating madness?' (ibid.: 48). He suggested that the rush to the new styles of illustration was in response to the longings of the advertiser for 'something different'. Walsh questioned the ability to achieve exact representation in any art form.

> For those who want advertising to go back to nature really do have a general idea of what they mean. That is, they have accepted certain conventions about how hands and faces and buildings ought to look in pictures. A generation brought up on calendar chromos, on dining-room paintings of fish and fruit, and – let us concede – on some acquaintance with the old masters, has made a sort of tacit agreement with the artist as to the sign language in which he shall be permitted to express himself. (ibid.: 49)

To Walsh, the conventions of the rising generation could only be found through trial and error. He took Flagg to task for reducing to cause and effect the influence of Cubism and Futurism on

new styles in advertising art. He said that Cubism and Futurism received public attention because they were an expression of changing attitudes towards painting. 'Modern advertising art is not the result of Cubist propaganda, but another expression of the same attitude' (ibid.). For Walsh, while their techniques may have distorted reality, there was a method to the madness of the modernists. The organized distortion of one subject may, indeed, lead to the vivid portrayal of another truth. Walsh said that the artist must ask: Does distortion detract from the usefulness of a representation or does it offer some compensating value in other directions?

> Sometimes they [modern artists] are merely frivolous, and would not want us to take them too seriously. More often they are sincerely reaching for inner meaning beneath the appearances, trying to express motion or emotion or some other impression that the merely photographic or the academic technique could not catch. And, on the whole, they do succeed in design, even when they fail in profundity. (ibid.: 114)

According to Larrabee, in an effort to impress clients with their modernity, some artists were creating advertisements that were utterly incomprehensible. He said that they were so absorbed in creating the new that they had forgotten the old axiom: 'The purpose of advertising illustration is to further the selling message – not to obscure it' (Larrabee 1928: 34). Larrabee took issue with advertisements where illegible type was submerged in a dynamic whirl of illustration. These advertisements, he said, were just as effective upside-down as right side up. 'As a selling message it reached the nadir of effectiveness and sagged a little below' (ibid.). Yet he also claimed that modernist art could be used with great effectiveness in advertising illustrations.

> One of the chief reasons for the existence of the new art is that its early exponents were trying to break away from what they felt to be the static quality of traditional painting and drawing. They sought something which would have movement, dynamic force, and which would more nearly express what the artist feels in series of states of consciousness instead of what he sees at one fleeting moment. (ibid.)

Larrabee suggested that artists should take advantage of the dynamism and bold forms of modernism to get attention and direct the eye more purposefully through the advertisement and towards the advertising message therein.

J. R. McKinney, Art Director of the McLain-Simpers Organization, claimed that there was a distinct difference between good and bad modernism being used in advertising layout and illustration. Referring to the bad examples as 'scrambled art', he said, 'The whole thing was jumbled to such an extent that it registered nothing but confusion' (McKinney 1928: 88). According to McKinney, the trouble with most of the attempts at modernism was that everything was sacrificed to gain attention, regardless of whether one could read or understand the ad. In what he called the good examples, modernism resulted in striking attention value, but without sacrificing the other elements necessary to good advertising. He believed that modernism in advertising would play an increasingly important part in the design, packaging and sale of goods. McKinney offered no examples or definitions of good and bad modernism, rather he relied on a pragmatic approach. Good modernism, like good advertising, would be determined after the fact. 'In the long run, the sales curve will tell the true story' (ibid.).

Byron Musser, President of Byron Musser Inc., believed that good modern art in advertising was an offshoot of the new schools in fine art that had broken with the old traditions and returned to the primitive. 'The art that remained endeavored to catch the essence or the soul of the subject. They went further than an attempt to represent nature and tried to express abstract ideas by using what they called significant form, to register on canvas their impressions and emotions, to express what the objects meant to the artist, what emotional effect it had upon him' (Musser 1928: 40).

According to Musser, good modern art in advertising tried to do the same. The 'modernistic'

illustration did more than attract attention and serve as decoration. It typified the peculiar qualities of the product; it caught its soul and created an atmosphere of smartness and luxury. Musser criticized the schools of 'fake' modernism, who he said 'have taken up the new style without having mastered the draughtsmanship of the older more conventional' (ibid.: 41).

Stuart Campbell, Art Director at Ray D. Lillibridge, Inc., said that the advertising art exhibited at the 1928 Art Directors' show was contemporary, not modernist. He said it contained the same elements as more conservative advertising art, but that it served them up in a different manner. Sophistication was the keynote of the day. This was achieved by eliminating details. 'Taking his cue from the caricaturist without necessarily going the limit, the contemporary artist leaves out the non-essentials and subtly emphasizes a feature here and a line there, with the result that his work carries more power' (Campbell 1928: 35). The contemporary artist tried to get his message over more quickly. This called for simplifying the atmosphere by merely hinting at the background. The 'hint instead of the whole' made for more sophistication (ibid.).

Don Gridley, a regular contributor to *Printers' Ink Monthly*, found that modernism had taken hold of the imagination of advertisers to a surprising extent, with luxury products for women receiving its greatest impetus. Major advertisers, including General Motors, had turned to modernism, although Gridley noticed that the use of modern styles in GM advertising became more marked as the price of the car went up. Food advertising, Gridley suggested, had stayed close to realism because women were more interested in the realistic presentation of food than in art technique.

> As a rule, the advertiser with the wide distribution of a product that retails for a comparatively small sum is chary of using modernism. . . . Luxury advertising is almost entirely gone modern. It is the rare thing, for instance, to find a perfume advertiser using anything but the new technique and it is among these advertisers that some of the most flagrant abuses of modernism occur. (Gridley 1928: 130)

Brian Rowe responded to Gridley's article, 'A Statistical Glass Applied to Modernism', by claiming that there was no modern art in American advertising. And while he agreed that Byron Musser presented a very adequate definition of modernism in his article, Rowe found that Musser's discussion of advertising art missed the point of his own definition.

> 'Express abstract ideas.' There you have the creed of the true modern, who has ceased entirely to be interested in the transcription of nature in any realistic way to his canvas or his paper, and is essaying the creation of significant form, quite unrelated to nature. He is trying to put emotions onto paper. He objects to being a camera; he essays to be an interpreter. If he feels impelled at any time to record an object on his canvas, he records not its shape, but its meaning, the emotions which it conveys to him, as he sees them in terms of shapes and lines and composition. (Rowe 1929: 48)

Rowe contended that what Gridley and Musser had labelled as 'modernistic' in their discussions was by their own description merely the simplification of representations of natural forms. Simplification, for Rowe, was the dominant characteristic and technique of schools loosely called modern. 'All these movements express a revolt against slavish realism. But they are just a difference of idiom, not a different language. They are all concerned with the description of the physical, not of the abstract' (ibid.: 134). Furthermore, Rowe doubted whether modern art could truly be enlisted by advertising to aid selling. 'As soon as you start showing the product, in any shape or form, you are at once barring the door to modernism. Modernism is not concerned with making portraits of physical things; it deals with the abstract' (ibid.: 48).

In another article, McKinney argued that the relationship between art and layout was so close in contemporary advertising that it was impractical to separate them. McKinney was of the opinion that modernism in advertising art had finally matured, justifying all the mistakes that had to take place in its early phases. '[S]o sweeping have been the changes that only occa-

sionally do we find in present-day advertising a trace of the modern art as it first appeared – experiments in geometry or dynamics instead of advertisements primarily intended to sell something' (McKinney 1929: 38). McKinney credited the supporters of modernism for challenging the formal rules of layout, while retaining an orderly arrangement of elements. 'Modern advertising art now stands forth clean-cut, well-mannered, and well-groomed.' But despite this, it is difficult to determine whether McKinney intended to praise modernism or to bury it when he added, 'Above all else, it has acquired the aristocratic mien' (ibid.: 39). He also credited individual artists who had spawned distinct schools of illustrating style. '[W]e have made tremendous strides forward in modernism, due to the individuality of a few leading artists and to the greater tolerance and the greater degree of acceptability that we have acquired' (ibid.: 100).

Walter Smith, Art Director at J. Walter Thompson Co., had the final word on modern art in the December 1929 *Printers' Ink Monthly*. 'We have gone about as far as is possible in the literal translation of ideas in our advertising art, and we are now developing those principles which have, until recently, been left to the painters and sculptors' (Smith 1929: 45, 126). Smith said that the emotional quality of painting should have its place in advertising, and he suggested that life-like representation be left to the camera. However, he did not see much of a place for purely abstract design in advertising.

Many will use the stuff merely because it's the latest thing and they wouldn't be thought old-fashioned . . . the substance of art is always the same and must be given form before it becomes art; it is only the difference in the choice of method that one period differs from another. Let us accept this new form, for it is of our generation. (ibid.)

The influences of modernism on advertising art were characterized by movement away from strict literalism and detailed representation and a tendency towards association and atmosphere. Under the new regime, perfect balance was no longer a requisite for advertising layout. Modernism was claimed to have simplified the task of composition by allowing the layout artist to neglect details that lent themselves to accurate representation in favour of shapes and forms that fostered the creation of a pleasant atmosphere. At the centre of the new school of advertising design was the 'visualizer' or layout man. The trick of catching the viewer's attention often lay in the peculiar arrangement of the illustrations. The practical goal was to dominate, in mixed company, over competing advertisements.

The key to the new modernist techniques was the use of contrast, but with pleasing effects. Action and speed, the watchwords of modernism, were better illustrated if liberties were taken with reality. The visual nature of actual products and literal representation were handicaps to the modern illustrator. Use of allegories, symbols and news tie-ins allowed the illustrator to transcend the mere material nature of mass-produced goods. The modern school of advertising art emphasized the unexpected subject and the indirect approach.

It is clear that the 1925 Paris Exposition signalled a turning point in the uses to which modernism was put in the advertising industry. Despite America's lack of involvement in the show, popular interest in modernism surged forward and never looked back as a result of publicity from the event. But while the Paris show may have spawned an explosion of modernist innovation and imitation, some foresaw its decline as early as 1929, when W. Livingston Larned penned what appeared to be a eulogy for modernism.

Modernistic art had its high hour of universal acclaim and is now giving way to other forms, slowly but surely. The daring thing was done, traditions smashed to smithereens, and hidebound conventions tottered from their ancient thrones. These ideals which [modernism] has given us, after a brave battle, will always make their presence felt in years to come. But advertising is ready for a new coat and a changed pictorial regime and pace. (Larned 1929c: 52)

It is important to note that innovation is a constant process within the advertising world and in the discourse on advertising art as witnessed in the trade publications of the 1920s. In some

respects, focusing on modernism as a theme distorts the general enthusiasm with which all innovation was heralded in the advertising world. There is little doubt that modernism came to advertising from without. But, for the most part, the advertising world merely adopted modernist forms that were already incorporated into the dominant practice of the art world. Indeed, the orderly approach to modernism in the advertising world did not indicate a mature attitude towards the restless and unruly nature of earlier avant-garde experiments. Rather, modernist practices themselves had become more disciplined by the late 1920s.

The discourse on advertising art in *Printers' Ink* and *Printers' Ink Monthly* addresses the manner in which the advertising world came to define and appropriate modernism in the 1920s. Although modernism was welcomed within American mass culture, it was not a product of the culture itself. It filtered down to the public from above, fabricated by artists and businessmen in the advertising world in service to commerce. As indicated by the advertising trades of the 1920s, modernism in advertising was formulated to attract attention, but to do so with pleasing results. While the advertising trade journals reveal that aesthetic codes and values were actively created and maintained by the advertising world – that is to say they were not inherent, but ascribed – they nonetheless reproduced specific hierarchies of status. The advertising world went to great trouble to project a highbrow image of advertising art by staging awards and exhibitions to celebrate its artistic achievements, but for the most part advertising art recognized no standards besides popularity.

As expressed in the trade journals, advertising's goals and achievements reflected desired outcomes and relations rather than real ones. The discussion of advertising art reveals that the advertising world actively engaged in the imitation of the forms, and in the appropriation of the rhetoric, of the art world. But it evaluated the artistic merits of a design based on the sales curve. Like any form of art, advertising art is transformative, in that it represents and thus, in a sense, reshapes the world. But, the direction of the transformation is inherently towards sustaining the dominant relations of market society. Advertising art is not without a stake in truth; it is true to the values and conditions of consumer culture. The advertising world not only debates the worthiness of particular art forms, it also projects images of what is worthy and what is not. Moreover, as a form of cultivation, advertising educates the public in what it is necessary to do in order to become worthy in consumer culture. The purpose of this study has been to explore the manner in which worth was ascribed to various traditional and modernist art forms in the 1920s, and to consider the processes by which aesthetic codes and values were historically located in specific social conditions and interactions. That is to say, within the advertising world of the 1920s, discussion of art was ideologically positioned in ways that were congruent with the systemic modification of capitalist social relations during the construction of an early Fordist social order in the United States.

Part 2: 1929–1963

Introduction to Part 2

DAVID HOLLOWAY AND JOHN BECK

The dynamo of mass production that fuelled the US economy during the 1920s transformed the expectations and the everyday lives of ordinary Americans, as domestic prosperity generated calls for a culture commensurate with the technological and economic largesse of the early Fordist miracle. While industrialists stockpiled European art in private collections, many American artists and photographers grappled with the material and ideological ramifications of the Machine Age and with the emergence of something resembling a fully-fledged mass market consumer capitalism. Sophisticated advertising campaigns sought to standardize desire for an electrified, automated, automotive American experience that materially outstripped anything the Old World could offer, visualizing a template for a new 'national' identity cut loose both from Victorian models of virtue and from the country's puritan heritage, and fabricated instead from store-bought objects and individualized acts of commodity consumption.

Accepting the Republican nomination for the presidency in the summer of 1928, Herbert Hoover announced that 'we shall soon with the help of God be in sight of the day when poverty will be banished from this nation' (quoted in Parrish 1992: 208). Later the same year, President Coolidge would tell Congress that 'The great wealth created by our enterprise and industry, and saved by our economy, has had the widest distribution' (quoted in Hobsbawm 1994: 85). The stock market crash of October 1929 and the Great Depression of the 1930s, however, revealed both the sectoral nature of capitalist-democratic 'prosperity' in the 1920s – agriculture in particular had remained in steady decline since the war, and the much vaunted 'boom' itself took place predominantly in the construction industry, and in the manufacture of cars and electrical goods – and its unequal distribution. Between 1923 and 1929 the disposable per capita income of the wealthiest 1 per cent of Americans in the non-farm population grew by 63 per cent, while the disposable income of 93 per cent of Americans actually shrank by 4 per cent (Fearon 1987: 67). Of the 27 million American families who filed income tax returns in 1929, 18 million lived on significantly less than the $2,500 cited by the Bureau of Labor Statistics as necessary for a 'decent standard of living' (Parrish 1992: 81–2). The effects of the Depression were devastating to an economy whose robustness was localized, and whose principal index of egalitarian prosperity turned out to be a temporary assertion of consumer (and investor) 'confidence'. The unemployment statistics alone are staggering, with some 13 million unemployed by 1933, a full 25 per cent of the workforce (Kennedy 1999: 163).

While the elite art of high modernism may never have looked more irrelevant, the critical dimension of formalist experimentation found new outlets after 1932 during the New Deal, as government initiatives recognized the centrality of cultural workers in the renovation of both American capitalism and a viable sense of democratic self-identity. Attacked from the Right as a crypto-socialist, and from the Left as a reformer appeasing capitalism (characterizations that contemporary Americans may have inferred from, among other sources, federally sponsored

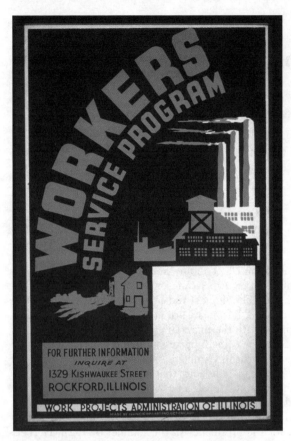

Fig. 12. Illinois WPA Art Project poster, promoting workers' education (1941). Library of Congress, Prints and Photographs Division, WPA Poster Collection, LC-USZC2-5209 DLC.

visual culture of the period – see Figures 12 and 13), Roosevelt persisted with a raft of 'Second New Deal' measures after 1934. Federal New Deal regulation did break (temporarily) the dominance of national politics by big business that had characterized the war years and the 1920s. But the New Deal, for all its creative destruction (and elaboration) of early Fordism, was designed to save and revivify – rather than destroy – what it regulated, and the contradictions of the new state-capitalism generated a plurality of visual engagements with (and embodiments of) New Deal policy from across the political spectrum.

Michael Ryan's essay analyses the debate between liberal policy-makers and the business-led Right by examining the formal and thematic construction of two contemporary films, the broadly liberal *Gold-Diggers of 1933* and the more conservative *My Man Godfrey* (1936). While critics have commonly viewed Depression-era cinema as largely 'escapist', Ryan argues that the formal strategies of Hollywood make-believe enabled a reimagining of the social order beyond the conservative 'realism' of New Deal opponents. The liberal, communitarian ethos promoted cinematically in *Gold-Diggers*, Ryan argues, follows Warner Brothers' support for the New Deal, while *My Man Godfrey* reverses the dominant metaphors of the earlier film, representing Universal Studio's individualistic turn against Roosevelt, as the Liberty League and other voices on the Right mounted a business-oriented critique of New Deal policies.

Continuing Part 2's engagement with New Deal-era visual culture, Joan Saab's essay considers the sponsoring of artistic production, and the organization of artistic labour, under the Federal Art Project (FAP), one of several national work relief programmes administered by the Roosevelt administration, whose aim was to provide 'useful' employment for unemployed cultural workers during the Great Depression, while integrating artistic production into the legitimation of New Deal policy. Saab discusses ways in which FAP participants sought to visualize the democratic potential of the New Deal by shaking off the elite status of 'high' art and reinstating collaborative practice and community involvement to artistic production. As such, FAP workers seized on the unrealized radical potential of the New Deal to be a transformative rather than merely reformist mechanism, and put it to work both culturally, but also materially, in the lived social relations of the time. To be a working artist on the FAP, as Saab shows, was to be a civic *worker* as well as an artist, a role that seemed akin, to some, during the era of the Popular Front, to the kind of disalienated activity of creative labour envisaged by Marx as the product of the end of capitalism.

In a further essay assessing the federal sponsorship of Depression-era visual culture, Eric Margolis discusses photographs of schools taken by employees of the state-funded Farm

Security Administration, and later the Office of War Information (FSA-OWI), between 1935 and 1943 – images that would form an ambitious visual archive, an 'imagined community of America' that would also function, like the FAP and other government-sponsored cultural activity of the time, as an aesthetic advocacy of New Deal state capitalism. As Margolis puts it, FSA-OWI photographers 'framed a therapeutic perspective, pointing the camera at things that need[ed] fixing'. Including work by established photographers such as Walker Evans and Dorothea Lange, and by emerging figures such as Arthur Rothstein and John Vachon, the imagined American community of the FSA-OWI archive was, Margolis suggests, a rather selective community sorted by abstract and aggregate 'types', rather than by the documenting of what New Deal ideology sought to promote as an inclusive social plurality – the archive is particularly silent, he notes, on the question of racial integration – and marked by a disinclination to interpret or analyse the economic factors leading to Depression and war. By 1942–3, Margolis observes, the patriotic photography of the OWI had all but erased, at least in the images it produced, the 'rigid stratification on the basis of social class, urban or rural location, race and ethnicity' characteristic of the locally controlled and funded school system. Margolis concludes with some observations on the recent digitizing of the FSA-OWI archive, and his comments on this may be read alongside other assessments of the impact of digitization on visual culture included in Part 4 of this book (see particularly the contributions by Grainge and by Hoskins).

The standardizations of American life made possible by the industrial development and new consumerism of the 1920s were disseminated in rather different ways by the 'collectivist' (or, at least, capitalist-collectivist) social programmes of the 1930s, preparing Americans for the hardening new notions of 'national' identity, consensus, duty and sacrifice that would accompany the mobilizations of World War 2 and the early Cold War (see Figure 14). If Europe had long been represented in America as the past, US elites now more than ever identified themselves as the future. In 1941, Henry Luce famously proclaimed the twentieth century the 'American century', and four years later, as Europe lay in ruins, Walter Lippmann wrote that 'What Rome was to the ancient world, what Great Britain has been to the modern world, America is to be to the world of tomorrow' (Patterson 1996: 8) (Figure 15).

Pennee Bender's essay discusses the visualizing of US economic and political interests in Latin America during World War 2, a war that transformed US international relations as much as it reconfigured the domestic political economy. Bender discusses the role of filmmakers working for the Office of the Coordinator of Inter-American Affairs (OCIAA) to promote the 'good neighbor policy' during WW2 – the policy of

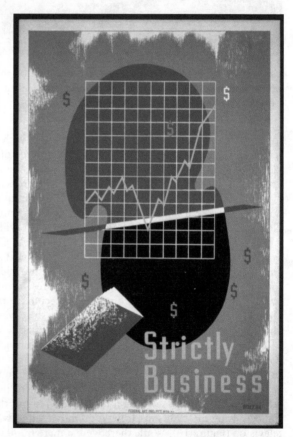

Fig. 13. Federal Art Project poster by John Buczak, promoting careers in business and finance (1936–9). Library of Congress, Prints and Photographs Division, WPA Poster Collection, LC-USZC2-808 DLC.

85

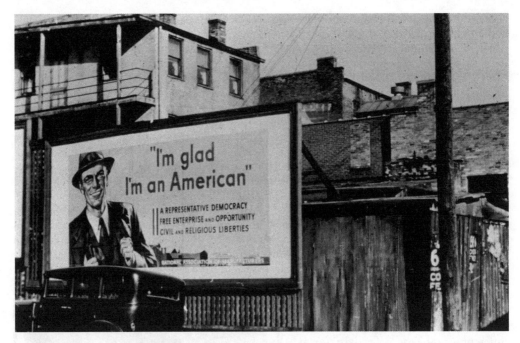

Fig. 14. A billboard in Dubuque, Iowa, paid for by the National Association of Manufacturers (1940). (Photo by John Vachon/Library Of Congress/Getty Images.) Courtesy of Getty Images.

fostering 'good' political and economic relations with Latin American states that had been initiated during the late 1920s and 1930s, the volume of US investment in South America having increased dramatically during the early part of the century, particularly in Mexico and the Caribbean. During wartime the disruption of European markets, and the opportunity to exert new influence in Latin American affairs while shoring the region against infiltration by the Axis powers, gave fresh impetus to the 'good neighbor policy', and the OCIAA (first Coordinator Nelson A. Rockefeller) was founded in 1940 to 'provide for the development of commercial and cultural relations between the American Republics'. Concentrating on newsreels and the partisan *March of Time* series of shorts, Bender argues that serious attempts by the OCIAA to present a nuanced and culturally-specific picture of Latin America were ultimately compromised by the formal and thematic limitations of the newsreel form, by deep-seated US prejudices towards Latin America, and by growing political acceptance in Washington that authoritarian governance in the region, including military dictatorship, was a legitimate modality for the protection and advancement of American corporate interests.

If the revival of the 'good neighbor policy' during wartime thus anticipated the full-grown 'Grand Area' strategy of the Cold War – the 'pragmatic' or 'realist' protection of the interests of American investors overseas – the function of filmmaking at the OCIAA also prefigured the centrality of mass visual media in the management (and unsettling) of consent in the postwar era. Mass transmission of visual information about the demands of American patriotism continued during the 1950s in Hollywood movies, and was increasingly reinforced in the home by television (Figure 16). While there were a mere 6000 television sets in the US in 1947, by 1969 86 per cent of the population had a TV (Boddy 1995: 41, 60). Television presented a largely 'middle'-class white face to the American public, much programming reinforcing strict gender divisions in the home and workplace, while presenting an imagined community of successful white households untouched by ethnic, gender, or class conflict. Westerns were also popular in American film and TV, typically presenting a heroic moral universe that retold the history of

bourgeois expansionism in the nineteenth-century US as the triumph of right over wrong, of white male authority over ethnic and female submissiveness, and of a 'national' (but also 'universal') essence – what John L. O'Sullivan once referred to as American 'futurity' (O'Sullivan 1839) – in conflict with the fleeting contingencies of the non-American past. While the affirmative nature of much TV programming and Hollywood film did not accord with the political views or aesthetic tastes of all Americans, the American mass media successfully constructed and disseminated a simulated American orthodoxy ('the American Way') that not only appealed to a certain kind of domestic conservatism and reinforced the moral universe of the national security state, but also came to represent the US as a global brand.

While fictional TV output tended to reinforce normative values and mimic cinematic narrative conventions, it is in terms of its 'non-fictional' and 'live' modes that television's unpredictable, and in certain circumstances its potentially subversive, agenda-shaping power, became increasingly evident. Cat Celebrezze's essay considers some of the historical and political conditions in which mass television spectatorship was constructed during the 1950s. Resisting the assumptions of critical

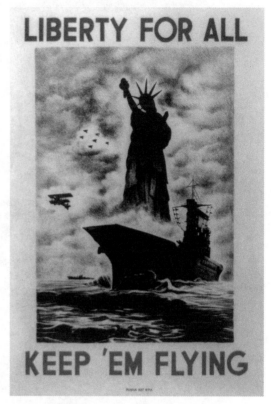

LIBERTY FOR ALL

KEEP 'EM FLYING

Fig. 15. Patriotic WPA poster during wartime (1941–3). Library of Congress, Prints and Photographs Division, WPA Poster Collection, LC-USZ62-91022.

discourses grounded in 'spectacle' and 'representation' (emphases that can function at times to dismiss or relegate the importance of audiences in the construction of visual and historical meaning), Celebrezze identifies a number of key moments – including the 1954 Army-McCarthy hearings in the Senate, which investigated attempts by associates of Senator Joseph McCarthy to avoid the military draft of a McCarthy-aide, G. David Schine – that crystallized the role of TV as a medium exposing history happening in 'real time' to an audience of participant-observers. For Celebrezze, the kind of TV watching configured by such 'live' televisual/historical events, and the apparently candid and unmediated disclosure of information they made possible, reveal the limitations of critical discourse that ascribes to TV programming a purely hegemonic social role, and to TV watchers an indifferent or passive role in the construction of historical meaning.

While noting that very few films were openly critical of Cold War militarism and consensus culture in the US, Tony Shaw's essay surveys a range of well-known Hollywood films that articulated Cold War American anxieties by other means, and includes an examination of Daniel Taradash's less well-known melodrama, *Storm Center* (1956) (described by Shaw as 'the only direct assault on McCarthyism produced from within Hollywood until the early 1970s', and a film that provoked considerable controversy on its release). But as Shaw notes, the commercial and ideological conditions of the early Cold War placed strict parameters around the functioning of dissent in Hollywood film. Movies that were ostensibly critical of the American Way were often undercut by their narrative emphasis on individual and personal relations, at the expense of a focus on the broader social, political and economic contexts in which *social* relations are shaped

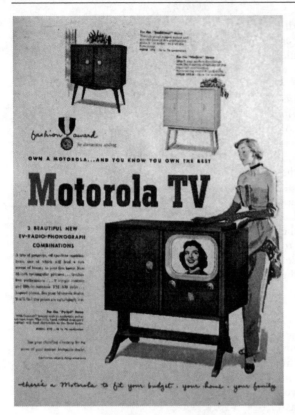

Fig. 16. An advertisement for a Motorola television set (1950). (Photo by MPI/Getty Images.) Courtesy of Getty Images.

and reproduced. In certain respects, as Shaw makes clear, *Storm Center* was a conventional early Cold War Hollywood movie, which denounced McCarthyism, as did other films of the period (covertly or metaphorically), from a civil libertarian position that upheld the official liberal democratic ideology of the national security state, fetishizing the Cold War, much as it was fetishized by political elites, as a conflict between democracy and communism.

More optimistic than Shaw, Neil Campbell focuses on another aspect of the visual image's disruptive, heteroglossic potentiality, discussing Robert Frank's influential collection of photographs *The Americans* (1958). Campbell sees Frank as a 'surreal ethnographer', a participant-observer of America's layered social and political fragmentation. What Frank's pictures show, for Campbell, is the material unconscious of Cold War American democracy, a divided and diverse social realm characterized by anomie and alienation, but also by a continued commitment to traditional ideologies of 'national' American belonging. In opposition to the early Cold War culture of 'containment', however, Campbell suggests that Frank explodes the regulatory structures of an orderly American self-representation, and literally exposes the contradictions – of race, class, and gender inequality – that were repressed in order to maintain both the public fiction of consensus and the reproduction of social order.

In the final essay of Part 2, David Wragg revisits the discussion of the limitations and possibilities of an avant-garde position under free-market capitalism – a theme raised in Part 1 of this collection by Holloway and McComb, in Part 2 by Saab, and in Part 3 by Beck, Frascina, and Kempf/Chalifour – in his discussion of Barnet Newman's 'utopian' Abstract Expressionist painting. Surveying the contested terrain of Abstract Expressionism and its relationship with mass culture, Wragg considers the problems raised both by the modernist thesis of artistic autonomy – placed under question during the 1930s but resurrected, partly as evidence of capitalist-democratic individualism in the 1950s – and the cultural criticism that has sought to counter a formalist defence of art. As Wragg demonstrates, the politics of form in the postwar years were as complex and contested as in any period before or since. Today, the dilemmas of Abstract Expressionism seem redolent less of the incorporation and crisis of modernism they also announced – what Saab calls the 'desacralized' art of the New Deal era giving way to a truly 'mass' Fordist culture following World War 2 – and look more like a relative high point in the troubled trajectory of modernism in twentieth-century American culture.

The New Deal and Film

Debating the New Deal: Gold Diggers of 1933 *and* My Man Godfrey

MICHAEL RYAN

Hollywood films of the 1930s are usually dismissed by historians as escapist fare. In his standard textbook, *Unfinished Nation*, historian Alan Brinkley writes: '[T]he commercial films of the 1930s . . . were deliberately and explicitly escapist: lavish musicals such as *Gold Diggers of 1933* (whose theme song was 'We're in the Money'), 'screwball' comedies (such as Capra's *It Happened One Night*, produced before his 'social' comedies), or the many films of the Marx Brothers – films designed to divert audiences from their troubles and, often, indulge their fantasies about quick and easy wealth' (Brinkley 1993: 748). Such assessments are not unusual, and to a certain extent, they are not unjustified. While the early 1930s saw the appearance of a few fine social problem films done in a realist style such as *Heroes For Sale* (1933), *I Am A Fugitive From a Chain Gang* (1933), and *Skyscraper Souls* (1932), many films from the mid-1930s to 1940, especially the musicals, the screwball comedies, and the children's films, participated in a therapeutic cultural labour that might be called 'escapism'. They were also, however, part of a wider transformation in both dominant cultural themes and in popular consciousness that was crucial to and inseparable from the public policies of the New Deal. For the New Deal to work, people's minds had to be changed. The wealthy had to be convinced that higher taxes were for the good of the country; the business community – largely conservative, primarily Republican – had to be convinced that the Democrats' new government programmes to spur employment, aid labour unions, and regulate business were not as reprehensible as they seemed; and people doused in the cold water of long-term joblessness had to be inspired to hope once again.

The Hollywood studios (especially Warner Brothers, the producers of *Gold Diggers of 1933*) famously threw themselves behind the New Deal (see Muscio 1997). Those experienced manipulators of emotion and belief made polemical entertainment films like *Gold Diggers* that were intended to make people believe in the new social experiment, even as they engaged in the fine art of make-believe. Indeed, it is the close relationship between the two meanings of 'make believe' that, I will argue, makes these rhetorical films so distinct. The rhetorical potential of popular film did not escape the attention of Roosevelt's detractors. By 1936, in the heat of the re-election campaign and the debate over the more aggressive taxation measures of the 'second' New Deal, *My Man Godfrey* (a pleasant 'escapist' screwball comedy in some respects, a sharp conservative polemic in others) appeared. Its director was Gregory La Cava, a one-time employee of conservative newspaper magnate William Randolph Hearst who also directed Heart's partially scripted *Gabriel Over the White House* (1933), a call for a rightwing coup as a solution to the Great Depression. *My Man Godfrey* argues in favour of the positions advocated by conservatives in business who were dismayed by Roosevelt's anti-business programmes and taxation policies after 1935.

Though frequently characterized as 'escapist', films of the early 1930s had, in fact, a difficult time escaping the Depression. *Gold Diggers*, for example, concerns a group of 'showgirls',

singers and actresses in Broadway musical shows, who are down on their luck because of the economy. At the outset, they are practising a number called 'We're in the Money', an ironic title, of course, as they are about to have the show shut down around them for lack of financing. With the help of Brad, a Boston blue-blood who is inexplicably slumming in the city and who donates the needed funds, the girls put on a show about the Depression itself. Brad's older brother, Lawrence, and his friend Peabody, both upper crust Bostonians, show up and try to prevent Brad from marrying one of the girls, Polly, because she is not respectable enough. Armed with lots of upper-class prejudices regarding 'gold-diggers', girls who marry for money, they themselves end up falling in love with two of the showgirls, Carol and Trixie. Lawrence falls in love with Carol who pretends to be Polly in order to get back at Lawrence for disparaging showgirls as gold-diggers. That 'true' romance is balanced by the more humorous gag romance between Peabody and Trixie, who is a genuine gold-digger and who intends to fleece him for all he has. In the end, all the romantic couples are happily joined, and that narrative assurance allows the movie to conclude with its one serious musical number – 'Forgotten Man' – from the new show that Brad has financed, a plea for help for the unemployed veterans of WW1.

Most films are about a vague and undefined historical present, but *Gold Diggers* has a more emphatic historical index than most. The period of its production and release, from 1932 to the spring of 1933, witnessed a deepening of the Depression which began in 1929 with the stock market crash. Laissez-faire president Herbert Hoover, elected in 1928, was defeated in the election of 1932 by Franklin Roosevelt, who promised more aggressive remedial action on the part of government. Hoover lost the election for several reasons. One was that he refused to offer assistance to people without jobs. An old-stock conservative, he believed that individuals were responsible for their own fates and that the poor should take care of themselves (see Warren 1959).[1] Another was the way he handled a protest march on Washington in 1932 by veterans of World War 1 who wanted the government to disburse bonus monies early that were due them at a later date. Thinking the Bonus March a Communist conspiracy, Hoover ordered the army to disperse the marchers. In the violence that ensued, several people died, and Hoover came to appear callous and uncaring. It is important that the marchers referred to themselves as 'forgotten men', and that Roosevelt, sensing an advantage, used that same phrase to refer to the unemployed in general during his presidential campaign (Daniels 1971).

The film draws on this discursive context in its references to 'forgotten men' in the final musical number, and by setting its story amongst the down-and-out. But it can also be interpreted as an argument in favour of Roosevelt's New Deal, with its generous programmes of government assistance for the poor and unemployed. The 'Forgotten Man' number, which concludes the film, ends with Carol singing to the audience, standing between a background of soldiers marching and a foreground of people turned towards her with outstretched arms. By now the song has become an explicit plea for assistance: 'Oh won't you lend a hand to my forgotten man'. The camera draws back to create an image of a large community of people of which her individual case is only a part. The sequence has thus evolved from a tight close-up of her face, which individuates her suffering and draws attention to her particular pain, to a long shot of her position within a larger community that shares her sense of suffering and joins in her plea for help. This act of generalization from the particular individual to the larger social community implicitly continues out into the film audience to whom the final plea is directed. The camera holds the long shot after it zooms out from Carol, but one senses that implied in the whole sequence is a continuation of the zoom and that more people, including the people in the audience, could be drawn into the image. (On the possibly mixed political implications of such communalism, see Roth 1977: 1–7.) If we think of Lawrence and Peabody as representatives of the same social group as Hoover and the Republicans who supported him, the film's argument in favour of the New Deal is again apparent. Like Hoover and the Republicans, Lawrence and Peabody are suspicious of the motives of poor people. They feel that when the poor ask for assistance it is a trick to deprive them of their wealth. The film depicts a transformation whereby the two 'upper'-class characters learn to trust the 'lower'-class characters. They come to see them as hard-working and virtuous. The historical significance of the film can be said to lie in

the lesson it offers to conservatives who opposed government assistance for the poor. The poor and unemployed can be trusted, it argues. They are not out for a free ride. They are, given a chance, willing to work hard and be responsible, industrious contributors.

But it is in the film's three musical numbers – 'We're in the Money', 'Pettin' in the Park' and 'Forgotten Man' – that the argument in favour of the New Deal finds its most sophisticated formal expression. During these musical interludes, the film seems to take a break from its story of the successful overcoming of class prejudice and engage in fabulous images with no apparent real or historical referent. Indeed, the musical numbers very explicitly abandon all pretence to represent reality, in this case a real stage, by expanding visual space and introducing actions that could only occur in a film studio. At these points, the film seems to move beyond referentiality altogether into a plastic play-space where obligations to history and reality no longer have a role in shaping what might occur. All three numbers depict a magical transformation of reality that is in keeping with the optimistic argument of the New Deal that economic 'reality' was plastic and transformable. At the very moment Roosevelt was promising to change an economic situation that seemed unamenable to change, the film portrays a mutation of limited theatrical space into a cinematic space that, because it allows a wider range of representation and image construction, suggests that the world itself can easily be transformed. Beyond realism – understood both as a psychological disposition to tolerate limits and to live within them, a disposition that characterizes the showgirl community, and as an aesthetic disposition to let the real shape the possibilities of representation – lie optimistic representational possibilities that seem to create realities of their own. The usual relationship between the real and theatrical representation is reversed.

This indeed was the argument of the New Deal: that the economic situation of the country was not a reality one had to live with because nothing could be done about it. Rather, it could be changed with effort, imagination, and will. The political project would have to be an aesthetic one of fabrication and reconstruction that entailed reversing the normal relationship between the economic 'real' and government or political representation. In the past, especially in the business-friendly 1920s, the economic real was prior to and determining of representation. Government adopted a deferential attitude towards a reality that was putatively outside its control. Government representatives did not presume to shape economic reality using artificial tools. Now, the New Deal government was promising to use just such artificial tools as administrative agencies and deficit spending to reverse the relationship between representation and reality by determining the course of economic reality. It is not so much that the New Deal was the social context that determined modernism; rather, the New Deal was itself a modernist government.

The progress of the musical numbers from first to last optimistically reverses an initial negative situation in which the real precedes and determines representation. Initially, economic hope is defeated by Depression realism, and aesthetic creativity is overwhelmed by the obligations of financial realism. The opening number – 'We're in the Money' – resembles the later numbers in that it offers not only thematic hope but also the aesthetic hope that the real can be remade by human contrivance. 'We're in the Money' operates through a kind of representational magic that seems to take hold of reality and mould it according to aesthetic, rather than realist or representational, dictates. It works through a confusion of the real and the imaginary in which the imaginary seems to trump reality. The first images we see in the film are of Ginger Rogers singing the title song. We are invited, without any other information to go on, to think of this as 'the movie itself'. In other words, we know from the title that it is likely to be a musical, and the opening number should therefore be 'the musical movie'. It isn't, of course. Instead, it is the rehearsal of a show on a theatre stage in New York, but initially we don't know this. The camera tracks away from Rogers and along a line of similarly money-clad women singing the same song. Suddenly, we are back to Rogers. The logical constraints of realist representation are overcome by the illogical tricks of cinematic representation. Next, Rogers sings the song backwards, as if the determinist logic of language was no longer relevant to a world of aesthetic play. Moreover, being 'in the money' is also, given the real economic situation of

the time, utopian, a kind of counter-realist declaration. Both in style and content, this musical number is about as un-Depressed as an audience at the time could possibly get. It is as if we have left reality behind, and the feeling of the audience coming off the Depression-era streets was no doubt akin to the one the musical numbers instil, a feeling of relief to have finally entered a world of beautiful and pleasing images in which the real succumbs to artifice and daily ugliness to aesthetics. 'Escape', indeed, but it is escape that has more to do with the relation between the real and representation, economic reality and aesthetics, than with evasion.

The bravura of the gesture lasts only so long. Just as we are beginning to think we are in a realm where representation and fantasy have come to replace reality and the imperatives of realist representation, the film cuts away from the singers to the producer, Barney Hopkins (looking very much like Harry Hopkins, a major player in Roosevelt's administration), standing in the audience looking on in a disgruntled manner. We know for the first time that we have not been watching 'the musical movie' but instead a rehearsal of a theatrical performance that is part of the realist narrative of the film. We are in an actual theatre that defuses the inspirational magic of the musical number and makes it beholden to the historical world and to the logic of realist representation.

That real world now intrudes in the form of both economic and aesthetic realism. Policemen enter the theatre and shut down the show, appropriately grabbing money emblems away from the showgirls, because creditors want to be paid. The style of these new images contrasts vividly with the style of the imaginary musical number and embraces instead the conventions of social realism – images of alley-ways and steel fire escapes that block the view and suggest the encounter of hard knocks and brave spirits.

The real also asserts its power in the form of a financial crisis for Barney. A policeman, dressed appropriately in funereal black, looms over him from the stage, literally blocking Barney's access to the play-world of aesthetic representation, and refuses his pleas for a break. It is a moment that defines the crucial moral as well as economic question the film seeks to address: should economic losers be helped by economic winners in defiance of the logic of economic realism, or should some new criterion other than realism be fabricated to adjudicate such questions?

The issue at this point in the film can be seen in terms of both the relation between representation and the real, and the relation between credit and purchasing power. If allowed to go on, the show would earn enough money to pay the bills, but that would be to put representation before the real, to allow the imaginary money of credit to create a reality, to make these poor people appear to be 'in the money' even though, in reality, they are not. Hopkins's argument is that this temporary reversal of the rules of economic realism would allow a new economic reality to be created, just as Roosevelt would argue that counter-cyclical borrowing by the government would allow for a priming of the economic pump that, by putting something 'insubstantial' and 'false' before something 'real' and 'substantial', would transform the real. Economic realism says that you should behave as if you have money only if indeed you possess money. You shouldn't sell what you don't have, and you shouldn't buy what you can't afford. The real precedes the (financial) representation. That is fiscal responsibility of the most conservative kind. According to that traditional fiscal logic, the real generates and justifies the representation. Money generates economic activities like shows, not the other way around. Therefore, the show has to close before it opens because there is not enough money to pay the bills, even if putting the show first (representation before the real) would generate the needed funds. Barney argues that, given a chance, the show could earn enough money to pay the debt, but the Hooverite realism of the police precludes giving assistance that would allow a mere representation, an artificial contrivance be it financial or artistic or both, to supersede the real.

Both argumentatively and representationally, the film sets out to reverse this initial negative situation whereby reality trumps the power of representation. Brad and Lawrence offer the financial help Barney was refused, and the show is indeed a success. And that success allows the show to put on musical numbers which themselves transform reality and overwhelm its constraints with the work of the imagination. Fittingly, the last number is almost prevented from

going on by a policeman, sent by Lawrence, who threatens to arrest Brad. But he is revealed to be an actor by Barney. Even the police, the agents of realism at the beginning of the film, turn out to be aesthetic effects by the end. Trixie, that emblem of the down-and-out lower-class trickster who manages to survive despite the dictates of economic reality, is herself dressed as a policeman at this point. If all of reality is aesthetically transformable, the film seems to suggest, why not the coercive core of economic realism?

Even the film's most 'escapist' elements participate in the argument in favour of Roosevelt's New Deal programmes. The final number is probably the most explicit example, but the very style of camera work throughout also conspires to lend credence to the liberal politics espoused by Roosevelt, an outlook that favoured a communitarian ideal over the individualist-survivalist ethic promoted by Republicans. During the first number, the camera pans and tracks across a park setting from one romantic couple to another. All are of different ages, professions and ethnicities, and the implication of the camera work is that they are all connected, all equally part of a community. In each of the musical numbers, especially 'Forgotten Man', the editing moves from highly individuated shots to ones that emphasize the placement of the individual in the social group. A preponderance of pan shots works to construct visual communities, and cutaways to single shots of individuals have the effect of interrupting these desirable, imaginative, communal visions of the aesthetic transcendence of the real. Throughout the film, the Hooverite ideal of economic individualism is undermined by camera work that suggests that people inhabit communities in which relations amongst equals are as important as individual differences.

Later, during 'Forgotten Man', the full resonance of that ideal will become more evident. After several tracking and pan shots that connect different people, the community bands together to address the audience with its appeal for assistance. Such assistance is only imaginable if one feels connected to others, and the camera work attempts to establish such a sense of connection for the audience. Moreover, a sense of empathy with others is possible only as an act of imagination, an ability to move beyond one's own cognitive limits (one's own reality) and enter others' lives. It would seem appropriate, then, that the musical numbers, those fantastic and imaginative departures from representational reality, promote just such a sense of the possibility of transcending the limits of lived reality as they also depict a possible community between very different kinds of people.

The liberal ideals that animate a film like *Gold Diggers* rest on a vision of the human personality as being flexible and relational. Virtue, in such a vision of the world, consists not of ideal individual qualities, but of helping connections with others who are part of one's field of relations. The film argues that people need each other, and those needs are the basis for fruitful relations that build positive communities. The liberal model of personality sustains the ideal of a social community in which relations of dependence make mutual assistance necessary. The self in this vision is not a tough, well-boundaried individualist; rather the self is fallible, dependent on others, and linked in a variety of ways to other people. Economic life is a web of relations between interdependent people, not the social equivalent of a billiard table on which hard atomized balls bounce off each other. The self is part of a community and cannot be isolated without harm from the relations of trust, care, and help the community affords.

The hard-nosed conservatism in economic and aesthetic matters against which the social argument of *Gold Diggers* is directed favours rather different visions of personality and community. The ideal conservative man is a self-sufficient, self-reliant individual whose virtue resides in a capacity for responsible action, the sources for which are found exclusively within himself. Ties of dependence on others are construed in this framework as emblems of weakness and effeminacy. Communal ties undermine the toughness required to survive as an individual; consequently, they are for women to look after. Government, rather than be perceived as an agent of the community that can aid the less well-off, is perceived as a threat to individual independence.

Moreover, the conservative preference for adherence to traditional moral values is also sanctioned and enabled by this ideal of personality. The strong individual is not weakened by the temptations of immoral action. Rather, moral virtue is premised on self-restraint, an emotional economy that saves personal forces in order to invest them profitably in one's own business or

family. Much humour is made of this model of moral personality in *Gold Diggers*, which depicts respectable Boston blue-bloods succumbing to the temptations of the flesh and learning to enjoy them.

Like differences in moral style, differences in aesthetic style are implied by the political differences between the two social philosophies. The two political visions not only see the world differently; they also represent it differently. In *Gold Diggers of 1933*, as I have suggested, editing works to establish connections between people. In a conservative film that favours a more individualist social philosophy, one would expect a quite different camera and editing style, one that draws attention to the importance of the individual and values the individual over the group or community. Whereas individual shots in a liberal film might connote loneliness or loss of community, in a conservative film cut-aways to an individual isolated in a frame of his own might connote strength or virtue, a positive alternative to a community that is portrayed more negatively now as being deranged or dangerous.

Such is the case with *My Man Godfrey*. Like *Gold Diggers*, it is set in the Depression, and it shares some of the topicality of that film. After an initial opening sequence set in a dump where unemployed 'forgotten men' live, the action moves to the house of a wealthy family, the Bullocks. Most of the action unfolds there until the end, when the narrative returns to the dump, which has been transformed in the meantime into 'The Dump', an upscale restaurant that provides jobs for the formerly unemployed men. The Dump is the off-screen creation of Godfrey, a homeless man hired to be the Bullocks's butler, who turns out to be a former Boston blue-blood who gave up the life of wealth after a failed romance, and who learned self-reliance and other conservative virtues from the forgotten men he encountered one night while contemplating suicide. Most of the story is taken up with Godfrey's attempt to deal with the conspicuously haywire family into which he is adopted. Irene Bullock, the scatterbrained younger daughter, takes him in as the new house butler after finding him on the dump during a scavenger hunt. She and her wealthy friends must find a forgotten man to fulfil the scavenger hunt list, and when Godfrey returns with her to the upscale hotel that is the hunt's headquarters, he upbraids the wealthy crowd for wasting their time on such silly pursuits. To the Bullock house he brings a similar sense of moral rectitude. He lectures Irene about the impropriety of coming into his room, offers Mr Bullock advice about his investments, and rebukes the older sister, Cornelia, for being a spoiled brat. He embodies a conservative ideal of social discipline and moral probity, while being himself in his role as butler an industrious, obedient, and hard-working servant.

In contrast to Godfrey, the Bullock family is loose at the moral seams. Mrs Bullock keeps a lover, Carlo, who is a mockery of high artistic and intellectual pretensions. Cornelia attempts to engineer an apparent jewelry theft that she hopes will be blamed on Godfrey. Irene declares an engagement to be married in a fit of petulance because Godfrey will not meet her demands for signs of affection. (She wants him to be her Carlo.) And Mr Bullock seems to have no control over his recklessly free-spending and wild-living wife and daughters, who bring horses and summons-servers home with them after late nights carousing and drinking.

The film is a comedy, and much of the comedy is generated by the contrast between the antic or petulant behaviour of the women and Carlo on the one hand, and the either frustrated or baffled reactions of Mr Bullock and Godfrey on the other. In one famous scene, Irene, irked at Godfrey, lies on the couch in hysterical collapse while Carlo attempts to cheer her up by pretending to be an ape and climbing over the furniture and up the walls. The cut-aways to Godfrey's cool observant reactions are meant to be some of the film's most humorous moments. What is noteworthy about them is that the cut-aways are both from Carlo to Godfrey and from the hysterical women to Godfrey, as if both forms of theatricality were somehow equally disturbing to the paragon of moral rectitude. Of equal importance, of course, is that the cut-aways move from a community which is depicted as dangerously out-of-control and depraved to an individual who is, through the editing, depicted as separate from the communal madness all around him. Alone in the frame, he seems protected by its boundaries from the ambient madness. His separate individuality comes to appear virtuous in contrast to the obvious failings of this particular community.

How might this editing gesture, which seems to belong to the conservative filmmaking vocabulary discussed above, cohere with the film's political argument? In order to answer that question, one needs to heed the sub-plot to the primary romantic plot between Irene and Godfrey. In that sub-plot Godfrey turns out to be, in fact, a wealthy Bostonian who comes to respect the unemployed because, unlike him, at least initially, they found strength within themselves and have not given up. In the opening sequence, we might have already guessed Godfrey's true origins. He smokes a pipe and is referred to by the other homeless men who live at the dump as 'Duke', a title of nobility. As yet we do not know why he is portrayed as noble, but as the film progresses it labours to convince us that he is one of the few natural nobles of the world, someone who through superior resourcefulness and individual initiative creates wealth. With the help of an old Boston friend, Tommy, who shows up at the Bullocks, Godfrey invests the money he gets for hocking Cornelia's pearl necklace, earns enough to buy the dump and transform it into The Dump (which houses and employs the former inhabitants of the dump), and is able to save the Bullock family from financial disaster by buying up the stock of the Bullock company. He is a perfect embodiment of what conservatives at the time were arguing: that economic entrepreneurs, left on their own, would be able to use their ingenuity to overcome the Depression – if only the New Deal would stop taxing and regulating them.

Coincident with his financial salvation is Mr Bullock's decision finally to evict Carlo through physical violence and to tell his wife (whose physical fluttering is associated with the out-of-control state of the family) to sit down and listen for once. Having declared early in the film that 'what this family needs is a little discipline', he exercises it at last. A bullock of course is a castrated bull, and Carlo's presence in the house is also associated with a goat, a metaphor for cuckoldry, since Mr Bullock is made a goat or an object of adulterous betrayal by his wife's lover. In the end, Mr Bullock's potency, both financial and sexual, is restored both by his own actions and by the entrepreneurial assistance Godfrey lends. Appropriately, he and Godfrey are framed together in a two-shot at this moment of the film, and Godfrey has at this point also put aside his servant's costume and resumed his businessman's clothes. He is once again endowed with the aura of value the cut-away edit provides, since it has become clear by the end of the film that his individualist actions alone, not the workings of the community, are what have saved this particular social world from destruction.

The sub-plot, then, concerns economic rejuvenation and the restoration of moral order, and it intersects with and overwhelms the main comedic plot that is dominated by the actions of the women and of Carlo. Indeed, one could say that all that is wrong or out of whack in the main plot is cured by what transpires in the more serious sub-plot. Mrs Bullock is put in her place and made to behave morally; spoiled brat Cornelia is reprimanded and taught a lesson in proper behaviour; and Irene the flibbertigibbet assumes the responsible role of Godfrey's wife. Most importantly, Carlo is expelled. He is referred to as a free-loader and is depicted as someone who eats too much. Unlike the morally upright, hard-working, responsible Godfrey, who accepts no help and finds the strength within himself to prevail against adversity, Carlo is a figure for the welfare cheat, someone who takes help instead of working. (That he is also coded as a foreigner, an intellectual, and an artist is probably important for the time, since many people who argued in favour of the liberal ideal of government assistance for the poor were foreign-born, socialist intellectuals, and many artists and writers were supported by the New Deal's Work Projects Administration.) Carlo is also an emblem of the infatuation of the intellectuals of the 1930s with the Soviet Union (see Denning 1996; Szalay 2000). He sings a dreary Russian song in a scene that laments the inability of Americans to recall the words to the 'Star Spangled Banner', and in another scene partygoers gather around his piano and sing a rousing Russian peasant song. Along with the ultimate triumph of the capable individualist and successful businessman Godfrey, the treatment of Carlo places the film in opposition to the Left intellectuals and artists of the time. That tax money taken from the wealthy should not be wasted on lazy free-loaders was of course a conservative argument during the thirties, as today. Carlo's physical appearance (played by an East European actor) and his association with Communism also codify him as Jewish. The upper-class opponents of the New Deal were as virulently anti-Semitic as they

were anti-New Deal, and in 1935, the year before the appearance of *Godfrey*, the two strains coincided. Roosevelt's new taxes on surplus corporate profits that year were widely believed to be the work of the Brandeis-Frankfurter, or Jewish, faction in Roosevelt's government.[2]

One of the crucial ideological conflicts of 1935 and 1936 was between the New Dealers, who increasingly attacked the business community and the 'malefactors of great wealth' for opposing their programmes of tax-fuelled government assistance to the poor (Roosevelt especially in the 1936 campaign lashed out at 'economic royalists'), and conservatives who responded by claiming that New Deal taxation to fund social programmes took money away from job-creating investments that only the business community could make (see Leff 1984; Wolfskill 1962; Weed 1994). Made in 1935 and released in 1936, the film signals its allegiance to that conservative community in several ways. Perhaps the most obvious reference to the political debates of the time is Mr Bullock's caustic remarks against taxes. 1935 witnessed a turn towards higher tax rates, and the film argues that such money might be more successfully used if left in the hands of business entrepreneurs. To Tommy, Godfrey remarks that the only difference between a bum and a man is a job. In other words, if tax monies were left in the hands of business, as conservatives contend, jobs would be created. Government merely gets in the way and interferes with potentially successful business enterprise.

Yet even as it argues for such 'liberty' for business people, the film also argues for family discipline and a workplace hierarchy that places workers under owners. The film's dual argument requires that the individual businessman, who finds within himself such resources as initiative, responsibility, and the will to work hard, should be left free to pursue his job-creating investments while everyone else, especially those who work for him, need to be subjected to the discipline and self-sacrifice that work requires. The necessary complement of the successful entrepreneur is the obedient worker who behaves responsibly to his employer and is industrious. Otherwise, wealth would not be created. Godfrey's former pals become his uniform-clad employees by the end, and although he and they now occupy quite different class positions, they remain loyal to him nonetheless. That of course is one of the film's important political points, one it achieves by astutely placing Godfrey in the dual position of economic winner and loyal servant who knows his place and accepts it willingly, at least while there. As Godfrey the butler he offers an image of how the responsible and devoted employees of Godfrey the investor should behave.

Conjoined to this vision of the successful leader and his followers, a vision that many conservatives in Europe and America were still willing to embrace before the Second World War made its shortcomings evident, is a vision of moral life as similarly disciplined. According to this vision, moral order consists of self-control and of the imposition of control by stern fathers on such familiar emblems of a morally wayward lack of control as foreigners, women, and the dark races (Carlo's name suggests Italy). The connection between economic philosophy and moral philosophy would seem to be that when things are out of control, as they certainly are in the Bullock household, wealth and the individual effort that creates it are wasted. Metaphorically in the film, absence of control also means that women come to dominate, as do artistic intellectual free-loaders; and economic men are deprived of the sexual potency that is associated with economic productivity. Social discipline thus entails the subordination of women to male mandate and the curtailing of wayward desires that transgress firm and proper moral boundaries. The moral significance of the numerous cut-aways in the film's editing to single frame images of strong male individualists, is that they portray the male as possessing a firm boundary separating him both from others (especially the hysterical female characters) and from immoral behaviour. He keeps his feelings within a firm moral frame, much as his body is contained within the well-boundaried container of the cut-away image. This sense of singular restraint contrasts remarkably with the images of lush sexuality in *Gold Diggers*. If sexuality in *Gold Diggers* carries the meaning of therapeutic care that compensates for the pains of the world, in *Godfrey* it is associated with a counter-productive immorality.

As one might expect, the attitude towards the aesthetic transformation of the real in *My Man Godfrey* more or less reverses what one finds in *Gold Diggers*. The artists responsible for such

transformations are portrayed as objects of scorn, and theatricality of the kind that in *Gold Diggers* associates performance with self-remaking or with the undermining of the ontology of the social authority of the police, is linked in *My Man Godfrey* to a destructive and self-indulgent female hysteria. Moreover, while *Gold Diggers* begins with a triumph of the real over the theatrical, *My Man Godfrey* begins by associating aesthetic play with dishonesty and with the extravagances of the 1920s, and ends by curing the Bullock family of its theatricality with a firmly applied dose of economic realism. One senses quite palpably how that film will progress in its opening credit sequence. The camera begins with images of neon-lit signs that give the movie's title and the names of the filmmakers; then it pans across a dark cityscape to end up at the dump, where a truck unloads a pile of garbage. Against aesthetic play, it poses a literal reality of dirt and hardship that becomes the basis for its argument in favour of economic realism.

The 'escapism' of 1930s' films is thus somewhat more problematic and complex than historians like Alan Brinkley infer. Indeed, one could argue that escapism – the idea that one might reverse the order of priority between the real and representation in order to 'escape' the coercive limitations of aesthetic as well as economic realism – defines the project of the New Deal itself. That the New Deal promoted the perception that the 'real' of economic life was subject to representational manipulation (regulation, taxation, redistribution, job creation, direct assistance in the form of 'relief', etc.) was as profound an achievement as the one normally acknowledged by historians as its greatest legacy – Social Security. That it stopped short at this perception and did not pursue the logical consequences of it, consequences that would lead one to conclude that the economic real is itself an enormous fabrication held in place by the illusion of the real, is perhaps its greatest failure.[3] The general acceptance of that perception, however, will not happen so long as historians and others continue to misinterpret culture as a simple addition to reality that can be characterized using words like 'escapism'.

Notes

1. 'If any one attitude lost the election in 1932, it was Hoover's refusal to use federal resources in direct relief' (Warren 1959: 208).
2. On the anti-Semitism of the upper class, see Scholnick 1990. On the widespread assumption that Brandeis and Frankfurter were responsible for the tax policies of 1935, see Best 1991. This verse of the time was supposedly about a conversation between Mrs and President Roosevelt: 'You kiss the negroes/ I'll kiss the Jews/ We'll stay in the White House/ As long as we choose'.
3. Where the economic 'real' means the use of a representation like money to purchase labour to produce goods that are purchased by labourers so that the money spent returns to employers to be recirculated as wages, a system of circulating representations that does make 'real' things but that also constructs a relational, groundless, numerical contrivance called 'wealth' that is drained from the system of circulation as its excess side-product.

Painting and the New Deal

Art and Work on the WPA

JOAN SAAB

In his 1935 painting *Artists on the WPA*, Moses Soyer depicts a communal artists' studio. The picture plane, seemingly only a part of the room, contains images of six artists at work painting and drawing. Created the same year that the Federal Art Project began, Soyer's painting is optimistic. The artists and their works are each distinct from one another. One man sketches a woman who is sitting in a chair smoking a cigarette an arm's length away from him. She looks slightly bored, oblivious to the activities taking place behind her. Over her shoulder, a man in blue work-clothes paints a scene of children playing. Next to him a woman creates a more bucolic figure-filled landscape. Three more artists work nearby. By portraying these artists alongside one another, yet in their own creative worlds, Soyer represents the experience of the government-funded artist as both collective and individual. This dualism – the ability to be simultaneously part of a group yet distinct – was one of the reasons so many artists embraced the New Deal art projects. Of course the living wage paid to them in the midst of severe economic conditions and the recognition of art work as legitimate work were two other key appeals. But the ability to maintain artistic autonomy, at least in theory, drew many artists to the government projects. It also produced a number of problems for artists and administrators alike as they tried to define the idea of the artist as a cultural worker.

The idea of the artist as worker was at the core of the Federal Art Project's ideology. Established in August 1935, the Federal Art Project was part of a national work relief programme co-ordinated by the New Deal Works Progress Administration (WPA), whose other agencies included the Public Roads Administration, the Public Works Administration, and the United States Housing Authority. The WPA was directed by Harry Hopkins, a long-time Roosevelt supporter and friend. The WPA imposed few limits on the type of work it financed. Its general guidelines specified only that the projects be *useful* and be undertaken in areas where unemployment was high. Its definition of 'useful work' was broad. In addition to the Federal Art Project, the WPA housed a number of other cultural relief programmes: the Federal Writers Project, the Federal Theater Project, the Federal Music Project, and the Historical Records Survey. The first priority of all WPA cultural projects was making work. Hopkins repeatedly reminded WPA Directors to 'never forget that the objective of this whole project is . . . taking 3,500,000 off relief and putting them to work. The secondary objective is to put them to work on the best possible projects we can, but we don't want to forget that first objective, and don't let me hear any of you apologizing for it because it's nothing to be ashamed of.'[1]

The inclusion of the fine arts in the massive national relief project had been in the works since the early days of the New Deal government. In a 1933 press release, Hopkins asserted that artists had been 'hit just as hard by unemployment as any other producing worker' and later that year the artist George Biddle wrote to Interior Secretary Harold Ickes urging the government to treat unemployed artists in the same way 'as the farmer or bricklayer'.[2] In 1935, the

idea of treating the artist as a 'producing worker', akin to the farmer or bricklayer, was a novel concept. By the 1930s, art in America was primarily the domain of a social elite intent on promoting its sanctity as a means of maintaining cultural control. The Federal Art Project directly challenged this notion of art. For example, at a 1938 dinner celebrating 'Art and Democracy', Holger Cahill, National Director of the Federal Art Project, announced to a large audience that through the government-funded art programmes which he directed, 'The restrictions which made art the special possession of the few, whose patronage fostered it as a luxury enjoyment have been broken down and removed. The public', he exclaimed, 'has learned to accept the artist as a useful, producing member of the social family.'[3] Cahill's claims are significant for a number of reasons. First, they encapsulate one of the guiding impulses behind the New Deal art projects – to integrate artists into American society by paying them a living wage to produce useful goods. His stress on art's usefulness, rather than its aesthetic properties, is particularly interesting in the context of garnering public acceptance of the artist as member of the 'social family'. Although he never clearly defined what he meant by usefulness, by stressing a national familial bond between artists and other citizens Cahill normalized the role of both artist and patron by locating them close to home.[4]

By the time of this dinner, the Federal Art Program, like most of the New Deal cultural programmes, was under attack. Cahill's speech can be seen as an attempt to win support for the struggling project. But his declarations were more than legitimizing hyperbole. Contrasting a long-standing notion of art as a privileged 'luxury enjoyment' with the work being done on the project, Cahill also highlighted the theme of the evening's dinner and a major goal of the Federal Art Project since its inception – how to link art and democracy. While this has been an often contentious, time-honoured American quest, for Cahill, integrating democracy and art included a number of specific objectives; among them attempting to redefine the place of art in American life by broadening art's constituencies, and opening to public debate the question of what exactly constitutes a work of art. In his years as Project director, Cahill attempted to reverse decades of thought which posited that the fine arts were akin to a religion, and that 'high culture' was something different from 'popular culture' in that it was 'transcendent' and 'sacred'. He presented an alternative cultural valuation system based on participation rather than alienation. Indeed, by breaking down and removing the barriers between the artist and the social family, Cahill in many ways was attempting to *desacralize* American art.

The process of desacralization encouraged by Cahill and other Federal Art Project staff marks a key moment in American cultural history, for it challenged the methods of cultural sacralization, outlined by historian Lawrence Levine and sociologist Paul DiMaggio, that began in the years following the Civil War and that ultimately led to the solidification of cultural hierarchies based on concepts of 'highbrow' and 'lowbrow' (Levine 1988; DiMaggio 1986: 41–61. See also Harris 1990; McCarthy 1991; Locke 1997; Rubin 1992; Varnadoe and Gopnik 1990a; Crow 1985; Greenberg 1992a). Following French sociologist Pierre Bourdieu, DiMaggio calls the men and women who seized control of the consumption, and to some extent the production, of high culture in America 'cultural capitalists', because they were both capitalists in the economic sense and collectors of cultural capital.[5] During the 1930s, however, the New Deal art projects made conscious efforts to loosen the tightly controlled grasp of these cultural capitalists and break down the boundaries between fine art and folk art and entertainment and education. Instead of using art to establish cultural hierarchies and enforce the hegemony of an urban elite, Project participants attempted to use art to erase these divisions. Through public works programmes, art education classes, demonstrations and lectures, the Federal Art Project attempted to make the consumption of art accessible to all Americans, regardless of race, class, or geography.[6] Federal Art Project employees presented art as an American birthright. Like the cultural capitalists before them, they stressed links between art and citizenship – but their models of both were participatory. Art would no longer be limited to gilded frames and low-lit galleries; rather, at least in theory, it would be everywhere and available to everyone – in post office and courthouse murals, in after school programmes and community art centres, in public lectures and demonstrations (see Figures 17 and 18).

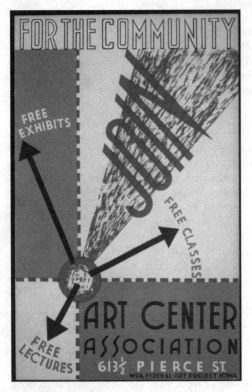

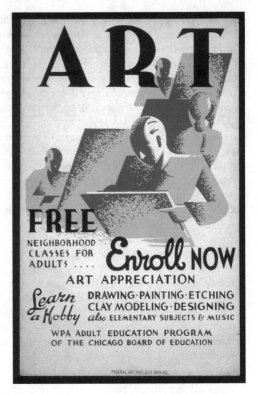

Fig. 17. Embedding art in community life during the New Deal (1936–9). Library of Congress, Prints and Photographs Division, WPA Poster Collection, LC-USZC2-870 DLC.

Fig. 18. Poster from the WPA Adult Education programme of the Chicago Board of Education, announcing free neighbourhood art classes (1936–7). Library of Congress, Prints and Photographs Division, WPA Poster Collection, LC-USZC2-5167 DLC.

In many ways Federal Art Project desacralization was rooted in New Deal rhetoric. Terms such as 'useful' and 'productive' were key buzzwords of the Roosevelt administration and their meanings, like those of 'art' and 'democracy', were highly contested. But attempts to link these terms were more than just rhetorical. Throughout the decade, government officials, artists and educators worked together to determine how to put these concepts into practice. Artists on the Federal Art Project were considered workers, yet they were seen as different from other workers and were bestowed privileges based upon these differences. Most could work in their own studios and on their own hours. Nevertheless, although most artists were often allowed to work in their own spaces on their own time, they were still considered government wage labourers, and the government was firm regarding the ownership of their artworks. Plans and sketches required approval, and in extreme cases artists were not allowed to sign their works or take them home.

In order to recognize different levels of artistic talent and include as many 'artists' as possible on the relief rolls, Cahill and his staff classified Project artists into four categories – ranging from 'professional' and 'technical' workers to 'ancillary' positions such as gallery workers and handymen – based on an evaluation of the applicants' practical skills. On the most advanced level (A) were the professional and technical workers. These were 'artists who are experienced in their skill and capable of producing creative work of a high standard of excellence'. Level A

workers provided leadership, supervision, and training on the projects. In addition to painters, sculptors, and graphic artists, 'others such as highly skilled craftsmen, photographers, teachers of art, lecturers, and research workers' fit in this classification. The inclusion of teachers, lecturers and research workers in the most advanced category highlights the Project's larger goals of cultural desacralization through education and the importance of teachers in carrying out Federal Art Project policy. The next level (B) were the skilled artists. These were artists 'able to produce work of recognizable merit but not of a quality equivalent to A'. On level C were less skilled and experienced artists, craftsmen, and apprentices. And finally, there were the unskilled workers (D) who fulfilled ancillary functions such as gallery attendants, handymen, messengers, and office help.[7] This multi-tiered classification system allowed for maximum participation on the Project's relief rolls. Indeed, by including technical workers and craftsmen in their criteria, Project officials shifted the focus from the idea of art as inspiration to art as a useful form of labour. Handymen, messengers and office staff helped art reach the public and were paid the same wage as the artists, teachers and craftsmen. But the hierarchical nature of the categories also suggests that there was still considerable resistance to completely desacralizing the artists' unique status.

Artists on the Federal Art Project worked 96 hours a month. This included the hours spent working on the actual projects as well as the supervised time spent in preparing work. It did not, however, include *unsupervised* time spent researching or preparing work, and the issue of supervision became a major source of tension between Project artists and administrators. Again Cahill played middleman, arguing that 'it should not be necessary for artists to leave their work to make formal appearances before timekeepers. This kind of interruption seriously interferes with creative work and is entirely unreliable as a check on the time the artist has worked.' Instead, Cahill proposed an 'automatic time checking arrangement' whereby artists submitted 'time reports' that were based upon a 'tentative estimate' of the hours necessary to complete their work, determined by regular consultations with 'the supervisor in charge of the specific project'. Both artists and administrators initially approved of this arrangement.[8] According to sculptor Robert Cronbach, 'such a system, [was] very open to abuse'. But, he continued, 'the striking thing . . . is not that such abuses did not occur – of course they did – but that they occurred so seldom'. On the contrary, he continued, 'when an artist became deeply involved in a major project, he completely disregarded the [mandatory] 15 hour rule and worked 40–60 hours a week' (Cronbach 1972: 140).

While the Depression was certainly a time of crisis, it was also a moment of possibility for many artists who habitually were out of work. Journalist Suzanne LaFollette wrote in a 1936 article for *The Nation* that 'the Depression of 1929 may prove to be the best thing that ever happened to American art. The government relief projects have not made the artist rich but they have kept him alive and given him what he sorely lacked, opportunity. He used to be poor and discouraged. Now he is poor and encouraged' (LaFollette 1936). Many artists agreed with LaFollette. For example, Thaddeus Clapp declared that on the Federal Art Project the artist was 'no longer an exotic, but an individual functioning freely within a society that has a place for him, no longer in an ivory tower but in contact with his time and his people' (Thaddeus Clapp, in O'Connor 1973: 206). And according to Cronbach, the Project artist 'felt that he was part of an important art movement; that his project would be seen by, first, his peers and also by a fair section of the public and the art world' (Cronbach 1972: 140). For artists, critics and Federal Art Project officials alike, the separation of artists from the ivory tower and their integration into the larger community was something to celebrate. The public nature of the Project also demanded a new relationship between artists and the patrons. Instead of creating for collectors and consumers, Project artists could now, at least in theory, create on their own terms. Like the artists in Soyer's painting, artists on the WPA were part of a group but still autonomous. They were workers and they were artists.

Indeed, throughout the 1930s, many artists identified themselves as members of the working class. At the end of the decade, for example, the painter and printmaker Rockwell Kent asserted:

I am a worker, in the sense that I earn my living by the work that I do. Whatever might be the nature of that work I would want security, good pay, and reasonable leisure for the enjoyment of life. I have worked lots of trades in the course of my life. If they were organized I joined. If they were not organized I worked to organize them, for I want a good life for myself, for my fellow workers, for the people of America.[9]

Kent's statement is interesting within the larger framework of the Federal Art Project. His definition of what constitutes a worker – someone who makes a living by the work that they do – is pretty straightforward. And, indeed, throughout the 1930s Kent earned a living by creating artworks. Yet for Kent, work also implied security, economic viability and access to leisure time; in other words, a lifestyle.[10] Moreover, his emphasis on the connection between 'a good life' and organized labour speaks to the more radical implications of the processes of desacralization. Throughout the 1930s, Kent also worked as a labour organizer, actively encouraging artists as well as other tradesmen to unionize.[11] He was not alone in his efforts. By proudly considering themselves workers, many artists joined with Kent in identifying with the working-class. Large numbers joined the Communist Party USA and many became active in its cultural offshoot, the John Reed Club.

Named after an American journalist who covered the 1917 Russian revolution, the John Reed Club was established in 1929 to give 'movement in arts and letters greater scope and force' and to bring art 'closer to the daily struggle of the workers'. By 1932, the John Reed Club had thirteen branches across the United States. Following the official Communist party line of 'art as a weapon', the John Reed Club stance was that art had a dual role to play in the Revolution. It was both an end (a true workers' art), as well as a means to that end (a tool to bring about radical change). The John Reed Clubs had six guiding points 'upon which all honest intellectuals, regardless of their background, may unite in the common struggle against capitalism'. These points included fighting against 'imperialist war', fighting for the 'development and strengthening of the revolutionary labour movement', fighting against the 'influence of middle-class ideas in the work of revolutionary writers and artists', and fighting against the 'imprisonment of revolutionary writers and artists, as well as other class-war prisoners throughout the world' ('Draft Manifesto of the John Reed Clubs', *New Masses*, June, 1932: 14). By simultaneously fighting for organized labour and against middle-class dominance in cultural affairs, the John Reed Club acted as an important agent in the desacralization process. Like the cultural capitalists they opposed, club members believed that art was a form of cultural (as well as political) capital. However, they self-consciously challenged elite notions of the fine arts by tying the process of artistic creation to the struggle for workers' rights. Like Cahill, they too considered artists useful and productive members of society.

In a 1936 letter to *Art Front*, John C. Rogers of Alexandria, Virginia wrote that 'More and more the artist is learning that his art is not a profession that isolates him from classification as a laborer; more and more the artist is learning that he has much in common with those of other trades and professions, the most important and common cause is the struggle to make a living.' He continued:

For years the artist has been something apart, something superior to the office clerk, the fish peddler, the ditch digger, the doctor, the movie actress, the student, or the professor . . . It was only until recent years that the artist became one with the worker, that the artist came down from his ivory tower and stood in the soup, bread and picket line with the rest of his toiling fellowmen and women. (Rogers 1936: 15)

As Rogers pointed out, during the 1930s the bread line and the picket line united artists with other labourers. Interestingly, the idea of the artist as a cultural worker took root in the Depression reality of the artist as an out-of-work worker. With unemployment at record levels, struggling artists no longer seemed odd. Artists joined the ranks of other unemployed Americans. As painter Robert Gwathmey recalled, 'I got out of art school in 1930. That was

the proper time for any artist to get out of school. Everybody was unemployed and the artist didn't seem strange anymore' (Gwathmey interviewed in Terkel 1970: 374). Similarly, in his 1975 memoir, Harold Rosenberg explained that 'the Depression brought forth the novel idea of the unemployed artist – a radical revision of the traditional conception, for it implied that it was normal for artists to be hired for wages or fees' (Rosenberg 1975: 197). Within the profound crises of the Depression, many artists capitalized on the moment to interrogate what it meant to be a cultural labourer. Perhaps this made it easier for the public as well as for many artists themselves to see the artist as a useful member of the social family. Since they were not producing art, there was no art to evaluate, just the condition of being out of work. By calling attention to their common unemployment and advocating for increased artistic opportunities across the country, Federal Art Project administrators attempted to challenge long-standing public perceptions of artists by integrating them into the national workforce.

Yet, despite their efforts, most artists never became workers like the farmer or bricklayer. Many did, however, realize a degree of newfound freedom in their work when the government projects replaced the private patron. For artists such as Cronbach, the government art projects were revolutionary in that they provided opportunity 'when there were no other equally valid outlets or markets for his work at this time' (Cronbach 1972: 140). The Federal Art Project's emphasis on the artist as worker and on art as a form of work challenged previous systems of patronage by removing the need for market-driven production. Instead, the initial emphasis was producer-driven. According to Gwathmey, the best thing about the projects was that 'artists for the first time . . . had a patron – the government – who made no aesthetic judgements at all . . . You were a painter: Do your work. You were a sculptor: Do your work. You were a printmaker: Do your work. An artist could do anything he damn pleased' (Gwathmey interviewed in Terkel 1970: 374).[12]

Nevertheless, the success of the Federal Art Project in integrating artists into the 'social family' as useful and productive workers led to a backlash, almost from the very start. In September 1935, less than one month after the Federal Art Project was inaugurated, the *Sunday Mirror* identified a group of Federal Art Project artists as 'Hobohemians . . . chiselers . . . and boondogglers biting the hand that feeds them'. Conservative newspapers, led by the Hearst Press, regularly attacked the government art projects for producing 'bad art'. Calling the artwork 'full of tripe', 'inane', 'disgusting', 'blotches of colour just smeared together' and 'not art of any kind', critics of the Project did not evaluate the projects in terms of relief; rather, they steadfastly adhered to traditional aesthetic criteria and notions of value in their denunciations. Once the formerly unemployed artists began to work, their artwork, not their productivity, became the object of critique. For example, in 1940 the *Chicago Tribune*, an anti-Roosevelt paper, ran a series of articles that attacked local WPA art projects as 'wasteful, ugly and communistic'. In particular the author of the articles singled out the work of the muralists Edward Millman and Edgar Britton as 'un-American in theme and design' and warned readers that their murals would 'exert an alien effect upon children and adults who view them'.[13]

To counter such charges, government officials attempted to normalize the work of the artist. They circulated publicity photographs of artists at work painting and sculpting in private studios, in public buildings, and in classrooms across the country. Moreover, the Federal Art Project mounted major publicity campaigns designed to reach a wide audience. At the 1939 New York World's Fair, for example, the Contemporary Arts Building was devoted entirely to the work being done on the Project. The building contained a model community art centre, with working studios for art and handicraft demonstrations, lectures, conferences, and performances. According to the *New York Times*, 'Almost every day some painter, sculptor, or graphic artist explains [a] demonstration . . .'[14] By displaying artists at work for a broad audience and providing an explanation of what it was they were doing, Federal Art Project administrators attempted to shift evaluative criteria away from aesthetic judgements by focusing instead on the idea that the artist was a useful worker. Stressing the building's ties to the New Deal art programmes, Cahill repeatedly emphasized the ways in which the United States government attempted to desacralize artistic production across the country. A pamphlet distributed by the

Federal Art Project at the Fair related the demonstrations contained within the Contemporary Arts Building to those occurring throughout America, ultimately arguing that 'at no time in the history of the country has the opportunity for participation in the creative arts been given to as many people as today in the United States'.

For administrators such as Cahill, participation was key. Artistic usefulness was not merely aesthetic, it was social, economic and political. Cahill's notions of usefulness were both forward and backward looking. He regularly tried to link the government art projects both to the glories of past civilizations and to the future success of American democracy. For example, in a letter to Federal Art Project administrator Ellen Woodward, he announced that 'the United States government in setting up its art programs has returned to the healthy tradition of art patronage which existed during the Renaissance and Middle Ages when thousands of artists were given an opportunity to work by patrons who believed in a living art'.[15] Cahill made regular allusions to the government's patronage as being part of a long and noble tradition. In a 1936 speech to the Southern Women's National Democratic Organization, he declared that 'the US government has become the greatest art patron in the world . . . and government support for the arts is no new thing. Governments in every age and in every part of the world have employed artists. Egypt, Greece, Rome . . . China and other oriental countries. . . .'[16]

But in the end, the renaissance that Cahill hoped for never materialized nor did the idea of the artist as a productive member of the social family fully take root. While many American artists embraced the principle of the government supported cultural worker as well as the idea that art was a form of useful work, they continued to maintain that their work was different from that of other workers, that they were not laying bricks or planting crops. In August 1937, for example, the painter Stuart Davis wrote in his diary that 'the artist must seek ways and means to participate in the struggle of the masses which is his struggle. He must make a people's art but that does not mean that he must lower his standards of artistic perception to the level of the artistically uneducated masses.' Rather, he continued, 'He must ask the workers for support to be an artist, not for the right to betray his art.'[17] While Davis identified with the 'masses' and saw their struggle as his, he was also committed to the idea that art should foster an 'aesthetic experience'.

Still, like Cahill, Davis believed that artists were important members of the social family. 'The painter', he wrote, 'is not only an artist but a member of society' (journal entry, 24 June, 1937). He was committed to the idea of a 'people's art', to linking art and democracy. For him this meant a democratizing of accessibility to art, as one part of a broader desacralization in the institutional discourses and sites through which art was consumed. 'The fight for democracy', he wrote, 'is a fight for more art, not less' (journal entry, 27 August, 1937). Like Cahill, Davis was also committed to the idea of cultural desacralization through education. 'Socially, politically,' he argued, 'the task of the artist is to sell the role of the artist to society', to educate the 'aesthetically uneducated masses'. But unlike Cahill, Davis held to more traditional modernist definitions of art based on pure 'aesthetic experience'. In another diary entry written in the summer of 1937, he asserted that 'the program of the artist should be towards increasing the opportunity of the masses to participate in aesthetic experience and not to eliminate the aesthetic experience from art'. For artists such as Davis, desacralization was rooted in the contemporary reception of art, not its production. Rather than break down the sacred aura around the fine arts, these artists wanted to make this aesthetic experience available to more Americans, in effect to democratize sacralization. The idea of the artist as a useful and productive worker worked well in theory when the artist, like the farmer and bricklayer, was unemployed. Once artists began to work, however, their artwork, not their labour, became the locus of critical attention. Yet, the contestations that arose over the value of the actual art produced and the means by which artists worked raised important questions about the definition of art, the meaning of artistic labour, and the calibration of aesthetic value. Rather than dismiss the Federal Art Project as a failed experiment, as many have done, we need instead to applaud it for attempting to bring the artist into the social family and for providing an accessible form of cultural capital to the American public.

Notes

1. Harry Hopkins, quoted in Memo to WPA administrators in Federal Art Project Collection, NY, AAA, reel DC54.
2. Biddle diary entry, 8 November, 1933. Reprinted in Biddle 1939: 269–70.
3. Holger Cahill, 'Art and Democracy', speech at Town Hall, New York City, 7 June, 1938. In uncatalogued Holger Cahill Papers in New York branch of the Archives of American Art (NY, AAA), Box 1.
4. Although he repeatedly used the term 'useful' to refer to the Project, he never concretely defined it. In most contexts the concept of utility was both literal – jobs and money – and ideological, a way of rhetorically obscuring dissent and social division.
5. For Bourdieu, taste, an amorphous category based on the aesthetic preferences of social elites, acts as a means of creating symbolic boundaries based on social distinctions (Bourdieu 1984). Bourdieu's notion of capital includes the different assets, attributes or qualities that can be exchanged for other goods, services or position. He identifies several different types of capital, including economic capital, social capital, and symbolic or cultural capital (Bourdieu 1977). Central to these forms of capital is the notion of *Habitus* or the 'total, early, imperceptible learning, performed within the family from the earliest days of life and extended by a scholastic learning which presupposes and completes it' (Bourdieu 1984: 6). Don Slater provides an excellent overview of Bourdieu's theory of distinction in Slater 1997: 159–63. He writes, for Bourdieu, 'taste – cultural patterns of choice and preference – is seen as a resource which is deployed by groups within the stratification system in order to establish or enhance their location within the social order' (ibid.: 162). According to Slater, Habitus is 'habitual and customary . . . Above all [it] is embodied, learned and acted out on the level of the body' (ibid.). While Bourdieu's work specifically refers to mid-twentieth-century France, his theories are relevant to scholars exploring American culture. According to Barry Shank, Bourdieu's 'theorization of the transformative nature of capital, its capacity to shift from symbolic, to social to economic with none of those forms being primary . . . forces the analyst (historian, sociologist) to look beyond the self-reporting of the participants in the social system being studied'. Moreover, Shank argues that Bourdieu is particularly relevant to American cultural historians because Bourdieu sees culture as 'an arena where capital – understood as the contested product of unequal social relations – is produced, and markets are the fields in which the contests over capital produce and reproduce social relations', and as a result, 'cultural history becomes a fundamentally important social practice' (Shank 2001: 96–109). For an excellent application of Bourdieu in an American context see Radway 1999.
6. Through its educational activites, in particular the establishment of Community Art Centers across the country, the Federal Art Project also attempted to make the production of art available to all Americans.
7. Cahill, 'The WPA Federal Art Project, A Summary of Activities and Accomplishments' (1938) RG69 Box 2062, 22.
8. Cahill, 'The WPA Federal Art Project'.
9. Rockwell Kent quoted in Frances Pohl paper given to the American Historical Association Annual meeting, January 2001.
10. Kent's desire for a 'good life' recalls the struggles for 'Eight Hours for What We Will' explored in Roy Rosenzweig's study of industrial workers in Worchester, Massachusetts (Rosenzweig 1983).
11. 'Kent's interest and involvement in the labor movement are reflected in correspondence with officials and members of a wide variety and large number of unions and related organizations, among them: the Farmers' Educational and Cooperative Union of America, Farmers' Union of the New York Milk Shed, International Workers Order, National Maritime Union, and United Office and Professional Workers of America. Of special interest is his participation, often in leadership roles, in various attempts to organize artists'

(from the 'Series Description' to the Rockwell Kent papers, Archives of American Art, *http://artarchives.si.edu/findaids/kentrock/kentrock_m7.htm*).

12. The government was not completely hands off all the time, however. There were a few high profile instances of censorship on the government projects. For more on this see McKinzie 1972; Harris 1995.
13. Clippings from the *Chicago Tribune*, 19, 20, 22 December, 1940, in RG69/DI.
14. From 1939 New York World's Fair Clipping File, MoMA Archives.
15. Holger Cahill to Ellen Woodward, 'Report on the First Three Years of the Federal Art Project', 21 September, 1938. In Cahill papers, Archives of American Art, Box 2.
16. Thomas Parker speech to the Southern Women's National Democratic Organization, NYC, 6 December, 1936. Holger Cahill Papers, Speeches reel 0284.
17. Stuart Davis, journal entry, 27 August, 1937. In Stuart Davis papers, Houghton Library, Harvard University.

The New Deal and Photography

Liberal Documentary Goes to School: Farm Security Administration
Photographs of Students, Teachers and Schools

ERIC MARGOLIS

Between 1935 and 1943 photographers for the Farm Security Administration and later the Office of War Information (FSA-OWI) travelled the United States under the leadership of Roy Stryker. Writing at the time, Hartley Howe summarized the intent of government photography: 'What distinguishes FSA photography are its objectives. The first is to tell people, through pictures, about the great human problem with which the Farm Security Administration is struggling: the problem of giving a decent break to the lowest third of our farm population. The other basic aim is equally sweeping – to make a photographic record of rural America' (Howe 1940: online). Thus was created the largest archive of documentary photographs then in existence. Photos were to be made available to the American people and were catalogued for access. Pictures were shot by photographers who already had reputations like Walker Evans and Dorothea Lange, others became famous *because* they worked on the project like Arthur Rothstein, formally Stryker's student at Columbia, and John Vachon who started as an 'assistant messenger' (Fleischhauer and Brannan 1988: 90). This essay surveys school photographs from the FSA-OWI archives, considering both the content of the photos and the nature of the archive.[1]

From its inception photography demanded catalogues so images could be identified and retrieved. Photographs were such vivid evocations of 'reality' that the possibilities of organized systems led the imagination to speculate about grand libraries. As early as 1859, Dr Oliver Wendell Holmes, enthralled by stereoscopic images, envisioned an 'Imperial, National, or City Stereographic Library' where people could visit to see 'any object, natural or artificial' (Trachtenberg 1989: 16). In 1942, Paul Vanderbilt developed a filing system for the FSA-OWI that Trachtenberg lionized as a 'prime cultural artifact of the New Deal' embodying 'the era's ideology of human history as "universal" and "progressive"' (Trachtenberg 1988: 45). This filing system, indeed the monumental collection itself was intended as 'the nucleus of a great photo documentation of all of America, the collective repository for the work of tens of thousands of photographers', a 'panoramic central' file (ibid.: 55).[2] Vanderbilt conceived of the collection as a 'visual conception of what America and its democracy looks like in a photograph' (cited in Preston 2001). In essence what Vanderbilt envisioned was a visual simulacrum of the 'imagined community' of America (see Anderson 1991).

In answering the question 'what is documentary?' Abigail Solomon-Godeau (1991: 169) described two possibilities. Every photo documents some *thing* and could be called documentary because it enjoys an indexical relationship with the object photographed. This was the more or less unquestioned view of photography from its inception through the 1920s when the term 'documentary' came in vogue. Conversely, no photos are really documentary in the sense of 'unmediated transcriptions' of things in the world. Cameras produce 'iconic signs – translating the actual into the pictorial'. Walker Evans, for one, was never comfortable with the term

'documentary', arguing that 'An example of a literal document would be a police photograph of a murder scene' (cited in Curtis 1989: 44).

Treading a fine line between the literal and the artistic led to the development of 'document-ary' as a specific genre like architectural, portrait, or landscape photography. Its origins can be found in photos made by police reporter Jacob Riis and the child labour studies of Lewis Hine (1980 [1909]). Riis's 'reformist tract' *How The Other Half Lives* (1971) became an exemplar for what Martha Rosler termed 'Liberal Documentary' which 'had its moment in the ideolog-ical climate of developing state liberalism and the attendant reform movements of the early-twentieth-century Progressive Era in the United States and withered along with the New Deal consensus some time after the Second World War' (Rosler 1981: 71). Documentary photogra-phers framed a therapeutic perspective, pointing the camera at things that need fixing. As Rosler explained, 'In the liberal documentary, poverty and oppression are almost invariably equated with misfortunes caused by natural disasters: causality is vague, blame is not assigned, fate cannot be overcome. Liberal documentary blames neither the victims nor their willful oppres-sors' (ibid.: 73).

The FSA-OWI photographs testify both to the genre of photography motivated by social concerns and to a particular liberal vision of the United States during the difficult years between the Great Depression and the middle of World War 2. Solomon-Godeau described the FSA as: 'a large-scale, federally funded propaganda machine initially conceived to foster support for New Deal programs, [that] took for granted that a photography of advocacy or reform should effectively concentrate on subject matter' (Solomon-Godeau 1991: 176–7). Many scholars of the FSA-OWI have noted the focus on the 'deserving poor', the omission of drunks, tramps and other evidence of 'social pathology', the stage managing and construction of images, and the inability of the camera and unwillingness of the camera operators to represent the economic conditions leading to Depression and war (Rosler 1981; Stott 1973: 58–9). For instance, Curtis observed that Russell Lee, one of the most prolific FSA photographers, 'studiously avoided com-positions that might convey worker dissatisfaction, loneliness, or despair' (Curtis 1989: 20). The shift in mission from documenting the misery and dislocations of rural America to the cel-ebration of community strength, production and patriotism that characterized the Office of War Information phase, has likewise been well examined.

The FSA-OWI project has always been controversial. Congressmen, mostly from the Right, attacked it for misrepresenting their districts. In a famous case, Arthur Rothstein moved a cow skull and this became a trope symbolizing a false and ideological manipulation pervading the whole effort (Curtis 1989: 71ff.). It nearly brought an end to the FSA documentary unit (Stott 1973: 61). At one point Stryker was even afraid that Congress would order the archive to be destroyed (Preston 2001: 47).

Ansel Adams, whose pictorial devotion to landscape is well known, wrote to Roy Stryker, 'What you've got are not photographers. They're a bunch of sociologists with cameras' (Stryker and Wood 1973: 8). Like sociologists the FSA photographers under Stryker's direction con-structed ideal types. Stott summed it up best when noting that 'documentary treats the actual unimagined experience of individuals belonging to a group generally of low economic and social standing in society (lower than the audience for whom the report is made) and treats this experience in such a way as to try to render it vivid, "human," and – most often – poignant to the audience' (Stott 1973: 62). During a turbulent period that saw the rise of radical political parties, documentary photography helped create an imagined American community by defin-ing who was a legitimate member and who was outside the pale.

In their book *Another Way of Telling*, Berger and Mohr made the point that 'In every act of looking there is an expectation of meaning' (1982: 117). In the rest of this essay I will discuss the conjunction of looking and meaning in some of the generally unfamiliar images of schools from the FSA-OWI.[3] Schools and children are used as metaphors for the future, and as state-ments about community responsibility and caring; they are frequently used as a measure of social well-being. As the following chart suggests, the number of school photographs increased steadily during the period. The content changed dramatically as well. As discussed below, the

number of shots of schools as 'social problems' declined and the number of statements of community well-being increased.[4]

Date	1935	1936	1937	1938	1939	1940	1941	1942	1943	Total
School photos	42	79	74	177	292	436	351	1305	1711	4467

Some, but by no means all of the questions posed by gazing at FSA-OWI school pictures are answered by captions. Most shots cannot stand alone in the way that Lange's 'Migrant Mother' and Rothstein's 'Dust Storm' do.[5] Those images became a visual simulation of the Depression but with, perhaps, the exception of Shahn's 1935 photo 'Young cotton picker, Pulaski County, Arkansas. Schools for colored children do not open until January 1st so as not to interfere with cotton picking', none of the school photos has achieved iconic status. This is a good illustration of the relationship between image and caption since, while Shahn's pictures of Black children labouring in the field are compelling, the written caption is all that connects the photo to schools.[6] As Berger and Mohr wrote:

> In the relation between the photograph and words, the photograph begs for an interpretation, and the words usually supply it. The photograph, irrefutable as evidence but weak in meaning, is given a meaning by the words. And the words, which by themselves remain at the level of generalization are given specific authenticity by the irrefutability of the photograph. Together the two then become very powerful; an open question appears to have been fully answered. (Berger and Mohr 1982: 92)

There were two conditions under which the photos were taken, and neither constituted systematic visual research. Either they were made *en passant*, as it were, when FSA photographers happened to visit a community and made a few exposures of school as part of the documentation of a town, a 'day in the life', the condition of farm workers, and so on; or the school was an assignment and photographers spent a day or two conducting a sort of survey. This was the case, for instance, with documentation of the FSA-operated schools at farm workers' camps, and Philip Bonn's photo essay in Schenectady discussed below. In no case was there a concerted attempt to use the camera to study a school over time. Nor did the photographers seek to document education and its effects as did Frances Benjamin Johnston in her famous work at Hampton Institute and Washington D.C. schools (Daniel and Smock 1974; Johnston 1966).

In keeping with the social concerns of Liberal Documentary, FSA photos depicted/created ideal types. The notion that the subjects are 'types' rather than specific cases is bolstered by captions that almost never reveal names or details beyond location and approximate date. Photographs and captions represent 'overcrowded schools', 'new schools', 'Negro schools' and so on. Individual photographs and whole series are clearly meant to indicate general social conditions. Every photographer shot classrooms and school grounds, creating a sort of baseline that might best be called healthy American schools. Thus Post Wolcott's 1939 'Part of classroom with teacher, Prairie Farms, Alabama'[7] is one of a series showing an African American teacher working with her students. Russell Lee's series at the Lakeview Project, Arkansas in 1938 included 'The school glee club'.[8] In 1943 John Collier Jr. made a number of shots at schools in Questa and Trampas, New Mexico like 'Grade school'[9] featuring smiling healthy-looking 'Spanish-American' children and teachers. Rothstein left shots from 1939 of classes in Colorado including 'Scene in school room in community building. San Luis Valley Farms, Colorado'.[10] And John Vachon made pictures at a rural school in Georgia in 1938, like 'Playground scene, Irwinville School, Georgia'.[11]

A second 'type' depicted an explicit social problem: children working despite the child labour and mandatory attendance laws of the Progressive Era. Examples include two previously noted: Shahn's 'Young cotton picker', and Allison's 'the girls don't attend school because they're "too old . . .'".[12] Additionally, in 1940 Jack Delano recorded 'Children picking potatoes on a large farm near Caribou, Maine. Schools do not open until the potatoes are harvested';[13] and, in

1938, Rothstein noted 'Family from Italian section of Philadelphia working in cranberry bog. Only families with many children are employed. Children are kept out of school for more than two months of the school year. Burlington County, New Jersey.'[14] These are strong illustrations of how Liberal Documentary photography supported the New Deal argument for government intervention to ameliorate social conditions. In a revealing dialectical reversal, during the war children working was transformed from social problem to virtue. In 1942 John Collier made a series about boys from West Virginia who left high school to go to New York State to help with the harvest,[15] and a year later Marjory Collins made a photo captioned 'Buffalo, New York. Peter Grimm, age ten, waiting with his wagon outside Loblaw's grocery store for customers to ask him to deliver their groceries. This was a rainy day with few customers. Sometimes Peter makes as much as three dollars on a Saturday. He pays for all his school supplies and much of his clothing. His mother, a twenty-six year old widow, is a crane operator at Pratt and Letchworth.'[16]

A third ideal type includes poor shack-like schools with broken desks, and overcrowded classes, and perhaps a single teacher. Many of these schools were in the rural south including the Ozark and Appalachian Mountains. For example, Shahn's 1935 'Interior of Ozark school, Arkansas'; Mydans's 1936 'Interior of Mt. Gilead (colored) school on area of Plantation Piedmont agricultural demonstration project. Near Eatonton, Georgia'; Post Wolcott's 1940 'Overcrowded conditions in a rural school near Morehead, Kentucky'; Delano's 1941 'At the Veasey school for colored children. Greene County, Georgia'; and Russell Lee's 1939 'Old school in Akins, Oklahoma. This town was formerly a cotton ginning center as well as trading center for the surrounding farm community. There is no ginning done there now and it has assumed the status of a ghost town.'[17] In the case of African Americans, segregated and unequal schools were shown. For example in 1938 Post Wolcott made pictures of 'White school house, Chaplin, Scotts Run, West Virginia' and 'Negro school. Scotts Run, West Virginia.'[18] The contrast argues for improving schools and perhaps against a ruthless Jim Crow. However, the alternative was not integration but 'separate but equal'. Poverty schools as a type constituted a visual argument for modernization.

Two further ideal types offer solutions to the social problems of working children and poverty schools. One type shows progress in the construction of new schools and consolidation of rural schools. The second shows FSA schools operated explicitly as New Deal programmes to aid farm workers and migrants. I'll give examples of each in turn. In 1941 Delano photographed 'The old Saint Paul Negro school which will be closed as a result of consolidation into a new school. Near Siloam, Greene County, Georgia', and 'Oakland community, Greene County, Georgia (vicinity). One of the new schools for Negro children.'[19] The Oakland photo shows a brand-new modular building that looks like one of the so-called 'Rosenwald schools'. These one-story white frame buildings had distinctive windows making them easily recognizable. Thousands of schools for African Americans were built throughout the South with community money and matching funds from the Julius Rosenwald Foundation. Rosenwald was a liberal philanthropist who made his fortune at Sears, Roebuck and Company (Hanchett 1987). In Delano's shots we are presented at once with a social problem and its solution.

The FSA operated schools as part of the migrant workers' camps under its control and as might be expected these were well documented. Two hundred and ten records can be retrieved from the FSA-OWI collection with search terms 'FSA' and 'school', including Prairie Farms, Montgomery, Alabama in 1939; Caldwell, Idaho in 1941; Odell, Oregon in 1941; Weslaco, Harlingen, and Robstown, Texas in 1942; and Woodville, California also in 1942.[20] There are photos of cute kids, children at lunch, nap time, ball games, classroom work, and recess. FSA staffers photographed brand-new buildings, medical care, school plays and flag drills. They depicted/constructed a world of happy healthy workers' children under New Deal programmes that stands in stark contrast to the scenes of poverty and destitution photographed earlier. One can see how, as Allan Sekula famously declared, 'Photography constructs an imaginary world and passes it off as reality' (1983: 193). There are far more photographs of 'happy schools' than problem schools, leading viewers to conclude that the problem was being solved. Of course it

was not solved, and the wretched poverty schools had to be 'discovered' all over again in the 1960s by Michael Harrington (1963) in his book *The Other America*.

The war time ideal emphasized health, welfare, and patriotism. Well-to-do successful schools were photographed to show a wide range of activities: medical care, lunch, art, theatre, music, progressive educational techniques, and modern equipment. In 1943 Philip Bonn made more than 150 exposures in Schenectady, New York including 'Story reading time in the school library at the Elmer Avenue Elementary School'; 'Art class at the Oneida School'; and, 'Music class orchestra rehearsal at the Oneida School'.[21] This assignment encompassing several schools shows a prosperous and strong school system. We see students involved in academic extra-curricular activity. Philip Bonn photographed a deaf child in a mainstream classroom (the only child with a disability I found in the entire collection).[22] He made photos in libraries, lunch-rooms and home economics class; he recorded students following the war news on a radio to depict a thriving school system educating citizens for a modern industrial democracy.

Under the OWI patriotism was increasingly highlighted. Indicative of this shift is the fact that before 1942 there was only a single image of saluting the flag while eighteen shots of pledg-ing allegiance to the flag were taken in 1942–3 alone. Wartime activities involving school chil-dren were extensively documented: scrap drives collecting rubber, paper, and metal; buying victory bonds and stamps; learning first aid; singing patriotic songs in Spanish for radio broad-cast to Latin America; planting victory gardens; schools for refugee children; schools for chil-dren of working mothers, and so on.[23] The celebration of government programmes and community power become even more common:

Buffalo, New York. Lakeview nursery school for children of working mothers, operated by the Board of Education at a tuition fee of three dollars weekly. An eleven year old boy brings his young sister and brother to school at 6:30 a.m. and stays with them until school opens. Their mother goes to work at 6:00 a.m.[24]

Manpower, junior size. Junior commando spirits ran high when children of all creeds and colors sang together the national anthem. Roanoke, Virginia school children took the initia-tive in mobilizing the first intensified junior commando organization to collect scrap for America's fighting forces.[25]

New York, New York. Italian-American children buying stamps and bonds at Public School Eight on King Street from mothers who volunteer to guard doorways and perform other duties in schools under the school defense aid program.[26]

By 1942–3 images of poverty had all but disappeared. Schools are depicted as serving a vital war need, as an organic part of the community, and as generally modern. And yet this carefully constructed photographic image was more propaganda than reality. In America, local control and funding of schools produced rigid stratification on the basis of social class, urban or rural location, race and ethnicity. The FSA concentrated on rural schools. During the war progres-sive robust schools in mid-sized cities and new consolidated schools in rural areas came to stand for American education, although there is no doubt that if a photographer had sought the poor rural segregated schools photographed in 1935 they could easily be found in 1943 – indeed they exist today.

Stryker's project left out whole groups. Neither FSA nor OWI offered a rationale for photo-graphing elite schools like Andover, Boston Latin, or Phillips Exeter Academy. Children in special schools, deaf, blind, learning disabled, and convalescent were likewise not part of the imagined community. They did not document reform schools or even orphanages and homes for dependent children. Curiously photographers also ignored the government-run Indian boarding schools. These schools had been extensively photographed from the 1880s through the 1920s, but despite the fact that the father of FSA photographer John Collier served as Indian Commissioner under Roosevelt and began a 'New Deal for Indians' there are essentially no Indian school photographs in the FSA-OWI archive.[27] The exclusion of indigenous peoples

continued; except for ten shots from Puerto Rico, there were no school photographs from American possessions like Alaska and Hawaii. There are no photos of Asian Americans in school. There are a few shots in the archive of the relocation of Japanese Americans during the war but none show schools. However, the National Archives has many photos of relocation camp schools including Dorothea Lange's striking shot of Japanese-Americans' children on the day of evacuation. I find it ironic that on the very day Japanese-Americans' children were physically excluded from the community, they were for the first time photographically imagined as patriotic Americans.

Where once the FSA-OWI was the largest and most accessible archive, photos from historic collections, newspaper and magazine morgues, and vernacular sources have been digitized and are now similarly available. Hundreds of thousands of online photos add to, and in some cases contradict, the image manufactured by FSA-OWI. News and vernacular photos collected by history archives document schooling but were not documentary *per se*; they highlight the FSA-OWI as a specific genre. These pictures and captions provide different views of schools. As critics have noted, FSA-OWI photographers did not record social pathology, thus reform schools and juvenile delinquents remained invisible. In 1941 there was a scandal over corporal punishment at the Colorado state reform school, which was reported in the *Rocky Mountain News* with a photograph captioned 'Joseph Janoskowsky, in a pinstripe suit, displays leather straps used in dungeon floggings, during State Civil Service Commission hearings, State Industrial School, Golden, Jefferson County, Colorado' (Figure 19). The National Archives includes a 1940 'Study of Youth', one photograph having the caption:

> Roosevelt High School, Oakland, California. High School Youth. High school graduate who is unemployed and spends his time hanging around the school. All his energies are spent racing around the school in his cut-down, souped-up Ford, particularly during periods when there are students around to watch him, 05/04/1940.[28]

News photographs like Figure 19 reveal that the sorting and selecting mechanisms of school and documentary photography produced exclusion as well as community. African Americans were clearly imagined to be part, but a completely separate part of the American community. Although Russell Lee and others made pictures showing ethnic diversity,[29] I found no photos in the FSA-OWI collection depicting racial integration. The Junior Commandos from Roanoke, Virginia mentioned above is an interesting shoot

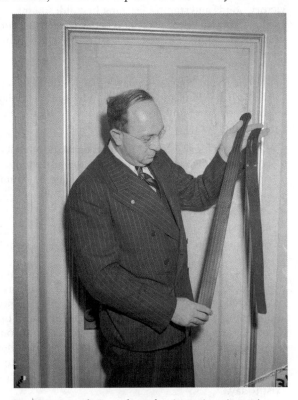

Fig. 19. Joseph Janoskowsky, in a pinstripe suit, displays leather straps used in dungeon floggings, during State Civil Service Commission hearings, State Industrial School (name changed in 1961 to Lookout Mountain School for Boys), Golden, Jefferson County, Colorado. Date: January 1941. Photographer Rocky Mountain News. Courtesy of Denver Public Library, Western History Collection, Call Number X-10085.

to examine by call number since, despite the caption 'children of all creeds and colors sang', Black and White children are not once seen in the same photograph. Yet there were integrated schools and classrooms in the Northeast and West. Perhaps the need not to alienate Southern Democrats during the New Deal kept government photographers from making any photos like Figure 20.

While the FSA-OWI was the first accessible archive, digital technology is rapidly expanding the universe of photos from every time period, including 1935–43. As other collections come on-line we come closer to the grand visual library envisioned by Oliver Wendell Holmes and Paul Vanderbilt. But that project is far more problematic than either of them imagined. If indeed every act of looking produces an expectation of meaning, what does it mean to look at a digital simulacrum, an imaginary community of Americans, constructed of millions of photographic images? Who is in and who is outside of this imagined community? Can our fundamental values – education, community, democracy – even be represented in this way? As Trachtenberg has explained, all filing schemes are blind to photographs, they are dependent on the connotative 'facts' in written texts – photographer, date, subject (Trachtenberg 1988: 54). My interest is in public grade schools, but unfortunately the FSA-OWI search engine does not allow Boolean operators like 'but' or 'not', severely limiting the utility of the archive. Examination of Marion Post Wolcott's entire shoot at

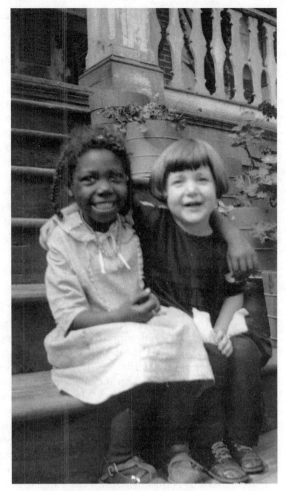

Fig. 20. *Children on porch*, probably in Colorado (1930–40). Photographer Harry Mellon Rhoads. Courtesy of Denver Public Library, Western History Collection, Call Number Rh-5387.

Bertha Hill, West Virginia in 1938 turned up additional photos of Mexican miners' children that did not happen to have the descriptor 'school' in the caption. It is essential to examine neighbouring negatives by number because there are large numbers of *untitled* photos that cannot be retrieved by descriptive searches, and photos missing the search term. Obviously the actual number of school photos in the collection may be several times the number retrieved. Many of the nearby negatives were 'killed' by project director Stryker who sometimes punched holes in the negatives or simply decided not to print them. Furthermore, FSA-OWI images were not 'coded' with 'controlled vocabularies' but rely on pre-existing captions (Arms 1999). For a revealing example that demonstrates the strengths and difficulties of using the system consider the problem of finding photographs of Latino students in public grade school. In the 1930s and 1940s neither the term 'Latino' nor 'Hispanic' was in use. As I have noted elsewhere, photographic archives reproduce 'historic amnesias, lapses and sins of omission, while continuing to overemphasize powerful, dominant and hegemonic structures' (Margolis 1999: 34). If we are

to use this resource effectively for new kinds of social research, we will have to grapple with these important issues.

In this essay I have offered a few suggestions for studying the FSA-OWI views of schools. Nearly seventy years ago, in thousands of shots from segregated southern shacks to well-equipped urban classrooms, teachers and students were posed or candidly photographed in everyday activities. Body language, facial expressions, clothes, tools, and the built environment are visible for our inspection. It seems as if we have a window into the past. But, viewers need to keep three warnings in mind: they are looking at photographs composed by persons having particular projects in mind, they are being exposed to constructed perspectives from a government-funded project, and photography is limited in what it can depict. Photos of schools are curiously one-dimensional. We have no idea what is being taught – or what was being learned. We cannot see how the teachers and students felt about their mutual endeavour, or what it meant to them. Community and education are multidimensional concepts that shrink when reduced to visual icons or ideal types which are often more suitable as propaganda than as insight. As I have suggested before, 'photography can capture the physical relationships of schools, but cannot make visible the social relationships of education: failure, intellectual excitement, oppression, resistance, or teaching/learning' (ibid.: 34–5).

Notes

1. The collection in searchable form is accessible at *http://lcweb2.loc.gov/pp/fsaquery.html*. As described by the Library of Congress, 'The collection encompasses the approximately 77,000 images made by photographers working in Stryker's unit as it existed in a succession of government agencies: the Resettlement Administration (RA, 1935–1937), the Farm Security Administration (FSA, 1937–1942), and the Office of War Information (OWI, 1942–1944). In addition, the collection includes photographs produced by other government agencies (e.g., the Office of Emergency Management) and collected from various non-government sources. In total, the collection consists of approximately 164,000 black-and-white film negatives, 107,000 black-and-white photographic prints, and 1,610 color transparencies . . . The core of the FSA-OWI Collection consists of approximately 164,000 black-and-white negatives, encompassing both negatives that were printed for FSA-OWI use and those that were not printed at the time ("killed" negatives)' (Library of Congress 2002).
2. Trachtenberg is quoting from Paul Vanderbilt's 'preliminary report' found in the Stryker papers.
3. Due to space limitations, I will not reproduce photos, only call numbers, but suggest readers use the search engine at *http://lcweb2.loc.gov/pp/fsaquery.html* to examine particular images and to explore the collection.
4. This is data which has not been cleaned. There is no handy way to separate dates like 1943 from lot number 1943 or other confounding numbers. It merely suggests the trend.
5. LC-USF34-009058-C and LC-USF34-004052.
6. The one exception is not actually a photo of school but Ben Shahn's 1935 series on cotton pickers in Pulaski County, Arkansas, see LC-USF33-006218-M5 and surrounding. Stott (1973) did not include any school photos, nor did Curtis (1989) in their histories of the FSA-OWI. Two shots are reproduced in Fleischhauer and Brannan (1988). Rothstein's 'School is out' from the Gees Bend, Alabama series. LC-USF34-025378-D and a Marjory Collins 1942 shot of a prosperous middle-class school in Lititz, Pennsylvania LC-USW3-011119-D.
7. LC-USF34-051760-D.
8. LC-USF34-031843-D.
9. LC-USW3-018139-E.
10. LC-USF34-028346-D.
11. LC-USF33-001144-M3.
12. LC-USF34-015791-E.

13. LC-USF34-041897-D.
14. LC-USF33-002911-M1.
15. LC-USF34-084055-E.
16. LC-USW3–026196-E.
17. LC-USF33-006090-M5; LC-USF34-006773; LC-USF34-055299-D; LC-USF34-046582-E; LC-USF34-033676-D.
18. LC-USF33-030142-M1 and LC-USF34-050049-E.
19. LC-USF34–044504-D; LC-USF34–046195-D.
20. LC-USF33-030322-M3; LC-USF34-039104-D; LC-USF34-070345-D; LC-USF33-003657-M3, LC-USF34-024760-D and LC-USF34-024957-D; LC-USF34-071624-D.
21. LC-USW3-033752-C; LC-USW3-033830-C; LC-USW3-033829-C.
22. LC-USW3-033736-C.
23. LC-USE6-D-010441, LC-USE6-D-007094; LC-USW3-013487-E, LC-USE6-D-010215; LC-USW3-000726-E; LC-USW3-009926-E; LC-USW3-042663-C; LC-USW3-009951-E; LC-USW3-028421-D.
24. LC-USW3-028421-D.
25. LC-USE6-D-006432.
26. LC-USW3-013969-E.
27. In 1936 Arthur Rothstein made a small series of photos of 'Pueblo Indians in the Indian Service School. Taos, New Mexico' cf. LC-USF34-002936-D. I have written on Indian school photographs elsewhere (see Margolis and Rowe 2002).
28. NWDNS-119-CAL-166.
29. For example, see Lee's 1942 shoot in San Leandro, California LC-USW3-001828-D.

Supporting Dictatorship in World War 2 News

'Flash From Brazil' – 1940s' Newsreels Present Latin America

PENNEE BENDER

The 1940s ushered in a period when Latin American music, dance, film stars and even cartoon characters inundated US movies and entertainment. Carmen Miranda sang and danced her way through Hollywood musicals. Xavier Cugat and his Latin band were radio and film stars. Young and old alike watched Donald Duck frolic with bathing beauties on Acapulco Beach and unite with cartoon characters from Mexico and Brazil in *Three Caballeros* (1945). And hundreds of newsreel stories and educational travelogues extolled the virtues and resources of Latin America to moviegoers around the world. Many of these images of Latin America were created or promoted by the US government through the Office of the Coordinator of Inter-American Affairs (OCIAA) under the direction of Nelson Rockefeller. The OCIAA Motion Picture Division worked with Hollywood studios, the five major newsreel companies, and educational documentary producers from 1940 to 1945. In its five-year existence, the division claimed to have influenced 288 feature films; assisted in the production and distribution of 1700 newsreel stories; presented 101 theatrical short subjects; and contracted for production and distribution of 722 16mm non-theatrical documentaries.

The newsreels, Hollywood movies, and educational films produced or influenced by the OCIAA during World War 2 helped US citizens redefine their national identity in relation to Latin America. The OCIAA used film to elicit domestic support for the Good Neighbor Policy, President Roosevelt's attempt to win Latin American support by replacing US military interventions with economic incentives and support for local military leaders. But the choice of subject matter and the presentation of Latin American leaders, the military, women, indigenous peoples, race and class differences, industrial development, and social welfare programmes went beyond concerns about wartime hemispheric solidarity. The films presented short- and long-term foreign policy goals and indicated how the OCIAA viewed the future role of the US in international affairs. The OCIAA's cultural programme represented a deliberate shift from the turn-of-the-century ideology as it created propaganda to re-form public notions of Latin America. As policy shifted away from US military interventions towards support of military dictators, the dominant portrayal of Latin Americans in the newsreels shifted from bandits and unruly masses to images of order and hierarchy. The promotion of Latin America as a stable US economic partner and the US as the major force in the development of a modern Latin America served as a prototype for increased US engagement in post-World War 2 international development.

By 1940, with the Nazi victories in Europe, and the loss of the European market for South American exports, the fear that Latin America would be the next target of fascist expansion spurred the US administration's interests in solidifying Latin American support for hemispheric defence. The OCIAA designed a propaganda programme to counter years of negative stereotypes about Latin America and sell the Good Neighbor Policy to the people of Latin America as well as the US. The agency viewed newsreels as key to its motion picture programme.

Newsreels were a popular source of news and information for Americans during the 1940s, reaching over 80 million viewers weekly as a standard feature in every first-run movie theatre. Despite public debate over newsreels' value as an information source, they offered audiences the rare opportunity to see and hear famous personalities, view events and locations from around the world, and share glimpses of sporting events. Like television news today, newsreels helped define the national culture during the 1940s, and both reflected and shaped politics, and social relations in the US. The newsreel portrayal of Latin America during World War 2 reveals the complex interactions between a government agency and the film industry and how US policy interests became visually encoded.

In 1935 at the age of 27, Nelson Rockefeller used his inheritance to purchase a significant interest in Creole Petroleum, a Standard Oil subsidiary in Venezuela. For the next five years Rockefeller was on Creole's Board of Directors. During the same period he gathered regularly with a small group of friends and advisors who called themselves 'the junta' to discuss Latin American political and economic issues, and develop ideas for social planning and economic development of the region.[1] In 1939, Rockefeller, with the help of his 'junta', drafted a memo outlining their ideas for a government agency to help stabilize Latin American economies and organize commercial and cultural relations. The memo discussed the importance of integrating US markets with Latin America and promoting cultural, educational, and scientific exchange. It also stressed the need for an organization separate from the State Department to promote cultural and commercial solidarity in the hemisphere in order to avoid association with the government and allow greater freedom and credibility in Latin America. In June 1940, Beardsley Ruml, a member of Nelson Rockefeller's junta and a New Deal advisor to President Roosevelt, introduced Rockefeller to Presidential aide Harry Hopkins. Rockefeller proposed this new agency. Hopkins took the proposal to the Roosevelt cabinet and after much wrangling between departments and personalities, President Roosevelt created the Office for Coordination of Commercial and Cultural Relations between the American Republics as part of the Council of National Defense on 16 August, 1940.

Prior to the bombing of Pearl Harbor the OCIAA was the only agency explicitly producing propaganda for the war effort. Its focus on Latin America spared it from the political liabilities associated with domestic propaganda, but from the start the OCIAA saw its mission as fostering a new popular image of Latin America through film, radio, the press and cultural programmes. According to its mission 'credo', the agency sought to convince US citizens that Latin America had much to offer the US economically, socially, aesthetically and spiritually and that Latin America's cooperation was essential to win the war, therefore Latin America should receive US assistance.[2] As a 10 December, 1940 opinion poll of US citizens illustrated, the OCIAA had a formidable task ahead. Asked to select from nineteen words those that best described the people of Central and South America, respondents from across the US expressed a largely negative image of Latin Americans by selecting quick-tempered (49 per cent), emotional (47 per cent), backward (44 per cent), and lazy (41 per cent) as the primary characteristics of the region.[3] The choices reflected many of the stereotypes that had been prevalent in US films since the 1910s and that the OCIAA sought to reverse through its massive propaganda campaign. The OCIAA's philosophy of utilizing private industry for all its programmes resulted in a motion picture propaganda campaign in which the business and creative forces within the US film industry would shape content as much as officials in the government.

In early 1941, the OCIAA began contracting with the major newsreel companies, all owned by Hollywood movie studios, for production of stories for Latin American release. Newsreel production budgets dictated that many of these stories would also be used in domestic releases. Newsreel companies found OCIAA production support particularly helpful as Axis-occupied Europe and Asia deported camera crews and banned exhibition of US newsreels. Government contracts allowed them to maintain staffing and production levels and expand their distribution in Latin America. The OCIAA argued that newsreels would acquaint the US public with inter-American defence activities, create an interest in these countries and people and help bring about 'international recognition of the fruition of the Good Neighbor Policy'.[4]

In 1941, they negotiated an 'experimental' arrangement with Hearst/MGM 'News of the Day' that was viewed as the beginnings of cooperative and systematic coverage of Latin America. 'News of the Day' agreed to send a camera crew to South America with travelling expenses provided by the OCIAA. The stories produced by this crew would appear under a special caption – 'Pan American News'.[5] 'News of the Day' selected one of its best known cameramen, Norman Alley, for the South American assignment. Alley had made headlines for his coverage of the bombing of the US gunboat Panay in Shanghai in 1938. He then had been assigned to the European war for most of 1940. The OCIAA hailed the agreement as an important symbol of the film industry's cooperation.[6]

Although the US Embassy assisted Alley in making contacts with Brazilian government officials and Alley negotiated sufficient access to President Vargas to film him during formal and informal events, the Brazilian military stonewalled him. It took six weeks for Alley to receive permission to film naval construction projects. He blamed the Brazilian government and Nazi influences in the military for his inability to shoot defence-related stories claiming the military was unwilling to expose its lack of preparedness.[7] After spending more than three months in Brazil, Alley travelled to Argentina where he faced even greater resistance in his attempts to portray Pan-American defence efforts.[8] A side trip to Uruguay also proved to be fruitless for Alley as he determined that while the country was very 'Pan-American minded' it had 'nothing to offer in the way of news pictures'.[9]

The 'News of the Day' cameraman's stories reflected his lack of fluency in Portuguese (or Spanish) and his limited access and understanding of Brazil. Alley adopted a travelogue approach filming mostly human interest or travel subjects. 'Artists Lured by Rio's Beauty' began with images of artists painting as a thin excuse to string together scenic shots of Rio's beaches and mountains. 'Carnival Time in Gay Rio' mixed women samba dancers and bathing beauty contestants with Hollywood-style generic Latin music and narration that stressed the 'South American way' and 'South American charm', with no specifics about Carnival in Rio. In these two stories and a longer one on Carnival, 'Revelry Rules Gay Rio', white middle-class Brazilians dominated the visuals and neither the shots of dancing crowds nor the narration gave an inkling of the large presence of Afro-Brazilians or their significant influence in Carnival and samba.[10] Visual emphasis was on exotic dancing or 'bathing beauty' women posing or performing for the camera. Alley's travelogue stories reduced Brazil to scenic locations, exotic women and colourful events, and contained minimal cultural or social information.

The Paramount and Universal cameramen supported by the OCIAA did not experience the same difficulties as Alley in filming hemispheric defence efforts. Paramount agreed to assign one of their leading cameramen, John Dored, to Rio de Janeiro. As Variety noted, 'Par[amount] will revamp its whole South American service in developing the good-neighbor policy for the company' (Variety, 12 March, 1941). Dored was a veteran war correspondent for Paramount who had covered the invasion of Poland and the Nazi campaign in the Balkans. A freelance cameraman, William Burton Larsen, who often supplied Pathé and Universal News, was stationed in Santiago, Chile. From April 1941 to December 1941 Paramount released eight stories on Brazilian war efforts and Universal issued five such stories. In 1942, the OCIAA's Newsreel Division worked with the newsreel companies to set up a pooling or cost-sharing plan for ongoing Latin American coverage. Under the OCIAA agreement, all the newsreel companies would share footage shot by Dored and Larsen. OCIAA would pay for one-half of the expenses of these crews while the five companies would cover the remaining expenses. The OCIAA also assisted the newsreels by providing high-priority air freight expenses for shipping exposed footage to New York City, where it was processed, edited, and shared by the five companies (Rowland 1947: 74–6).

The stationing of OCIAA-funded cameramen in Latin America allowed the OCIAA greater control over some aspects of newsreel coverage, but several releases indicate how little control the Office had over the final product. Throughout 1942, domestic newsreels contained many stories the OCIAA listed as priority topics and used footage by OCIAA-supported camera crews. The OCIAA-initiated stories generally focused on Latin American defence efforts or

Latin American support for the war such as the 24 August, 1942 Universal News lead story on Brazil's declaration of war for which OCIAA supplied footage and direction. This story was considerably longer than most and the narration contained detailed information about Brazil, its army, navy, and munitions industry and ended with the comradely sign-off 'We welcome our Brazilian brothers-in-arms!'[11] Even though the story used generic shots of anti-Axis demonstrations, the Nazi embassy, munitions plants, and troops, it closely followed OCIAA directives and offered a more sophisticated and respectful view of Brazil than the 'News of the Day' stories. Six months' later, however, Universal's 'Brazil, Too Feels War Pinch' followed newsreel traditions rather than OCIAA directives and presented a different message. The OCIAA supplied the story idea and suggested the narration: 'The two-wheelers are having their day. Heretofore the Brazilians never went in for bicycles. Auto traffic was too heavy and bicycles were considered dangerous. . .'[12] Yet the narration on the released story altered the facts and took on a condescending tone:

> The people of our good neighbor to the South have quickly adapted themselves to the hardships and inconveniences of war, the stoppage of all private cars has been accepted cheerfully by a bicycle-loving race. They get around, even if it does mean that all public transportation is further overtaxed. All this overcrowding is looked upon as just another contribution to the war effort. These Brazilians would ride on the roof if it meant help in winning the war. They're always cheerful about it all. Their philosophy is just give me toe room amigo, and I'll reach my job.[13]

The flip tone and emphasis on cheerful acceptance of hardship were common in newsreels of the period, but did not present a dignified or accurate portrait of Brazilians. The scripts provided by the OCIAA often mimicked the newsreel style, but were fact-filled and very careful to be culturally specific in their descriptions of Latin American countries. Despite OCIAA efforts to influence newsreel images and narration, the newsreels continued to present generic, travelogue images of exotic locations associated with sexual desire and demeaning stereotypes throughout the war years.

The hundreds of newsreel stories focusing on Latin America between 1940 and 1945 generally fell into several standard news categories. By far the most numerous were stories on the war effort and how Latin American nations either supported the war or were affected by it. Political stories that covered visiting dignitaries, elections or overthrows of government were the second most prevalent, followed by stories on Pan-American solidarity such as Mexican-born soldiers fighting with US troops or Eleanor Roosevelt greeting South American girl scouts. Newsreel stories also highlighted economic ties between the US and Latin America and human-interest stories such as religious festivals, or carnival. Latin American sports (most often horse racing); fashion shows; visiting US celebrities, especially movie moguls and stars; and the standard disasters – volcanoes, train wrecks, and earthquakes – appeared on a regular basis. Within these broad news categories, the stories offered recurring visual themes, and subtle messages that are best illuminated by analysis of individual stories – those directly influenced by the OCIAA as well as the regular coverage of events.

Several visual and narrative motifs appeared in many of the Latin American newsreel stories – some continued earlier stereotypes of the region, while others forged a new image of Latin America as a stable and trustworthy partner. From the 1910s through the 1930s Hollywood films had provided Americans with a steady stream of stereotypical images of Latinos as greasers, bandits, revolutionaries and Latin lovers.[14] These stereotypes were essential to the Western genre and provided the most prominent ethnic characters in early Hollywood movies. 1920s' newsreels often followed these Hollywood traditions by presenting events in Latin America as chaotic and Latin Americans as emotional and violent at best or more likely, as bandits, revolutionaries or primitive natives. In the 1940s, these stereotypes continued with the 'rioting masses' motif that visually accompanied stories on elections or coups. Stories covering Mexican elections in 1940, the attempted overthrow of Cuba's military ruler, Batista, in 1941,

and the Argentine coup in 1944 used numerous wide-angle shots of crowds demonstrating, destroying property, or fighting and portrayed only the violence, not the broader political or economic issues. A number of Paramount News releases focused on chaotic demonstrations and 'wild clashes'[15] with no images of individuals or opposition leaders. The images and narration re-enforced the 'hot blooded', 'volatile' stereotype of Latin America. With the exception of Argentina in 1944, the nature of politics or political rulers was not examined in any of the newsreel stories.

In contrast to the turmoil and violence of the 'rioting masses', under OCIAA tutelage the newsreels regularly presented the image of political stability in the form of parading masses, either workers or military, intercut with political leaders waving from a balcony. Independence celebrations in Brazil, Chile, Mexico and Argentina as well as presidential inaugurations and Labor Day parades that included prominent military displays became mainstays of 1940s' newsreels. Along with having the advantage of being predictable stories that could be scheduled in advance and provide generic but moving images, these stories fulfilled the dual mandate of the OCIAA to express sincere US interest in Latin America, and to expose US audiences to Latin American society. However, the newsreels' visual presentation reduced Latin American politics and society to images of orderly hierarchy and mass acceptance of the ruling power. The narration emphasized that the region was not allied with the Axis nations and had traditions of freedom, but provided no information about the current political process or the prevalence of military dictators in the region. The images from Brazil, Mexico, Dominican Republic, or Chile were all strikingly similar. Newsreel cameramen photographed the crowds from medium-wide perspectives so individual faces were not visible and the people vied with banners, flags, or placards for dominance in the frame. On the other hand, political leaders were presented in medium close-up, often from a low angle and framed within the frame by architectural details from the building behind, thus reinforcing the impression of power and stability. These images presented a visual code of mass support for Latin American rulers along with a sense of order and hierarchy that is rarely replicated in stories about the US political process or US democracy. This visually implicit support for the ruling order mirrored US government support for dictators in Latin America despite their political ties to fascism.

During the 1940s, the State Department and the US business community with Latin American investments preferred the stable, orderly governments offered by military dictators in at least fifteen Latin American nations (Schmitz 1999: 46–84). Since the early 1930s, support for military dictators and national military power allowed the US to avoid military intervention and was a useful strategy under the Good Neighbor Policy. However, with the rise of German and Italian fascism in the late 1930s, the US government was caught in a bind. Its reliance on the local military to maintain order in Latin America resulted in authoritarian leaders who were sympathetic to Nazi ideology, and who often had received aid or training from Germany. Yet as the war intensified in Europe, US national security concerns required that Latin American military establishments side with the US. This situation forced the Roosevelt administration to revise the Good Neighbor Policy and to increase its military support in the form of training and advisors.[16]

Although the narration and inter-titles are crucial to comprehending newsreel stories, it is often the juxtaposition of text and image that made points or revealed attitudes and stereotypes of Latin America. In the Paramount News story on Army Day in Guatemala the juxtaposition of narration and marching soldiers ridiculed Latin Americans. The narration intoned, 'all the Guatemalan military is honoring a Mexican official' over images that included young boys marching with toy guns and 'reserves in colorful uniforms' showing soldiers in traditional Mayan dress. In another Paramount story, 'Flash from Brazil', a high-society horse race served as a backdrop for a story on 'South American Styles' in women's fashion. While the images cut from one startled and unsuspecting woman to another, all wearing prominent hats, the commentator ironically referred to 'high fashion' in Rio. Compared to most newsreel fashion stories that featured professional models and well-rehearsed visual presentations, this story was an unflattering approach that mocked Brazil's 'fashionable' upper-class women.[17] These stories

openly poked fun at Latin Americans and highlight the newsreels' one-dimensional presentation of the region.

In May 1941, the OCIAA contracted with *The March of Time* to produce two or three releases on Latin America and to provide the OCIAA with footage to produce its own non-theatrical documentaries.[18] *The March of Time* releases followed a significantly different format than regular newsreels. Created in 1935 by Time/Life, *The March of Time* blurred the lines between fiction and news by including re-enactments of news events. By 1938, *The March of Time* had rejected the standard newsreel format of six to ten stories totalling ten minutes issued twice weekly and decided to cover one topic for up to twenty minutes each month. *The March of Time* also eschewed breaking news topics for more interpretive and detailed coverage of a subject. And unlike the newsreels, which avoided controversy, *The March of Time* sought provocative subjects and courted controversy by presenting a partisan position. Despite these differences, Time, Inc. marketed *The March of Time* as a newsreel and it followed enough newsreel traditions to be regarded as such by most viewers.

The two *March of Time* releases on Latin America openly dealt with politics and addressed some of the more controversial issues in inter-American relations. In addition, 'The Argentine Question', released in early 1942, gave a major portion of the voice-over to an Argentine voice. The two releases closely followed the OCIAA directives of stressing inter-American unity and shared political and cultural values. 'The Argentine Question' consisted of three distinct sections. The first had the signature Westbrook Van Voorhis voice-over narration strongly defending Argentina's choice to remain neutral and 'guid[e] its own destiny in a world at war'.[19] The narration stressed that the Argentine leaders and the population supported democracies and opposed the Nazis. Unlike the other newsreel portrayals of Latin American politics 'The Argentine Question' presented strong images of Argentine politicians as professionals attending meetings, reviewing papers, and speaking before Congress. The lighting, framing, and pacing of the visuals, as well as the voice-over narration, presented the politicians as modern, effective and highly respectable.

The second section argued the case for Argentine neutrality. An unidentified, but Spanish-accented voice took over the narration and provided a general portrait of Argentina. Beginning with urban life, the narration and visuals emphasized modern buildings, busy streets, large homes, mechanized factories, and US companies such as Swift and Armour. The voice-over noted Argentina's economic and cultural ties to Europe and argued that its middle-class citizens hoped to maintain their comfortable life and let the war pass them by. This section delineated the class structure and its relation to political power in Argentina. The narration acknowledged the political clout of the wealthy, conservative, landowning class and visually took a political stance by portraying the wealthy landowners as the idle rich, lounging on a great lawn and playing with hunting rifles. In contrast, the working-class gauchos were described as 'without voice in Argentine politics' and romanticized as folkloric, playing guitars and dancing. The Argentine voice ended the section by calling attention to resentment over the US ban of Argentine beef and appealing for an end to the 'hard feelings between nations and neighbors'.[20] Throughout the visuals served as illustration to a driving narration, but the high production values, the close-up images of workers' faces, dramatic composition within each frame, and flowing movement within and between shots was striking and allowed for easy identification with the Argentine people as modern and dynamic.

A title card introduced the final section focusing on Argentina's commitment to remain neutral, yet to uphold Pan-American unity. In this short coda to the story, the Van Voorhis narration advised Argentina that neutrality may not be a realistic option, but couched this message as the growing realization of many Argentines. Over close-up images of Argentine troops, and accompanied by an upbeat march, the voice-over warned: 'the thoughtful Argentine knows . . . that the time has come when every nation must make its final and inescapable choice in this great world struggle. A choice between despotism or democracy. Time marches on.'[21]

The programme skilfully defended Argentina's neutrality while simultaneously calling for it to take sides, and raised issues of hemispheric tensions while stressing continued unity. The first

and last sections went beyond the reporting of Argentina's neutral position to plea for tolerance by the US and to appeal to the Argentine military to abandon neutrality. The middle section, with its first person voice-over, extensive use of close-up images of modern urbanites, factory workers, artists, students, and professionals, closely followed OCIAA directives by visually stressing similarities to the US and promoting identification with the Argentine people.

Two years after 'The Argentine Question' and shortly after the military coup in Argentina, *The March of Time* released 'South American Front – 1944'. With the rise of Juan Domingo Perón in Argentina, this release reversed its pro-Argentine position, and contrasted the new situation in Argentina with a glowing portrait of Brazil's war effort, to make an explicit comparison between a failure of the Good Neighbor Policy and a success story.[22] Using much of the same footage as 'The Argentine Question', the first two and half minutes of 'South American Front – 1944' attacked the new military dictatorship in Argentina. The programme was particularly critical of the large landowners. The same footage of wealthy men playing with rifles from the earlier release was now combined with narration about the landowners' anti-US stance giving the images a sinister edge. The Argentina sequence closed by introducing the US policy, debate on events in Argentina. Secretary of State Cordell Hull described the new government as a setback to the Good Neighbor Policy as well as to the work of the OCIAA, while Senator Hugh Butler attacked US expenditures in Latin America and called for an end to the US as the 'rich uncle'.[23]

The attack on Perón's rise to power was immediately followed by a highly laudatory sequence on Brazil that far outweighed the ominous events in Argentina and directly countered Senator Butler's position. *The March of Time* producers opened the second section with a travelogue presentation of the beauty, glamour, and strategic importance of Brazil, then raised and dismissed the issue of President Getúlio Vargas as dictator stating that his rule was 'a benevolent, personal dictatorship' with popular support.[24] The images reinforced the positive interpretation of Vargas and his military supporters. Vargas, as the 'good' dictator, was shown wearing a business suit, not a uniform, and in intimate conversation with an aide, smiling, nodding, and laughing to the accompaniment of flowery classical music. Likewise the military officers were shot at a formal dinner, no marching troops or menacing weapons, just men eating, talking, smiling, and laughing with one another. Elegant dining scenes were a common newsreel trope for presenting celebrity, wealth, and power. After dispelling the 'liberal' argument against Vargas, the programme went on to present the OCIAA programmes in Brazil highlighting advances in education, public health, and sanitation without mentioning that the programmes were sponsored by OCIAA. The last section focused on Brazil's contribution to the war effort through natural resources as well as troops. Throughout the programme, Brazilian officials were individually introduced both visually and by name. This level of attention to foreign ministers is unusual for US newsreels, but clearly would have pleased the Brazilian government. The film covered all the OCIAA's main objectives and shamelessly promoted OCIAA's programmes in Brazil. The visuals supported OCIAA goals through close-up shots of workers, professionals, and students, and dramatically framed images of industry and modernization that underscored similarities between Brazil and the US.

The OCIAA considered the Newsreel Program a great success, with over 1700 newsreel stories about Latin America and its war efforts reaching US and Latin American audiences. But OCIAA did not acknowledge many of the drawbacks of the newsreel form. The production style and attitudes of newsreel producers limited the quality of the content. The newsreels' formulaic stories, based on little or no original investigation and created by cameramen, news editors, and writers who had very little knowledge about Latin America resulted in superficial presentations and occasionally stories that ridiculed Latin Americans. Stories of one to two minutes in length accompanied by melodramatic narration or following travelogue conventions worked against providing substantial cultural awareness of Latin America. Overall newsreel story selection and narration conveyed a few simple messages. They stressed the natural beauty and cultural attractions of the region, Latin American contributions to the war effort, the hierarchical structure of political power, and the region's admiration of US leaders, fashion, and

culture. These points followed OCIAA objectives even as they continued stereotypical and simplistic portraits of Latin America.

In addition to these explicit points, the newsreels often conveyed implicit messages through their narrative form and visual motifs. Newsreels had long relied on a limited repertoire of visual motifs that offered a sense of action combined with exoticism such as marching soldiers, parades, and rioting crowds. The prominence of images of military order and social hierarchy in the Latin American stories reflected US policy objectives of maintaining order and military alliance at whatever cost. The travelogue style of many of the sports and fashion stories, as well as feature pieces by Alley and others emphasized the passivity of Latin America in contrast to the active role of the US cameraman and viewer. These stories cast the viewer as consumer and Latin American nations as static and often sexualized objects to be viewed or consumed. Visual emphasis was on scenic locations, exotic events, and 'colourful' people presented to please the viewer. These stories purported to represent Latin American culture, but only as it related to the interests of US viewers. *The March of Time* more closely followed OCIAA directives and philosophy and offered a far broader range of images of Latin America, more close-ups of people from a range of social classes, more images of urban and rural landscapes, and occasional sync sound. Unlike the studio newsreels, these programmes directly raised issues of class divisions, concentrated political power, and the role of the military in Latin America. But in the end the messages they conveyed were similar to the newsreels – they largely reassured US audiences that Latin America was loyal to the US, highlighted US development programmes in Latin America, and focused on US policy issues

The newsreels propaganda programme tried to merge OCIAA policy, Hollywood studio economic interests, time pressured production schedules, and standard newsreel reporting formats. It proved to be a messy process that only partially fulfilled the stated goals of the OCIAA. The newsreels avoided events or stories that showed political or social movements contrary to US diplomatic or economic interests and presented most nations mainly as loyal foot soldiers in the anti-Axis cause. The newsreel images supported acceptance of militarization and dictators as the norm and as the symbol of order and stability in the region. Overall the OCIAA films represented a shift away from portraying the region as in need of US control or military interventions, towards images and stories that portrayed positive images of hierarchical rule, expressed Latin American acceptance of US military aid, and US economic development solutions. All issues that would dominate US postwar foreign policy goals for the region.

Notes

1. Members of this group included Beardsley Ruml, director of the Spelman Fund, an executive with R. H. Macy's department store, and an advisor on the National Resources Planning Board; Jay Crane, the Treasurer of Standard Oil of New Jersey; Wallace Harrison, an architect and long-time friend of Nelson Rockefeller; Hugh Robertson, the manager of Rockefeller Center; Robert Hutchins, president of University of Chicago; William Benton, an advertising executive; and Joseph Rovensky, vice-president of the foreign department of Chase National Bank. See Reich 1996: 165.
2. 'Philosophy and Organization of the Office of the Coordinator of Inter-American Affairs', undated document, Rockefeller Archive Center (RAC), Rockefeller Family Archives (RFA), RG 4, Washington Files, CIAA Box 8, Folder 61, pp. 1–5.
3. Respondents could pick as many terms as they felt appropriate, so the percentages add up to more than 100 (Johnson 1980: 18).
4. Memorandum, 26 June, 1942; To Wallace Harrison; From Francis Alstock; Subject: The objective of the Motion Picture Division. p. 1 National Archives and Records Administration (NARA), RG 229, E-1 Central Files, Box 207 and Project Authorization, Inter-American Conference Newsreel, 1/42, NARA, RG 229, E-1 Central Files, 3. Information – Motion Pictures, Newsreels, Box 217, Folder: Inter-American Newsreels.

5. Executive Committee Meeting Minutes, 1/15/41, NARA RG 229, E1-Central Files 4. Administration Organization, Box 435, folder Motion Pictures, pp. 2–3.
6. Press Release 14, 14 January, 1941, RAC, Family Archive, NAR, Washington Files, CIAA, Box 8. Folder 67, p. 2.
7. Letter from E. B. Hatrick, Vice-President and General Manager of Hearst Metrotone News to John Hay Whitney, 6 August, 1941 that contains extensive quotes from Norman Alley's letters and reports. NARA, RG 229 Central Files, Information – Motion Pictures, Newsreels Box 217 Folder Pan American Newsreel, 'News of the Day'.
8. Alley quoted in a letter from E. B. Hatrick of 'News of the Day' to John Hay Whitney of the Motion Picture Division of OCIAA, 6 August, 1941. NARA, RG 229 E-1Central Files – Information-Motion Pictures Box 217 Folder, Pan Am Newsreel – 'News of the Day', p. 3.
9. Ibid.
10. 'News of the Day' newsreels by Hearst/MGM are available at the UCLA Film and video Archive, Los Angeles, CA.
11. NARA, Universal New Collection, Box 126, V. 15, no. 113.
12. 'War Time in Rio – Suggested Commentary' NARA, Universal News Collection, Box 131, V. 16, no. 163.
13. Universal News scripts, NARA, Universal News Collection, Box 131, V. 16, no. 163.
14. In the 1910s, the Mexican 'greaser' was a regular villain in Westerns, later replaced by the Mexican 'bandit'. In contrast to the role of villain, the 'Latin lover' was another typical Latin image as represented by Rudolph Valentino and Ramon Navarro. In 1919, movie producers and the State Department received complaints from the Mexican government about Mexican characters and settings that emphasized squalor and violence. Then in 1922, the Mexican government banned all films by any company that produced a film with unfavourable images of Mexicans. Panama followed with even stricter regulations. Hollywood's response was to shift locations to other Latin American countries, especially Argentina and Brazil. In 1931, the Brazilian and Cuban governments protested the portrayal of national characters and threatened to ban all films of the offending studios. These protests spread to Nicaragua and became a topic of discussion at the 1936 Pan American Conference in Buenos Aires (see Richard 1993: x; Woll 1977: 16–19, 33–4).
15. Paramount News release sheet 1940, Issue no. 91 '47 Die in Mexican Election Riots', Paramount News Collection, Sherman Grinberg Archive – Release Sheets.
16. In 1938, the US had only five military missions and less than 25 military advisors active in Latin America. By the end of 1941, every Latin American nation had a military mission and the number of army, navy, and air force advisors had grown to over 100 (see Haines 1977: V.1).
17. Paramount Issue 93 7/18/42, 'Guatemala's Army Day' and Paramount Issue 101, August 1941, 'South American Styles', Sherman Grinberg Archive.
18. Project Authorization, *March of Time*, May 1941, NARA RG 229, E-1 Central Files, 3 Motion Pictures/ Newsreels Box 217.
19. Voice-over narration for 'The Argentine Question', 1942 *The March of Time* Vol. 8, Issue 7; March, 1942. Available on New Line Home Video *The March of Time: America at War – Friend and Foe Part 1*.
20. Ibid.
21. Ibid.
22. *The March of Time*, 'South American Front – 1944' Vol. 10, 8, March 1944. Available on New Line Home Video *The March of Time: America at War – Friend and Foe Part 2*. The inter-title between the Argentina story and the Brazil story reads: 'Though Argentina is today the example of failure in the Good Neighbor Policy, US relations with Brazil have shown steady progress in the right direction.'
23. Ibid.
24. Ibid.

The Emergence of TV as a New Mass Medium

The Birth of American Televisual Spectatorship

CAT CELEBREZZE

Why do people watch television when so much of it is so bad? This question, which underlies debates regarding the political and cultural character of television, is invariably answered in a causal, circular fashion. People watch television, it is argued, because it is dominated by sensationalist programming that watchers are either powerless or indifferent to resist. Inversely, it is claimed that the television industry creates sensationalist programming because such fare consistently gets the ratings. This type of causal explanation reduces the televisual universe to the singularities of watcher indifference or industry hegemony. While these are real aspects of television's cultural character, positing watcher indifference and industry hegemony as television's sum and substance dismisses television outright as a media anathema to representation and communication. Though an appealing argument to students of media criticism, such a dismissal naturalizes something that is historical, contingent, and central to debates regarding television: the fact of watchers.

Instead of reifying watchers and reducing them to passive spectators, this essay examines the internal logic of watching and the historical emergence of watchers within the United States during the late 1940s and early 1950s, the period during which television became, statistically speaking, a mass medium. The purpose of the essay is to investigate the contingent foundations of television watching in the United States. Although it is easy to take for granted the longstanding, problematic existence of television watchers and mass reception, the notion that television watching is *sui generis* sacrifices historical questions that are also relevant to current understandings of television and its cultural character within the United States. How, exactly, is watching television different from other forms of watching? How did this visual form emerge, historically, within an American context? What aspects of television watching exist, beyond the methodological, philosophical and political horizons imposed by the concepts of spectacle and representation – concepts that tend to de-emphasize or ignore the interaction of the watcher with television as a visual culture?

As a social activity, televisual spectatorship is dependent on a distinct visual practice called monitoring. From the Latin term, *monere*, meaning 'to warn', monitoring is the watching action of an overseer or 'one that warns'. Produced by television's unique configuration of time and space, TV monitoring differs from other forms of watching because it requires the active participation of the watcher, who must 'oversee' and constantly shift back and forth between radically distinct 'grammars' of space: electronically scanned space and domestic space, public space and private space, mediated electronic space and immediate physical space. But more than shifting between televisual space and non-televisual space, monitoring also requires the watcher to be able to shift between different televisual spaces. As Paolo Carpignano points out, 'In countless situations we are presented with a series of spatial references, where the weatherman will point to and show the weather outside, the anchor of a news programme will turn to the

reporter in the field, and the control tower will dialogue with the astronaut in space' (Carpignano 1997: online). TV monitoring, then, requires a capacity for 'spatial switching' on the part of watchers.[1]

Monitoring also requires a type of temporal switching. Optically, monitoring is possible because of the retina's capacity to retain the light reflected off an object for a full tenth of a second, whether the object remains visible or not – what is called 'persistence of vision'. Sociologically, monitoring may involve, for example, shifts between the short time intervals of commercials and the longer temporal sequence of programmes. Technically, monitoring requires the watchers to experience the relay of television transmission as 'real time'. Defined by the temporal relay of transmission, electronic images are cognitively absorbed as if they were received from the source instantaneously and without interval – a type of 'persistence of memory'. The act of monitoring involves novel cognitive processes distinct from the skills required for the linear, abstract experience of reading, or those inherent to the closed temporality of cinematic experience.

The novel cognitive processes involved in TV monitoring are not, however, experienced uniformly. Rather, the unique temporal and spatial switching demanded from watchers while monitoring depends on the type of electronic image encountered while watching. In his influential work on cinema, Gilles Deleuze gives a detailed typology of images that cinema affords the viewer in relation to time and space that can also be used to describe the electronic images that watchers encounter through monitoring television (Deleuze 1997a; 1997b).[2] In Deleuze's schema, images are of two types: movement-images and time-images. The key difference between these two types of images resides in the watcher's relationship to time while monitoring television. When watching movement-images, the watcher encounters the passage of time solely through action unfolding on the screen in a linear fashion. In other words, movement-images reduce time to what Deleuze calls 'sensory motor situations' (Deleuze 1997a): action with a beginning, a middle, and an end. As David Rodowick explains, 'time is measured only dynamically, as a process of action and reaction rebounding across contiguous spaces' (Rodowick 1997: 3–4). While watching movement-images, the watcher relates to a temporal universe outside their own – a predictable and chronologically unfolding temporal universe. As such, movement-images are pivotal to the formulas of American broadcasting staples like sitcoms and soap operas. When monitoring the movement-image, monitoring is a habit, in that monitoring is automatic, pre-established and secondary – indeed sublimated – to that of the movement-image and its reduction of time to action unfolding in screen space.

In contrast, the time-image is unhinged from 'rational' sequencing of movement and 'reveals or makes visible the hidden ground of time' (Deleuze 1997b). With time-images, 'time is no longer reduced to the thread of chronology, where past, present and future are aligned on a continuum' (Rodowick 1997: 4). Freed from the cliché of beginning, middle, and end, the time-image allows watchers to relate to time via pure sound and optical situations. 'Time no longer derives from movement, [rather,] "aberrant" or eccentric movement derives from time' (Rodowick 1997: 5). While watching time-images, watchers encounter the unpredictable character of a temporal universe that bears directly and simultaneously on the watcher's past, present, and future. The time-image allows the watcher to encounter a simultaneity between 'event-watching' and 'event-happening'. As such, time-images are pivotal to American broadcasting staples like live news and sports coverage. With time-images, monitoring is experienced as an event (rather than a representation), in that those monitoring are directly tied to the time and space of the time-image taking place – a 'double-becoming' of both those that monitor and that which is being monitored.

Historically, movement-images were the dominant form of early broadcasting. News segments had a beginning-middle-end format and simply featured a man reading reports – truly 'radio with pictures'. Live entertainment, whether *The Milton Berle Show* or the local variety shows exteriorized the watcher and exhibited time narratively through what Saul Carson of the *New Republic* describes as 'a series of corny acts and amateurish singing that would not pass muster at a grammar school graduation' (quoted in Kisselhoff 1995: 87). Time-images could

only be encountered if something went wrong during a broadcast or in specific TV genres such as sports coverage. The dominance of movement-images in early broadcasting was the product of a belief held by many in the early television industry – most notably CBS's President William Paley – that television was simply an extension of cinema. Because industry leaders predicted that 'the success of television will depend to a large measure on the ability of television stations to acquire the best available films' ('FCC Bids Hollywood End Feud' 1951: 1), early TV monitoring was shaped primarily by cinema time:

> Film had long been dominated by its own kind of time, made by splices in the editing room. The final tempo and rhythm were generally created not by an actor, nor by actors interacting, but by an editor and the director working with him. The possibilities of this kind of control had led to production methods in which films were shot in fragments – often as short as two or three seconds. A feature film might consist of seven or eight hundred shots. The manipulation of 'film time' offered creative pleasures so beguiling to film makers that they had virtually abolished 'real time' from the screen. (Barnouw 1982: 160–61)

Determined by cinema time, early TV monitoring did not involve events for which the outcome was still in doubt, i.e. time-images. With television-as-cinema, the watcher encountered movement-images created from edited representational narratives, fixed in celluloid, 'frozen out of the past and projected in the present', effectively separating the watcher from the temporal universe of the event. As such, the monitoring of movement-images worked 'to disguise and suspend the passage of time' (Doherty 1998: 359–74) and to exteriorize the watcher from the narrative.

As the domain of movement-images and cinema time, early television was not taken very seriously, since entrenched film industry interests openly opposed having their films or their talent broadcast for free on television.[3] Due to this, stations had three relatively ineffectual broadcasting choices for replicating the movie theatre experience at home: low budget films contracted from smaller production companies, kinescope recordings of live performances, or live theatre. With their cheap production, low budget movies were meagre substitutes for the aesthetic experience and suspension of disbelief encountered in big-screen Hollywood epics. As a second option, kinescopes were also unsatisfactory. Made by filming a programme from a television monitor, kinescopes produced a distorted and murky picture. Although efforts were made to improve kinescopes 'to the point where recordings made under certain controlled conditions are now considered acceptable in the same sense as radio transcriptions' (UNESCO 1953: 75), their grainy recorded quality could not compare with the movie-going experience. Although broadcasting live theatre edged towards the vision of television-as-cinema, it too was problematic. In order to maintain the illusion and integrity of physical theatrical space, camera crews had to operate with one stationary camera, making wide shots the norm. Without the benefit of close-ups and multiple camera work, the monitoring of theatrical performances on television entailed nothing like the excitement of seeing *Gone with the Wind* or *The Wizard of Oz* at the movies.

Extending cinema's closed spectacle-driven temporality to television without the benefit of either the cinematic environment – large numbers of spectators, dramatic lighting, public space, and so on – or the film industry's approval, meant that TV monitoring was a less enjoyable imitation of, and a paltry substitution for, cinematic spectatorship. This mismeasure between monitoring television-as-cinema and cinematic spectatorship itself left television a potent, but underdeveloped, medium. As a result, the monitoring of television seemed an interesting though inconsequential social activity to many. In addition to the uncooperative film industry, technological problems made television-as-cinema hard to achieve. Prior to the more reliable signal connection made possible by microwave transmission after 1952, the unreliability of the AT&T co-axial cable and the haphazard functioning of camera equipment consistently interrupted the monitoring experience. As early studio technician Harry Coyle commented, 'At DuMont in those days, to do something extra special was to stay on the air. If we did an hour-and-a-half

show for just a half-hour, that was a victory. Forget losing *a* camera, this was where all you saw was a slide because *all* the cameras were out' (quoted in Kisselhoff 1995: 104).

Despite these travails, well over one and a half million TV sets were in use in the United States by 1949 (UNESCO 1953: 85). As yet, however, television viewing remained demographically divided 'between the barroom trade on one hand and well-to-do ladies on the other' (quoted in Kisselhoff 1995: 143). With most television sets in either wealthy white homes or local taverns, television provided little competition for news and entertainment media with higher household penetration, such as radio and newspapers. Constituted by the inconsistently available movement-images of television-as-cinema and the infrequent time-images of live sports coverage, early broadcasting gave no indication that television would ever become anything more than 'Pictures. You watch a test pattern with music on and wait for wrestling to come up' (ibid.).

What changed the social function of TV monitoring, and the cultural significance of television? The answer lies in the television industry's exploitation of the duration and simultaneity of the 'live' event. Live TV coverage established television monitoring as a legitimate cultural activity through which watchers could encounter unfolding events of local, national, and political significance. As live coverage of events became embedded in programming, a new type of televisual spectatorship emerged – one based on time-images rather than movement-images. The cultural emergence of time-images and the legitimacy of monitoring, however, did not spring forth fully realized, rather it took a very specific series of events to initiate watchers into monitoring time-images and to make evident to the then-fledging television industry the economic viability of time-image based programming.

KTLA and Kathy Fiscus. On 27th April 1949, four year old Kathy Fiscus fell into a well while playing near her San Marino, California home. Newscasters Bill Welsh and Stan Chambers from the Los Angelos television station, KTLA, spent an unprecedented twenty seven and a half hours covering the unsuccessful rescue attempt, interviewing spectators and rescue workers while providing a live feed to KTLA viewers with remote equipment. Eventually, stations nationwide picked up the live feed via the co-axial cable. The KTLA coverage of the Fiscus tragedy captured a unique moment in the history of televisual spectatorship, as time-images rather than movement-images grounding the monitoring experience.

What is significant about the KTLA coverage, and makes it pivotal to this time-image transformation in TV monitoring, was that it introduced duration and simultaneity in broadcasting and monitoring. Because of the nature of the event, KTLA pushed the limits of what was then known about the tolerance of transmitter equipment. As Bill Welsh recalls:

> No television station ever operated for thirty straight hours. They would go on for four or five hours and shut down. Klaus [KTLA's station manager] said 'I don't know how long we can stay on the air. The transmitter might melt down, but we'll go till it does.' It never melted down. We discovered that a television transmitter is much better if it is left operating all the time. (ibid.: 177)

In testing the technology's operational capacity, KTLA provided for watchers a monitoring experience characterized by an unprecedented temporal continuity and a simultaneity between the 'relayed time' of event-watching and the 'real time' of event-happening. The exceptional duration and simultaneity of the coverage convinced station managers across the country that television didn't need epic Hollywood movement-images to provide a compelling activity for watchers: broadcasting events as they unfolded could attract eyes too. Although monitoring sports events did involve the experience of duration and simultaneity to a greater extent than other television genres of the time, the KTLA coverage was distinctive because the events occurring were of both local import and national interest.

The significance attributed to the KTLA coverage of the Fiscus tragedy tends towards anthropomorphizing television technology as something that 'came of age' as a news medium capable of competing with the big boys – radio and print. Bill Welsh himself commented, 'now,

television not only made you laugh, but had a heart and soul as well' (ibid.: 178). Beyond such reifying readings of television technology, what is important about the KTLA coverage is that it redefined TV monitoring as a social activity and enhanced further the legitimacy of televisual spectatorship as a mass cultural activity.

The Kefauver Crime Committee. Between January and March 1951 the Senate Committee to Investigate Crime (known as the Kefauver Committee for its chairman Estes Kefauver), held hearings on organized crime in cities throughout the United States. The effort to establish the fact of organized crime and its links to government officials garnered testimony from nearly 800 witnesses while an estimated 20 to 30 million Americans watched on television (Kefauver 1968: 10–12). In New York City, WPIX alone generated an unprecedented 44 hours of coverage while stations in 21 cities in the East and in the Midwest picked up the live feed via the co-axial cable ('Crime Hearing is TV Smash' 1951: 1).

Like the reporting of the Fiscus tragedy, the Kefauver coverage also elicited anthropomorphic claims about television's mettle. The editors of *Broadcast Magazine* went as far as to suggest that the hearings had transformed television overnight from 'everybody's whipping boy to a public benefactor' (*The First 50 Years of Broadcasting* 1982: 106). Again, in avoiding a technological determinist reading of television what becomes apparent is that the time-image based coverage of the hearings reinforced watchers' expectation of duration and simultaneity. In addition, the Kefauver coverage illustrated for station managers and watchers alike the extent to which televisual spectatorship had grown. St Louis reported a slow down in sales activity during the hearings ('Carroll Glues St. Louis to its TV Screens' 1951: 13) while irate Washington D.C. viewers swamped WTOP with phone calls when the station cut the hearings short to air 'The Baptist Church Hour' ('Viewers Protest Religion' 1951: 58). As one *New York Times* editorial put it: 'the audience itself is, we venture to say, more startling than any disclosure thus far produced by the committee' ('The Captive Audience' 1951: 32).

With the largest example of time-image based coverage to date, the Kefauver hearings firmly established television monitoring as a national activity. Between the KTLA and Kefauver coverage, TV monitoring changed from a novel but unreliable visual practice separating watchers from the events they monitored to a social activity of genuine cultural consequence bearing on watchers' temporal universe. This change would prove pivotal in the events that ended the career of the man who made 'point of order!' a national catch-phrase.

The Army-McCarthy Hearings. In November 1953, during the second round of the House Un-American Activities Committee (HUAC) hearings on the alleged 'Red Menace', the Army drafted an aide to Senator Joseph McCarthy, G. David Schine. In an effort to secure special privileges for Schine, McCarthy's chief counsel, Roy M. Cohn, pressured everyone from the Secretary of the Army down to Schine's company commander. When the Army issued a detailed report on Cohn's improprieties in March of 1954, McCarthy alleged a vast army conspiracy to hold Schine hostage in order to prevent the HUAC from exposing the communists within military ranks. Between 22nd April and 17th June 1954, the Senate Permanent Subcommittee on Investigations held the Army-McCarthy hearings, covered by ABC and DuMont, generating 188 hours of live feed for stations across the nation to pick up via microwave transmission (Figure 21).

During live coverage of the Army-McCarthy hearings, watchers again experienced the duration and simultaneity of time-image broadcasting – and encountered a radically different Senator McCarthy. Instead of monitoring McCarthy through the movement-images of dramatically scripted press conferences, the coverage of the hearings furnished watchers with time-images of the Senator that captured his unpredictable and bullish propensity for abusive, self-righteous behaviour. Resonating with the Fiscus and Kefauver coverage, the Army-McCarthy hearings made TV monitoring part of the political arena itself, comparable to reading and listening as a vital social activity. Seemingly aware of the cultural power and political significance that TV monitoring had garnered as a social activity during the telecasts, Senator Stuart Symington (Democrat, Missouri) remarked to McCarthy towards the end of the hearings, 'the American people have had a look at you for six weeks. You are not fooling anyone' (Doherty 2001).

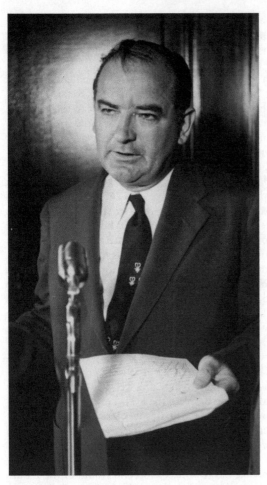

Fig. 21. Republican politician and anti-communist Joseph McCarthy (1908–57), after the Senate censured him for financial irregularities in 1954. (Photo by MPI/Getty Images.) Courtesy of Getty Images.

In addition to the live telecasts of the hearings, CBS's *See It Now* also contributed to McCarthy's downfall, and emphasized the important role played by watchers' monitoring of time-images. Just before the hearings began, *See It Now* pieced together clips from newsreel footage to present McCarthy as 'the principal witness against himself' (Gould 1954: 18). For the segment, host Edward Murrow and producer Fred Friendly claimed they were documenting 'from Mr. McCarthy's own utterances and actions . . . the Senator's frequent reliance on "Congressional impunity and the half-truth" to persecute rather than investigate' (ibid.). CBS televised the report on Tuesday 1st March and received 12,348 telephone calls and telegrams in response to the programme. Over 1000 letters requested that it be aired again ('Praise Pours in on Murrow Show' 1954: 19).

The Kathy Fiscus, Kefauver, and Army-McCarthy coverage redefined the activity of TV monitoring, for both watchers and the television industry, as a cultural practice with currency and consequence beyond that of representational viewing. For watchers, monitoring now meant witnessing events for their duration as well as occupying the temporality created as these events unfolded. For the television industry, these events and the visual culture of monitoring emerging around them furnished the financial impetus to reconsider the 'cinema television' paradigm. By 1955, the experience of monitoring time-images came to define televisual spectatorship as much as the habit of monitoring movement-images.

The overview of television watching presented here – one that focuses on the historical and sociological development of monitoring as a visual practice hinging on the experience of movement-images and time-images – illustrates the composite character of television watching. Television watching is experienced by watchers as both a habit elicited by representational movement-images and as a temporal happening encountered via the simultaneity and duration of time-images. And although representation (the notion that electronic images are *ideological* copies of direct experience) and spectacle (the notion that the time and space of the 'viewing subject' is necessarily distanced and distinct from that of the 'observed object') can account for the production and consumption of movement-images, time-images seem to elide these two conceptual mainstays of media studies. Such an elision seems to explode the conceptual limits of both representation and spectacle – and the theories of media criticism which rely on such concepts in order to posit American televisual spectatorship as anathema to culture and communication.

Although representation and spectacle are important concepts for investigating the functions of electronic culture in capitalist societies, they cannot necessarily account for what happens

when a watcher monitors time-images. If, for a moment, we put aside the notions of representation and spectacle, an alternative dimension of televisual spectatorship becomes apparent – a dimension that is both historical and cultural. To understand American televisual spectatorship one needs to pay attention to the historical development of monitoring as an innovative visual practice and to the emergent significance of monitoring as affording a radical presence to watchers in relation to the events they monitor. Interestingly, American televisual spectatorship emerged during what is remembered – correctly or incorrectly – as one of the most conformist eras in United States history – the 1950s. As a time associated with McCarthyism and social control, atomic warfare and fear, poodle skirts and centrism, the 1950s is also a time when events of national importance ceased to be defined by participation in physical time and space and began to be accessed through a decentralized presence made possible by electronic time and space. In this sense, the presence of watchers through monitoring time-images can be explored as a challenge to the 1950s' historical climate of conservatism.

In light of this history, American televisual spectatorship as a visual practice and radical presence cannot be defined as good or bad, but must itself be understood as a composite, or as what Deleuze calls 'Multiplicity'.[4] On the one hand, American televisual spectatorship is historically unique because it is what Marshal McLuhan calls a 'cool medium' – a medium that produces mosaic or iconic images and 'requires each instant that we "close" the spaces in the mesh by a convulsive sensuous participation that is profoundly kinetic and tactile' (McLuhan 1994: 18). Monitoring the electronic time-image is a 'total involvement in an all-inclusive nowness' (ibid.: 314). Such is the radicality of television watching – a nowness and a presence for watchers that was not a part of the experience of previous media like print and cinema.

On the other hand, this 'presence' and 'nowness' is not a utopian abstraction; rather it is beholden to the conditions of its historical emergence. As such, this radicality implicit in monitoring time-images is tempered and conditioned by very specific forms of solicitation established during the 1950s – forms that pushed monitoring into everyday life, as exposited by the history presented here. As such, American televisual spectatorship involves a radical presence of watchers where time-images are concerned, often solicited via forms established by the KTLA, Kefauver, and Army-McCarthy coverage, most notably tragedy, criminal investigation, and political scandal.

What is interesting from a historical perspective is to map the repetitions and differences of these soliciting forms: how have time-images and movement-images shifted? More specifically, how has the duration and simultaneity of monitoring contracted and expanded beyond its initial manifestations in the KTLA, Kefauver, and Army-McCarthy coverage? What events have marked these shifts? How has the solicitation of watchers as a radical presence been further encapsulated by the repetition of the cultural forms of tragedy, criminal investigation, and political scandal? How have these repetitions involved differences from their earlier forms? These are the investigations that are opened up by analyses that rely on asking the historical question: From whence the watcher?

Notes

1. For a philosophical analysis of monitoring as an aesthetic experience see Cavell 1982 and Weber 1994.
2. Deleuze's writing is a defence of cinema as a social form and mode of philosophy in the face of 'the question of the crisis of cinema [that is] often raised under the pressure of television, then of the electronic image' (Deleuze 1997a: x). However, it is possible to say that the shift in cinema and in the concepts created in the history of cinematic images with which Deleuze is concerned – when 'the movement-image of the so-called classical cinema gave way, in the post war period, to a direct time image' (Deleuze 1997b: xi) – is a shift that occurred precisely when monitoring television based on time-images began to gain cultural currency.
3. Television-as-cinema had other critics besides the film industry. Not wanting theatre conditions at home to cut into their sales of light bulbs and lighting products, Westinghouse

Electric Company issued a stern warning that 'persons who try to duplicate the darkened conditions of a motion picture theatre in their living rooms for watching a television set may cause eyestrain to viewers' ('Light with TV Urged to Lessen Eyestrain' 1952: 22).

4. Henri Bergson used the term 'multiplicity' to describe the metaphysical problems that constitute experience as composites, connoted by difference and divergence (Deleuze 1991: 117) rather than sameness and synthesis. For Deleuze, Bergson's concept of multiplicity is important since it is the first step towards a philosophy of difference freed from the 'negative difference' between model and copy implemented with the 'Platonic wish to exorcise simulacra' (Deleuze 1994: 265).

Negotiating the Cold War in Film

The Other Side of Hollywood's Cold War: Images of Dissent in the 1950s

TONY SHAW

For most Americans, the Cold War was more of a mediated experience than a real one. For while it is true that thousands of US soldiers fought in 'hot spots' like Korea and Vietnam, hundreds of American athletes competed with their rivals from behind the Iron Curtain, and dozens of US entrepreneurs traded in an increasingly open Soviet economy, few other Americans came face to face with 'the enemy'. This was mainly because the combination of Eastern self-segregation and Western containment rendered regular, day-to-day communication between the two camps virtually impossible. Yet despite the creation after 1947 of these two 'sub-universes' (Hobsbawm 1994: 373–5), most Americans seem to have developed a clear sense of what life on 'the other side' was like, and what they were fighting for and against during the Cold War. Doubtless, the roles played by the family, teachers, workmates and politicians – to name but a few important agencies of influence – were central to many Americans' comprehension of the Cold War. Given the increasingly powerful position established by the mass media in everyday American life in the second half of the twentieth century, however, it is not surprising that scholars have also highlighted the part played by the nation's newspaper chains, television networks, and publishing houses in fashioning popular attitudes towards the Cold War.

Cinema arguably ranks as the most influential of all of America's visual media during the Cold War. Unlike television, for instance, cinema provided moving images of events, issues and personalities from the very beginning to the end of the conflict, from the 1917 Bolshevik Revolution to the Soviet Union's demise in 1991. Hollywood also exported the United States' liberal-capitalist ideals to every point on the globe. American Cold War cinema was at its zenith in the 1940s and 1950s, a period when East-West tensions were consistently high and domestic Cold War values became fully institutionalized, and before the nation's major television networks established their dominance as providers of news, views and entertainment. During these two decades, feature films, newsreels and documentaries supplied millions of Americans with compelling images of the conflict, all of which – either directly or indirectly – formed part of the Cold War's propaganda battle for hearts and minds. Owing to the power and reach of the movie camera during this era, audiences could *watch* 'their boys' in action in Korea, *see* the terrible power unleashed by hydrogen bomb tests, and witness *with their own eyes* the dangers posed by the Soviet Union in such movies as R. G. Springsteen's *The Red Menace* (1949) and Henry Hathaway's *Diplomatic Courier* (1952).[1]

Academic interest in this 'golden age' of American Cold War cinema has traditionally been split along two lines. The first has concentrated on the political attacks that Hollywood suffered at the hands of the Committee on Un-American Activities of the House of Representatives (HUAC) in the late 1940s and early 1950s and the subsequent 'blacklisting' of a generation of filmmakers. The second has exposed the role played by Tinsel Town in actively fostering a hatred of Communism during the McCarthy era, through such notorious Red-baiting pictures

as *Big Jim McLain* (Edward Ludwig, 1952) and *My Son John* (Leo McCarey, 1952). Of late, historians have added a third strand of enquiry, based largely on official documentation declassified since the end of the Cold War. These records have revealed the more subtle ways that bodies such as the US Central Intelligence Agency and the United States Information Agency utilized film during the Cold War, by secretly funding movie projects and by placing agents within the film community to alter film content.

This essay explores a relatively neglected dimension of the Hollywood Cold War story – those movies and moviemakers which, in the 1950s, expressed disquiet with aspects of the super-patriotic, anti-communist consensus. Of all the phases of American Cold War cinema, the fifties represent certainly the most conservative. Only the Reagan era in the early to mid-1980s comes close to it in terms of the production of movies that, like John Milius's post-nuclear war drama *Red Dawn* (1984) and Tony Scott's testosterone-fuelled fighter-pilot adventure *Top Gun* (1986), revelled in killing communists. The appearance in the early 1960s of a number of prominent pro-liberal or anti-Cold War films, such as John Frankenheimer's *Seven Days in May* (1964) and Sidney Lumet's *Fail Safe* (1964), merely serves to underline the extent of Hollywood's political conformity during the previous decade (Schwartz 2000: 100–03, 95, 285–6). If one looks closely, however, a small number of feature films can be found that, in one way or another, subverted Cold War orthodoxy in the 1950s. By examining one movie in depth, Daniel Taradash's little-known *Storm Center* (1956), I also want to show how cinematic radicalism of the period had its limits.

Science fiction movies flourished throughout the Cold War and especially during the 1950s, when seemingly omnipresent images of aliens, giant insects and white-coated megalomaniacs projected the United States as a nation on a constant state of alert. While such images have been submitted to a multitude of interpretations over the years, most analysts argue that the majority of them dramatized the need for Americans to pull together in the face of internal and external political and social threats. Some movies had more obvious Cold War connotations than others. Numerous films, like Christian Nyby's *The Thing* (1951) and Cameron Menzies's *Invaders from Mars* (1953), made quite overt connections between the danger to national security posed by aliens and the threat feared from the Red Menace. Others, such as the slug-like movements of Irvin S. Yeoworth, Jr.'s *The Blob* (1958), provided an objective correlative for the right-wing fear of 'creeping communism'. Harry Horner's *Red Planet Mars* (1952), in which Martians prompt the overthrow of the Soviet government via religious radio broadcasts, suggested that evangelical Christians like Billy Graham were right – that the Cold War was a clash of faiths: one tolerant and true, the other fanatical and false (see Biskind 2000: 102; Murphy 1972: 31–44; Warren 1986; Shaw 2002: 5–30).

If most filmmakers exploited for politically conservative ends one of the decade's more artistically exciting genres, a few others used the greater freedom which science fiction – with its fantastic plots and peculiar conventions – afforded for social and political protest. Boasting a horrific assortment of radiation-engendered mutant monsters which threatened Earth with death and destruction, films like W. Lee Wider's *Killers from Outer Space* (1953) and Gordon Douglas's *Them!* (1954) bespoke the fears that many Americans had of an atomic age spiralling out of control.[2] Of greater interest to this essay, however, are those movies in which aliens appeared as benevolent forces, warning Earth of the lunacy of the nuclear arms race and/or preaching East-West peaceful coexistence. Jack Arnold's *It Came from Outer Space* (1953), for example, used the hostility shown towards a group of harmless visiting aliens by their hysterical small-town hosts to condemn contemporary America's paranoid fear of the Other. The film stridently defends society's loners and non-conformists via its support for the lead character John Putnam (played by Richard Carlson), who helps the pod-people to escape from the mob-like authorities. By depicting parts of the USA as narrow-minded and virtually barbarous, it also suggests that the 'civilized' West might have more to learn from the Other Side – terrestrial and extraterrestrial – than prevailing discourse would allow. 'I think science fiction films are a marvellous medium for telling a story, creating a mood and delivering whatever kind of social

message should be delivered,' opined Arnold, a former producer of government documentaries. 'If ten per cent of the audience grasped it, then I was very successful' (Arnold quoted in Biskind 2000: 159; Pirie 1981: 277, 280).

Robert Wise's *The Day the Earth Stood Still* (1951), Burt Balaban's *The Stranger from Venus* (1954) and Herbert Greene's *The Cosmic Man* (1959) all concocted versions of the alien Other to emphasize (after the initial xenophobia dissipates) the destructive power of atomic weapons and humankind's paradoxical blind allegiance to the false ethic of deterrence (Broderick 1991: 19–20, 76, 89). Wise's film rates as particularly subversive. Superficially, its tale of a spaceman named Klaatu (Michael Rennie) who arrives on Earth with Gort, an indestructible robot equipped with a death-ray, in order to break the Cold War deadlock and so save the universe from an inevitable nuclear war, was preposterous. And yet *The Day the Earth Stood Still* had serious points to make about both nuclear brinkmanship and the Red Scare. It conveyed the unwillingness of world leaders (including US President Harry Truman) to compromise, even over such issues as a meeting site. It portrayed the US government as cynical and ruthless, imprisoning the well-meaning Klaatu lest his message cause domestic unrest, then, aided by a sickeningly compliant mass media, hunting him down like a wild animal after he escapes. And, most unusually for films of this era, it depicted pacifist intellectuals sympathetically. Location work in Washington D.C. and the presence of real-life news commentators like Elmer Davis helped lend the film a sense of actuality and immediacy. So too did the fact that, when the film was released, American troops were dying in Korea and Senator Joseph R. McCarthy's allegations of a communist conspiracy were dominating the headlines.

Nuclear film historian Mick Broderick has argued that Klaatu's farewell authoritarian ultimatum – that if humans fail to coexist and threaten to extend their violence, his own planet would use its power to reduce the Earth 'to a burned-out cinder' – could be read as a then-contemporary metaphoric interpretation of American foreign policy, 'a sort of post-World War II proclamation from the United States to the global community, [the US] having monopolised (and demonstrated its willingness to use) nuclear weaponry' (ibid.: 20).[3] However, it seems unlikely many Americans would have seen the movie in this way, especially given the blow to the nation's confidence caused by the Kremlin's detonation of its own nuclear device in 1949. Producer Julian Blaustein told the press at the time that, aside from it being great entertainment, he wanted his movie to show that 'peace is not a dirty word'. Scriptwriter Edmund North sought to put across the same message, albeit subliminally, by comparing Klaatu (whose adopted name is 'Carpenter') with Jesus Christ. Whether it was the film's political overtones, its innovative technical effects, or the strong acting, *The Day the Earth Stood Still* appears to have had quite an impact on audiences. It was extremely successful at the box office, and today is commonly ranked among the ten greatest science fiction films of all time.[4]

A quite different set of films which questioned the Cold War consensus were those that either went a stage further than *The Day the Earth Stood Still* to explore the harsh realities of life after a nuclear war, or which graphically showed the violence and madness of war in general. Arch Obeler's *Five* (1951) was Hollywood's first post-apocalyptic film and presented a dystopian picture of a deserted world inhabited by a handful of brawling atomic war survivors. Although it portrayed nothing of the true horrors of World War Three, it did depict something of the awfulness of radiation poisoning. The film was also one of the very few during the Red Scare period that portrayed a black character sympathetically and a neo-fascist negatively. *Five* appears to have been severely weakened by Obeler's radio-writing background, however; reviewers found the film 'tepid' and 'ponderous' owing to an undue emphasis on dialogue at the expense of action (*Monthly Film Bulletin*, November 1951: 356; Baxter 1979: 156–7). By contrast, Stanley Kramer's taut drama *On the Beach* (1959), based on Nevil Shute's best-selling novel telling of a US submarine crew awaiting death in Australia from wind-blown nuclear fallout, prompted national and international controversy due to its hard-hitting anti-nuclear stance. US Secretary of State Christian Herter privately called it 'extremist, ban-the-bomb propaganda', while the director of the Office of Civil Defense Management, Karl Harr, decried the film for making his fallout shelter programme appear 'utterly hopeless'. Despite government

efforts to undermine it, the movie generated $6.2 million in US domestic rentals, making it the eighth highest-earning film of 1959 (Poe 2001: 91–102).

Overall, Hollywood made a great deal of money in the 1950s out of glorifying conflict, largely via action-packed Second World War adventures. To many filmmakers and film watchers alike, celebrating the 'good war' against Nazism helped morally underpin the present one against its totalitarian twin, Communism (Wills 1997: 154; Doherty 1999: 265–81). Among the rare exceptions to this were David Lean's Anglo-American production *The Bridge on the River Kwai* and Stanley Kubrick's *Paths of Glory*, both released in 1957. Both of these films used the world wars – in Lean's case the second, in Kubrick's case the first – to emphasize the futility of military conflict and the agonies suffered by ordinary conscripts at the hands of authoritarian generals and politicians. *The Bridge on the River Kwai* was scripted by two self-exiled Hollywood blacklistees, Carl Foreman and Michael Wilson. *Paths of Glory* anticipated Kubrick's dark satire on nuclear deterrence, *Dr Strangelove* (1964) (Sayre 1982: 185–9; Baxter 1979: 165–98).

A third category of celluloid Cold War dissent relates to films which, in allegorical form, condemned those who led and tacitly condoned the witch-hunting of the Red Scare era. The best known example of this is *High Noon*, a 1952 United Artists Western produced by Stanley Kramer, directed by Fred Zinnemann, and written by Carl Foreman. The movie told the story of Will Kane (Gary Cooper), sheriff of Hadleyville, who is refused help from a cynically fearful townsfolk when a gang leader recently released from jail returns to exact revenge on Kane for arresting him. During the HUAC hearings in Hollywood in September 1951, at the same time that the filming of *High Noon* was taking place, Foreman, a member of the Communist Party between 1938 and 1942, took a version of the 'diminished Fifth', refusing to confirm or deny his Party membership. This action prompted Kramer to cut off his association with Foreman, shortly after which the latter moved to London to escape the blacklist. Foreman subsequently declared that *High Noon* was a parable about HUAC's onslaught on Hollywood and 'the timidity of the community there'. This message was understood by some within the film trade when it was released. Equally, others interpreted the film quite differently, with some even appropriating it for official Cold War purposes. Tellingly, the most influential political reading of the film seems to have been Harry Schein's in 1955, which asserted that it was 'an explanation for American foreign policy', an allegory for the United Nations' fear of the Soviet Union, China, and North Korea, and its failure to support the United States in its intervention in Korea (Schein 1955: 316; Murphy 1999: 255–9).

Allan Dwan's *Silver Lode*, another broody Western released two years after *High Noon* in 1954, focused more overtly on the nature of liberty, truth and memory in a free society. This B-movie told the story of Dan Ballard (John Payne), a respected citizen in the town of Silver Lode, who on his wedding day is accused of murder and robbery by four men from Discovery led by US Marshal Ned McCarthy (Dan Duryea). Though entirely innocent, Ballard finds himself on the run, deserted by his erstwhile friends and hunted down on the basis of allegations, suspicion and circumstantial evidence alone. In the ironic denouement, Ballard and McCarthy fight it out in the town clock tower, where the villainous false lawman is eventually killed when a bullet from his own gun ricochets from the Liberty Bell. As a final twist, we then learn that the document which has helped clear Ballard's name is itself a forgery. In this way, the film seemed to be criticizing the very process of political investigation and sneering at the public's willingness to accept 'evidence' that either suited them personally or corresponded with the temper of the times (Walker 2001: 739).

Films that challenged prevailing American Cold War values *openly* were very rare indeed in the 1950s. This is hardly surprising given Hollywood's inherent love of capitalism, the political pressures imposed on filmmakers by the likes of the HUAC, the Federal Bureau of Investigation, the Catholic Legion of Decency and the American Legion, plus the well-established links between many studio heads and government. One film that struck a range of dissenting notes, and which has attracted considerable attention from historians, is Herbert Biberman's *Salt of*

the Earth (1954). Made independently by the blacklisted Biberman, Michael Wilson and Paul Jarrico, *Salt of the Earth* was a powerful drama based on the 1951–2 strike by the Mexican-American zinc miners of Bayard, New Mexico, who had demanded equality with their Anglo colleagues, as well as safety regulations on the job. The film was so successfully suppressed by Hollywood, federal and state governments, and organized labour that it was shown in only one New York theatre and, despite rave reviews and prizes in Europe, did not go into general US release until 1965. For its defiance of the blacklist, and its socially conscious unionism that sought to break down racial barriers, bridge class divisions, and enlarge the role of women, *Salt of the Earth* has been described as 'the single most anomalous cinematic legacy of Cold War America' (Doherty 2000: online).

The one mainstream Hollywood movie of the era that bears some comparison with *Salt of the Earth*, in terms of its reconstruction of a real-life case of political persecution and its deprecation of Cold War America's lurch to the right, is Daniel Taradash's 1956 melodrama *Storm Center*. Hitherto largely ignored by historians, this film is worthy of sustained analysis for two reasons. First, it represents the only direct assault on McCarthyism produced from within Hollywood until the early 1970s[5] and, second, the film paradoxically won approval from a number of nationalist pressure groups whose rampant anti-communism and anti-liberalism had helped fan the flames of the Red Scare. An examination of *Storm Center* therefore reveals both the potential that existed for open Cold War dissent in Hollywood in the 1950s, and the lines of attack on Cold War orthodoxy beyond which filmmakers were either not prepared or not able to go.

The origins of *Storm Center* lie in the summer of 1950, when Elick Moll suggested to his fellow liberal-minded screenwriter Daniel Taradash that a letter he had read in the *Saturday Review* might provide them with a basis 'to fight McCarthyism through film'. The letter, written by Darlene Essary, described the dismissal of her friend Ruth Brown, who had been librarian at the Bartlesville Public Library in Oklahoma for thirty years, amid implications of subversive activities that included her participation in interracial programmes. In March 1951 Taradash and Moll persuaded the Stanley Kramer Company, which had a long-term contract with Columbia Pictures giving Kramer control over the subject matter of his films, to purchase their story. Titled 'The Library', its themes of book-burning and character assassination, leavened with anti-intellectualism and 'political ambition disguised as patriotism' amounted to, in the screenwriters' opinion, 'a dangerous picture about dangerous ideas'. The core of the film was to be the librarian's battle against pressure to remove books labelled communist and therefore subversive in a Red Scare atmosphere.[6]

For four years, between mid-1951 and mid-1955, the shooting of 'The Library' was postponed. A series of personal, commercial and political obstacles held up production. First, veteran star Mary Pickford agreed to play the lead role of the librarian, Alicia Hull, only to drop out of the project in late 1952, partly for fear of working with what her friend and influential right-wing Hollywood gossip columnist, Hedda Hopper, called 'that red, Stanley Kramer'. Next, Irving Reis, the film's director, died in the summer of 1953. Following this, in 1954, Kramer's Company, a number of whose employees had resigned or been fired as a result of their encounter with the HUAC in 1951–2, parted ways with Columbia, leaving 'The Library' in its hands.[7] In early 1955, Taradash, who had won the 1953 screenplay Academy Award for *From Here to Eternity* (directed by Fred Zinneman), formed an independent production company, Phoenix Corporation, with his old Harvard friend Julian Blaustein, and made a two-picture deal with Columbia. Harry Cohn, Columbia's chief, was then persuaded to give Phoenix $800,000 for 'The Library', with Blaustein and Taradash agreeing to work respectively as producer and director for profits but no salary. In August 1955 filming of what was now called *Storm Center* finally got under way in Santa Rosa, California, with the legendary Bette Davis playing a matronly Alicia Hull. The 90-minute movie was released in the US a year later, in the summer of 1956.[8]

The plot of *Storm Center* revolves entirely around the character of Alicia Hull, a devoted public servant widowed during the Second World War. As librarian of the Kenport Public

Library, she has been for over 25 years not merely a custodian but a loving guide who helps mould the future generations of her New England town. In turn, the children of Kenport regard her as a friend and counsellor, her favourite being Freddie Slater (Kevin Coughlin), whose anti-intellectual father resents his son's bookish habits. Over a seemingly innocuous lunch one day, city officials ask Hull to remove from her shelves a tome, *The Communist Dream*, which they feel is subversive 'garbage'. In exchange they promise to build her long-desired children's wing. Hull at first acquiesces, but then quickly reverses her decision, sensing bribery and an assault on the freedom of expression. The next day, in the film's key scene, reminiscent both of events in Bartlesville and the HUAC hearings in Hollywood years earlier, Hull defends her action before the city council. In response to charges that she is in danger of turning 'the library into a propaganda agency for the Kremlin', Hull argues that the book actually exposes the truth about communism and that having it in the library is testimony to America's faith in its citizens' ability to make judgements for themselves. One of the council members, Paul Duncan (Brian Keith), then produces a file on Hull, which points to her membership of a number of wartime communist front groups. Upset by Duncan's implications and his burrowing into her private life, Hull declares that she detests communism but that she also disagrees with censorship. Duncan retorts by calling her 'a dupe' for those people 'who hide behind our laws . . . to destroy our laws', but agrees with his colleagues that Hull should be forgiven so long as she removes *The Communist Dream* and accepts the council's right to 'screen' all the library's 'questionable material' henceforth. When Hull stands firm, saying that the council can remove the book but only at the cost of dismissing her, the council feels it has no option. Several members fear losing power if the press learns that they have been 'soft' on communism. Consequently, Hull is fired and replaced by Martha Lockridge (Kim Hunter), Duncan's fiancée.

Smeared in the local newspapers as a Red, Hull, once a much-loved pillar of the community, is systematically ostracized by the townsfolk. Friends and acquaintances are too scared to campaign on her behalf lest they be branded communists. Even the children shun her, compounding her sense of loneliness and desperation. All of this has a profound psychological effect on Freddie Slater who, suffering from frenzied nightmares and told by his father that Hull has poisoned his mind with 'crummy notions', begins to hate her. His emotions come to a head some months later when, at the ceremonial opening of the library's new children's wing, Freddie throws a fit and tearfully denounces Hull as a communist in front of everyone. That night, ashamed and confused, Freddie sneaks into the library and sets it on fire. As Kenport's inhabitants watch aghast as one of their most treasured civic buildings burns to the ground, and as the camera lingers on the flaming volumes of Beethoven, Mark Twain and Shakespeare, they realize their collective wrongdoing. Duncan gets his comeuppance: first condemned by his council colleagues as a political opportunist whose red-baiting has debased American civil liberties, then dumped by Martha for his scheming cruelty. The film wraps up neatly when, amid the ashes and the craven townsfolk, Hull declares her determination to help rebuild the library. 'And if anyone ever again tries to remove a book from it,' she adds fiercely, 'they'll have to do it over my dead body.'[9]

Storm Center was seen at the time as a politically radical movie by many commentators – and for justifiable reasons. Support for it came from the former First Lady, Eleanor Roosevelt, and the influential Washington columnist Drew Pearson, with whom McCarthy had had a long-running public feud. The American Library Association's Library Bill of Rights was used in a brochure distributed by the Motion Picture Association of America, together with President Eisenhower's 'Don't Join the Book Burners' speech of 1953, delivered in the midst of McCarthy's months-long assault on the overseas libraries of the US International Information Administration.[10] The Catholic Legion of Decency gave the film a 'separate' classification, used for only the fifth time in twenty years, on the grounds that it was 'a propaganda film' that 'offers a warped, oversimplified and strongly emotional solution to a complex problem of American life'. One writer, Jerry Davis, saluted Taradash and Blaustein for capturing on screen a sense of the ugliness of what had happened to the Hollywood Ten and other beleaguered screen artists.[11] From one of the liberal journals that Ruth Brown had been sacked for circulating in 1950, the

Nation, came this ringing endorsement: 'It should be hard to convince a woman's friends and neighbours that she is an enemy agent. The great merit of *Storm Center* is that it shows – with no sentimentality and little melodrama – how very easy it is' (Hatch 1956).[12]

However, it would be a mistake to exaggerate *Storm Center*'s political audacity and non-conformity. For a start, the film expresses no sympathy at all for the plight of the thousands of American communists or left-wing 'fellow travellers' whom the national security state had labelled traitors. The movie is careful to depict Alicia Hull as a respectable civil libertarian who abhors communism, not as a radical outsider. Secondly, far from questioning the United States' role in the Cold War, the filmmakers explicitly supported it. 'We're telling Russia we can read a book designed to be inimical to democracy', Taradash told the industry paper, *Variety*, 'and yet not be damaged by it, because we are stronger than Russia.' This and the movie's celebration of Hull's 'typical' provincial American pluck in the face of bullying politicos, helps to account for the strong backing *Storm Center* received from a number of ultra-conservative organizations which had campaigned successfully for Ruth Brown's dismissal in 1950, such as the Daughters of the American Revolution. After all, the film would have carried a very different message had Hull, like Brown, abandoned her community, rather than staying to rebuild it after what is presented as a temporary loss of sanity.[13] Thirdly, via Hull's keynote speech, in which she compares *The Communist Dream* with Hitler's *Mein Kampf*, the film significantly encourages the audience to look on communism and fascism as two halves of the same coin, and thereby to reduce the Cold War to a struggle between democracy and totalitarianism. This was one of the chief refrains of official and unofficial American Cold War propagandists (Adler and Paterson 1970: 1046–64; Lucas 1999).

Fourthly, the movie deletes all references to Ruth Brown's work for racial equality in Bartlesville, which was the main reason why she was fired. While this can be attributed mainly to the scriptwriters' targeting of McCarthyism, and to the perceived need to give audiences a story they could easily comprehend, *Storm Center* missed an opportunity to show that during the Red Scare anti-communists were often driven by ulterior motives – economic, personal, and racial. Finally, even the strongest theme of the movie – its excoriation of the McCarthyite practices of censoring books, smearing intellectuals and persecuting liberals for pre-Cold War political activities – was, by 1956, to all intents and purposes out of date. McCarthy's own four-year assault on domestic communism had ended in 1954 with his censure by the Senate for unethical tactics, after which witch-hunting had slowly lost its appeal (though not its effect). Had *Storm Center* appeared in the early 1950s, when political informing, stigmatization and guilt-by-association were at their peak, it would undoubtedly have packed a political punch. To many critics of varying political persuasions in 1956, however, the film came across as preachy, artificial and hysterical.[14]

Between 1947 and 1960 the major Hollywood studios released an approximate total of 300 feature films per year (Lincoln 1976: 377). A relatively small number of these movies, some of which have been mentioned above, were explicitly anti-communist or anti-Soviet. A far greater number lent implicit ideological support to the US government's Cold War stance through their inherent endorsement of rugged individualism, consumerism and patriotism. Even movies that professed to show the dark underside of American family life – epitomized by James Dean's delinquent Jim in Nicholas Ray's *Rebel Without a Cause* (1955) – underpinned the Cold War consensus by suggesting that acutely personal relations outweighed wider social, political and economic concerns (Sayre 1982: 102). Looked at in the context of these hundreds of movies, the fourteen or so 'subversive' films analysed in this essay obviously amount to a puny retort.

Making movies that encouraged audiences to question cherished national values during wartime is not something that Hollywood had (or has) ever found easy. During the early stages of the Cold War the innate conservatism of the American film industry was reinforced by a unique number of externally and internally imposed pressures, of a political and economic nature. Never before had industry personnel and output been politically scrutinized so exhaustively as they were in the late 1940s and early 1950s. The institutional trauma this caused was

made worse by the sharp drop in cinema attendance figures during the era, a depressing phenomenon which tended to act as a further disincentive to producers to take political and artistic chances on screen. The result was an overarching culture of censorship and self-censorship in relation to the Cold War on the film trade's part. Any filmmaker that courted Cold War controversy risked being labelled anti-American at worse or naïve at best. One angry trade press reviewer of *Storm Center*, for instance, wondered whether its director realized how simple it would be for others to turn his film into Soviet propaganda:

> Our Central Intelligence Agency would do well to keep its eye open for the appearance behind the Iron Curtain of prints of this film that are altered, by dubbed dialogue, inaccurate sub-titles or otherwise, so as to make it appear that Americans are now setting their public libraries afire.[15]

Such statements of ideological anxiety, tinged with paranoia, substantiate the general picture historians have painted of a nervously fundamentalist American film industry during the early Cold War. This essay has shown that a small number of filmmakers did not entirely conform to the conventional picture. Driven by a combination of liberal beliefs and a determination to make 'thinking' movies, semi-independent producers like Stanley Kramer and Julian Blaustein were able to challenge – albeit in a small way – some of the dominant national views about US nuclear policy and internal political subversion. Most of the time it was safer to do this allegorically, but on a few occasions there was open defiance. Movies like *The Day the Earth Stood Still*, *Salt of the Earth* and *Storm Center* thus demonstrate that the US film industry was not officially straitjacketed in the way that Soviet cinema was during the same period. This is not to say, of course, that American filmmakers were as free to comment on the Cold War as most moviegoers surely believed.

Notes

1. For cinema attendance figures in the United States during the 1940s and 1950s see Gomery 1997: 443–51. For more on Hollywood's Red-baiting movies during the late 1940s and 1950s see the overview in Shain 1974: 334–50, 365–72.
2. See, for example, the review of *Killers from Outer Space* in the *Monthly Film Bulletin* (May 1954: 75), and the review of *Them!* in the *Monthly Film Bulletin* (September 1954, p. 131).
3. Mark Jancovich argues that *The Day the Earth Stood Still* is deeply authoritarian in other ways. In particular, 'it calls for the repression of individual feelings, interests and desires, all of which are simply defined as both irrational and destructive', and strongly implies that experts had the right to keep 'ordinary people' in line (Jancovich 1996: 41–3).
4. Blaustein cited in *The Day the Earth Stood Still* microjacket, British Film Institute Library, London. See also Pirie 1981: 276; *Starburst*, No. 206, October 1995: 51–3.
5. Though John Frankenheimer's *Manchurian Candidate* (1962) was, at least in part, a critique of 1950s' American right-wing extremism, it was not until the release of Sydney Pollack's *The Way We Were* (1973) and Woody Allen's *The Front* (1976) that filmmakers focused specifically on the McCarthy witch-hunts. See Badsey 1998; Schwartz 2000: 355, 120.
6. Daniel Taradash Papers, Boxes 3, 24, 33 & 81, American Heritage Center, University of Wyoming, Laramie. For more on the Brown case see Robbins 2000.
7. See 'Mary Pickford Hops Out of Stan Kramer's "Fire" Because It Isn't Tinted', *Variety*, 19 September 1952; Taradash Papers, Box 81; 'Kramer may Temporarily Shelve "Circle of Fire"', *Variety*, 21 November 1952; Taradash, '"Storm Center" Course: Forthcoming Drama Followed Rugged Trail Before Reaching the Screen', *New York Times*, 14 October 1956.
8. For the letters that Davis received from local women's club leaders in Santa Rosa, warning her not to take part in a subversive film, see Higham 1981: 194.

9. *Storm Center*, a Phoenix Production for Columbia Pictures, directed by Daniel Taradash, written by Taradash and Elick Moll, and produced by Julian Blaustein.
10. Taradash Papers, Boxes 24 & 33; Columbia publicity material, *Storm Center* microjacket, British Film Institute Library, London.
11. 'Civil Liberties Toting "Storm Center" Separately Classified by Legion', *Variety*, 11 July 1956; Taradash Papers, Box 33.
12. For more on the Brown case and the *Nation* see Robbins 2000: 64–7.
13. 'Taradash Says "Library" Will Be More Anti-Red than "Usual"', *Variety*, 6 July 1955; review of *Storm Center*, *Film Culture*, Vol. 2, No. 3, 1956, p. 25.
14. For critical reviews of *Storm Center* see, for example, Bosley Crowther, '*Storm Center*', *New York Times*, 22 October 1956; Father Finlay, *The Catholic World*, Vol. 184, No. 1099, October 1956, pp. 64–5; Philip T. Hartung, 'The Malady Lingers On', *Commonweal*, Vol. 64, No. 19, 10 August 1956, pp. 466–7. For a closer analysis of the relationship that *Storm Center* bore to the Ruth Brown case see Robbins 2000: 150–53.
15. *Films in Review*, Vol. 7, No. 8, October 1956, p. 417.

Cold War 'Containment Culture' and Photography

Robert Frank's The Americans *and the 1950s*

NEIL CAMPBELL

Robert Frank's *The Americans* collected images from a road trip across the USA whose aim was 'the observation and record of what one naturalized American finds to see in the United States that signifies the kind of civilization born here and spreading elsewhere' (Frank in Tucker and Brookman 1986: 29). Its grainy, unconventional, photographs of America's complex and divided social landscape made it a controversial collection that struggled to find a publisher in the climate of Cold War suspicions of any perceived anti-American visions. It was, therefore, published initially by Delpire in France in 1958, and only found a US publisher with the alternative Grove Press the following year. As Frank's words show, his road trip had a specific methodological approach that brought him close to his subjects and their landscapes as he both observed and recorded their diverse lives. In this respect his mode of investigation as a photographer has much in common with ethnography, believing as it does in participant observation as its key method, while remaining simultaneously aware of the tensions between being either too much 'inside' or indeed 'outside' the objects of enquiry. Frank's relationship to the USA, as a newcomer from Switzerland, positioned him on this very borderline between the inside and the outside, contributing to his unusual, dialogical approach, torn between 'hope and sadness' (see Campbell 2003).

Frank 'was marked by Parisian Surrealism', by its 'disdain for descriptions untransformed by psychic energies', its fascination for the 'unconscious meanings and emotions triggered by the encounter with certain external objects including the degraded and unremarked thing' (Osborne 2000: 129). As James Clifford argues, 'surrealism in an expanded sense . . . values fragments, curious collections, unexpected juxtapositions', its diverse forms constituting a multi-layered response to 'a reality deeply in question' after World War 1 (Clifford 1988: 118, 120). Surrealist photography, for example, favoured techniques that 'doubled, multiplied, fragmented or mounted a physical assault on the representational image', questioning the premises and assumptions of photo-realism (Osborne 2000: 165). Ethnography – literally 'culture-writing' – 'decodes and recodes, telling the grounds of collective order and diversity, inclusion and exclusion . . . writing about, against and among cultures' (Clifford and Marcus 1986: 2–3). Dealing in 'partial truths' ethnography works in the 'field' seeing cultures as complex and 'relational', full of 'voices' clamouring for expression, but resisting in its more 'dialogical modes' the urge to synthesize or restrain certain voices at the expense of others. In this style of information gathering the ethnographer questions 'monophonic authority', preferring heteroglossic, collage-like patterns (ibid.: 15) that form an 'assemblage containing voices, other than the ethnographer's' (Clifford 1988: 147). Thus Clifford sees a productive link between surrealism and ethnography, describing an 'ethnographic surrealist practice' that 'attacks the familiar, provoking the irruption of otherness – the unexpected . . . a play of similarity and difference, the familiar and the strange, the here and the elsewhere' (ibid.: 145–6).

142

Robert Frank's photography echoes these ideas, based as it is upon encounter and dialogue, juxtapositional and jarring in form, and always engaged with 'the invention and interruption of meaningful wholes in the work of cultural import-export' (ibid.: 147). Leaving Switzerland in 1946 for Paris, Frank travelled on to the USA and Peru where he discovered 'the beginning of a whole new way of photographing' that evoked a sense of his own silent displacement amongst alien cultures marking his work forever, most obviously in *The Americans*, where he approached the USA from outside, capturing its cultural landscapes with all the critical capability of the ethnographic surrealist confronting a strangely familiar and yet disturbingly contradictory world (in Westerbeck and Meyerowitz 2001: 352).

Arriving in New York in 1947 Frank uncovered, as the Beats would simultaneously, a culture edging towards a totalitarianism rooted in consumerism, consensus politics and paranoia, where the Truman Doctrine divided the world into the 'free' and 'unfree', promising 'a way of life free from coercion' where America would stand against 'terror and oppression', and 'fix', 'control' and 'suppress' recalcitrant peoples (Griffith 1992: 112–13). Containment abroad was increasingly replicated at home, with policies limiting perceived threats to American 'freedoms' and domestic order epitomized by the trials of the Rosenbergs and Alger Hiss, and the actions of the House Un-American Activities Committee. As the 'ethnographic surrealist', Frank exposed this consensual America as a hegemony under which the 'interests and tendencies' of particular groups created a 'compromise equilibrium' where values, objectives and cultural meanings incorporated Americans into dominant structures of power, believing that the promised good life could be theirs (ibid.: 161). Resisting normalized, idyllic advertising images and mythic political propaganda, Frank instead became increasingly aware of America's 'fractured frames of reference, its infinite regression of half-lives, its proliferation of contaminated sites, its bounty of waste' (Nadel 1995: xii).

Such domestic containment formed around the assumption that America had achieved economic abundance, Galbraith's 'affluent society' (1958), providing the driving force for a just cultural and political order with a core of agreed beliefs and values that signalled what Daniel Bell termed 'the end of ideology', since a nation liberated from economic scarcity was in turn liberated from social conflict (see Bell 1960). The power of such 'large cultural narratives' was 'to unify, codify, and contain – perhaps *intimidate* is the best word – the personal narratives of its population', emphasizing the need for approval and validation by others in what David Riesman, in another key text of the times, *The Lonely Crowd*, called 'other-directedness' (Nadel 1995: 4). For Riesman, 'other-directedness' meant a person's 'adjustment' to 'the character he is supposed to have, and the inner experiences and outer appurtenances that are supposed to go with it', ensuring they 'fit the culture as though they were made for it'; a notion emphasized poignantly with the rise of suburbia as a standardized, uniform existence in America's culture of abundance (Riesman 1965: 240–42).

These elements of the 1950s' consensus were, of course, contrary to Bell's claim, precisely ideological, validating institutionalized core values of the white family, consumption, containment and capitalism as the right-minded solution to conflict and injustice. Shocking differences still remained below the surface in a postwar world of segregation and poverty, exposed in Michael Harrington's *The Other America* as an invisible nation hidden by the veil of 'a familiar America . . . celebrated in speeches and advertised on television and in magazines . . . [as having] the highest mass standard of living the world has ever known' (Harrington 1963: 9). The investigative writer has much in common with Frank's photography, travelling 'off the beaten track' away from the 'tourist' routes, making 'an invisible land' visible through confronting 'well-meaning ignorance' and 'social blindness', and representing the 'atomized' with 'no face . . . no voice' – 'to tell a little of the "thickness" of personal life in the Other America' (ibid.: 10–12, 24). The idea of 'thickness' draws on Gilbert Ryle's ethnographic concept of 'thick description', later made famous by Clifford Geertz as 'piled-up structures of inference and implication . . . knotted into one another . . . at once strange, irregular, and inexplicit' (Geertz 1993: 7, 10). Frank's photographs echo this ethnographic 'thick description', recording complex 'texts', 'foreign, faded, full of ellipses, incoherencies, suspicious emendations . . . in

transient examples of shaped behaviour' (ibid.: 10). Hence in *The Americans* 'Trolley – New Orleans' conveys a divided nation of gender, race and class hierarchies where people sit silently suspended, framed within the photograph staring outward. Both Frank and Harrington shared an urgent need to record, for, as the latter put it, 'The problem . . . is to a large extent one of vision . . .' since if 'They cannot see. They cannot act' (ibid.: 156, 155). Frank's acts of seeing constantly draw the viewer into multiple layers of vision, as in 'Trolley', breaking up conventional frames, challenging the audience to see the world differently and to ask questions of the 'normal' perspectives provided in the dominant mythologies of the 1950s.

The overly-planned 'Orgworld' of the 1950s (Rosenberg 1961: 284), with its bureaucratic, managerial 'white collar'-class controlling its new economy and denying the possibility of the unpredictable, reminded Frank too much of his parents' Switzerland. In contrast, Frank's style eschews control, deliberately breaking the visual conventions of hegemonic America epitomized by *Time* and *Life* magazines and 'The Family of Man' exhibition with their orderly, contained narratives. Instead, Frank's surreal angles and mobile reframings, learned in part from *film noir* watched in Europe and New York during the late 1940s, intervene to recast order and containment in an unstable field challenging systems of authority, convention and control, with the inclusion of 'moral ambivalence . . . criminality . . . complex contradictions in motives and events . . . conspir[ing] to make the viewer co-experience the anguish and insecurity . . . [,] that state of tension instilled in the spectator[,] when the psychological reference points are removed' (Borde and Chaumeton 1996: 25). Certainly, reading *The Americans* as a sequence recalls *film noir*'s corrupt officials, duplicitous politicians, femme fatales and its constant questions and shifting sensations created through uncanny compositions and lighting (see Sass 1998). The images plunge the viewer into an ambiguous, partial construction of filmic fragments, swirling invitations to narrative that tease and provoke the eye and the mind, generating complex social questions and doubts.

Frank's friends, Jack Kerouac and Allen Ginsberg, also struggled in responding to this 'Orgworld', becoming a mixture of what Riesman called the 'anomic' and the 'autonomous', that is, either unable to conform or be 'adjusted', or choosing not to be (Riesman 1965: 242–3). Ginsberg, as so many of the Beats, sought to revitalize America to reclaim an older Whitmanesque vision of democratic freedom and possibility, a vision that had, they believed, been lost in the 'tight web' of postwar conformity (ibid.: 243). 'America will be discovered', Ginsberg wrote on Independence Day 1959, in a comment that could easily apply to the photographs Frank had taken across the nation and published in the USA that same year. Michael McClure's essay on the first public reading of Ginsberg's 'Howl' in 1955 encapsulates the Beats' doubts about a society losing its vision of possibility in favour of a containment culture at home and abroad:

> We hated the war and the inhumanity and the coldness. The country had the feeling of martial law. An undeclared military state had leapt out of Daddy Warbucks' tanks and sprawled over the landscape. As artists we were oppressed and indeed the people of the nation were oppressed . . . We wanted to make it new and we wanted to invent it and the process of it as we went into it. We wanted voice and we wanted vision. (McClure 1982: 12–13)

By May 1957 *Howl and other Poems* was charged with obscenity in the law courts, proving McClure's dark vision of a 'gray, chill, militaristic silence' (ibid.), and confirming Norman Mailer's claim in 'The White Negro' (1957) that 'One could hardly maintain the courage to be individual, to speak with one's own voice . . .' (Mailer 1972: 271). As a resistance to this 'slow death by conformity', Mailer called for 'the isolated courage of isolated people', an existential rebellion 'to live with death as immediate danger, to divorce oneself from society, to exist without roots, to set out on that uncharted journey into the rebellious imperatives of the self' (ibid.). Despite Mailer's romanticizing of black oppression, his sense that the 1950s was like being 'jailed in the air of other people's habits . . . defeats, boredom, quiet desperation' maps onto Frank's photographic quest as 'a frontiersman in the Wild West of American night life'

creating a new 'language of Hip', full of 'energy' and 'movement', with 'its emphasis . . . on complexity rather than simplicity', where 'each man is glimpsed as a collection of possibilities' (ibid.: 272, 281–5).

In 1947 Frank wrote to his parents that America 'is really a free country. A person can do what he wants' and yet simultaneously claimed 'There is only one thing you should not do, criticize anything' (in Tucker and Brookman 1986: 14). This double sense of postwar America resonates through Frank's photography, recalling the ambiguous meanings of 'Beat' as being 'beaten' as well as 'up-beat'. In fact, in 1957 Frank wrote, after his trip to photograph *The Americans* was complete, that 'criticism can come out of love. It is important to see what is invisible to others. Perhaps the look of hope or the look of sadness' (ibid.: 31). This dialogue between hope and sadness reflects much Beat work, torn between extremes of love and hate, yearning and loss, and it's no surprise that Frank stated 'The greatest influence on me after leaving little Switzerland were the Beatniks who showed me that you really ought to go your own way to the end. The point is not finding answers or climbing up the ladder – this is what shaped me' (Frank 1987: 22).

Kerouac wrote the introduction to *The Americans* in 1959, made the film *Pull My Daisy* with Frank in 1959, and took a road trip with him in 1958 to Florida, whilst his French Canadian heritage and outsider Beat sensibility connected him to Frank's dislocation in the land of dreams, exploring many of these feelings in his fiction. In *On the Road*, Sal Paradise, searching for the promise his name implies, wakes up, literally and metaphorically, to the real New World as an outsider:

> I was far away from home, haunted and tired with travel, in a cheap hotel room I'd never seen . . . I was just somebody else, some stranger, and my whole life was a haunted life, the life of a ghost. I was half way across America, at the dividing line between the East of my youth and the West of my future . . . (Kerouac 1985: 19–20)

Frank, 'far away from home' and 'haunted' by his journey into America was like Paradise's 'stranger', a 'ghost' drifting with his camera into the secret spaces of the everyday. Later Kerouac wrote of Frank, moving like a ghost with the 'strange secrecy of a shadow', capturing 'scenes that have never been seen before on film' and, like Paradise, seeing 'the dividing line[s]' of America (in Frank 1993: 5). The lines, boundaries and divisions everywhere in Frank's work deliberately cut-up perspective and interfere with vision, as in 'Rooming House – Bunker Hill', where the eye is assaulted by angles and lines denying us even the identity of the central figure. Kerouac appreciated Frank's multi-layeredness, writing in 1958 of how he photographed 'a big car-trailer with piled cars, two tiers, pulling in the gravel driveyard, but through the window and right over a scene of leftovers and dishes where a family had just vacated a booth'. This multiplicity of images, tier on tier, captured a complex vision through 'reflections everywhere in chrome, glass and steel of cars, cars, road, road', in an 'art-form that was not unlike [Kerouac's] own' (in Tucker and Brookman 1986: 38):

> lights flashing now in the 4 a.m. rain, the lonely look of a crossroad stoplight, the zing of telephone wires into the glooming distance . . . And GULF, the big sign, in the gulf of time . . . in all the pure hotdog roadstand and motel whiteness in a nameless district of USA. (ibid.: 40)

For Kerouac, Frank produced a 'sad poem' (in Frank 1993: 9), an idea endorsed by the photographer: 'When people look at my pictures I want them to feel the way they do when they want to read a line of a poem twice' (in Greenhough and Brookman 1994: 98). The emphasis on rereading and multiplicity again reinforces the dialogic structures of Frank's work as an intermediary, moving the viewer (in *all* senses of the phrase) between assumptions, codes of seeing and frames of reference, engaging them fully for 'Something must be left for the onlooker. He must have something to see. It is not all said for him' (ibid.: 108). Similarly, Ginsberg's poetry assaulted formal assumptions and styles, claiming that 'conventional form' was 'too symmetrical, geometrical,

numbered and pre-fixed – unlike to my own mind which has no beginning and end, nor fixed measure of thought (or speech or writing) other than its own cornerless mystery'. For him, the way forward was 'direct transcription of visual and other mental data' (in Allen and Tallman 1973: 324–5).

If Frank's work is usefully compared with the sensibility of the Beats, it can also be contrasted with *Life* magazine whose visual hegemony paralleled the postwar consensus:

> I wanted to sell my pictures to *Life* magazine and they never did buy them. So I developed a tremendous contempt for them, which helped me . . . I also wanted to follow my own intuition and do it my own way, and not make concessions – not make a *Life* story. This was another thing I hated. Those god-damned stories with a beginning and an end . . . obviously I will make an effort to produce something that will stand up to all those stories but not be like them. (in Greenhough and Brookman 1994: 107)

In 1941 *Life*'s owner Henry Luce defined 'The American Century', claiming that the nation's values were the world's guiding light and stating that his publication's mission was 'To see life; to see the world; to witness great events; to watch the faces of the poor and the gestures of the proud; to see strange things' (in Tallack 1991: 18). Robert Frank's brief statement at the opening to his *Black White and Things* echoes this ironically, in its matter-of-fact starkness: 'somber people and black events / quiet people and peaceful places / and the things people have come in contact with'. The implied neutrality of *Life*'s ethnographic 'see / witness / watch' is interrogated by Frank's ambiguous, destabilized, 'moving', surrealist-tinged photography, engaging the viewer in a dialogical, unfinished process rather than transmitting a ready-made story with pre-packaged values and assumptions of 'pictorial commoditization' (Tagg 1988: 14).

Reflecting on *The Americans* in 1972, Frank appreciated the radical nature of his work:

> Young people and students picked up THE AMERICANS. They recognized and understood my language. They listened to voices that had no part in the 'System.' Aware of Hypocrisy around them, dissatisfied with slogans from preachers and patriots, they began to question everything. THE AMERICANS became for many an affirmation of what they felt about their country . . . that's what I cherish the most. (Frank 1972: n.p.)

Perhaps it is another photographic project of the times, *The Family of Man* (1955), curated by Edward Steichen and partly funded by Coca-Cola, whose values best encompass the spirit of this period and against which one can read Frank's 'questioning' images. Steichen chose photographs, which included some by Frank, to reflect and to reinforce a postwar cultural narrative defining a global America-led 'united nations' in which politico-social tensions and differences were underplayed in favour of harmony, hope and regeneration. Steichen claimed that the exhibition was 'a mirror of the universal elements and emotions in the everydayness of life . . . a mirror of the essential oneness of mankind throughout the world' creating a new order, healing differences and oppositions that had for so long structured the world: 'devotions/antagonisms', 'heart-aches/exaltations', 'individual/family', 'human consciousness/social consciousness' (Steichen 2000: 3). One exhibition caption simply read 'We shall be one person', typifying the intention to naturalize an apparently logical order of things defined by couples, marriage, family, rituals, work, all overcoming the calamities and divisions of the modern world. Developing what he had learned from Walker Evans's *American Photographs*, Frank's sequencing and askew social commentary in *The Americans* 'answers' Steichen's exhibition with its complex and ambiguous variance on *The Family of Man*'s universal themes. Frank rejects its 'rhetoric of amelioration' and 'undercut[s] a unitary reading of American culture, the celebration of middle-class life, and . . . the belief that photographs could tell a story about this assumed reality', opting instead for multiplicity and uncertainty, deliberately frustrating the viewer's urge to conclude and to reconcile differences with images that are overflowing with possible meanings and jarring tensions, forcing them outward, away from the centre and any comfortable single meanings (Sandeen 1995: 160).

In *The Americans* every left-hand page is blank, with the image on the right, inviting the viewer to respond with their own 'script', creating a dialogue with the photograph and with the book's sequence of images. In the first photograph, 'Parade – Hoboken, New Jersey', we stare at a brick wall and a bisected American flag, noticing on either side two women, themselves separated, almost caged in windows and obscured by the flag or a window shade. They seem 'blind', for we cannot see their eyes clearly, and their 'parade' is distanced and uncelebrated as they wait, immobile in semi-darkness. The flag, a motif that recurs in *The Americans*, and traditionally a symbol of national unity and purpose, divides the viewer from the women, the women from each other, and cuts them off from the world beyond their window. Vision is interrupted here both for them as subjects and for us as viewers, and any orderliness is undone by Frank's deliberate reframing techniques whereby doorways, windows, vertical and horizontal lines and shadows remind us we are looking at a photograph. In addition, Frank's use of unusual, unsettling angles calls attention to the act of photographing, to the 'grabbed' shot, the voyeuristic moment where divided worlds collide. Such encounters take various forms, being antagonistic, intrusive, or, indeed, an act of communion in which differences feed some momentary connection between the foreign, white photographer and his subjects.

The collection's initial images of stern grey men ('City Fathers – Hoboken, New Jersey') and jubilant political workers making no eye contact ('Political Rally – Chicago') are traditional symbols of male, centralized power, reinforced by the draped bunting and the elegant, classical public buildings that smack of the official and bureaucratic agencies of governmental authority. The viewer recalls the silent, immobile, contained women cut off from the 'parade' by the flag in the first photograph, establishing a non-linear narrative connecting motifs and threads throughout the collection. Power is regularly associated by Frank with white, middle-aged men who are in the public sphere, involved in the 'parade', in stark contrast to the imprisoned, 'blinded' women in their darkened rooms merely observing what others 'do'. In fact, gender and race relations emerge as central to these opening pictures, establishing a prominent set of hierarchies in the book, as in the photograph of the funeral in South Carolina where black chauffeurs wait by their cars. Here, again, the women are linked in the viewers' minds to these six black men on the edges of the public ritual, distracted, bored, thoughtful – waiting for their employers to return from the event at which they have no part to play except as workers. Frank's women and these black men begin the collection's fascination with the marginalized, often characterized as waiting or watching from the periphery, or passing through, without access to the abundant promise of postwar America. In this image, however, the third figure from the left looks ambiguously at Frank and the viewer, breaking the photograph's 'neutrality', causing us to question if this is empathy or exploitation in the 'ethnographic' moment. Is Frank a photographic tourist, like those condemned in Harrington's *The Other America*, trying to present American 'slices of life', or does the returning look create a bond in which the subject/object power relations are interfered with? Such looks return the camera's gaze and break apart the aura of the photographer's 'invisible eye' as it documents an anonymous event, reminding us of Frank's presence in the crowd, his selection and his intention.

Any supreme 'authority' and power is, therefore, fractured in the dialogical exchange between the image and audience, and within the space of the image itself. This is clear in 'Savannah, Georgia', with a military man and a woman on a crosswalk and the photographer stepping in their path, literally confronting them with his camera. This uneasy image captures both the woman's uncertain pleasure at the street photographer's mimicking of the 'paparazzi' glamour shot and the anger of her military partner, very much a Cold War man, for whom photography signifies intrusion, revealing secrets and 'standing in the way' of official, State-authorized action. Frank's interest in sequence and narrative is striking here, for the next photograph is a recruiting office with the photographer outside the door looking in, seeing part of the flag and the feet of the officer on the desk – 'Join the Navy. Ask me about it'. The invitation to 'ask' is at odds with the clandestine nature of the image's dark, secretive doorframes and the barriers between the audience and this institutionalized, militarized world. The image itself does 'ask' us, once again, to respond, to 'answer' it in some way and so enter, not the room

itself, but a dialogue with the tensions and contradictions it reveals, epitomized by the incomplete flag and the image's shadowy margins. Similarly, in the edgy and ambiguous '4th July, Jay, New York' the flag dominates once more, here reversed, tattered, patched and transparent, as if its symbolism both screens reality and yet still might be 'seen through' to an alternative 'Independence Day' suggested by the two girls skipping underneath the flag that recalls, ambiguously, the last image from *The Family of Man*, whose children walk out of the darkness into the light with the promise of 'A world to be born under your footsteps. . .'

In Frank's *The Americans* youth, like blacks and women, are a recurrent aspect of this 'waiting' culture, tapping into the emergent Beat feelings and the incipient 'teenage' revolution of the mid-1950s. There is a group seen waiting by a jukebox, their eyes pointed to by the ornate machine and linked uncannily to the sign on a wall behind, 'BLINDS'. Are these 'blind youth', echoing the women in 'Parade', waiting to become part of the nation, finding solace in each other or the emergent music of the 1950s? His youthful characters are diverse, ambiguous and problematic; rich kids at a drive-in, apart and distracted, black and white bikers, Puerto Rican transsexuals in New York. This latter image epitomizes Frank's juxtapositional use of the 'found', here the punning sign behind his subjects ('DON'T MISS MISTER MISTIN') prefaces the complex cultural politics of the image, which positions Frank and his viewers behind railings looking at the three as if they are in a zoo. The apparent dominance and control of the photographer-as-ethnographer, turning subjects to objects, is undermined by the subjects' poses and by the mimicry of the central figure, whose hand forms a mask through which he gazes upon the photographer like the camera that looks upon him/her, thereby reversing easy notions of exploitation or intrusion. As always, Frank is aware of the multiple, surreal possibilities of the photographic image, here related to the act of spectacle and to self-performance, as the subjects 'control' the image and 'use' the moment for their own purposes, adopting and subverting 'normal' glamour photography or documentary traditions as modes through which to articulate their own creative priorities. Replacing the uncomplicated ethnographic document Frank creates a dialogic encounter, shifting power between the object–subject and the photographer–viewer in a series of exchanges about race, gender, power and the politics of 'looking' itself that do not cancel out the subjects' authority. In the gaze between lens and eyes, Frank challenges dominant power relations and visual traditions in similar ways to that of his Abstract Expressionist and Beat friends.

Like Ginsberg's 'shorthand notations of visual imagery, juxtapositions of hydrogen juke-box – abstract haikus', Frank's spatial images juggle language, form and idea within a 'field' across which emotion, imagination and thought could play (in Allen and Tallman 1973: 319). In this Frank shares much with Charles Olson's concept of 'composition by field', opposing 'closed verse' with a new formal experimentation based on high energy 'projective' or 'open verse', valuing 'kinetics', 'principle' (form as an extension of content) and 'process'. The improvised mobility of Frank's street photography has much in common with Olson: 'get on with it, keep moving, keep in, speed, the nerves, their speed, the perceptions, theirs, the acts, the split second acts, the whole business, keep it moving as fast as you can, citizen' (Olson 1966: 17). Olson insists that 'the conventions which logic has forced on syntax must be broken open' in the complex 'space-tensions of a poem' (ibid.: 21), so that what results, as in Frank's photography, is challenging, unsettling and always relational.

Consider the photograph 'Ranch Market, Hollywood', whose dialogic 'field of vision' creates Olson's tensions and relations by juxtaposing within the frame a working woman's face frozen with boredom, almost half asleep, staring beyond the frame, surrounded by the sleek, shiny surfaces of her workplace. In contrast, the world that she 'serves' signifies American commodity fetishism overseen by the smiling face of Santa Claus inviting the customer to buy more. The visual 'script' emphasizes commodification, size, value and excess: 'Jumbo size', 'extra', 'Bigger and Better than Ever', whereas she seems detached from this cycle of economic 'value' and hearty consumption. As a woman and a worker, her 'value' is defined as economic and therefore part of the market in which she is pictured, and her only defence is her stoicism and her gaze outside and beyond the reflective surfaces of her gaudy workplace.

In 'Barber shop through screen door – McClellanville, South Carolina' Frank creates a surreal space of simultaneity where elements intersect in patterns of dialogue: the inside and outside, human and non-human, detail and uncertainty, the seer and seen, light and dark, work and representation, voyeurism and documentary, transparency and opacity, reality and abstraction, absence and presence. As we try to 'read' this photograph Frank denies us the security of convention by denying us the clean edges of separation and distance that characterize 'reality' as categorizable differences – 'this' and 'not this' – and recognizable codes. Instead, things blur and connect as the reflection of Frank and his camera *reframes* the photograph from within, turning the act of representation back on itself so that 'front' and 'back', subject and object lose their anchorage as fixed vectors in our assessment of what is real, offering a productive ambiguity of multiple frames and screens that serve to 'recode' the image. The eight (at least) windows in the photograph mirror the lens, reminding us that despite its fixed position (in the camera, in the hands of Frank, in McClellanville, South Carolina) what this image creates is an 'unfixing' through which the representation of the everyday invites us to dwell on (and in) the possibilities and problematics of photography.

The dialogic nature of this image carries over into the next photograph 'Backyard – Venice West, California', whose equally specific title implies precision, clarity and exactitude, almost like an exercise in mapping. However, the titles mislead the viewer, for what is presented is the antithesis of conventional order. In 'Backyard' Frank achieves a similar effect to the first image but without employing its reflections and complex intersections. Instead, he frames a yard whose patterns, shapes and tensions provide a field of vision that befuddles the eye, causing the viewer to question the 'real' again. The image's 'voices' are full of contradictions and quirky juxtapositions, like the central figure sheltered by the flag, apparently at peace amid the yard's seeming chaos. It is a productive 'chaos' symbolizing the possibilities of the nation the flag represents, a hybrid mixture of rusting cars and fecund vegetation, of tract-home regimentation and proto-environmental recycling. Frank's deliberate confusion draws us into the dynamic relations of the image once more, noticing in the details of the backyard a hidden history, easily overlooked in the search for the grand narrative. But as always in Frank's work, the micronarratives matter – the 'backyards' and 'barbershops' tell an alternative history, or surreal ethnography, of America, like that in Ralph Ellison's *Invisible Man* (1952): 'Ask your wife to take you around to the gin mills and the barber shops and the juke joints and the churches, Brother. Yes, and the beauty parlours on Saturdays when they're frying hair. A whole unrecorded history is spoken then' (Ellison 1965: 379). This 'unrecorded history' tells ground-level stories of American people and places, a surreal ethnography which although often messy, muddled and unfinished, holds within the 'waiting' a sense of promise embedded in stoic resistance and the will to continue. The supposed 'order' of established lives and regimented expectations about what constitutes 'normality' are refigured in this surreal image, as so often in Frank's photographs, for this man at ease, smoking in his backyard, with his feet up amongst the debris, is a man who has found some equilibrium between order and chaos, stasis and mobility, convention and eccentricity, and he occupies a hybrid space, neither one thing nor the other, but *of both* – a dialogical 'other' space that weaves out of the fragments a contradictory, jagged 'history' in resistance to any assumed and 'natural' way of being. For all its implied criticism of the 1950s, Frank sees within America a diverse and divided nation of freedom and restriction, youth and age, poverty and plenty, a living mix of voices that play across the photographs like shadows and light, a dialogical pattern of immense, provocative and persistent ambiguity.

Reading Abstract Expressionist Art

Aesthetics, Politics and 'Cultural Theory': Barnet Newman's Utopian Painting

DAVID A. WRAGG

The critical literature on Abstract Expressionism is now so voluminous, and the issues so over-determined, that readers may be relieved to know that in this essay I do not propose any kind of survey, though there are certain reference points that cannot be avoided in any argument oriented towards 'cultural theory'.

To declare my hand at the outset, I am interested in the necessity of a certain resistance to 'cultural theory' on the part of Barnet Newman's painting, or rather the suggestion of resistance contained in a comment he made about his painting in 1962. At the same time, it must be maintained that such theory is absolutely necessary to our understanding of why this, and other Abstract Expressionist paintings, become socio-political objects. This means that I am both critical and supportive of a certain kind of formalist reading which appears for some critics to downplay the importance of social-political criteria. I want to argue that as an artistic object created and viewed in specific social-political circumstances, Newman's painting becomes political when it is resistant to the politics it can be held to represent. Readers will soon realize that my argument is not confined to Newman's paintings, though it accepts his insight into the plight of Abstract Expressionism as a historically specific event. In this respect though, my argument about the nature of free-market capitalism in the USA, where we can point to certain contradictions around the idea of artistic 'freedom' as being foundational, is bound up with some of the broader paradoxes of modernity, and the fate of avant-garde art within this perspective.

What, I want to ask, does it mean to think of Newman's painting as a kind of *protest* against the conditions in which it finds itself? What kind of 'protest' can an abstract painting – expressionist or otherwise – be said to articulate? To answer this question we must investigate some critical positions which view painting's aesthetic existence as a contentious issue in the context of its social epistemology – that is, its meanings as a set of social and political, as well as aesthetic, practice. To get this argument going I will firstly offer some remarks on the phenomenon of avant-gardism where Abstract Expressionism is concerned, since the phenomenon of 'avant-gardism' involves a crucial sense of art's entwinement with the idea of social *critique*. This will also help me to set out a good deal of my theoretical ground regarding the socio-political importance of aesthetic experience.

Clement Greenberg's contentious, by some now discredited, theory of Modernism – announced in 1939 (though anticipated in England by Whistler in the nineteenth century, and reformulated by Roger Fry and Clive Bell before World War 1) – begins by connecting the phenomenon of reflexive painting to the rise of commodified culture, whose code word is 'kitsch' (Greenberg 1992a[1]). Greenberg's claim is that painting protests about the forces of commodification by turning in on itself, to emphasize the fundamental characteristic peculiar to painting, and only to painting: the two-dimensional nature of the surface on which paint is applied. In a halting progression that leads to Abstract Expressionism, this reflexivity gives rise to abstract

150

art, prefigured in those Impressionist paintings in which the surface ceased to function as an illusionist 'window' through which a pictured content is displayed. Allied to this process – and this is the important thing in what follows – Greenberg gives to Modernist type painting an *aesthetic* importance, in which such perception is taken to be 'intuitive', ineffable and irrational. I take these qualities to stand in opposition to the rationalizing tendency of modern societies. Where capitalism is concerned – and it must be borne in mind that Greenberg started out on the political left – we have a situation in which the profit motive determines the nature of all cultural products to the extent that art risks being just another commodity to be bought and sold, like a pair of shoes, a can of beans, or whatever. Under the logic of what Marx called 'exchange-value' these things are essentially all the same. Clearly, if art's aesthetic dimension can be theorized as a kind of *remainder* to this sense of rationality it can function as the (self-) critical other of exchange-value. Modernist painting thus cultivates its own social marginality for the sake of its sociological critique. In a move which appears to deny art's sociological meanings but which is in fact crucial to its oppositional value, Greenberg claims that Modernist painting must be approached as an exclusively optical experience. The crucial theoretical move occurs when such experience is linked to art's aesthetic existence and its reflexive progression towards abstraction. These connections cannot really be prized apart; nevertheless it does make some sense to think of art's aesthetic identity as a kind of sociological critique, however 'dumb' from the perspective of a sociological understanding which seeks to identify and interrogate art's plight at the hands of rationalization.

Greenberg's sketch of a socio-historical context for art in 1939 arguably disappears in his later essays, leading some critics, and later Greenberg himself, to argue that the theory ultimately fails the test of political credibility set by its own left-wing impetus (see, for example, Harris 1993).[2] I will be – somewhat hesitantly – disagreeing with this view in due course. If Greenberg's *later* sense of avant-gardism is predicated on aesthetically autonomous abstract paintings – and on the triumphant emergence of Abstract Expressionism as the all but culminating example of a trend begun unconsciously, as it were, by Manet in the 1860s (see Greenberg 1992b) – it is obviously at odds with a resoundingly left-wing kind of Realist art whose *raison d'être* has been to emphasize the socially engaged function of aesthetics. All forms of art involve reflexive elements, of course, but in Greenberg's early model it is art's overriding reference to the painterly surface above all which provides for a critique of commodification and the concomitant reduction of individual and collective freedoms that go with a left-wing view of modern, or 'late', capitalist societies. For me, Greenberg remains important here because: (a) his theory of Modernism unites the ideas of social critique and 'intuitive' aesthetics while also expressing the *tension* that arises when one half of this equation is allowed to dominate the other; and (b) his attention to the surface of painting can be construed as a thoroughly *paradoxical* attempt to account for what happens when painting becomes aware of itself *as* painting, and not as anything else. This is paradoxical because aesthetic intuitionism cannot, for reasons that originate with Greenberg's sense of Kantian philosophy,[3] communicate with rational attempts to understand the laws that govern society and painting's place within it. In other words, the *aesthetic* experience of painting, at least in Greenberg's Kantian sense, resists not only the logic of the capitalist market-place, but also the one-sidedness of critical accounts that try to ignore the political ambiguities of that experience, at least if we understand politics to be the rational understanding of social contradictions in the cause of social improvement – an improvement which would include the social reintegration of art. One might cite here Eva Cockcroft's 1974 essay on the abduction of Abstract Expressionism by the CIA as a 'weapon of the Cold War', which inevitably encloses the paintings' aesthetic identities in a politicized account of art's socio-political vulnerability (Cockcroft 1992).

In a world given over to the values of the profit-motive and the commodity form, art's aesthetic ineffability – its 'intuitive' or irrational quality – stands as a kind of uselessness; scandalous because from the point of view of exchange-value art *must* be reduced to its value as a commodity. Greenberg allows that the avant-garde cannot completely detach itself from the logic of capitalist society, but his theory, whether in 'early' *or* 'late' form, is based on a powerful

critique of that logic and its implications for aesthetic perception. Essentially, I take from Greenberg the idea that art has something to offer that exists, however paradoxically, outside the means-end thinking that dominates the kind of economic determinism of modern life, however much this determinism is masked or elaborated by ideals of democracy, social mobility, technological progress, individual rights, the freedom of self-expression, and so on. In saying this, I want to avoid any kind of crude base/superstructure argument in which art is *merely* a function of its economic determinants. Yet only a fool would deny that art has to exist in a world where real power is vested in the predominance of economic over cultural values. In this sense, one might say that economics simply *are* the predominant form of modern capitalist culture, and that what art 'puts back' into society is subject to the very means-end thinking which in its critical mode it wants to avoid. Aesthetic experience of the kind I have in mind here, then, stands perilously close to the edge of invisibility, and this is both a bad and a good thing. It is a bad thing because aesthetic experience cannot afford to be gobbled up by its reduction to just another commodity, but good thing because art's aesthetic marginality guarantees its uselessness a profoundly critical force. One could put this another way by saying that aesthetic experience exists as the Other, or radical alterity, of commodification and means-end thinking, and in this condition it suggests something important for a more developed sense of social freedom and responsibility than capitalism can provide.

Mine is hardly a new argument, of course. Matthew Arnold wrote along similar lines about poetry in *Culture and Anarchy*, while the whole thrust of a certain kind of 'English Studies' remains devoted to social improvement through aesthetic responsiveness, even though 'Cultural Studies' commentators have exposed some of the ideological assumptions of this enterprise.[4] Coming closer to home, Michael Fried's extension of Greenberg's Modernism in *Three American Painters,* first published in 1965, claims that attention to the demands of aesthetic experience is a crucial part of individual and social enlightenment. Here, it seems, there is a 'correct' way of looking at a Pollock drip painting, or a Rothko colour field canvas, which delivers 'the denseness, structure and complexity of moral experience – that is, of life itself, but life lived as few are inclined to live it: in a state of continuous intellectual and moral alertness.' Ergo, the 'formal[ist] critic of [M]odernist painting . . . is a moral critic: not because all art is at bottom a criticism of life, but because [M]odernist painting is at least a criticism of itself' (Fried 1992: 773). Note the orientation here: by turning inward in Greenbergian fashion, art and the aesthetic experience it generates interrogates its own means, to the extent that 'originality' becomes the code word for a kind of *social* self-interrogation and improvement. I say 'improvement', but this actually misrepresents the fraught nature of modernist perception in Greenberg and Fried. Both these writers operate with a profound sense of social crisis which Abstract Expressionist painting both represents (its marginalized claims for morality in a non-moral world) and points beyond (life as it *might* yet be lived). Such painting therefore represents a *need* for something better than it can *wholly* express, by dint of its ambivalent relationship to the world in which it lives. Thus too for critics, who attempt to offer rational arguments for a kind of experience which is fundamentally *irrational*. Fried talks about critics who may well be wrong in their assessments of a painting's *artistic* worth, and by extension wrong about that painting's *social* significance. And yet 'being wrong is preferable to being irrelevant; and the recognition that everyone involved with contemporary art must work without certainty can only be beneficial in its effects' (ibid.: 774). Why beneficial? Presumably because, at least as I have framed things so far here, aesthetic uncertainty – that is an uncertainty about aesthetic effects – arises when the critic senses the tension between the closures of his *social* diagnosis and the uncertainty of art's *aesthetic* identities.

This is a very important issue when we come to the idea of Abstract Expressionism and 'cultural theory'. All cultural criticism proceeds from political assumptions. To take an example already mentioned, Cockcroft's exposure of the CIA's cultural investments in Abstract Expressionism inevitably closes down the uncertainty of the paintings' *aesthetic* worth in an argument which abrogates their existence to an exposure of Cold War rhetoric. In this argument, the values of 'freedom' in the USA are pitted against the relative unfreedoms of artists in

the old USSR and Eastern Bloc. Cockcroft's is a critique of ideological deception when she finds that the socially anomalous art of the Abstract Expressionists was promoted to demonstrate artistic freedoms in the USA as part of a *covert* operation of artistic sponsorship. But there is a real danger here, anticipated in Greenberg and Fried, that an identification of art as a political football in the 1940s and 1950s may reduce the critical force of aesthetic perception by saturating it with a counter-politics, even as an oppositional sense of aesthetics is thereby paradoxically preserved. In her second paragraph Cockcroft remarks: 'In rejecting the materialistic values of bourgeois society and indulging in the myth that they could exist entirely outside the dominant culture in bohemian enclaves, avant-garde artists generally refused to recognize or accept their role as producers of a cultural commodity' (Cockcroft 1992: 82). The word 'myth' is well chosen, particularly in view of the historical avant-garde's aspirations for social change, but the risk is that the 'uncertainty' of aesthetic perception gets lost in the act of critical completion. The question is: what happens to aesthetic experience when the world is seen to be political through and through?

Now I hasten to add that I am *not* suggesting that aesthetics can exist outside politics, any more than I want to argue that art exists in some value-free domain outside history. (Nor am I suggesting that history can simply be collapsed into politics if we can locate moments of resistance which reject the current limitations of political positions.) Cockcroft's timely essay was a major contribution to the literature on Abstract Expressionism, and it is quite rightly required reading for a certain kind of 'Cultural Studies' art history. But the ability of aesthetics to *resist* the political closures heaped upon it now seems to me to be the major talking point in Cockcroft's essay. The essay thus deconstructs its own premises when these are apparently predicated on a politicized reading of what counts as artistic 'freedom' in the USA in the period in question. What the essay exposes is therefore counterposed by what aesthetic experience cannot reveal. There seems to be a kind of dialectic operating here between Cockcroft and the implications of Greenberg–Fried on art's moral value. In this dialectic, the political football of Abstract Expressionism is still booted back and forth, but the issue of what art might mean in and of itself when stripped of its political accretions is strangely preserved. It is this sense of an art which transcends, albeit impossibly, the depredations of politics that seems to lie behind a notable comment made by Barnet Newman, in an interview conducted in 1962: 'Almost fifteen years ago Harold Rosenberg challenged me to explain what one of my paintings could possibly mean to the world. My answer was that if he and others could read it properly, it would mean the end of all state capitalism and totalitarianism. That answer still goes' (quoted in Wood *et al.* 1993: 155).

The paradox here is that in arguing for his painting's opposition to political coercion Newman is obviously making a political statement. But the 'Utopian' gesture towards a world beyond the two social systems underpinning Cold War rhetoric, and therefore beyond 'the political', should not be underestimated. Yet what does it mean to speak of a 'Utopian' element in Abstract Expressionist painting? How does such an element actually signify in the paintings themselves? How is one to recognize it beyond the arguments of a Greenberg or a Fried? Is it merely a function *of* those arguments or does it have an independent existence? If so, how can that existence be verified, if not in some sort of critical discourse, even if that discourse belongs to an 'ordinary' spectator offering her opinion on a work hanging on the gallery wall? In short, how are we to understand the Utopian potential of aesthetic experience generally, and in Abstract Expressionist works in particular?

We must first acknowledge the kind of reading, represented by Jonathan Harris's work on Abstract Expressionism, that respects the differences between individual Abstract Expressionist works with reference to a collective left-wing politics in the 1930s, problematically registered when artists such as Pollock and Rothko later find themselves in political extremis, occasioned by the climate of the Cold War and revelations about Stalin's nefarious activities in the USSR. This argument holds that aesthetic decisions – for example the use of abstraction – can be recuperated with reference to a critique of Greenbergian Modernism, on the grounds that the '"autonomy" or "relative autonomy" of avant-garde art' and its Utopian aspect are in the end

socially blind to the very effects that bring the autonomy thesis into being in the first place. Drawing on Walter Benjamin's essay 'The work of art in the age of mechanical reproduction', Harris sees 'Utopian' criteria as contaminated by a kind of art-for-art's-sake refusal of social engagement, represented by Fried's concentration on the 'actual experience' of art (quoted in Harris 1993: 72), with all its ineffable aesthetic residues, organized around Greenberg's core idea, expressed in the essay 'Complaints of an Art Critic' (1967), of aesthetic intuitionism – that is, to repeat, the idea that involuntary aesthetic experience somehow stands outside of rational determination. Harris prefers Greenberg's 'Avant-garde and kitsch' over 'Modernist Painting' because the former essay has a 'Cultural Studies' (or 'cultural theory') focus the latter lacks. In 1939, says Harris, Greenberg had correctly identified, somewhat against his own argumentative logic, the divided nature of contemporary culture which actually gave rise to the latter theory's exclusionary emphasis on aesthetic quality as the primary motor for 'moral' judgement. In other words, ideas of 'autonomy' must themselves be socially, historically and politically situated, and any claims for aesthetic experience as 'Utopian' contextualized in these terms.

This kind of argument seems at first, and even second, glance to be perfectly reasonable. By opening out the idea of aesthetic registration in Abstract Expressionism to the wider frames of 'late' capitalist modernity, Harris performs an important act of critical integration, in which the 'failure' of Abstract Expressionist works to signify in an obvious socially committed way is balanced by an effort to understand why and how that 'failure' came about. Here, the 'failure' to pursue the political commitments of the 1930s by Pollock and others is seen to reflect critically on the plight of an art menaced by a 'freedom' to paint which is ideological through and through when such freedom is predetermined by the values of capitalist rationalization. But it is precisely at this point that the idea of a Utopian aesthetics needs to be disentangled from political necessity. Theorists of ideology – Althusser for example – are caught in a performative contradiction when they define ideology in terms of an unreachable horizon of consciousness: if there is no outside to ideology, what is the epistemological status of the theory on which this premise is based? 'Ideology' in Althusser performs a double function when it is both the limit of freedom and a critical gesture towards its abolition. Newman's comment can surely be interpreted as a desire to escape this kind of double bind for the sake of a world unconstrained by the twin evils of capitalism and state socialism, and it thus has a Utopian element in its appeal to a form of aesthetic vision which has not yet come to be. Of course, such a vision must perforce be fashioned out of the ruins of modernity, but that is not to deny the gesture 'beyond' politics. In this sense, Newman's painting protests against a number of things, among which one might cite its inevitable commodification by the art market; the ideological construction of painting by the museum space and its inherent narratives of spectatorship; the academic culture industry with its own 'internal' logic of critical production; the indifference of 'mass' culture to painting and 'the arts', and so on. But my point is that its gesture towards aesthetic freedom cannot be explained *solely* in these terms which have become central to the 'new' art histories, because they are already 'corroded' by political necessity – I give 'corroded' scarequotes to indicate the political 'uselessness' of aesthetics. So I would maintain that Newman's 'ideal' painting wants to exceed the closures that readings such as Harris's impose on it. This closure arises not so much from the operations of 'cultural theory' in Harris's insistence on the 1930s as a formative context for Abstract Expressionist works, but from an unwillingness to give Greenberg a more open hearing. Harris misses the connection that can be made between 'Avant-garde and kitsch' and 'Modernist Painting', if we can see in the later essay a tightening of the Utopian boundaries drawn around the importance of aesthetic experience, rather than a mere abandonment of the socio-political context that informs the 1939 essay, with all its Trotskyist underpinnings. A more generous assessment of Modernist theory then grants us the kind of ambiguity that I am looking for in this essay: a kind of ambiguity that sees aesthetic experience, vested in Abstract Expressionism as Greenberg's and Fried's favoured art, as bound up with, but oddly disconnected from, the wider concerns of modernity, of which the Cold War becomes in both Cockcroft and Harris the 'local' example of modernity's trials and tribulations.

Such an ambiguity is necessary to preserve what is worth hanging onto in Modernist theory

while subjecting it to an essential critique on behalf of rational, as opposed to 'intuitive', principles. Something along these lines occurs in Jay Bernstein's essay on Abstract Expressionism first published in 1996, particularly in its dialogue with T. J. Clark. Clark, as a major advocate of the 'social history of art'[5] takes issue, like Harris, with what are taken to be the inadequacies of Greenbergian Modernism, particularly its apparent insistence in 'Modernist Painting' on bracketing off social issues from the consideration of painting's aesthetic dimensions. While I am conscious of skewing both Clark's and Bernstein's arguments away from a central issue in the latter's essay, where Greenberg is not foregrounded as such, Bernstein's interest, via Adorno and Heidegger, in the relationship of Abstract Expressionism to 'late' capitalism is important for my sense of what aesthetic perception stands to lose/gain when it protests à la Newman. If Newman's remark is, as already suggested, about what Bernstein calls 'perceiving, representing [the act of perceiving], and the *limits* of perceiving and representing' (Bernstein 1996: 8, my emphasis) it must perforce be commenting in some way on what we can and cannot know about the (visible) world, and thus be about the *resistance* of abstraction, and indeed of art more generally, to the explanatory discourses heaped upon it.

Given the notorious 'resistance to reading' of Abstract Expressionism, particularly in those accounts like Harris's which want to make the paintings amenable to a fully visible politics of representation in which the inadequacies of Greenbergian Modernism are exposed, we are entitled to talk about aesthetic remainders, residues, irrationalities and ineffabilities as part of a *critical* discourse in which these things are not trampled over for the sake of political clarity. Hence my earlier questions – which on logical grounds I cannot answer – about how the Utopian element of Abstract Expressionism actually signifies. In my understanding of Bernstein's argument, this point is bound up with a larger one about the framing conditions for our current understanding of art. The issue here is one of diremption, or the splitting off of 'human nature [as this has become under the technologism of modern societies] and nature' (ibid.: 9). Bernstein is, of course, preoccupied with the reduction of experience in capitalist societies to what Adorno thought of as instrumentalized rationality and means-end thinking, in which everything, including human subjectivity, is measured according to its exchange-value. So '[t]he cultural crisis generated by science, technology and capital is a crisis of subjectivity and meaning; the [post-Hegelian] disenchantment of the world is the proximate and ground cause of this crisis' (ibid.). Via Adorno and Heidegger, Bernstein claims that Abstract Expressionist paintings express this cultural crisis by dint of their fraught meditations on the value of aesthetic experience, where this can be construed as in some way compromised by the paintings' socio-political framing conditions. Hence the protest. Hence too, the whole problem of what looking at Abstract Expressionism through the lens of 'cultural theory' represents when *seeing its works as aesthetic* is the point at issue. To see them 'properly' as aesthetic objects is in this sense to confront the problem of diremption. As Bernstein puts it, quoting the Adorno of *Aesthetic Theory*: 'The marrow of experience has been sucked out of the concrete. All experience, including experience that is removed from economic experience [including, then, aesthetic experience – JB], has been emaciated' (ibid.). The problem, then, is to restore aesthetic experience to 'economic' experience without simply crushing it in the jaws of the vice from which it has just escaped.

I am suggesting that the privileging of aesthetic experience in Greenberg and Fried suggests that the intuitive or ineffable nature of that experience can act as a critical bulwark against the political closures operating in certain kinds of 'cultural theory'. Now this is not to say that Clark or Harris do not care about aesthetic experience – quite the opposite. But as writers whose work has been informed by Marxist metanarratives, they have to confront the long-standing problem of how aesthetic experience is to be understood when it is menaced by the rationalizing tendency in theory, 'cultural' or otherwise. This is not, of course, an argument against theory, or an argument which advocates that Abstract Expressionist works can somehow stand by themselves to be intuitively understood. As I said earlier, Cockcroft is essential reading if we want to know how Abstract Expressionism was positioned and exploited by Cold War propaganda. What I like about Bernstein's reading is the way in which it uses theory to argue against itself

on behalf of art. In doing so it makes Adorno's relationship to Marxism a key issue, so that Adornoan critical theory becomes the necessary object to be transcended in a world beyond diremption. Given the ironically reflexive, and often despairing, politics of postmodernism it seems almost laughable to think that an aesthetic contemplation of Abstract Expressionism can do much to move us away from the edge, but the idea of art's freedom from domination – the point of Newman's remark – is worth hanging onto because if this hints at a world in which art might be socially integrated it also hints at a world beyond the present limits of cultural politics, however valuable these may be for casting fresh light on difficult and contested issues. And this in turn hints at the possibility that rational and aesthetic modes of experience, alienated from each other at the philosophical level in Kant's Enlightenment, and at the social level by the maw of instrumentality and means-end thinking, can come together to make modernity a thing of the past.

According to Bernstein, the reflexive turn in modernist art – the reflexive turn that functions as a cornerstone in Greenbergian Modernism – reflects critically on a world which cannot provide sufficient meanings for art's existence. It cannot do this because it has distorted what it means to be human, or to be free, in the fullest sense of our potential as human beings. Here, works of art, and abstract works in particular, protest because that is all that they can do. Or to put it in Bernstein's terms: 'If there are no positive meanings outside art that can be cited, then art will be forced to cite itself, the fact of its continuing, without anything to support that self-citation other than works. What such works allow is *the experience of the absence of experience*' (ibid.: 16, his emphasis). As Bernstein points out, to have the possibility of being fully human inscribed in the alienated space of aesthetics is indeed 'outrageous and ludicrous', when in a world given over to the commodification of human 'freedoms', any promise borne by the art of a Newman or a Pollock, a Rothko or a Lee Krasner, is already overdetermined by its political identities which are 'heroic, self-serving, self-important, fatuous and kitsch all at the same time' (ibid.). One might argue that Greenbergian theory suffers from just these problems, but then so does so much 'cultural theory' when it assumes the impossible burden of maintaining art's unique importance in a world governed by international capital, global terrorism, George Bush II, and the politics of 'democracy'. Outrageous and ludicrous but, as Adorno argued, desperately important.

In 'The Decline of Cubism', published in December 1948 in *Partisan Review*, Greenberg held that the impetus of the avant-garde – in fact 'the main premises of Western art' no less – had passed from Europe to the United States, 'along with the center of gravity of industrial production and political power' (Greenberg 1992c: 572). Having named Gorky and Pollock, Greenberg's equation of aesthetics and capitalism inscribes the predicament of Abstract Expressionism in Modernist cultural (rather than 'just' aesthetic) theory. It is arguably this equation which had already prompted Newman in October 1947 to prioritize the value of aesthetic experience in the face of 'the domination of science over the mind of modern man', where scientific or rational understanding achieves the status of 'a new theology'. What Newman bemoans is the kind of 'modern' science, with the 'rhythm of its logic-rite', that has 'overwhelmed the original ecstasy of scientific quest, scientific inquiry' (Newman 1992: 567). The Adornoan resonance of Newman's language is obvious enough. However, in claiming that 'man's first speech was poetic before it became utilitarian' (ibid.: 569) Newman elevates art above all other human activities, thus making a paradoxical move in which aesthetics is connected to a model of human development from which it is currently annexed. Such a structural opposition between centre and margin grants aesthetic experience a role in human affairs which only serves to underscore the domination of 'science' over those affairs. As with Greenberg, and later Fried, this move does not *remove* aesthetics from socio-political discourse; rather, it points up the *tension* involved when something taken to be ineffable confronts that which is 'known' only too well. For Newman, as for Kant, the idea of a science of aesthetics is a contradiction in terms, a marker of modernity's diremption.

The annexation of Greenbergian aesthetics from arguments about 'the social history of art' tilts our understanding of Abstract Expressionism too far in the direction of a postmodernist

conception of art's fraught social identity, with the concomitant risk of cynicism after the demise of the Marxist left. The long view of art – that is the view which sees art as part of the unfolding history of modernity, rather than just an example of a 'local' politics – provides a context for understanding 'big' claims like Newman's about art's meanings, its situation *vis-à-vis* the freedom to create, and its Utopian dimension. What Harris calls Greenberg's 'unexplained intuition of "rightness" or "wrongness" based on the experience of the works themselves' (Harris 1993: 72) – in other words the quality of aesthetic experience such works are held to contain or provoke – becomes important when such experience becomes the sign of a life worth (or possibly worth) living in spite of a thoroughly reified world. To hang on to the values of High Art in these circumstances does not mean that other cultural and political issues disappear. Quite the reverse: an insistence on the *self-critical* value of aesthetic experience sharpens our perception of what it means to have such an experience in the first place in relation to cultural knowledge, and thus how the idea of cultural difference, governed in Harris's case by the old 'high'/'mass' culture divide, is shaped in a world dedicated to the reduction of *all* experience by exchange-value.

Thus, when we speak about 'cultural theory' in the context of Abstract Expression we must not use this term to explain the art of Newman, if by explain we mean to give an account which remainders the complexity of aesthetic experience in the search for political credibility. Rather, we must continue to regard the whole question of political epistemology as a necessary evil in the face of an unreachable Utopia that is both historical and pressingly critical of the history we have created for ourselves.

Notes

1. This collection also contains relevant essays by Fry and Bell. See in particular Bell's 'The Aesthetic Hypothesis', first published in 1914.
2. For a revealing, and probably disingenuous, interview with Greenberg, see Burstow 1994: 33–5.
3. On the discordance between rational and aesthetic criteria – so important for a raft of (post)-Kantian thinkers on modernity, of whom Nietzsche is the crucial example – see J. M. Bernstein (1993), particularly his Introduction.
4. See, for example, the work of Terry Eagleton. His *Literary Theory. An Introduction* (1983), made quite a splash when it was first published, and continues to appear on academic reading lists.
5. See, for example, Clark's essay in Frascina and Harris (1992: 40–50), abstracted from *The Painting of Modern Life. Paris in the Art of Manet and his Followers* (1985). On Abstract Expressionism, see Clark 1999 (Chapter 7), which incorporates ideas in previously published material referred to by Bernstein.

Part 3: 1963–1980

Part 3: 1965–1980

Introduction to Part 3

DAVID HOLLOWAY AND JOHN BECK

As we have seen in Part 2, the power of visual media to produce consent during the Cold War was internally troubled at times by the immediacy and unpredictability of TV news, by the liberal agenda of certain strands of Hollywood film, and by photography, art, and art theory attuned to the embedded contradictions of the 'American Way'. Throughout the 1960s and early 1970s, the political and visual literacy of many Americans – especially among the massive youth market produced by the postwar baby boom and weaned on mass visual culture – placed visual culture at the centre of many of the decades' historic struggles, containments and acts of dissent (Figures 22 and 23).

Calling upon the cameras of the mass media to broadcast images of racist brutality and a series of astonishing and courageous acts of civil disobedience, media editors and Civil Rights activists in the South realized the political power of the visual image's indexical relation to the real. In the hands of a racially diverse group of photographers, as Deborah Willis shows in the introductory essay to Part 3 of this collection, photographing the Civil Rights movement, and being photographed as part of it, functioned as a self-conscious act of personal and collective testimony for many of those involved, providing iconic images of resistance and commitment that were syndicated around the world. Willis looks at the history of photography's involvement in the movement, from the heroism of the Montgomery Bus Boycott and the martyrdom of Emmett Till in 1955, through two of the huge Civil Rights demonstrations of the 1960s – the 25,000 strong march from Selma to Montgomery in March 1965,

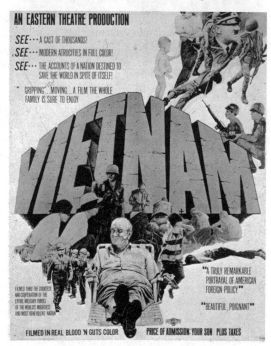

Fig. 22. A spoof Anti-Vietnam war poster (1968) advertising an Eastern Theatre Production of a film, *Vietnam*, which is 'Filmed in real blood'n guts color' and states, 'Price of Admission: Your Son plus Taxes'. A smiling President Lyndon Johnson lounges in the foreground. (Photo by MPI/Getty Images.) Courtesy of Getty Images.

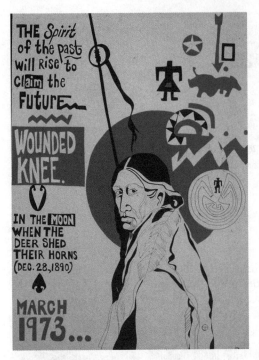

THE *Spirit*
of the past
will Rise to
claim the
Future

WOUNDED
KNEE.

IN THE MOON
WHEN THE
DEER SHED
THEIR HORNS
(DEC. 28, 1890)

MARCH
1973...

Fig. 23. A poster commemorating the massacre of Wounded Knee (March 1973). (Photo by MPI/Getty Images.) Courtesy of Getty Images.

and the colossal March on Washington in August 1963.

The 1963 March on Washington was one of the great achievements of Civil Rights activism. While the March reflected the success with which the Kennedy administration harnessed popular activism in support of federally-sponsored legislation, it was also an important moment in the early history of the New Left. Indeed, 1963 was a pivotal year – expressions of mass popular dissent in Washington and Birmingham, the enforced integration of the University of Alabama (following that of the University of Mississippi the previous year) and Martin Luther King's *Letter from Birmingham Jail* competing with the assassination of President Kennedy, and with important historical markers such as the signing of the Nuclear Test Ban Treaty and the publication of Betty Friedan's *The Feminine Mystique*, for the attention of historians and cultural critics.

Alongside essays in Part 2 of this collection by Celebrezze, Shaw, Campbell, and Wragg, Willis's account of the role played by photography in the Civil Rights movement reminds us that many of the paths that would intersect in the dissensus of the 1960s were already well marked in the previous decade. It would be risky, however, to assume that the mainstreaming of what Tom Wolfe memorably called 'radical chic' in the 1960s meant that an unproblematic radicalism, or a 'revolutionary' movement, was abroad in the US. During the 1960s and 1970s the position of dissent within the machinery of capitalist-democratic visual culture on one hand, and the representation and reproduction of new social and cultural formations on the other (feminism, the Civil Rights movement, black power, the antiwar movement, 'New Hollywood', a politicized artistic neo-avant-garde) was complex and frequently contradictory.

Where Willis demonstrates that one source of photography's power as a political medium during the 1960s lay in its attachment to the 'real', Jean Kempf and Bruno Chalifour trace what they see as a steady erosion of social and political 'commitment' in American photography that was also under way during the 1960s, a draining of radical energies from a 'professionalized' and institutionalized photographic practice that would gather momentum through the 1970s to become, they argue, the governing mode of subsequent decades. Kempf and Chalifour's polemical essay locates a depoliticizing of American photography and its slippage into 'solipsism' in the institutionalization of photography as a recognized discipline, and in the attendant professional apparatus of galleries, curators, publishers, college degrees, and canon of recognized artists and texts that grew up around it. As TV and other media replaced photography as the prime site for journalistic reportage, they contend, photographers turned to art and advertising and embraced the same *mise en abyme* of representation that has emerged as one intellectual mode of the dominant 'postmodern' paradigm in universities of the capitalist-democratic North and West since the 1970s. In the second half of the twentieth century, they argue, the iconic social and political forms that photography once produced were replaced by a new meaninglessness of the visible, and by the dissolution of photography's potential to act in tandem with other agencies as a funnelling of political transformation.

Kempf and Chalifour's essay is also, in several respects, a meditation on the fate of modernism in the visual arts, and so picks up again the discussion initiated in Part 1 of this collection (see Holloway and McComb) and continued in Part 2 (see Saab and Wragg). As discussed by Saab, the cultural initiatives of the New Deal attempted to work into the autonomous art of high modernism a form of social responsiveness akin, if in rather different terms, to the utopian dimension achieved briefly in Russian revolutionary art of the early twentieth century. After World War 2, however, and the ascendancy of the United States as leader of the 'free world', the need to demonstrate 'actually existing' liberty under the American Way found in modernism a means of display that translated 'high' cultural forms into political as well as economic capital. American modernism, especially in painting, came to represent, in crypto-evolutionary art historical terms, the 'triumph' (to borrow Clement Greenberg's word) of Americanism, and a powerful cultural weapon in the Cold War against the Stalinized Eastern Bloc.

The reinscription of high art as distinct from mass visual culture held the further advantage of invigorating the art market and preserving the entrepreneurial agency of the artist as a cultural counterpoint to the rugged capitalist-adventurer. The renewed attempt at preserving a 'high' cultural autonomy, however, was eventually compromised from within, as mass culture became the object of fascination for artists themselves. The major Pop artists of the 1960s – Warhol, Rauschenberg, Johns, Rosenquist – evoked masscult's logics while cannibalizing its products in surrealist-inspired assemblage that knowingly reproduced the operational paradigm of advertising in the manufacture of a space, as Thomas Crow observes, 'in which commodities behave[d] autonomously and create[d] an alluring dreamscape of their own' (Crow 1996: 36).

Following Kempf and Chalifour, two further essays in Part 3, by John Beck and Francis Frascina, are concerned in different ways with the changing fortunes of a prospective American avant-garde. Beck examines the shifting status of the Zapruder film of the Kennedy assassination, showing how the history of postwar American art reveals a collapsing of older cultural categories, such that the vernacular evidence of a home movie has been reconfigured as an iconic artistic/historical object. In recent years, as Beck discusses, the status of the Zapruder film has led professional valuers to compare the film directly to 'art', and to describe it as comparable in status and economic value to works by Matisse and Andy Warhol – a development Beck attributes to the transformation, since WW2, of what is thought to constitute 'high' art (especially in art history and cultural theory), and to the emergence of postmodern readings of visual texts since the 1960s. The recent history of the Zapruder film reveals, Beck suggests, much about the continued fetishization of the 'art' object (even under conditions of postmodern simulation), and about the pathological insistence on the endless repetition and circulation of iconic images in the visual economy of the late-twentieth-century US.

Frascina's essay demonstrates how the dilemmas of Abstract Expressionism discussed in Part 2 by David Wragg were answered, at least in part, by the emergence of radical DIY art publishing in the 1960s and 1970s. Binding his critique into the broader social and cultural struggles of the time, Frascina discusses the challenging of institutional art practices by collective and non-studio art initiatives that cut against the grain of established cultural values in the US. His essay assesses both the radicalism of contemporary independent art publishing – particularly its attempt to construct a non-commodified art produced by creative acts of disalienated labour, and the emergence of resistant feminist art forms – and its limitations. The publications Frascina considers addressed dilemmas which were central to oppositional visual culture at the time and remain vital today, not least the difficulty of engaging dominant capitalist-democratic practices and ideologies while evading appropriation by them, and the corresponding need to engage marginalized constituencies without becoming 'ghettoized'. As Frascina suggests, these negotiations were fraught and not always successful, 'the paradoxes of . . . dissent and critique within a dominant consumerist culture reliant on manufacturing a desire for spectacular novelty' remaining entrenched in many of the avant-garde practices and publications of the time.

What is clear, however, is that the collapse of Fordist consensus-culture during the 1960s and 1970s produced a self-reflexive challenge to established art institutions that was in no way a

merely 'internal' struggle against formalism. Indeed, the earlier evacuation of history from art as a set of institutional and social practices during the 1950s, articulated and sanctified by Clement Greenberg, was clearly a modality (however undecidable) of Cold War 'containment', and revisionist critique of the gallery and the 'art object' during the 1960s and 1970s is shot through with the tensions of the period.

Disillusionment with the authority of institutionalized art was a characteristic feature of much post-1960s' visual culture, driven, like so many disillusionments of the time, by the catastrophe of Vietnam, by the violent loss of political and community leaders, and by increasing social disorder. Dissatisfaction with the Civil Rights movement's non-violent activism led to a new militancy among many African Americans, and the increasing willingness of activists – from the Black Panthers to the Weathermen to Earth First! – to meet institutional violence with violent dissent is a measure of the acute alienation of many young Americans from capitalist-democratic ideology during the period.

It would be simplistic, however, to frame the 1960s as a decade of widespread radicalism summarily swept away by Nixon's 'silent majority' in 1968. What the crises of the period produced was not so much the failure of 'revolution' as the integration of a peculiarly American form of identity politics into the late- (and subsequently post-) Fordist matrix, as the 'consensus' or 'containment' culture structural to the reproduction of 'high' Fordist political-economy in the late 1940s and 1950s fell apart. Real gains, and some losses, were made by the reformist social movements of the 1960s. But the enduring characteristic of the post-1960s period has been the remarkable reinvigoration of a supremely plastic capitalist-democracy capable of meeting the challenge of a pluralized, multicultural United States, and equipped with a cultural vocabulary of ideological and commodity forms that continue to rearticulate, as Thom Gunn once said of Elvis Presley, 'revolt into style'.

The power of the visual icon, discussed by Beck, is also the subject of Robert Hariman and John Lucaites's essay. Hariman and Lucaites argue that Nick Ut's iconic image of a naked Vietnamese girl fleeing a napalm attack during the Vietnam War, like other iconic photos of the twentieth century, provides a performative engagement with public affairs that is, due to the visual nature of the communication, emotional as well as discursive. Hariman and Lucaites show how the 'accidental napalm' photo mobilized public concern in America over the prosecution of the war, but did so by appealing to and reaffirming the same ethic of liberal individualism despoiled in the picture. Discussing the subsequent media interest shown in the fortunes of the girl, Kim Phuc, as she grew up, the essay suggests that the developing 'human interest' narrative has served to massage and neutralize the political importance of the original photo by constructing a narrative of conventional liberal recuperation that draws us away from, rather than back towards, the destruction of Vietnam.

The negotiation of radical social movements in popular visual culture of the 1960s and 1970s is also discussed in essays by Bill Osgerby and Linnie Blake. Osgerby examines the iconography of the 1960s' 'single girl' in a variety of visual sources, including photo-spreads and advertising in *Cosmopolitan*, and popular 'new femininity' TV shows and film of the 1960s. Osgerby argues that such texts simultaneously articulated and undercut emergent feminist discourse, converting social criticism into a rhetoric of personal fulfilment he describes as 'commodity feminism' – a reinscription of the social as the private, and of commodification as 'liberation', that is given a 'post-feminist' context in Anna Gough-Yates's reading of the TV show *Sex and the City* in Part 4, and that echoes the dilemmas of the avant-garde discussed throughout this collection. Blake's focus is on the new generic hybrid of urban *noir* Western that emerged in the 1970s following the exhaustion of the traditional Hollywood Western, a hybrid that fused conventional genre tropes and put them to work in a wide-ranging scrutiny of contemporary political and social values. While television undermined the dominance of the movies as the primary visual narrative form after the 1960s, Blake notes that the decline of the major studios opened a critical space for new intellectual and political positions in Hollywood film. But, as she also notes, in movies such as *Taxi Driver* and *Little Big Man*, those positions were as often marked by a pessimistic sense of historical disorientation, and by a recycling of

older hierarchies and myths, as by any cogent challenge to the decaying social orders of late Fordist America.

The film school generation that produced so many socially engaged Hollywood movies during the 1970s would also help to reverse the fortunes of the film industry, with the renovation of the spectacular effects-heavy blockbuster towards the end of the decade. In this and several other respects, a film such as George Lucas's *Star Wars* (1977) might be seen retrospectively to mark the emergence of a reinvigorated right wing that would reach its fulfilment with the election of Ronald Reagan in 1980. Conservative elements within the Carter administration, Soviet development of medium-range nuclear weapons targeted on Western Europe, and the invasion of Afghanistan in 1979, had all helped shift US foreign policy rightward: indeed, it was Carter who initiated the military build-up inherited by and generally credited to Reagan (Edwards 1996: 278–9).

The importance of Hollywood in the political worldview of the 40th President of the United States has become a cliché, generally cited in order to trivialize as simplistic Reagan's political and intellectual milieu (Figure 24). But the popularity of Reaganism, an ideological stew of old social-Darwinism, nostalgic nationalism and the new Christian Right, was essential for the legitimation of Reaganomics, a more conflicted melding of Keynesian/Fordist

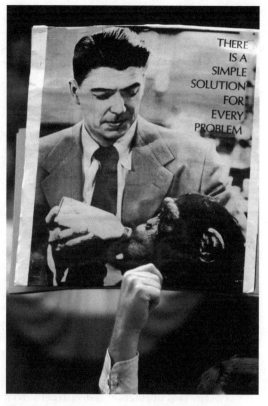

Fig. 24. A poster (1980) depicting Ronald Reagan bottle feeding a chimp in his 1951 film, *Bedtime for Bonzo*, is held aloft at a Democratic Convention in New York. (Photo by Luiz Alberto/Keystone Features/Getty Images.) Courtesy of Getty Images.

deficit-financing and aggressive cuts to social spending, accompanied by the intensive deregulation of corporate power and tax cuts for the super-rich. Reagan, as is often noted, was an intuitive capitalist-democratic politician, who sensed both the correlation between his own world-view and Hollywood's, and the populist potential in each. As such, the cliché about Reagan's 'Hollywood' world-view perhaps tells us as much about certain traditions of Hollywood film as it does about the fundamentalism of Reaganism and the new Christian Right. Certainly Reagan was more than happy to name his Cold War version of what we now call National Missile Defence after Lucas's nostalgic (though technologically advanced) space opera.

Visualizing Political Struggle

Civil Rights-era Photography

DEBORAH WILLIS

This essay examines photography's role in documenting Civil Rights protests in a variety of forms during the 1950s and 1960s. It explores how photography motivated the general public and aroused public opinion, and it analyses how photography informed social consciousness. In viewing the photographs of social protest activities and Civil Rights leaders discussed in this essay, we may tend to believe that, to varying degrees the medium of photography is an open-ended and didactic form of visual expression; and, further, that the photograph merely authenticates the written word. But as Roland Barthes writes in *Camera Lucida*,

> The photograph does not necessarily say *what is no longer*, but only and for certain what has *been*. This distinction is decisive. In front of a photograph, our consciousness does not necessarily take the nostalgic path of memory (how many photographs are outside of the individual time), but for every photograph existing in the world, the path of certainty: the photograph's essence is to ratify what it represents. (Barthes 1981: 85)

These photographs remind us that our actions today will affect the future, just as the actions of courageous individuals during the Civil Rights movement changed the world. They also remind us that photographers played a crucial role by documenting the varied experiences of living in a segregated society, and calling upon it to change.

Photographers had begun to record and to publicize the large issues concerning the race problem, such as racial violence against blacks and the struggle for equal rights for all Americans, and to document protest movements even at the beginning of the twentieth century. Some of the earliest known protest photographs include images of NAACP demonstrations against lynchings, Jim Crow laws, Ku Klux Klan rallies, and protesters outside of federal and state government buildings calling for the end of segregation in the 1930s and 1940s. The use of smaller hand cameras and faster film stock drastically changed this type of reporting, and eventually these tools became widely used by photographers covering the marches, rallies and protesters. By the early 1950s, the concept of both the modern Civil Rights movement and photography began to change in America, the coverage of organized mass demonstrations, boycotts, and resistance movements founded by dedicated black and white Americans against Jim Crow laws throughout the South establishing what Vicki Goldberg (1991) refers to as 'a new pattern for the coverage of social activism'. For the first time, photographers told the story of a mass protest movement in the United States. News and documentary photographers focused their cameras on Civil Rights activities, including demonstrations, sit-ins and protests in Southern cities. At the same time, black picture magazines like *Our World*, *Flash*, and *Ebony* flourished with the same mission as more widely distributed publications such as *Life* and *Look*, which were introduced as all-picture format magazines in the mid-1930s, and which had

become the most popular news magazines in the history of photojournalism. Throughout the 1950s and 1960s, a racially diverse group of photographers made compassionate and terrifying photographs of the harsh realities of the struggle for the right to vote, fair employment and equal opportunities.

The decade of the 1950s was pivotal for the initial visualizing of the movement. Photographers focused on events like the cases brought before the Supreme Court, such as the *Brown v. Board of Education of Topeka, Kansas* ruling in 1954 and the attempt at widespread school desegregation; the murder of young Emmett Till in 1955; boycotts led by both local citizens and the black clergy; and the activities of Southern resistance groups such as the Citizens Council and the NAACP's Legal Defense Fund. Photography documented the Jim Crow signs for 'colored' waiting rooms, seating areas, drinking fountains and restaurants. The segregated signs, one room or fountain marked 'colored' and the other 'white' demonstrated simply, in visual form, what it meant to be a member of the privileged class and the underclass in the American South.

During the most active years of the Civil Rights movements, a significant number of photographers worked to document the struggles, achievements, and tragedies of the freedom movement. Many travelled from the North and a small number photographed within their own communities. South Carolina-based photographer Cecil Williams recalls, 'When I started freelancing for *Jet*, the *Afro-American, The Crisis*, and the Associated Press, black weekly newspapers relied heavily on freelancers like myself to cover news from the black perspective because wire news coverage was sparse . . . As tragic as these circumstances were, it was this background and climate that made me not only a photographer, but a chronicler of the most significant humanitarian movement in the history of humankind' (Williams 1995: 4). When the headlines addressed the ending of legalized segregation on public buses, following a Supreme Court ruling prompted by the year-long Montgomery Bus Boycott of 1955–6, photographers such as Charles Moore, Ernest Withers, Gordon Parks, Richard Saunders, Bert Miles and Moneta Sleet, Jr. recognized the historical significance of the time and their roles as recorders and interpreters of the movement.

When Emmett Till, a young black teenager from Chicago visiting Money, Mississippi, was brutally beaten and killed in 1955 for whistling at a white girl, his swollen body was photographed and published in *Jet* magazine. Photography played a significant role in Till's story that summer, both prior to his murder and after:

> He had brought with him photos from his junior high school graduation in Chicago, which showed both black and white students. Seeing that the Southern children were impressed, Emmett commented that one of the white girls in the photographs was his girl friend. This prompted one of the local boys to say, 'Hey, there's a white girl in that store there. I bet you won't go in there and talk to her.' Calling the boy's bluff, Emmett went in, bought some candy, and as he was leaving the store, said to the woman, 'Bye, baby'. (Wilkinson 1997: 84)

The all-white, all-male jury found the white male defendants who had killed Till not guilty.

Memphis-born Ernest Withers was hired as a photographer for the Emmett Till murder trial, which lasted a week. After the trial, Withers returned to Memphis where he co-published and distributed a pamphlet on the murder trial titled *Complete Photo Story of Till Murder Case*. It was sold for one dollar a copy. This act revealed Withers' concern for preserving the memory of this horrific experience. As he wrote in the circular, 'we are not only depicting the plight of an individual Negro, but rather of life as it affects all Negroes in the United States. In brief we are presenting this photo story not in an attempt to stir up racial animosities or to question the verdict in the Till Murder Case, but in the hope that this booklet might serve to help our nation decide itself to seeing that such incidents need not occur again' (Withers *et al.* 2000: 60).

The 1960s provided many opportunities for photojournalists to record the Civil Rights movement in the United States. Its activities were unfolding on the streets in virtually every rural town and urban city in the American South, with organizations such as the Student Nonviolent

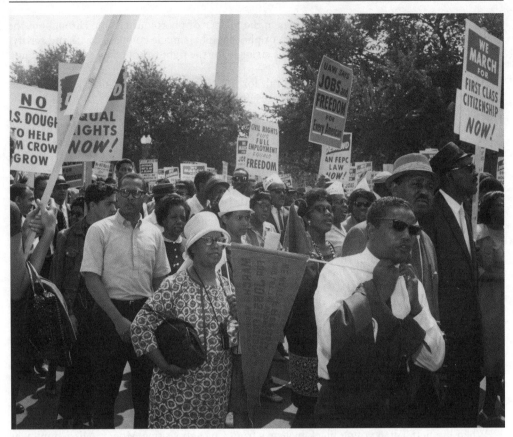

Fig. 25. Protesters at March on Washington. c. 1963. Photograph by Jack T. Franklin.
Courtesy of the African American Museum in Philadelphia.

Coordinating Committee (SNCC), Congress for Race Equality (CORE), and Southern Christian Leadership Conference (SLC) leading the way. The tragic death of four little girls in a church bombing at the Sixteenth Street Baptist Church in Birmingham in 1963 was documented by photographers. During the same year, throughout the country men, women, and young people were organizing busloads of Americans who were planning to attend the March on Washington in August, the largest Civil Rights demonstration in American history. Through photographers' coverage of the day the contemporary viewer is privileged to see how effective the March on Washington was. Photographs not only captured the spirit of the moment, they also served as a visual narrative of events such as the initial organizing meetings for the March. Photographers captured images of the participants who travelled by buses, trains and cars, as well as those who walked and joined hands to help stage the massive demonstration in the nation's capital (Figures 25 and 26). These moving visual testaments of the event include formal and informal studies of the American people, whether leaders, celebrities, or the people whose voices demanded to be heard. Images of celebrities such as Harry Belafonte and James Baldwin committed to the movement and the ideals of the democratic doctrine show them standing with everyday people (Figures 27 and 28). There were intense crowd shots and close-up portraits of proud and determined people.

In other areas of America, photography and television news vividly told the story of Freedom Riders travelling throughout the South, and the murder of three Civil Rights workers, James Earl Chaney, Michael Schwerner and Andrew Goodman, in Mississippi, in June 1964. By the mid-1960s, the protest movements had become a national crusade for human rights for all

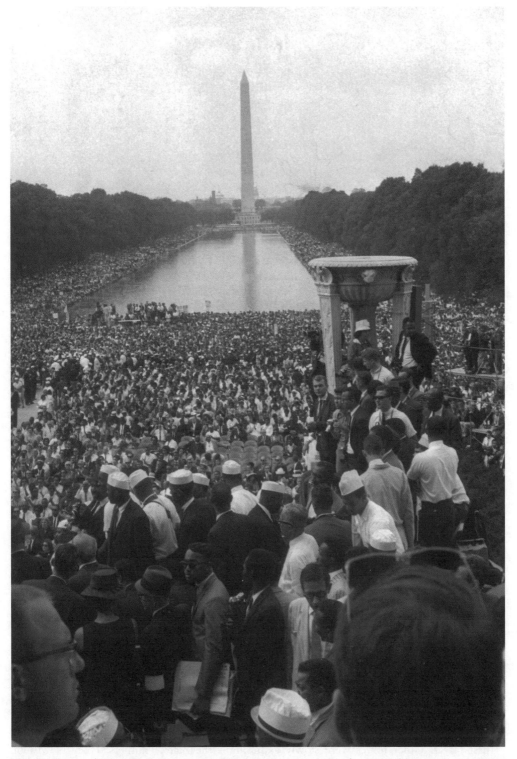

Fig. 26. View of Washington Monument and Protesters at March on Washington. c. 1963.
Photograph by Jack T. Franklin. Courtesy of the African American Museum in Philadelphia.

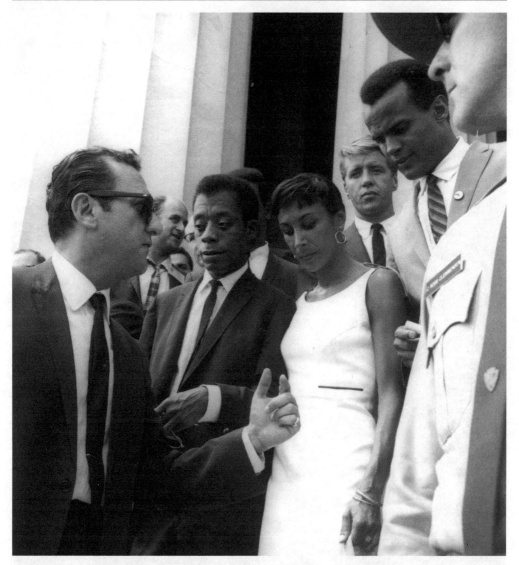

Fig. 27. James Baldwin, Harry and Julie Belafonte, at March on Washington. c. 1963.
Photograph by Jack T. Franklin. Courtesy of the African American Museum in Philadelphia.

oppressed people. Newspapers and magazines throughout the world had published gripping images of racial hatred and police brutality in Birmingham, Selma, Montgomery, Oakland and Los Angeles, and of racial unrest in cities across the Unites States.

As well as its coverage of the integrationist struggle for Civil Rights, during the 1960s photography also recorded the emergence of, and was used by, the Nation of Islam (NOI). Gordon Parks recalls his photographs of Civil Rights activism in this way.

In 1963 the turbulent black revolution was steadily building and *Life* magazine wanted to cover it. The Muslims and Malcolm X, their fiery spokesman, had become the magazine's first target. Other forces were slowly gathering – the Black Panthers, Huey Newtown, Stokely Carmichael, Eldridge Cleaver, and Bobby Seale would come later to stridently berate racism throughout the nation. Infiltration into their volatile camps by a white publication

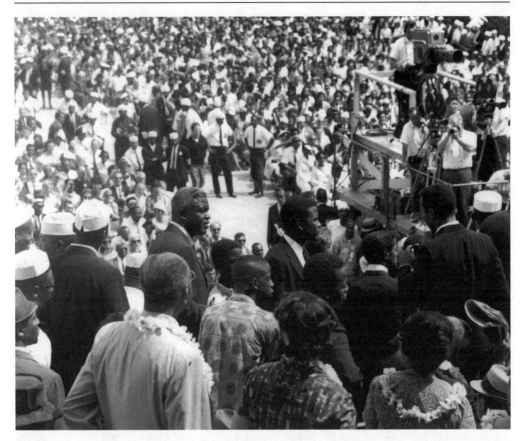

Fig. 28. Jackie Robinson, Sidney Poitier and Sammy Davis, Jr. at March on Washington.
c. 1963. Photograph by Jack T. Franklin. Courtesy of the African American Museum in
Philadelphia.

> that was held suspect seemed impossible. Whatever attempts the magazine had made had
> fallen flat. It seems reasonable that at the time, *Life*'s editors would question my ability to
> report objectively about black militancy. I was black and my sentiments lay in the heart of
> black fury sweeping the country. (Parks 1997: 240)

Cameramen from television stations, newspapers and magazines were on hand to document
these events, demonstrations and conditions that impacted on the conscience of America. The
small triumphs in local communities and the disappointments in the larger cities are forever
etched into our memories primarily because of the camera lens. The impact of the movement
caused committed photographers such as Jack Franklin, Danny Lyon, Bruce Davidson, R. C.
Hickman, Leonard Freed, Benedict Fernandez, Roz Payne, Beuford Smith, Jonathan Eubanks,
Roy DeCarava and Parks to document both the brutalizing events and the triumphant rallies.
SNCC photographers such as Doug Harris, Elaine Tomlin, Bob Fletcher, and Matt Heron were
at the forefront, documenting the voter registration drives in the South.

Many families experienced episodes of hostile confrontation that intensified during the years
of the social protest movements. Black families and white sympathizers were killed, hosed,
jailed, and subjected to Jim Crow laws across the United States. Photographers witnessing these
events created a new visual consciousness for the American public, establishing a visual lan-
guage of 'testifying' about individual and collective experience. During this difficult and
complex time, photographers sought to create a collective visual memory that would empower

171

communities, while at the same time provide evidence of their fears, struggles, defeats, goals and victories. The photographs they made allow the viewer to look critically at the complexities experienced by the leaders, followers and communities they documented.

They also testify to the complex experience of the photographers themselves. Curator Steven Kasher asserts that 'some photojournalists covering the movement realized that they were recording crucial moments of a nation in transition, and they were inspired by that prescience of historical significance. Some, even in the South, were angered by the scenes of racist injustice that they witnessed and came to support the cause of civil rights, insinuating that support into their pictures' (Kasher 1998: 12). Photographer Bruce Davidson, for example, recalls an event from the Civil Rights movement that affected him deeply and personally:

> In the spring of 1965, I returned to the South, joining the Selma march in Alabama. Hundreds of people were marching the fifty miles from Selma to Montgomery, the state capital. There were reporters, press, TV crews, helicopters, police and the National Guard, making the event seem like a parade. As I walked with the marchers, I photographed them by themselves and when they stopped to rest. I took pictures of them looking straight into the camera. They confronted an invisible audience with proud, determined looks. During the night that the march ended, Viola Liuzzo, a white civil rights worker from Detroit and mother of four children, was killed by a shotgun blast through her car windshield. The next morning I saw the bloodstained seat, shattered glass fragments and skid marks where her car had gone off the road. The violence in the South had reached into me deeper than my personal pain. (Davidson 1978: 12)

Davidson's photographs capture and revisit such moments of tragedy and hate, determination and strength. Working on this series of photographs, he confronted many issues about the role of the photographer in documenting violence, demonstrations, and defiance. Davidson's keen attention to environmental detail and human gesture encourage us to add his images to our collective memories. Photographs of his such as the one of a woman centrally positioned between policemen, her arm twisted and the movie marquee in the background reading 'Damned the Deviant', challenge and reinterpret what we've learned in the past; through images such as these we gain a broader understanding today of the determination of young black and white Americans in the years between 1960 and 1965.

Davidson's photographs during the 1960s depict the tragedy of hate as well as the determination of the community and the strength of its leaders. His culturally imbued images are simultaneously affirming and disarming. A photographer working during a tumultuous period of American history, Davidson focused his camera on the seemingly small moments that changed the shape and form of the Civil Rights movement. His photograph tells a compelling story about community pride and survival, work, love, and self-determination. These small moments gave voice to the continued frustrations of the local communities. Davidson shows us that there is more to the Civil Rights movement than the violent and racially charged images we so often see.

Danny Lyon was another photographer who helped create a new visual consciousness for the American public during the Civil Rights movement. As Lyon recounts, about his experience in Albany, Georgia,

> Smoking a corncob pipe, drifting in and out of the southern accent he had picked up in Mississippi, [SNCC executive secretary James Forman] was serious, extremely polite, and always under pressure. Forman treated me like he treated most newcomers. He put me to work. 'You got a camera? Go inside the courthouse. Down at the back they have a big water cooler for whites and next to it a little bowl for Negroes. Go in there and take a picture of that.' With Forman's blessing, I had a place in the civil rights movement that I would occupy for the next two years. James Forman would direct me, protect me, and at times fight for a place for me in the movement. He is directly responsible for my pictures existing at all. (Lyon 1992: 30)

Lyon's photograph of the water cooler and bowl plainly depicts the horrific reality for black people in Albany, Georgia. The 'white' water fountain is larger, free flowing with a quick switch of the dial; while the drinking water fountain for the black man, woman, or child, short or tall, was the size of a small bowl that appears to be not even three feet from the floor. As the perfect visual metaphor for 'Jim Crow', this photograph, like many others of its type, helped mobilize the protest movement.

In 1969 *Ebony* photographer Moneta Sleet, Jr. became the first black photographer to win the coveted Pulitzer Prize in photography for his photograph of Mrs Coretta Scott King and her daughter at the funeral of Dr Martin Luther King, following King's assasination in April 1968. Sleet first met Dr King, then a 28 year old Atlanta minister who was emerging as the leader of the Civil Rights movement, while on assignment in 1956. Their association had flourished as the movement dominated the black press, with Sleet covering Dr King receiving the Nobel Peace Prize in Sweden in 1964 and the march from Selma to Montgomery in 1965. Although employed by a monthly magazine, *Ebony*, Sleet was eligible for the Pulitzer because his photograph of Mrs King was used by a wire service and published in daily newspapers throughout the country. Sleet's contribution to photojournalism is his extensive documentation of the marches, meetings, and rallies of the Civil Rights movement, focusing on people singing spirituals while demonstrating and marching. Coverage of the fledgling Civil Rights movement had given *Ebony's* sister publication, *Jet*, its reputation and in the early years his photographs appeared in both.

Photography and photographers such as these were instrumental in galvanizing young people, motivating cultural change and defining the significance of the struggle for human and civil rights that eventually forced the federal government into creating laws against racial domination and discrimination. Photographs of anonymous Americans and leading figures such as Martin Luther King, Jr. and Malcolm X marching, protesting, participating in sit-ins and attending rallies, showed the world that blacks were indeed fighting back, and depicted the new Southern black as rebellious and deviant.

Charles Moore's photographs of Martin Luther King's arrest for loitering, in Alabama in 1958, show graphic evidence of this new black citizen. In one, Dr King, wearing a hat and suit, is jostled by police officers. Dr King looks directly at the camera and his gaze focuses on the viewer. This intersection of gazes is both unsettling and fixed, Dr King negotiating this moment of powerlessness to one of empowerment as result. The image bears visual testimony to Dr King's own observation that 'The tension which we are witnessing in race relations in the South today is to be explained in part by the revolutionary change in the Negro's evaluation of himself . . . You cannot understand the bus protest in Montgomery without understanding that there is a New Negro in the South' (quoted in Morris 1984: 106). During this period of black self-consciousness and radicalization, black photographers and black artists responded and contributed to this politicized cultural climate with acts of visual self-representation and new expressions of black pride and identity. These artists organized exhibitions of black art that explored physical beauty, black political power and their African heritage. The term 'black' was itself transgressive, and it became a positive self-definition for many African Americans.

Towards Postmodernism

Post-World War 2 Photography in America: From Committed to Solipsistic Art

JEAN KEMPF AND BRUNO CHALIFOUR

Because of the photograph's indexicality, photographers can barely escape being 'committed' in a way that painters rarely have been, as they are bodies directly engaged with their 'subjects', and photography has for the largest part of its history been associated with an actively political activity. Until the mid-late 1950s, almost all twentieth-century American photographers could be seen as belonging to a 'committed' tradition of American *relevance* – a tradition that was political, and republican, in that it accepted the possibility of social change, viewed photography as a means of social intervention, and stressed the necessary construction of communities of shared beliefs through participation in viewing experiences.

At one end of the spectrum the Farm Security Administration, the Photo League, and figures such as Robert Capa, Eugene Smith, as well as magazine, documentary and journalistic photographers, all produced 'committed' photography, that is to say a type of photographic practice based on the assumption that showing the world (and usually its darker sides) was a means of acting upon it. But even the work of such high modernists as Alfred Stieglitz, Edward Steichen, Ansel Adams, Walker Evans or Paul Strand embodied the ethos of community and 'relevance'. Whether idealistic (Strand) or materialist (Evans), or even spiritualist (Stieglitz, Minor White), their eventual goal, the improvement of human life, rested on a strong humanist philosophy. For Strand 'artistic purity meant ethical purity' (Green, 1984: 19), and the same could be said of many American photographers of the pre- and postwar period. For Edward Weston, Dorothea Lange, Margaret Bourke-White, W. E. Smith or Ansel Adams, for example, the pursuit of perfect technical mastery in the 'fine print' (where the photographer used 'previsualization' techniques, thinking first in terms of the final artefact, then shaping the whole process backwards, as it were, so as to create the image exactly as it was conceived) was inseparable from the evocative meaning of the photograph.

Paradoxically, however, as Civil Rights protest, the emergence of second-wave feminism, and opposition to the Vietnam War broke down years of intense 'normalization' during the 1960s, American photography seemed to shift overwhelmingly from clear commitment – even of the most tepid and generalized form – to cool, artistic, 'plastic' detachment. The agenda changed radically, and in a rather short period of time. By the 1970s, the remnants of socially oriented practices such as mainstream photojournalism appeared seriously devalued, as demonstrated in the influential New York critic A. D. Coleman's repeated appeals that a new 'commitment' should replace the inoperative concept of objectivity (Coleman 1979; Eisinger 1995: 54; Lyons 1966). The 'committed' discourse had been displaced from human documentary to landscape photography, a move first instigated by Ansel Adams and his campaigning on behalf of the Sierra Club and exemplified by the exhibition *New Topographics* curated by William Jenkins at the George Eastman House in 1975. Landscape photographers such as Lewis Baltz, Jo Deal, and Robert Adams, participating in *New Topographics*, addressed the negative impact of urban

sprawl and reckless industrial exploitation of natural resources as well as pollution issues. Later colour photographers such as Robert Glen Ketchum, Terry Evans, Robert Dawson, David Hanson, and John Pfahl would investigate further a path whose climax can be appreciated in Richard Misrach's epic series, *Desert Cantos*. This shift was not accomplished, however, without manifesting the same ambiguities as earlier practices. By the 1980s 'commitment' had come to mean the extreme particularization of photographic practice, and a repudiation of the universalizing tendency exemplified by key exhibitions of the past such as *The Family of Man* (1955). Such practices were showcased by the series of exhibitions that Nathan Lyons, the then assistant director of the Eastman House in Rochester, NY, organized in the early 1960s. At the Museum of Modern Art (MoMA) in New York, John Szarkowski, appointed director of the photography department in 1962, 'revealed' the works of Diane Arbus, Garry Winogrand, Lee Friedlander, and William Eggleston. The main characteristics of these photographers had to do with the idiosyncrasies of their visions and styles but their commitment to humanism, a notion at the core of 'committed' or 'concerned' photography (as defined by Cornell Capa) was peripheral.

By the end of the 1980s, the very possibility that photographers could or should act politically through their work was openly under attack. Preoccupations had shifted from the general 'political' world to more clearly defined themes, namely gender, ethnicity, or sexual preferences. This shift away from 'political politics' resulted from a clear internalization by artists – and in our case photographers-artists – of a conservative pressure on the public and private sphere (and here the Mapplethorpe 'controversy' dwelling on sexual preference and the definition of 'obscenity', and their funding by public money comes to mind).[1] The social role of photography had shifted, from a modernist commitment that saw form as an intervention in society, to a new formalist expression which, despite its apparently committed stance (in Cindy Sherman's work, for example, or that of the 'New Topographers'), functioned *structurally and economically* within the commodified realms of art; even though, as in the case of the New Topographers, the photographers themselves may have made political comments and analyses about their work and environment. This essay describes the complex shift that happened in American photography between the mid-1950s and the late 1970s, and identifies some of its institutional, social and historical causes.

The last representative moment of 'commitment' in American photography was the *Family of Man* exhibition (1955), a late example of the large, popular exhibitions shown at International Expositions since the nineteenth century. Everything about the *Family of Man* made it a perfect, seamless extension of the 'communication' techniques practised by the then powerful illustrated magazines.[2] The exhibition was notable for the total control of the curator/editor, Edward Steichen (the newly appointed director of the newly created Department of Photography at the Museum of Modern Art in New York), and his assistant Wayne Miller, and for the disappearance of the photographer/author as such. At the *Family of Man* the pictures were mounted 'flush', in various sizes, at various heights – in other words, as they would appear on a magazine page, with the pictures subservient to a master narrative using them as raw material. The exhibition, criticized by Barthes (1957) and Sontag (1977) as perversely universalistic,[3] spoke in a *collective* voice which attempted to erase the subjective point of view, turning it instead into a sort of language of nature, a voluntary disappearance hiding the work of ideology (Barthes 1982a). Even at the time, though, *The Family of Man* was already at odds with the current doxa, which was in the process of shifting the focus from the social to the personal statement of the image maker, or returning to high modernism's reflexive analysis of the medium (Bezner 1999: 169). A counterpoint to Edward Steichen and Wayne Miller's *Family of Man* can be seen in the numerous group shows that Nathan Lyons organized at the George Eastman House, *Photography at Mid-Century* or *Photography 63* for instance. These shows were based on the 'Salon' model in which each artist is represented by one or two pieces that must stand on their own, next to others which are totally unrelated. These were surveys reflecting the contemporary production of fine art photography but not consciously proposing any 'reading' of 'the world'. In *Photography at Mid-Century*, for instance, abstract compositions by Minor

White, Walter Chappell, Carl Chiarenza, Gyorgy Kepes, Aaron Siskind, and Nathan Lyons himself, were juxtaposed with a landscape by Ansel Adams, a portrait by Yousuf Karsh, a street scene by Robert Doisneau, 'committed' images by Eugene Smith, Henri Cartier-Bresson, Cornell Capa, or Werner Bischof. *Photography 63* focused on young photographers; its artistic slant was close to what *Subjektive Fotografie* was doing at the time in Germany.

This shift, and the normalization of intellectual and artistic life it entailed, had a lot to do with the historical conditions of American cultural life in the 1950s, where the atmosphere created by the Cold War, the response of conservative opponents of the New Deal, and the corporatization of art (museums being philanthropic but not disinterested ventures) had a 'taming effect' on politically involved photographic practices, making social criticism seem less 'natural', if not entirely beyond the pale. A case in point is the history of the Photo League, which was blacklisted in 1947, and disbanded in 1951. The first League, called the Film and Photo League, was created in 1930 as the result of a merger between the Workers' Camera Club of New York and The Labor Defender Photo Group. Their goal was to produce films and photographs that would document and support the struggles of the American working class, as well as train a new generation of documentary photographers and cinematographers. In 1936, the photographers left, distancing themselves from the philosophy defined by the International Communist Movement, and founded the Photo League of New York. Their goal was not only to produce politically involved documents, but also to teach and train new members in photography that would give a 'true' picture of the world, an alternative to the capitalist press. The League, which was blacklisted by the House Un-American Activities Committee in December 1947, was one of the creative hubs of American photography. All the major players of the field, from Ansel Adams to Walker Evans or Beaumont Newhall had had some form of contact with it, either as a member or a teacher, or even occasional lecturer. The normalization of American social life in the 1950s, for which HUAC has become emblematic, had important consequences for American photographers. Even Paul Strand, whose work could hardly be seen as proselytizing or overtly politicized, felt compelled to emigrate to France in 1949 as the result of the HUAC investigations into the activities of the League and its blacklisting.

The time was thus ripe for a more introspective, and in some cases almost mystical, photography. This was not far removed from the apparently 'value free' practices in contemporary Abstract Expressionist painting (for which, as Harold Rosenberg put it, 'The big moment came when it was decided to paint . . . just TO PAINT. The gesture on the canvas was a gesture of liberation, from Value – political, aesthetic, moral' [Rosenberg 1952: 23]). The politically conservative atmosphere of the late 1950s encouraged a retreat into the safe enclave of creative individuality, an exploration of the tropes of the medium, and a shift away from the collective ethos of instrumentalized art, in both its American 'committed art' and Soviet socialist realist forms. Metaphor replaced metonymy, as visual arts – among which photography's indexicality made it the most exposed to the 'world' – embraced allegory and aestheticism in a return to the symbolism and pictorialism (the renewed interest in older and alternative processes) of over half a century earlier (Bezner 1999: 220; Wallis 1984).

As John Szarkowski noted, between the 1910s and the 1950s photography in ink had achieved 'virtual hegemony' in public, visual media in the United States, and had consequently affected large audiences, turning photography into a truly democratic art, and photographers into powerful 'players in the world of large affairs' (Szarkowski 1989: 249–93). In advertising, in photojournalism, in commercial photography, working for publication had created a new sense of authority for the photographer. This led on the one hand to increased dependence on commissioners and the chain of production before and beyond the photographer (editors and art directors), and on the other hand to stardom for some practitioners, and a new awareness of the social and ethical responsibility of the photographer – W. Eugene Smith being a case in point, despite his idiosyncrasies. Some, such as Margaret Bourke White, Richard Avedon or even Walker Evans – who by the early 1960s lived in New York's Upper East Side – became part of the cultural jet set. Others, such as Robert Capa, who turned out many of the icons that constructed the invented history of the twentieth century, were made into mythic figures.[4] The

decline of the photojournalist and documentarian (the great photo magazines *Look* and *Life* would finally fold in 1971 and 1972 respectively) led to the creation of photographic cooperatives on the model of Magnum Photos, whose function was to 'increase the authority of the photographer and his control *vis-à-vis* the magazines' (Szarkowski 1989: 250). It was also accompanied by a shift in photographic practice closer than ever towards the art world.

Among the factors eroding the dominant position of the documentarian and photojournalist was the advent of television as the main window on the world, as photography made way for images which flooded the public and private sphere. The work of photographers such as William Klein, or Robert Frank, can be seen as an aesthetic testimony to this sense of loss, paralleling a political and social loss of innocence with an ironic commentary not so much on the world (the United States for Frank, certain international cities for Klein) as on representation and the profession of photography itself (Klein). In *Life Is Good and Good For You in New York: Trance Witness Revels* and *New York* (1955), *Rome* (1959), *Tokyo* and *Moscow* (1964), Klein departs from the American tradition of the large format camera and the fine print. Equipped with a 35 mm camera, he walks the streets of the cities of the modern world. People are captured in their daily activities through the distortion of a wide-angle lens. The resulting black and white images show high contrast and coarse grain.

Less politically or socially inclined than Frank, Klein presented the viewer with 'right in your face' images, photography 'New York style', where the camera is held right under the noses of the subjects/spectators who glance ambiguously at it. There is little to be learnt about the people before the camera in Klein's work: these images are about the photographer, whose presence provokes the glances – a visual provocation that is the exact opposite of Henri Cartier-Bresson's philosophy as defined in 1952 in *The Decisive Moment* (*Images à la Sauvette* in its French edition). There is very little 'decisive' in Klein's images, just moments caught. Klein's crude and violent (especially compared to Frank's distanced eye), but ultimately merely formal relationship to the world is best exemplified in his *Broadway and 103rd Street* (*New York*, 1955) where a man facing the camera points at the photographer under the eye of young teenager. *Near Bowery* and *Candy Store, Amsterdam Avenue* (both in *New York*) illustrate Klein's participatory although ambiguous relationship to his models, and ultimately to photography, which, in his hands, lost most of its documenting, indexical potential. In *Near Bowery*, a young boy surrounded by two smiling girls, engages the camera with his own smile while an older boy whose head is cropped by the frame holds a gun to his left temple. In *Candy Store*, a photograph whose negative has obviously undergone careless exposure or processing, a young black boy is squatting in front of a checkered wall covered with cigarette ads. He is wearing some sort of Hawaiian short-sleeved shirt, and stares at the camera. Next to him, to the left, an older boy stands, whose upper body has also been cropped out. The only participatory interaction left between operator and spectator is what Roland Barthes defined as the *punctum* in *Camera Lucida* (1982), discrete elements in photographs that allow the viewer to *project into* them whatever he needs/wishes to or, to put it differently, to transform them into self-referential spaces.

Two structural developments resulted from the evolution of the status of photography, and in turn accelerated it, allowing for the autonomization of the photographic field: first, the establishment of an intellectual tradition in photography, through education and criticism; and second, photography's entry into the art world, with its institutions (museums, galleries, and private collections) and its market (its specialists, its auction houses, its constant rise in prices through the practice of limited editions, and the creations of categories such as 'vintage prints').

The expansion of higher education, boosted by the G.I. Bill, in the United States after World War 2 had similar effects on photography as on other disciplines, the proliferation of photography curricula for a new and varied audience producing increasing numbers of graduates who in turn sought teaching positions (see the Horrell Reports on photographic education published by Eastman Kodak from 1964 to 1983;[5] Lewis *et al.* 1973: 7; Coleman 1998). The Society for Photographic Education, created in 1963 in Chicago, is one perfect example of the new intrication of teaching, practice and conservation characteristic of the period. The Society's goals

and means were defined during its Invitational Teaching Conference of 1962, held at the George Eastman House. The majority of the participants had links with Rochester (through George Eastman House and the Rochester Institute of Technology) or Chicago (the Institute of Design, better known as the 'New Bauhaus', as it had been directed by Moholy-Nagy since the late 1930s). The conference was divided into think-tanks whose discussions dealt with all aspects of how to teach photography, from pedagogical technique and the designing of courses, to how to teach the history of the medium and educate the photography critics of the future.

The expansion of higher education that led to the creation of institutions such as The Society for Photographic Education shifted the economics of professional photographic practice. As more teaching positions became available the immediate economic support traditionally offered by press or documentary assignments, alongside commercial studio work, became less critical and so stimulated the market for 'art' photography.[6] By the 1970s, students taught during the previous decade by the first generation of 'institutional' teachers themselves sought jobs as curators and advisors, or became the owners and employees of the gallery system. Also significant in the new 'plastic' approach to photography were the government agency grants, especially those provided by the NEA (the National Endowment for the Arts, whose programme of direct grants to photographers and support to museums began in 1971, six years after its creation under President Johnson; it expanded until its drastic reduction in 1983) as well as grants from private corporations, and from foundations such as the Guggenheim Foundation (Foresta 1984; Lafo 2000: 30; NEA *http://www.nea.gov*).[7] The developments in photographic education also brought a new version of the photographic 'star system', with 'a particular college, university, or art institute . . . considered photographically significant not because it had, say, an intelligently structured and well-rounded programme which gave students a thorough grounding in the history of the medium and all the diverse processes it encompasses, but rather because Harry or Aaron or Minor or Ansel or Jerry was teaching there' (Coleman 1979: 198). Almost as significant, the development of art teaching in higher education provided photography – until then regarded largely as a form of 'applied', 'mechanical' or second-rate art – with the 'high art' or fine art paradigm. New, younger photographers readily embraced it as traditional 'transitive' modes (i.e. self-consciously, socially engaged practices) became less and less attractive, for financial as well as 'status' reasons.

This shift gathered momentum as photography developed a critical tradition. While books and articles had been published on the history of the medium, and various literary assessments of photography in the tradition of Stieglitz's *Camera Work* still existed, as late as the mid-1950s an autonomous criticism of the photographic image combining aesthetic criticism, art history and ontology, had yet to materialize. *Aperture*, created in 1952, may qualify as the first real venture in this field. By the late 1970s, however, curatorial and scholarly work had structured the field, relayed by numerous symposia, conferences, lectures, scholarly journals, newsletters and associations, providing access to photography and photographic education through a model which now very closely resembled that used in the study of painting.[8]

By the early 1970s a 'serious' market for photographic images was developing, whose players went beyond the little galleries devoted to photography to reach the big established ones and the great auction firms – Phillips, Sotheby's, Christie's and Swann (Lafo 2000: 27–8). Their field was both contemporary production, and ancient prints and vintages, which by the late 1970s had acquired great value. These institutions did not merely sell images. They also built a market, buying great quantities of images and storing them (Alexander 1998: 698). Simultaneously, as John Szarkowski noted, and along with technological improvements in colour photography, the art gallery emphasized 'the wall', driving a new emphasis on colourful images 'that can claim a room', a development that has had a dramatic effect on both subject and form, and that has done much to define present-day photographic practice (Szarkowski 1989: 281).

Not surprisingly, the currency of the photograph as a 'committed' visual image became devalued in proportion to its rising value on the art market.[9] The first of a series of economically viable photography galleries selling work by well-known photographers was the Witkin Gallery, which opened in New York City in 1969. The Witkin was followed by the Light Gallery

(1971), the Castelli Gallery and the Malborough Gallery of New York (1975). Prints by photographers such as Edward Weston and Ansel Adams, which had sold for prices between $5 and $50 during the twenty years following the Second World War, now reached $200. In 1972 Adams sold four 16×20 inch prints of *Moonrise Over Hernandez* for $200 each during the first week of his show at the Witkin Gallery. In the same period he appeared on the front cover of *Time Magazine*, had one of his landscapes printed on cans of Hills Bros Coffee, and was advertising Nissan cars. By 1980 a 16×20 inch print of *Moonrise Over Hernandez* was estimated at $10,000–$12,000 by Sotheby's in Los Angeles, and another one sold for $9,000 at Sotheby's, New York.

The aesthetic emphasis on the wall also meant an institutional emphasis on the museum. From the 1930s until the 1960s, one of the very few art museums to buy and show photography was MoMA. In the 1970s, however, many art museums, a good number of which belonged to academic institutions, expanded their photography collections (one of the goals of such a move was to provide teaching tools) or created new ones (Alexander 1998; Davis 1999: 393–7). The recent and on-going proliferation of academic programmes in photography necessitated and justified the creation of teaching collections in university libraries as well as the opening of galleries. Szarkowski's role in this process of institutionalization has often been noted, and it would be difficult to underestimate his influence, as Director of Photography at MoMA, given MoMA's leadership in the field.

To equate a modernist phase in photography and the visual arts with formalism, while seeing postmodernism, as some postmodernist critics would wish it to be seen, as a return to the 'inescapably social nature of all art' (Eisinger 1995: 247), is to miss the essential self-referentiality of much contemporary art between the 1960s and 1980s. Key studies of the period such as Susan Sontag's best-selling essay *On Photography* and Roland Barthes's strange, meditative and widely read last book, *Camera Lucida*, accentuated a shift from an emphasis on the signifying properties of the photograph to an emphasis on the vacancy of meaning in the visual image. Proposing an investigation into the ontology of photography, Barthes reverted instead to a limited range of discrete photographs, of which he had little to say except what they revealed of his own sensibility and personal history. Such a critical position led him to develop what amounts to a metaphysics of the photo-image (I am the image and the image is I/eye), and helps explain the success of the book.

These critical propositions tied in neatly with a photographic practice that increasingly mimicked or pastiched the forms of earlier, indexical, 'committed' photography. It was as if the heightened consciousness of photographic history resulting from an 'academicization' – and thus professionalization – of photography (and more generally of art), led most practioners to *make* (as critics would stress) facile and solipsistic images based upon the recycling of styles from the past. Thus, Eggleston would 'reread' Evans, Meyerowitz, Cartier-Bresson, Shahn, and later Sherman would make a rich place under the sun for herself by merely extending a senior project based on pastiche (*Film Stills*) that she had begun at SUNY Buffalo in 1976. Self-referentiality being then the latest *idée à la mode* (thereby merely rediscovering what the eighteenth century did with finesse and gusto, and what modernism had done half a century earlier) one had to quote and metaphotograph if one wanted to have the slightest chance of selling one's 'project' (another pervasive concept).

This new emphasis on the recycling of old forms produced a peculiar homogenizing of photographic style: put bluntly, there was little difference between the abstract photographs of Aaron Siskind (praised by Henry Holmes Smith in *Aperture*) and those of Lee Friedlander or Garry Winogrand (promoted by John Szarkowski), or even the apparently 'documentary' works of Diane Arbus or Nicholas Nixon. Aesthetic styles and critical categories such as 'subjective' and 'formalist' became blurred or were rendered inoperative by this new photography, which mixed and revisited them with a distanced and ironic eye (Bezner 1999: 220–21). This general appropriation of forms, characteristic of Callahan, Eggleston, Meyerowitz and numerous others, became a huge cottage-industry of the photography scene from the late 1960s to

the 1990s, and addressed itself less to the content or subject of the photograph than to the self-referential 'field' (Bourdieu 1993; 1995) in which visual images were produced, circulated and consumed. Photography, that is, became increasingly concerned with the circumstances of its own construction as a discourse, and progressively less interested in commenting on the broader social and political world framing the production of the photographic image.[10]

Something akin to the shift that Russell Jacoby describes in *The Last Intellectuals* also took place in photography at approximately the same time. 'Raised in city streets and cafes before the age of massive universities,' Jacoby wrote, 'last generation intellectuals wrote for the educated reader. They have been supplanted by high-tech intellectuals, consultants and professors – anonymous souls who may be competent, and more than competent, but who do not enrich public life' (Jacoby 1987: ix–x). In broadly similar terms, the relation of the photographer to a larger audience, and photography's *democratic* function (in the fullest sense of the word) was lost to a technical and market competence whose discourse was both endogamic and hegemonic.

By the end of the 1970s, most photographers took the instability of the image (its essential polysemic, non-grammatical, even non-communicational nature) for granted, leading them to create 'alternative' sources of authority, or to project their own version of 'truth' in the battle of signs that had characterized political and social life since the 1960s.[11] This led in turn to splits within the profession. Some, in the Ansel Adams tradition, centred on the production of crafted images (invoking the techniques of previsualization, the Zone system, and the fine print), while others, influenced by French post-structuralism and postmodernism, turned towards theory and academia, where they also trained future gallery-owners and curators, and became artists using photography rather than artist-photographers.

The main casualty of the 'postmodern turn' was not, however, the notional *objectivity* of representation (which had long been seriously questioned),[12] but rather the very possibility of aesthetic *honesty* – that is to say, the possibility of constructing a discourse on the world which would be 'better' than any other discourse, on the grounds that it could serve as a basis for possible consensus. Just as the camera had earlier appeared to be the very instrument of modernity and modernism, by the 1970s it had come to represent the aporia of representation, embracing styles and practices that were self-reflexive, self-referring, and highly 'critical' (Szarkowski 1989: 275). Or, to put it in different terms, by brushing aside – or blowing up – the very existence of the real, postmodernist art, criticism and for that matter theory, destroyed all notion of 'indexicality'. It is not our aim in this (critical) essay to mourn the passing of 'realism', especially in an age when the notion of indexicality has been deeply shaken by digital technology. We cannot but note, however, that the rise of postmodernism has corresponded and, as evidenced by the huge commercial success of postmodern art and architecture, has fitted perfectly with, a broad depoliticization of society.[13]

The institutional evolution of American photography in the 1970s and 1980s did not, of course, lead to the creation of one single aesthetic. Indeed, one is struck by the variety of uses of the medium in this period, from Avedon to Friedlander, or from Robert Cummins to the 'New Topographics'. Cindy Sherman's work, or Barbara Kruger's, are very different from that of Judy Dater or Sally Mann. And there is apparently little in common between the 'directorial mode' of a Duane Michals or a Jerry Uelsmann, and the 'straight' approach of a Lewis Baltz or a Robert Adams, the aesthetic of a Callahan, Siskind, Eggleston, or Gibson, and the reportage of a Larry Clark. But while these photographers share in common a belief in the essentially 'mediated nature of contemporary life . . . the unreality of commercial culture' (Davis 1999: 402), their work seeks to reinvent culture in another, secluded space, rather than to engage with the existing one in any significant way.

But the most pervasive aesthetic of un-commitment initiated during the 1970s can be found in the contamination of contemporary photography by the metaphor of the scientific experimental protocol. This aesthetic has as its principal reference point the Rephotographic Survey Project of 1977 (and its sequel *Third View* in 1999), whose aim was to duplicate *exactly* nineteenth-century images of the American West and present them side by side with the originals. Innumerable other 'projects' and 'typological' works followed, bringing together a pow-

erful discourse of authority (science) with the equally powerful discourse of deconstructive criticism.[14] Such a practice, which seeks to hold all ends at the same time, is fundamentally ambiguous and non-committed. It resembles and inspired the 'statementism' – i.e. the attitude of apparently 'mere' recording – of much contemporary photography visible in the peculiar interest in 'landscape' and 'survey' photography.

Photographic practices in the 1970s and 1980s evidence the obvious commodification of culture and the disenchantment of the world. What is less obvious, however, and what photography helps us problematize more clearly because of its strategic position in relation to the visible world, is another feature of Western – and singularly American – societies of the post-industrial age, namely their atomization verging on anomie. In that respect photography, which was ideally placed to reinvent the function of representation in social transformation, operated a rather different sociological shift that had broad aesthetic implications. By falling into the traps of simplified (commodified) versions of the philosophical relativism of the Foucault of *Les mots et les choses* or of a Derrida, by accepting in exchange for power, money and visibility the comfortable niche offered by contemporary art, photography ceased engaging the world, ceased disturbing people. This culture of the 'minimal', of the extremely local, and of identity centred on difference (the fragment) rather than unity (the totality), has paralleled similar movements in society (see Lasch 1978 and 1984, Schlesinger 1992, Gitlin 1995). In such contexts formalism amounts to solipsism, and thus the abandonment of the public arena to the pure forms of market exchange, and to the disappearance of 'master narratives' which were in fact coherent and operative instruments for the implementation of social change.

Notes

1. Similar shifts had taken place slightly earlier in the field of 'ideas' and academe, as shown by the depoliticization of critical debates and the rise of '(French) Theory' on campuses (see Gitlin 1995; Horowitz 1987).

2. Photographic communication has a history of its own, but it should also be considered as one part of the development of the techniques of mass persuasion, and more generally of trade, in a mass society (see Jussim 1974; Marchand 1985).

3. In the Introduction to the exhibition catalogue, Steichen wrote 'The Family of Man exhibition . . . is the most ambitious and challenging project photography has ever attempted . . . It was conceived as a mirror of the universal elements and emotions in the everydayness of life – as a mirror of the essential oneness of mankind throughout the world.' The exhibition, he suggested, explored 'basic human consciousness rather than social consciousness' (Steichen 1955). The show contained 503 photographs by 273 photographers from 68 countries.

4. Robert Capa's fame is due, to a great extent, to the photographs he took during the D-Day landings on 6th June, 1944, and his controversial photo of a dying republican soldier taken during the Spanish Civil War ('Loyalist Militiaman at the Moment of Death, Cerro Muriano, September 5, 1936'). Capa's brother, Cornell, founded the International Center for Photography in New York, in 1974.

5. From 1964 to 1983, eight reports on the state of education in photography, film, and the graphic arts were published by the Eastman Kodak Company under the supervision of Dr Horrell (Eastman Kodak publication T-17).

6. 'It is probable that teaching had supplanted commercial or magazine work as the "other" work of most serious photographers by the late 1970s' (Baltz 1985: 157).

7. The first Guggenheim fellowship was granted to a photographer in 1937 (to Edward Weston, for his 'California and the West' project). Robert Frank's *Americans* is the notorious outcome of a fellowship he received in 1955.

8. Alongside more popular, mass-distribution magazines, the most influential publications included *Aperture*, *Afterimage* and *October*, and during this period the work of Henry Holmes Smith, Rosalind Krauss, Douglas Crimp, Craig Owens, Alan Sekula, and Alan

Trachtenberg reached a broad audience of practitioners and students. Also important was John Szarkowski, whose strategic position in the milieu made him much more than a mere critic, and A. D. Coleman, whose voice first rose in 1968 from the pages of *Village Voice*, and who presented himself as an anti-Szarkowski (whose limitations he repeatedly denounced). See Davis 1999: 422–7; Starenko 1983: 4–5.

9. A similar criticism was made by Gene Thornton in the various pieces he wrote in the mid-late 1970s for newspapers and journals, essentially *The New York Times* and *Art News* (see Eisinger 1995: 238ff.).

10. The great expansion of photographic criticism and scholarship also produced a rewriting of the history of photography. Along with the discovery of little-known photographers (from EJ Bellocq to the nineteenth-century survey photographers), a reappraisal of modernism also took place. The 1930s, in particular, were heavily revisited. Walker Evans, for example, was reinvented as a cool, anti-authoritarian, detached *regardeur* (on the model of the Baudelerian *flâneur*), and became a major icon of American photography (Bezner 1999: 224–5).

11. The transformation of 'reality' into images had been largely anticipated by American modernists such as Walker Evans, and then studied in society at large (particularly in politics and the public sphere) by Daniel Boorstin in *The Image* (1961), and of course by Marshall McLuhan in *Understanding Media* (1964), and in its interesting application *The Medium is the Massage* (with Quentin Fiore, 1967).

12. Photographers of the Hine/FSA/Smith persuasion believed that *photographs* did not lie, but that *photographers* could be liars.

13. If politics is on the way back today it is largely from other quarters, and in particular through the renewed social sciences. Art seems to have lost its role as vanguard of 'consciousness'.

14. Freidus's anthology *Typologies* (1991), which includes Ed Ruscha's gas stations, Lynne Cohen's observation rooms and practice ranges, and Roger Mertin's trees from New York State, is a good compendium of these practices.

Visual Violence in History and Art

Zapruder, Warhol, and the Accident of Images

JOHN BECK

Possibly the most scrutinized and iconic piece of film of the twentieth century was shot by a dressmaker on his lunch hour with a standard 8mm camera.[1] Abraham Zapruder's twenty-six seconds of Kodachrome II Safety film documenting the assassination of President John F. Kennedy on Friday, 22 November, 1963, has entered the visual language of American culture as decisively as any corporation's logotype, any artist's signature style. Indeed, reference to the 'Zapruder film' is enough to call up an entire range of pictorial and cultural connotations: Jacqueline Kennedy's pink outfit clashing with the luminous flat green in the background, the fierce black and chrome of the limousines flashing in the Dallas sun, the shock of red from the President's head; Lee Harvey Oswald, Jack Ruby, the Warren Report, the magic bullet theory, the CIA, Cuba, 'the sixties', and so on. In a sense, compressed into the celluloid of the Zapruder footage is the chromatic index of late-twentieth-century life in the United States.

Like the Beatles, who would make their US debut shortly after Kennedy's murder, JFK, and the assassination film in particular, have come to signify something fundamental about 'the sixties', at least as the decade has become periodized in the folk memory of the American population as a time of radical transformation and rupture. Don DeLillo has said that the Kennedy assassination was the moment when American culture 'changed in important ways. There's the shattering randomness of the event, the missing motive, the violence that people not only commit but seem to watch simultaneously from a disinterested distance' (Begley 1993: 299). 'When I think of John Fitzgerald Kennedy', writes fellow novelist Douglas Coupland,

> I think of those glossy black polyvinyl chloride J.F.K. hairdos that the band Devo used to wear in the early 1980s . . . Or maybe I think of Andy Warhol's funeral silkscreens of Jacqueline Kennedy all blue, flat, sterile and repetitive. Perhaps I remember the paranoia of Oliver Stone's movie, 'J.F.K.'. Or perhaps I think of John Kennedy Jr. and Daryl Hannah on the cover of *People* magazine. I might even think of the passages about John Kennedy in Norman Mailer's somewhat saucy book 'Marilyn'. . . . But when I think of John Kennedy, I, like most people, tend to think primarily of the assassination. (Coupland 1993: online)

For Coupland, the existence of the Zapruder film 'opened the gates to all our other tabloid fears and curiosities', allowing Americans 'to ruminate long past the point after which there is nothing left to say'. Without the film, he concludes, 'there would never had been the visual touchstone for three decades of questions about what really happened' (ibid.).

Coupland's observations are useful in that he demonstrates the way remembered visual information works associationally and synthetically, producing a complex set of reference points that move back and forth in time, across media and modulating registers of the serious and the trivial. If, as Coupland observes, 'the Kennedy Administration was largely Pop', and

the core memory of that administration is the assassination, then the President's murder, like everything else 'under Kennedy', must be understood in the light of paintings 'by Rauschenberg, Rosenquist or, (of course) Warhol' (ibid.).

What I want to suggest is that the Zapruder film itself as visual icon, and the history of its reception, have made a significant contribution to the shifting criteria of what constitutes art since the 1960s. At the same time, the transformation of art practice – and art theory – since Pop, along with the way this transformation has been absorbed into the broad visual culture of the United States, has made it possible to conceive of something like the Zapruder film as a kind of *objet trouvé* that can be read, to all intents and purposes, as art. Indeed, in recent years, in some quarters the film has been read in this way. To conceive of the Zapruder film as art is problematic but suggestive, for it takes for granted that it is not the agency of the artist that produces something called art, but that instead it is the act of designating something as art that alone determines the art status of an image or object. In discussing the Zapruder film as art, the very idea of the artist must be irrelevant since the existence of the film is a mere accident of history. Something has happened to the condition of art, and I believe the accident of the Zapruder film both impacts on changes in the reception of visual images and is at the same time itself changed in the process. The film, of course, is itself symptomatic of these changes in the reception and evaluation of visual images. The Zapruder film is impossible to conceive without the mass production and consumption of moving images by non-professionals with access to sophisticated amateur image making technology. The fact that Abraham Zapruder felt compelled to make a film of the Kennedy visit is not remarkable in itself; indeed, it is the very banality of his desire to record images that locates the film at the historical point where such practices become commonplace.

There is something irresistible in the pairing of the Kennedy assassination and Andy Warhol, and not just because of Warhol's prompt and sustained response to the event.[2] The collision of glamour and violent tragedy is an enduring preoccupation of Warhol's work, and his subject matter oscillates between the vacuous mediation of mass culture celebrity snaps and the equally blank stare of the ambulance chasing press image or police mugshot. From images like *129 DIE IN JET (Plane Crash)* (1962) through *Thirteen Most Wanted Men* (1963) and the numerous images of the 'death' series of car crashes, disasters, and electric chairs, as well as those of race riots and atomic explosions, Warhol's early-1960s' silkscreens replay technological and social collapse with a lurid, endlessly reproducible facticity that matches the apocalyptic colour clash of the Zapruder film's pink and green. At the same time, Warhol's celebrity A-list scrambles fragile Hollywood icons (Monroe, Presley, Taylor) with art world stars (Rauschenberg, Cunningham, himself) and politicians (Jackie, of course, and others like Nelson Rockefeller) to produce, in conjunction with the ephemera of domestic American life (soup cans, stamps, dollar bills), an index of riotous consumer narcissism that is both viciously eradicated of value yet also aggressively rapturous.

Often lifted from the pages of *Life* magazine, Warhol's news images play back the *Life* 'treatment' of American reality, to use former editor Loudon Wainwright's word, not merely in order to demonstrate the interchangeability and reproducibility of simulated events (though they do achieve that), but also to make visible the domestication of violent images into spectacle. As Wainwright has written, once represented in *Life* magazine 'an event somehow transcended the event itself . . . The production in light and shadow seemed bigger than the reality it came from' (quoted in Simon 1996: 36). Not surprisingly, Henry Luce's magazine wasted no time tracking down the traces of light and shadow that remained of the Kennedy assassination.

Abraham Zapruder made three copies of his original film. Hours after the assassination, Richard Stolley of *Life* magazine, hearing of the film's existence through a stringer, contacted Zapruder and by the next day had signed a contract for all reproduction rights, the original film and one copy for $150,000.[3] Two other copies went to the Secret Service. With the purchase of the film by *Life*, as Simon has observed, 'public access to the most crucial moments of the murder . . . was limited to what the magazine chose to reveal' (Simon 1996: 37). What Americans knew of the Zapruder film during the 1960s, then, came from still reproductions of

individual, decontextualized frames. The rapid and startling fact of the filmic event as moving image remained withheld and mysterious. *Life*'s slow release of information from the film over the course of the next few years in a sense functioned as a reminder of the complete text's absence from the public sphere. Thirty-four black and white images from the film first appeared in the 29th November edition of *Life*. Five consecutive frames, in colour, appeared on the cover of the 2nd October 1964 edition, accompanying a story on the Warren Report by Congressman Gerald Ford, with eight frames printed in colour inside, including the infamous frame 313 showing the president's head exploding. Frame 230 ('A key moment in the controversy') is reproduced on a black ground for the cover of the 25th November 1966 issue under the headline 'Did Oswald Act Alone? A Matter of Reasonable Doubt'. In this edition the reader is promised a 'frame by frame' examination of the film by Governor of Texas John Connally. This magazine also reproduces a full page colour photograph of Connally bent over stills from the Zapruder film with a magnifying glass ('Did Oswald Act Alone?' 1966: 39). Thirty-one colour reproductions of numerous frames of the film accompany this feature, varying in size from 5×3 inches to almost full page. The picture of Connally, however, is the biggest of them all, driving home the sense that forensic analysis of the Zapruder footage is the real story here, the business of interpretation having overtaken in importance the assassination itself.

The sustained and repeated close reading of the surface of the film frames, driven by the desire to get to the truth of the assassination, implies that the image will, eventually, yield its hidden secrets to the patient examiner. As interpretation and counter-reading multiply, however, what seems to happen is that, like any textual analysis, as the text becomes dissected ever more finely, the more pluriform become the interpretations. The closer one gets, the more one sees. Or, more accurately, perhaps, the more one sees, the less one knows. What the proliferation of conspiracy theories and scientific analyses reveal is the power of the text to resist containment; indeed, the Zapruder film – as text – is ultimately and inevitably as resistant to interpretive mastery as any other sign system. The Cold War penetrative scrutiny that is applied to the film, with its determination to see somehow through the obfuscatory surface to the notionally concealed 'truth' of the image, produces the precise opposite of its intended outcome, as waves of microscopic examination yield little more than further layers of ambiguity, anxiety, and suspicion.

Warhol's work resolutely, too, refuses the penetrative gaze. If Abstract Expressionism had celebrated autonomous, authentic creation and facilitated the critical dehistoricization of painting as self-evidently self-sufficient, the low materials of Warhol's art, their hands-off mechanical reproduction, and their determinedly historical contemporaneity signalled a radical desacralization of the uniquely crafted art 'work'. The studied blankness of Warhol's silk-screens, however, does not mean that there is nothing there. Instead of the security of authorial presence, Warhol's work offers the absent presence of the real. The famous lack of affect in his work, then, mimics the notion of the photographic image as indexically related to its subject, while at the same time, through a series of moves that might include repetition, inversion, cropping, shifting colour schemes, or adjustments of scale, shows the permeability of the image. It is as futile to try and see *into* a Warhol silkscreen (as provocatively transparent as that word is) as it is to see through the Zapruder celluloid into history in order to locate the gunman (or gunmen). What Warhol's work does do is expose the impossibility of 'deep' reading even as his press photographs hail back to the events that made them possible. As Art Simon observes, in the contending interpretations of the Zapruder film, and in the gridded images of some of Warhol's Jackie silkscreens, is a 'similar negotiation between a faith in the truth-bearing powers of the image and the epistemological anxiety resulting from prolonged scrutiny and juxtaposition of the photographic evidence' (Simon 1996: 103).

The fact that all but one of the seven images Warhol uses in the Jackie works appeared in *Life* within two weeks of the assassination suggests that the artist is explicitly engaging with the dominant representation of events. As such, as Simon argues, Warhol's images become part of a 'rejection of history as constructed by the government and its advocates in the mainstream press and dislodged the narrative procedures by which this history was transmitted' (Simon 1996: 105).

The absent presence in American public life of the Zapruder film as moving image lurks behind both *Life*'s selected edits and Warhol's Jackie silkscreens, a kind of 18.3 fps phantasm.[4] While everyone knew the film existed and periodically were offered tantalizing stills, the witholding of the film clearly stoked anxieties over a cover-up regarding the assassination. Significantly, the film's eventual public airing came about due to the prolonged scrutiny of the evidence undertaken not by official experts but by a copyist. In 1968, *Life* hired Technical Animations, a New Jersey film lab, to make a 35mm print of the film. A year later, the film was copied again by Technical Animations employee Robert Groden, who spent six years tinkering with the film, removing shakiness, improving image clarity, slowing down and magnifying crucial sections. This enhanced version was first shown by Groden at the Politics of Conspiracy conference in Boston sponsored by the lobby group the Assassination Information Bureau in January 1975. Groden's retrieval of the film for the public might be said to be both a creative rewriting, in the sense that the 'enhanced' version can no longer properly (if it ever could) be claimed as the raw data Abraham Zapruder shot in 1963, and an act of counter-cultural espionage.

Viewing the bootleg Zapruder film certainly became something of a counter-cultural event during the early 1970s, its shady and unofficial passage into the world evidence enough for many of the existence of a conspiracy. Don DeLillo depicts such a screening in his novel *Underworld*, where the event is seen as 'rare and strange', and where the audience gasps repeatedly 'in blurts of disbelief' at the headshot because it was 'completely new, you see, suppressed all these years' (DeLillo 1997: 488). These gasps of disbelief can be heard on Geraldo Rivera's *Goodnight America*, when Groden's version of the film was shown two months after the Boston conference on 6th March 1975. This was the first time a national audience had seen the film in motion. A month after the film's TV debut, *Life* returned copyright to the Zapruder family for $1.

Persistent complaints regarding government secrecy surrounding the assassination led, in 1992, to the passage of the bill creating the Assassination Records Review Board (ARRB) which was to oversee the release of all federal records. Over the next two years the Zapruder family made unsuccessful attempts to retrieve the original film from the National Archives, and in 1997 the film was declared an assassination record by the ARRB who moved to confiscate the original. It was only now that the issue of the film's value arose. It is here, over thirty years after the assassination, that the status of Zapruder's film and of Warhol's silkscreens again becomes an interrelated issue.

By law, the Zapruder film became the property of the people of the United States on 1st August 1998. Since the film was already stored in climate-controlled conditions in the National Archives at College Park, MD, the transfer of ownership from the Zapruder family to the American people should have been a merely administrative exercise. Stalemate over what constituted a fair price for the film, however, stalled the final transfer of ownership. The Zapruders originally asked for $18.5 million, while the government initially offered $750,000, with a ceiling price of $3 million. The Zapruders then had the film valued at somewhere between $25 million and $40 million (see Friedan 1998; Riechmann 1999; Pollock 1999: 1).The family licensed the film to MPI Home Video for commercial release in 1998, Abraham Zapruder's son Henry explaining that they hoped that 'the revenues from the sale of the video would help us finance the cost of dealing with the United States' (quoted in Pollock 1999: 1).[5]

Steve Johnson, acting as an appraiser for the Zapruders, argued that a price of $33.8 million was justified as the film should be considered a work of art. He arrived at this figure after an 'exhaustive search for an object comparable' to the assassination film, and came up with Leonardo da Vinci's Codex Leicester, manuscript documents bought by Bill Gates in 1994 for $30.8 million (Pollock 1999: 1). 'The colors are beautiful', observed Johnson of the Zapruder footage, suggesting that the 'ever-familiar hues of tragedy – the pink of the first lady's outfit, the red of the wounds, the green of the grass, the bluish-black of the presidential limousine – would not have been better if selected by Warhol or Matisse' (quoted in Riechmann 1999: online; Pollock 1999: 1).

Johnson draws upon conventional terms of art appreciation in order to establish the aesthetic value of the film, describing its chromatic richness and allegorical significance. He also,

notably, selects two master colourists as points of comparison. Not only are Warhol and Matisse household names whose works are known to fetch extremely high prices, they are also representative of, respectively, distinctively American and European cultural sophistication and excellence. Johnson's appraisal tactically situates the Zapruder film within a respectable art historical context, implying that the proper place for the film would be alongside Warhol and Matisse in an exhibit of twentieth-century art. As such, its monetary value should match its aesthetic worth. To reinforce his position, Johnson also prepared an in-depth comparison of frame 182 of the film and Alfred Stieglitz's iconic 1907 'fine art' photograph 'The Steerage'. Even a single frame from the Zapruder film offers, Johnson concluded, 'far more dramatic emotive power' than a masterpiece of twentieth-century photography (Pollock 1999: 1).

The government appraiser, C.C.M. Associates, unsurprisingly took a different view, placing a far lower price on the film. Without projection, they argued, the film is merely 'a tiny strip of celluloid tightly wound on a plastic reel' (quoted in Riechmann 1999: online). As a description of the material object, this is as instrumental a conclusion as one could come to. However, there is more than just a tussle over price at stake here. While C.C.M. Associates have clearly located the significance of the film to lie in its reception rather than its material properties, they are also, intentionally or not, engaged in a debate about the nature of twentieth-century art. Johnson's argument for the Zapruder film as art appeals to a history of pictures hanging in galleries, and, despite the fashionable reference to Warhol, is a conservative position that expects art to be a stable object of contemplation viewed within a recognized institution of art, and among other objects of comparable value and prestige. The C.C.M. position, in contrast, might be seen as inadvertently somewhat more avant-garde, associated with the twentieth-century avant-garde critique of institutional art that favours process over product, challenges the autonomy of the art object, and views conventional art galleries as the treasure chests of bourgeois culture. C.C.M. certainly recognizes the film as a work of mechanical reproduction that is valueless in and of itself and that can only gain cultural value through viewing.

Both sides of the debate are in agreement that the film is of great cultural significance. The disagreement over what the object of significance actually is goes to the heart of twentieth-century debates over art and reproduction. The stand-off over the Zapruder film is not just about money, though naturally the imbrication of financial interests in the production of art and an art market are not to be ignored. It is, tellingly, about originals and copies, stable objects and the politics of reproduction, dissemination, and reception. The copyright of the film was always to be retained by the Zapruders; it was the original reel of film that generated the dispute.[6]

While Johnson's formalist argument about the qualities of the film appeals to a sensibility that sees the intrinsic value of great art as a secure financial proposition that can only increase in price – he cites Van Gogh's *Sunflowers*, sold for nearly $40 million in 1987, while another Zapruder expert, Sylvia Leonard Wolf, refers to Warhol's *Orange Marilyn* that made over $17 million in 1998 – the material fact that the film is, as the government pointed out, a tightly wound strip of celluloid, cannot be avoided.[7] The government position, that 'Films are desirable for their content, not as relics or objects', is, on the face of it, irrefutable, though what constitutes 'content' here might need elaboration (Johnson's 'tragic' palette might not, to government appraisers, be on their list of contents). What cannot also be dismissed is that even as the Zapruder dispute was being arbitrated, copies of the film on VHS and DVD were being sold nationwide for $19.99.[8]

Valuation of the film thus appears to pivot on its status as art or documentary evidence, as object or information, artefact or mass product. While the Zapruder appraisers insisted on the 'fine art' aspects of the film's formal integrity, the government experts insisted that its significance lay in its reproducibility. If the film was to be designated art, as Johnson claimed it was, this is by no means a way of saving it from the debasement of mass reproduction, for it would then enter the global art market as commodity. As such, the government appraisers would still be correct, even if the reproduction of the film was for different ends. As another of the experts involved in the dispute, Beth Gates Warren, explained, if the film was sold publicly, major auction houses would compete for the right to sell it. Warren imagines a 'lavishly illustrated

catalogue', a world tour of the film and the possibility that 'a selection of images from the Film could be enlarged and displayed in a tasteful, artistic manner' (Pollock 1999: 1). At this point the argument seems to be more concerned with marketing style than aesthetics, although perhaps these are not so different as we might imagine.

Even C.C.M., for all its utilitarianism, could not resist getting involved in the debate over aesthetic value. While the appraisers asked the right question – 'Is there an equivalency between the Zapruder camera original and works that are judged to be fine art?' – their conclusion that 'Ultimately, Art resides in the eye of the beholder' is not exactly helpful and merely fudges the issue (Pollock 1999: 1).

The crux of this dispute is not that the Zapruder film is art but that it should ever have been considered as art. It is only possible to conceive of the film as art now because post-1960s' art has made it possible to include 26 seconds of 8mm film in the category of what constitutes an art work. The kind of work produced by artists during the 1960s and 1970s – process art, conceptual art, electronic art, earthworks, and the emergence of the installation, film and video, not to mention photography, as major visual forms of 'advanced' art – managed, for a time at any rate, to, in Lucy Lippard's phrase, dematerialize the art object (Lippard 1997).[9] Pop, and especially Warhol's 'factory' method of production initiated a critique of the foundations of what constituted art practice on the romantic and bourgeois model: rejection of the artist's individualized mark as evidence of the transmission of genius. Implicit in this is also the rejection of the 'vision' of the artist as uniquely able to imaginatively transform, and thereby redeem, the fallen world of things (though this rejection, while resisting the bourgeois model, also surrenders art itself – particularly in Warhol – to bourgeois commodification); rejection of the uniqueness of each piece of art (although each 'Warhol' remains one of a kind, and therefore keeps its value as such, at least visually there is an element of interchangeability within a series); rejection of connoisseurship and the 'fine' art tradition of tasteful contemplation. Despite the artist's deep fascination with and successful engagement with American commerce, then, Johnson might have been wise to steer clear of Warhol as a point of comparison, since Warhol's practice flies in the face of the old school formalism Johnson appeals to in order to rate the Zapruder film. Indeed, the mass-produced, infinitely reproducible nature of the photographic image is precisely what Warhol used to contaminate the rarefied domain of the fine art original.

Official ownership of the Zapruder film was transferred to the National Archives, as we have seen, on 1 August, 1998. Finally, on 3 August, 1999, the special arbitration panel of the Justice Department awarded $16 million plus interest to the Zapruders for the acquisition of the film ('Abraham Zapruder Film Chronology'). In 2000 the Zapruder family donated their personal collection of slides, photographs, videos and other items, along with one of the original first generation copies of the film, and copyright of the film to the Sixth Floor Museum at Dealey Plaza ('Abraham Zapruder Film Press Conference' 2000). The original and two remaining copies are held by the National Archives.

In handing over copyright, the Zapruder family made the following statement:

Since November 22nd, 1963, our guiding principle has been to strike a balance between respect for the sensitive nature of the film's images and an appropriate response to the public's demand for access to the film. All decisions through the years have been guided by the balancing of these two overriding interests. ('Abraham Zapruder Film Press Conference' 2000: online)

The history of the Zapruder film, its status as evidence and artefact, and the questions of ownership and reception, have never been straightforward. Indeed, befitting its position as *the* document of the most controversial, symbolic, and overdetermined crime of the twentieth century in the United States, the film has been fought and pored over, duplicated, manipulated, and put to the service of innumerable causes, conspiracy theories, and possible cover-ups.

While the importance of the film as representational trace of Kennedy's demise has never been in doubt, it is also a supremely important text in the history of American visual culture.

The history of the uses and abuses of the Zapruder film offers a powerful insight into the contra-dictions and challenges faced by a culture beginning to lose faith in the indexicality of photo-graphic representations. The Zapruder film stands both as a cause of that loss of trust in the veracity of images and also as a sign for how the interpretation of visual information might now have to be approached. The late-1990s dispute over the status of the film suggests that the issues raised by the iconic presence of the footage have not been fully resolved; however, the confla-tion of the aesthetic merits of Zapruder's 26 seconds of 8mm film and Andy Warhol's silkscreens does indicate how far the categorical boundaries separating art and other forms of visual infor-mation have broken down since the 1960s. Both the Zapruder film and Warhol carry a consid-erable share of the responsibility for that breakdown.

Notes

1. Zapruder's camera was a Bell & Howell 8mm Director Series movie camera that shot 16mm film, exposing only one side. Once used, the film was reversed and replaced in the camera where the other side could be exposed. In the laboratory the film would be split down the middle to produce a single reel of standard 8mm film (Wrone 2003: 10).
2. Between 1963 and 1968 Warhol produced a number of pieces using press photographs of Jacqueline Kennedy. In the first, *Jackie (The Week That Was)* (1963), Warhol used all the press photographs subsequently repeated in other Jackie works, including *Sixteen Jackies* (1964), *Nine Jackies* (1964), *Three Jackies* (1964), *Gold Jackie* (1964), two versions of *Round Jackie* (1964), three pieces called *Jackie* (1965), one with eight panels, one with 35 blue panels, and one with 16 panels, *Jacqueline Kennedy No. 3* (1965), *Silver Jackie* (1966), *Two Jackies* (1966), and *Flash – November 22, 1963* (1968). I list these works here mainly to draw attention to their titles, which reveal much about the 'factory' mode of production, not least the anticipatory post-Fordist diversification of numerous 'editions' of essentially the same model.
3. The sum Zapruder received is, along with most aspects of the history of the film, open to debate. See Simon 1996: 36.
4. The FBI confirmed that Zapruder's camera filmed 18.3 frames per second (Wrone 2003: 39).
5. MPI reported sales of 130,000 copies as of May 1999, though it is estimated the Zapruders made less than $300,000 from the video (Pollock 1999: 1).
6. C.C.M. argued that 'the camera original no longer plays a direct role in generating income for the copyright holder' (Pollock 1999: 1).
7. 'Orange Marilyn', noted Wolf, 'shares with the Zapruder Film the additional element of fas-cination with violence and tragedy' (Pollock 1999: 1).
8. The film went on sale in July 1999.
9. The precedent for this critique of the institution of art is, of course, Marcel Duchamp, whose *Fountain*, a mass-produced urinal signed 'R Mutt', was submitted (but not shown) for the Exhibition of the Society of Independent Artists in New York in 1917. For Duchamp's defence of the work, see Duchamp (1992: 248).

New Modes of Dissent in Art of the 1960s and 1970s

Visual Culture and Strategies of Resistance: from Semina *to* Heresies

FRANCIS FRASCINA

This essay considers examples of visual practice in America that combined new emphases on critical writing with innovative processes of production and distribution. The chronological starting point is Wallace Berman's *Semina*, a sub-cultural series of individually mailed products, sometimes referred to as 'magazines' or 'journals', which were produced in California in the late 1950s and early 1960s. The end point is *Heresies*, which from its founding in New York in the mid-1970s aimed to be a broad-based circulation journal produced by a women's collective of artists, writers and activists advocating feminist socialism.

In October 1992, Michael McClure, poet and writer, reopened a box containing all nine issues of *Semina*. Each issue was in a different format of collated images (including photographs and artworks), poems, papers and textures, which were glued and assembled and placed in a folder or envelope. McClure identified characteristics that led the recipients of *Semina* to interpret the relationship between production and reception as acts of resistance to contemporary norms of art practice and everyday culture. America after 1945 was an era of commodity catalogues and consumerism; self-service art alongside convenience foods in supermarkets; a large growth in numbers of entrepreneurial dealers and museums/galleries; and increasing activity by socially mobile collectors and investors (see Marling 1996. On the art market see Robson 1995). There were few possibilities for acts of resistance to consumer society and to the unwanted acquisitive desire of the art-market, particularly those acts that also created transgressive cultural pleasure for artists' communities. McClure, part of Berman's community, recalled:

> One cannot purchase or request a *Semina*; it simply comes to you. The magazine is outside the realm of commodity and merchandising and purchase. There's nothing to consume. . . .
> In fact, the way you lose a *Semina* is by lending it to a dear friend and they end up keeping it because they also find it to be a wonder. (McClure 1992: 60)

For McClure *Semina* was, therefore, 'un-American'. It was against 'what in those days we called "The American Way"', which was 'the Korean War, the grey flannel suits, the military preparedness to wage war behind the Iron Curtain or the Bamboo Curtain' (ibid.).

In the 1970s, for many artists who had experienced the previous decade's counter-culture, struggles for Civil Rights, antiwar protests and the rise of the women's movement, the 'American Way' was still dominant. Now, it was the Vietnam War, the grey suits of Watergate and military corporations, CIA covert involvement in the assassination of President Allende in Chile in September 1973, and continued prejudice whether related to gender, race, or sexual orientation. In such circumstances, to be a woman and an artist meant dealing with systems of exclusion both in galleries and museums and in conventions of criticism in journals. In the latter, characteristics of non-masculine identities were treated as 'other' to criteria of 'quality'. For

Berman, a man, in the 1950s *Semina* was a creative strategy characterized by a personal politics and a non-conformist community. For many women in the 1970s, too, the 'personal is political' was a claim that necessitated strategies of group activity rather than a reliance on individual actions, which were too often socially and culturally marginalized. Women's groups had ambitions to engage critically with the cultural status and distribution networks of major art magazines as strategies of politicized intervention. To do so, they addressed fundamental questions. How to act collectively as women, to provide forums for cross-disciplinary artistic practice and opportunities for historical and theoretical experiment? How to combine critical reappropriation of uses of language, transforming oppressive assumptions about gender, with innovative visual images? How to provide opportunities for exhibition and education against the grain of patriarchal power?

In 1971, *Womanhouse* was created collectively by women and opened to the public as an exhibition site between 30 January and 28 February 1972 in an abandoned house in Los Angeles. There followed women's journals, such as *Chrysalis, The Feminist Art Journal* and *Women Artists Newsletter*, which became *Women Artists News*. In November 1975, the Heresies collective formed out of a gathering in Manhattan, New York, to welcome Miriam Schapiro, one of the principal organizers of *Womanhouse*, back from California. The gathering brainstormed plans for a new art journal and an educational equivalent in New York for the Feminist Art Program at CalArts, Valencia, which was half an hour drive from Los Angeles and established by Schapiro and Judy Chicago. They were the first to theorize and develop a programme of art education based on feminism. Just over a year later, in January 1977, the first issue of *Heresies, A Feminist Publication on Art and Politics* appeared with a statement inside the front cover:

> HERESIES is structured as a collective of feminists, some of whom are also socialists, Marxists, lesbian feminists or anarchists; our fields include painting, sculpture, writing, anthropology, literature, performance, art history, architecture and filmmaking. While the themes of the individual issues will be determined by the collective, each issue will have a different editorial staff made up of contributors as well as members of the collective. Each issue will take a different visual form, chosen by the group responsible.

The radicalism of this 'editorial' statement has to be measured by the context of visual art in America from the late 1950s to the 1980s, which underwent major transformations. Some developments were rooted in traditions of modernist abstraction and autonomy, the claimed separation of art from life, as a resistance to the perceived negative and pervasive effects of mass culture, industrial production, and Cold War conservative politics. Well-known examples range from work by Abstract Expressionists, such as Jackson Pollock, Willem de Kooning and Barnett Newman, and supportive texts by Harold Rosenberg and Meyer Schapiro in the 1940s and 1950s, to paintings by Kenneth Noland, Frank Stella and Jules Olitski, and the art criticism of Clement Greenberg and Michael Fried in the 1960s. Other transformations such as Conceptual Art in the 1960s and 1970s were produced by exploring relationships between the conventional status of the art object, critical theory, and the function of representations within institutionalized art history. For example, John Baldessari's *Terms Most Useful in Describing Creative Works of Art* (1967–8) consists of a large canvas (113.75 by 96 inches) with acrylic painted text listing 54 terms, in three vertical columns, from conventional descriptions of art works. His *This is Not to Be Looked At* (1967–8) consists of canvas with acrylic painted text, which are the words of the title, beneath a photoemulsion image of a copy of *Artforum*, which was the most highly influential art magazine of the 1960s. Many conceptual artists and those who produced Earthworks, including Robert Smithson and Michael Heizer, were ambivalent about the world of art magazines, galleries, dealers, collectors and museums. While in the format, site-specific location and scale of their work, such artists attempted to resist the aesthetic conventions and expectations of established elites, cultural hierarchies, and social power, the flow of funds for their subsistence and art projects was still, largely, from art world sources. Two well-known

examples are: Smithson's *Spiral Jetty*, 1970 (a 457 metre coil on a 10 acre site at Rozel Point, Great Salt Lake, Utah) and Heizer's *Double Negative*, 1969–70 (9 metres by 458 metres by 15 metres, with a displacement of 240,000 tons, Virgin River Mesa, Nevada). The actual earthworks could not be bought and sold, collected and displayed in museums and galleries like paintings or sculptures. However, photographs of them could and funds for the projects came from sources of entrepreneurial dealership that the works appeared to critique.

Nonetheless, each of these developments can be described as avant-garde in the politicized definition of the term, with its origins in nineteenth-century cultural resistance to the alienating process of modernization and urbanization, the regulatory systems of factory labour and discipline, and the standardizing effects of consumerist commodities and novelties. Such works can also be interpreted as resistant to established curatorial classifications, institutionalized appropriation, and individual collectors' desires to be represented by their love of art. There were similar arguments about the characteristics of Minimalist art from the 1960s. Minimalism by Carl Andre, Don Judd, Robert Morris, or Richard Serra can be interpreted as the negation of dominant cultural values whether those of populist consumerism or of art-buying elites. Their use of materials, such as rusting steel, slabs of wood, and wire mesh, which evoke the values of construction and industrial production, were resistant to conventional criteria of beauty and aesthetic experience. On the other hand, it has been argued that such resistance was steeped in the codes of masculinity, technocracy and mass production in America as an imperial power during an era characterized by the Vietnam War and domestic inequalities. Earthworks, too, had their equivalent in military activity. *The New York Times*, dated 5 April 1970, published a photograph of a United States military earthwork in Vietnam. The First Infantry division had bulldozed through the jungle, north west of Saigon, to create their emblem, a pentagon with a '1' in the centre, which measured a mile and a half across. This was the same month that Smithson completed *Spiral Jetty* as an artistic earthwork in Utah.[1]

At the same time as some American practitioners were exploring the 'resistant' qualities of 'autonomous art' or critiques of art world conventions through various politicized strands of conceptual art, others in the 1960s were prompted by more explicit engagements with social and cultural elements of American life, aspects of a broader visual culture than that sanctioned by critics and institutions, and a politics of explicit resistance to American foreign policy and domestic norms ranging from antiwar struggles to varieties of counter-cultural production (see Frascina 1999). In either explicit artistic engagement with these concerns or in implicit strategies of resistance, there were fundamental questions of production, dissemination, constituencies and communities. McClure was part of a community of artists, poets, musicians, photographers, and novelists, based on the West Coast, concerned with cultural, social, and sexual critiques of Cold War America in the late 1950s and 1960s. Many members of this community regarded their country as largely racist, homophobic, xenophobic and obsessed with a cocktail of consumerism, colonialism, military superiority, and repression. In the two major centres of San Francisco and Los Angeles, communities of artists and intellectuals produced a range of work often characterized as 'Beat Culture'. The lifestyle and works of Wallace Berman were highly influential on contemporaries, particularly those concerned with a sub-cultural identity and constituency that was counter to established rules of social decorum and official institutions. In 1957 Berman's first exhibition at the avant-garde Ferus Gallery, Los Angeles, was closed by the police on the grounds of obscenity, though the work at issue was by another artist, Cameron. Berman had included Cameron's drawing of sexual intercourse in *Semina* 1, which formed part of one of Berman's assemblages, entitled *Temple*, at the Ferus Gallery. Reluctant to re-enter the world of galleries and dealers, partly out of fear of public censorship, he continued to produce issues of *Semina*, which he had begun in 1955, and posted to members of his cultural community. There were nine issues, with the final one appearing in 1964 (for context, see Phillips 1995; Solnit 1990: 1–23; Cándida-Smith 1995: 225–68).

All issues of *Semina* were different in format and main themes. They were produced using a mixture of handmade, printed and collage techniques. These follow in the traditions of the Cubist collage/assemblage processes of Picasso and Braque in the early years of the twentieth

century. They also evoke Dada and Surrealist works where ready-made images, texts and uncanny juxtapositions are both expressions of the 'author' and potential resources for 'readers/viewers' as producers of meanings. The French word 'collage' literally means sticking or gluing. Uses of the word, in particular contexts, can also imply pasting or paperhanging with connotations of advertising, billboards, public notices and decorating. Colloquially, 'collage' also means having an affair, or an unmarried couple 'living in sin'. The colloquial usage is apt in the context of visual and verbal conventions and traditions. Words and images cohabit, producing novel combinations and contexts. Conventions, genres and expectations of high art and the supposedly incompatible materials of, and references to, popular and mass culture are found in intimate, even transgressive, embrace. Robert Duncan, poet and writer, stressed that each issue of *Semina* was not an exercise in conventional editorial discrimination or 'esthetic judgment' but a 'collage': the 'fashioning of a context . . . a mode of attack upon the real or upon established relations, breaking into and deranging sacrosanct images' (Duncan 1978: 19–20).

Berman acquired a small 5 by 8 inch hand press, which he used as one resource for *Semina*. It provided a means of mechanical reproduction alongside the handmade, and collected elements, including poems and prose by living and dead writers. These were placed together for the recipient to sort or arrange into whatever sequence they wished. The word 'semina' has Latin roots and is the Italian for seedtime; sowing; seed. It has therefore been interpreted as suggesting insemination and dissemination, semen and seeds, cultivation and new life. The seed references are also plausibly related to drug origins including marijuana. The cultivation of new contexts from the 'seeds' of the contents of *Semina* and the evocation of Surrealist dream and drug imagery are also consistent with Berman's sub-culture. Such contexts ran counter to the careerist and time management metrics of the 'American Way'.

Berman made 150 copies of *Semina* 1 as a 'First and Final Printing'.[2] None of the issues went beyond the 350 copies for *Semina* 5, which was on the theme of Mexico. Two issues were devoted to single poems and particular images. *Semina* 3 is entirely Michael McClure's 'Peyote Poem' with cover images of mescal buttons, signifying the stimulant drug, and the rituals of Indians – including fertility dances – from Northern Mexico and Southwestern USA. *Semina* 9 is an envelope containing McClure's 'Dallas Poem' on the assassination of President Kennedy in Dallas, 22nd November 1963. On the front is a photograph of Jack Ruby, a local nightclub owner, shooting to death Lee Harvey Oswald, accused of assassinating Kennedy, in the basement of the Dallas police station. The last four issues of *Semina* were more engaged with social, sexual and political aspects of American life. Some copies of particular issues were personalized and some left incomplete, never sent.[3]

From recollections and interviews it is clear that Berman was a revered character in a particular Californian community, which connected groups and individuals in Los Angeles and San Francisco. In 1966 photographs and captions by Dennis Hopper appeared in *Art and Artists* on the subject of 'The West Coast' (*Art and Artists*, vol. 1, no. 2, May 1966, pp. 66–9). Under his photograph of Berman, Hopper recalled that 'Berman started assembling objects in 1947' and 'may be the first assemblage artist in California'. He continued, 'His [Berman's] Los Angeles home is a key point in the constant traffic of artists, poets, and musicians in the San Francisco–Los Angeles–Mexico City matrix . . . He is the High Priest of the Scene' (ibid.: 66). Hopper's metaphor of a matrix including Mexico City established an important connection with the traditions of magic realism, which had been made earlier in an article on Berman in *Artforum* by John Coplans. Coplans credits Berman as the source of the California assemblage movement and notes that he is not mentioned in MoMA's 'encyclopedic compendium on the Art of Assemblage' in 1961.[4] For Coplans, Berman 'began to draw with bizarre, naïve and vulgar American surrealist overtones. In these drawings he projected all the underground vernacular of the jazz world and the dope addict, sometimes reconstructing portraits of jazz musicians such as Joe Albany and Charlie Parker or erotic fantasies with overtones of magic realism mixed with bepop and surrealism' (Coplans 1964: 27). Coplans regarded Berman as 'the major link to the existentialist and surrealist poets, dramatists and writers' who established assemblage art in California 'as a poetic art with strong moral and spiritual overtones'. Importantly, California

assemblage was 'the closest development to a true surrealist root in the American vernacular' (ibid.). The combinations of surrealism and magic realism placed Berman's roots in traditions antithetical to the brand of modernism – emphasizing abstraction, autonomy and modern specialization – gaining dominant status both on the East Coast and in powerful journals.

In format and dissemination, the nine issues of *Semina* were attempts to evade the forces and pressures of art-market commodification, a fast growing phenomenon in the postwar USA. From one point of view, these 'magazines' were part of a politicized project in which Berman made art because he was uninterested in the financial returns of *productive labour*, being paid by a publisher or editor. They were the result of *unproductive labour*, made because of the necessity and drive to be creative. From another point of view, they were the product of a self-indulgent, drug-induced sub-culture obsessed with utopian fantasy. Richard Cándida-Smith identifies the paradoxes. Berman the citizen demonstrated in favour of Civil Rights and protection of the environment and marched in opposition to the Vietnam War in the mid-1960s. With him he carried a banner displaying the photograph of a black person's hand giving the finger (see photograph in Cándida-Smith 1995: 276) which he had juxtaposed with a Jack Kerouac lyric in *Semina* 8: 'I am that noise which / must against their / common paraphrase / charge deceit'. Cándida-Smith continues:

> In 1971 he won a Linus Pauling Peace Prize for the best visual art promoting world peace. Yet to the degree that Berman the artist could be said to be a social critic at all, his stance was irresponsible and defeatist, as he warned of the dangers of active involvement in public life. Rather than commenting on the social events of the day, Berman used *Semina* 8 to reaffirm his belief that poets find their success in the private rather than the public realm. (ibid.: 276–7)

The proliferation of experimental and collaborative writing in little magazines, from San Francisco to New York, during the 1960s demonstrates that Berman was not alone in such a belief (see Clay and Phillips 1998). The paradoxes, however, of dissent and critique within a dominant consumerist culture reliant on manufacturing a desire for spectacular novelty, remained entrenched.

By the end of the 1960s resistance to the 'American Way', its cultural, political, social and sexual norms and its emphases on individual creativity was observable in a range of manifestations. Many of them were produced out of debates about feminist strategies from the late 1960s onwards. On the front cover of *RAT*, dated February 9–23, 1970, a headline declared that women had taken over the running of this underground, radical newspaper based in New York. A feminist 'revolution' within the editorial collective was prompted, on the one hand, by the 'enormous tangled problem of sexism both on the staff of the paper and the content of the products' and, on the other hand, by the political failure to 'suggest directions for action' (*RAT*, February 9–23, 1970: 2). The context for the latter was evoked by front-page headline references to the Black Panthers and to the Weatherwomen, which had agendas for direct action.

A few months later, on the West coast, *Goodbye To All That!*, a self-styled 'newspaper for San Diego women', was founded. Its emblem was a rising rayed sun/eye illuminating the globe and ringed by a message: 'THE POWER OF WOMEN UNITED CAN FREE US ALL'. Two early issues of the paper included antiwar photomontages by Martha Rosler. The first was on the back cover of the third issue, dated 13 October 1970. Rosler transformed a photograph that first appeared on the front cover of *Life* magazine, dated 8 November 1968. The photo of Nguyen Thi Tron, a twelve-year-old Vietnamese, who lost the lower part of her leg to gunfire from a US helicopter, was accompanied by the headline 'As the bombing stops – THIS GIRL TRON'. Inside there was a twelve-page photo essay with photographs by Larry Burrows and text by Don Moser. On the cover of *Life* magazine, Tron stares at a craftsman finishing work on her wooden artificial leg. In the photomontage, Rosler placed Tron inside a comfortable American sitting room with sofa and television by taking the image of domestic comfort from a contemporary magazine. The resultant contrast produced a work as part of a series entitled 'Bringing the War Home: In Vietnam'. Rosler, who worked on the collective producing

Goodbye To All That!, placed her photomontage in this small circulation underground news-paper to produce a multiple critique: of mass-circulated images in magazines such as *Life*; of Americans' passivity at home in the face of civilian casualties caused by their government's foreign war; and of the contemporary art world's indifference to politics.

Rosler's choice of an image from *Life* magazine engaged with a publication read by millions (eight million subscribers in 1970), largely from the white middle class, for whom a *Life* visual image provided a powerful distilled version of dozens of newspapers and magazines (see Doss 2001). In December 1969, *Life* reproduced colour images of the My Lai massacre of men, women, children and babies by American GIs. The photographs and the text reside in a context of stories, adverts, images and juxtaposition that both disrupt the magazine's sequence and encourage readers to pass on. Rosler's photomontages critically engage with the latter process, enabling viewers of a non-mainstream radical newspaper to realize ways to resist the norma-tive power of the visual in *Life* magazine. Issue number ten of *Goodbye To All That!*, 9–21 March 1971, included a second photomontage by Rosler. In this double page spread (6–7), a format common in *Life* magazine, the envisaged viewer/reader is placed inside a comfortable contemporary American living room, excerpted from a design magazine, with a wall of windows through which GIs in a Vietnamese war landscape provide the outside world to the inside 'private' space. The caption, signed 'Martha', reads:

> In a secluded vacation spot, privacy isn't a problem, so you can go all out with glass, for view, light, and visual spaciousness. Simple or no-pattern coverings, soft colors, and small-scale furnishings add to illusion of size. Blue of the ceiling and brown of the beams extend through the glass walls to the eaves from the living room to the outdoors.

The New Left provided the agenda for underground newspapers, like *RAT* and *Goodbye To All That!*, which were designed to represent, in texts and images, revolutionary possibilities emanating from contemporary counter-culture, and to provide reliable reports of events, actions and critiques ignored by mainstream media. Imbued with the possibilities and limita-tions of New Left/counter-culture critique, such newspapers addressed dilemmas central to strategies of resistance in America since the 1950s: How to produce effective critical represen-tations, which are against the grain of dominant values and norms, while evading processes of appropriation into mainstream culture? How to engage communities and constituencies on the cultural margins without being marginalized or ghettoized? How to transform and transgress repressive social and cultural attitudes and beliefs without being condemned for special plead-ing? How to address a broad constituency without being blind to the paradigmatic closures of sub-cultural obsession?

On 24 January 1970 the women on the *RAT* collective took direct action: 'the *RAT* office was yielded to an all-women's collective . . . joined by more than a dozen other unaffiliated women and sisters from WITCH, Redstockings, the Gay Liberation Front, LNS and Weatherman, who shared in the totally collective spirit and energy that has gone in this issue' (*RAT*, February 9–23, 1970: 2). One of them, Robin Morgan, was about to see the publication of her landmark collection of texts titled *Sisterhood is Powerful: An Anthology of Writings from the Women's Liberation Movement* (Morgan 1970). This was one of several creative and pedagogic contributions to '*herstory*'. For example, in 1971 the New York based Women Artists in Revolution (W.A.R.) published *A Documentary Herstory of Women Artists in Revolution*, which followed the photocopied and stapled format of Art Workers Coalition col-lections of documents published in 1969 (WAR 1971; AWC 1969, a and b). Further, W.A.R. waived what they regarded as the normal process of capitalist copyrights permission for *A Documentary Herstory*: 'Permission to reprint documents copyrighted herein by W.A.R. is hereby granted to Women's Movement groups for distribution free or at cost' (p. 2). The late 1960s was a period in which radical products were the result of subversion of systems of control, one of them being 'permissions', and the use of basic technologies of reproduction, such as photocopied documents and 'catalogues', as critiques of mass-produced printing. Specialist

art magazines, such as *Artforum*, are examples of the latter. Basic printing techniques and paper characteristic of daily newspapers were characteristics of *RAT* and *Goodbye To All That!* They are the low-tech development of the handmade and small print processes of *Semina*.

Direct action was one interventionist strategy. Another was the formation of 'collectives', the antithesis of individualism, some of which produced their own compilations of texts and founded new gallery and exhibition spaces. An example is the A.I.R. Gallery in Manhattan, which was established to show the work of women artists. By the mid-1970s such developments became one of the bases for the emergence of new journals generally, such as *The Fox*, 1975–6, and for the production of texts/object-based work, most significantly by women. These were produced to cross the normal divide between production and critical reception of art works. Some artists became critics and theoreticians, and several saw no distinction in their practice between the production of 'objects', with reference to the 'visual', and the production of written material: both were 'texts'. Importantly, for artists informed by feminism this was a moment when the struggle with enabling theoretical texts – most notably from psychoanalysis – and the struggle with the fundamentals of what a practice should be, were inextricably entwined.[5] Here, for instance the practices of Mary Kelly, Adrian Piper, and Martha Rosler in the 1970s are exemplary. All engaged with the conventions of language in their work, producing written texts both on their work and on broader critical debates.

A central strategy was to participate in collective enterprise as a critique of the authorial voice (normalized as male), as a contribution to a mutually supportive community and as a nurturing environment for creative expression and dialogue. The Heresies collective and the journal of the same name contributed to radical revisions of the practices of critical writing and production. One aspect was the development of 'page art', which had several forms including the convention of the double page. For example, in the first issue of *Heresies*, the collective included two photo text works by May Stevens: *Tribute to Rosa Luxemburg*, 1976, and *Two Women*, 1976 (28–9) from her 'Ordinary, Extraordinary' series. Stevens combined images and text from the life and murder of the revolutionary socialist Rosa Luxemburg and the life of her own mother Alice Dick Stevens. For May Stevens the new context and combination brought together relationships between the personal and political, the autobiographical, patriarchy and 'herstory', authority and violence. On pages 58 to 59 two images by Nancy Spero were juxtaposed: *Bomb Shitting*, 1966, from 'The War Series', one of several works produced as visual critiques of the American war on Vietnam, and *Torture in Chile*, 1976. The latter is a text piece on the brutal torture of women in the Buen Pastor Jail under the Pinochet regime, which had come to power in a military coup with CIA support. *Heresies* 1, devoted to 'Feminism, Art and Politics', began with the main editorial statement, which lists the twenty members of the main collective, next to a reproduction of a poster by the Australian artist Mandy Martin. In the main foreground of this photomontage of Vietnamese men and women walking across rice fields, a woman carries both a gun and a baby in a back harness. In the middle distance, in the rice field, is a massive symbolic monument made of a 'Coke' bottle on a plinth including the word 'Big, Big, Coke'. Around the image, like a frame is a text: 'THE DRIVE OF THE U.S. IS TO REPLACE THE TRADITIONAL STATUS OF VALUES OF THE VILLAGE SUCH AS WRITING GREAT POETRY . . . WITH NEW ONES LIKE OWNING A T.V. SET.'

In the following 112 pages of *Heresies* 1, with its front cover of black text on red ground, there are 38 diverse entries. For example the first four begin with 'From the First-Issue Collective', making clear the structure of the project: a main Heresies collective (later referred to as the 'mother collective') as distinct from individual issue editorial collectives. The statements by the six members of the collective for the first issue (2–3) reveal the different stances of each person.[6] Diversity of view within a collective structure was a major strength of the journal, though it held the potential for a lack of main focus and struggles to resolve debate and decisions for action within the practical constraints of production deadlines. Next was an essay, 'Towards Socialist Feminism', by Barbara Ehrenreich (4–7) followed by 'Tijuana Maid' by Martha Rosler (pp. 8–13). Rosler's piece is in fact the third part of a larger project (*Service: A Trilogy on Colonization*) and is entitled *Tijuana Maid Food Novel 3*, which was sent out as

postcard novels. The use of rectangular boxes around text in the pages of *Heresies* conveys this original format. On the subject of the exploitation of Mexican migrants and the use of food in affluent bourgeois culture, Rosler's work functions in four ways. First it exists as eleven units in Spanish and English translation in a run of approximately 300 with costs as part of the documentation (Postcards, paper $10.77; postage $300; printing $20; miscellaneous $5). Second it exists as a process of mailed and received postcard 'novels'. Here, there are references to the legacy of mail art and Berman's *Semina*. Third it exists within the body of *Heresies*. Fourth there is the version published by Printed Matter Inc., New York, a radical publisher and distribution network for artists' 'books', journals and other non-conventionalized products. Directly after Rosler's contribution is an essay by Eva Cockcroft, 'Women in the Community Mural Movement' (14–22), illustrated by reproductions of nine murals from around the country. The first is Vanita Green's *Black Women*, 1970, in Chicago with portraits of famous Black women from Aunt Jemima to Angela Davis. Soon after completion the mural was defaced with large splashes of white paint.

The diversity of texts included in the first issue of *Heresies* is evidence of the publication's educational and creative agenda. The emphasis on 'herstory', historical and contemporary, cultural and political, and on the importance of the visual in art and everyday experience roots the magazine in the legacies of underground or alternative press publications of the 1960s and early 1970s. From the first issue, too, the strategy of 'double coding' is evident: for example, in Rosler's 'Tijuana Maid'. This strategy was manifest in practice and historicized later by Lucy Lippard. She observed artists from the early 1970s onwards, who were committed to feminism, or cultural politics, or the body as a site of repressed knowledge, using strategies and practices of critical writing, production and display that traversed conventional boundaries. Lippard described this, in the early 1980s, as the 'Trojan Horse' effect of 'double coding' with respect to art works, or performances, or publications, or site-specific interventions that have critical meanings both inside and outside dominant institutions (Lippard 1984: 340–58).

Heresies and other journals, such as *Chrysalis*, cut across the grain of established cultural values in the USA and contributed to their radical revision. However, the 'mother' and individual issue collectives of *Heresies* suffered from a number of closures, particularly related to relationships between class, sexuality and ethnicity. In 1989, the Heresies collective asked Moira Roth, feminist art historian and critic based in California, to review all of its 23 issues. In the essay, which was included in a twelve-year anniversary publication, Roth identified some main dilemmas and problems (Roth 1989: 84–8). One of them related to the structure of collectives and the process of discussion, resolution and action. There were sometimes unresolved tensions between the 'mother collective' and the 'issue collective' leading to a loss of focus. There were also instances of ideological and aesthetic disagreements within individual collectives. An even more basic criticism was that in 'the original mother collective of 1977 there were no women of color; moreover, this group of white women represented a definite bias toward heterosexuality' (ibid.: 86–7). Although some of the issues of sexuality were addressed in *Heresies* 3, 'Lesbian Art and Artists', the relationships between sexuality, gender and race were neglected despite the commitment of the 'mother collective' and 'issue collectives' to involve women of colour. Even the collective producing the anniversary issue was entirely white. Partly, this had to do with an inability to attract young women of colour to the project.

There were related problems characteristic of many radical collective enterprises. The history of *RAT* is one example. With *Heresies*, there were problems of adequate funding for the publication and payment to contributors. The energy of participants and volunteers over time was negatively affected by other commitments, the legacies of uneven workload within the collectives and a lack of consistency in meeting realistic deadlines. Hence, between 1977 and 1989 the quarterly publishing schedule should have realized 48 rather than the actual 23 issues. Clearly, a commitment to collective enterprise had to negotiate individual careers and personalities and the pressures of contemporary society dominated by discourses of individualism and wealth creation. *Heresies* tried to avoid a single editorial voice or house style, preferring to represent a wide range of views, information and images. This can be criticized for being too pluralistic and

over emphasizing a refusal to resolve debates. On the other hand, for *Heresies* the danger of 'consensus' was the imposition of power and the neglect of quiet 'voices' in a conversation based on full respect for all speech acts within the collective. When *Heresies* was founded it entered into a particular moment within feminism when issues of 'essentialism' and 'social construction' were being debated and divergent art practices pursued. In 1977 it was a radical contribution to a historical moment in the United States. By the late 1980s and the Reagan backlash with the 'culture wars' at the turn of the decade, *Heresies* had to maintain its alternative or oppositional role in circumstances that were not the same as those of the moment of its founding. Maintaining critical relevance to changing circumstances is a dilemma for all radical interventions. In all, 27 issues of *Heresies* appeared up to its financial demise in 1993.[7]

Claims for the 'aura' of the art object were strong elements in the production and reception of radical art in America from the 1950s onwards. Abstract Expressionism, Pop Art, Minimalism, Earthworks all relied on variations of notions of awe, the sublime, imaginative life, and non-utilitarian use value. Their radicalism was also compromised by the art-market's rapacious appropriation of visual excitement and novelty. Berman's *Semina* and *Heresies* act to deconstruct 'aura' and the power of the art-market, though in different ways, and to resist both official culture and avant-gardism stripped of its original politicized functions. They were, of course, fraught with their own contradictions. *Semina* has become, like the ephemeral, transitory and throwaway characteristics of Cubist collage, collectable within the systems of exchange value and dealers' catalogues. The handmade, no matter how resistantly rough, has a market. *Heresies*, part of feminism's critique of individualism and authorship in constructions of gender stereotypes, had to confront the journal's historical place, the context of its radical moment, and recognize the dilemmas of its own collective strengths. Both practices, though, have a strong use value for those for whom 'heretical' roles are fundamental to strategies of resistance.

Notes

1. Luis Camnitzer juxtaposed the image of *Spiral Jetty* and an extract from *The New York Times* from 5 April 1970 including the photograph of the emblem of the First Infantry Division bulldozed in Vietnam in his *April 1970* from the 'Agent Orange' series, 1984.
2. On a card with his address soliciting contributions and materials.
3. See the complete and incomplete examples of *Semina* in the Wallace Berman Papers [Archives of American Art (AAA), Roll 5282].
4. Catalogue by William C. Seitz. Exhibition at MoMA (2 October–12 November 1961); the Dallas Museum for Contemporary Art (9 January–11 Febuary 1962); and San Francisco Museum of Art (5 March–15 April 1962).
5. One of the outcomes of the debates, struggles and tactics of the early years of the women's movement was a realization that new 'sites' had to be established for the various 'voices', 'images' and 'analyses' to be represented. Many new venues for visual work were founded and existing venues tactically utilized.
6. Joan Braderman, Harmony Hammond, Elizabeth Hess, Arlene Ladden, Lucy Lippard, May Stevens.
7. The phenomena of group networks and collectives produced not only journals but also 'alternative space' exhibitions and the desires for archive resources such as Political Art Documentation/Distribution (PAD/D), established in 1979 by Lucy Lippard and others. PAD/D, whose office was in the War Resisters league Building in NYC, also produced the periodical *Upfront*. Lippard was a central figure as a critic, collaborator and activist from the AWC in 1969 through to *Heresies*, PAD/D and beyond.

Photographing the Vietnam War

Democratic Accountability and Liberal Representation in American Iconic Photography: the Image of 'Accidental Napalm'

ROBERT HARIMAN AND JOHN LOUIS LUCAITES

The naked little girl is running down a road towards the camera in Vietnam, screaming from the napalm burns on her back and arm. Other Vietnamese children are moving in front of and behind her, and one boy's face is a mask of terror, but the naked girl is the focal point of the picture. Stripped of her clothes, her arms held out from her sides, she looks almost as if she has been flayed alive. Behind her walk soldiers, somewhat casually. Behind them, the roiling dark smoke from the napalm drop consumes the background of the scene.

The photo (Figure 29) was taken on 8 June, 1972 by AP photographer Nick Ut, released after an editorial debate about whether to print a photo involving nudity, and published all over the world the next day. It then appeared in *Newsweek* ('Pacification's Deadly Prize' 1972) and *Life* ('Beat of Life' 1972) and subsequently received the Pulitzer Prize. Today it is regarded as 'a defining photographic icon; it remains a symbol of the horror of war in general, and of the war in Vietnam in particular' (Buell 1999: 102; see also Goldberg 1991: 241–5). Amidst many other exceptional photographs and a long stream of video coverage, the photo has come to be regarded as one of the most famous photographs of the Vietnam War and one of the most widely recognized images in American photojournalism (Kinney 2000: 187; Sturken 1997: 89–94). Its stature is believed to reflect its influence on public attitudes towards the war, an influence achieved by confronting Americans with the immorality of their actions (ibid.: 90; for a more sceptical perspective see Perlmutter 1998: 9).

These claims are true enough, but they do not explain much. By 1972 there had been many, many press reports and a number of striking photos that would suffice as evidence for any claim that the US was fighting an immoral war. Indeed, by 1972 the public had seen burned skin hanging in shreds from Vietnamese babies, a bound Vietnamese prisoner of war being shot in cold blood, and similar pictures of the horror of war (see, for example, Buell 1999: 62–7, 78–81; Griffiths 1971; Faas and Page 1997). The photograph could not have been effective solely because of its news value, nor does it appear to be especially horrific. In addition, the captioning and other information about the causes of the event and its aftermath would seem to limit its documentary value. The story is one of 'accidental napalm' (as the photo was captioned in some reports, e.g. *New York Times*, 9 June 1972: 1A; see also Lester 1991: 51–2); the strike was by South Vietnamese forces (not US troops); the girl was immediately tended to and taken to a hospital. As an indictment, there isn't much that would stand out after cross-examination. And why would a still image come to dominate collective memory of what is now called the first television war, a war the public experienced via kinetic images of fire fights, strafing runs, and helicopters landing and taking off in swirls of dust and action (Sturken 1997: 89; Franklin 1994; Hallin 1986)?

The task remains of fully explicating the public appeal of this photograph: to understand why it is an exceptional example of the public art of photojournalism, how it is capable of doing

Fig. 29. Photograph by Nick Ut. Reprinted by permission of AP/Worldwide.

moral work, and how it continues to function within collective memory. To answer these questions, it is helpful to place the photograph within a genre of visual representation. We define iconic photographs as those photographic images reproduced in print, electronic, or digital media that are widely recognized, are understood to be representations of historically significant events, activate strong emotional identification or response, and are reproduced across a range of media, genres or topics (see Perlmutter 1998: 1–34; Hariman and Lucaites 2001 and 2002). Examples include the migrant mother anxiously staring past the camera into the Great Depression, American soldiers raising the flag during the battle for Iwo Jima, and a lone protester facing a tank near Tiananmen Square.

We believe that these photographs fulfil important functions in American public life. At the least, they reproduce dominant ideologies, they shape understanding of specific events and periods (then and subsequently), they influence political action both topically and by modelling relationships between civic actors, and they provide figural templates for subsequent communicative action. As they do so, the icons exemplify a crucial relationship between modern, liberal-democratic public culture and the practice of photojournalism. In large, heterogeneous polities linked through technologies of mass communication, both citizenship and state legitimacy may depend on visual practices that can fill in the relationship of the abstract individual to the impersonal state. The still photograph in particular seems to be suited to framing political conflict within familiar patterns of cultural representation, providing embodied performances of political identity, and activating aesthetic norms that can shape collective memory. Thus it is that photojournalism can underwrite democratic polity by providing resources for thought and feeling that are necessary for constituting people as citizens capable of collective action.

These resources are not always available within print journalism, nor is the verbal text always capable of doing the heavy lifting required to change public opinion and motivate action on behalf of a public (or private) interest. This claim runs against the grain of theories of the public sphere and public deliberation, which assume that visual practices necessarily disrupt a society's ability to make sound judgements (Habermas 1989). It also overlooks the role and persistence of visual materials and discourses of spectatorship in the formation and development of democratic societies and of the public sphere itself (see Olson 1991; Fliegelman 1993). Instead of seeing visual images as threats to practical reasoning that can at best illustrate the news for a mass public, we believe they can provide crucial social, emotional, and mnemonic materials for democratic identity, thought, and action. This potential is most evident in the iconic photograph.

To advance these arguments, it is necessary to examine specific photographs according to a set of critical assumptions. Because they are valued as artistic achievements within public media, iconic photos must be structured by familiar patterns of artistic design. Because of their position and frequent reproduction in public media, iconic photographs function as a mode of civic performance (Bauman 1989; Schechner 1985; Bauman and Briggs 1990; Conquergood 1991). In addition, performative engagement is inevitably more or less emotional: it activates available structures of feeling within the audience to define, enhance, or restrain the emotional dimension of an event, and it bonds audience, performance, representational object, and social context with a feeling of desire or satisfaction. Finally, within the performative space created by the iconic photo there occurs a series of transcriptions (Eco 1992: 33). We believe that images become iconic because they co-ordinate a number of different patterns of identification from within the social life of the audience, each of which would suffice to direct audience response, and which together provide a public audience with sufficient means for comprehending potentially unmanageable events. Because the camera records the décor of everyday life, the photographic image becomes capable of directing the attention across a field of gestures, interaction rituals, social types, political styles, artistic motifs, cultural norms, and other signs as they intersect in any event.

Thus, the icon does not so much record an event as it organizes a field of interpretations to frame public response. Because some photos co-ordinate a particularly rich set of transcriptions, they can provide aesthetic resolution of a basic contradiction or recurrent crisis within

the political community. Consequently, the icon can continue to shape public understanding and action long after the event has passed or the crisis has been resolved pragmatically. By embodying a rich field of cultural resources for framing a collective response to disturbing events and persistent problems, the iconic photograph provides the mass media audience with 'equipment for living' as a public (Burke 1973: 293–304).

The photo of the injured girl running from a napalm attack is a moment of visual eloquence. It provides a complex construction of democratic accountability that was uniquely suited to the conditions of representation in the Vietnam era, while it also embodies conventions of liberal identity that have become increasingly dominant within American public culture since then. This ongoing mediation of public life can be explicated by both examining how the photo's artistry shapes moral judgement and tracking subsequent narrative reconstructions and visual appropriations of the image in the public media. We hope to show how the photograph managed a condition of moral and aesthetic fragmentation to construct public judgement of the war, and how that challenge to American legitimacy has been neutralized within public memory by a liberal rhetoric of individual compensation.

The illusion of strategic control had been shattered by the 1968 Tet offensive, all pretence of consensus had been killed in the 1970 shootings at Kent State, and by 1972 even those prolonging the war were relying on a rhetoric of disengagement. To those living amidst the public controversy about the Vietnam War, it seemed as if the war made no sense and American society was coming apart at the seams. Americans needed to get out of Vietnam, but without leaving all sense of coherence behind. The public was ready to be persuaded, but it also was overwhelmed by the cascade of news reports, speeches, demonstrations, and at-the-scene visual coverage. If an image was to be persuasive, it would not be because of either the realism ascribed to the photo or its relationship to a single set of moral precepts (see Tagg 1988; Burgin 1996). A logic of public moral response had to be constructed, and it had to be one that was adapted to the deep problems in the public culture at the time. This iconic photo was capable of activating public conscience because it provided an embodied transcription of important features of moral life, including pain, fragmentation, a call to obligation, tragic identification with the other, modal relationships among strangers, betrayal, and traumatic memory.

The little girl is naked, running right towards you, looking right at you, crying out. The burns themselves are not visible, and it is her pain – more precisely, her communicating the pain she feels – that is the central feature of the picture. It is the primary fact of her experience, just as she is the central figure in the composition. As she runs away from the cause of her burns, she also projects the pain forward, towards the viewer, and it is amplified further by the boy in front of her (his face resembles Munch's famous drawing of *The Scream*). This direct address underscores her relationship to the viewer. Unlike most photojournalism, she faces the lens, which activates the demanding reciprocity of direct, face-to-face interaction. The photograph projects her pain into your world.

This confrontation of the viewer cuts deeper still. Her pain, as with all great pain, disrupts and breaks up the social world's pattern of assurances (Scarry 1985). Thus, her pain is inseparable from her nakedness, as both tear the social fabric. Just as she has stripped off her clothes to escape the burning napalm, her raw, bare skin challenges the norms of decorum governing public representation (Hariman 1995; Farrell 1993). Girls should not be shown stripped naked in public, but then, civilians should not be bombed. Print journalism should not hide damaged bodies behind daily 'body counts', 'free fire zones', and other euphemisms, and governments should not hide brutality behind narratives of justified military action, moral constraint, and national purpose. Like the explosion reverberating in the background, the image communicates a profound sense of rupture that was permeating public consciousness.

This sense of fragmentation was heightened by the media practices defining the Vietnam War. Day after day the public saw a jumble of scenes – bombings, firefights, helicopter evacuations, patrols moving out, villages being searched – that could seemingly be rearranged in any order. This stream of fragmented images reflecting a war without clear battle lines dovetailed perfectly

with the government's lack of either a plausible rationale or coherent strategy. Try as the proponents of the war in Vietnam might to resurrect the idea of a theatre of war with clear battle lines, battles, and victories, all on behalf of a justifiable political objective, such ideas were at odds not only with the nature of that war, but also, and perhaps more important for their persuasive objectives, with the visual media that were shaping public knowledge of the war. In short, what was a sorry truth about the war became a dominant feature of its coverage.

The napalm photo is a model fragment. Featuring anonymous figures in a featureless scene that could be occurring anywhere in Vietnam, lacking any strategic orientation or collective symbol, confounding any official rhetoric of the war's purpose or US commitment to the Vietnamese people, devoid of any element of heroism, and focused on an unintended consequence, the scene would not seem to qualify as an event at all. In place of narrative structure, however, it provides a moment of sharp, unexpected emotional intensity, and this pathos gives the image its rhetorical power both to reveal the meaninglessness of established patterns of rationalization and disrupt moral indifference. Thus, the photo's embodiment of an aesthetic of fragmentation not only captured the character of a purposeless war, it also embodied the moral predicament the war presented to the American public. How can any idea of right conduct be established within a condition of political and representational incoherence?

The girl's pain demands an answer, which begins with her nakedness. As Michael Walzer observes, even hardened soldiers are averse to killing an out of uniform (unmarked) enemy (Walzer 1977: 138–43). It is one thing to kill a soldier, but to kill a naked human being violates the most basic injunction against murder. Simple vulnerability, particularly as it is symbolized by nakedness, puts us in an elemental moral situation. Like the parable of the Good Samaritan, which featured a naked man discovered along a road, the girl's naked vulnerability is a call to obligation, and, as in the parable, one that has occurred unexpectedly. In the words of John Caputo, 'Obligation happens' (Caputo 1993: 6). Obligation can appear out of nowhere, without regard to one's social position, directly encumbering one in ways that are decidedly inconvenient and, worse, that may disrupt deep assumptions regarding how one's life is patterned and what the future should hold. Thus, the photo abruptly calls the viewer to a moral awareness that cannot be limited to roles, contracts, or laws, or buffered by distance. A fragmented world is still a world of moral demands, only now they may be most pressing when least expected, and the demand itself can shatter conventional wisdom.

This identification with the stranger has both a modern face and the structure of classical tragedy. The girl's nakedness provides a performative embodiment of the modern conception of universal humanity. (She could be a poster child for the Universal Declaration of Human Rights, and as an adult she has served as a goodwill ambassador for the United Nations.) The dramatic charge of the photo comes from its evocation of pity and terror. We see a pathetic sight – the child crying in pain – and as we enter into her experience we feel both pity for her (or compassion towards her) and the looming sense of terror that lies behind her injuries. The terror (or fear or horror) that tragedy evokes comes not from the physical injury itself but from the social rupture behind it, which is why Aristotle noted that the most moving tragedies involved harms done off stage and within the family (Aristotle 1973: 1453b). The picture reproduces this design. First, despite its patently visual nature, the napalm attack is already over and the girl's burns are not visible – most are on her back, and the photo's low resolution minimizes the others. Second, she is a child – a member of a family – and familial relationships are either modelled (between the children) or broken (between parents and children, as the biological parents are absent and the other adults are indifferent soldiers). The pity for the child is compounded by this sense of social breakdown – again, the horror of war is the destruction of social order and of meaning itself. Her pain activates the terror of tragedy, which comes from the realization that humans can be abandoned to a world no longer capable of sympathy, a world of beasts and gods, of destructive powers and impersonal forces, of pain without end.

This tragic structure is filled out by the relationships between the children and the soldiers. The crucial fact is that the soldiers are walking along slowly, almost nonchalantly, as if this were an everyday experience. Their attitude of business as usual contrasts vividly with the girl's

203

sudden, unexpected, excessive experience of pain and terror. The message is clear: what seems, from looking at the girl, to be a rare experience sure to evoke a compassionate response, is in fact, as evidenced by the soldiers, something that happens again and again, so much so that the adults involved (whether soldiers there or civilians in the US) can become indifferent, morally diminished, capable of routinely doing awful things to other people. Precisely because the photo is operating as a mode of performance, its formal implication is that what is shown is repeated, and repeatable, behaviour (Schechner 1985: 35–116; States 1996: 20). The photo that will be reproduced many times is itself not the record of a unique set of circumstances, but rather a dramatic depiction of those features of the war that are recurring over and over again past the point of caring. As the girl screams and other human beings walk along devoid of sympathy, the photo depicts a world of pain that reverberates off of the hard surfaces of moral indifference. This is why knowledge of the circumstantial events (such as the girl receiving treatment immediately) rightly provides no qualification to the moral force of the photograph. The knowledge that would matter would be a demonstration that this was a rare use of napalm, or that US forces and their Vietnamese allies almost never harmed civilians in the war zone. But, of course, by 1972 the truth of the brutality of the war had breached the surface of national consciousness.

The photo is not about informing the public at all; rather, it provides a performance of social relationships that provide a basis for moral comprehension and response. These modal relationships in turn can exemplify morally significant actions such as self-sacrifice or betrayal. The napalm photo features two betrayals. Whether American or Vietnamese, the soldiers are agents of the United States who are supposed to be protecting the girl, yet they appear content merely to herd her and the other children down the road. The soldiers are not helping, they even seem to be treating the children like prisoners of war (for guns are still drawn), and they are indifferent to the suffering before them. While a little girl seems to appeal directly to the public for help, it can do nothing while its representative in the picture adds insult to injury. As the girl is betrayed by the institutional figures who are supposed to protect her, so is the public betrayed by the same institution.

Although the activity within the frame directs public response, the fact that this is a photograph – a 'static' image – means that time has been stopped. The picture holds its experience of terror and uncompleted action for all time, while having the activity within the frame eternally repeat itself (for that is what it is, performatively-restored repetitive behaviour). This mythic sense of eternal recurrence corresponds perfectly to the phenomenological structure of trauma. One simultaneously feels stopped in time (or thrown outside of time, temporal movement, history, change) while constantly repeating the actions within that isolated moment (see Herman 1992; Shay 1994). The normal flow of time has been fragmented into shards of isolated events, while the traumatized subject remains trapped in memory, unable to break out of the ever recurring pain. Although this psychological state is commonly thought to result from exposure to carnage, Jonathan Shay has pointed out how the deeper cause is a sense of betrayal (Shay 1994: 3–22). Likewise, an iconic photo that is said to capture the horror of war is not gruesome, but it does freeze the spectator in a tableau of moral failure. Worse, one is helpless, unable to change anything about what happened and yet is still before one's eyes. This sense of powerlessness extends to control of cultural memory itself, as the image circulates through the media, recurring again and again unbidden.

Thus, the photograph came to provide symbolic representation of the American public's experience of the Vietnam War. Somehow, for no evident reason, the United States was conducting an immoral war. Worse yet, although it seemingly was close to the action, the American public could only watch as American troops did terrible things to other people. Even when wanting to do the right thing, one was stuck in time, unable to restore what had been broken. Nor would the photograph allow any excuses. The basic conditions of modern American warfare are all there. Imperial action in a distant, third world country far from the public's direct control; massive, technologically intensive firepower being used to spare American soldiers' lives at enormous rates of 'collateral damage'; mass media coverage sure to induce guilt while apparently providing no means for action. The moral danger of this world is captured

tonally in the picture's composition of light and darkness: As the dark smoke blots out the sky, and while the girl bathed in light has in fact been seared with liquid fire, the elements of the sublime are present but out of order, gone demonic. Light hurts, darkness towers over all, awe is induced by destruction, terror is not sublimated to a transcendent order. The image calls a public to moral awareness, but its rhetorical power is traumatic.

The photo's activation of the structure of trauma is evident as well in its subsequent history of interpretation. According to Shay, the crucial step towards healing from a traumatic experience is to construct a narrative of one's life that can contextualize the traumatic moment (Shay 1994: 188–93). The narrative does more than soothe, for it addresses the crucial characteristic of trauma, which is being bracketed from any sense of temporal continuity. The traumatic moment is stopped in time, and narrative gets time moving again so that the moment may eventually recede, dissipate, or become complicated by other elements of larger stories.

This photo has produced several narratives. The most frequently told of these is the story of the relationship between the girl in the photo and the photographer (Buell 1999: 102–03). Both of Vietnamese ethnicity, they became lifelong friends as he helped her relocate to Canada. The story functions as a convenient displacement of responsibilities while breaking out of the traumatic moment without either involving the American public directly or leaving them completely out of the story.

A more recent variant of this story is Denise Chong's *The Girl in the Picture*, which chronicles the girl's personal odyssey of recovery while trying to free herself from the publicity generated by the photo. 'She felt as though the journalistic hounds would make her into a victim all over again. "The action of those two women [journalists, one with a camera] on the sidewalk", she lamented to Toan, "was like a bomb falling out of the sky"' (Chong 1999: 6). Note how this narrative replays the iconic performance of the photograph. Allied technology continues to harm an innocent Vietnamese civilian, while the public again is drawn into an act of inflicting pain it did not authorize, an act that can only be redeemed through empathic identification with her suffering. The traumatic 'scars [that] war leaves on all of us' (ibid.: bookjacket flap) are then ameliorated by a narrative of her life after the war.

Another, rather peculiar story is that of the Reverend John Plummer, who confessed to be the officer who had ordered the air strike that burned the girl. Plummer staged an elaborate reunion with the girl (now a woman) at the Vietnam Veterans Memorial in Washington, D.C., resulting in a second picture entitled 'The Meeting at the Wall', this one of the two of them smiling cheek to cheek as if at a honeymoon resort in the Poconos ('At long last' 1997). It turned out, however, that Plummer had not ordered the air strike ('Vets challenge minister's account' 1997). What is most interesting about this revelation is that, although there was much discussion of the misrepresentation, the response of many commentators was charitable. The lack of scandal (especially among veterans) about a veteran's phony confession of guilt is remarkable, but it can be explained. On the one hand, the assumption of excessive guilt is a characteristic of the post-traumatic stress disorder suffered by some veterans (and an understandable attempt to overcome their paradoxical sense of being criminals in a morally incoherent world). On the other hand, the fact is that both veterans and the public needed such a story of reconciliation.

A moment of fragmentation, confusion, and terror elicits narratives of restoration, but these are decidedly liberal narratives. They focus on individuals, and salvation comes from escaping the political or psychological confines of national identity. Although the focus on the individuals in iconic photos is a convention of subsequent media coverage, it has particular resonance here because the photo itself embodies a model of liberal identity. There is no more basic sense of individual autonomy than the naked body – a body that exists prior to any social qualification or enhancement and that is the object of all universal prohibitions against detention, assault, torture, and murder. Her bare, vulnerable person is all that she has to claim, and it is the primary basis for her claim for the protection of others. This embodiment of personal autonomy and its violation by the military sets up the basic dialectic of liberalism, which is the tension between the individual and society. The individual requires social support but inevitably is constrained, coerced,

harmed, wounded, and scarred by other people, and society provides individuals with the organization and resources they need to survive while demonstrating that anyone is replaceable.

The girl is surrounded by figures embodying standard social roles and relationships: children, brothers and sisters, an older girl holding the hand of a younger boy, a small child turning to an adult figure as if to a parent, and, finally, (adult) soldiers behind (young) civilians. The society that is supposed to be protecting the individual through organizations such as the family and the army has failed to do its job. Now the 'accidental' nature of the napalm is even less consolation: of course the individual can be harmed by society, both in its routine operations and especially as it breaks down under pressure. Inevitably society will be indifferent to any one individual, even when that individual is suffering, as the soldiers in the picture demonstrate so well.

This fragment of a war having no clear orientation towards any strategic objective, the image of a society breaking down under attack from both enemies and its own forces, the figure of a naked individual isolated in pain though surrounded by others – these several levels of the photograph combine to articulate the psychic structure of modern liberalism. Collective action has no purpose, society is a necessary evil, the individual is the locus of meaning, and the basis for answering the call of another is recognition of her autonomy and corresponding right to be free from violence. So it is that the photograph has become a means for schooling Americans in liberal reactions and a corresponding view of history. The photograph is itself a transcription of the public culture: it recodes a public controversy about the morality of war as a story of innocent individuals ambushed by history. It recodes the deaths and mutilations of millions of people as a story of how an individual has been wounded. It recodes questions of justice as a rhetoric of healing. Nor is this transcription entirely to be faulted, for it certainly is a highly moral construction, perhaps the most powerful means for activating moral awareness in American society. Yet by the time that 'Kim's Story is one of forgiveness – of the personal and public healing of wounds from this century's longest, most divisive war', it has become a story in which personal experience not only represents but also displaces public relationships (*Kim's story: online*). In addition, the more the physical wound persists as a metonym for all the damage done by the war, the less concern there need be regarding larger forms of responsibility. Physical wounds need only medical care and time to heal; some political traumas can only be resolved by confronting questions of justice and injustice by both leaders and nations.

This relationship between the physical wound and a rhetoric of healing that can displace concerns about justice is most evident in the picture of Kim with her infant child (Figure 30) ('Portrait of Kim Phuc' 1995; 'Sixtieth Anniversary of *Life*' 1996: 102; Chong 1999: 191). This picture may also be an attempt at something like a visual sequel to the iconic photo, and one that supplies a Hollywood ending for the story. The continuities and discontinuities between this photo and the icon establish the key differences in effect. Her nakedness is still there, but it has been carefully controlled by changes in posture and camera angle to maintain the modesty expected of a grown woman and a tranquil public culture. Her injury is still there, of course, but now the effects of the war are to be dealt with on an individual basis, and those who created them are no longer in the picture, no longer capable of being interrogated or condemned.

Perhaps the soldiers have been replaced by the scars on her skin. The display of the scars also reveals the relationship between the physical and symbolic dimensions of the two images. In the iconic photo, her physical wounds were not visible; they were communicated by her expression and the other child's cry of terror. Thus, the physical harm that was the most basic consequence and moral fault of American military actions was depicted indirectly. In the sequel, the physical harm is revealed, but given its relationship to the other features of the picture it acquires a different significance. Now the wounds are superficial, for they appear to have no effect on the woman's internal health. Inside, she is capable of bearing a 'normal', healthy baby. And what a baby it is: unblemished, its new, smooth skin a striking contrast to her mature scars. Now the physical damage to Kim is merely the background for a tableau of regeneration. Although she is not doing that well in one sense, for she is still scarred, she obviously has achieved one of the great milestones of personal happiness by giving birth to a beautiful child.

Fig. 30. Photography by Joe McNally. Reprinted by permission of *Life*/Joe McNally.

While the past is still present, it is inert – no more than ugly tissue that may be an embarrassment but that has no power to prevent a new beginning and personal happiness. In America, history lasts only one generation.

The sunny optimism of this story of war's aftermath is validated by the rest of the composition. Her beatific expression and the figural enactment of Madonna and child portraiture suggests a serenity in which traumatic memory or persistent conflict has no place. Likewise, in place of the dark smoke from the napalm blast, the background of this photo is a darkened blank

wall. This gentle décor and her carefully draped clothing invoke all the conventions of retail studio photography, which in turn anchor her happiness within a familiar scene of private life: the framed portrait that is displayed proudly by the child's grandparents.

All of these changes occur within a thoroughly traditional transcription of gender roles. The muted sexuality of her late girlhood has been channelled into the conventional role of motherhood. Men clearly maintain their monopoly on violence (Ehrenreich 1997: 125), while a woman embodies the virtues of nurturing, and Vietnam and peace itself remain feminized while war and the American military establishment retain their masculine identity. The scene defines private life as a place centred on women and children, where mothers are devoted to and fulfilled by caring for their families.

The shift from public to private virtues is encoded by taking a second photo for public dissemination in a manner similar to taking a photo for distribution within one's family. The substitution of photos provides a double compensation: Kim has been given a beautiful child to replace her own damaged childhood, and the second image is given to the public in recompense for its past discomfort. The baby also replaces the other children in the original scene – those running down the road and those who did not make it. The war is over, and children who could be running in terror for their small, vulnerable lives are now sleeping quietly in their mothers' arms. Moreover, where the earlier children were Kim's siblings, and so the sign of collective identity, this child is her child, her most dear possession and a sign of the proprietary relationships essential to liberal individualism. The transformation is complete: from past trauma to present joy, and from the terrors of collective history to the quiet individualism of private life.

Thus, this sequel to the iconic photo inculcates a way of seeing the original image and the history to which it bore witness. A record of immoral state action has become a history of private lives. Questions of collective responsibility, and of justice, have been displaced by questions of individual healing. The wisdom that recognizes the likelihood of war's eternal recurrence has been displaced by a narrative of personal happiness and of a new, unblemished, innocent generation. Our comparison of the two images is not a chronicle of misrepresentation, however. The second photo's visual reinterpretation of the war is achieved not by distorting the iconic photo but rather by extending designs in the original that were essential for its moral significance and rhetorical appeal. Because those designs carry a bias towards liberal ideology, the photo has a strong ambivalence. On the one hand, a partial record of a supposedly incidental moment became a defining event of the war, one capable of negating the moral certainty and aesthetic unity of the American culture that had coalesced during World War 2. On the other hand, this photo is not only a transgression, but also the enactment of another model of political identity always available within American public life, one that comes of age amidst the prosperity and the contradictions of the postwar era. It doesn't just tear down one set of ideals, for it also advances the habits of another way of life.

In this liberal sensibility, actions are meaningful because symptomatic of internal conditions rather than because they adhere to proven models of character. The individual's experience is the primary locus of meaning, and conflict resolution may be as much psychological as political. The individual's autonomy and human rights supercede any political identity, and obligations are encountered along the road rather than due to any sense of tradition or collective enterprise. Collective action is essentially moral and humanitarian rather than defined by national interests, but it also is ad hoc, not directed by long-term objectives and analysis. The fundamental tension in political life is between the individual and society, and once the individual is protected other political possibilities are likely to be deferred to the more immediate engagements of private life.

The photograph of the napalmed girl could move a society to action because it articulated a specific historical predicament through a visual vocabulary that also sanctioned preferred habits of response to any public address in that era. Those habits also have been evident in America's relationship with Vietnam since the end of the war and in the continued appropriation of the photo. This iconic image has become a parable of liberal representation.

'Commodity Feminism' in 1960s' Visual Culture

Sex, Style and Single Girls

BILL OSGERBY

In 1968 the slick advertising slogan 'You've Come A Long Way, Baby' announced the arrival of Virginia Slims. A new brand of cigarette launched by the Philip Morris tobacco empire, Virginia Slims were set apart from the competition by being pitched towards what was perceived as a propitious, new consumer market – young, independent and upwardly-mobile women. The Virginia Slims advertising campaign was constituent in wider shifts in popular visual representations of femininity in America during the 1960s. Across the fields of advertising, film and TV, and other non-visual popular culture, the period saw the emergence of a new configuration of femininity – the young and cosmopolitan 'Single Girl'.

In the world of the Single Girl, puritanical reserve and domestic slog were pushed aside in favour of a lifestyle whose credo emphasized individual pleasure and personal 'liberation' through commodity consumption. The Single Girl was a prevalent visual image across US popular culture during the 1960s, but it was in the pages of *Cosmopolitan* magazine that she was codified most comprehensively. Originally a homely general features title pitched to American housewives, *Cosmopolitan* got a full makeover during the mid-1960s. Revamped and repositioned in the market as the glamorously exciting Bible of the Single Girl, the magazine's features, editorials and advertising exuded a lively pizzazz, its heady cocktail of sexual freedom and stylish consumerism propelling circulation figures from under 800,000 copies a month in 1965 to more than one million five years later.

Although products such as Virginia Slims and *Cosmopolitan* cultivated an aura of independence and freedom, many within the women's movement were deeply critical of what they perceived as an exploitative commercial strategy. Betty Friedan, leading light of American feminism, had already fixed her sights on American advertisers in her 1963 bestseller, *The Feminine Mystique*. According to Friedan, modern society's 'mystique of feminine fulfilment' was a sham. Describing what she termed 'the problem with no name', she pointed to the feelings of profound dissatisfaction among women who, despite being well educated and financially secure, were prevented from realizing their full potential and remained trapped in the 'comfortable concentration camp' of suburbia. Friedan did not see consumerism and advertising as the source of women's oppression, but she certainly saw them as making a significant contribution. Advertisers, Friedan argued, 'blanket the land with persuasive images, flattering the American housewife, diverting her guilt and disguising her emptiness' (Friedan 1963: 218). As President of the National Organization for Women (NOW, founded in 1966) her critique extended to a broad range of what she regarded as sexist representations of women in American advertising. Beginning in 1970, NOW and a coalition of women's groups launched an all-out assault on advertisers, with activists occupying the editorial offices of the *Ladies' Home Journal* and placing stickers stating 'This Ad Exploits Women' on ads considered demeaning. Particular scorn was reserved for the iconography of the Single Girl, which seemed both manipulative and a trivialization of feminism's political stand.

Friedan's critique was influential, but her view of advertising and consumerism as breeding grounds for uniformly oppressive ideologies of female passivity was problematic. As Mica Nava has noted, Friedan's ideas can be situated in a long tradition of cultural criticism that has perceived people as the helpless victims of a commercial machine that works 'to construct "false needs", to indoctrinate and manipulate men and women into social conformity and subordination' (Nava 1987: 205). As Nava observed, this view of people as 'duped and passive recipients of conspiratorial messages designed to inhibit true consciousness' (ibid.: 207) distorted the complex relationships between cultural texts and their audiences. In contrast, more recent theoretical perspectives have understood popular audiences as more active and selective in their consumption of advertising images.[1]

The 1960s' Single Girl archetype was also more complex and contradictory than its critics allowed for. Certainly this 'new' femininity was, in large part, a media construct – an imagined ideal generated in wily marketing campaigns. But representations of the swinging Single Girl were not simply a vehicle for a manipulative 'false consciousness'. The world of the 1960s' Single Girl was a realm of fissures and contradictions that offered spaces where (at least *some*) women were able to engage meaningfully with the cultural shifts taking place around them, rejecting dominant feminine ideals of family-centred domesticity in favour of a sexually confident feminine identity focused around the pleasures of modern leisure and personal consumption.

During World War 2, shifts in the sexual division of labour provoked limited social anxiety since women's increased paid employment was generally accepted as a temporary wartime expedient. In peacetime, however, the degree of social and economic autonomy gained by women proved difficult to reverse and the shifting boundaries of gender roles occasioned marked unease. As a consequence, the postwar period saw a battery of social and political strategies that sought to reinstate and buttress 'traditional' gender roles. These can be seen as a key component in what a number of historians have seen as a culture of 'containment' that evolved in America during the Cold War.

At the heart of these ideologies of containment stood the image of the prosperous, nuclear family. As Elaine Tyler May shows in her comprehensive (1999) study of postwar domesticity, strategies of 'domestic containment' (manifest in both government policies and across a multitude of popular texts) promoted marriage and home-making as fundamental to the strength and vitality of democratic life.[2] Strenuous efforts were made to encourage working women to return to the home, but the proportion of women aged fourteen and older who were active in the labour force continued to grow – from 25.4 per cent in 1940, to 29 per cent in 1950 and 34.5 per cent in 1960 (Rupp 1982: 36).

Growth was especially pronounced in office work. Between the wars clerical jobs had proliferated as the consumer industries and state agencies expanded, but even this increase was eclipsed by the phenomenal growth that took place during the boom years of the 1950s and early 1960s. As the office labour force swelled further, it also became increasingly 'pink collar' in character. As Julie Matthaei shows, secretarial and clerical jobs were originally dominated by men, but with the expansion of the business and service sectors in the early twentieth century, opportunities steadily opened up to middle-class women (Matthaei 1982: 220). By the early 1960s almost one of every three employed women worked in a clerical or secretarial job (ibid.: 282) and by 1974 four out of five office workers were women (Howe 1977: 10). At the same time, however, Matthaei notes that the nature of clerical and secretarial work changed, so that it no longer represented a route to 'move up the ladder' through experience (Matthaei 1982: 222). According to Matthaei, office work became characterized by a sexual division of labour, with men dominating the more prestigious, powerful and highly paid managerial positions, while women were generally confined to clerical jobs that became 'permanently subordinated, dead-end positions, which allowed women to keep their femininity but did not give them pay commensurate with their skills' (ibid.: 223).

Despite this, like its forerunners the *fin de siècle* New Woman and the 1920s' flapper, the ideal of the 1960s' Single Girl emphasized independence and individual fulfilment outside the constraints of domesticity. Where the Single Girl departed from her antecedents, however, was

in her less inhibited sexuality and her thirst for commodity consumption. Earlier 'new femininities' had resisted sexual repression, but the Single Girl ideal pushed harder against conventional morality through its emphasis on the expression of sexuality outside the bounds of marriage. And, while the 1960s' Single Girl archetype did not necessarily denote social privilege, her materialist ardour was unmistakable – a trait constituent in the wider transformation of American lifestyles and cultures that took place amid the postwar consumer boom.

Above all else, it was the phenomenal success of Helen Gurley Brown's pink collar handbook, *Sex and the Single Girl*, which proclaimed the arrival of a new, independent and ambitious brand of femininity in 1960s' America. Throughout the 1950s Brown had worked as a secretary for the prominent advertising agency Foote, Cone & Belding. The early 1960s saw both her promotion to become one of the country's highest-paid ad copywriters and her marriage (at the age of 37) to successful movie producer, David Brown. Published in 1962, Brown's book was a self-improvement manual for the modern woman, offering step-by-step guidance on personal appearance, home budgeting, work life and (especially) the tricky art of flirtation. A publishing phenomenon, *Sex and the Single Girl* sold more than two million copies within three weeks of its launch, the book and its author quickly becoming a focus of popular fascination and controversy.

Much of the interest was sparked by Brown's insistence that young, single women should relish their sexual independence. This was a radical stance in the still relatively conservative moral climate of 1962. As Barbara Ehrenreich and her associates observe, the seismic impact of *Sex and the Single Girl* stemmed in large part from the way the book 'legitimized the sexual possibilities opening up to young, urban working women' (Ehrenreich *et al.* 1986: 59–60).[3] Also central to the 'new life' mapped out in *Sex and the Single Girl* was an enthusiasm for the pleasures of personal consumption. Her book, Brown explained, was 'not a study on how to get married but how to stay single – in superlative style' (Brown 1962: 8). 'Far from being a creature to be pitied and patronized,' Brown explained, '[the single woman] is emerging as the newest glamour girl of our times':

> She has more time and often more money to spend on herself . . . A single woman never has to drudge. She has more money for clothes and for trips than any but a wealthy married few. (ibid.: 3–4)

For Hilary Radner, the success of *Sex and the Single Girl* was constituent in the wider emergence of a new ideology of 'singleness' oriented around commodity consumption. In this respect, Radner argues, the iconography of the Single Girl offered both possibilities and constraints to American women during the 1960s. On the one hand, the Single Girl ideal represented a feminine identity that worked 'largely in the interests of an expanding consumer culture', providing a cultural archetype that met the imperatives of an economy which 'required a mobile workforce with significant discretionary income' (Radner 1999: 4). At the same time, however, Radner emphasizes the aura of autonomy that surrounds representations of the Single Girl. Crucially, Radner argues, the Single Girl was a working girl who 'extract[ed] a paycheck from her boss rather than grocery money from a husband' (ibid.: 10). Supplanting the domestic ideal, therefore, the Single Girl ideal offered a feminine identity outside the bounds of marriage, an identity that was empowered not only through its sexual confidence but also, more broadly, through its expertise in image-making and its manipulation of consumer products.

With the runaway success of *Sex and the Single Girl*, Helen Gurley Brown became a national celebrity, and was soon recruited by Hearst Publications as editor-in-chief of their ailing women's magazine, *Cosmopolitan*. Largely aimed at the suburban homemaker, *Cosmopolitan* had championed an increasingly outmoded domestic ideal. Brown, however, transformed the magazine into a torchbearer for pink collar femininity. Under her aegis the magazine was revamped and repitched to appeal to the 'Cosmo Girl' – an imagined model of sassy femininity that Brown envisioned for her intended readership of employed and independent 18- to 34-year-olds. The strategy proved a master-stroke. Brown was hailed as 'the working girl's Simone de Beauvoir' as

Cosmopolitan's circulation figures rose by more than 100,000 in the first year of her control, while advertising sales grew by a staggering 43 per cent (*Newsweek*, 18 July, 1966).

Brown's authorial voice pervaded the new *Cosmopolitan*. In her monthly editorial, 'Step Into My Parlour', Brown presented herself as the embodiment of the glamorous Single Girl ideal and encouraged readers to follow in her stylish footsteps. December 1966, for example, saw Brown regale her readership with details of a thrilling trip to Europe. 'I feel passionately that I must get you there if you haven't been yet and I will start lighting the fire *now*,' Brown effused as she recounted her tale of suave cocktail parties with movie executives in Majorca and high tea with John Paul Getty at his English castle (*Cosmopolitan*, December 1966).

The same themes of jet-set excitement and carefree hedonism also became the stock-in-trade of *Cosmopolitan*'s features and photospreads. Even before Brown's appointment as editor (in June 1965) the magazine was beginning to celebrate the Single Girl ethos. In February 1965, for example, a special report spotlighted the exhilarating lives of 'Single Girls in New York City'. Underscoring the Cosmo Girl's aversion to mundane domesticity, the feature enthused that 'The expanding horizon of modern America offers many more choices than the traditional housewife's role to today's energetic young woman – but the opportunity to exercise her choice seems nowhere as wide open as in the Mecca of Manhattan' (*Cosmopolitan*, February 1965). Under Brown's control, the theme was amplified and extended. A feature on apartment complexes designed for swinging singles, for example, highlighted a smorgasbord of opportunities for freedom and pleasure:

> After the bloody mary parties and the tennis tournament and the continental breakfast and the gym workout and the sauna bath and the volleyball game and the ski club meeting and the dinner dance, then we're going to have some fun . . . some real *fun*! (*Cosmopolitan*, June 1966)

A similar bold élan also registered in *Cosmopolitan*'s fashion features. In June 1966, for example, a photospread entitled 'Travel Clothes to Start Something In' came with the warning 'Don't wear *any* of these things unless you expect action'. Mostly shot from below and skewed at an angle, the images were charged with the dynamism of 1960s' modernism and set models in an assortment of movement poses against a range of exciting backdrops. One photo, for example, saw a young woman stride purposefully up the steps of an airline lounge – suitcase in hand, her air of independence and adventure was underscored by the audacious flares and swirling print of her trouser suit ('wear it to dinner with a maharaja'). Another image was set in a decidedly futuristic airport terminal. One hand placed confidently on her hip, the other nonchalantly raising her sunglasses, the model's pose connoted self-assurance and sexual confidence, qualities that complemented her racy 'paw print' cotton dress, daringly unzipped to reveal a black piqué bra ('Marvelous for exploring the Casbah . . . Marvelous for *anything*'). Generally, movement and travel were recurring themes in the magazine's fashion spreads. In 'Dreamy Clothes to Make a Getaway In', for instance, a selection of chic outfits were modelled in the context of a variety of romantic travel fantasies stretching from the desert sands of Arabia to a Polynesian beach idyll and an elegant voyage on the Mediterranean (*Cosmopolitan*, December 1966). According to Radner, these themes were typical of a stylistic shift in fashion photography that, during the 1960s, gave full play to the Single Girl ethos by emphasizing action and movement. This was an approach to photographing models, Radner argues, that 'freed the women from a domestic *mis-en-scène* and from the studio. It emphasized fluidity and movement, a certain style rather than a set of commodities' (Radner 2001: 185). At the same time, however, Radner sees this photographic style as expressing the paradoxes of the new femininity. For, while the Single Girl ideal certainly stepped outside traditional discourses of femininity (with consumerism displacing maternity in the construction of the feminine), the notions of activity and agency were always kept in check by a visual emphasis on youth and a quality of frivolous 'girlishness'. This was a paradox embodied in *Cosmopolitan*'s covers. The Cosmo Girl was surrounded by text pointing to a host of exciting lifestyle possibilities (careers, sex, leisure), but the model was invariably posed as a passive (sexualized) object of the reader's gaze.

Laurie Oulette also points to the contradictions at the heart of the Single Girl ideal. In her analysis of the development of *Cosmopolitan* during the 1960s, Oulette highlights the way the magazine 'spoke to major changes in women's economic and sexual roles, while also constructing a particular social identity for her "working girl" readers' (Oulette 1999: 360). Drawing on Judith Butler's concept of gender as a 'performance', or a 'corporeal style' fabricated through a set of performative acts (Butler 1995: 31), Oulette argues that *Cosmopolitan* 'celebrated an exaggerated femininity that hinged on the transformative power of artifice' (Oulette 1999: 365). Stressing the fluidity of female subjectivity, *Cosmopolitan*, Oulette suggests, encouraged its readers to make themselves over into something new, or even construct multiple selves – its choice of exciting 'new looks' and ideas for cunning romantic gambits offering its readership an arsenal of performative tactics for ascent through the social hierarchy. At best, however, this was an escape rather than a revolt. Rather than challenging dominant systems of power relations, Oulette argues, the Cosmo Girl sought individual improvement within them (ibid.: 369). Equally ambivalent was *Cosmopolitan*'s configuration of sexual independence. The 1960s saw the magazine give increasing attention to issues of sexuality and sexual freedom, with features on female orgasm, birth control and sexual experimentation, but Oulette suggests that this construction of female sexual desire 'was linked to upward mobility through men' (ibid.: 372). *Cosmopolitan*'s romantic excerpts and short stories, for example, encouraged women to identify with female heroines whose male sexual partners (or desired partners) were above them socially and economically, while the magazine's male centrefolds (the first, actor Burt Reynolds, appeared in the April 1972 issue sprawled out on a bearskin rug that discreetly covered his manhood) linked female desire to what the male object represented socially and economically (ibid.: 371).[4]

The Single Girl archetype, then, was characterized by tensions and contradictions. Certainly, there was an emphasis on independence, sexual freedom, upward-mobility and individual fulfilment through consumerism. But this 'new femininity' was still mediated through ideals of romance in which dominant patterns of gendered power relations remained essentially intact. The contradiction was especially explicit in an advertising campaign for the Ford Mustang. First rolling off assembly lines in 1964, the sporty Mustang was designed to appeal to consumers who identified with 'youthful' themes of adventure and fun. Ford saw the pink collar market as especially lucrative, and in 1966 a special 'Six and the Single Girl' promotion coupled the power of the car's engine with the allure of Helen Gurley Brown's archetype. Like *Cosmopolitan*, Ford's advertising copy called attention to the Single Girl's independence, depicting her as an individual who was confidently out and about at 'the mountains for the weekend' or 'off for dinner with the girls'. At the same time, however, this freedom was only made possible through masculine intervention and the ability of a 'husky, suave brute of an engine to squire her around town'. In other ways, too, Ford's advertising was underpinned by representational codes that configured femininity as passive and submissive. The slight soft focus of the ad's image, for example, evoked the connotations of conventional romance. Apparently set in a woodland glade, meanwhile, the ad drew on traditional forms of visual identification that associated women with 'soft and gentle' nature – qualities that were further emphasized by the bunch of yellow flowers clasped by a blonde model and playfully arranged on the Mustang's hood. The model's pose, moreover, was also significant. Bent across the front of the car, her position highlighted the phallic power of the 'masculine' car – associations that were reinforced by the use of a wide-angle lens to accentuate the size of the Mustang's engine grill. Ford's advertising campaign, then, may have configured the single girl as a free spirit, but this freedom was effectively 'reined-in' by visual codes that juxtaposed a meek and 'fluffy' femininity against the 'masculine' power of the sportscar.

Ford were not the only ones to cash-in on pink collar spending power. Many other brands also launched their own Single Girl sales campaigns. In 1971, for example, a 'Scotch and the Single Girl' promotion for J&B whisky featured a glamorous model who assuredly knocked back her drink while shooting pool with her barroom pals. Again, however, this imagery was shot-through with contradictions. On one hand, the ad depicted a form of femininity that was

affluent, urbane and spirited. But, at the same time, the ad's visual codes also configured the Single Girl in terms of passivity. Perched on the edge of the pool table, for instance, the pouting model's 'singleness' (and hence her sexual availability) was visually emphasized by the fact that she filled much of the frame of the image. And, rather than confidently meeting the look of the audience, the model's eyes were submissively averted – the J&B advertising campaign effectively constructing the Single Girl as the sexualized object of an implicitly masculine gaze.

The Virginia Slims advertising campaigns, meanwhile, went from strength to strength. *Cosmopolitan*'s success also continued. By the mid-1970s the magazine was reaching more than two million readers, its advertising sales were still soaring and twelve foreign language editions had been launched. *Cosmopolitan*'s Single Girl formula also set the tone for the array of women's glossy lifestyle magazines that followed, as well as leading the way for a new genre of soft-core pornography aimed at women. First off the mark was *Playgirl*. Launched in 1973 by West Coast publisher Douglas Lambert, *Playgirl* was a deliberate attempt to reconfigure *Playboy* magazine for a female market. A few months later a competitor was also launched, Bob Guccione (publisher of *Playboy*'s arch rival, *Penthouse*) working with his wife, Kathy Keeton, to launch *Viva*. Both *Playgirl* and *Viva* included a higher quota of sexual content than *Cosmopolitan*, though they shared the penchant for personal independence and consumer hedonism that characterized the Single Girl ethos.

In television and film the Single Girl was also a notable presence. Moya Lucket, for example, points to the way that the notions of sexual independence forged in *Sex and the Single Girl* and *Cosmopolitan* also surfaced in the TV series *Peyton Place* (ABC, 1964–9) (Lucket 1999). Loosely based on Grace Metalious's scandalous 1956 novel of sex and intrigue in smalltown New England, *Peyton Place* departed from the representations of women as homemakers that had been a stock feature of American TV series during the 1950s. But the new focus on female sexuality, Lucket argues, was not unswervingly progressive. In *Peyton Place*, for example, the show's focus on two teenage heroines – blonde, virtuous Allison Mackenzie (Mia Farrow) and dark-haired siren Betty Anderson (Barbara Parkins) – summoned up the traditional virgin/whore dichotomy around which femininity has conventionally been disciplined and judged (ibid.: 79–80). At the same time, however, Lucket suggests that this dichotomy was also often ruptured by twists in the show's plotlines that sometimes harboured 'radical implications' through their transgression of sexual conventions and taboos (ibid.: 89).

The Single Girl archetype was also central to the 1960s' sleuth and spy crazes. *Honey West* (ABC, 1965–6), for instance, featured Anne Francis as a glamorous and resourceful female gumshoe. Though this 'private eyeful' was, in some respects, inscribed by a male gaze, Julie D'Acci argues that *Honey West* also presented a powerful and autonomous image of femininity, with a title character who 'might control her own desires as well as the narrative, and might wield power in the public sphere along with cars and weapons' (D'Acci 1997: 82). This was a construction of femininity clearly indebted to the British action series *The Avengers*. Though not itself screened on ABC TV until 1966, the network's executives were impressed by the British show's sexy, yet active and challenging, heroines – Cathy Gale (Honor Blackman), followed by Emma Peel (Diana Rigg) – and in *Honey West* they sought to develop an American equivalent (see Miller 2000: 54). The NBC network followed suit with its own show centred around a daring female adventurer, *The Girl From U.N.C.L.E* (1966–7). Low ratings, however, meant that neither series survived its first season and the networks pulled back from the 'action girl' formula.

On the big screen, however, the Single Girl had greater endurance in the form of the Bond girl. For Tony Bennett and Janet Woollacott the heroines of the 1960s' James Bond novels and movies represented 'a free and independent sexuality, liberated from the constraints of family, marriage and domesticity', though they saw this 'liberation' as essentially geared 'to the requirements of the new norms of male sexuality represented by Bond' (Bennett and Woollacott 1987: 35). Radner, however, is more positive. Like the Single Girl, the Bond girl, Radner argues, was 'a free agent, operating in her own interests' (Radner 1999: 9). From this perspective, the Bond girl was an emblem of wider changes in gender roles in which family and kinship no longer necessarily regulated a woman's situation. Instead, '[e]conomic status, her ability to negotiate con-

sumer culture as both agent and object of exchange, had become the prime determinant of social expectations' (ibid.).

It is, perhaps, possible to exaggerate the kind of 'liberation' represented by the Single Girl's sexual expression and thirst for consumerism. The promise of independence and hedonism, for example, was largely the preserve of the white middle-class. During the 1960s, *Cosmopolitan* sporadically included features dealing with the lives of African American women, but in articles such as 'The Negro Girl Goes Job Hunting' (March 1967) themes of 'race' were configured only as an unfortunate 'social problem'. During the 1960s the Single Girl market was largely a white phenomenon, and until the early 1970s most African Americans were prevented from participating in the consumer spectacle by a combination of white racism and trenchant economic inequality.

The degree of meaningful 'empowerment' associated with the Single Girl ethos is also open to question. In their analysis of advertising in women's magazines during the 1980s, for example, Robert Goldman and his colleagues argue that the commercial market re-routes (and thus depoliticizes) feminist discourse into the logic of commodity relations. In these terms, advertisers 'connect the value and meaning of women's emancipation to corporate products', thus producing a kind of 'commodity feminism' in which feminist discourse is co-opted into the market and feminism is reduced to a simple 'attitude' or lifestyle that can be purchased in a perfume, a designer outfit or a sleek sports car (Goldman *et al.* 1991: 335). The same argument might also be applied to the captivating world of the 1960s' Single Girl. After all, while her pink collar career afforded her independence, this was achieved only through engagement with the dominant forces of the market and its ideals of gender and sexuality. Such an interpretation, however, would be unduly pessimistic. Rather than duping women with images of a depoliticized feminism, the iconography of the glamorous and cosmopolitan Single Girl offered women a feminine identity through which they could engage meaningfully with the cultural shifts taking place around them – many rejecting the dominant feminine ideals of passive, family-centred domesticity in favour of a more active and sexually confident identity focused around the pleasures of modern leisure and personal consumption.

Notes

1. During the 1980s, for example, authors such as Janice Radway (1984), Ien Ang (1985) and Angela McRobbie (1991) all pointed to the elements of agency and discrimination that existed in women's engagement with popular texts, and subsequent analyses of consumption have generally acknowledged the capacity of consumers to construct their own meanings and cultural identities around the products of the commercial market.
2. May acknowledges, however, that for many people domesticity had its attractions and was not simply imposed from 'above' on a hapless population. Against an unsettling background of rapid social change and the looming threat of nuclear war, she observes, many men and women eagerly embraced marriage and parenthood as 'a source of meaning and security in a world run amok' (May 1999: 18).
3. Other writers, however, have been more critical of Brown's manifesto. Radical feminist Sheila Jeffreys, for example, argues that the mission of *Sex and the Single Girl* was to turn women into sexual objects, and that in the book's advice 'the 1960s single woman was given only one function in life, the stimulation of the male sexual appetite' (Jeffreys 1990: 107). Indeed, in general, there is more than a modicum of truth to arguments that much of the 1960s' 'sexual revolution' was mediated by a patriarchal discourse that extended and intensified the sexual exploitation of women. Much of the gushing prose in *Sex and the Single Girl*, for example, was taken up with tutoring women in ways to mould their appearance and behaviour to appeal to men.
4. The same might also be said of Jacqueline Susann's tale of Single Girl upward mobility, *Valley of the Dolls* (1966). Indeed, excerpts from *Valley of the Dolls* were featured as a 'special book bonus' in the June 1966 edition of *Cosmopolitan*.

New Genre Forms in 'New Hollywood' Film

Partly Truth and Partly Fiction: The Western, the City Movie and the American 1970s

LINNIE BLAKE

Throughout the American 1970s, against a backdrop of economic crisis, military defeat in Vietnam, and a loss of faith in the moral leadership of the Presidency engendered by Watergate, two ostensibly very different kinds of genre film – the Western and the City Movie – provided a disorientated American people with a range of visual representations and interrogations of the contradictions of their age. In the 1970s, despite their differing cinematic history and their generically distinctive conventions, both types of movie came to share a common will to expose and explore the matrix of contemporary evils that characterized the period. These ranged from the authoritarian militarism that had underscored American life from the accession of Kennedy to the resignation of Nixon, the Civil Rights violations of the latter's terms of office, the might of the government-business matrix, specifically in its impact on the natural world, and the plight of the poorest and most marginalized of the nation's citizens – particularly within the period's 'stagflationary' cities. This was a period, too, in which the formulation of what would come to be termed 'New Hollywood' would not only bring about significant changes to the ways in which films were financed, produced and distributed, but would also enable a new generation of filmmakers (some academically trained, some making the crossover from television[1]) to produce a number of highly self-reflexive revisions of Hollywood genre movies for an American audience that was itself engaged in a reconsideration of the old certitudes regarding their nation's history, and its claims to the political, economic and moral leadership of the 'free world'. During the early years of the 1970s, moreover, when the seven major studios were all struggling with major losses, low-budget, youth-oriented cult films like Dennis Hopper's *Easy Rider* (1969) had seemed to point the way to a new kind of moviemaking for a new era. It was such a trend in cinematic production that opened the doors of Hollywood to the film school generation – men like Martin Scorsese, a graduate of New York University, and Paul Schrader of the American Film Institute's Centre for Advanced Film Studies.

This essay will illustrate how, in the 1970s, established directors such as Arthur Penn, and rising stars of the New Hollywood such as Martin Scorsese and Paul Schrader would deploy their extensive knowledge of Hollywood genre films to explore the cultural ramifications of – and artistic possibilities inherent in – the political, economic, and military crises of the American 1970s. In films such as *Little Big Man* (1970) and *Taxi Driver* (1976), Penn, Scorsese and Schrader would creatively scrutinize the ways in which the generic conventions of Western and City movies had hitherto engaged with the genocidal violence of the historic West, and with the social deprivation and ethnic sectionalism of the American city under free-market capitalism. Each director would explore how, as Jimmy Carter phrased the matter in his 'Crisis of Confidence' speech of 1979, a nation so historically proud of 'hard work, strong families, close-knit communities and [its] faith in God' had fallen to 'worship self indulgence and consumption' in an attempt to 'fill the emptiness of . . . lives' (Carter 1979: online) in which the historical

216

dreams of manifest destiny and American exceptionalism were recognized as either culturally redundant or historically false.

Certainly, given the timbre of the times it is perhaps unsurprising that a number of contemporary directors should have embraced the Western genre as a means of reassessing both cinematic representations of the American past and the incertitude of the present.[2] Ever since Thomas Edison produced his first cinematographs of Buffalo Bill Cody's Wild West Show in 1894, the Western had always been the movie genre most overtly concerned with the coming into being of the American nation, and specifically with the qualities imparted to its people by the pioneering experience on the country's western and south-western frontiers. Between 1926 and 1967, moreover, more Westerns had been produced than any other kind of genre movie, approximately a quarter of all films made during these years taking the West as their subject and their setting (Belton 1994: 206). Historically, visual representations of the American landscape had enabled Americans to house ideas of an essential national identity within a landscape sufficiently monumental as to echo the grandiose aspirations of manifest destiny. John Ford, for example, had given the world Monument Valley as the archetypal Western landscape by skilfully counterpoising the monolithic sandstone columns that were his location and the equally primeval, decidedly mythic dramas – such as the revenge narrative of the Ringo Kid in *Stagecoach* (1939), or the quest narrative of Ethan Edwards in *The Searchers* (1956) – that he chose to set at their feet. In the iconography of the classic Western, moreover, we can see Hollywood providing Americans with a visual means for making sense of their 'manifest destiny', whilst erasing any alternative claims to competing visions of American identity, or competing claims to the land.[3]

The generic codes of the Western offered audiences, American and otherwise, an accessible and entertaining means of looking at American history – with the 'ritualization of collective ideals, the celebration of temporarily resolved social and cultural conflicts, and the concealment of disturbing cultural conflicts' (Schatz 1995: 97) forming a mainstay of the genre's entertainment value. As Penn and Scorsese clearly recognized, the audience's ability to spot the genre's visual conventions, to pre-empt the narrative's resolution and draw parallels across films and periods, enabled directors to stitch audiences into the politics of pioneering in a way that transformed the realities of history into a set of predictable patterns and conventions broadly supportive of the dominant ideology, and readily transmissible by mass culture. Accordingly, for directors such as Penn and Scorsese, these conventions could be skilfully redeployed to function as a direct critique of contemporary establishment ideology, specifically America's mission into the communist wilderness of Vietnam, its historic degradation of the North American landscape and its native peoples, and its institutionally sanctioned racism, sexism and homophobia. For filmmakers such as Scorsese, moreover, such Western conventions could even be married to those of the City Movie to underscore the intrinsic corruption of the pioneering ideal and its further degradation at the hands of urban-industrial capitalism.

Arthur Penn's *Little Big Man*[4] was released at the end of 1970, the year in which American troops were sent into Cambodia, resulting in strikes for peace across some 451 college campuses, and the death of four demonstrators at Kent State at the hands of the National Guard. It was the year in which the Chicago Seven stood trial and President Nixon, in office since November 1968, made his infamous plea to 'the great silent majority' (Nixon 1969: online) of Americans, the guardians of old standards and old values who stood in opposition to the peace protesters and Civil Rights activists who beleaguered his administration. *Little Big Man* undertakes a fundamental reassessment of the ideology of the classic Western and indicts it as a distortion of America's historic past (and contemporary establishment self-image) that has not only covered up the nation's genocidal origins but has made national heroes out of murderers. Starring Dustin Hoffman, Chief Dan George and Faye Dunaway, the film acts as a visual illustration of the first-person testimony, given in voice-over, of Jack Crabb who, at the astonishing age of 102, recounts the twenty years in which he vacillated between Cheyenne and settler cultures on the western frontier. His narrative commences with the annihilation of his family by the Pawnee as they crossed the Great Plains, takes in several historic events (such as the so-called

Battle of Washita and the life and death of the gunfighter Wild Bill Hickok) and culminates shortly after the Battle of the Little Big Horn on 25 June, 1876. Throughout the movie, Penn draws upon the iconography and ideology of the Western hero promulgated by Hollywood, re-examining those discourses of rugged, pioneering individualism familiar from the traditional Western and, earlier, from the Leatherstocking tales of James Fenimore Cooper or the socio-cartographic explorations of William Byrd.[5]

Standing beyond the injunctions of the law, Hollywood's Western hero had lived by a code of his own making, a code which would have the Ringo Kid assert in *Stagecoach* that 'There's some things a man just can't run away from'. Here was the American Adam in the unproble-matic garden of the New World – macho template for American moral rectitude, and evincing an implicit distrust of the anti-individualism inherent in collective or social endeavours. With one foot in the camp of progress, expansion and futurity, the other in the world of nature, he may be conceptually linked to the Native American, whose land he shares and whose world-view he well knows. Nonetheless, and in keeping with the paradox of America's fetishization of the natural world that its will to progress and expansion has destroyed, that selfsame hero had also been implicated, in films such as *The Man Who Shot Liberty Valance* (1962) in the onward march of 'civilization'.

Such was the nature of the Western hero that Penn drew upon in his creation of Jack Crabb, whose picaresque experience of frontier culture is appropriately diverse, appropriately paradox-ical. Jack has, after all, been a pioneer on a wagon train, the adopted son of a minister, a gun-slinger, a shopkeeper, a mule skinner with the cavalry, a snake-oil salesman and the town drunk. And he is also, for much of the film, a Cheyenne, or 'human being'. Such a plotline enables Penn to evoke both the iconography and narrative staples of the classic Western with sensitivity and humour, the 'going native' motif evoking films such as *Broken Arrow* (1950), the cross-dressing sister reminding us of Joan Crawford in *Johnny Guitar* (1954), Crabb's 'gunfighter period' slyly referencing *My Darling Clementine* (1946), the search for his lost wife evoking *The Searchers*, the revenge plot echoing *Stagecoach*, the protagonist's journey between cultures referencing *The Wonderful Country* (1959), and the education of the greenhorn echoing, once more, *The Man Who Shot Liberty Valance*. Here too are the great grass plains, forested mountains and rivers of clear water. There are the one-horse white towns, complete with saloons, newspaper offices, jails and general stores. The world of the cavalryman, the cardsharp, the town preacher and the small-town whore are all here; the Hollywood world of the Western, humorously evoked. But the film also presents us with a perspective on white settlement that purports to be that of the dispossessed Native Americans, whose tribal structures, conceptions of honour, traditions of hospitality and nature-centred wisdom – traditionally occluded in Hollywood film – are all depicted here. For the native inhabitants of the American landmass, Penn argues via the elderly chief Old Lodge Skins, everything was alive, all waters flowed into the great ocean of life and, as such, all life was precious. This decidedly 1970s', avowedly countercultural philosophy, is embodied in the Cheyenne's proud acceptance of Little Horse as a 'heemanay' – a kind of camp, cross-dressing entertainer with no interest in killing people. The countercultural agenda of *Little Big Man* is also reflected in the Cheyenne's openness regarding other aspects of sexuality too, specifically the willingness of tribal women to share the sexual favours of available men. It is further reflected in their preference for symbolic warfare over senseless slaughter and clear respect for tribal, hence social and cultural, difference.

The countercultural appropriation of Native American culture in *Little Big Man* was also emphasized by the casting of Dustin Hoffman (Hoffman had acquired solid countercultural cre-dentials following his lead role in 1967's *The Graduate*) and by the film's representation of settler society, which for all the humour of its portrayal is shown to be rotten from the bottom to the top. There is the sexual hypocrisy of the exquisitely beautiful blond Miz Pendrake, the preacher's wife and later prostitute, lasciviously bathing the adolescent Jack whilst humming John Ford's favourite piece of diegetic music *Shall we Gather at the River*. There is also the fraudulence of the pioneering entrepreneur Alerdyce Merryweather, whose progressive loss of organs and limbs is an allegory of the degenerate nature of the dream of American free enter-

prise. And, on an institutional level, there is the purposeful annihilation of the buffalo by Buffalo Bill Cody as a means of starving the Indians off the great plains (the selfsame Cody heralded as a hero of pioneering endeavour in his own Wild West Show and Edison's cinematograph, and the same Cody that Robert Altman would mercilessly satirize as a fake and phoney some six years later in *Sitting Bull's History Lesson* [1976]). On an institutional or governmental level, too, there are the activities of the Seventh Cavalry commanded by George Armstrong Custer. Accompanied by their genocidal regimental theme tune *Garryowen*, in *Little Big Man* the Seventh Cavalry are not the forces of civilization, riding to the rescue of beleaguered white settlers, as once they did in *Stagecoach*. In this film, they are psychopathic killers led by an insane careerist with his eye on the Presidency, massacring Cheyenne first in the scene where Sunshine gives birth in silence, and then at the so-called Battle of Washita, a real life historical event previously unmentioned by the Hollywood Western.[6] To a contemporary audience, watching the Asiatic-looking women running from the flame and rifle fire of the American military, the parallels with the war in Vietnam, and particularly with the My Lai massacre in March 1968, would have been inescapable. In the manner of the Western hero, Jack Crabb may embody the worlds of civilization and savagery, but the film makes clear that it is with the Cheyenne that civilization lies.

This is not, of course, to argue that *Little Big Man* is a work of history. The framing device of the 'tall tale' makes this clear, and the historical fact that Wild Bill Hickok dies before Little Big Horn underscores the point. This film also mythologizes the West, specifically the Native Americans, in a way suited to contemporary ideological needs. Exemplifying a tendency that has continued through a range of revisionist Westerns, most notably 1990's *Dances With Wolves*, *Little Big Man* is an attempt to legitimate contemporary countercultural struggles by attributing a set of distinctively 'alternative' ideas and attitudes to Native Americans. In *Little Big Man*, as in the counterculture of the 1960s and '70s, we see a genuine will to transcend the official version of American history and culture (as promulgated by the bosses, the government, the educational system, the squares and the Hollywood studio system), and an attempt to give America an alternative history in which harmony, love and peace had once reigned. Even in the 1970s, the traditional Western's key conceptual oppositions, as defined by Jim Kitses (1969), are very much intact – wilderness and civilization, the individual and the community, freedom and restraint, purity and corruption, tradition over change. They have simply been inverted as a means of addressing the present moment.

In *Little Big Man* it is not the case, as the nihilistic snake-oil salesman Alerdyce Merryweather argues, that 'nothing matters'. In 1970, the meaning of America matters a great deal, and it was in part in the revisited Western genre that this meaning was consistently interrogated. As filmmakers such as Martin Scorsese recognized, however, this questioning of national character, national destiny, had also formed a mainstay of a very different Hollywood genre – the City Movie. Since the 1920s, gangster melodramas such as *The Exciters* (1923), *While the City Sleeps* (1928), *Come Across* (1929) and *Alibi* (1929), had provided lurid, titillating exposes of urban corruption, and had foregrounded a sense of the city as an alien and parasitical entity that was fundamentally hostile to America's traditional institutions of family and religion, and that repudiated long-standing dreams of national exceptionalism by its domestication of immigrants and their 'alien' European lifestyles and politics.

If the myth of the frontier had become imprinted on the American consciousness by the visual conventions of the Western, then it was to City Movies (the gangster classics of the 1930s and the troublesome world of 1940s' *film noir*) that filmmakers such as the Italian-American Scorsese turned, for a means of representing the fictive nature of the dominant ideologies associated with the West and the Hollywood Western. If the Western had championed an ideal of WASP American subjectivity, then the same could certainly not be said of the City Movie. In the later gangster pictures of the pre-code era, movies such as *Little Caesar* (1930), *Public Enemy* (1932) and *Scarface* (1932), performers such as Edward G. Robinson (born Emmanuel Goldenburg), James Cagney (an Irish-American street fighter who taught himself Yiddish to survive in the Jewish ghetto) and Paul Muni (born Friedrich Muni Meyer Weisenfreund) had

traced the criminal careers of a number of immigrant criminal warlords against a background of the Depression-era city. Emphasizing the ethnic diversity of the American metropolis and the amoral violence necessary to ensure the survival of its inhabitants, the genre underscored the enormous gulf that lay between the pioneer ideal and contemporary urban realities.

The City film was a genre that would lead to the creation of an avowedly urban and distinctively stylized cinema, *film noir*, a term that appeared towards the end of 1946 when French cinema critics remarked upon the new bleakness of the American movies of the previous five years which, free of Nazi censorship, they were at last able to consume. In films like Huston's *The Maltese Falcon* (1941), Billy Wilder's *Double Indemnity* (1944) and Fritz Lang's *Woman in the Window* (1944), King Vidor's *Gilda* (1946) and Howard Hawks' *The Big Sleep* (1946), French critics had observed how the cultural primacy of the rational, ordered and symmetrical pre-war world of directors like John Ford had given way to something far darker, as screenwriters and directors addressed themselves, often very explicitly, to the contemporary American experience, adopting the iconography of the city to evoke the horrors of the present. In such city-bound genres as the gangster movie and *film noir*, the dangerous corruption of the city, its dark streets glistening in the rainy night, evoked a sense of moral fluidity where truth, whatever that may be, was very hard to see. Whereas the Hollywood Western had opted for openness and horizontality by which to capture the magnificence of God-given nature, evoking space, symmetry and smoothness of line in its use of natural lighting, invisible editing and linear resolution-driven narratives, everything in the *chiaroscuro* world of the cinematically complex City/noir movie was broken, angular and vertical.

There was no 'big sky' here, but an interior world of tenement kitchens and bedrooms, backroom dives, complete with pool or card table, cheap offices (with a bottle of bourbon in the desk drawer), flashing neon, sleazy bars, Art Deco nightclubs and houses of ill repute. The Western's insistent usage of the establishing shot, long shot and medium long shot was here abandoned in favour of close-ups and extreme close-ups, with several characters often squashed within the frame, adding to the visual claustrophobia of the genre. *Noir* shows its audience an alienating environment in which enclosed and smothering settings (the inside of cars, trains and boxing rings, jail cells, barred fire-escapes, elevators and cramped tenement rooms, stairwells and corridors) all impart a sense of delimited lives that is the diametrical opposite of the Western's expansive potentiality. Here extreme angles (frequently high angles) are used to emphasize the insignificance or fragility of characters, coupled with extreme *chiaroscuro* to evoke a world of frames within frames and shadows within shadows. The city was depicted as a world in which life was cheap and nobody was to be trusted. *Noir* was a genre that set out to evoke the contemporary American city, and the lives lived within it, in all their incertitude. But it was also a meta-textual evocation of the frontier, reconfigured in these films as the frontier between the savagery of the city and the purported civilization of an absent and half-remembered rural past.

At the end of the 1970s, the sense of nihilistic and opportunistic violence that had haunted representations of the American city since at least the 1920s had never been so palpable or so pressing. As OPEC (the Organisation of Petroleum Exporting Countries) held the United States to ransom, the nation plunged into the worst economic crisis since the Great Depression, and several American cities, including New York, lunged close to bankruptcy. With Watergate, the 1960s' race riots and the ultimate failure of America's endeavours in Vietnam and Cambodia also still fresh in the public mind, Scorsese's hybridized Western-City/noir movie, *Taxi Driver* (1976), with a screenplay by Paul Schrader, evoked all the horrors of the present, all the lost promises of the past.

Inspired by 1972's attempted assassination of Alabama Governor George Wallace by Arthur Bemer – who sought fame for himself in the manner of a Lee Harvey Oswald, Sirhan Sirhan or James Ray[7] – *Taxi Driver* is set within the alienating environment of late 1970s' 'stagflationary' New York. As unemployment rose, public sector workers were laid off and public services such as garbage collection and law enforcement collapsed, the black economy flourished, with drug dealers and prostitutes (many of them illegal immigrants and children) in great demand.

For many New Yorkers it was a city in which the very fabric of society seemed to be unravelling, a city characterized by dissatisfaction and despair. In *Taxi Driver* it is a city structured by the disordered perceptions of the film's central protagonist Travis Bickle, disenchanted Vietnam veteran and social misfit. Convinced of the utter corruption of his city, and yet imbued with a warped *noiresque* ethic which, in a Western way, posits the potential regeneration of the social body through an act of redemptive violence, Travis plans to assassinate Senatorial candidate Palatine whilst courting the favours of Palatine's WASP campaign worker Betsy (Cybil Shepherd), and attempting to rescue under-age prostitute Iris (Jodie Foster) from her pimp and lover, Sport (Harvey Keitel). Carrying with him a strong sense of his own morality, yet too disordered in thought to have a cogent ethical system, Travis inhabits a New York of the mind, a mythical territory conceptually related to Ford's Monument Valley, where 'a man's gotta do what a man's gotta do' in the absence of any perceptible law. But this is also a very *noiresque* film, with its moody jazzy score, its first person voice-over, its canted camera angles, the stylized movements of its players and its low-key lighting. In *Taxi Driver*, in other words, we see the Western frontier transposed to the streets of the disorientating contemporary city to create a genre movie which is a peculiar type of contemporary, hybridized Western-*noir*, the visual lexicon of both, highly contrasting genres, combining to produce a potent critique not only of the American present, but also of mass-cultural representations of the past.

Taxi Driver is a film that self-consciously repudiates the studio-bound conventions of classic *noir* and sets out to incorporate the sights, sounds and textures of city life in much the manner of the French New Wave and the Italian Neo-Realists before it. As such, the film's insistent alignment of Travis's perspective with that of the camera on the one hand, and the playful experimentation with the possibilities of destabilizing the audience's gaze through unusual camera movements on the other, disorientates the viewer; thus echoing Travis's own disorientation and implicating the audience within it. The inclusion of the archetypally *film noir* (and, as in Arthur Penn's work, neo-Western) voice-over, however, offers no real clarification of the reasons why Travis acts as he does beyond his own distorted logic. Travis Bickle is a kind of Western hero who is also a degraded or debased *noir* protagonist (in much the same way that a *noir* hero such as Raymond Chandler's Marlow drew on older, masculine, Western conventions and codes). Still the lone self on the frontier of national experience, as in the Ford Western, still uncomfortable with women, estranged from their domestic world and operating according to a moral code of his own making, Travis continually pits the sick and venal world that is his own urban wilderness (a world of whores, skunk-pussies, buggers, queens, fairies, dopers and junkies) against the puted civilization that could be instituted, if only a 'real rain' would clean up this open sewer of a city of its filth and scum. In this mass-culturalized society, where taxi drivers attempt to sell a piece of Errol Flynn's bathtub as assiduously as snake-oil salesmen hawked their specious wares on the frontiers of the West, and those riding in taxis insistently outline what a .44 magnum can do to a woman's pussy, Travis's comparatively pure desire to 'really, really, really do something' to ameliorate the horrors of the city is contrasted with the corruption he sees all around him. What he craves, in common with the Western as a genre, is stability, permanence and tradition. What he gets, in common with the world of *noir*, is disorientating and self-diminishing social change. He becomes, in the process, a bifurcated Western-*noir* hero, in Betsy's words 'a prophet and a pusher, partly truth, partly fiction, a walking contradiction'.

This is not, of course, to argue, as Robert Kolker has done, that 'Travis Bickle is the legitimate child of John Wayne and Norman Bates: pure, self-righteous, violent ego and grinning homicidal lunatic; each the obverse of the other; each equally dangerous' (Kolker 2000: 227). He is more profitably viewed, I would argue, as the bastard child of John Wayne's Ethan Edwards and Humphrey Bogart's Sam Spade, a man who gropes for a moral code that would make his violence personally and socially redemptive. In questing after this identity, Travis may purchase an array of weapons, the Magnum of Dirty Harry, the Walther PPK and the .25 automatic used by James Bond, or the snub-nosed Smith and Wesson.38 used by Mike Hammer. Nonetheless, he discovers that in the city all identity is unstable and all morality is entirely relative. This is, after all, a milieu in which, in Sport's words, he can do anything he likes with the

under-age prostitute Iris, fuck her in the mouth, in the ass or come on her face. He can shoot a grocery shop robber, murder one of Iris's johns and even Sport himself, but he must never, ever take bourgeois Betsy to an inappropriate movie!

Divided neatly in Travis's mind between the good woman and whore, Scorsese's depiction of women thus evokes the Western's traditional division of the gender into schoolmarmish civilizers, as in *The Gunfighter* (1950) or *The Big Country* (1958), and morally loose good-time girls, as memorably realized by Marlene Dietrich in *Destry Rides Again* (1939) and *Rancho Notorious* (1952). In *Taxi Driver* the schoolmarm is Betsy – the tall blonde WASP he first sees outside the Charles Palatine campaign headquarters near Columbus Circle, an area where New York sleaze transmutes into corporate respectability, a world of petty ambitions and banal bourgeois romance, a clean well-lighted place a million miles from Travis's own. The good-time girl short of a good time is the teenage prostitute Iris – first encountered attempting to escape her pimp Sport on the junction of Third Avenue and 13th Street, a site of real under-age prostitution in contemporary New York. But unlike the Western, this film is not content with stating the binarism and then recouping the hooker for marriage and motherhood, as is the case for example in *Stagecoach*. Instead, Scorsese deploys the binaristic female paradigm to link the worlds of political ambition and corporate power-broking to the city's seedy underside, illustrating how Palatine and Sport are not at all dissimilar – despite the latter's illegal line-of-work and Plains Indian outfit, and the former's senatorial ambitions, obligatory suit and impressive staff of yes-persons. Both Palatine and Sport, Scorsese seems to argue here, are defendants of private enterprise and the free-market economy, both use the power of words to sway the gullible or vulnerable, and both are, primarily, looking after number one. Betsy too is far less innocent than she would have us believe, with her coy hair-flicking and moral panic in the face of a soft-core porn movie. And Travis, it seems, perceives this, aware also of the innocence of the child-whore Iris, whom he pays to be with but does not touch, indulging her childish liking for things sweet, and staying in touch with her parents following her return to home and family.

That Travis receives public acclaim for his frenzied attack on those who pay for the pleasure of sexually violating children, and those who live off such earnings, underscores the absolute moral relativism of this world, the instability of all categories and value judgements, the sheer illegibility of the self, or the motivations of the self, in the city. It is a noir sensibility propounded by a Western hero adrift in contemporary New York, a character every bit as divided and contradictory as a buckskin-wearing Shane, in his cowboy boots and mohican. In the film's most famous scene, as Travis gazes into his mirror, cocks an imaginary gun and repeatedly intones 'you talking to me?' to his own reflection, we see the logical culmination of the film's *noir*-Western iconography. Here is a man who would not take it any more, whose dispossession of a cluster of quintessentially American ideals (not least the dream of proactive masculine endeavour in the dangerous lands of the old West) is compounded by his tortured entrapment within the broken city of the present; where a gunfight to the death offers no resolution, and no redemption of the present, or the past, is possible.

In the neo-Western that is *Little Big Man*, and in the hybridized *noir*-Western that is *Taxi Driver*, it is thus possible to chart not only the peculiar social malaises of the American 1970s, but the degeneration of the rhetoric of American exceptionalism that had underpinned not only the doctrine of manifest destiny, but also mass cultural Hollywood representations of national origins and identity. In the light of Vietnam, Watergate and the contemporary economic crisis, the 1970s' Western not only revised and reconceived the frontiers that the classic Western had drawn between savagery and civilization, individual and community, dreams of freedom and the realities of American life. The *noir*-Western also effectively relocated that frontier onto the streets of the contemporary American city, where competing social groups were locked in battle over the moral legitimacy of America's government, both at home and abroad. In evoking the imagery of urban corruption that had been common cinematic currency since the 1920s, films such as *Taxi Driver* gave the world a new kind of neo-Western and quasi-*noir* hero – a disturbed and disturbing apotheosis of the 1970s, that darkest of American decades.

Notes

1. Academically trained directors included Martin Scorsese and John Carpenter. Those moving from TV into film included William Friedkin and Joseph Sargent.

2. Including Elliot Silverstein in *A Man Called Horse* (1970), Ralph Nelson in *Soldier Blue* (1970) and Robert Aldrich in *Ulzana's Raid* (1972).

3. Such iconography, assiduously deployed in Westerns, included the landscape itself and the iconic means of Western transportation – the ubiquitous horse of the cowboy or cavalry-man, ridden without saddles by the nature-proximous Indians, stagecoaches for women and travelling salesmen, trains with rear platforms expressly for the purpose of fistfights or fighting off Indians, buggies used by doctors and mules by miners. There was also iconographically significant clothing – the open-necked shirts and wide-brimmed hats, jeans and boots of the cowboy (John Wayne's standard costume for over forty years), occasionally replaced by the buckskins sported by Alan Ladd in *Shane* (1953) to signify the hero's affinity with the natural world. There was the military uniform of the cavalryman, dashingly sported by Henry Fonda in *Fort Apache* (1948) and elsewhere, the black hat of the preacher, such as is worn by Donald Pleasance in *Will Penny* (1967) and the black costume of the hired gun such as Jack Palance, also in *Shane*. For women there are the wide skirts and tight corsetry of the respectable poke-bonneted female citizenry, say Grace Kelly in *High Noon* (1952), the breast and leg revealing ruffles of the barroom good-time girl (say, Kate Jurado in the same film). And, of course, there is the machinery of violence – ranging from the Colt 45 of the gunfighter through Winchester and Springfield rifles to the hatchets and bows and arrows of the Indians.

4. Adapted from Thomas Berger's 1964 novel by the screenwriter Calder Willingham who had previously written both Stanley Kubrick's *Paths of Glory* (1957) and *The Graduate* (1967).

5. See Cooper's *The Pioneers* (1823), *The Last of the Mohicans* (1826), *The Prairie*, *The Pathfinder* (1840) and *The Deerslayer* (1841), and Byrd's *History of the Dividing Line* (1728; published 1841).

6. The 'Battle' of Washita consisted of a surprise attack by some 800 members of the Seventh Cavalry on peaceable Arapaho and Cheyenne encampments on the safe lands of the Western Indian Territory (1868), an attack that killed over a hundred Native Americans, including dozens of women and children (many of whom they scalped) and some nine hundred of their horses.

7. Alleged assassins of John F. Kennedy, Robert Kennedy and Martin Luther King respectively.

Part 4: 1980–2001

Part 4: 1980–2001

Introduction to Part 4

DAVID HOLLOWAY AND JOHN BECK

Although the domestic and international contexts of the 1980s and the 2000s are superficially quite different, in certain respects the Reagan era was also the first years of our time. The 1980s set in train, ambiguously and with significant recourse to older Fordist models (notably the recession-busting return of Keynesian deficit financing and the remilitarizations of the decade) a range of capitalist-democratic practices that have since been consolidated in the emergence of the so-called 'Washington Consensus' – a post-Fordist, 'neoliberal' model of governance and economic restructuring, in which US elites today wield global influence as much through the manoeuvrings of the World Trade Organization, the International Monetary Fund and the World Bank, as through direct political intervention or military force. A Reaganite backlash against the cultural liberalism of the 1960s and 1970s, moreover, generated public controversies often referred to as the 'culture wars' – a sharpening of debates (and divides) over identity politics, multiculturalism and affirmative action, whose emergence was coterminous with the political and economic stagnation of Fordism (and the decaying of Fordist 'containment' culture), and that continue to shape policy initiatives and modes of cultural criticism today. The 1980s was also the decade in which US elites first declared a war against international terrorism, and were themselves censured by the World Court for the orchestration of terror in Latin America, and by the United Nations General Assembly for subversion of international law.

In Part 4 of this collection contributors consider some of the conflicted social contexts in which visual culture and the formation of visual taste have been shaped, in the culturally contested and economically retrenched, but also hugely expanded global realm of late-twentieth- and early twenty-first-century American capitalist-democracy. Contributors focus particularly on a set of recurring issues – the US-led globalization of capitalism, identity politics and the culture wars, and established and emergent discourses of visual 'memory' – that overlap and intersect from one essay to the next.

Grounded in primary research spanning 1000 different ads placed in seven different American magazines during 1995, Katherine Johnson's essay argues that in the era of the post-Fordist, US-led global market, advertising is motivated as much by the need to 'sell' globalization itself as by the need to sell more tangible commodities. In an analysis that proceeds from the categories of 'Regulation School' Marxism, Johnson argues that one aim of post-Fordist advertising has been to disseminate understandings of global capitalism that facilitate its reproduction as a 'common sense' ordering of everyday social life. As she shows, corporations and businesses advertising in magazines whose readerships are differentiated by their aggregate class, ethnicity and gender, seek to socialize their 'target markets' to the globalization of capitalism in distinctly different, often contradictory ways. As Johnson notes, this contradictory positioning of different target markets by ads selling globalization articulates both the arbitrary

227

character of capitalist legitimation and the conflicted social relations to which capitalist 'regulation' responds, and that it helps sustain and reproduce.

Johnson's critique of advertising's embeddedness in the broad ideological shiftings of the 'neoliberal', post-Fordist age, is complemented by Sophia McClennen's essay on the visualizing of Latin America in movies handled by the film production and distribution company Miramax during the mid-1990s. During the endgame of the Cold War Grand Area in the 1980s, the 'domino theory' of states collapsing in succession to Soviet influence or to progressive non-Soviet movements for social justice and national self-determination – what Chomsky calls the danger a 'good example' posed to the interests of US investors overseas (Chomsky 1992: 7–77) – bequeathed a legacy of American horrors across large areas of South America. Nicaragua and El Salvador, in particular, have become names that evoke the catastrophic international reach of US elites just as fully as Vietnam, Cambodia, Laos, East Timor, Grenada, Afghanistan, or Iraq. In the post-Cold War 1990s, the pursuit of a 'Grand Area' for international US investment focused on the promotion of market 'liberalization' and the breaking down of barriers to international 'free' trade, particularly in 'developing' countries; and as McClennen suggests, the neoliberal drive to abolish barriers to the global circulation of first world capital has been a cultural process, as well as – and often at the same time as it has been – an economic one.

During the 'reforming' of trade in the Americas under the aegis of NAFTA (the North American Free Trade Agreement) in the mid-1990s, McClennen argues that Miramax films visualized a Latin America more suited to the neoliberal discourses institutionalized in NAFTA than to the government/business/military matrix of the older Fordist Grand Area. Discussing Miramax's key films of the 1990s set in Latin America, McClennen suggests that, consistent with the globalization of elite US economic interests, the films have in common an aesthetic that embodies the neoliberal dismantling of borders (or barriers) to American trade, erasing the historical, political and cultural specificity of the fictive Latin American worlds they depict. In the 'neoliberal aesthetic' of NAFTA-era Miramax films, she suggests, what earlier generations viewed as Latin American Otherness is hollowed out and made banal by the commodifying of what is (or once was) culturally Other, and by the visual incorporation of that Otherness, on film, into an aesthetic which thus mimics and reproduces the voracious logics of US/global capitalist exchange.

Paul Grainge's essay examines a range of issues structuring the relationships between capitalist globalization, the digitization of visual culture, and the discourses of 'memory' embedded in poster art, fine art prints, photojournalism and popular film of the 1990s. Grainge notes that the globalization of capital and information flows, and the deregulation and privatization of the public and corporate spheres associated with post-Fordist capitalism, have led to the destabilizing and reconfiguring of institutions, ideologies and modes of visualization that once relied for their authority on their seeming fixedness and stability. Grainge discusses, in particular, the unsettling of the ideas of nation-state sovereignty, citizenship and urban identity, and the anxious encoding of these historical displacements in contemporary visual taste regimes. Drawing on the work of Andreas Huyssen, his essay considers the popular taste for monochrome aesthetics at the end of the twentieth century. Like the emergent field of memory discourse itself, black and white aesthetics are notable, Grainge argues, for their powerful desire to 'mark time', or to stabilize historical experience, in a period characterized by increasingly rapid turnovers of capital and information and by the non-indexical visualities of digital representation – with digitization itself read, much as McClennen reads the cultural commodifying of a previously 'exotic' Latin American Other, as a structural feature of capitalist globalization, rather than as an outgrowth or superstructural expression of it.

The destabilizing of established taste regimes, ideologies and institutions that has accompanied the restructuring of older Fordist modes, also stimulated the 'culture wars' controversies of the 1980s, 1990s and 2000s, fuelling the emergence of an 'identity politics' that has crossed multiple overlapping struggles and concerns, and that has articulated a range of hegemonic and counter-hegemonic positions. The complex negotiation with and subordination of the 'Asian Other' in the revived Vietnam war film genre of the 1980s, for example, has as one referent the

dramatic return of Cold War militarism and the revitalizing of Grand Area strategy during the Reagan years. But as LeiLani Nishime demonstrates, cultural memory of earlier Cold War militarism in a film such as *Rambo* (1985), *the* Vietnam movie of the '80s, can also be read in powerful ways in the contexts of contemporary racial/ethnic and gendered struggles within the US itself.

Drawing upon and developing the category of the 'gaze', traditionally the provenance of feminist-psychoanalytical film theory, Nishime shows how the construction of gendered identities in *Rambo* forms one part of the film's broader construction of 'racial' norms (and vice versa), in a period marked by a rapid rise in the Asian population in the US, and by volatility in relations between Asians, Asian-Americans and 'white' Americans. In *Rambo*, Nishime suggests, whiteness is not, as would normatively be the case, the putative 'absence of race'. Instead, the visible marking of Rambo/Stallone as a racialized and gendered body in the film, and the visual fetishizing of that body on screen, constructs a cinematic gaze in which the notional 'universality' of white masculinity (upon which the construction of women and non-'white' identities depend for their presentation as subordinate Others) is compromised and withdrawn. In this regard, the danger the film sees in an initial surrendering of the gaze to the Other inaugurates the movie as a reactionary visual encoding of the 'cultural backlash' of the Reagan years, leading to a visual reappropriation of the gaze in *Rambo*, and thence to a reinscription of racial and gendered relations in terms of normative hierarchies and flows of power.

Culture wars controversies over 'appropriate' representations of masculine bodies and masculine sexuality reached new heights at the end of the 1980s, when the Republican Christian Right attacked the work of homosexual photographer Robert Mapplethorpe – Senator Jesse Helms famously destroying a collection of Mapplethorpe's work on the floor of the Senate – and the federal agency funding its exhibition, the National Endowment for the Arts (NEA). When a touring Mapplethorpe retrospective, *Robert Mapplethorpe: The Perfect Moment*, reached Cincinnati in 1990, the city's Contemporary Arts Center was indicted on obscenity charges, and an already smouldering row over the photographer Andres Serrano's 'Piss Christ' (1989), in which an image of Christ on the cross is seen submerged in Serrano's own urine, ignited into a national debate over public funding for 'minority' arts and selective ownership of First Amendment rights. Remembered on its tenth anniversary by the local city press as 'a Cincinnati beachhead for the Culture Wars' (Demaline 2000: 3), the prosecution of the Contemporary Arts Center, though unsuccessful, confirmed in dramatic fashion both the rise of the new Christian Right and the overt re-politicizing of culture – as well as the polarizing of cultural politics – that marked the Republican ascendancy of the 1980s. Although it was the mid-1990s before Republican domination of Congress would lead to huge cuts in federal funding for the arts, William Ivey, chairman of the National Endowment for the Arts between 1998 and 2001, remembers the Cincinnati controversy as a defining moment, 'the one that let the genie out of the bottle and demonstrated the power of images in creating political conflict around artistic work' (ibid.).

In his essay, Denis Flannery reflects on the hostility Mapplethorpe drew from the Right in a discussion of the place of the pair, and of pairing, in Mapplethorpe's photography. Characterized, Flannery suggests, by its qualities of 'adjacency' and accidental repetition, and 'marked by a combined incoherence and simplicity', the figure of the pair stages an implicit resistance to grand narrative that has political as well as artistic value for gay visual cultures. For Flannery, it is Mapplethorpe's interest in the indeterminacy of the pair that makes his work 'queer', as well as 'gay'. Flannery draws upon a number of positions taken in queer theory – among them 'queer' as the appropriation of the homophobic and its reworking as the affirmation of sexual difference; 'queer' as the transgression and relativizing of normative sexual codes; 'queer' as the de-exoticizing of the 'gay' and its inscription in the banal ordinariness of the everyday – to suggest that Mapplethorpe's photographs of pairs constitute a distinctively 'queer' visual culture whose political impact is shaped in large part by the striking formalism of the images he made.

Culture wars controversies during the 1980s and 1990s touched diffuse social bases and informed numerous public debates, many of which were grounded in struggles over the meanings

of American history, and over the construction of public historical memory in school and university curricula, popular culture and the arts. Maren Stange's essay addresses the retrievals, contestations, constructions and reconstructions of memory in the work of contemporary African American photographer and multi-media artist Carrie Mae Weems.

Stange situates Weems's visualizing of autobiographical and 'racial' memory within a long tradition of African American cultural and intellectual history that has privileged the recuperation and (re)writing of the past (and the reconstitution of missing, stolen or occluded histories) as the basis for political and cultural investigation, and activism, in the present. Particularly influential on Weems's work, Stange notes, has been Richard Wright's image and text narrative of African American migration, *12 Million Black Voices* (1941). Stange shows how Wright's fusion of African American folk-memory with a broader treatment of diasporic identity formed by global economic exchanges informs Weems's own visualizing of a 'transnational' African American past and present. Stange also comments on the influence of photographer Roy DeCarava, and on Weems's appropriation of images and forms drawn from commercial publicity materials, scientific documentary, pornography, art photography and reportage. Weems's collectivizing and recombination of these earlier images, Stange notes, and her incorporation of earlier forms as a formal principle structuring her own work, undermines the indexicality of the images she makes. Instead, the self-consciously formal qualities of Weems's image-making encourage viewers to respond intertextually and deconstructively to representation of African American pasts and presents, and to adopt a transnational point of view that crosses both geographical and cultural borders and blocks of historical time.

As Stange's essay implies, the culture wars and multiculturalism may have unstitched the seams of the older 'white' histories once taught in American schools and universities, and transmitted in both popular and elite cultural forms. But as Jonathan Gayles and Elizabeth Bird show, the 'expeditionary discourse' of a successful Hollywood movie like *Jerry Maguire* (1996) reminds us how entrenched aspects of American popular cultural representation remain in the colonial gestures of an earlier era. Gayles and Bird bring an 'anthropological' approach to the analysis of the film, whose critical and commercial success during the mid-1990s may be due, they suggest, to its embodiment of mythological and symbolic (that is, dominant and white) 'truths' about white identity and African American Otherness in the United States. In an 'expeditionary discourse' familiar, they suggest, from a racialized stockpile of white American legend and myth, the eponymous protagonist of *Jerry Maguire* 'goes native', coming to know and transform the 'deserving' black Other, while rejecting as deviant and contingent those aspects of black Otherness which cannot be thus recuperated by the dominant culture.

Anna Gough-Yates's discussion of the contemporary TV show *Sex and the City* highlights once again the extent to which popular visual culture at the beginning of the new 'American century' has been successfully incorporated within – at the same time that it has challenged – aspects of capitalist-democratic legitimacy in the United States. Gough-Yates reads *Sex and the City* as a 'post-Feminist' text, where the historicizing category 'post feminist' refers not to a period in which the claims of feminists have lost their popular appeal or been repudiated by masculine authority, but to a period in which the assumptions and practices of 'second wave' feminism – the heterogeneous feminist discourses of the 1960s and 1970s – have been contested both by those hostile to feminism as such, but also by feminists for whom the value of the 'second wave' today lies partly in the emergence of a more nuanced and pluralistic feminist praxis for which it helped clear the way. Gough-Yates shows how the 'popular feminism' of *Sex and the City* draws upon aspects of second wave feminist discourse, while also moving some way beyond it in a (class specific) inscription of female 'liberation' in acts of commodity consumption. Gough-Yates's reading of *Sex and the City* presents us with a text that is thus recognizably a product of the feminist (and capitalist) histories that precede it, her account of the show's privileging of collective female experience and friendship echoing some of the second wave 'strategies of resistance' discussed by Francis Frascina in Part 3 of this collection. The essay might also be read as an extrapolation of what Bill Osgerby refers to, also in Part 3, as the nascent 'commodity feminism' of the 1960s' Cosmo Girl.

Andrew Hoskins's essay on TV news coverage of the Bill Clinton/Monica Lewinsky sex scandal and the unfolding crisis of 9/11 returns us to the variegated cultural politics of visual memory examined by Grainge, Nishime and Stange. The advanced technology of news gathering and the digitization of media storage and retrieval systems has led, Hoskins suggests, to the production of 'new memory', which works in part through the production and visual dissemination of 'flashframes of history', iconic televisual moments that have entered into US and global memory, shaping both our understanding of events as they happen, and our recollection of the American past. Today, Hoskins suggests, it is through TV images that the corporate and political elites who influence television's content and form have come 'to define and verify what is historically real', and in some notable cases (exemplified by the Clinton-Lewinsky sex scandal) have actually shaped the actions of protagonists in 'stories' which are then reported on TV as 'news'. Hoskins's observation that TV flashframes *reify* historical events, suppressing and discarding certain meaning-giving contexts while privileging others, is particularly suggestive in the context of momentous public events such as 9/11. Hoskins discusses the technical assemblage of live TV coverage of the terrorist attacks on the US and their immediate aftermath, showing how the conventions of network TV coverage helped clear the way for the Bush Doctrine by depicting the US as a nation already at war. Cross references may be made, here, to Hariman and Lucaites' and Beck's essays on iconic visual culture in Part 3 of this collection, and to Margolis' essay in Part 2. Readers may also wish to contrast Hoskins's reading of the closures enacted by contemporary 'real time' TV with Celebrezze's account of live broadcasting during the 1950s, in Part 2.

Marketing 'Post-Fordism'

Advertising the Global Economy

KATHERINE JOHNSON

Advertising, while not providing an unproblematic 'reflection' of society, can create symbolic representations of particular world-views that teach us 'common sense' ways of thinking, and media representations can function as powerful, if inadequate, educators. The globalization of the economy has been one of the defining features of the late-twentieth century, and the processes associated with economic globalization have been routinely represented visually in advertising that has encouraged American citizens to conceptualize the global economy in particular ways.

This essay is based on analysis of a thousand ads that appeared in seven different magazines during 1995, spanning several race, class and gender target markets, the majority of which were located within the business 'community'. I analysed ads from *World Trade* and *Fortune* magazines because of their appeal to overwhelmingly white upper- and mid- to upper-class business audiences respectively. *Newsweek* had a broader class target market but, again, a majority white readership. *Black Enterprise* and *Hispanic Business* target the mostly male business class of minority populations in the United States. With a readership of mostly white, middle-class women, *Working Woman* was one of the few magazines targeting women involved in business. Finally, I looked at advertising contained within *Sports Illustrated* to determine how a non-business magazine would advertise the global economy to its readers. Although more than 80 per cent of *Sports Illustrated* readers are white and 80 per cent are men, the magazine also had a significant readership among minority groups and women (around 20 per cent). Analysis of magazine advertisements targeting diverse markets during one year establishes clear representational patterns, the ads functioning *ideologically* to facilitate a 'common sense' understanding of the global economy consistent with the continued reproduction of global capitalism, an economic system that operates in the interest of a very small minority of the world's population.

According to the 'regulation school' of economic theory there is a connection between a 'regime of accumulation' (in this case, global post-Fordist capitalism) and a 'mode of regulation' (the cultural and institutional structures within the social system that take a primary role in the maintenance and reproduction of the regime of accumulation – in this localized instance, advertising). Regulationists theorize that there must exist 'a materialization of the regime of accumulation taking the form of norms, habits, laws, regulating networks, and so on that ensure the unity of the process, i.e. the appropriate consistency of individual behaviours with the schema of reproduction' (Lipietz 1986: 19; see also Harvey 1990: 120–21). As Lipietz suggests, the means of adjustment to the collective principles of the regime of accumulation are '[a]t the basic level, . . . simply the extent to which entrepreneurs and workers are in the habit of conforming, or are willing to conform, to these principles, because they recognize them (even reluctantly) as valid or logical' (Lipietz 1986: 2). Playing a part in the mode of regulation, the ads considered in this essay encourage an understanding of the global economy that seeks to

socialize their readerships in various ways, so as to facilitate the reproduction of capitalist social relations in their current, global phase.

Harvey suggests that 'the socialization of labour power to the purposes of capital accumulation' occurs through the formulation of ideologies, where ideologies may be defined as 'meaning in the service of power' (Harvey 1990: 123–4).[1] As Thompson notes, the study of ideology '[r]equires us to investigate the social contexts within which . . . symbolic forms are employed and deployed; and it calls upon us to ask whether, and if so how, the meaning mobilized by symbolic forms serves, in specific contexts, to establish and sustain relations of domination' (Thompson 1990: 7). While one ad or ad campaign does not, by itself, determine our perceptions, the pervasiveness of advertising can foster particular understandings of the world, and by exclusion, contribute to the delegitimation of other, equally valid ways of understanding. Examining the meaning of the ads in relation to the larger social and historical context is therefore paramount to understanding their ideological nature.

In order to reflect critically upon the global economy as it is represented in advertising, one must first adequately understand the context and the social consequences associated with the globalization of capital and the rise of transnational corporations. Overall, three main aspects distinguish economic globalization from earlier modes of production. First, the shift from Fordism to post-Fordism dictated changes in the production process, from assembly line mass production to flexible accumulation or 'just-in-time' production. Second, information technology and information processing became increasingly important for the successful functioning of the economy. Finally, changes in the regulation of capital produced profound changes in the quality and quantity of economic activity throughout the world.

The deregulation of capital within the global economy removed earlier obligations on financial institutions, and governments, to use capital to serve the community or nation from which it originated (Barnet and Cavanagh 1996). Freedom to enter and exit a market without regulation, which has been fostered at governmental level by, for example, the withdrawal of taxes imposed on currency-exchange transactions, means that many traders no longer use the capital to invest in production or commerce, but speculate on currency exchange rates, attempting to make money off its fluctuations (Greider 1997). Government, according to Harvey, now occupies a 'problematic position', called upon 'to regulate the activities of corporate capital in the national interest at the same time as it is forced, also in the national interest, to create a "good business climate" to act as an inducement to trans-national and global financial capital, and to deter (by means other than exchange controls) capital flight to greener and more profitable pastures' (Harvey 1990: 170). To create a good business climate for multinational corporations, governments offer tax incentives, and in some cases have even prohibited unionization (Greider 1997: 63). Corporations have reacted to the changes associated with free trade policies by trimming down corporate activities to so-called core competencies, and downsizing the labour force to be responsive to fast-changing markets. According to Brecher and Costello, 'Job security has become more the exception than the rule as corporations, in the name of "competitiveness", have replaced union seniority systems and stable job structures with "flexibility" and subcontracting' (Brecher and Costello 1994: 23).

Ranney, and Brecher and Costello also suggest that there is a strong interconnection between the increased mobility of post-Fordist capital and the competitive driving down of production costs. 'Mobility' offers the opportunity 'to move to low cost areas' and 'pit the peoples of different nations against one another.' By using the threat of moving as a club, 'corporations can extract wage and work rule concessions from workers in their home country'. And such mobility allows companies to challenge or escape such claims on surplus value as 'health care, welfare, and subsidized housing programs; worker and consumer safety standards; and environmental regulations' (Brecher and Costello 1994: 52; see also Ranney 1993). And, as Korten suggests, the rules of the global economy are overpowering:

> Any corporation that does not play this game to its limit is likely to become a takeover target by a corporate raider who will buy out the company and profit by taking the actions that

the previous management – perhaps in a fit of social conscience and loyalty to workers and community – failed to take. The reconstruction of the global economic system makes it almost impossible for even highly socially conscious and committed managers to operate a corporation responsibly in the public interest. (Korten 1996: 29)

Corporations have become disconnected from the larger social obligations associated with their activities. As Greider indicates: 'Social cohesion and consent, even the minimal standards of human decency, are irrelevant to free markets. The essential purpose of deregulation, after all, is to free the market functions of such noneconomic considerations' (Greider 1997: 334). Corporations have responded to the challenges and realities of market liberalization associated with globalization by removing all barriers to economic efficiency, regardless of the social cost.

The policies and practices reflected in the changing global economic environment have had a profound effect on everyone, not just on those directly involved in corporate production or financial institutions. The shift in production has brought unparalleled prosperity for some and crushing poverty for others. The transformation of regions and communities adversely affected by shifts in production 'are not the result of any inherent "competitiveness" problem, but of policies promoted by the interests that benefit from [the] heightened trade' associated with the globalization of capital (Noponen et al. 1993: viii).[2]

The economic processes and the social and political conditions associated with globalization are the result of political choices, not market imperatives. But an ideological analysis of post-Fordist advertising reveals multiple strategies of representation that make the hand of the market invisible, deflecting attention away from relationships of power, thereby reifying the processes by which the global capitalist economy operates. Ideological meaning can be embedded in visuals alone, as in one common theme, found in ads throughout the sample, that naturalized the world as a business-world, and that asserted the businessman's control over the precarious and unpredictable global business environment. Ads for the companies Ascom Timeplex [F 5/29/95] and RGA [WT 1–2/95] both showed part of a man's arm, dressed in a suit, holding up the world. The hand in the RGA ad was balancing the image of the Earth on one finger, as if spinning it like a basketball. The visuals can also be reinforced by text, serving to fix more specifically the ideological meaning of the ad. An ad from T. Rowe Price added text to reinforce the naturalizing image of corporate control over world affairs. Having set his briefcase down, a man dressed in a business suit is shown picking up the world as if to examine it. The text reads, 'To find you the best investment opportunities on earth, we leave nothing unturned . . .' [WT 9/95]. Encouraging readers to visualize the interconnectedness of the world in terms of business opportunities rather than, say, environmental concerns, serves to reinforce the particular ideology of global trade without questioning the specific social conditions under which that trade takes place. In addition, by routinely *naturalizing* the global economy, representing it, for example, as a stormy sea, a tidal wave, or lightning, advertising may hinder our ability to recognize the purposeful role of human activity in the shaping of economic processes, and our ability to conceptualize what can be done about the increasing social disparities characteristic of post-Fordist capitalism.[3]

Given that economic globalization is not equally rewarding for each demographic strata of the population, the 'appropriate consistency of individual behaviours' (Lipietz 1986) that modes of regulation attempt to ensure must be varied. Advertising, for example, attempts to socialize different strata of the labour force to the processes of production in different ways, and its encouragement of distinct demographic markets to conceptualize the global economy differently demonstrates its ideological function. Different race, class and gender groups are encouraged to participate 'appropriately' in the reproduction of global capitalism through the construction of a global economic 'common sense' specific to that target market.

The content of ads placed in *World Trade* and *Fortune* magazines during 1995 represented the global economy as if it were a given, assuming a shared logic about globalization between advertisers and readers. These ads depicted processes associated with globalization – changes in the corporation such as just-in-time production or the role of information and information

technologies – positively, as if they were already 'common sense', as in this ad for the global shipping company, Emery Worldwide:

(Visual: two-page ad, the top three-fourths of which is an elongated drawing of the globe with lines demarcating longitude and latitude and outlines of continents. An Emery Worldwide jet spans the width of the globe and is drawn so the tail section curves with the curve of the globe. The bottom fourth of the ad is all text. The top line, in much larger font relative to the rest of the ad, reads:) Contoured [i.e. as naturally as the Earth] to fit your global shipping needs. (Visual: in much smaller font:) . . . We call it Customer-ization: shaping our capabilities and schedules to meet your specific global shipping needs, giving you the flexibility to respond to market changes overnight. [*WT* 1–2/95][4]

It would be incorrect, however, to assume that advertisers do not have to socialize readers of *World Trade* and *Fortune* to the reproduction of global capitalism. While the regulation of dissent within groups that benefit less or not at all within the current structure of global capitalism may be the more difficult task, readers of *World Trade* and *Fortune* magazines are also given an overtly ideological representation of the processes and effects of globalization. At times, for example, ads from these magazines also serve as reminders about the rules of engagement; that is, if you want to survive and thrive in the tough climate of the global economy, you need to participate appropriately.

(Visual: An all text ad in black font. Background colour is bright green with a quotation from Will Rogers in a larger font size and set off in yellow highlight.) 'Even if you're on the right track, you'll get run over if you just sit there.' Will Rogers. (Visual: still on a green background, but with significantly smaller font.) You've reengineered and you feel you're on the right track. But the competition is gaining on you. You need to move ahead and you must move fast. . . [Gemini Consulting, *F* 11/27/95]

Ads placed during 1995 in *Newsweek*, *Black Enterprise*, *Hispanic Business* and *Working Woman* differed significantly from the majority of ads found in *World Trade* and *Fortune*. Based on the volume of ads that appeared in *Newsweek* advocating specific political positions favourable to global capital, it is clear that advertisers did not assume a positive predisposition of *Newsweek* readers towards globalization (the need to explicate the benefits of globalization for the US economy suggesting the further need to contain criticism of global capitalism for, and within, *Newsweek*'s broad but predominantly white target market). One strongly worded, two-page advertisement in *Newsweek* from The CIT Group, self-described as 'America's Most Experienced Asset-Based Lender', advocated fewer governmental regulations over business activities.

(Visual: two-page ad, visually split in half lengthwise by a black background in the upper-left section with large, white text:) It's Time To Demand Less From Washington. (The upper-right section is what appears to be a digitally altered image of the US Capitol building. The view of the Capitol highlights the presence of a man's dress belt tightly cinched around the outside of the rotunda, squeezing it into a shapelier figure. Smaller sized black text with a white background covered the bottom half of both pages, reading in part:) Demand less red tape and less red ink. Demand more sensible regulation, fewer subsidies and lower deficits. Demand less government so that we can all achieve greater prosperity. Then accept that the private sector will have to pick up the slack as the public sector continues to pull back. What can you do? You can invest in your company as well as in your community. . . [*NW* 10/30/95]

Yoking visual representation of the iconic seat of US democracy to the plea for a shrinking state, the ad visualizes a model of capitalist government, and business, that has increasingly prevailed in the era of capitalist globalization, asserting its universality ('so that we can all achieve greater prosperity') in the interplay of visual image and text.

The suggestion that the private sector would pick up the slack as the public sector pulls back, however, contradicts recent trends. As Robert Reich, former Secretary of Labor in the first Clinton administration, remarked, 'Americans always assumed that when companies did better, the people that work for them should do better too . . . That was the implicit moral code that guided the economy for more than three decades after World War Two . . . But that compact has come undone' (Reich 1997: 292).

The majority of ads directed at *Sports Illustrated*'s target market did not directly address the processes of production associated with global capitalism. Instead, these ads emphasized the positive involvement of multinational corporations within different American communities. For instance, during 1995 Nissan placed twelve different 'Hometown Heroes' ads in *Sports Illustrated* featuring different individuals or groups from various parts of the country who were involved in sports-related volunteer activities within their communities. In the visual juxtaposition of community heroism on one page (a reassuring narrative in an age of impersonal restructuring and global capital flows), and an ad for Nissan cars on the facing page, the ad not only imbues the commodity with community. By incorporating 'community' and 'heroism', by visual juxtaposition, within the Nissan brand, the ad also seeks to socialize its target market to the privatized and deregulated global market by ascribing a public good to the private, corporate ownership of capital. Interestingly enough, nowhere in this ad, or in similar ads, does it say that Nissan donated any money or any other assistance to the organizations or individuals recognized. The absence of other types of representation of globalization in *Sports Illustrated* is important, in that it suggests that advertisers assumed readers of the magazine did not need to be convinced of the veracity of globalization in the same direct, purposeful way the advocacy ads had to work to convince *Newsweek* readers of its benefits. Instead, readers of *Sports Illustrated* were only encouraged to conceptualize the global economy in terms of corporate community involvement.

Ads in both *Hispanic Business* and *Black Enterprise* addressed their target markets as active, legitimate participants in the global economy, much like readers of *World Trade* and *Fortune*. Yet each market was also addressed by ads that acknowledged the negative economic and social realities of American minority communities within the current global regime of accumulation. Ads in these magazines stressed the global corporation's role in helping 'lift up' individuals out of their disadvantageous social position. For example, Anheuser-Busch, a multinational corporation with interests in beer production, adventure park entertainment, and packaging, ran two different ads in *Hispanic Business* during 1995 highlighting its involvement in providing educational scholarships for Hispanic students via the National Hispanic Scholarship Fund (NHSF). One ad saluted the twentieth anniversary of the NHSF. The visual was a drawing of a graduation cap as it was tossed into the air. The large print read: 'Our Hat's Off To You, NHSF!' The smaller print read in part: 'Making college possible for more than 24,000 Hispanic men and women is indeed a proud achievement . . . It has been a great honor to be your major supporter for the past dozen years . . .' [HB 6/95].

Juxtaposing ads that discussed the way corporations envisioned their role in US communities was revealing. Ads in *Newsweek*, *Sports Illustrated*, *Black Enterprise*, and *Hispanic Business* depicted corporate support for arts and educational programmes, community volunteer programmes, and other efforts to support the underprivileged. In fact, one ad in *Hispanic Business* specifically suggested that corporations have a role in ensuring equitable treatment of minorities and women within the economy [ad for Reebok, HB 4/95].

Ads placed in *World Trade* advocated a rather different approach to corporate participation within local communities. For instance, ads suggested establishing Foreign Sales Corporations to be used as tax shelters.

(Visual: one column of text filling up one fourth of the page. Top third of ad features large, white text on a black background.) Right now, you're paying 15% to 30% more taxes on your export income than you need to. (Visual: bottom three-fourths has black text on a white background. In bold, large, black text reads:) Here's what to do about it. (Visual: much

smaller font:) Set up a Foreign Sales Corporation in the U.S. Virgin Islands. An FSC is an off-shore instrument created by Congress that allows a U.S. company to lop as much as 15% to 30% off the taxes on its export-derived income. A U.S. Virgin Islands FSC is easy to set up and inexpensive to maintain. It requires no staffing or facilities, just a 'postal' relationship with an FSC management company and a nominal fee to the government. . . (Visual: the bottom fourth of the ad is separated by dashes, a coupon, indicating that this section is to be faxed.) For more information on money-savings FSCs . . . [U.S. Virgin Islands, *WT* 1–2/95]

The visual progression of the ad through larger to smaller font sizes, draws the reader's gaze sequentially through the identifying of a problem, followed by a challenge to corporate inertia – 'Here's what to do about it' – to a solution, whose 'small print' acknowledges and accommo-dates the concerns of 'ethical investors', legitimizing off-shore investment as a democratic (and thus unproblematic) act of Congress. The use of alternate black and white fonts, which can be limiting to advertisers, is here turned to the company's advantage, the juxtaposition of white text/black text emphasizing both the simplicity of the solution offered by FSCs, and their unproblematic (black and white) functioning in global business practice. Other ads in *World Trade* drew on the same visual structure, juxtaposing diminishing font sizes in black and white to embed a logical 'common sense' in the suggestion that corporations should locate their busi-nesses in Free Trade Zones – which exist so that companies can repatriate 100 per cent of profits back into the organization without paying any state or city taxes in the communities near where these zones are located [see ad for Jebel Ali Free Zone, *WT* 6/95]. The black and white, common sense frame of these ads, is of course highly selective. *World Trade*'s target market is not asked to consider the ramifications of, for example, eliminating the tax base for the communities in which the company is located. These ads suggest a very different role for corporations within society than that outlined in *Sports Illustrated*.

Looking at how specific issues were addressed in contrasting ways for different target markets highlights the construction of a specific global economic common sense for each market; each market being positioned differently in the ads' description of the processes of glo-balization, and in the conceptualization of that market's role within those processes. The iden-tification and importance of a company's position as a 'global' competitor, for example, was represented in various ways in publications for different target markets. Typically, ads found in *World Trade* or *Fortune* emphasized the importance of a company's global reach, using this as an indicator of the company's success in the global market-place.

(Visual: two-page ad, the top three quarters of which is a photograph of a man baking multi-ple loaves of bread in an open wood-fired oven. Inset within the picture are the words:) How did we rise to the top of the computer industry? We deliver the freshest technology in the busi-ness. (Visual: smaller text on white background:) . . .Every day, we deliver the newest, fresh-est PC technology to our customers around the world. Acer builds PCs daily at 30 manufacturing sites worldwide. So we're closer to markets – closer to you. This regional approach to manufacturing helps cut our inventory times to half the industry average. And guarantees you the freshest technology and pricing, not month-old product. [Acer, *F* 8/21/95]

Here the naturalizing of the global market is again carried visually, the written text underlain with an image – breadmaking – that is both homely and, more or less, universal. For the most part, however, ads found in *Sports Illustrated* or *Newsweek* de-emphasized the global nature of a company, instead stressing that specific products were 'made in America', or 'exported from America', and so on.

(Visual: a two-page ad with six different photographic images on a white background. The final image on the bottom right is that of the Honda Accord. The images are not in propor-tion to each other, but are all the same size.) Cooked up in America since 1855. (Visual: a juicy hamburger.) Handcrafted in America since 1868. (Visual: a pair of cowboy boots.)

Performed in America since 1909. (Visual: sign for 'live jazz tonight'.) Pedaled in America since 1865. (Visual: old-fashioned bicycle.) Played in America since 1845. (Visual: a base-ball.) Manufactured in America since 1982. (Visual: a Honda Accord Sedan. Underneath the images is the following text:) Four out of five Accords sold in America are manufactured here. By people and for people who aim high. . .What it all adds up to is the Accord. An excellent example of American quality for the past twelve years. [Honda, *SI* 2/6/95]

By the visual association of stereotypically 'American' products and activities with the manu-facturing of Honda cars, the reader is encouraged to conceptualize these cars as 'American' and not 'foreign'. The irony is that 'the question of "American-made" has become ludicrously com-plicated and subject to endless manipulation' (Greider 1997: 213) by multinationals that switch 'citizenship' of products among countries to create the most efficient *regulatory* environment; the environment, that is, which will contain or displace from view the contradictions that underpin the functioning of the global, post-Fordist regime of capital accumulation.

Similarly, the conception of the consumer's role within the global economy is presented dif-ferently across publications aimed at different markets. Although the depiction of the global economy as a 'force-of-nature' spanned markets, during 1995 there were a number of ads in *World Trade* and *Fortune*, and to a lesser degree in *Hispanic Business*, that also stressed the ability that members of these markets had actively to shape the future of the global economy.

(Visual: Photograph looking down on an airplane flying above the clouds. Just below the plane in large font:) The people changing the world are changing it with a Challenger. (Visual: in smaller font:) The more things change, the more business leaders fly Challenger aircraft. Its versatility, efficiency and productivity have made it the corporate jet of choice for CEOs in an ever-demanding, ever-evolving business world. . . [Canadair, *F* 6/12/95]

Throughout 1995, however, no ads in *Working Woman* or *Sports Illustrated* addressed their readers as having such an active role in the shaping of the global economy. Instead these mag-azines ignored women altogether, and conveyed for sports fans only the positive role corpora-tions play in local communities. The paucity of ads representing globalization in *Working Woman* magazine was particularly noticeable. In contrast to ads attempting to legitimate glo-balization targeted at other markets in other publications, throughout 1995 it was clear that advertisers rarely regarded women as significantly involved in the processes of globalization, or sufficiently powerful, politically, to challenge the social relationships associated with the global economy. Interestingly, although a number of ads in *Hispanic Business* did address its target market as legitimate participants in the global economy, there were some ads that suggested readers of *Hispanic Business* were not always schooled in the ways of economic globalization. Readers were told that corporations would look more favourably on them if they spoke the 'language' of globalism. For example, an ad for Rockwell, a multinational corporation with interests in 'automation, avionics, defense electronics, telecommunications, aerospace, automo-tive and graphic systems' [*HB* 6/95], was directed at minority suppliers with whom Rockwell might do business. The text reads, in part:

(Visual: four drawn cartoon dialogue bubbles containing acronyms common to the jargon of the global economy – TQM, CPI, EDI, and JIT. Each acronym is in a different font style, suggesting four different people uttering the words. In medium sized, bold text:) We're looking for suppliers who speak our language. (Visual: smaller font:) Total Quality Management. Just-In-Time Delivery. Continuous Process Improvement. Electronic Data Interchange. If terms like these are part of your high tech business, it's time you spoke with Rockwell. Our diversified businesses maintain their leadership positions with the help of suppliers whose management practices are as progressive as their technologies. If that describes your small, minority or women-owned business, we hope you'll describe your company to us. . . [*HB* 6/95]

If *Hispanic Business* readers were knowledgeable about the global economy, as demonstrated by their mastery of the language of business, then they were welcome to join those at Rockwell who apparently already possessed the insight, strength, and vision to 'maintain their leadership position' within the globalized post-Fordist regime of accumulation. The nature of that insight, strength, vision and leadership clearly favours the reproduction of global capitalism. None of the ads in *World Trade* or *Fortune* questioned the ability of their target market to speak the language of globalization.

While ideologies provide the framework through which one understands the world and work best when one does not recognize their presence, an ideology that does not take into consideration the actual, lived experience of people within their concrete, historical circumstances may lead people to question dominant ideological assumptions. As Williams reminds us, the reality of any hegemony, in its form as practical consciousness, 'is that while by definition it is always dominant, it is neither total nor exclusive' (Williams 1977: 113). Although few in number (approximately 1 per cent of the total sample analysed for this essay), throughout 1995 the publications discussed here also featured ads that revealed certain problematic realities inherent in a 'broadly dynamic, and consequently unstable, capitalist system' (Harvey 1990: 122). Whether or not particular ads attempted to suggest a resolution for the problem depicted depended on the relationship of the problem to the market at which the ad was targeted. When an ad representing problematic issues was salient for the reader of the magazine where the ad appeared, the ad attempted to resolve the issue (at least within the ad itself) according to the dominant logics of the global economy. When an ad representing problematic issues was not salient to the reader, the ad left the problem unresolved.

The overall business environment represented in ads placed in both *World Trade* and *Fortune*, was characterized as turbulent and stressful, a business world where corporations have had to, or need to, downsize, rightsize, re-engineer, and restructure. Unlike ads found in *World Trade*, a few ads in *Fortune* straightforwardly acknowledged the increasing demands on workers brought on by corporate restructuring.

> (Visual: all text ad, with the first sentence taking up over three-quarters of the page. Different words/phrases are in different sized fonts:) Downsizing is only (medium font size) right (next line, small font size) when you can do something (next line, medium font size) powerful (next line, medium-large font size) with what's (next line, medium font size) left (next line, large font size). (Visual: in very small text:) Unless downsizing is an integral part of a plan for growth, it usually achieves nothing more than damaged company morale. And, to add insult to injury, research has shown that over the long term, most companies that downsize to increase shareholder value are unsuccessful in their quest. . . [Mercer, F 9/4/95]

Differences in font size encourage the reader to understand the ad in a specific way. Reducing the size of the word 'right' relative to the rest of the sentence suggests a sympathetic understanding of the negative connotations associated with downsizing. In much the same way, visually emphasizing the words 'powerful' and 'left' through the use of a larger text size indicates the positive connotation of downsizing preferred by Mercer Management Consulting. All of the ads that recognized problems with worker morale as a result of downsizing justified the practice, emphasizing that downsizing was absolutely necessary to remain competitive in the global market-place. Yet, even in their bleakest representation of capitalist restructuring, the ads never acknowledge the consequences of downsizing for the newly unemployed. The ads addressed morale among the remaining workers, as opposed to the workers just 'downsized'.

Given advertising's overriding desire to create an appropriately friendly consumer environment, it should not be surprising that the symbolic representation of economic globalization in advertising provides an ideological picture of that reality. Recognizing the ideological nature of advertising, though, requires more extensive knowledge of the processes and consequences of globalization than are typically provided by mainstream capitalist media. Without extra-textual knowledge, it would be easy to accept the limited world-view of economic globalization

represented in the ads, and if we do not recognize that their picture of the global economic reality is indeed ideological, that '[t]he movement toward economic globalization is no expression of democracy, nor is it the kind of "evolutionary" process that its advocates claim it is' (Mander 1996: 17), then our ability to function as citizens (rather than as consumers) in a democracy is hampered. We need to continue to examine the role that the circulation of messages and social cues found in advertising has in our conceptualizing of, and participation within, the global economy. Above all else, as Tabb suggests, 'We need . . . to have the economy serve human needs rather than accept the continuous sacrifice of working people to such ideological construc-tions as competitiveness, free markets, and the alleged requirements of globalization' (Tabb 1997: 29).

Notes

1. Ideologies contribute to the development of a particular world-view; but they do not neces-sarily reflect pre-given positions in a conscious attempt to manipulate the masses by politi-cal or economic elites. Although it is important to recognize which social groups are in a position to naturalize a world-view into a 'common sense' that furthers their political and economic interests, '[i]deologies produce different forms of social consciousness rather than being produced by them' (Hall 1981: 19). In fact, ideologies work best when their influence is unrecognizable.
2. While 'globalization (of capital) is not the source of all the world's ills . . . the reduction in labor, social, and environmental conditions . . . results directly from global competition for jobs and investments' (Brecher and Costello 1994: 21). Aronowitz and DiFazio argue that the intensification of problems such as crime, homelessness, hunger, educational opportu-nities, loss of tax revenues to pay for public services, and many other social issues are asso-ciated with these critical changes in the economy (Aronowitz and DiFazio 1994: xi).
3. It must be much easier, for example, to decide to relocate overseas, to take advantage of lower labour costs, if one does not address the consequences for the abandoned community, or examine the working conditions that make cheaper labour possible. It would be easier to make these kinds of executive decisions if one conceptualizes the processes of production and set of social relationships associated with the global economy as an inevitable flow of events, part of the natural course of doing business in changing economic times. (For a more thorough discussion of the data and results discussed in this essay, see Johnson 2000.)
4. Ads discussed should be seen as exemplar ads, illustrative of common themes within the data.

Commodifying Latin America in NAFTA-era Film

The World According to Miramax: Chocolate, Poetry and Neoliberal Aesthetics

SOPHIA A. McCLENNEN

This essay focuses on how the practices of Miramax, a subsidiary of Disney and a 'major independent' (Wyatt 1998) studio, are indicative of the role of certain films in a pro-globalization, transnational consumer society. I am especially interested in the ways that Miramax markets itself to 'American' consumers through the fetish of the foreign, art house or independent film.[1] Miramax can be credited with reviving public interest in foreign cinema, but what does it sell? By analysing a number of key Miramax films distributed in the US that represent Latin American culture, I argue that we have to read Miramax and its success as symptomatic of the US-global economy, the changing status of national cultures, and as the marker of an emergent neoliberal aesthetic in 'American' culture.

Founded in 1979 by Bob and Harvey Weinstein, Miramax began as a distributor of independent and foreign films. Famous for their marketing abilities and for targeting audiences beyond art house venues, Miramax radically changed the landscape of independent cinema in the US. With the success of films such as *sex, lies and videotape* (1989), *The Crying Game* (1992) and *The Piano* (1993), Miramax proved that independent and foreign films could be highly profitable investments. These successes dispelled the notion that 'quality' cinema was anathema to profitable cinema. As proof of the Weinsteins's ability to back successful films, the company had earned 83 Oscar nominations by 1997 (Eller 1997: D4). In addition to a vast library of films with Oscar nominations, Miramax has also been notorious for 'its marketing savvy, particularly the ability to apply "exploitation" techniques to art house product' (Wyatt 1998: 83). For instance, they arranged for Claudia Ohana, the actress who plays a young girl forced into prostitution in *Erendira* (1983), to pose for *Playboy*. This combination of controversy and quality reveals a central component of Miramax's innovative marketing. Whereas independent films traditionally tracked according to two distinct categories (exploitation and art house), Miramax has habitually combined these categories, promoting their films as entertainment for both types of audiences. As a result they expand the market and build the financial success of the films they distribute. Bob and Harvey Weinstein have maintained consistently that there is no reason why 'so-called art house movies cannot be mass-market, and play in local neighbourhood theatres' (Pulver 1997: 2).

Another key feature of the company's marketing has been an emphasis on its own role as an independent distributor, outside of the domain of major Hollywood Studios. Based in the trendy Tribeca district of New York City, Miramax has promoted its image as a scrappy, feisty, risk-taking company that does not have the bureaucratic apparatus of the major studios. In fact, Harvey Weinstein, the more flamboyant of the brothers, is given frequent media coverage for his rough style. For example, 'Harvey regularly tells the story of how he locked the Chinese producers of Zhang Yimou's *Ju Dou* into a room at the 1990 Cannes Film Festival until they'd agreed to sell him the North American rights' (Pulver 1997: 2). Even after their acquisition by

Disney in 1993, Miramax has continued to exploit its image as an independent film company. 'We're the guerrillas,' Bob Weinstein suggested before the takeover. 'We snipe and we hit and we win a few battles, then we retreat. We're good at being niche players. We don't want to grow up and be another Walt Disney' (Gubernick 1989: 109).

Since its inception Miramax has taken great interest in marketing foreign cinema to US audiences. The Weinsteins determined early that foreign cinema was an excellent source of quality product that could succeed in the US with the right marketing techniques to support it. The company has been a virtual powerhouse in the US distribution of foreign films: box office statistics credit Miramax with distributing six of the top ten grossing foreign films in the US during the 1990s (see *http://www.filmfestivals.com/academy/oscar_2000/3_foreign/top20.htm*). They decided to market foreign films as 'mainstream independents' and have abandoned the language of 'art-house' which often signified a small, elite audience (Perren 1998: 92).

As Miramax tailored its marketing to a broader and broader audience and as it attempted to move foreign films into mainstream cineplexes, the entire geography of the US film business was in flux. The 1980s and 1990s signalled a rise in the globalization of Hollywood with a wave of mergers between US interests and between Hollywood and foreign media companies (Balio 1998: 64). During this period, the Weinstein's found that constraints on their capital limited their successes. They often had to sell video distribution rights to films they acquired, as in the case of *Reservoir Dogs* (1992), which greatly reduced their return on investment (Perren 1998: 103). Their available capital also restricted how many films they could release in a given year. Clearly the ambitions of the Weinsteins were out of sync with their means.

Simultaneously, Disney wanted to expand into new markets beyond the family-oriented. By the mid-1990s Disney was a highly diversified company with strong holdings across the media spectrum and yet some areas of the entertainment business remained outside of their domain (Wasko 2001). Taking note of the success of foreign and independent films, Disney began to look into acquisitions, purchasing Miramax in 1993 and Merchant-Ivory (a production company) in 1994. Disney purchased Miramax for $80 million, acquiring all the films in the Miramax library. In return, the Weinsteins gained the ability to produce their own films (albeit with certain budget restraints) while maintaining their creative autonomy (as long as they did not release NC-17 films).[2] In addition, their films were given the support of Disney's enormously successful video distribution company, Buena Vista Home Entertainment.[3] This access to Disney's distribution facilities has greatly affected Miramax's acquisition of foreign titles, since the company could subsequently market their films globally (Eller 1995: D1). For instance, Harvey Weinstein claims that '*Il Postino* would not have done the kind of "record business" it did overseas if it hadn't been released through Disney's Buena Vista International' (ibid.).

The acquisition of Miramax by Disney and of New Line by Turner Broadcasting Corporation in 1993 caused anxiety throughout the film industry, especially for those affiliated with independent cinema. Many have noted concrete transformations in the practices of Miramax since the acquisition. In particular, the Weinsteins have distanced themselves from controversial films (Perren 1998: 31). Changes in content have been accompanied by changes in their business practices, since the Weinsteins have the financial backing of Disney. Wyatt points out that 'Miramax . . . has become more aggressive in buying distribution rights to completed films, with their efforts increasing the price for product' (Wyatt 1998: 84). At one time heralded for opening up the independent film industry, certain critics now characterize Miramax as an independent film monopoly that crushes competition and restricts the market: '[S]ome have come to view the company as the indie film world equivalent of Microsoft – an unapologetic giant capable of smothering competition' (Dutka and Clark 1997: 1). Since the acquisition, Miramax may have shied away from scandal, but not from profits. In fact Harvey Weinstein made this point clear when he dismissed the idea that the company had altered the kind of films it markets: 'I think we're getting much more corporate, but still not changing our taste in films' (Spotnitz 1993: G5). Their taste, then, is driven more by a desire to reach an ever-widening market than by some idealized notion of bringing foreign and independent films to US screens.

Miramax's acquisition by Disney also came at a time of intense attention to the effects of

globalizing media on markets outside of the US. Debates related to trade agreements, such as GATT (General Agreement on Tariffs and Trade, implemented in January 1995) and NAFTA (North American Free Trade Agreement, implemented in January 1994), have generated concern over the ability of national markets to restrict imports from the US. I would like to add to the consideration of how globalization affects media culture by turning attention to the ways that foreign products are marketed within the US. Just as globalization has altered the cultural consciousness of global consumers who purchase US commodities, reducing the consumption and consideration of local and national products, US consciousness of the cultural identity of its global neighbours has shifted. This shift has been particularly noteworthy in the case of US reception of products from Latin America.

One of the most significant shifts relates to the need in the US to see Latin America as a trade region rather than as a volatile, unruly set of nations that need guidance and intervention. Ever since the Monroe Doctrine of 1823, which warned Europe to stay out of the affairs of the Americas or risk US retaliation, and the Roosevelt Corollary of 1904, which claimed that the US could resort to 'the exercise of an international police power' in situations of 'wrongdoing or impotence', the US has characterized its relationship to Latin America as one of a big brother who must guide and control the other nations of the Americas (Roosevelt 1904). The US media during the Reagan and Bush years (1981–92) repeatedly characterized Latin America as a land of human rights violations, barbaric politics and dangerous people. Douglas Kellner explains that: 'The Reagan era was one of aggressive military intervention in the Third World, with an invasion in Grenada, the US-directed and financed Contra War against Nicaragua, the bombing of Libya, and many other secret wars and covert actions round the globe. Hollywood film nurtured this militarist mindset and thus provided cultural representations that mobilized support for such aggressive policy' (Kellner 1995: 75). While films such as *Missing* (1982), *Salvador* (1986) and *Under Fire* (1983) were critical of the role of the US in Latin America, major mainstream productions tended to support the image of the US as justified in using military force to control the region. Blockbuster movies such as *Romancing the Stone* (1984), where a romance novelist has to rescue her sister from Colombian kidnappers, and *Die Hard 2* (1990), where Bruce Willis has to save his wife from South American terrorists, served to reinforce the impression of Latin America as a land of barbarians and criminals.

Without question these images persist in US media culture following the Reagan-Bush era, but at the same time the increasing entrenchment of neoliberal economics in the region has signalled a wave of images that depict the region as non-threatening and commodity-friendly. Neoliberal economic practices between the US and Latin American nations began roughly in the early 1970s with US support of the dictatorship of Augusto Pinochet in Chile (1973–89) and with economic policies associated with Milton Friedman's 'Chicago boys'. Not to be confused with neoliberal *politics* advocating political freedom, neoliberal economics refers to the notion that economic transactions should take place in a large, unregulated, free market. This belief translates into an intensification of former liberal economic policies, where the capitalist exchange of goods reaches new geographical areas, markets new types of commodities, and where people and nations are understood principally in terms of market metaphors. 'For neoliberals it is not sufficient that there is a market: there must be nothing which is not market' (Treanor 2002). Paul Treanor points out that under neoliberal economics the market becomes the ethical foundation for society 'substituting for all previously existing beliefs' (ibid.). Neoliberal economic practices can be noted throughout Latin America in the privatization of government-owned industry, the reduction in government regulations on trade in the region, and the progressive elimination of the concept of 'the public good' (Martínez and García 2002). Pierre Bourdieu argues that neoliberal economics *'call into question any and all collective structures* that could serve as an obstacle to the logic of the pure market' (Bourdieu 1998: online). As a consequence, the concept of the nation loses cultural power and practical significance and is replaced by the commodity and the corporation. When the nation loses meaning so do cultural products that correspond to national identities, leading to the 'progressive disappearance of autonomous universes of cultural production, such as film, publishing, etc' (ibid.).

Logically these shifts in economic and social policy have also resulted in aesthetic shifts. The 'neoliberal aesthetics' I refer to in my title signify this representation of global culture. Paving the way for free trade, the neoliberal aesthetic abolishes the borders between nations. These borders are both literal, i.e. the US-Mexico border, and figurative, since the borders between national histories and conflicts are also erased. Under neoliberal aesthetics the nation is empty of history and struggle, no longer capable of posing international threat. Instead the nation is only meaningful as a source or site of commodities and exchange.

The latest trend in marketing Latin America, the packaging of the region as 'pure spectacle' (Burton-Carvajal 1994: 141), builds on earlier practices in US reception. In this sense it is not new, but rather an intensification and refocusing of marketing tools used by the US culture industry since the mid-twentieth century. We might think of examples like the Hollywood films of Carmen Miranda in the 1940s and Disney's classic *Three Caballeros* (1945). The difference in the cases I will analyse below is that these films were not made in Hollywood.

Miramax, both before but especially after its acquisition by Disney, has been at the forefront of marketing foreign films with what I have called a 'neoliberal aesthetic'. Whether or not the films have an overt political message or reflect social struggle, Miramax's marketing tends to obscure these elements in favour of a focus on the superficial and the sensual. The spin provided by Miramax casts the film as foreign, i.e. exotic, but also universal, in so far as the stories can be consumed in a way that is not tied to regional specificity. Moreover, the films typically fall into the classic Hollywood narrative cinema style and, when they do offer aesthetic alternatives, these are easily subsumed to the larger narrative project. The intense commodification of these films and of the issues represented in them reveals Miramax's neoliberal agenda, since the company has been exemplary in expanding the market for their films and of transforming cultural elements into market properties. Ironically, in many cases this has meant that there has been a discrepancy between the film marketed by Miramax and the actual film moviegoers watch. Both *Il Postino* and *Strawberry and Chocolate* were advertised as comedies, for instance, even though neither film is particularly funny. Miramax, as the marketer for the film, sets the tone for audience reception, functioning, in essence, as the meta-spectator and attempting to dictate the way that subsequent spectators will receive the film. Clearly, the savvy filmgoer can view against these prescribed readings, but my interest here is in underscoring the ideal, non-confrontational spectator envisioned by Miramax.

Miramax films *Like Water for Chocolate*, *The Postman* and *Strawberry and Chocolate* were released during a period in which the economic relationships between the US and Mexico, Chile and Cuba were under reconsideration. Released in the US in 1993, *Like Water for Chocolate* coincided with the debates about NAFTA, and with heightened anxiety, in some quarters, about the impact of Mexican immigration on the US. *The Postman*, released in mid-1995, coincided with a push to include Chile in NAFTA; and *Strawberry and Chocolate*, released in early 1995, came in the middle of renegotiations of the US embargo of Cuba.[4] The neoliberal aestheticizing of these countries is furthered in each of these films through the commodifying of Latin American 'otherness' as a series of highly sensual, and sexual, objects of consumption. As neoliberal films, all three narratives 'universalize' their point of view by focusing on a central love story (*the* universal or global human story) accompanied by a significant dose of sexual images. Moreover each film is an adaptation of a literary text that tones down the political edge of the original story.

Grossing 21.7 million in its US release, *Like Water for Chocolate* was the most profitable foreign film in history. Presenting the tale of Tita, a woman who is forbidden to be with the man she loves by a family tradition that requires the youngest daughter to serve her mother and not marry, the film reduces Mexican national identity to easily consumable products empty of history and struggle.[5] In fact, as in the case of all three films I am highlighting, the promotional publicity on the video/DVD jacket does not even mention the national location of the film. A number of features of the film contributed to its enormous success in the US – the eroticized love story between the characters Tita and Pablo, the depiction of Mexican culture (especially food) as sensual and exotic, and the 'apolitical' treatment of the Mexican Revolution and the border region.

The film supports a long tradition of eroticizing Latin Americans, both male and female, and it presents a popularized magical realism that contributes further to the image of Latin America as exotic 'other': for example, Tita is able to breastfeed Pedro and Rosaura's baby even though she has never been pregnant, her food magically conveys her emotional state to all who eat it, and she dies by eating matches that consume her life spirit. Certain scholars have noted that the film is about more than 'magical realism and food', but Harmony Wu points out that 'this is the level at which a majority of US filmgoers consumed the movie' (Wu 2000: 186). The easy flow of the film narrative allows the viewer to swallow the images on the screen, objectifying Tita's body along with Pedro's dominant gaze, savouring the sexy combination of food and passion, and marvelling at the magical real events that take place on the isolated ranch.

The representation of the border as a non-violent, peaceful region of exchange further helped the film's appeal. Taking place in the Rio Grande/Eagle Pass area, the repeated long shots of the isolated ranch house where the family lives contrast with contemporary images of a border teeming with Mexicans anxious to cross into the US. Border crossings take place throughout the film and in each case the result is innocuous and non-confrontational. In fact, if border-crossing is seen as a threat it is to Mexicans, since when Pedro and Rosaura cross to live in Texas their son dies because he is unable to eat any of the food given to him. When Tita falls into despair after hearing the news, she is taken to Dr John Brown's house to live. As she slowly recovers, he proposes marriage to her, but ultimately she cannot marry him because of her love for Pedro. Once again, a negative image of border-crossing is rewritten: Tita's refusal to marry Brown overshadows the image of the Mexican who wants to come to the US and find a spouse in order to gain citizenship. This makes the later marriage between Esperanza (Hope) and Brown's son, Alex, read more like a happy-ending of free trade and international collaboration. Significantly Dr Brown's voice-over narrates the last moments of Tita's life as she consumes matches and burns up all of her passion, providing a frame to Tita's sensual life that is controlled by Brown's US-style reason and pragmatism.

A further feature of the film's neoliberal aesthetic is its emptying of Mexican history. Set during the Mexican Revolution of 1910, the film avoids dealing with any of the broader historical and social issues surrounding the Revolution by concentrating on female, domestic spaces. Gertrudis, Tita's older sister, is the key link between the ranch house and the Revolution. Fleeing on horseback after devouring a passion-provoking meal, Gertrudis becomes the lover of a Villista soldier. After spending time in a brothel quenching her thirst for sex, Gertrudis becomes a general in the Revolution. Her involvement, though, never connects to the class struggles that were at the heart of the conflict and her return to the family's ranch never causes her to address the issue of land redistribution in the context of her own family's property. Summing up her apolitical engagement with the Revolution, near the end of the film she visits Tita and states: 'Revolution wouldn't be bad if you could eat at home'. True to the neoliberal aesthetic it embodies, this Miramax film suggests to viewers that culinary pleasure and the consumption of 'foreign' food eclipses the dangerous reality of historical conflict.

The Postman was another Miramax success story, topping the US box office gross of *Like Water for Chocolate* by $100,000. Based on a Chilean novella, with French and Italian actors, and a British director, *The Postman* is a tale of friendship between Chilean poet, Pablo Neruda, and an Italian postman, Mario. With its transnational crew and its cross-cultural content the film loses ties to territorial specificity and gains the neoliberal gloss of the global. A substantial revision of the original work by Antonio Skármeta, *Ardiente paciencia (Burning Patience)*, *The Postman* displays the neoliberal aesthetic by manipulating and misrepresenting the historical events around Pablo Neruda's life, toning down his leftist politics and playing up his reputation as the universal/global poet of love. Unlike *Like Water for Chocolate*, whose diegesis is a willing accomplice to the erasure of Mexican history, *The Postman* offers the viewer multiple options varying from political engagement to sensual passivity. And yet, similar to *Like Water for Chocolate*, Miramax's marketing stressed that the film was an apolitical, romantic comedy, highlighting the 'Latin' sensuality of the women loved by the two leading men.

While there are many departures from the original novella, the most significant are the

modifications in the setting, historical period, and friendship of the main characters. Skármeta's original tale of Neruda and his friendship with a postman was uniquely Chilean, and was carefully historicized. Set in Chile before and during Pinochet's 1973 coup ousted elected president Salvador Allende, the novella explored the connection between politics, history, art, and personal relationships through the friendship between Pablo Neruda and his teenage postman. The remake takes place, not as Neruda is being asked to run for president in Chile in the late 1960s, but rather as he is fleeing political persecution in his homeland (Neruda left Chile after a call for his arrest in February of 1949 and returned in August, 1952). The depiction of Neruda as an exile, unwanted in his native land, characterizes Neruda as a 'landless' poet, constructing a neoliberal depiction of Neruda as a 'poet of love', whose 'universal' calling, and hence global identity, is emptied of local ties. Though the film presents two visions of Neruda, the poet loved by the people or the poet loved by women, it favours casting him as the poet of romantic love. For Mario, Neruda is a celebrity who has seduced women across the globe – a truly neoliberal lover – and his friendship with Neruda is predicated on his desire to enlist Neruda's help in seducing Beatrice. It is only after he comes to idolize the poet that he begins to emulate Neruda's communist ideals. With Mario as the viewer's guide, the film reifies Neruda, stripping the poet of his historical agency and politics. In this sense, the film represents a neoliberal Neruda whose poetry is recast from political to pop through mass marketing and the replacement of social commitment with artistic aura.[6]

In contrast with the film remake, in the original novella it is Neruda who dies at the end as his friend reads telegrams offering asylum while the sounds of tanks and guns roar outside his home. The friendship between the two men has grown into real respect and solidarity. In the Miramax remake, it is Mario who, disillusioned by his friend's abandonment, is killed at a political demonstration where he was due to read a poem in honour of Neruda. Unlike the original, Mario's loyalty to Neruda suggests male weakness and his friendship becomes a form of suicide. In this way the Miramax film reverses the camaraderie between Neruda and Mario depicted in the novella. In fact the film suggests that Mario was foolish to care for the poet, since the poet is actually single-minded and selfish, incapable of solidarity, and no different from the deceptive politician who controls the Italian island for his own personal gain. The neoliberal version of Neruda reduces his life's works to romantic poetry and an ethic of individual self-interest. Whereas Mario in the novella gains a friend, a love of poetry, a family, and a sense of politics, in the remake he aspires to all of these but dies a naïve idealist.

Marketed as a comedy, 'A fun-filled celebration of life at its entertaining best!' (Video jacket) Miramax also distributed, with Robert Redford, the Cuban film *Strawberry and Chocolate*, a complex film that reveals the scope and limits of the neoliberal aesthetic. *Strawberry and Chocolate* was the most successful Cuban film in US history and its incorporation as an example of the neoliberal aesthetic seems possible not least because of the characters' fetishizing of foreign, capitalist commodities: Nancy deals products on the black market, Diego's apartment is filled with contraband, and David, the good revolutionary, enjoys drowning his sorrows with the scotch of the 'enemy' – *Johnnie Walker*. Another key factor that signals the film's neoliberal optic is its sensual and sexual content. Apart from a title change that substitutes Che Guevara's call for a new revolutionary society with ice-cream flavours, the principal adaptation of Senel Paz's short story, 'El lobo, el bosque, y el hombre nuevo' (The Fox, the Forest, and the New Man), is the addition of female characters. The film opens with David misreading his fiancée's coyness as they are about to consummate their relationship, which leads her to marry another man. It closes with David's successful initiation into the world of heterosexuality by Diego's friend, Nancy. The nude images of three women, a rarity in Cuban films, and the addition of heterosexual sex undoubtedly helped create wider market appeal.

Nevertheless, the film pales in comparison with the economic success of *Like Water for Chocolate* and *The Postman*. One possible reason for this difference is that the film does not have the same production quality as the other two. Moreover, even though the film may be a heterosexualized view of homosexuality and intolerance, it is still a film with a gay main character and such films have yet to be welcomed by the US mainstream. Another key reason, espe-

cially as we consider the neoliberal disavowal of the nation state, is the fact that the film is 'Cuban'. Unlike the other two, which are stripped relatively easily of their politico-national referents, this film centres on Cuba and its political crises. Diego, although he has been discarded by the regime, remains a Cuban nationalist and he constantly refers to Cuban cultural icons, teaching David about his cultural heritage. References to José Martí, Che, Lezama Lima, and others would likely distance viewers unfamiliar with Cuban history. Even though the film was marketed as a light-hearted comedy about a young man's initiation into sex and the intellectual world, the film's representation of a nation in crisis may have thwarted foreign viewers' desires to consume the 'other' flavours of Cuba.

Both *Like Water for Chocolate* and *The Postman* were marketed along with tie-in products, whereas *Strawberry and Chocolate* had fairly limited promotion. Interestingly, Miramax has been critiqued for favouring certain films in its promotional strategies. Critics see the uneven marketing support of Miramax as indicative of its major studio-style, where profits are more important than supporting small quality films (Dutka and Clark 1997: 1). These practices can also be read as further evidence of their neoliberal economic *modus operandi*. In an unprecedented marketing strategy Miramax Films and Doubleday Publishing jointly promoted *Like Water for Chocolate* in their film and book versions – the first time a hardcover book was released simultaneously with a feature film (Galbraith 1993: F3). Like the film, the book was tremendously profitable, hitting top ten lists of both the *NY Times* and *LA Times* (ibid.). This cross-promotion, coupled with a publicity tour where the writer of the screenplay and the book Laura Esquivel did interviews and appeared in restaurants, increased the numbers of consumers for both products. Similarly, *The Postman* received cross-promotion with the release of an English version of Antonio Skármeta's original text and a compact disc of music from the film, which included popular icons like Sting, Madonna, Julia Roberts, Glenn Close and Wesley Snipes reading Neruda poems. 'The company didn't use burger-chain tie-ins or Massimo Troisi dolls to merchandise the picture, but it did sell 30,000 copies of the 1985 Antonio Skármeta novel on which the film is based, and another 25,000 books of Neruda poetry' (Corliss 1996: 9). When Massimo Troisi died twelve hours after filming wrapped, 'Marketing masters Miramax capitalized on that poignancy' – selling *The Postman* as a film that records the last moments in an actor's life (Oldenburg 1996: D4).

The consequences of the hyper-commodification of films that represent foreign cultures are considerable given that US filmgoers often rely on films and other mass media for the bulk of their information about other cultures. Moreover, by commodifying the 'otherness' of the foreign cultures they depict, Miramax's film selections also tend to diminish the notion of the nation as a meaningful site of cultural difference – politically, economically and ideologically – with the result that mainstream US audiences are able to consume foreign films while reinforcing the overdetermination of the US as the central source of national and international identity. As a further example of the trend I have been describing Miramax released *Chocolat* (2000), a film in English about a woman of French and Mayan heritage who opens a chocolate shop in a small, French provincial town, only to be snubbed by the conservative majority. The film emphasizes the fact that chocolate originated with the Mayans, and, once again, the Latin American reference serves to provide an exotic and sensual backdrop since consumption of the right kind of chocolate causes the consumer to lose inhibitions and experience the pleasure of the world. Marketed as a film about tolerance, the film thus also has a parallel message about consumption: those that don't consume don't live well!

Notes

1. Given that I want to emphasize that 'America' refers to the broader region of the north and the south, I will use US to refer specifically to the United States as opposed to 'America', which places the nations to the south under erasure.
2. The NC-17 rating is the equivalent of the old X-certificate.
3. Wasko states that Buena Vista was the top video company in the US for seven years (from 1993 to 2000), making it twice the size of its nearest rival (Wasko 2001: 19).

4. In the case of Cuba, George Bush signed the Cuban Democracy Act of 1992, just before the film was released. After two planes piloted by Cuban exiles were shot down off the Cuban coast, Clinton supported the Helms-Burton Law of 1996 that included sanctions for US trade partners doing business with Cuba. Many US businessmen and economic advisors continue to lobby for a reversal of the embargo (see Peters 1998).
5. Seen within Mexico the film engages intertextually with a number of Mexican film genres, such as the revolutionary melodrama, particularly films about *soldaderas* (Mexican female soldiers), and the *carbaretera* (fallen women films).
6. It is noteworthy that, like the film, the compact disc of Neruda's poems released by Miramax has only one poem that has an overtly political edge to it – 'Walking Around'.

Visualizing 'Memory' in the Age of Global Capital

A Taste for Black and White: Visuality, Digital Culture and the Anxieties of the Global

PAUL GRAINGE

The study of visual culture, in both its emerging interdisciplinary form and in the major category fields of art history, cinema studies and photographic theory, has been drawn overwhelmingly to the consideration of representational analysis. Visual meaning has frequently been explored through close attention to the representational content of an image, and to its particular constitution of, or challenge to, a historically specific reality. This contribution pursues a less frequent, but no less significant, form of analysis concerned with 'nonrepresentational' effects in the visual/cultural terrain. According to Richard Dyer (1992; 1997), nonrepresentational effects are produced by abstract sign systems such as colour, light, texture, music, movement and rhythm that have no referent – i.e. they do not constitute reality in and of themselves – but which are nevertheless infused with codes, and articulated within discursive formations, that help create particular kinds of feel and meaning. In this way, they can be linked to culturally and historically determined sensibilities. This contribution is concerned with aspects of visual feeling in the climate of contemporary globalization, a moment not only marked by the increased volume and speed of transmissible images, but also by changing relations of space and time, reality and simulation. Specifically, I want to consider the emergence of the black and white image in taste regimes of the period. As a visual style and cross-media effect, the popularity of black and white can be read as a visual reflex of particular tendencies, and potential anxieties, produced by and within the global media sphere.

Anxiety is one of a number of diagnostic conditions ascribed to contemporary globalization; it is linked inextricably to the workings of capital on a global basis, and to new configurations of identity and hegemony that are emerging in a transnational and increasingly deterritorialized world system. Arjun Appadurai has written of the manifold 'anxieties of the global' produced by 'a world fundamentally characterized by objects in motion' (Appadurai 2001: 5). If, as he suggests, globalization has generated a host of disjunctive flows – those of people, objects, finance, technology, images, ideologies – this new and highly porous global configuration has unsettled organizations, institutions and values that have relied for their authority on a once apparent stability and fixedness. The nation-state is the most obvious, and oft-cited, example of such destabilization. In what Saskia Sassen (1996) calls the 'new geography of power', the nation-state has become subject to transitions brought about by forms of interaction and overlap with the global economy. While the national and the global are not discrete or mutually exclusive conditions, notions of (state) sovereignty and citizenship have been challenged by globalization, generating acute anxieties across the political spectrum.

While raising conditions of possibility for new kinds of democracy and cosmopolitanism, globalization has also, and at the same time, loosened the anchoring effects of territorialized history and identity, linked as they have become to the slow but inexorable erosion of national formations. Audiovisual geographies are a part of this transition, becoming detached, in the

words of David Morley and Kevin Robins, from 'the symbolic spaces of national culture, and realigned on the basis of the more "universal" principles of international consumer culture' (Morley and Robins 1995: 11). Contemporary visual culture is inordinately shaped by global media industries that are organized and that operate along transnational lines. This has created new image markets but it also bears significance for what Morley and Robins call 'imaginary space', the particularized sense of space and time that became subject to gradual but palpable shifts in perception in the last quarter of the twentieth century.

These shifts have been examined by Andreas Huyssen (1995; 2001) in his work on contemporary memory culture. Arguing that space and time are contingent categories subject to historical change, Huyssen explores the proliferation of memory discourses in Europe and the United States since the late 1970s. The emergent interest in memory is, he suggests, part of a powerful desire to 'mark time' in a culture beset by changes within its spatial and temporal imagination. Central to this transformation is the speed and style of high-tech media: from the speed of communication that has developed from satellites, media technology and electronic networks, to the forms of media and digital representation that have been produced in, and as part of, a culture of simulation and instantaneity. Huyssen suggests that: 'the turn towards memory is subliminally energized by the desire to anchor ourselves in a world characterized by an increasing instability of time and the fracturing of lived space' (Huyssen 2001: 57–77). One might say that negotiating a sense of lived time is a dimension of the anxiety of the global that has come to be expressed in cultural terms. Witnessed not least by the profusion of practices figured around memory, memorialization and local heritage, the assertion of time has become a significant means of dealing with the 'quickening pace of material life'.

If the reconfiguration of space and time has been powerfully aided by the speed of high-tech media, leading to particular anxieties about temporality and the nature of place-bound identity, the media sphere has produced parallel anxieties about the form and constitution of reality itself. This has become associated most distinctly with developments in digital technology and the capacity for producing 'virtual' space and reality. Computer networks are, of course, integral to the contemporary information economy, and digitization has enabled a form of global movement and interaction previously unimagined in modern history and experience – from the dematerialization of business sectors like global finance, to revolutionary developments in communication such as the Internet. It is the impact of digital technology on (and as a form of) representational media, however, that has compounded what Lawrence Grossberg calls the 'dissolution of the anchoring effect' in postmodern cultural life (Grossberg 1997: 191–252). Digital technology has raised fundamental questions about the referential status of the visual image. Notions of authenticity and indexicality have been seriously problematized by the possibilities of computer-generated imagery. Concepts of indexical realism that once secured (however naïvely) the truth-status of the photographic and cinematic image, have increasingly given way to a deeper realization of the constructedness of visual discourse and imaged reality.

Robert Burgoyne has set these issues in relation to contemporary Hollywood film. Specifically, he considers the changing status of the documentary image from something principally understood as a trace of the past to 'something available for imaginative and poetic reconstruction through computer alteration' (Burgoyne 2003: 223). Demonstrated by the use and manipulation of archival footage in films such as *Forrest Gump* (1994) and *JFK* (1991), Burgoyne writes: 'With its increasing use of morphing techniques and computer generated visual environments, the cinema would seem to be a medium that now refuses history in the sense of origins, authenticity and documentation' (ibid.). The same might be said of contemporary photojournalism, and other representational modes that lay claim to some kind of visual or epistemic truth. When in 1995 a *Time* magazine cover shot of O. J. Simpson was found to have been digitally altered and Simpson's face darkened, public debate focused not only on the racial implications but, also, on the compromised status and authenticity of the photographic image. Digital technology has been taken up in various ways, and with different discursive stakes. Rarely, however, has the concept of authenticity been untroubled by its creative and often spectacular deployment in the global media sphere. In the 'imaginary space' of contem-

porary global culture (at least as it is experienced in the West), temporal and *referential* moorings have come under new and particular forms of pressure.

Globalization is by no means a new issue. It acquired a conditional specificity in the mid-1990s, however, as debates about neoliberal restructuring were absorbed within public policy, corporate strategy, and the media and information industries. One should not underestimate the degree to which globalization is strategically produced in discursive as well as material terms. It is not simply, as some advocates would have it, the result of progressive modernization, technological determinism, or the inevitable triumph of global free markets. As Saskia Sassen writes, the 'global economy is something that has to be actively implemented, reproduced, serviced and financed. It requires that a vast array of highly specialized functions be carried out, that infrastructures be secured, that legislative environments be made and kept hospitable' (Sassen 2001: 262). Globalization is not a given or universal condition. In economic terms, it has been facilitated by state and corporate initiatives and is characterized by discrepant effects and disjunctive flows. And yet, globalization cannot be reduced to neoliberal or other purely economic definitions. Contemporary globalization has produced *cultural* effects that may certainly relate to the exigencies of capital mobility, but that also manifest themselves in more discreet economies of feeling and experience. John Tomlinson (1999) has described this as the 'mundane experience' of globalization, referring to cultural practices and/or structures of feeling that may be touched or informed by the global but that do not engage with it (politically or experientially) in any direct or obvious sense.

The analysis of visual taste is especially relevant here. If there is a 'growing need for spatial and temporal anchoring in a world of increasing flux in ever denser networks of compressed time and space' (Huyssen 2001: 74), one might ask how a desire for continuity and cultural moorings – a need that Huyssen equates with the resurgence of memory – has been expressed in visual terms. If feelings of time and authenticity have been unsettled, even at some subliminal level, have compensatory strategies come to negotiate or temper these effects? What representational, or nonrepresentational, forms have acquired cachet and significance within or in response to the new image markets of global culture? It is in this context that I wish to situate the popularity and discursive bearing of the black and white image as it emerged in American visual culture during the 1990s.

During the last decade of the twentieth century, the black and white image became a popular style within the taste regimes and visual strategies of American consumer culture. Commercially, monochrome was taken up in global brand campaigns by the likes of Coca-Cola, Apple Computers and Calvin Klein, and became a defining style of consumer art within the image industries that sell posters and prints through high street chains and home-improvement wholesalers. In the media sphere, black and white developed a new kudos within the photojournalistic strategies of news weeklies such as *Time* and *Newsweek*, it appeared in Hollywood features ranging from *Schindler's List* (1993) to *Celebrity* (1998), and it became the visual linchpin of rerun cable stations such as American Movie Classics. In significant ways, the use and profile of black and white developed in a specific conjuncture that saw the increased commodification of memory in cultural life, and where new digital technologies and printing processes had, by the early 1990s, saturated the visual market-place with colour imagery. I have argued elsewhere that black and white assumed a heightened significance in this period, figured as an aesthetic 'nostalgia mode' that could punctuate the norms of visual reception (Grainge 2002).

Black and white is a visual code with multiple meanings. It can be used to suggest intellectual abstraction, artistic integrity, documentary realism, archival evidence, fashion chic and film classicism depending on the nature of a text's production and reception. However, there are perhaps two dominant connotations or meta-abstractions that have become central to the visual effect and signifying character of 'black and whiteness' in contemporary visual culture. These underpin and constitute the specific nature of black and white 'feeling'. In different ways, I would argue that black and white has become associated with the very categories that have been unsettled by the global media sphere: authenticity and time.

251

Discursive manifestations of these two themes have marked the entire history of the (black and white) photographic image. Within both art and documentary photography, a discourse of authenticity has long framed and maintained the power of the camera image to capture lived reality transparently (Orvell 1989). At the beginning of the twentieth century, the photographic image was conceived as the authentic rendering of a more intense perceptual reality, and set the terms for black and white's enduring sense of aesthetic veracity. This was accentuated by Hollywood's use of colour during much of the studio era. Until television networks normalized colour within viewing sensibilities in the 1960s, colour was largely associated with genres of spectacle and show, compared with black and white that remained linked to ideologies of realism and cultural verisimilitude (Neale 1985). Despite the dramatic decline in the use of black and white from the mid-1960s, monochrome has maintained a purposeful and mutually defining relationship with colour in conventions of use. Connotations of black and white 'authenticity' remain in much photographic theory and practice. Roland Barthes, for example, suggests that colour is a 'coating applied later on to the original truth of black and white' (Barthes 1993: 81). Monochrome is frequently defined as a quintessential aesthetic of the authentic. This cannot be divorced, however, from black and white's deepening association with time and the past.

When colour became the visual norm, black and white was progressively distinguished as a style from a different era. Since the 1970s, black and white has developed a nostalgic aura; it has come to function and be sold as an aesthetic of memory. Whether in movies such as *The Last Picture Show* (1971) and *Manhattan* (1979), or in the café-bar prints of photographic work by Alfred Stieglitz, Richard Avedon, Edward Curtis or Dorothea Lange, the black and white image has become a mode of stylized temporality.[1] The question here is not whether black and white is visually *more* 'authentic' or 'temporal' than colour. This would be misleading. Variations of shade, tone and signifying context can influence the function and meaning of both. Black and white has many registers of shade, light and texture (sepia, chiaroscuro, grainy, glossy), just as there is a spectrum of tone, clarity and fading in colour imagery and film stock. Super-8 footage in colour may be loaded with significations of memory, just as black and white fashion photography can signify contemporary glamour. The point is not the substantive or inherent qualities of any specific (mono)chromatic form. Rather, it is the means by which visual imagery, in this case black and white, has become more readily associated with particular temporal and authenticity *effects*. I want to consider these effects now in a particular example that relates black and white to anxieties about cultural anchoring in the global media sphere.

David Harvey suggests that images of permanence in political and commercial culture represent 'the fleeting, superficial, and illusory means whereby an individualistic society of transients sets forth its nostalgia for common values' (Harvey 1990: 288). The popularity of black and white within international image markets may be one useful point of investigation. The global market for prints and pictures emerged in the mid-1980s through international poster industries growing out of New York, London and Paris. Recognizing the potential market for middle-brow consumer art, publishers and home-improvement superstores such as IKEA (which commands 12 per cent of the world market in print sales with 8 to 10 million annually), developed catalogues of paintings and photographs that inspired a burgeoning market in high quality prints. While posters became affordable decorations in the 1960s, inspired not least by the changing relationship and accord between art and commerce (embodied in the work of Roy Lichtenstein and Andy Warhol), they became an up-market mass-produced commodity in the 1980s. Art images not only made profit in themselves, they helped stoke the more lucrative market in picture frames. The black and white photograph became one of several stylistic alternatives in this developing image field.

The popularity of black and white imagery in the 1980s and 1990s gave particular photographs iconic weight. Peter Hamilton estimates that Robert Doisneau's image of two lovers kissing in a scene of Paris springtime romance, 'Le Basier de l'hôtel de Ville', sold over a million copies between 1985 and 1995 (Hamilton 1997: 75–150). Hamilton relates the success of this image within France to nostalgia for a sense of stable nationhood challenged by urban decay,

social disorder and pressing questions of immigration. What remains unexplained, however, is the broader international appeal of Doisneau's image. Hamilton does not take into account the possibility that symbolic images/spaces of national culture have been 'realigned on the basis of the more "universal" principles of international consumer culture'. Doisneau's work is sold in global image markets and may appeal to kinds of nostalgia that are not specifically national in kind. 'Le Baiser de l'hôtel de Ville' may well construct notions of Frenchness (as did the original image when published in *Life* magazine in 1950), but it might also figure 'universal' tropes of romance or satisfy general investments in the aura of the past. Simply put, nostalgic desires must be understood in relation to international cultural dynamics of production and consumption.

Within the visual markets of Europe and North America, monochrome has become a fashionable style in the aesthetic regimes of middlebrow taste, attaching itself to particular representational collections within the poster and print industry. Together with natural landscapes and celebrity portraiture, city images – principally those of New York and Paris – have become dominating forms of wall art. The popularity of city images is linked to aesthetic conventions of art and place. The sheer volume of New York images preserved in city museums and photographic archives has been expedient to commercial picture agencies, servicing the impulse to repackage urban imagery as pictorial art. However, the currency of New York is also significantly linked to the historical status of the city as the centre of international modernism, replacing that of Paris in the late 1940s and early 1950s. Discussing ideologies of modernist subjectivity and urban darkness expressed by New York artists and photographers in the early postwar period, James Naremore writes, 'Black and white cityscapes of the Manhattan skyline became virtually synonymous with the artistic sensibility, and they began to appear with increasing regularity throughout visual culture – in the younger generation of street photographers; in films such as *The Naked City*, *The Windows* and *The Detective Story*; and in the graphic, monochromatic effects of nonrepresentational painting' (Naremore 1998: 172). Interesting here is the change in visual signification that black and white cityscapes have accrued. No longer do they signify urban darkness but rather a form of city romance and urban memory that have less connection with *The Naked City* and more with *Manhattan*; they encapsulate Woody Allen's nostalgic observation that 'no matter what the season was, this was still a town that existed in black and white and pulsated to the great tunes of George Gershwin'. In a period where metropolitan centres such as New York, Paris, and London are being reconstituted as global cities, nostalgia has become a significant mode in the popular visualization of urban life and culture.

It is worth returning at this point to Peter Hamilton's suggestion that Doisneau's early postwar photography has become linked in contemporary France with a desire for stable nationhood challenged by urban decay, disorder and immigration. While somewhat overdetermined as a critical and national reading, there is a suggestion here of cultural anxiety that may be linked more broadly to transitions in the global economy and their particular impact on city life and narratives of nation. Of course, New York images are popular first and foremost because they are readily figured as tasteful wall art. The photographs of Andreas Feininger and Lewis Hine (together with a host of anonymously ascribed pictures) have assumed the status of lifestyle choice in the image catalogues of contemporary publishers. And yet, if posters offer a guide to popular tastes and aspirations, it is necessary to ask what images of New York may reveal in social and cultural terms. What aspirations or, adversely, what anxieties do black and white city prints suggest?

A popular set of nostalgic images, sold internationally by IKEA at the end of the 1990s, showed New York labourers waving merrily from the precarious heights of unfinished skyscrapers; construction workers from the 1930s were pictured eating lunch, taking naps and conducting theatrical tea parties on inch-thin girders a dizzying distance from streetlife below. For sheer iconic value, these replaced Doisneau's Parisian lovers within mainstream appeal. Representing a form of 'nostalgia without memory' – Arjun Appadurai's (1990: 3) term for nostalgia that is plundered from the archive and marketed for mass consumption – the images helped 'mark time' around particular visions of New York City. Much like Doisneau's photography of Paris, tasteful wall art

in the 1990s was frequently cast in terms of metropolitan memory and sensate images of urban modernity. The taste for black and white, shaped by leading picture industries based in first-tier global cities, relied on the nostalgic appeal of urban scenes in periods and eras *before* the emergence of global/city culture. In certain terms, this helped generate a particular foreclosure of contemporary urban reality, a reality indelibly linked, according to Saskia Sassen, to larger global processes.

In her theorization of the global city, Sassen suggests that metropolitan centres like New York, London, and Paris demonstrate how 'a multiplicity of globalization processes assume concrete, localized forms' (Sassen 2000: 91). This includes the international reconstitution of capital in power centres dominated by service-based economies and finance industries. Just as significantly, however, global cities include a labour market of low-income workers increasingly made up of immigrants and women. For Sassen, the growth in demand for low-wage workers in global cities, matched with a simultaneous explosion of wealth and power, has intensified the degree of socio-economic polarization, generating a 'new dynamics of inequality' that has come to inflect the entire social geography of city life and its components of political entitlement and cultural consumption. While cities such as New York have always been marked by inequality, the contemporary scale and force of the global economy is specific, powerfully shaped by transnational movements of capital and labour unaligned with particular stakes in national borders or communities.[2]

All of this may seem a long way from the international market for black and white images. However, if media images are becoming integral to the constitution of imagined space, the nostalgia for 'vintage New York' is perhaps indicative of attempts within dominant culture to stabilize and aestheticize moorings through the patterning of taste. In a period where transnational political and economic restructuring is beginning to challenge Western ideologies of history, modernity and nation – and for which cities like New York have been figured discursively as both crucible and totem – monochrome is an aesthetic that marks time and slows pace; it is evocative of periods and eras before the vicissitudes of the contemporary global moment. A black and white 'New York' calendar for 2002 – produced in France, printed in Belgium, and sold in Europe, Canada and the United States – declared: 'Few other city names conjure up such a wealth of images as the world-renowned New York . . . the images portrayed here provide a selection of remarkable and nostalgic views of some of the city's best-known icons.' While produced in the global media sphere, black and white images invariably sell an idea of memory and continuity. In this case, a nostalgia for common values is vested in a projection of metropolitan life and community infused with vibrancy and grandeur: the jovial games of sky-rise construction workers, the majesty of Brooklyn Bridge and the Flatiron Building, the street bustle of Fifth Avenue and Times Square. Nostalgia is geared towards national visions of city building and identity in a time when such dynamics have become subject to resolutely transnational cultural and capital forms.

If, at some level, New York nostalgia can be read as a synecdoche for anxieties about global/city culture – about temporal anchoring in national space – it also responds visually to concerns about authenticity. If anything revealed the place and location of New York in the dynamics of contemporary globalization, it was the September 11th attack on the World Trade Center. Amidst the physical and psychological damage of the attack grew a resiliently local and sympathetically global identification with New York in the present and past. Black and white images of the city took on a new discursive inflection. Not only did they satisfy a widespread cultural nostalgia for the city's iconic heritage, they also helped ground a sense of reality unhinged by the collapse of the Twin Towers. The authenticity effects of black and white helped counter the gruesome and profoundly surreal image of destruction that was likened in the media to the special effects of a disaster movie. Senior writer for *Time*, Lance Morrow, provides a compelling example of this in his coda to the magazine's September 11th special issue.

This was terrorism brought to near perfection as a dramatic form. Never has the evil business had such production values. Normally, the audience sees only the smoking aftermath – the

blown-up embassy, the ruined barracks, the ship with a blackened hole in the waterline. This time the first plane striking the tower acted as a shill. It alerted the media, brought cameras to the scene so that they might set up to record the vivid surreal bloom of the second strike ('Am I seeing this?') and then – could they be such engineering geniuses, so deft at demolition? – the catastrophic collapse of the two towers, one after the other, and a sequence of panic in the streets that might have been shot for a remake of *The War of the Worlds* or for *Independence Day*. Evil possesses an instinct for theater, which is why, in an era of gaudy and gifted media, evil may vastly magnify its damage by the power of horrific images. (Morrow 2001: 49)

Implicit in this commentary is the power of digital imaging. From the spectacle of devastation created in *Independence Day* (1996), where skyscrapers are destroyed by hostile alien others, to expressions of perceptual doubt – 'am I seeing this?' – Morrow's critique of image culture is significantly addressed to the 'gaudy and gifted' *digital effects* of the new media terrain and its impact on visual sensibility and 'theater'.

According to Andrew Darley, digital technology has become associated with a new regime of spectacle. Crossing cultural genres such as the Hollywood blockbuster, computer animation, music video, advertising, simulation rides and computer games, Darley suggests that, in aesthetic terms, digital technology has led to a particular foregrounding of appearance, form and sensation; it represents 'a shift in sensibility towards far more involvement with surface appearances, composition and artifice' (Darley 2000: 4). The black and white image is part of this culture; it is subject to computer morphing and visual deployment within digitized cultural genres (consider, once again, the visual manipulation of archival footage in *Forrest Gump*). And yet, the spectacle of digital culture is overwhelmingly associated with colour (Grainge 2003). Black and white is often deployed as an alternative expression of depth and authenticity. It is perhaps for this reason that monochrome images of New York acquired particular currency after 9/11.[3] In visual terms, they helped ground city icons with a referential permanence that countered the spectacle of profound destruction – a form of devastation that was all too real but had the digitized feel of Hollywood simulation.

In the same *Time* issue as Lance Morrow, Nancy Gibbs concluded her companion essay with a description of Czech tourists buying postcards of the World Trade Center, souvenirs of a prelapsarian world. Gibbs wrote: 'The attacks will become a defining reference point for our culture and imagination, a question of before and after, safe and scarred' (Gibbs 2001: 48). If this describes a watershed within and also beyond the imagination of the United States, New York nostalgia has acquired an enduring poignancy. Black and white images of the city have been inscribed with gravity, as well as memory, in the form and discourse of contemporary visual culture.

In the product catalogues of international publishers such as Fotofolio, Pomegranate, Graphique de France, Nouvelle Images and the Art Group, black and white is one of many stylistic categories of consumer art and wall decoration. It exists between themed collections of prints such as 'abstract', 'impressionist', 'classical', 'landscapes', 'waterviews', and 'Winnie the Pooh'. Black and white is a matter of taste. And yet, the profusion of black and white prints in the image markets of Europe and North America does raise questions about the historically determined sensibilities that have figured such images *as* tasteful. I have suggested that the resurgence of black and white is linked to the discursive valuation of memory and time in contemporary culture. It is also tied to the saturation of colour and to uncertainties about the referential status of the visual image, instilled by the impact of digital technology and printing processes.

Rather than examine specific representational effects generated by digital technology and the global media sphere, I have briefly explored a visual style that reacts to, and seeks to efface, its relation to these technological and material conditions. Black and white is a nonrepresentational effect with an aura (and artistry) of pastness. As such, it can appear to transcend its production and circulation in contemporary image culture. If black and white can marshal particular temporal and authenticity effects, these have acquired significance in the figuration

of particular representational subjects. New York is a pointed example, especially in the after-math of September 11th. As a way of visually anchoring forms of city identity and nationalism – and potentially disarticulating social and political transitions that have come to effect these formations of identity – black and white nostalgia has been taken up as a visual discourse in the negotiation of change. If monochrome has any relation to the so-called 'anxieties of the global', it is in the capacity to mark time, and suggest continuity, in a period where transna-tional flows of people, capital, technology and politics are exerting pressure on traditional ideo-logies of reality and belonging.

Notes

1. Black and white has accrued a certain 'timeless' quality in contemporary visual culture; as an aesthetic of memory, monochrome images frequently appear *of* time but not always spe-cifically *in* time. If the content of a black and white image is often secondary to questions of colour and tone, monochrome has become associated with visual classicism and the gener-alized aura of the past (see Grainge 2002: 98–124).
2. For Sassen, this has not only engendered massive distortions in growth and profit-making within urban economies, it has generated the potential for new politico-economic align-ments. Specifically, it has raised strategic possibilities among the concentrated diversity of migrant workers and immigrant communities making claims on the city (and their economic and social position within it) that move outside and beyond traditional narratives of nation. She writes, 'insofar as the sense of membership of these communities is not subsumed, it may well signal the possibility of a transnational politics centred in concrete localities' (Sassen 2000: 91).
3. Indicative of this trend was the trade in black and white city images by New York City street vendors after 9/11. Black and white postcards of New York significantly outnumbered colour images in key tourist zones. This included familiar 'vintage' images of buildings, bridges and other symbols, but also contemporary images including the searing beams of light that were projected upwards as a form of spectral memory in the weeks immediately following the collapse of the Twin Towers.

Remembering Vietnam in the 1980s

White Skin, White Masks: Vietnam War Films and the Racialized Gaze

LEILANI NISHIME

While many critics point to a backlash against women's liberation and the counter-culture evident in Vietnam War films, most neglect an equally important aspect of the 1960s' revolution, changes in immigration laws. The increasing visibility of the Civil Rights movement pressured Congress to pass the Immigration Act of 1965, abolishing national-origins quotas and equalizing the numbers of immigrants eligible to settle in the US from the Western and Eastern Hemisphere.[1] When *Rambo*, the most successful Vietnam War film ever, reached the screens in 1985, the impact of the 1965 Immigration Act was inescapable. In 1970 the census counted 1.5 million Asians in America, and by 1980 that number had more than doubled to 3.7 million. By the end of the 1980s that number would double again to 7.3 million. At this point, Asians made up 35 per cent of all immigration to the US. Like the last large wave of Asian immigration to America almost 100 years earlier, the volume of new Asian immigration prompted fears about a 'yellow invasion'. With the majority of Asians settling on the West Coast, Hollywood had to take notice.

It seems to me no accident that the renewed popularity of Vietnam War films coincided with the explosion of the Asian population in the US as well as the social conservatism that marked the Reagan Era.[2] Although Vietnam War films of the time are ostensibly about the events of the 1960s and early 1970s, many critics have pointed out how the films actually reflect the concerns and desires of the 1980s, a particularly volatile time in relationships between Asians, Asian-Americans, and mainstream white America. Not only did major shifts in the make up of Asian populations in the US occur, but Japan's boom time economy and the decline of industry in the US also spawned both envy and anger (the most famous example being the 1982 beating to death of Vincent Chin in Detroit by out-of-work auto workers). This essay will argue that the trauma suffered by soldiers in Vietnam War films of the 1980s makes manifest contemporary fears and anxieties about the changing face of race in America.

Out of the myriad of Vietnam War movies released in the 1980s, one particular scene in that most typical of action adventure movies, *Rambo: First Blood, Part II*, remains with me. Rambo climbs to the top of a hill to be taken back to base but is abandoned by an Army helicopter. The camera pans away, and we see him surrounded by a sea of encroaching, threatening Vietnamese soldiers. This scene powerfully dramatizes a crucial moment in the modern construction of white masculinity. Despite earlier examples in the film of Rambo's almost magical ability to escape harm, this time he cannot slip away unseen. Now he is all too visible and vulnerable as the lone white man standing on the open hilltop against the backdrop of an endless stream of identical Asian troops.

This scene reveals the real terror and threat posed by the Asian characters: they make Rambo white – white as a significant, *visibly marked* position. In this scene whiteness is not the absence of race but is recognizable *as* a race, and, within the narrative of the movie, this recognition

exposes him to danger. The fear that drives the narrative is not merely Rambo's sudden visibility but what it represents, the decentring of whiteness and the threat to whiteness as an assumed norm.

At the centre of Vietnam War films is the struggle to control meaning. The battlefield is the body, and the ultimate prize is control of the gaze.[3] While criticism about 'the gaze' predominantly centres upon gender, the Vietnam War film genre illustrates how race can intervene in and complicate feminist film-theory. In *Looking for the Other* Anne Kaplan asks the question, 'What happens when the look is returned – when black peoples own the look and startle whites into knowledge of their own whiteness' (Kaplan 1997: 4). While Kaplan concentrates on the contributions of non-white filmmakers, my interest here is in the reaction of mainstream Hollywood film to the reversal of the gaze. The ability of the Other to return and command the gaze disrupts normalized understandings of race. This scene from *Rambo* plays out the darkest anxieties surrounding a loss of the gaze to the Other. In these films the site of power shifts temporarily from the traditional white mastery of the gaze to a gaze controlled by the Asian Other. Thus, racial anxieties are framed within relations of looking, relations that are played out on the bodies constantly displayed in the Vietnam War and action film genres.

Rambo is particularly well suited to this study since it capitalizes on two of the most popular film genres of the 1980s, Vietnam War and action films. The action film, with its focus on the spectacular display of the hero's body, is adept at addressing the issues that haunt Vietnam War films. The twin concerns of race and gender lie at the heart of these films, and we understand both cultural constructions as functions of the body. While we may talk about race and gender as socially constructed categories, we, as a culture, still read bodies as 'naturally' gendered and racialized – we believe that the body gives us biological and material evidence that both race and gender exist in some objective way.[4] While white males have long occupied a normative position, women and people of colour are marked as female and racialized. Nowhere is that mark more visible and visceral than on the body. One result of this is that women and people of colour have always been more thoroughly *embodied* than white men. Action films promise a body that we can read and fix in familiar gender and racial roles. However, that intimate focus also threatens to reveal the ideological boundaries that allow race and gender to become visible.

The concern of this essay is the ways in which the disruption caused by the Other's gaze is contained and trained through the bodies of the film's stars as represented on screen. As a more detailed look at the movie will demonstrate, the racial 'play' set in motion by an intense focus on Rambo's body threatens to reveal the contingent nature of race. Yet the discovery of race as a construct provokes fear and loathing in the film, rather than the celebration and valorization found in most race criticism. Each time race is destabilized in the movie, it is followed by a mad scramble to reinscribe race in terms of existing power relations. Thus, the racial subtext of the film is not just Rambo's struggle to recentre whiteness and become 'raceless' once more. The subtext also reifies the racial and gender identity of the Asian characters, and forecloses on the Other's ability to be a viewing subject. The film illustrates how Vietnam War films' twin projects of developing and consolidating an image of America as white and male depend upon the strict enforcement of gender and racial categories.

While much critical attention has been given to the role played by Vietnam War films in assuaging fears about the changing role of women in America, discussions of race have been almost entirely absent from the analysis of the genre. Some excellent analyses, including work by Susan Jeffords (1989) and Tania Modleski (1991), convincingly show the importance of gender in understanding the psychological work of the genre. However, their almost exclusive emphasis on gender ignores the equally important category of race. Jeffords claims, 'The unspoken desire of Vietnam representation, and its *primary* cultural function, is to restage "the Nam" (*read: gender*) in America' (Jeffords 1989: 52, my emphasis). Shifting the focus to include race as well as gender makes clear the inextricable connections between the two.

As Jeffords shows, and as many other critics of Vietnam War narratives have noted, Vietnam War films function as a reflection and a revision of America's participation in the Vietnam War. This focus on the meaning of the war to America and Americans works to exclude almost com-

pletely the Vietnamese people (Studlar and Dresser 1990; Klein 1990). The Vietnamese usually appear as dots in the landscape or as unnamed victims, soldiers, or prostitutes. We view them in crowd scenes and in long shots, and they almost never rate a close-up. They barely seem to exist in their own country.

Perhaps the most egregious example of the persistent focus on the American experience in Vietnam is the Brian De Palma movie *Casualties of War*. The movie follows a small group of soldiers who kidnap a Vietnamese girl and repeatedly rape her for several days. However, the true significance of the film is not the young girl's suffering, but the loss of innocence of the film's hero Ericson, a new recruit played by Michael J. Fox. The Vietnamese girl, whose name we never learn, may be the story's catalyst, but the attention never wavers from the movie's lead actor. Since we only see her in the context of her kidnapping, and because she cannot speak English and is not subtitled, she never emerges as a character.

However, her victimization is made manifest in the fully developed character of Ericson, and the last third of the film deals exclusively with his guilt over his inability to save the girl. In the critical rape scene the camera cuts away from the assault on the Vietnamese girl for a close-up on Ericson's anguished face. When the other soldiers finally stab the girl she falls from a bridge screaming, but her cries are drowned out by the sympathetic cries of Ericson, and, significantly it is his voice, not hers, that we hear last. Once again the camera cuts away just before she hits the ground to focus on the prone and injured Ericson and the 'real' death of his ideals. In both these scenes, we are made to understand that the girl's rape and death are merely a metaphor for the authentic site of suffering, the American soldier. As Charlie Sheen's character declares at the end of *Platoon*, 'We fought the enemy, and the enemy was us.' To say that the real enemy and victim of Vietnam were 'us', allows these films to ignore the cost of the war to the Vietnamese people, and to leave unprobed questions about racism and US colonialism in Southeast Asia. Ultimately, the Vietnamese are erased from their own war.

While it is true that Vietnam War films invariably focus on white Americans in Vietnam, criticism about the genre tends to replicate this same absence. Asian characters and bodies seem to vaporize, leaving almost no trace in the commentary on the genre. In the rest of this essay I seek to reinsert the Vietnamese into Vietnam War films as well as Vietnam War film criticism. But rather than try to locate an 'authentic' Vietnamese voice in these films and, by doing so, imitate the colonialist gesture of speaking for those who are silenced, I will look at both the presence and absence of Asian bodies in the films. How are the Caucasian bodies of the film's stars constructed in relation to those Asian bodies? And what sort of agency is given to the alternately ghostly, grotesque, pathetic and threatening figure of the Vietnamese?

Rambo: First Blood, Part II made an enormous splash when it opened in 1985, surpassing even the first film in terms of box office receipts and water-cooler conversation. With its far less ambiguous politics, the sequel abandoned *First Blood*'s battered anti-hero in favour of the engorged action hero, and consequently, the name 'Rambo' entered the popular lexicon.[5] In the film, Rambo revisits Vietnam to rescue POWs still being held years after the end of the war. Rambo attempts to rewrite the story of Vietnam in more comprehensible terms, asking 'Do we get to win this time?'

Unlike World War 2, America's last great cinematic war, the Vietnam War was a guerilla war, and its visual language gives us a very different image of military conflict. The sense of an invisible enemy who constantly watches is almost an obsession in Vietnam War films. For example, the climax of *Full Metal Jacket* involves a sniper attack on the film's heroes who must constantly expose themselves to fire as they run from one pile of rubble to the next. The sniper, in one of the buildings, has a bird's eye view of the soldiers and proceeds to pick them off one by one. In *Platoon*, a fear-crazed soldier begins to shoot wildly into the jungle, sure that the Vietminh surround the small group of soldiers, observing their every move. Finally in *Aliens*, (which writer/director James Cameron has called his Vietnam War film) the action centres upon the siege of a small band of humans by uncountable alien monsters. As one marine says, 'My God! They're everywhere.' These scenes metaphorize the seemingly inescapable fear of being surrounded, invaded and observed by the Other.

The first scene immediately after Rambo's discovery on the hilltop reveals a figure dressed only in a loincloth and dripping with mud, hanging from a crossbar in a pose that recalls a crucifixion. As he twists to and fro, he is completely exposed to the controlling eyes of his future torturers as well as the audience members. Since he is suspended above the fully-clothed Vietnamese soldiers, the emphasis is on his body and flesh and the absolute difference between him and those who surround him. Not only has he failed and been captured, he now hangs in public display for the dominant and punitive gaze of his Asian captors. While his earlier display for the camera provided elements of performance, this display, which is integrated into the scene, is clearly meant to invoke a more sadistic gaze.[6] This scene is quickly followed by the lengthy torture scene, where Rambo, now stripped to the waist, writhes and moans while strapped upright with arms apart – the better to reveal his shaven and oiled chest.[7]

This visibility is a sign of the decentring of whiteness, and Rambo must pay the price for racializing whiteness and making it visible. At this point, the intersections of race and gender become more evident. The torture scenes emphasize, and narratively act out, Rambo's feminized position as an object of the gaze. His essentially feminine position, his 'to-be-looked-at-ness' in Mulvey's appropriately awkward phrasing, comes as a direct result of his visibility as a white man. It makes sense, then, that the movie would move from his sudden visibility (the scene on the hill), to his place as the object of a sadistic gaze (the crucifixion scene).

In the scenes that follow, Rambo is bound spread-eagled, half-naked, and moaning in what is almost a parody of pornographic rape fantasies. As the captain escalates Rambo's torture, he tells him, 'You may scream, there is no shame in that.' But, of course, that is exactly why Rambo resists screaming so long, because in this hypermasculine world screaming is shameful, 'weak', and, most importantly, feminine.[8] This is not to say that Rambo occupies a fully feminized position, since his overtly and overly masculine body also occupies the screen, yet this display of masculinity is undercut by his assumption of the female position in the generically codified torture/rape scene.

As if we need further evidence of the debilitating effects of visibility, the film cuts quickly between Rambo and the prisoners of war, providing the audience a vision of Rambo's future. At the very moment Rambo gives in to his captor and screams we cut away from his face as if we cannot witness his moment of weakness. Instead we are shown a row of white American POWs. The prisoners wince at the sound of his screams, perhaps recalling their own similar torture, emphasizing an identification between Rambo and the prisoners. The frail, pale, and emaciated prisoners provide a stark contrast to the bulging body of Rambo, and amply demonstrate the results of a life lived among Asians. The prisoners' bodies physically represent their loss of power. Their acquiescence to their captors shows the audience the wrong response to their position as subjects of the gaze, and it is up to Rambo to complete the cycle of the rape-revenge genre.

What is key to note in both of these torture scenes is the sheer physicality of Rambo/Stallone. He has become fully embodied and is unable to transcend or control the meaning of that body. As Kaja Silverman has pointed out in her work on male masochism, the figure of the tortured male allows us to see what is normally disavowed, thus disrupting the social order.[9] In this instance, the ideological assumption of whiteness as natural and the violence of racial hierarchies are laid bare. Rambo's torture acts out and emphasizes his inability to escape the limits of his own body. Like many marginalized people, Rambo can no longer act as the place marker for 'just human'. Instead he is *white* human attached to a specific, racialized body.

In Vietnam War movies, the only character who can and will eventually return to the idyllic state of invisible whiteness is the character who resists being viewed by the Asian characters. One of the most explicit examples of this lesson is in *Deer Hunter*'s almost unwatchable Russian Roulette scene. De Niro's character is the only one of the three male leads who confronts his captors when forced into the game of Russian Roulette. The emphasis here is on De Niro's point of view and his 'manly' ability to return his captor's gaze. The other two men cry and look away, unable to withstand the taunting by the Vietnamese soldiers. They are doomed by the open acknowledgement of their vulnerability and of their position as an object of the gaze. In the

end, only De Niro is able to return to white American society, while the 'weakest' of the three remains in Vietnam – suicidal, demoralized and doomed to live amongst the Vietnamese. The audience, safe in the knowledge that the hero will not be killed midway through the movie, can ally themselves with the De Niro character. They stayed and suffered through this long, drawn-out sequence, and, unlike the other characters, they refused to turn away. As their reward, they can travel back with De Niro to a place where his whiteness is the norm, saved by his masculinity and his resistance to feminized gender roles.

In the end, Rambo manages to save his gaze and avert even a metaphoric rape. His torturers, in a fit of Freudian overstatement, pull out Rambo's own oversized knife, and, holding it just below his eye, threaten to cut him. Just as Rambo's hard body seems to resist penetration, the flesh of his cheek withstands the hot knife, and he receives a burn mark rather than a breach of his flesh. Like De Niro's character in *The Deer Hunter*, Rambo resists penetration and 'feminization'. But, in the manner of the rape-revenge narrative, his long torture sequence gives narrative and moral force to the annihilation of the Vietnamese soldiers which follows.

Carol Clover theorizes that the rape-revenge film allows for a 'calculated, lengthy, and violent revenge of the sort that would do Rambo proud' (Clover 1992: 159). Since his loss of masculinity comes as a result of his association with the Asian characters, Rambo's masculinity must be reclaimed through a re-formation and re-formulation of those relationships into more conventional hierarchical patterns. To 'become a man', Rambo must find a way to reposition himself, *vis-à-vis* the Asians who surround him, and reassert the centrality and normative power of whiteness; thus mastering the discourse of race and ridding himself of the mark of whiteness. Rambo's relationship to the Vietnamese woman, Bao Co, provides the narrative map upon which we can chart the recovery of his masculinity and an unmarked racial position, as well as the disappearance of his racially marked and limited body.

When the half-Vietnamese character of Bao Co (Julia Nixon) is first introduced, the audience, like Rambo, can only catch fleeting glimpses of her through the trees. Her androgynous army fatigues and wide straw hat make it impossible to view her body clearly, and we cannot tell if she is male or female, friend or foe. Unlike Rambo, she can enter villages and even the prison compound openly, unnoticed. Her identity, like her body, is elusive and fluid. She can speak both Vietnamese and English and is strong, independent, and even macho. In her early scenes, it is difficult to know how we are to read her racially. We are immediately shown her familiarity with, and acceptance among other Vietnamese, yet her green eyes, fluent English and stories of her father's involvement with the CIA, contribute to the perception of a racial as well as a gender ambiguity. In addition, our first introduction to Co does not conform to the conventions of the Vietnam film genre. Neither the typical cowering victim nor an aggressive prostitute, Co is clearly the master of her surroundings. The failure to place Co clearly within the pantheon of Vietnam War female characters further confuses our ability to read both her character and her race.

Even more fascinating in this testosterone-driven genre, Co starts with more knowledge and more firepower than Rambo. When he first encounters Co, Rambo is lost and without most of his weapons or food, forcing him to depend upon her for guidance and aid. Since Rambo is figuratively blind and speechless, she must show him the way and speak for him. Like the post-WW2 cinematic heroines discussed by Kaja Silverman, the trauma of the Vietnam War opens up a more flexible and powerful subject position for Co. As Silverman notes, in order to 'shore up the ruins of masculinity' the female characters in the film assume 'agency which is the usual attribute of the male character, thereby further undermining sexual difference' (Silverman 1992: 52). In terms of race, Rambo's vulnerability as a white man in an Asian country displaces him from the centre of the action and shifts the racial and cultural norms. Thus, the sharp divisions and hierarchy of race are imperilled.

This destabilization of racial and gender differences creates a feeling of unease in the film. In two parallel scenes this anxiety over the collapse of hierarchical differences finds its expression in the tension between the narrative and the camera. In a scene early on in the film, Rambo views Vietnamese soldiers through the floorboards as he hides underneath a hut. At this point,

before he is exposed on the hilltop, Rambo is still hidden and invisible. This same scene reoccurs midway through the film as Rambo is being tortured. Only this time it is Co who peers through the floorboards, invisible to the soldiers. Since, as I argued earlier, the torture scene marks the most heightened moment of gender and racial instability in terms of Rambo's position as the white male hero, this scene throws into confusion the familiar gendered and racialized conventions of who looks and who is looked at. However, just as the filmmakers back away from a more brutal violation of Rambo by merely slashing his cheek rather than piercing his eye, they also pull back from a full assertion of Co's masterful gaze. We first see Co looking through the floorboards and then we get a middle shot of Rambo being tortured. Unlike the similar, early scene where Rambo spies on the soldiers who are framed by the floorboards exactly *as Rambo would see it*, this time we see Rambo as another person in the room would see him. Although this shot may be voyeuristic, it does not replicate Co's point of view. As if to emphasize this distinction, we then have a reverse shot of Co's eye through the floorboards, reasserting her position as the object of the camera's gaze even as she gazes upon Rambo.

The points of divergence between these two similar scenes undermine their subversive potential and, instead, act to reinscribe racial difference. When Rambo views the Vietnamese soldiers we never break out of our identification with his point of view. The floorboards reinforce the distance between us/Rambo and the Other(s). In direct contrast, in Co's scene the camera moves between the space beneath the building and the inside of the room. Like the earlier scene, we are occupying the same space as Rambo while Co is being figured as the Other who is separated from the viewer by the floorboards. These two scenes recapitulate the already overdetermined relationship of self and Other, of seeing and being seen. By refusing to align the camera's vision with Co's point of view, the camera angles reiterate the film's narrative rejection of any view but that of white America, as represented by Rambo. Thus the implications of Rambo's position as viewed object in relation to Co's position of subject/viewer is softened by the camera's refusal to align itself with the Other.

The camera work tells us visually what we will soon learn narratively. As Rambo's power and identity become ever more imperilled, Co's role becomes more narrowly defined. Eventually, the inexorable pull of genre works to assign a clear position for Co so that the film can move from the unease of a female character in active resistance to her 'proper' role, to the cinematic pleasure of narrative closure.[10] This closure depends upon a reification of gender and racial roles.

Through a series of narrative twists Co eventually abandons her army fatigues and unstyled hair for make-up. By the time Rambo escapes from his torturers, she is wearing a tight fitting *cheong sam*, and a single long braid, both fetishized signs of Asianness. She is reduced to a simple, single identity so that all other visual clues fall away and the only salient features are those that reinforce an Asian, female subject position. Then, in true Madame Butterfly fashion, she begs Rambo to take her back to America, they kiss, and then she is immediately killed.[11] Not surprisingly, one of her racial markers is, in part, responsible for her death. Her costume change from military fatigues to a bright red *cheong sam* makes her an easy target in the jungle, and she is shot trying to escape with Rambo. Despite an exploration of ambiguity and the narrative of loss, Co ends up dressed in her Hollywood-ethnic dress, playing out the most stereotypical of colonialist narratives.

In a move familiar to readers of feminist film-theory, Rambo projects his lack of power and his inability to master either the language of masculinity or race onto Co. Rambo's lack, which is now embodied by Co, serves as a reminder of the threat of castration. As a result, she must be fetishized in order to reassure the viewer and disavow that threat. Feminist film-theory discussions of this process of fetishization have focused on the place of women in this scenario, but in the case of racial fetishization the focus is on racial as well as sexual difference. The possibility that race is culturally constructed and that it 'speaks the subject' is denied through the fetishization of the signs of racial difference. Rambo's body is the normative centre once again, and it is Co's body that has a race and a gender. The fetishization of her body points out the differences that 'count'. Racial and gender roles have been neatly attached to a body and effec-

tively contained and controlled, so Co must die since she is no longer narratively useful.[12]

Like the dead Vietnamese women who litter other Vietnam War films such as *Full Metal Jacket* and *Casualties of War*, Co's death marks the final turning point of the film. We now enter the last phase of Rambo's racial transformations. At the same time that Co becomes more clearly defined as a fetish, Rambo regains his masculinity and phallic power. After Co's death, the film erupts in an extended sequence of violence, explosions, and the quick cutting and multiple camera perspectives characteristic of action-adventure films. While the first part of the movie offers up Stallone's body as an object of admiration or punishment for both the Vietnamese in the film and the audience, the camera in the last part of the movie can barely find or track the constant movement of our protagonist. Now on the offensive, he buries himself in a hillside so that only his eyes are visible, he hides in a tree hollow and camouflages himself with vines, and he lays in wait under the water – each time leaping out to catch the Vietnamese soldiers, and the movie's audience, unaware. He becomes part of the scenery, a part of Vietnam itself, seeing but unseen. The gaze of the camera that once caught Rambo in its unwavering eye now swoops over the countryside to be 'surprised' by Rambo's sudden appearances.

This final spectacle allows Rambo to return to the fantasy of whiteness as invisibility, as a race that has no race. Rambo can recentre whiteness as an unmarked norm, and his machismo and military aggression returns with a vengeance. We are given the spectacle of war and destruction but we are deprived of Rambo's body. At this point in the film, Rambo acts out the power relations inherent in the visual marking of race. If whiteness is the norm, then other races are marked by difference. Race exists as a visible object for the unmarked, white gaze, denying the agency of the racialized subject. Rambo's invisibility gives him the power to look at the Vietnamese soldiers without being seen, and the power to gaze is literalized by his superhuman ability to wipe out whole cadres of soldiers single-handedly. His body is elusive, indestructible, and no longer bound by the rules of physics. By assuming a superhuman role, Rambo manages to escape the constraints of his body in terms of both reality and race.

In its fantasy rewriting of the Vietnam War, the film desperately attempts to hold back the tidal wave of demographic changes wrought by the 1960s' immigration law. The genre of 1980s' Vietnam War films in general and *Rambo* in particular can be read as a response to the threat Asian immigration poses to the dominance of Euro-Americans in the US. However, the only place for the Other in this film is either as a completely contained reflection of a white fantasy (Bao Co) or dead (the Vietnamese soldiers). In the end, the film offers a particularly bleak vision of US racial relations.

Notes

1. An Immigration Act of 1976 also provided for refugees from Vietnam, Cambodia, and Laos in direct response to the end of the Vietnam War. Over 75 per cent of Vietnamese, Cambodians and Laotians living in the US arrived after 1975. This and other demographic statistics cited here are taken from the US Census Bureau website.

2. The Vietnam War films of the mid-1980s followed an earlier spate of films released in the late 1970s including the now classic *Boys in Company C* (1978), *Coming Home* (1978), *The Deer Hunter* (1978), and *Apocalypse Now* (1979).

3. I am working from an understanding of the gaze as hierarchical and as structuring of power relations as discussed in Laura Mulvey's famous essay 'Visual Pleasure and Narrative Cinema' (1988). Mulvey argues that the object of the gaze (in this case, the female movie star) is placed in a submissive position *vis-à-vis* the mastering gaze of the male gendered camera.

4. This belief persists despite the declared 'death of race' in both academic and popular culture. For an early discussion of the topic see Appiah 1986.

5. *Rambo* was number #71 of America's top grossing films (not adjusted for inflation) as of 2000, the most lucrative Vietnam War film ever. (*http://us.imdb.com/charts/usatopmovies.html*).

6. See Hansen (1991) for a fuller discussion of the distinctions between the fetishistic scopo-philia that characterizes our frustrated attempts to view the quick cuts and fragmentation of the earlier scenes, and the voyeurism, with its attendant sadism, that characterizes the scenes where Rambo is tortured by the Vietnamese.

7. Steve Neale argues that, 'The mutilation and sadism so often involved in [Paul] Mann's films are marks both of the repression [of homosexual voyeurism] involved and of a means by which the male body may be disqualified, so to speak, as an object of erotic contempla-tion and desire' (Neale 1983: 8). As Neale suggests, the film's narrative allows the (male) audience to deny and simultaneously enjoy the homo-eroticism of the scene. This position as an object of 'contemplation' leads us to an even more threatening aspect of Rambo's vis-ibility.

8. As Carol Clover notes in her analysis of horror films, the suffering of the film's heroes clouds the distinction between feminine and masculine roles and male and female bodies. 'Sex in this universe, proceeds from gender, not the other way around. A figure does not cry and cower because she is a woman; she is a woman because she cries and cowers' (Clover 1992: 13).

9. In the chapter 'White Skin, Brown Masks' in *Male Subjectivity at the Margins* (1992), Silverman offers her most complete analysis of the relationship between masochism and race. While I find her argument that the masochistic yearning of T. S. Lawrence actually promotes a type of mastery (i.e. nobility in suffering) compelling, her claim that Lawrence's masochism enables him to identify with the racial Other does not apply here. Instead, I'd like to emphasize the sadistic aspect of Rambo's torture as a punishment for recognizing racial difference. In becoming visible, Rambo is subjected to a sadistic gaze.

10. De Lauretis (1984) argues that the retelling of familiar stories and the reiteration of gender roles and hegemonic conventions are the source of the audiences' pleasurable response to genre film.

11. A more complete exploration of Asian/White relations and the endless repetition of Madame Butterfly themes and plots in cinema can be found in Marchetti 1993.

12. Homi Bhabha recognizes a similar balance (or imbalance) of power and says, 'Therefore, despite the "play" in the colonial system which is crucial to its exercise of power, colonial discourse produces the colonised as a fixed reality which is at once an "other" and yet entirely knowable and visible' (Bhabha 1999: 371). In the same way, Rambo's ability to regain the 'play' of whiteness depends upon a foreclosure of a 'play' of identity for Bao Co.

'Queer' Photography and the 'Culture Wars'

Robert Mapplethorpe's Queer Aesthetic of the Pair[1]

DENIS FLANNERY

Austere classicism, visceral sexual representation, the adoration of celebrity and an almost zen contemplation of immediacy, mortality and the spirit – these are some of the persistent thematics of Robert Mapplethorpe's *oeuvre*. At times they are present with conscious deliberation. At others they permeate his output – and even more its posthumous reputation – with a less conscious though uncanny persistence. One such thematic, I argue in this essay, is the pair. This is a crucial and pervasive component of Mapplethorpe's work, in terms of what he chose to photograph, how he chose to photograph it, in terms of his practical and ethical methods and in terms of the readings, assumptions and controversies which his photography has generated.

Mapplethorpe's role in gay US visual culture can, I think, be understood through thinking about the pair, *as opposed to* the couple. The distinction between the pair and the couple is an important one and worth outlining at this early stage. We can think of a pair as a nonce combination, practical, almost accidental and in some ways just obscure. But a pair, be it of earrings, buildings, hands or bodies, also implies the combination of two identical or harmonious elements. Sometimes these can match the assumed dimorphism of the human body, as in the relationship between ears and earrings. Sometimes they can embody cultural contradiction, as in the combined will to dominate yet also to celebrate fraternity which marked, until 2001, the Twin Towers of the World Trade Center in New York. Relations within pairs involve subdivision, complementarity and extension. The why of the couple is self-referentially evident, the why of the pair difficult to access. The pair, it seems to me, is marked by a combined incoherence and simplicity. Pairing happens for any number of layered or contradictory reasons, and in pairing there is simple adjacency.[2] One thing is just next to another. Within that 'being just next to' – as distinct from its 'being derived from', say, or its 'being contingent upon' – inheres the pair's iconic allure and also its resistance to grand narrative. Many a nineteenth-century novel, to allude to a powerful means whereby grand narratives have announced and naturalized themselves, ends with the establishment of a couple. None that I know of builds towards a pair's reconstitution. And this is the first major distinction between a pair and a couple. The establishment of a pair, even a monumental pair like the Twin Towers, has an enigmatic relationship to grand narratives.[3] The pair is accidental, practical, the result of arbitrary or whimsical factors. The couple, on the other hand, is both generated by and in turn ensures the perpetuation of large narrative models (proper gendering, sexual conformity, fidelity, the nation, the family). Couples emerge from big narratives and, even at their sweetest, simplest and most sentimental, promise that grand narratives will be perpetuated or paid the dubious but ultimately confirming tribute of mimicry. So when, in 1986, Mapplethorpe photographed a couple and their children in *The Neidpath Family*, the juxtaposition of husband and wife is set not only against their child and their dog but also has as its background monumental eighteenth-century portraits of both specific men and a mother and children, the heads of all

nearly obscured by the elaborate palanquin which frames the trendy yet aristocratic couple. To photograph them was, for Mapplethorpe, to represent them as participants in a formalized grand narrative. And between the participation of the couple in this narrative and their status as the objects of its production there is, this photograph seems to suggest, very little to choose.

So a key distinction between the couple and the pair is their respective relation to narrative. We can add to this Lauren Berlant's description of 'the couple as a paranoid structure posed in and against the modern world'. For Berlant, the emergence of this structure is an ideal opportunity for questioning a powerfully assumed synonymy between marital attachment and 'life'. Once looked on as an emergent structure whose impact is partly to forestall the posing of questions, most notably questions about the 'sheer incoherence', as Berlant terms it, of perversion and desire, the couple can be seen not simply as a narrative telos but as a pointer towards other modes of attachment which, in their very simplicity and their distance from grand narratives, have no need to muster coherent effects and have, therefore, a much more telling, sophisticated and 'real' impact on how we perceive attachment. Finally, thinking about the questions which the dominant, ever emerging, structure of the couple can *prevent* getting asked means, for Berlant, asking about 'the economies of violence within which modern love is formed'. A figure whose work represented, reconsidered and provoked further extensions of the relationship between love and economies of violence, Mapplethorpe, especially in his representation of the pair, does indeed 'clarify the traffic in erotophobia that projects violence onto *sexuality*, as opposed to the fantasy of love's sublating achievement' (Berlant 2001: 441).

If Mapplethorpe photographed pairs, saw the practice of photography as one of pairing and relied on his participation in pairs as a way of ensuring his great success then, I will suggest, his photographic practice has an ongoing value and impact as a place in which modes of attachment and practices of intimacy get scrutinized, interrogated and celebrated.

When I told a friend that I was writing this piece he sent me the following text message: 'Robert Mapplethorpe, the photographer? Wow, he's done some crazy stuff . . . Check out his portrait of Ken Moody and Robert Sherman . . . Scary!' The reaction to Mapplethorpe and the prospect of writing on him evidenced in Adam's text is worth considering, not least because it encapsulates so much of what, in bigger and less spontaneous spheres, Mapplethorpe did, and what his work has generated. First, Mapplethorpe the name is immediately paired with a practice and a reputation: 'Robert Mapplethorpe, the photographer?' The one follows the other in a mode of linkage and wonder. Then a pair of adjectives is marshalled: 'crazy' and 'scary', the first applied to Mapplethorpe's *oeuvre* ('Wow, he's done some crazy stuff!') and the other applied to a particular portrait ('Scary'). Bracketed by designations of madness and visceral, comic fear, Mapplethorpe's *Ken Moody and Robert Sherman, 1984* is recommended as one to check out, the one which best instances Mapplethorpe's place in a crazy realm, and the one which best instances the fearful, and delightful, aspects of his work. Of course this photograph could not be more emblematic of a pair. His eyes serenely closed, Moody is photographed from the bare shoulder up, light reflects from his black skin which manages to look both utterly statuesque and also – in the merciless focus and clarity of the photograph and its reproduction – subject, as skin, to a nearly medical scrutiny. Sherman also stands behind Moody, though from the viewer's standpoint just next to him, rather like one letter after another in any written word. Sherman's whiter than white skin and shaved head is paired in ruthlessly symmetrical and complementary contrast with Moody's. Both men are completely bald; both are without eyebrows. Though Moody's eyes are closed, Sherman's are open. The only point of real darkness in Sherman's representation (apart from his freckles which are also rendered with hi-tech, merciless precision) is the one visible pupil of his left eye which gazes, unseeing, blankly, tenderly, at some point in the distance. The skin of his neck and upper body either touches Moody's or else it hovers, with tantalizing emphasis, a few millimetres from his unseeing counterpart. This is a picture which is difficult to forget, to turn away from and, even more, difficult to read. There is an amazing simplicity in the pairing of these two men. It emphasizes above all else their similarities and their proximity, it plays with the possibility of yoking its image to one or more nar-

ratives of sexual, racial, violent, tender possibility but, because its focus is so relentlessly on formal parallel and contrast it keeps the comfortable application of those narratives at bay, although they are never forgotten. If it can be called scary, this image can also be called queer. This photograph is frightening to the extent that it represents naked human male proximity with such ambiguous intensity; what, if anything, passes between these men is way in excess of anything that can comfortably conform to any given narrative model of intimacy, even one which calls itself 'transgressive'. The double representation of Moody and Sherman is certainly illustrative of Freud's assertion in 'The Uncanny' that the double is both tortuously an 'assurer of immortality' and 'an uncanny harbinger of death' (Freud 1990: 357). It is very difficult to decide if we are looking here at the ecstasy of complementarity or a scenario of fatal annihilation; part of the photograph's impact lies in keeping this difficulty operative. Furthermore, its impact relies on the fact that although Moody and Sherman are *formally* represented as if they were doubles their highly emphasized differences make them function much more as a pair, and therefore as an exercise in accident and adjacency. It is the very simplicity and banality of their being together in this photograph which make it, I'm suggesting, so very violent and undecidable at the same time.

The kind of photograph invoked in my friend's text message is by no means unique. Looking through the catalogue for the National Portrait Gallery's exhibition *Mapplethorpe Portraits* we find titles such as *Christine and Rebecca Grounds, David Hockney and Henry Geldzhaler, Bill T. Jones and Arnie Zane, Larry and Bobby kissing, Thomas holding Amos* and, finally, *Philip Glass and Robert Wilson*. These are single photographs of pairs and they echo Mapplethorpe's earlier emphasis on the photograph's status as an object, and frequently an object designed to accommodate pairs, with materials, objects and persons doubled and juxtaposed. Writing about the 1974 images *Wood on Wood* and *Black Shoes*, Richard Marshall has pointed out that they both 'utilize dual pictures and wide frames that outscale the actual images they surround. In fact, Mapplethorpe designed and constructed the wood-grain frame before he knew what it would contain' (Marshall 1988: 11). The famous iconic portrait of Patti Smith which provided the cover of her first album, *Horses* (1975), is also a double portrait. The image reproduced on the cover is carefully placed in a double wooden frame and to its left is an image of Smith seated so that the great iconic image is like one frame of a film or a graphic novel. She is not just photographed standing. The double image records her decision to stand. And at a very slight push we could add to all this Mapplethorpe's own 1985 self-portrait which provided the cover for the National Portrait Gallery's 1988 exhibition. Handsome, remote and pained, he is photographed with slicked hair and an open-neck shirt, the solidity of his still head and fixed gaze paired with the ghostly aura, reminiscent of nineteenth-century spirit photography, of the magically rendered motion which has brought the photographer/model into his classical stance.

So we have seen that pairing is a foundational element of the presentation of Mapplethorpe's earliest and most iconic images. Pairing is there in the forms of a still image and the traces of the movement which have brought it to that stillness. It is there in the representation of artistic collaborators (Philip Glass and Robert Wilson), a man and a cat (Thomas holding Amos), two men kissing, dancers together, friends posed with jokey solemnity on a roof, and sisters – Christine and Rebecca Grounds who are themselves photographed, according to Peter Conrad, with more than a nod towards the ghostly: 'The older girl has emerged from the younger while she sleeps, like a thought-balloon floating out of her head or the imago bursting from its chrysalis. She creeps almost stealthily into life: could this be the spirit making its escape from the cast-aside, dormant body?' (in Mapplethorpe 1988: 14). The ease with which we can move from a contemplation of the pair in these examples to a contemplation of the supernatural might well be further testimony that there is something 'scary' about Robert Mapplethorpe's work but, more basically, it testifies to the range of the pair images he made. Pairing does not amount to the representation of two in togetherness, for Mapplethorpe. Even when he photographs a pair kissing – as in the Larry and Bobby photograph – Mapplethorpe is not interested in the photograph's role in furthering a received narrative of intimacy for these men. Rather the photograph is about a moment of adjacency for the pair, and about a more simple but complex

practice of proximity. This particular moment for Larry and Bobby might be a one-off. It might also be one of a continuum of such moments. The image does not prioritize or emphasize either option. In a simple and contemplative way it raises as many fundamental questions about intimacy as the double portrait of a rock icon at the moment of her emergence, a self-portrait which invokes a haunting, and an utterly decorous photograph of two young sisters which makes the youngest child the corpse mother of her older sister's infant spirit.

The photographic representation of pairs is, therefore, a pervasive factor of Mapplethorpe's work. We have seen that the term 'pair' covers many modes of association, is not reducible to assumptions about the couple and is something which produces a ghostly effect. What is, though, 'queer' about these representations (as opposed to simply 'gay')? How might they amount to a queer aesthetic? And how might they illustrate, complicate or critique some embedded values in gay US visual culture? Like all big questions these are best answered in specific terms but I want to outline some of what is particularly queer about Mapplethorpe's representation of the pair as opposed to what might be 'merely' gay about it. For me the interest and value of queer as a moment and concept lies in five key components. First, there is reversal: queer takes an injurious term, reappropriates it as a mode of affirmative self-designation yet in doing so hangs on to its reappropriative power.[4] It accomplishes, in short, the feat of making an injurious term affirmative without making it nice. Second, there is the mode of action which inheres in its etymology. As Sedgwick noted:

> Queer is a continuing moment, movement, motive – recurrent, eddying, *troublant*. The word 'queer' itself means across – it comes from the Indo-European root – *twerkw* which also yields the German *quer* (transverse), Latin *torquere* (to twist), English *athwart* . . . The immemorial current that queer represents is . . . relational, and strange. (Sedgwick 1993: xii)

Third, queer is all about impact, that which is and which denotes the 'strange, odd, eccentric . . . shady, suspect'.[5] There is no possibility of mere designation or simple disclosure in queer; as a mode of representation it, like Mapplethorpe (perhaps because it is so inspired by him), makes waves. Fourth, queer is about the interface between power and category, a way of reminding us, in Bill Turner's words, of the failure of fit between person and category.[6] The cultural and political passions out of which queer theory and queer political movements began in the US were predominantly passions around some pretty immense questions of category – survival and the historico-political direction of a nation would be two. Queer as a moment is historically immersed in and responsive to the mismanagement of the AIDS crisis and the accompanying genocidal wishes, fears and fantasies (and resistances thereto) which that moment unleashed in the US. Lastly, queer is about critique, about taking the intellectual into the everyday and recognizing in the workings of the everyday the continual deployment of and reflection on modes of critique.[7] To these five – reversal, action, impact, the interface between power and category, critique – I would add a sixth. Queer is about the ordinary, the everyday, the banal, the established. Your family history, your local gym, the politics of the workplace, great books by great authors, the music piped in supermarkets, the conduct of 'straight' society may spring from time to time into new life under the aegis of the lesbian or gay but are, I would contend, more thoroughly and consistently comprehensible when their queerness is assumed and embraced. This is why I think that the pair, in its functionality, incoherence, simplicity and sheer ordinariness, is an entity of potentially great interest for queer theory and why, although Mapplethorpe is everywhere readable as a gay photographer, he is most interestingly seen as a queer artist when he photographs pairs.

There are very few senses in which the photographs we have discussed so far are, therefore, not queer. But I want to consider one very famous photograph, *Helmut and Brooks NYC, 1978*, with close reference to some aspects of queer as a cultural practice as I have just outlined it. For many of us this is a photograph of two men having sex. This, therefore, makes it 'gay'. What, though, makes it queer? Well, certainly because one man is fisting the other in this photograph it highlights, like many of Mapplethorpe's S&M photos, a fragile borderline between

injury and pleasure. Assumptions about what might be injurious, where pleasure might be found, how the viewer's gaze might initiate and promote different kinds of identification with, between and across the two men in this photograph, are made objects of cool, formal reflection. And in that process of representing the visceral and erotic in so coolly framed and aestheticized a way, the Mapplethorpe of this photograph might be said to cut across many cultural sectors and practices.

It is very easy not to notice that this is, in fact, a domestic photograph. The fisting does not take place in one of the dedicated spaces of gay porn – the gym, the back room, the studio, the mechanics workshop, the deserted island, for example – but was actually taken in Mapplethorpe's home. *Helmut and Brooks* is as domestic a piece of American art as Louisa May Alcott's *Little Women* is a domestic piece of American literature. Furthermore, there is a remarkable formal continuum between the skin of both men in the photograph and the chair on which one of them kneels. In itself, therefore, the photograph seems to me to invoke a key American tradition of ecstatically collapsing and reinventing the distinction between persons and things. This tradition is alive from say Poe, Dickinson, Whitman and James to Chuck Palahniuk's *Fight Club* to Donna Haraway's cyborgs. The remorselessly elegant compositional lines and parallels between bodies and the leather of furniture, the making of a chair the place not where the body is rested but where the body is turned around to provide rest, exercise and erotic release seems to me to participate, traditionally and queerly, in a strand of American cultural practice which records, perpetuates and celebrates new (and often violent) relations between bodies and objects.[8] If the body/object relationship in this photograph can be described as traditional then it is also important to bear in mind that the object itself is traditional. In this regard, Richard Meyer writes 'For all the attention (and panic) that has been directed at Mapplethorpe's photograph of *Helmut and Brooks*, it has gone unremarked that the 'seat' upon which this sexual transaction unfolds is, in fact, a Morris chair, c. 1910–12' (Meyer 2001: 306). So we might see this photograph as occupying and juxtaposing the cultural domains of pornography, 'high-art' eroticism, the domestic photograph, American literature of sentiment, a tradition in American writing which gleefully and violently collapses the distinction between persons and things and the traditional worlds of antique collecting.

In the occupation of these varied cultural domains, the photograph would correspond to Sedgwick's emphasis on queer as that which cuts across; this image is indeed, to echo her words, 'relational, and strange'. A third aspect of queer which we identified was its momentum of cultural impact. This photograph is nothing if not impactful and a key part of this is not only its range of sexual representation but also the relationship between the image and its title. Imagine for a moment that this photograph was just called 'NYC, 1978' or 'Fisting' or something more banal and diffuse (how about 'Close Contact'?). Would it have the same impact? I very much doubt it. A scenario of sexual contact photographed in the most visceral, aesthetic, antisentimental way, every factor of its visual presentation (if not its content) exuding 'high art', has as its title *Helmut and Brooks, NYC, 1978*. This is the kind of title one might expect to see written in a personal or family album, perhaps next to a snapshot of two friends taken by an easily recognizable New York tourist spot, or a fond remembrance of a family trip kept in a doting parent's (or lover's or spouse's or sibling's or child's) wallet. The title exudes the sentimental, the mundane and even the familial. And those qualities are juxtaposed with a content and a mode of presentation that might be assumed to be light years away from these qualities. The mundane pairing of the title is wildly at odds with the form and content of the photograph. Except, of course, that it is more than likely that familial, sentimental, tourist photographs of Helmut and Brooks, either separately or together *do* (or did) exist and so the title pulls us towards the prospect of the photograph's models participating in the mundane scenarios alluded to in the title's articulation, and thereby creating a continuum between the mundane and the tabooed. And to this we might add another point that is all too easily forgotten: fisting *is* mundane. At the same time, though, the photograph does not bother to differentiate seriously between Helmut and Brooks. We might well assume the existence of a crude left/right, top/bottom analogy and assume that the man fisting is Helmut while the man being fisted is

Brooks. Other photos by Mapplethorpe (like the Moody and Sherman portrait) work in this way on a simple left to right analogy; the first named person is the one on the left, the next named is the one on the right. This photograph may well follow that particular protocol but ultimately the distinction between the two men is impossible easily to gauge. *Helmut and Brooks* is a queer photograph in ways in which even very explicit representations of fisting in pornography are not because, in part, of the analogies that can all too easily be drawn between it and queer critical/cultural practice, but more basically because of its explosive employment of the mundane practice of pairing – pairs of bodies, pairs of names, the pairing of flesh and furniture, and, most tellingly, Mapplethorpe's smartly disingenuous use of his title as it is paired with his image.

Mapplethorpe photographed pairs. He also saw the practice of photography as one of pairing. The narratives of Mapplethorpe's career are peppered with instances of different forms of collaboration, trust and adjacency which, rather like the pairs he photographed, are both about intimacy and also about exceeding powerful norms of intimacy. We might think about his relationship with Patti Smith in this regard, one which took the forms of lover and beloved, photographer and model, artist and muse, and – following Mapplethorpe's death – mourner and mourned.[9] For Lisa Lyon a similar, though less extensive dynamic can be said to have been operative (see Mapplethorpe 1997). Just as with Smith, Mapplethorpe combined many erotic, aesthetic and career roles with Sam Wagstaff. And on a more basic but utterly more telling level a key relationship in Mapplethorpe's career was his ten-year association with the printer Tom Baril, which began in 1979 and only ended with Mapplethorpe's death (Danto 1992: 343). Like Lucien Chardon and David Sechard in Balazc's *Lost Illusions* (1837–43) Baril and Mapplethorpe acted out in their work the binaries of matter and form, idea and execution, just like Mapplethorpe and his ghostly self in his 1985 self-portrait or the Grounds sisters as he photographed them in 1980.

These relationships might be said to illustrate a key aspect of the ethical framework of Mapplethorpe's photography as articulated by Arthur Danto, and that is trust. For Danto trust is the key component of Mapplethorpe's *oeuvre* and it is evident in the openness, specificity, formality and distance which distinguish Mapplethorpe as a portraitist and as a producer of intensely erotic tableaux. If anything, it might be said that the difficulty we might have drawing any kind of line between these two genres – which, for example is *Melody and Paul Wadina, 1979* or *Brian Ridley and Lyle Heeter, 1979*? – illustrates how principles of trust, between models, between 'tops' and 'bottoms', between photographer and subject and between those subjects (including Mapplethorpe himself) and a wider world are utterly crucial to everything about Mapplethorpe's work. This ongoing extension of trust spreads, for Danto, to his own writing about Mapplethorpe:

> In the case of Mapplethorpe, my sense, right or wrong, is that I would be able to trust him as a person because trust is so central to his style of photographic address, and to so high a degree a condition of the implicit contract between him as artist and his subjects. (Danto 1992: 318)

It seems to me that Mapplethorpe's emphasis on the pair has much to do with Danto's foregrounding of an ethic of trust. For Danto, these bonds of trust in the process of making photographs are contingent, targeted and utterly foundational to both photography as a cultural practice and Mapplethorpe's impact and legacy as an artist.

After his own death, of course, others would pair themselves with Mapplethorpe not in relations of collaboration, patronage or publication but in much darker and emotionally obscure relations of persecution, censorship and unwitting promotion. If, in life, Mapplethorpe photographed pairs and made pairing the condition of his visual practice then, in death, he found himself dancing a *pas de deux* with the Republican Senator Jesse Helms in a way which spookily (and comically) re-enacted some of the more productive, aesthetic and bracing dynamics of

pairing in his own work. Helms's mission was, in Richard Meyer's words, 'to impose content restrictions on federally-funded art'. Its targets were sexual 'minorities', in particular a definition of 'homosexuality' that was as incoherent as it was narrow, modes of cultural funding and, of course, the federal power which enabled them. And this mission was successful, although in pursuit of that success Helms found himself (inadvertently, on a conscious level) acting as a promoter and disseminator of Mapplethorpe's work.

The vision of Helms frantically attempting to cordon off Mapplethorpe's homosexuality through the decidedly odd means of photocopying photographs like *Mark Stevens, Mr. 10½ inches* for distribution to his fellow senators, bringing examples of Mapplethorpe's work home to his wife, Dorothy or, my favourite, *inventing* in his denunciations new (and not altogether unappealing) Mapplethorpe images such as 'two men of different races in an erotic pose on a marble-top table' certainly has a more than passing interest for anyone interested in the psychodynamics of censorship (see Meyer 2001: 295, 292). In Judith Butler's wonderful reading of the Mapplethorpe/Helms controversy she writes:

> Prohibitions work both to generate and to restrict the thematics of fantasy. In its production, fantasy is as much conditioned as constrained by the prohibitions that appear to arrive only after fantasy has started to play itself out in the field of 'representations'. In this sense, Mapplethorpe's production anticipates the prohibition that will be visited upon it; and that anticipation of disapprobation is in part what generates the representations themselves. If it will become clear that Helms requires Mapplethorpe, it seems only right to admit in advance that Mapplethorpe requires Helms as well. This is not to say that Mapplethorpe knew before he died that Helms would appear with amendment in hand, or that Mapplethorpe should have known better. On the contrary: Helms operates as the *precondition* of Mapplethorpe's enterprise, and Mapplethorpe attempts to subvert that generative prohibition by, as it were, becoming the exemplary fulfilment of its constitutive sexual wish. (Butler 2004: 194)

Butler's emphasis in this passage is clearly on the dynamic of conditioning and production that, for her, exists between representation and prohibition. She does not consider the specific content or form of the representations concerned. I would contend, though, that Helms's relation to Mapplethorpe, as outlined with wry comedy by Richard Meyer, and as subject to Butler's analytic scrutiny, echoes the structure of queer, quotidian pairing which marked Mapplethorpe's photography. It is no accident that the photograph which Helms invented – two men of different races in an erotic pose on a marble-top table – is a photograph of a pair. Because it is only through the pair that the kinds of representation Helms found so compulsively reprehensible are possible. Let us imagine for a moment that the photograph Helms imagined did exist. And let us imagine that Mapplethorpe called it (as he called many such photographs) *Andy and Bruce, 1981*. In our imaginary title, just as with Helmut and Brooks, there is a pairing and date with no sense of how the pair relate to the date, with no sense necessarily of who in the picture is who – which is also often the case with Mapplethorpe's pair pictures. There is the adjacency, which might be very explicitly sexual or only allusively so. There is the date which registers the year of that proximity, but tells us nothing of how that temporal placement works in terms of Andy's or Bruce's past or future, either separately or together. So in the photograph there is, certainly, the marble-top table, there are the two men of different races who are named and placed in a history, and there is the erotic pose. But that is all there is. Huge narratives halo around this representation – narratives of the couple, of racial proximity, domination, and violence, of sexual identity, of reprobation, of affirmation. But because the photograph is the photograph of a pair it refuses these narratives, yet in that very refusal it evokes them. Evoked and refused, these narratives revisit the photographs and their maker through the bemusement, pleasure, confusion or – in the case of Helms – ire of the viewer. The viewer can only access the pair and the narrative refusal through being in some way adjacent to the photograph, and this crucially echoes the raw adjacency of Andy and Bruce in Mapplethorpe's (and Helms's, and my) imaginary representation. It is only by means of the representation of the pair *in* the photograph

that the pairing of prohibition and representation in the form of Helms and Mapplethorpe can take place.

It is easy to think of persons in Mapplethorpe as whole entities, even when formally, as in the Moody and Sherman photograph, or erotically, as with Helmut and Brooks, it is the very whole-ness and separateness of persons that is called most into question. But conceptually, and ety-mologically, the pair is closely connected with what I referred to earlier as the 'assumed dimorphism' of the human body. In photograph after photograph Mapplethorpe celebrated this dimorphism, representing feet, hands, breasts, eyes, buttocks, the lineaments of the back. For Mapplethorpe, therefore, pairing involved not only a simple and incoherent practice of adja-cency between persons but also the celebration of dimorphism within persons. The best example of this, I think, and the last photograph I will consider here, is *Sigourney Weaver, 1988*. Her skin heightened to an unnatural whiteness, photographed against an intensely black back-ground and wearing long black gloves adorned with pearls, Weaver frames her own face with her hands, the gloves and the pearls replicating within the photograph Mapplethorpe's labour in its production. The pearls work almost to create the illusion that Weaver has opened some kind of internal zipper to reveal her own statuesque beauty. Pairing within the body is made to replicate the labour of photography, and the photograph records the illusion of the body's split-ting within itself, the better to emphasize its own splendour. In this image Mapplethorpe makes pairing between, pairing within, and the near-violent creation of pairs utterly integral to this portrait's existence, just as pairing was so essential to the tender riskiness and generative poten-tial of his own queer photographic project.

Notes

1. I am very grateful to Adam Bray for his readiness to let a casual text message bounce so unpredictably into the public domain, to Mick Gidley for encouraging me to write about photography, to Stephen Campbell for drawing my attention to Richard Meyer's work and to Sasha Roseneil for her invaluable encouragement and her infallible sense of the judicious, sympathetic question.
2. My use of the word 'adjacency' throughout this piece owes a lot to Elaine Scarry's wonder-ful discussion of the potentially causative relationship between the experience of beauty, adjacency as a mode of pleasure, fairness, ethical conduct and political justice in *On Beauty and Being Just* (1999: 114).
3. I use the term 'grand narrative' with reference to David Harvey's emphasis on postmodern-ity as the historical moment wherein grand narratives are abandoned and refused in *The Condition of Postmodernity: An Enquiry into the Origins of Cultural Change* (1990: 43). Harvey's use of this term derives in part from Jean-François Lyotard's *The Postmodern Condition: A Report on Knowledge* (1984).
4. In a political and critical sense the word 'queer' is dependent on a certain reversal of assump-tions and roles. Judith Butler stresses this in her essay 'Critically Queer' when she empha-sizes that uses of the word amount to a 'significant reversal'. She asks: 'If the term is now subject to a reappropriation, what are the conditions and limits of that significant reversal? Does the reversal reiterate the logic of reversal by which it was spawned? Can the term over-come its constitutive history of injury?' (Butler 1993: 223).
5. This is an often overlooked component of queer thinking but one beautifully articulated by Sasha Roseneil in her *Common Women, Uncommon Practices: The Queer Feminisms of Greenham* (2000: 5).
6. For a historically sensitive discussion of the troubled relationship between queer theory and the category see Turner 2000: 8–11.
7. In so far as Judith Butler's *Gender Trouble* is a foundational text of queer theory then it is, I think, crucial to bear in mind that it was written in what she terms 'the tradition of imma-nent critique', that is initially as a critique of feminism from within feminism. This quality

of 'withinness' is something which can, does and (I think) should radiate through critical or cultural practice that is in any way queerly aware (Butler 1999: vii).

8. Just as the skin of both men has as its continuum the leather of the chair so also does the left arm of the man being fisted reach up and around the chair's back in a gesture which parallels the reach up and around of the other man into his own body. This parallelism nearly suggests that the chair itself is in some way being fisted and that, therefore, it can participate in the sensation and affect of the erotic exchange.

9. In this regard see Smith's 1988 'Memorial Song' which emphasizes pairing as the pursuit of common and divergent aims, the practice of common dreaming and the parity embodied in the structure of a bird's feather (Smith 1998: 156).

Transnationalism in Contemporary African American Photography

Memory, History and 'Universal' Narrative in the Work of Carrie Mae Weems

MAREN STANGE

The work of contemporary photographer and image maker Carrie Mae Weems has always invoked history, not only tracing the material markers of its processes, but also preserving and commemorating its discursive forms. Over two decades, Weems has moved from documentary-style, captioned, black and white prints to elaborately deployed installations involving complex assemblages of visual and audio elements. In these pieces, images may appear on gauzy banners that surround the viewer, or in poster form, accompanied by text passages or audio elements, and objects. She is currently working in film. Just as Weems's pieces have been linked by repeated formal elements, they have thematized recurrent issues concerning identity and the presence of the author in her work. The increasingly diffuse and intertextual forms of her most recent work underscore a wider range of historical concerns. Foregrounding new elements of specific narratives we might think we know, 'leading us to new ways of thinking about history', as one critic says (McInnes 1999: 20), this work engages as well the possibilities of a universal referent.[1]

Weems herself is among those author Richard Wright called 'first born of the city tenements' (Wright 1988: 142). As Wright's family had done in the 1920s, Weems's parents and other family members left Mississippi sharecropping, moving to Portland, Oregon in the 1950s, where Weems grew up. Wright's 1941 image and text narrative of African American migration, *12 Million Black Voices: A Folk History of the Negro in the United States*, amalgamated his own experiences with those of 'the collective humanity' of 'we millions of black folk who live in this land', creating what he called a 'folk history' (ibid.: 5–6, 12). Trained in folklore as well as art, Weems found a model in Wright; her 1991 installation 'And 22 Million Very Tired and Very Angry People' links her work explicitly to *12 Million Black Voices*, and, as we shall see, other work echoes, transmutes, and explicates for a new generation – and different gender – Wright's assertion (in the language of his time) that 'theme for Negro writers will rise from understanding the meaning of their being transplanted from a "savage" to a "civilized" culture in all of its social, political, economic, and emotional implications' (Wright 1994: 104).

Seen by some as Wright's 'only admiring portrait of blacks' (Rampersad 1988: 128), *12 Million Black Voices* became an 'instant Bible' for photographer Gordon Parks, and the poet and intellectual Langston Hughes taught it in creative writing courses (Parks 1966: 190, 199; Rampersad 1988). Reprinted in 1988, it is the subject of current discussion by critics including Houston Baker, Paul Gilroy, and Farah Griffin (see Baker 1991; Gilroy 1992; Griffin 1995). Wright's prescient text for the book, initiated when FSA exhibit and book designer and erstwhile journalist Edwin Rosskam invited him to compose the text and collaborate in photograph selection, fulfilled his long-standing desire to address the dynamics of African American history (see Kinnamon and Fabre 1993: 44), to tell the story of the 'complex movement of a debased feudal folk toward a twentieth-century urbanization' (Wright 1988: xix–xx). Photo-edited by

Rosskam, the volume is an innovative intervention in a well-known series of photo-text books that featured photographs made for the New Deal's Farm Security Administration (FSA) photography project (1935–43), one of the most notable products of which was James Agee and Walker Evans's *Let Us Now Praise Famous Men* (see Lange and Taylor 1939; MacLeish 1977; Agee and Evans 1941).

Wright's determined conflation of the American narrative he anchors in folk memory with what we now call 'diasporic identity', and his effort to locate Afro-US history and culture globally, are relevant today as they were in the 1940s. The narrative begins with an account of the slave trade set in the context of both African civilizations and the Euro-American Renaissance, and follows the course of slavery as an economic system to the point of the Civil War, when the inevitability of industrialization made slaves and the 'inheritors of slavery' seem 'children of a devilish aberration, descendants of an interval of nightmare in history, fledglings of a period of amnesia' (Wright 1988: 27). Writing in the present tense to detail the sharecrop system, African American life in the South, and the Great Migration of the 1910s and 1920s which brought millions of African Americans to Northern cities, he closes his second chapter with one of the book's few statistics: 'From 1890 to 1920, more than 2,000,000 of us left the land' (ibid.: 89).

Of this vast movement, which doubled its size during World War 2 and reshaped the modern American metropolis, Wright argued that

> brutal, bloody, crowded with suffering and abrupt transitions, the lives of us black folk represent the most magical and meaningful picture of human experience in the Western world. Hurled from our native African homes into the very center of the most complex and highly industrialized civilization the world has ever known, we stand today with a consciousness and memory such as few people possess. (ibid.: 146)

Contending as well that blacks and whites are bound by 'deeper' ties than those that separate us, and that 'black . . . history and . . . present being are a mirror of all the manifold experiences of America', he suggests that 'what we want, what we represent, what we endure is what America *is*', and that '*we* are *you*' (ibid.). Wright insists that 'if America has forgotten her past, then let her look into the mirror of our consciousness and she will see the *living* past living in the present, for our memories go back, through our black folk of today, through the recollections of our black parents, and through the tales of slavery told by our black grandparents, to the time when none of us, black or white, lived in this fertile land' (ibid.). Ending on a note of hope and affirmation, he places blacks 'with the new tide', maintaining that 'Hundreds of thousands of us are moving into the sphere of conscious history' (ibid.: 146–7).

Weems has referred to both the 'memories [that] go back' and the formal qualities of Wright and Rosskam's volume in several of her key works. For Weems, growing up in the 1960s and 1970s, the Civil Rights movement and the contradictions generated in its wake were an ongoing dynamic that must have underscored the sense of generational difference sharpened by her parents' Northern relocation. Prompted to study art by 'a pervasive crisis in left-wing politics during the late 1970s', as one critic claims (Kirsch 1994: 9), and hence highly conscious of the traditions in which she works as an American photographer and of her own work as historical and political intervention, Weems began in the 1970s as a documentary 'street shooter' who thought to 'capture the human condition' in candid, unposed images, as she said (quoted in ibid.: 10). But, guided by her folklore training, she moved quickly to include written texts, so that her 'Family Pictures and Stories' series, completed in the early 1980s, combines candid family shots, rephotographed family portraits, and her own first person narratives of 'family folklore' drawn from interviews and offered as both captions and an audiotape version (see Figure 31).

Initiating the work by revisiting immediate family living close by in Portland, Weems admitted initially to some apprehension about the welcome that she and her project might receive. The photographs display a disarming blur and fuzziness, like snapshots by a participant in a family event. They are concerned, notes art historian Judith Wilson, to specify the '"look" of working class Afro-US culture'. Wilson suggests that Weems has 'carefully distinguish[ed] its

Fig. 31. *Mom at Work*. From Carrie Mae Weems's Family Pictures and Stories series. Courtesy of the artist and PPOW Gallery, NY.

features from the undifferentiated and frequently romanticized abstraction known as "the black masses"' (Wilson 1994: 54, n.45). Here, Weems may have looked not only to Wright but also to another photographic forebearer, Roy DeCarava, who collaborated with Langston Hughes on the photo-text book *The Sweet Flypaper of Life* in 1955 (see Stange 2000: 279–305). In that book, intentionally subversive of objectifying documentary forms, Hughes complicates the representation of family life by using as his narrator a Harlem grandmother, Mary Bradley, who loves and praises those she's 'got to look after' even as she delineates their flaws. Rodney, her 'favorite grandboy', is a teenage father, 'lost in his youthhood', although 'it just might not be his fault' (DeCarava and Hughes 1967: 7–11, 31). Sugarlee, mother of Rodney's child, 'don't worry her mind with him', though others among Rodney's girlfriends take different attitudes (ibid.: 86–90). Son-in-law Jerry, whose 'children are crazy about him', a point DeCarava's intimate interior photographs support, doesn't always come home every night (ibid.: 52). To daughter Melinda's efforts at reform, Mary Bradley suggests: 'Long as Jerry brings his wages home, he don't always have to bring his self' (ibid.: 61).

Like the fictional Mary Bradley, narrator Weems proffers both good and bad news along with her pictures: 'Dad and Son-Son really love each other. But when they're drinking things have been known to get out of line, ya know. Well, the last time they were on "full", one thing led to another and before anyone knew what was happening, they'd both whipped out pistols and boom!!' Likewise, the information that, 'Like my mother, my sisters and I all had children by the time we were sixteen or so', becomes an occasion both to recount Weems's mother's dismayed response to news of Weems's too-early pregnancy, and to point out that her parents now 'have plenty grandchildren'.[2]

Prompted, she asserts, by a 'desperate search and need to lock down something certain about my past', Weems visited and photographed an elderly relative who had stayed behind in Mississippi when other family members moved north in the 1950s, finding him in a state of extreme poverty. Included as well in the six-year project are Weems's grandparents, Ozzie and Albert Polk, providers of the family's 'financial center and the spiritual force', with information that Grandfather Albert, said to be the son of a Jewish travelling salesman from Chicago, could pass for white and often used this to advantage in business dealings.[3] Surely it is not only Weems's 'desperation' but also her displacement – even detachment – from this world that enabled this commemoration, as her opening text, citing her apprehension about returning home after a long absence, suggests.

In contrast to the snapshot-like, apparent informality that characterized 'Family Stories', in the 'Ain't Joking' and 'American Icons' series Weems made in the late 1980s images were shot with a large format camera and carefully controlled lighting, giving the photographs the studied, neutrally non-specific look of commercial imagery. In the same way, the captions anchoring them drew their vocabulary and tone from the 'folkloric' discourse of American racism which is always 'in the air'. The elegantly distanced, drumstick-wielding figure in the picture titled 'Black Woman with Chicken' clashes with her caption, forcing viewers to create, Weems has said, a 'double meaning', as we shuttle uncomfortably between photograph and caption in search of elusive resolution (Cooks 1995: 73). A diptych juxtaposing a gorilla's head and a black man's torso, captioned by the riddle 'What's a Cross between an Ape and a Nigger?' requires viewers to slide a panel open to read the answer: 'A retarded ape'. To act on the desire for this knowledge requires viewers to overcome the gallery's traditional prohibition against touching displayed works of art. Deftly placing us in this conflicted situation, Weems ensures that her piece – despite the neutrality of its straightforward images – offers no grounds for disengagement. Nor were the usual gallery-goers the only ones discomfited: at the Rhode Island School of Design Gallery, black custodians went on strike upon viewing 'Ain't Joking'. Even when told that the artist was a black woman, one worker refused to return (ibid.: 75).

Weems retained in her pivotal 1990 'Untitled (Kitchen Table)' series of twenty images the studio setups, static poses, and controlled lighting that refer to commercial imagery and that distance the work from claims to documentary authenticity. The lengthy texts that accompany the images are a tissue of clichés from popular lovesongs and sayings; yet they add up to a

loosely woven story of an intensely felt romance, which some viewers have assumed to be auto-biographical, not least because the main model is Weems herself. However, set in generic inter-iors and 'speaking' time-worn phrases, Weems and the series' male protagonist seem to enact above all an insistence on gender and race as cultural constructions.

In subsequent work, Weems has continued to deploy familiar codes signifying commercial, non-'original' visual (and linguistic) discourse, and to force her viewers to respond intertextu-ally and deconstructively to her work. 'Colored People' (1989–90) offers black and white mugshot-like images arranged singly and in triptychs, and vividly hand-dyed. The range of hues corresponds roughly to her written list of the 'colors' subsumed by the legal and vernacular 'black': 'Pitch Black, Dead Black, Blue Black . . . Chocolate Brown, Coffee, . . . Deep Brown, Honey Brown, Red Brown, Deep Yella Brown, . . . High Brown, Low Brown, . . . Tan, High Yalla, Lemon, . . . Caramel'. Their rich variety overwhelms any attempt to preserve the binary categories generally used to contain 'race' (Kirsch 1994: 16; Wilson 1994: 48).

It is at this juncture that the exhibition, 'And 22 Million Very Tired and Very Angry People', marking an explicit homage to Wright's book, marks as well an opening in Weems's work towards a specifically transnational perspective. The format used in 'And 22 Million Very Tired and Very Angry People' echoes that of the 'Kitchen Table' series, suggesting that the fifteen sepia-toned Polaroid colour images in the show – still lifes of objects such as a rolling pin, alarm clock, or manual typewriter, or of figures with faces concealed – be read as a politically situated compan-ion piece to 'Kitchen Table', thematizing – in contrast – frustrations in the realms of collective rather than personal action. At the same time, banners hung above the photographs carrying texts by figures including Malcolm X, Fannie Lou Hamer, Antonio Gramsci and Weems herself evoke the publicly militant front of a demonstration, to which the title likewise ironically gestures.

Calling African American identity 'an uneasily tied knot of pain and hope whose snarled strands converge from many points of time and space', Wright in *12 Million Black Voices* foresaw the transnational conception of diasporic culture and identity that became familiar in the 1980s and 1990s. The 'black Atlantic', in Paul Gilroy's term, is a cultural space encompass-ing the displacements – and the connections – imposed by the 400-year history of the Atlantic slave trade. 'I've always been interested in searching for my African ancestry outside of an American context', Weems maintains, turning her attention in the 1990s to 'Africanisms main-taining themselves in the United States' (quoted in Grundberg *et al.* 1995: n.p.; see Gilroy 1992).[4] The 1991 assemblage of photographs, text passages, and objects titled 'Sea Islands Series' (see Figure 32) tells what happened when Weems 'went looking for Africa', as a series of mounted ceramic plates included in the exhibition proclaimed. Weems used the exhibition's component parts to actualize and ironize her search: she 'found Africa' in 'uncombed heads acrylic nails & Afrocentric attitudes Africans find laughable'.[5] But she also photographed in the Sea Islands along the coasts of South Carolina and Georgia, where the Gullah (from Angola, birthplace of many American slaves) culture of the black majority still living there makes spe-cially evident the African traces that undergird American culture. Weems used the work of Zora Neale Hurston, her folkloric predecessor in the area, to gather her material, and the plates are perhaps a reference to the folk custom of placing the last cup, plate, and spoon used by a departed family member on the grave.[6]

In this series Weems first made use of the so-called 'Zealy daguerreotypes', striking images of nude African-born men and women slaves made in South Carolina in 1850 at the request of Harvard natural scientist Louis Agassiz. Agassiz believed that photography – viewed as a uniquely objective scientific instrument in 1850 – could offer 'natural' evidence to bolster his claim that Africans 'have differences from other races', and would thus establish firmly that 'blacks and whites did not derive "from a common center"' (Trachtenberg 1989: 53). Weems tones, repeats, and in some cases flips the images, using them as a kind of refrain, the vignetted ovals and their subjects' straightforward gazes framing other elements of the piece.

Photographing on Goree Island and Cape Coast, African departure points for the slave trade, Weems was struck, unexpectedly, by the beauty of the region's architecture. She wrote of the series exhibited in 'Landed in Africa' and 'Africa Series' (1996) that 'the slave coast, its look,

Fig. 32. From Carrie Mae Weems's *Sea Island Series*. Courtesy of the artist and PPOW Gallery, NY.

scale, and dimension' afforded architectural studies in which the great beauty of colonial forts and slave barracoons is purposefully contrasted to the 'horrific reality of what happened' in those places (Grundberg *et al.* 1995: n.p.). In the interior of Africa she found (as had Richard Wright before her) that she was a foreigner irrespective of skin colour, in one instance being denied permission to photograph a shrine in a Hausa village (Piche *et al.* 1998: 17).

A second meditation on African/African-American relations is offered in 'From Here I Saw What Happened and I Cried' (1996), which includes only appropriated images, none Weems made herself. Formal features including text within the framed area of the image, and the repeated motif of monochrome tinting, recall Weems's earlier exhibitions, linking them together as emanations of a continued train of thought. And Weems has also repeated images from one series to another, equating the photograph's framed surface and content with text, caption, and mechanical manipulation as but another syntactical element in the message currently under construction.

'From Here I Saw What Happened and I Cried' was commissioned by the J. Paul Getty Museum in Los Angeles and was first exhibited there. The commission was intended as a response to an exhibition at the Getty of rare photographs of African Americans in the mid-nineteenth century, selected from both the Getty's own collection and that of private collector Jackie Napolean Wilson ('Hidden Witness' 1995: n.p.). Including no 'original' photographs by Weems, Weems's show refers to no photographer but only photographs, no perspective but only perspectives. Its images appropriated from disparate sources, and its textual narrative of brief, evocative phrases, constitute an organized assemblage of identifiable visual and verbal codes, structured, as Wright's text was, around the insufficiently acknowledged absences of both a tale and its tellers. 'There are no stories of the middle passage,' claims Weems; 'One hundred million people were stolen and sold from their homes, shipped across the world, and not a single story of that journey survives' (ibid.: 22).

The show 'starts' with a large blue-tinted profile portrait of a woman in West African head-dress – the Mangbetu woman Nobosodru, photographed in 1925 – looking to the right.[7] Text superimposed over this image reads 'From Here I Saw What Happened'. At the end of the 32-image sequence, the same portrait, flipped to look left, reappears with text reading 'And I Cried'. The intervening images, and the superimposed texts composed by Weems, sketch a roughly chronological narrative of African American life. Marked by the repeated opening phrase, 'You became', the text constructs an array of subject positions: 'A scientific profile, . . .

a negroid type . . . mammie, mama, mother . . . confidant, . . . root worker juju mamma voodoo queen . . . an accomplice . . . riders and men of letters . . . boots, spades, and coons', and, near the end, 'anything but what you were . . .'

The pictures selected appeared 'originally' in the realms of commercial publicity and illustration, scientific documentary, pornography, art photography, and reportage. Near the beginning are, again, J. T. Zealy's slave daguerreotypes. Weems also includes (without attribution) Robert Frank's well-known image of a black nurse holding a white baby, Garry Winogrand's of an interracial couple with a young monkey, and Robert Mapplethorpe's infamous 'Man in a Polyester Suit', cropped and vignetted. Much of the power of the work resides in the seamlessly constructed uniformity of its presentation – which extends to identical sizes, shapes, and tints of the images, as well as the text spacings and placements; the texts are all in capital letters without punctuation, horizontally centred within each image, and exactly level around the gallery walls.

Just as the text repeatedly marks the distance between the 'I' that sees 'from here' and the 'you' that changes perpetually – but only into 'anything but what you [are]' – so the pictures foreground the mechanics of reproduction and the inevitability of mass circulation rather than any claim for authenticity or indexicality. Weems's manifest appropriation and manipulation of visual history undermines any notion of photographs as mirrors exactly representing reality. The exhibition structure evokes a split, hybrid viewing position and, more specifically, Weems situates the viewing eye and speaking 'I' in 'Africa', fixing for both gaze and narrative a transnational point of view. In this perspective are located the possibilities for reassembling traces of the past into new, if only temporary, unities. Thus Weems renews in a current idiom the possibilities for 'something real' that inhere in the very ambiguities of diasporic 'double vision'.

'From Here . . .' offers a perfectly balanced – and perfectly unresolved – array of social, political, aesthetic, and photographic concerns; not least among them the role of the black image maker or – perhaps more accurately – image manager. As Thelma Golden points out, Weems's relation to the project can be conceived as curatorial, her intervention not just a recontextualization but a revised pedagogy of visual culture made by and about African Americans (Golden 1998: 31). In retrospect the project marks a significant point in Weems's career. The readily assumed curatorial role is testimony to the indisputable solidity of Weems's identity as artist, and thus to her freedom from the necessity that individual artistic self-assertion be autobiographical as well.

In the late 1990s and at the century's turn, she created a series of three 'fabric suites'. These installations of semitransparent muslin banners and stretched canvases are arranged floor to ceiling in the gallery, bearing large scale, even life-sized, digitally transferred images, selected from many sources. Spoken texts address epochal historical events. 'The veil-like images hovered over and around viewers, who were forced beyond a safe viewing distance and into physical contact with the recontextualized pictures', wrote one critic, noting as well the 'whispered' effect of Weems's spoken audio text as it 'floated through the gallery' (Desmond 2002: 75). 'Ritual and Revolution', first of the fabric suites, begins with banners imaging Weems herself, arrayed in white robes and flanked by the classical columns of the Great Altar of Pergamon, every visual detail, it would seem, arranged to connote 'universality' in a Western context (see McInnes 1999: 14). Weems has long considered 'whether it might be possible to use black subjects to represent universal concerns', as she has said (Patterson 2000: 24). Yet these visual connotators of such concerns are immediately problematized not only by the history of the Pergamon Altar – brought to Berlin from Turkey in 1890 and now displayed there in its own museum – but also by the exhibition's title terms, which underscore the unlikelihood of universal meaning, their pairing unfixing rather than fixing their binary relation – are they opposites? complements? parallel categories? Universality is inalterably problematized, Weems suggested in an interview in Berlin, where the piece was on view in August, 1998, by the hypervisibility of the black body in the West: the 'black body presence articulates, by its very nature . . . a resistance. Whether that is my intention or not doesn't matter, but my presence is a disruption and a reminder of something that has happened in . . . American culture'. In contrast

is the non-presence of the 'Jewish body as reminder', as 'a consistent voice of resistance and a consistent voice of challenge to a kind of German hegemonic culture' (Cabanas: online). A Berlin reviewer, she noted, described 'Ritual and Revolution' as 'kitsch', a response which Weems found 'quite wonderful' and not offensive, attributing it to the lavish materiality that embodied the artist's message of ineluctable resistance, a richness of material form that looked – in Berlin – 'too elegant, too beautiful, . . . too soft' (ibid.). An American essayist, in contrast, noted that the 'terror' of Weems's appropriated images of Holocaust victims, Civil Rights protesters, and Cambodian prisoners, is 'mitigated by the sheerness of the fabric', which makes 'such images . . . as permeable to light, to the fragility of light, as they should be to emotion, intellect, understanding' (Larson quoted in McInnes 1999: 16).

The last of the fabric pieces, the 2000 'Hampton Project', is the most historically specific. A commission initiated by Williams College, its purpose was to celebrate the connection between its alumnus Samuel Chapman Armstrong and Hampton University, which he founded in 1868 as Hampton Normal and Agricultural Institute to offer academic and vocational education to former slaves and their children, and, from 1878 to 1923, to Indians. The unexpectedly fraught history of the exhibition seems metonymic of Hampton's own history; its institutional mission, as described by cultural historian Judith Fryer Davidow, having been to 'transform the primitive, squalid, and disorderly into the improved, well kept, and civilized' (Willis-Kennedy 2000: 67). Davidow's terms, eerily echoing, in a darker register, Richard Wright's 1937 denomination of 'theme' for 'Negro writers', leave no doubt of the material's resounding ideological charge. The history of Hampton is perhaps doubly charged for contemporary interpreters, especially if we are unconnected to the institution. Hampton is emblematized by and most often discussed in terms of photography, having been first documented in 1900 by photographer Frances Benjamin Johnston, whose 159-image *Hampton Album* was displayed at the Exhibit of American Negroes at the 1900 Universal Exposition in Paris and widely circulated in the United States, winning a grand prix at the Pan American Exposition in Buffalo in 1901 (Glenn 2000: 64; Kirstein 1966). Johnston's sumptuous platinum prints were more recently exhibited and republished by the Museum of Modern Art in New York, which now holds them, gaining a wide audience of viewers.

Well aware of these complexities, Williams College and Hampton initiated a project in which a contemporary African American or Indian woman photographer would, according to Hampton University Museum Director Jeanne Zeidler, respond both to Johnston's work and to life at Hampton University today (Zeidler 2000: 76). As in Weems's previous fabric work, the piece includes digital transfers of images appropriated from many sources as well as some made by Weems herself (see Figure 33). Thirteen images of Hampton students, graduates, and surroundings, spanning over fifty years, were taken from Johnston's album and from the Hampton archives, including work by Hampton's Camera Club. Other images originate in the Williams College archives, Edward Curtis's archive, and other documentary, art world, and photojournalistic sources. Her concept, Weems has said, developed in considerable part out of conversations with Hampton students (Weems 2000: 79).

Weems's accompanying text addresses the dynamics of the transition that Hampton's education sought to effect, seeking to open 'a critical dialogue that focuses on the problematic nature of assimilation, identity, and the role of education' (ibid.: 78). The text conflates Hampton with other paternalistic nineteenth-century institutions, and with missionary projects which sought, as she says, to produce students 'educated away from yourself, [who] gave up Ogun, Ife, Yemoja, Obatala & Wankan alike for a single alien god', making 'progress' measured 'by your successful distance from your past' (Weems, exhibition text in Patterson 2000: 72). A concluding section of exhibition text juxtaposes an acknowledgement that 'against the odds/I saw you become many things you/weren't supposed to be', with a list of Indian names – some of the thirty-eight such names to be found on headstones in the Hampton cemetery. Their burial there, Weems asserts, 'is contrary to Native American spiritual belief' (Weems 2000: 78).

With retrospective humour, Weems calls the Hampton materials she worked with 'a gold mine and a land mine'. Noting that she knew 'a critical approach' would discomfit the 'museum

Fig. 33. From Carrie Mae Weems's *The Hampton Project*. Courtesy of the artist and PPOW Gallery, NY.

administration', she insists that 'nothing moves forward without looking at the multiple levels of reality . . .' (ibid.: 78–9). To Jeanne Zeidler, such multiplicity is exactly what the project lacked: 'The approach she proposed was in direct opposition to the efforts, ongoing for well over a decade at Hampton, to break down stereotypes, to treat contemporary and historical people as individuals with unique stories, and above all, to have them speak for themselves about their lives.' At the Hampton Museum, wrote Zeidler, the effort is to 'strive never to portray people as nameless victims. We try not to assume or to convey that all Native American students or all African American students have the same experience, same goals, same beliefs, and same reactions to historical forces.' In the 'Hampton Project', Weems has 'appropriated images of real people who have/had real lives and real stories, and decreed meaning that may or may not fit the facts of these individual lives'. Finding the exhibition concept 'incompatible with Hampton's approach to using historical information and cultural materials', the Museum declined to exhibit the show (Zeidler 2000: 77).

The 'critical dialogue' Zeidler initiates here takes shape around the very questions of biography as form and content, of history and memory, of author, authority, and authenticity, that Weems has thematized throughout her career. Like the disturbingly close, yet gauzily permeable, banners of her installations, the debated terms and identities overlap, complement, and conflate as well as distinguish and oppose. Unfixing both the tale and its teller, Weems's art constructs temporary unities; and like the American culture that it figures, her work proposes universality as a desire among many.

Notes

1. Many thanks to Sophie Naess for essential research assistance for this essay.
2. Carrie Mae Weems, 'Family Pictures and Stories – TEXT'. Distributed in xerox by PPOW Gallery, 532 Broadway, New York, NY 10012.

3. Carrie Mae Weems, 'Family Pictures and Stories'. Distributed on audiotape by PPOW Gallery, 532 Broadway, New York, NY 10012.
4. Distributed in xerox by PPOW Gallery, 532 Broadway, New York, NY 10012.
5. Installation text printed on a ceramic plate, reproduced in Weems (1995: n.p.).
6. Weems's text recounting burial customs is in Piche *et al.* 1998: 16–17. McInnes notes that Weems 'culled . . . sayings from Zora Neale Hurston's . . . essays' (McInnes 1999: 21, n.6).
7. The photograph is identified as George Specht's, taken during the 1925 Croisiere Noire expedition (Powell 1997: 29).

Anthropology at the Movies

Jerry Maguire as 'Expeditionary Discourse'

JONATHAN GAYLES AND S. ELIZABETH BIRD

Jerry Maguire, the break-out movie for director Cameron Crowe, was one of the most success-ful films of 1996. Although not originally conceived as a 'blockbuster', it garnered numerous awards and huge box office and video profits, and is approaching the status of a modern classic. One important factor in *Maguire*'s success lay in the way it retold a narrative that has deep cul-tural resonance – a story of personal redemption through travel and knowledge of the 'exotic other', with the concurrent redemption of that very 'other'. In that respect, it belongs in the same tradition as 'going native' films like *Dances with Wolves*, and it carries with it the same baggage related to race and power (Baird 1996).

Within the discipline of anthropology, analysis of film has largely focused on ethnographic films – documentaries intended to describe a culture different from that of the presumed audi-ence. Rarely do anthropologists venture into the analysis of popular, fictional movies. There is no reason why they shouldn't; MacDougall defines visual anthropology as 'an anthropology of visible cultural forms . . .' (MacDougall 1997: 283), while Morphy and Banks describe the field as 'the exploration of the visual in the process of cultural and social reproduction' (Morphy and Banks 1997: 17), adding that it 'must include the visual cultures of the West . . .' (ibid.: 21). Ginsburg (1994) argues that films are indeed documents which may offer entry into cultural attitudes and values. Yet her arguments have largely been applied to films produced by non-Western societies. Anthropological analysis of feature films has been neglected since Weakland, writing in 1975, argued that analysis of feature films is 'surprisingly close to traditional anthro-pological interests and methods' (Weakland 1995: 45). Anthropological interest in mass media is growing rapidly, especially in the area of ethnographic audience research (see Bird 1992; Askew and Wilk 2002); nevertheless, close cultural analysis of specific cinematic texts, which Weakland recommends, remains rare.

Occasionally, anthropologists do look at Hollywood films asking, for instance, whether they are 'accurate', especially in representations of ethnicity (Spitulnik 1993), or even in their repre-sentation of anthropologists themselves. Thus Chalfen and Pack discuss how anthropologists reacted in horror at the almost burlesque style of the 1998 movie *Krippendorf's Tribe*, with its stereotypes of both 'natives' and anthropologists. At the same time, their short analysis of *Krippendorf's Tribe* goes beyond issues of accuracy, taking them on paths rarely trodden by anthropologists, as they stop treating the movie as a failed ethnographic account, and start treating it as a 'native document'. They recognize that we do not look at a myth or a folk-tale for a mirror account of a culture, although we may indeed recognize cultural specifics in it. We know that the localized details of clothing, food, and custom in the tale are part of the whole package, contributing to the local, native understanding of the story as 'authentic'. But the meaning of the story goes far beyond those simple issues of representational accuracy. Instead, argue Chalfen and Pack, we should examine how the movie includes narratives that have cul-

tural meaning to the audience, such as notions of the exotic, of the absent-minded academic, and 'the ideal of being adopted by tribal members . . .' (Chalfen and Pack 1998: 104).

Chalfen and Pack suggest that the most interesting question raised by *Krippendorf's Tribe* is not whether the harried hero is actually an accurate representation of anthropologists, but why this particular representation is assumed to work for audiences, and what it can tell us about the culture's understanding of both anthropology and the 'exotic other'. So, rather than taking their cues from ethnographic film analysis, they take them from the cultural analysis of Drummond (1996), one of the few anthropologists to develop the study of movies as 'native documents'. Drummond does not focus on 'art house' movies or critical triumphs, as film scholars might; he is not concerned with aesthetics or individual genius. Instead, he explores popular blockbusters, like *Star Wars*, *Jaws*, and *ET*, arguing that these are the texts that allow us access into the structures of contemporary culture.

So an anthropological approach asks not whether a movie is literally 'true', but whether it 'rings true' to the audience. In Drummond's terms, it confirms a mythological or symbolic truth. That truth may not be perceived in the same way by all viewers; audience reception studies tell us that men and women, or people of different ethnicities, may read the image very differently (Bird 1996; Bobo 1995; Cohen 1991; Shively 1992).[1] For the Hollywood moviemaker or TV producer, authenticity is a careful mix of actually researching the setting of the film for accuracy, so that no glaring errors disrupt the audience's sense of appropriateness, and gauging the 'truth' that the audience actually wants to see. In theory, creating an ethnographic film is different, although the impulse to produce something that conforms to audience expectations is often at the root of many debates about ethics and accuracy in ethnographic film, especially those aimed at a large, television audience (Wright 1992). Ethnographic films are also 'native documents', encoded with particular ways of seeing the world, often resulting in stereotypically exoticized representation in nominally 'factual' documents (Lutz and Collins 1993). Indeed, ethnographic film has long been criticized for its tendency to succumb to grand narratives of the exotic, casting the (white) anthropologist as intrepid explorer and bearer of civilization. Tomaselli describes this narrative as an 'expeditionary discourse' (Tomaselli 1992: 209) that has traditionally undergirded ethnography: 'these journeys make sense as a "coming to consciousness", of encountering and coming to know the "Other"' (ibid.: 210). As a classic example of the discourse operating over an extended period, Tomaselli offers the anthropological treatment of the San people of the Kalahari (popularly known as 'Bushmen'), in both print and visual ethnographies, arguing that this is emblematic of the way anthropologists have framed 'exotic' people, while using them to explore their own identities. This discourse is not confined to anthropology, but in fact pervades mainstream, White culture, as Tomaselli recognizes, including in his discussion the popular treatment of the San in novels and such movies as *The Gods Must be Crazy*. Popular culture is saturated with the discourse, from museum exhibits (Karp and Levine 1991) to movies (Baird 1996; Shohat and Stam 2002) to travel writing (Pratt 1992) and popular journalism (Peterson 1991); it is 'hidden in plain sight around us' (di Leonardo 1998: 10).[2] Thus we use the narrative of *Jerry Maguire* as an entrance point into the culture that made and responded to its 'expeditionary discourse' – a discourse that is so naturalized that the filmmaker, like ethnographic filmmakers before him, almost certainly did not plan or recognize it as such.

The relationship between White sports agent Jerry Maguire (Tom Cruise) and Black football player Rod Tidwell (Cuba Gooding, Jr.) is one of two central relationships in this film. After an initial crisis, Maguire 'goes native' with Tidwell, losing credibility with his colleagues, his fiancée, and the culture they represent. Maguire then works on 'converting' Tidwell, the native, while Tidwell teaches Maguire about love and women, thus allowing him to connect with his new love interest, Dorothy Boyd, with whom he has the other central relationship. Our analysis will focus on the relationship between Tidwell and Maguire, as the 'expeditionary discourse' is played out in it.

The first contact between Maguire and Tidwell comes at a moment of extreme crisis for Maguire. He has just been fired from his job, his life is in disarray, and he faces the traditional

moment when the reluctant hero is thrown into a perilous situation. He rushes to call and retain his clients before they are claimed by the sports agency that formerly employed him, while his former protégé is placing calls in an attempt to steal his clients. Amid a full telephone panel of calls on hold, Maguire finds himself struggling to retain Tidwell, who is clearly not a major star. Their exchange here is one of the more telling (and famous) scenes in the film. Viewers watch both parties, providing pointed visual contrast between the worlds of Tidwell and Maguire. Amid pulsing and thumping rap (jungle) music, Tidwell demands Maguire's attention, demanding he perform specific acts. Tidwell is pushy, loud, and unreasonable. Eventually, Maguire performs successfully and retains Tidwell as a client, but, when he hangs up, his other calls are long gone.

This scene constitutes Maguire's rite of passage, during which he separates from his former life, and begins the process of 'going native': Tidwell begins by enthusiastically priming Maguire, asking 'Are you ready Jerry?' Maguire assures him he is, to which Tidwell shouts: 'Here it is . . . Show me the money!' He repeats the directive several times, dancing as if in a frenzy, and ordering Maguire: 'Say it with me one time, Jerry!' Maguire repeats it, each time more loudly, as Tidwell eggs him on, claiming he has competing agent Bob Sugar on another line. Finally, Maguire is yelling down the phone: 'Shoooooow meee the moneeeey!' over and over again. In a frenetic call-and-response, Tidwell then yells: 'Do you love this Black man?' and Maguire shouts, 'I looove the Black maaaan!' Tidwell dances on, high-fiving his brother, and pushing Maguire further. 'Who's your motherfucker?' he screams, to which Maguire yells 'You're my motherfucker!' His trap sprung, Tidwell suddenly becomes quiet, remarking conversationally, 'Congratulations, you're still my agent,' as Maguire becomes painfully aware of the looks on his stunned co-workers' faces.

In this scene, Maguire, the displaced White man, essentially 'goes native' to retain Tidwell. With Tidwell incessantly calling him 'brother', he casts off his own culture, and embarks on an expedition into the unknown. We will find out that through this journey, familiar to us from legend, popular culture, and anthropology, he will transform himself, and, almost incidentally, his informant/guide. Within this scene the location switches between Maguire, in shirt and tie in his office, and Tidwell, in his home, shirtless with his loose sweat pants barely staying up. As Maguire desperately attempts to save his career, a dancing Tidwell occupies Maguire's time by forcing him to yell obviously unfamiliar phrases and slogans. As Maguire is forced to scream 'I love the Black man!' in his decidedly lily-white office, it is a moment of great humour and much meaning. His colleagues watch him in disbelief, and as Maguire is departing, Blacks suddenly appear in the office, watching intently. Until then, no Blacks are prominent in any camera angle, except for the posters of athletes; in fact there are only five, extremely brief, shots of Blacks. Yet during Maguire's farewell speech, there are no less than 23 shots of Blacks. Additionally, there are four consecutive shots with Blacks constituting at least half of the extras in the shot, with Blacks forming the majority (2/2, 3/4 and 3/4) in three of these. Perhaps we receive a glimpse of Maguire's destination in the journey about to be taken. The important point here is that Maguire's prolonged engagement with Tidwell is shown to place Maguire's entire career (and his very identity) in jeopardy. He could not play the silly games required by Tidwell, and at the same time maintain his distance and his career. He had to make a choice, and the decision forced him down from the veranda of his high-rise office, out of his world of comfort and confidence.

In the 'expeditionary discourse', anthropologists and explorers have historically laid claim to exotic peoples as 'theirs', presuming to speak for them, to represent their best interests, and to present them to the dominant culture. The next scene between Maguire and Tidwell reflects this well. Maguire has made his decision, and he is now embarking on the 'selling' of Tidwell, which will mean retooling his wild image. At a sports marketing convention we find Tidwell dressed awkwardly and looking lost. 'What am I doing here Jerry?' he asks. He is the exemplar of the native lost in a strange land. Luckily Maguire takes responsibility for him: 'I want (everybody) to see you for what you are: the best kept secret in the NFL . . . You are fast, fierce and wildly charismatic.' Maguire calms the spooked Tidwell and assures him that the bright lights and strange sounds of the (apparently) new world can't harm him. Whose 'secret' is Tidwell?

He is Maguire's. For decades the ultimate anthropological/expeditionary fantasy was to 'discover' a 'new' people and expose them to the civilized world, and this dynamic operates here. Maguire proceeds to 'present' Tidwell to his colleagues, while a dutiful Tidwell says little, shakes hands, and smiles on cue.

However, Tidwell is not immediately embraced, and Maguire reaps the consequences of his choice to go native. Maguire had managed to persuade the top college prospect, Frank Cushman, to stay with him after he was fired, and during the convention he interrupts Tidwell and abruptly departs to cater to Cushman. While relaxing with the prize prospect and his father, Maguire tries to persuade the father to commit in writing. The father, leaning forward for effect, tells Maguire that he signed with Bob Sugar an hour ago. 'You were in the lobby with that Black fella.' It is the ultimate catastrophe on the night before the draft, and it makes starkly clear the relationship between Maguire's going native and his downfall, as his life begins to fall apart. We watch Maguire's fiancée turn on him, punching and kicking, after he realizes that their relationship is hollow, and ends it. She represents the soullessness of his culture, and his time in 'the field' has changed him. On the plane home we see a funny and important moment, as Maguire sits with his only client. Drunk with alcohol and self-pity, he is reassured by Tidwell, who grabs his hand: 'We're together on this. Know what I'm saying. We're gonna be as one – the both of us,' before bopping his head to the music of James Brown. Maguire, in a moment of clarity, slowly says, 'Oh my God,' with disgust dripping from his voice. Maguire has lost everything and finds himself attached to this native, on whom he must depend.

Now Maguire has to make the best of his new cultural status, and he begins bringing Tidwell into the mainstream. Page (1997), analysing media depiction of Black men, argues that the imagery defines them as 'embraceable', meaning those men who conform to White ideals of behaviour – and 'unembraceable' – those who refuse to conform. Within the expeditionary discourse, this dichotomy coincides with that between Savage and Civilized, and as the conversion proceeds, we see before our eyes the transformation of Tidwell from 'unembraceable' to 'embraceable' Black male. The famous 'shower scene' is a pivotal moment. Maguire has asked one of Tidwell's team officials for a favour in making a lucrative-but-fair offer to Tidwell. This request is summarily rejected and Maguire finds himself at a dead end. In the locker room after a game, he reports to Tidwell, who is angry. A fully-clothed Maguire tries to 'convert' Tidwell by talking sense into the naked native, an image not easily forgotten. He appeals to Tidwell to 'bury the attitude'. Tidwell responds, 'Wait! You're telling me to dance!' He continues: 'Do your job. Don't tell me to dance. I am an athlete. I am not an entertainer!' Of course Maguire *is* asking Tidwell to dance, by trying to get him to understand that 'his people' (Maguire's people) want to see joy, not Tidwell's truculence. Tidwell, ignorant, arrogant and most certainly unembraceable, wants to stay unconverted.

One can imagine few circumstances where a heterosexual male will bow to another male who is naked, yet Maguire, in perhaps the most striking scene in the film, then literally bows before Tidwell, imploring him to 'Help me help you!' To bow is to show deference, and this is the first such action by Maguire. Why now? Maguire has no other options. At his wit's end, he humbles himself before the naked savage, begging for assistance from the savage to help the savage. We know that if Tidwell remains unconverted, he will be destroyed along with Maguire; but meanwhile Tidwell mocks Maguire, and stands naked and defiant as he leaves.

Tidwell is swiftly brought back to earth. An insulting offer from his team leaves him lost and confused, and he pleads to Maguire: 'Jerry, tell me what to do. You tell me to eat lima beans and I'll eat lima beans.' The native, arrogant and ignorant, realizes the value in the missionary's message. When lost and meek, Tidwell is eminently more embraceable, and the bond between the two is strengthened when he decides not to accept the contract and pursue free agent status. Without this contract, any career-ending injury will be disastrous, but it is a risk they will take together. They embrace with a strong handshake, and Maguire's native status is solidified.

Now Tidwell is the native, who needs Maguire to make wise choices. Tidwell accepts a job endorsing a car dealership, in which he must ride a camel and wear a turbaned crown, representing 'Camel Chevrolet'. The turban and camel help frame Tidwell as a native, and although

he attempts to instruct the director about the camera angle that will make him 'look more pow-erful' it is clear he has no power here, as he is repeatedly ordered to 'Get on the camel!' His input, although *he* is the native, is irrelevant, and Maguire must rescue him. The story moves on to the Big Game, where Maguire has to shoo off Bob Sugar: 'Get away from *my* guy' [empha-sis added]. Tidwell thanks him for coming and Maguire responds with 'What can I say? You're all I've got.' It is a reminder that Tidwell has been claimed by Maguire and protected from those who will not 'look out' for him. This exchange happens just before the big *Monday Night Football* game – Tidwell's great opportunity for recognition. As they both look out onto the lighted field, Maguire stands next to Tidwell like a proud parent.

The game is on the line and Tidwell runs his pass pattern. He leaps and makes the game-winning catch but falls awkwardly on his neck after being tackled. The stadium goes quiet, and there is panic in the Tidwell household, where his family watches the game on TV. Tidwell lies on his back, apparently unconscious, while the trainer fails to arouse him. Suddenly from the stands a lone female voice cries out, 'We love you Rod!' It echoes. A team trainer claps his hands in front of Tidwell's face and his eyes open. Slowly he rises and the crowd roars. Next comes an amazing moment. Tidwell begins to dance. He dances and dances, preening for the camera, while the announcers react in surprise. Tidwell ends his performance by climbing the stands and being embraced by his adoring fans.

We might call this scene 'Tidwell's rebirth' – into a faith where one must die before being reborn. After hearing 'We love you Rod,' Tidwell awakens to a point of transition – when the door to the world described by Maguire opens up. His dance was a celebration of much more than a touchdown – it was a conversion. Remember his earlier words: 'Don't tell me to dance.' Now he dances before a delighted crowd; he is finally embraceable, both figuratively and liter-ally. Five embraces occur at the climax of the film. First, Tidwell jumps into the stands and is physically embraced by the fans. Next, 'In Rod We Trust' is flashed on the giant electronic screen; the television audience embraces him as he blows kisses in return. When Tidwell emerges from the locker room, he ignores the mob of reporters and asks, 'Where's Jerry?' Maguire steps in and they embrace; Maguire again claims his convert. Finally, he is embraced by a mob of cameras and microphones as Maguire departs. He is no longer the 'other'. We need hardly mention that this is a *Christmas* edition of *Monday Night Football*.

Like all good anthropologists and explorers, Maguire learns from the natives. A theme of the film is his inability to connect emotionally with women, since his worldly cynicism has dulled his senses. Luckily for him, the relationship between Tidwell and his wife Marcy is one of openly expressed mutual admiration. Through the Tidwells' relationship, Maguire rediscov-ers this portion of himself, with Tidwell becoming his Native 'spirit guide', as he struggles to relate to his new girlfriend, Dorothy. There is a restaurant scene in which the Tidwells bemoan the fact that Marcy sees movies without Rod. They begin to kiss and coo, upon which Maguire attempts a clumsy imitation with a kiss on Dorothy's hand and then her forehead. Later, Maguire seeks advice from Tidwell about dating a single parent; later still, after Maguire's rushed wedding, Tidwell recognizes Maguire's lack of self-honesty and confronts him. Finally, after his triumph, amidst a barrage of cameras, Tidwell emotionally celebrates his triumph with Marcy over the telephone. Maguire sees this and rushes to reclaim his estranged wife in the movie's final resolution.

Throughout the film, Tidwell is juxtaposed against 'TP', his younger brother. TP is larger than Tidwell and much darker. We first encounter him in a room in his older brother's house. Rod is on the phone, berating Maguire about his contract, when he hands TP the phone to greet Maguire. 'Hello, Brother Maguire,' says TP, slowly and mockingly. As Tidwell moves through his home, TP follows him. The only distinguishable words on the front of his T-shirt are, 'Yes, I am Black', while the back clearly reads 'Do not arrest this man'. As TP follows his brother into the kitchen for the 'show me the money' scene, he holds a football and dances behind Tidwell.

The movie's climax addresses TP in a significant way. The big football game has playoff implications for Tidwell's team, the Arizona Cardinals, but most important for the story is the huge opportunity for Tidwell to shine and gain leverage for a contract. The Tidwell family

watch on TV; as the game begins TP, still holding a football and wearing an 'X' pendant high-lighted with cowry shells, says ominously 'better not mess up for *Monday Night Football*'. As Tidwell is punished with crunching tackles, TP critiques his play, finally remarking 'He ain't gonna have nothing left for next season. He gonna end up killin' himself.' Marcy, patience waning, tells him to be quiet, and with the game on the line, the quarterback fires the ball to Tidwell in the endzone. He makes the incredible game-winning reception, then is knocked cold, in what potentially could be a career, or even life-ending moment. As everyone else is silent, TP interjects 'See, told you he was too small for the NFL.' After Marcy tells him to 'shut up', he continues, until Marcy yells, 'TP, shut up, shut up. Can't you be loyal to your brother who loves you?' She then physically attacks him. As the movie concludes, Tidwell is being interviewed on ESPN about his new contract. He goes into a litany of gratitude and affection; addressing TP he says, 'You're militant but I got nothing but love for you.' TP is wearing the same shirt he was wearing at the start of the film.

This contrast between the newly converted Tidwell and his younger brother is important. TP is the ultimate native. He has no real name, he envies his brother, and he represents an extreme 'dark and exotic other'. Yet the character somehow does not fit easily in the movie. Why did Tidwell need a younger brother who is aggressively pro-Black and envious, even sadistic? The answer lies in the need to clearly mark Tidwell's conversion into an embraceable Black male; as Page puts it, 'an image deemed "too black" can rapidly lead to public denouncement' (1997: 107). This contrast is underlined by the apparent implausibility of TP's hostile reaction to the 'conversion' scene. TP's insensitivity at this point is awkward and rather mystifying; he has not reacted like this before. It seems unlikely he would openly display such antipathy towards the brother who provides his home and livelihood. If his brother's career ends, where does that leave him? Even if he harboured envy, why would a brother openly trumpet a potentially life-altering injury as an opportunity to say, 'I told you so' in front of his family? In any case, we are led to believe that Tidwell had an outstanding college football career, and at least a consistent professional career. It would be nonsensical to assert that his brother was too small for the NFL. The point of the exchange seems to be to draw more clearly, and at this precise moment, the demarcation between the newly acculturated, forgiving, and embraceable Tidwell, and his militant brother, who represents the unembraceable Black male – the male who will not convert, and thus is doomed to failure. Although TP's role in the film is small, and almost appears superfluous, it actually has an important narrative function. His militancy has been established in many subtle ways: his darker skin, the T-shirt, the smirking greeting to Maguire, and finally the 'X' medallion, which commonly refer either to Malcolm X himself, the Spike Lee film *X* or both. Either way, Malcolm X is an icon of Black militancy, embodying much of what White America has feared. None of this is overtly addressed in the film, but in order for the redemption narrative to work, TP must provide the foil for the converted Tidwell.

In reading *Jerry Maguire* this way, we do not argue that it is a 'racist' movie. Rather, we suggest that close readings of popular movies can help tell us something about the narratives that resonate in mainstream culture. Gabler argues that over this century, film has become the central mass medium of our culture, as movies 'interpenetrated reality in a way no other art or entertainment had, in part because as a photographic medium they were fashioned from the materials of reality . . . the movies played in our heads and seemed to replicate our own consciousness. Conspiring with the dark, they cast a spell that lulled one from his own reality into theirs until the two merged' (Gabler 1998: 50).

Gabler's point echoes our earlier argument on the importance of studying movies anthropologically. A film's images and narratives are not random, nor are they *only* the reflection (and reproduction) of a particular director or screenwriter's vision. To be popular, a film must speak to its audience; it is not a reflection of reality, but is 'fashioned from the materials of reality', and must ring true. We argue that an important element in the success of *Jerry Maguire* was the way it told a familiar story about the journey of one White man into the unknown territory of the Other, a journey through which he found redemption, and also redeemed the Native, who learned to accept his role in the dominant culture. For the Native, this redemption means

rejecting aspects of his culture that are deemed unembraceable by the dominant culture, while at the same time, he is able to teach his mentor about more 'real', even 'primitive' things like spontaneity and love. In fact, the film contains time-honoured themes and images which reflect 'exotic' encounters and the dogged determination of the self-sacrificing missionary who refuses to give up on 'his' charge. These themes correspond with traditional, white anthropological notions of the self/other dichotomy and the 'claiming' of exotic peoples. As Grace writes, in an analysis of the career and image of Robert Flaherty, the pioneering filmmaker: Flaherty 'needed "Nanook" to tell him who he was – and was not . . .' (Grace 1996: 141).

The relationship between the two men is not equal in this narrative; the movie is Maguire's story, not Tidwell's. And it raises the same kind of questions that the 'expeditionary discourse' of anthropology must face. At one point in the film, Tidwell asks Maguire: 'Are we really friends?' It's a question that ethnographers and ethnographic filmmakers also face, either explicitly or implicitly in their relationships with those they study (Tomaselli 1996), and it's a question that seems to nag at all the issues of race and power that are explored in the movie. Through films like this, the culture explores uncomfortable notions about race, retelling them in familiar ways.

This is not to say that *Jerry Maguire* is simply a retread of old, colonial discourse. As Drummond writes, culture 'has to be continuously rethought; the conceptual parameters that define the system must accommodate new and ever more complex perturbations' (Drummond 1996: 33). For instance, expeditionary tales, whether Malinowski's canonical Trobriand ethnography (Malinowski 1922) or pot-boiler captivity narratives, have long been a vehicle for exploring different notions of sexuality, as the white protagonist observes the habits of the natives with either disgust or admiration (Bird 1999). In movies like *Dances with Wolves*, the hero learns about love and caring through watching the Lakota. Yet it is very rare in popular culture to see African Americans as people from whom Whites can learn about love and sex. In this respect, *Jerry Maguire* 'breaks the rules', for it is Tidwell's loving relationship with his wife that is the vehicle through which Maguire learns about love and commitment. Only through the tutelage of Tidwell does Maguire learn to develop a tender relationship with Dorothy. Their courtship is marked by constant interaction, not only with Tidwell, but with a range of 'Others', from a deaf couple, through Mariachi bands serenading them as they eat, to a wedding visibly populated with people of all ethnicities. The thread of this story is that only through severing his ties with the decadent lovelessness of his culture can Maguire learn true love and commitment. While this is an old theme, it takes on a new spin in the movie – mythical themes keep their power, but they also transform with the culture.

Popular narratives are a way into the values, fears, and concerns of a culture. *Jerry Maguire* is not overtly about exploration and redemption, in the way an Indiana Jones yarn might be, but it employs the same tropes more subtly. It is also not explicitly about race – yet it would not have 'worked' if Tidwell had been White, with the narrative tension of race removed. A close reading of *Jerry Maguire* as native document may help us see how the ideology of race and power is naturalized (Hall 1995) through a story that reworked themes of long and continuing cultural resonance.

Notes

1. While we do not explore reception ethnographically, we believe our personal identities as viewers are significant. One author is a middle-aged, White woman, the other is a young African American man. This does not *define* us as people, but it is relevant to our experience of the movie, and we believe our differences work together to strengthen our argument.
2. The cited references document many examples of the 'expeditionary discourse' in popular culture. Other examples are easy to find. For instance, media publicity for a highly successful 1998 Florida museum exhibit, 'Empires of Mystery', described how the exhibit 'plans to make visitors feel like they're on an expedition to the most remote corners of Peru – or in an Indiana Jones movie' (Sherman 1998: 8).

Negotiating Feminism in Contemporary TV

'What's Sex Got To Do With It?': Signifying Post-Feminism in Sex and the City

ANNA GOUGH-YATES

Produced by Darren Starr for Home Box Office (HBO), *Sex and the City* has attracted, and continues to attract audiences of 10.6 million viewers in the US, capturing many more through syndication across the world (Richards 2003: 147). Unsurprisingly, the show has prompted a great deal of attention, picking up dozens of awards from the television industry, including a Prime Time Emmy award for Outstanding Comedy Series and Golden Globe for Best Comedy Television Series. Most of the popular press reaction to the show has focused on its 'innovative' nature, arguing that it is a sign that women have reached a new era of gender equality that can be defined as 'post-feminist'. In the *Los Angeles Times*, for example, Mimi Avins has favourably described *Sex and the City* as 'the first post-feminist love story' (Avins 1999: 1). According to Avins, the show is adept at exploring the modern 'romantic landscape', and how it has been 'irrevocably altered by women's economic independence'. In *Newsweek*, Yahlin Chang and associates have been equally complimentary, claiming that *Sex and the City*'s 'undomesticated fantasy world is seeping into the daily lives of single women' (Chang *et al.* 1999: 60–62)

Other commentators have also understood *Sex and the City* as a post-feminist text, but have viewed it with some antipathy because of this. The 'post-feminism' of *Sex and the City*, they argue, is not evidence that gender equality has been accomplished in real life, or that feminism is redundant. Instead the show, along with other 'post-feminist' texts, contributes to what the journalist Susan Faludi has described as an all-encompassing 'backlash' *against* feminism and its achievements (Faludi 1992). The message of post-feminist texts is false, it is claimed, depicting women as liberated, but sorry about it. When the media portrays career women – an often cited example being television's *Ally McBeal* – they are shown as unhappy and loveless. Whilst they have high salaries and powerful positions in the workplace, the emotional lives of fictional career women have been ruined by liberation because they can't find a man who won't feel emasculated by them. The ultimate aim of post-feminist discourse, 'backlash' commentators argue, is to push women's roles back to the traditional, and to mask the fact that gender inequalities still pervade the social structure.

As Joanne Hollows has argued, the 'backlash' thesis is an attractive one because of its simplicity, and it does not just circulate in popular journalism (Hollows 2000). Feminists working within cultural studies have also developed versions of the 'backlash' thesis, often citing the reluctance of female students to declare themselves 'feminists' as evidence of the success and perniciousness of 'post-feminist' discourse. What 'backlash' theorists ultimately require of contemporary women – and the 'post-feminist' media they consume – is a feminist 'make-over' which visualizes identities that are deemed pro-second-wave feminist. What 'backlash' theory fails to acknowledge, however, is that there are many 'competing' feminisms in circulation. Moreover, whilst many of these feminisms may not see themselves connecting easily with what

'backlash' theorists see as the 'real' feminism of the second-wave, this does not mean that feminism has ended (ibid.: 192).

It is within this framework of 'competing' feminisms that I propose to explore *Sex and the City*. My analysis of this text will move away from defining post-feminism as a period with no further need for feminism, or as an era where feminism has come to an end. Instead, I want to suggest that *Sex and the City* can tell us something about the shifting context of contemporary debate about feminism. The 'post' of 'post-feminism', therefore, signals what Charlotte Brunsdon has identified as a historical era that is post-second-wave feminism of the 1970s (Brunsdon 1997). The post-feminist era is one that is, necessarily, partly informed by feminism. In these terms, to describe something as post-feminist is not the same as saying it came totally *after* the event, or that it is a backlash *against* feminism. Indeed, whilst *Sex and the City* is by no means a feminist text, it is evidence that feminist issues are still in, and on the air.

As its title suggests, one of the central preoccupations of *Sex and the City* is sex – and particularly the busy sexual relationships and the sexual satisfaction pursued by its four key characters. Until recently, sex has not been typical fare for a mainstream US television drama. American television currently groans with the weight of programming that has been popularly termed 'post-feminist' due to a narrative focus on the lives of unmarried, white, heterosexual, metropolitan, professional women who are dissatisfied with their lot. Situation comedies such as *Caroline in the City* (CBS, 1995–1999), *Suddenly Susan* (WBTV, 1996–2000), *Just Shoot Me!* (NBC, 1997–2003), and *Leap of Faith* (NBC, 2002) have been popular sites for the exploration of 'post-feminism', as has *Ally McBeal*. However, part of what differentiates these texts from *Sex and the City* is that the preoccupations of their lead characters are more traditional, and the Carolines and Allys of their titles obsess about romantic prospects and finding 'Mr Right'. Carrie and her friends, on the other hand, have largely foregone their romantic fantasies in preference for the thrills of carnal delights.

As Jane Arthurs has argued, it is the institutional conditions of *Sex and the City*'s production that have enabled it to have sex, and not romantic love, at its core (Arthurs 2003: 84). *Sex and the City* is produced for HBO (owned by AOL Time Warner Inc.), which is a hugely profitable, advertising-free, cable and satellite subscription network with upwards of 27 million subscribers (Peterson 2002). HBO is particularly popular with the American middle classes, due partly to its emphasis on 'quality' television. Many of its shows have high production values, complex plots, and characters and storylines that build over longer periods of time than network produced programmes.

HBO's success with subscribers is also linked to its prowess for successful niche marketing (Arthurs 2003). Instead of offering a mixed schedule akin to that seen on network television, HBO offers multiple channels that are fine-tuned to the apparent needs and lifestyles of specific audiences. HBO's 'mutliplex' channels include HBO Family, HBO Comedy, and HBO Latino, as well as the highly successful HBO Signature, offering 'distinct and diverse programming that appeals to today's smart, sassy and sophisticated woman . . . Signature touches a woman's heart, mind and spirit' (HBO Signature 2003).

Another aspect of HBO's success is also widely thought to be its willingness to take risks in programme development. HBO's Chief Operating Officer, Jeff Bewkes, and Chairman and CEO Chris Albrecht are known in the industry to follow their 'gut' instincts when it comes to programming, and to reject market research generated programme development that is increasingly employed by the networks (Peterson 2002). In interviews, programme producers working with HBO have also frequently talked of the 'creative freedom' they are accorded (Gay 2002: 16–21). Much of this stress on 'creativity' is part of HBO's own marketing and promotion strategy, encapsulated by its famous slogan 'It's not TV. It's HBO'. HBO, therefore, likes to position itself squarely in what Anna McCarthy has termed the 'liberal narrative' of television history, where it is 'transforming' television genres as a response to the shifting demands of the television audience and the liberalization of American society in general (McCarthy 2003: 92). HBO's position as a subscription-only provider makes 'risk' taking in programme production a more viable possibility than it is for the networks. HBO's programming – including *Sex and*

the City – is known for containing full frontal nudity, sexually explicit dialogue and profanities, and soft-core pornography in the evenings, which would not be options for networks seeking the approval of advertisers and mainstream audiences. Arthurs has also observed that subscription only channels have greater freedom from government regulation than non-subscription television providers do, which has helped to make the explicit focus on the sex lives of *Sex and the City*'s women characters a possibility (Arthurs 2003: 88).[1]

The socio-political climate in which *Sex and the City* is aired has been one of intense debate about changing patterns of sexual relations and everyday life in general. Indeed, social life in late-twentieth-century America has undergone what John D'Emilio and Estelle Freedman have called a dramatic reconfiguration (D'Emilio and Freedman 1997: 361). Central to this reconfiguration is the increased participation of women in the labour force – particularly married women and mothers. There have also been startling increases in sexual activity outside of marriage, the number of cohabiting couples, the median age of first marriage, divorce, and births to unmarried mothers. In addition, the average size of households is diminishing, and over 30 per cent of households in the US are now classified as non-family units – which is a larger proportion than ever before.

Since the 1960s, the climate for the discussion of sexual expression has also altered beyond recognition. The AIDS epidemic, and the activism it has produced in the gay community, has instigated what d'Emilio and Freedman describe as 'a cultural outpouring that addressed homosexual passion, intimacy, and desire as much as it did illness and loss' (ibid.: 367). AIDS has forced many mainstream institutions such as churches, and the medical and health establishments to engage with, and negotiate with the gay and lesbian communities. Lesbian and gay activists have also pushed, sometimes successfully, for legislation to protect their rights. In turn, these campaigns have attracted media attention, which has increased the visibility of gay and lesbian life in the US.

The meanings and experiences of sexuality have also altered for heterosexuals, and studies such as the 'National Health and Social Life Survey' have identified significant changes in sexual mores (see Laumann *et al.* 2001). By the 1990s, the age of first consensual intercourse was found to be falling, teenagers were having more sexual partners, and patterns of partnering in general were moving away from long-term monogamy.

It is not surprising that these changes have brought with them some vociferous critics. The most vocal in these discussions have been the conservative 'Religious Right' that emerged as a constituency of the 'New Right' during the 1970s and 1980s. Building significant political strength over a period of two decades, the Religious Right is committed to a vision of a society that is tamed by the moral authority of religious belief and the family. Advocates of Religious Right politics argue that America is currently in a state of moral decay. As evidence of decline, they point to what they see as a contemporary trend towards sexual transgression and the weakening of the traditional family structure (D'Emilio and Freedman 1997: 361–6).

The Religious Right is also explicitly anti-feminist, because it lays the blame for the 'decline' of American morality at the feet of the second-wave feminist and sexual liberation movement (see Conover and Gray 1983). Religious Right groups have even formed their own alternatives to the second-wave feminist National Organization for Women (NOW), including Concerned Women for America (CWA), which, in feminist terms, seek to turn the clock back.[2] Sympathizers with Religious Right ideals have attacked the 'immoral' policies that they see as resulting from 1970s' feminist activism. They condemn feminism for promoting, for example, the Equal Rights Amendment (ERA), the legalization of abortion, gay and lesbian rights, the detachment of the welfare system from an ideology that actively promotes the traditional family unit, and the expanded availability of contraception (D'Emilio and Freedman 1997: 362).

Feminist activism of the 1970s, however, has also encountered some challenges from closer to home. The second-wave feminist movement fragmented in the late 1970s due to contestation over the unity of 'sisterhood'. Many women argued that the second-wave's hegemonic framework for understanding the experiences of women had been based largely upon the experiences of white, middle-class, heterosexual women. Women of Color, for example, asserted

that second-wave feminist politics excluded their interests and failed to address the different sites of oppression and struggles faced by Black women. Other minority groups, such as lesbian feminists, also claimed that second-wave feminism did not give adequate representation to their concerns (Brooks 1997: 16–18). These women maintained that second-wave feminism needed to generate new ways of understanding women's social positions and subjectivities. Furthermore, feminism would need to develop new revolutionary strategies that would fully engage with issues of women's diversity.

The fragmentation of the second-wave has led to considerable disagreement about how the extent and range of contemporary feminist projects and perspectives can be defined. 'Postmodern', 'Black' and 'Third World' feminisms are, for example, amongst the broad-range of theoretical and political perspectives that commentators on feminism have identified as conspicuous amongst feminists of the 'post-feminist' or so-called 'third-wave' era (see, for example, Jordan and Weedon 1995; Lown 1995; Kenway 1995; Walby 1992). The meanings of terms such as 'oppression' and 'patriarchy', which many feminists of the 'second-wave' had agreed upon as keystones for feminist theory and action, have also been questioned, many feminists deeming them too monolithic in scope for understanding the complexities of women's subjugation.

Despite the fragmentation and contestation over feminism of this period, gender inequality, together with other forms of inequality, is still a site for struggle. And whilst there is significant disagreement between women about what feminism was, is, and should be, feminism and ideas about feminism have increasingly been taken up and represented in popular culture – producing what Hollows has termed 'popular feminism' (Hollows 2000: 193). It is these changing discourses around feminism, sexuality, and the place of women in social and economic life, that frame and guide the representations of femininity that are integral to *Sex and the City*.

The idea that a popular television programme for women should generate some feminist resonance is not particularly new for American television. In turning to shifting demographic, sexual, and political trends for subject matter, *Sex and the City* is in many ways typical of television programming since the 1960s (see, for example, Spigel and Curtin 1997; Osgerby and Gough-Yates 2001). *Sex and the City*'s focus on the lives of white, single, urban-dwelling career women can be traced back to – and beyond – *The Mary Tyler Moore Show* of the 1970s (CBS, 1970–1977) (see Dow 1996). Indeed, as Bonnie Dow (1996) has argued, prime-time television has never left the single working woman alone for long, offering her up to viewers in various forms including *Dr Quinn, Medicine Woman* (CBS, 1993–1998), and the sitcoms *Cybill* (CBS, 1995–1998), and *Ellen* (ABC, 1994–1998).

A common facet of 'single woman' television of the past, and one that remains influential in *Sex and the City*, is the emphasis on female solidarity, and pleasure in female friendship. Writers including Dow (1996), Tasker (1998) and Hollinger (1998) have all observed that despite its fall from grace as a concept in feminism, 'sisterhood' remains an influential way of signifying 'liberated women' in popular texts. *Sex and the City* picks up on this tradition of representation with an explicit focus on the friendships between its four main characters. Indeed, in HBO's official companion to the show the reader is drawn into the world of *Sex and the City* with a parodic play on the traditional fairy-tale opening: 'Once upon a time on a small island not too far away, there lived four smart, beautiful women who were all very good friends' (Söhn 2002: 12). Notably absent from this tale are the 'knights in shining armour' or the 'handsome prince' who will rescue the women from their single 'dilemma'. In their place are friends who like 'to eat, drink, date, and shop, but mainly they [like] to *talk*' (ibid.: 13).

While 'Prince Charming' is very much a fantasy, female friendship, conversation, and support are a major component of *Sex and the City*, and a clear avowal of second-wave feminist rhetoric about the role of talk in women's liberation. In every episode, the four friends meet over brunch, dinner, or after-work drinks, where they discuss a dilemma that Carrie will later write about in her newspaper column. The questions under discussion are never too serious (although they may raise major issues for the characters), typical examples being 'Are we simply romantically challenged or are we sluts?', 'In a relationship, when does the art of compromise

become compromising?', and 'What's it all worth?'[3] The questions provoke discussions on sex, relationships, and emotions, and the meetings function as a contemporary version of second-wave feminism's consciousness-raising group. With the help of her friends, each woman in the show reveals her feelings about Carrie's quandary, and they help each other to weigh up the variety of possible responses.

Many of the issues that arise in these meetings, and throughout the programme generally, were of concern to feminists of the second-wave and continue to raise issues for the four women, who exist in a society that does not entirely approve of, or welcome, their sexual and financial independence from men. When Carrie sleeps for the first time with 'Mr Big' (so called because he is Carrie's 'big' love), for example, she attempts to deal with the sexual double-standard, and her concern that he may no longer respect her.[4] Miranda's pregnancy raises issues for her about her femininity, motherhood, and freedom. Fearing that she does not have the 'mothering gene' (she feigns joy at her sonogram on hearing she is pregnant with a boy), the series traces Miranda's visit to an abortion clinic (she later abandons the idea), decision not to marry the child's father, anxieties about how to juggle work and childcare, and qualms about her desire for sexual fulfilment during pregnancy.[5]

The 'consciousness-raising' meetings also produce frank revelations about the women's sex lives. All of the women are sexually active and enjoy sex with a variety of partners, and their freedom in this respect, and their willingness to talk about their activities, is a signifier of their 'liberation' from pre-feminist sexual norms. In discussions that are resonant of Masters and Johnson (1966), Koedt (1973: 198–207) and Millett (1970), the four women talk about their 'right' to sexual satisfaction, dumping men who do not live up to their expectations in the bedroom.[6] The possibility of sexual pleasure without men is also a topic of discussion for the four friends. Indeed, the fact that so many of the men they meet are either sexually or socially dysfunctional in some way or other means that the women are driven to consider alternative ways of achieving sexual satisfaction. The subject of female masturbation features prominently in a number of story lines, as it did in the discourse of 1970s' feminism (see, for example, Dodson 1986). Masturbation is depicted, however, as a desperate measure for women in a city devoid of adequate men. In an infamous episode from Season 1, 'The Turtle and the Hare', a vibrator called 'The Rabbit', with a 'bunny ear' clitoral stimulator, is the hot topic for discussion. Discovered by Miranda, she quickly takes Carrie and Charlotte to the sex toy store where she convinces them to purchase it.[7] For Charlotte, this is a turning point as she discovers that she can reach orgasm any time she pleases – something unachievable for her with a man. 'The Rabbit' becomes such a good companion that Charlotte becomes a recluse before her friends decide to confiscate it!

The possibilities of sexual pleasure and relationships with women are also discussed in the series, and the fact that lesbianism is considered an option is used to signify the liberated status of Carrie and her friends. The show's take on lesbianism is liberal, where 'being lesbian' is depicted as a matter of 'natural' sexual preference, with little social stigma attached. This effectively curbs the development of lesbian narratives because lesbianism is a 'preference' that the four women do not 'naturally' have.[8] In a couple of episodes, both Miranda and Charlotte fantasize about being lesbian, not because of their sexual desires, but because of the power and freedom they think it would offer them.[9] The relationship-phobic Samantha even has an affair with the exotic Maria over three episodes, but soon tires of 'talking about feelings', 'sharing romantic baths', and of sex without a penis.[10]

In terms of their sexual behaviour, *Sex and the City*'s female characters personify and acknowledge the successes of 1970s' feminist activism. With the support of each other, all of the women break with pre-feminist norms for appropriate sexual behaviour, and are comfortable with, and express, their desires. The sexual freedoms enjoyed by Carrie and her friends, however, are also used to signify the post-second-wave status of the show, affirming the irrelevance of 1970s' feminism to contemporary society. The topics discussed by the women in their 'consciousness raising' meetings deal with the characters' individual choices and moralities. Female desires are equated with the requirement for individual sexual fulfilment. In *Sex and the*

City, therefore liberation, is a personal matter, a lifestyle choice available to all women, which can be made without a political commitment to feminism.

While *Sex and the City* acknowledges 1970s' feminist activism through its depiction of a sexually liberated group of professional women and friends, the show also rejects a significant element of a 1970s' feminist identity in its foregrounding of consumerism – particularly fashion – as a mode of feminine pleasure. Many feminists of the second-wave argued that women's adherence to fashion and beauty locked them into patriarchal relations, objectifying and dehumanizing them (see Wilson 1985). Some feminists advocated the reclamation of a 'natural' feminine self through a rejection of feminine dress. Others foregrounded 'doing your own thing', which as Elizabeth Wilson has argued, ultimately amounted to a 'feminist style' of dress (ibid.: 242). A central component of *Sex and the City*, however, is the stylishness of the four friends, and particularly Carrie's love of high fashion. It is this focus on fashion that confirms that *Sex and the City* is not a 'feminist' show.

The fashion consciousness of *Sex and the City* is reflected in the extensive coverage it has received in the style and fashion press. Sarah Jessica Parker (Carrie) and Kristin Davis (Charlotte), in particular, regularly appear on the covers and fashion pages of magazines such as *Cosmopolitan* and *Marie Claire*, and tips on how to get their 'look' are regular features of makeover magazines like *In-Style*. The show's costume designer, Patricia Field (who owns her own Manhattan boutique) has also become a celebrity in her own right, and her costume decisions are viewed by some as eclectic and controversial. The show's association with fashion is extended by its explicit reference to the fashion labels that each woman wears, and it has been the launch pad for many covetable fashion items from couture designers.

All of the characters, but particularly Carrie, are depicted as knowledgeable about fashion and beauty, defining themselves through a range of feminine 'looks', which they shift between depending on circumstance and mood. The performative qualities of fashion are emphasized as Carrie veers from a T-shirt and cardigan with jeans for a comfortable night in, to hair in bunches and a fairytale 'Heidi' dress for a picnic in the park, to a romantic Grace Kelly style Givenchy dress for a hot date in a bar with 'Mr Big'. Miranda's status as a lawyer means that she dresses in sharp tailored suits for days at the office, constructing a sombre and 'masculinized' professional self. On social occasions, however, Miranda 'transforms' herself with attire that is more 'playful', a penchant for ethnic patterned prints and bright colours constructing a more soulful and 'earthy' femininity.

For all of the women, but Carrie in particular, fashion is intensely pleasurable. Carrie's enjoyment of fashion is excessive, because her life revolves around it. She lives in an apartment which her collection of clothes and shoes almost swamp, refuses to throw any item of clothing away, and will even make herself penniless for a pair of intensely desirable shoes.[11] Furthermore, Carrie's love of fashion is usually inconceivable and threatening for the men that she dates, who care little to nothing about it. When Aidan moves into her apartment, for example, he is infuriated by Carrie's refusal to clear out her clothes and make some room for him.[12] Berger is flummoxed when Carrie takes him shopping at Prada, shocked at the prices, and quietly furious when she buys him a shirt as a gift.[13] Indeed, Carrie and her friends' enjoyment of fashion is primarily self-enjoyment, which is only shared by gay friends like Stanford Blatch, and by other fashion-conscious women.

In some senses, therefore, Carrie and her friends' love of fashion is not 'anti-feminist' because it emphasizes their distance and autonomy from men. Indeed, fashion effectively 'liberates' the friends from what many of the heterosexual men they encounter would like women to be. The use of fashion and style to alienate men from women can be seen as a means of re-emphasizing traditional perceptions of consumption as women's work ('irrational' and 'frivolous'), in which 'real men' do not partake. This division is underlined by the presence of Carrie's boyfriend, Aidan, who designs and makes his own furniture out of natural materials such as leather, and later by Berger who is a serious author (as opposed to a 'light-hearted journalist' like Carrie). The 'triviality' of fashion, however, is lessened by the four women's love of *haute couture*. Indeed, *Sex and the City* constantly 'name-drops' designers, which emphasizes the 'artistic

genius' behind high fashion, as well as the difference between the characters' love for fashion and that of 'ordinary' (and presumably less-liberated) women.

For feminists of the second-wave, one of the most dehumanizing aspects of women's fashion and beauty practices resulted from the way they were seen to construct women as passive 'objects' for the pleasures of the 'male gaze' (see Wilson 1985). While Carrie and her friends do spend much of their time putting together a 'look', it is frequently envious or disapproving women (the 'twenty-somethings' and 'the marrieds'), and not men, who look at them. The four women also spend a great deal of their social lives on the prowl for men, and this involves a great deal of ogling – especially for Samantha – whose desiring gaze is powerful, and disconcerting for the firemen and farm-hands it celebrates. Carrie is also as much controlling of, as she is controlled by, the 'male gaze'. Indeed, her entire career rests on the observations she makes of others in New York, and men who slight her find themselves becoming the subject of gossip and scrutiny for the whole of New York!

In relation to fashion and consumer culture, therefore, *Sex and the City* is an ambiguous text for feminism. By refusing to reject fashion, and by caring about it so much, Carrie and her friends can be seen to perpetuate women's enslavement to a masculine-defined norm for femininity. In this sense, the show is distinctly post-feminist. On the other hand, the 'outlandish' *haute couture* fashions worn by Carrie and her friends are not greatly appreciated by desirable men, and function as challenges to the more traditional forms of feminine clothing that women less independent from men are compelled to endure. The four women's self-determination in terms of what they wear, how they decorate their apartments, and how they spend their money therefore produce exciting and pleasurable forms of feminine identities. By gratifying themselves through fashion and style, the women manage to unite their desires for the femininity consumer culture promotes, with their thirst for independence and autonomy.

Sex and the City is a contradictory text for feminism, and can be characterized as 'post-feminist'. It is not, however, 'anti-feminist' in the way that Faludi and other 'backlash' commentators would have it. As I have shown, *Sex and the City* is a product of an era where feminism, and the impact of 1970s' feminism on American society, is under debate. This interrogation of feminism has come from outside, and from within feminism. However, to describe this as an era of 'anti-feminism' or of 'backlash', and to equate *Sex and the City* with anti-feminist discourse is, I have shown, an overly simplistic analysis.

Carrie and her friends do not embody the feminist identities 1970s' feminism envisaged. Their identities are, however, one of many modes of contemporary femininities present in popular culture that are informed by, and articulated in relation to feminism. For 'backlash' theorists, *Sex and the City* is the opposite of 'feminist' television because the identities it offers viewers are not 1970s' feminist. This is, however, a remarkably rigid and ahistorical way to think about the relationship between feminism and identity. Indeed, it isn't entirely surprising that many young women have rejected the label 'feminist' altogether, given the identity that 'backlash' theorists have on offer is of an 'old-fashioned' feminist, formed by their mother's generation. If feminism has a future at all with young women, then we need to be more flexible in our thinking about what a contemporary feminist identity might be. Perhaps 'popular feminism' such as *Sex and the City* can offer a starting point for this, offering discourses and images about feminist themes that are powerful for young women, and open to 'third-wave' re-formulation.

Notes

1. *Sex and the City*'s sexual focus may be unusual for television, but it is not out of the ordinary for other forms of popular culture deemed 'post-feminist'. Women's magazines, popular literature such as 'Chick Lit', and advertising have long advanced more frank representations of female sexuality (McRobbie 1996; Winship 2000; Philips 2000). Many glossy women's magazines, for example, have developed a distinctive rhetoric about female sexual confidence and independence, which has become an integral part of the lifestyle aspirations they promote.

297

2. Other less conservative and less religious women's groups that have been formed to counter the impact of second-wave feminism include the Independent Women's Forum (IWF), and The Women's Freedom Network (WFN).

3. *Sex and the City*, Season 3, Episode 6: 'Are We Sluts?'; Season 4, Episode 9: 'Sex and the Country'; Season 4, Episode 16: 'Ring A Ding Ding'.

4. *Sex and the City*, Season 1, Episode 6: 'Secret Sex'.

5. Miranda's pregnancy occurs throughout Season 4. Whilst Miranda decides not to go through with her abortion, this episode also provokes admissions from both Samantha and Carrie that they had abortions in their youth, which neither of them regret.

6. The 'liberation' of sexual desire was, of course, a major issue for feminist activists in the women's liberation movement of the late 1960s onwards. Studies on women's sexual responses, such as William Masters and Virginia Johnson's *Human Sexual Response* (1966), identified clitoral stimulation as the source of female orgasm. Dramatic changes in the availability and effectiveness of contraception also fuelled the sexual liberation movement, allowing women to take greater control of their lives by divorcing sexual relationships from pregnancy. From this vantage point, women's liberationists of the late 1960s and early 1970s, such as Anne Koedt *et al.* (see Koedt 1973) and Kate Millett (1970) argued that sexuality and its place in social life was a key issue (D'Emilio and Freedman, 1997: 251).

7. Comella (2003) claims that this episode led to a substantial growth in women's purchases of 'The Rabbit' in US sex toy stores. Miranda's vibrator also appears in later episodes, most notably when, much to her frustration, Miranda's new Ukrainian cleaner tries to 'clean up' her life by replacing it with a figure of the Virgin Mary. *Sex and the City*, Season 3, Episode 3: 'Attack of the Five-Foot-Ten-Inch Woman'.

8. Anna McCarthy has noted in relation to *Ellen* that gayness has become a feature of storylines in many contemporary situation comedies, and is used to connote sitcom's 'evolution' as a mirror of social change. McCarthy argues, however, that gayness and televisual seriality remain oppositional concepts, 'as if the ongoing flow of situations and character development . . . is unable to accommodate a same-sex world of desires and identifications' (2003: 90). Unsurprisingly therefore, *Sex and the City* contains lesbianism within episodes, or short storylines.

9. *Sex and the City*, Season 1, Episode 3: 'Bay of Married Pigs'; Season 2, Episode 6: 'The Cheating Curve'.

10. Desperate to please Samantha, Maria returns home with a strap-on dildo, but it satisfies neither of them, and the relationship quickly ends. *Sex and the City*, Season 4, Episodes 3, 4 and 5: 'Defining Moments'; 'What's Sex Got to Do With It?'; and 'Ghost Town'.

11. *Sex and the City*, Season 4, Episode 16: 'Ring a Ding Ding'.

12. *Sex and the City*, Season 4, Episode 13: 'The Good Fight'.

13. *Sex and the City*, Season 6, Episode 5: 'Lights, Camera, Relationship'.

Constructing History in TV News from Clinton to 9/11

Flashframes of History – American Visual Memories

ANDREW HOSKINS

To imagine defining historical moments of the twentieth and twenty-first centuries is to *visualize* them. Human memory is dependent upon visual imagination to picture the past. In classic studies of visual imaging by psychologists (for example Bartlett 1932), the familiarity of an image leads to a retrieval of its context. In this essay I argue that just as personal memory works by matching the here-and-now with an intelligible there-and-then, by shifting context, re-framing meaning and selectivity television is becoming a global memory bank that is both liberating and lethal.

Sociologists (notably Maurice Halbwachs 1992) claim that memories only work if they are socially framed. The problem with global television, given the increasing consolidation and concentration of media power in the hands of fewer and fewer global networks, is whose frame will count. This has long been the focus of media scholarship (see Gitlin 1980; McQuail 1983). But recent shifts in the technology of satellite news-gathering and complex digitalized information storage and retrieval systems, have greatly increased both the power and the danger of these new memory devices. At the same time, and perhaps as a consequence, historical memory has become increasingly contested, as it has become increasingly mediated. The capacity of television to forge and reforge past events in news, documentary, soaps and film, delivered daily to mass audiences, has effectively unsettled traditional history. 'New memory' (Hoskins 2001; 2004) is essentially the shifting relationship between that which has been variously called 'social', or 'collective' memory (seen as human, fallible but authentic) and 'mediated' memory (seen as artificial and manipulated, but paradoxically more reliable).

A contestation of new memory is particularly in evidence in the United States, which is at the very heart of the global electronic media. Twentieth- and twenty-first-century US history continues to be defined and redefined today by television, particularly historical moments that are marked in American consciousness *because of* their initial capturing and dissemination by the medium. The 1991 Gulf War, 9/11 and the 2003 Iraq War, the beating of Rodney King by policemen in Los Angeles in 1992 and the 1998–9 Clinton-Lewinsky scandal, for example, are all events dominated by their television coverage. The Baghdad night-sky illuminated with explosions and tracer-fire and the collapse of the Twin Towers, the white police group beating a solitary black man, and the tell-tale Clinton and Lewinsky looks and embrace, are all definitive television moments in US history. Simply, it is difficult to conceive of these events and their consequences without reference to their televisual context.

Since the introduction of television as a mass medium there have occurred key televisual moments – which I am calling *flashframes* of history – that have entered into American, and indeed global mediated memory. These include events that have been captured on other media and then later 'remediated' and much more extensively disseminated via television. To understand the impact of these moments this essay examines US televisual events of the 1990s and

2000s. In doing so it assesses the changing role of 'televisuality' (Caldwell 1995) in mediating US collective memory. In an era when CNN and other US television news networks have established a commanding visual presence on the US political stage, there has emerged an intensifying contestation of memory, and ultimately of history itself, by US elites. The technologically advanced immediacy of real-time news coverage has empowered the corporate visual media whose 'live' representation and reflexive dissemination can actually shape the event being televised as news. In these circumstances, the medium is even more difficult to separate from the message, and the ultimate historical *documentation* of an event. This poses a potentially considerable challenge for those wishing to articulate alternative readings of US history that clash with the all too often visual 'self-evidencing' of history-in-the-making. And it is this instant and saturating televisual mode of historicization that, so far, has dominated the political and cultural landscape of twenty-first-century America.

A much greater degree of technological mediation and an apparently ubiquitous electronic media, have transformed firstly the shaping of news events as they unfold in real-time, and secondly the means by which differently mediated events enter into collective memory and history. What, for example, is the nature and effect of the historiographic space of a television screen when the medium becomes the *primary* 'subliminal point of reference', and thus the site of the *production* of the 'original' memory? Increasingly, the impact of live and/or repeated visual images and sounds can be seen reflexively to feed into and shape the very event defined as subject, the so-called 'CNN effect' (Boden and Hoskins 1995; Livingston 1997; Volkmer 1999; Robinson 2002) altering the moment-by-moment trajectory of events. In this way, the medium is not only the message but also enters into the constitution of society itself.

Undoubtedly, the historical past of the US is increasingly televisual. The saturation of news media often leads to events being instantly commodified in a visually-intelligible form. The sheer presence of increasingly portable cameras enabled by advances in technology has meant that very few defining historical moments, events and catastrophes are not captured and etched on the visual collective consciousness of American and indeed global audiences. Television has contributed significantly to a 'transformation of visibility' (Thompson 2000: 33) in politics and history, where public and private areas of life become part of a mediated montage of news and entertainment. In circumstances where television imagery comes to define and verify what is historically real, mediated events can appear detached from reality. To engage with an image, a still, a photograph, is simply more difficult when there is such a profusion of others to encounter and make sense of. Gitlin, for example, identifies this problem:

> one way to navigate through the flux and overflow is to preserve certain images on the hard disk of near-consciousness while regularly dumping the rest. Flooded with vastly more versions of reality than we could ever begin to grasp, verify, or think through, we learn how to . . . disbelieve and suspend belief a hundred times a day. (2001: 127)

However, television actually functions in this way itself through a process of 'innovation, repetition and discarding' (Adam 1990: 140–41). And, as Gitlin acknowledges, there are 'ritual moments of total saturation and relative motionlessness when vast numbers of people attend to the same "breaking story"' (2001: 166–7). In these times, there occurs a certain *displacement* of events outside of the news story that dominates the moment, and, the bigger the event the greater the compulsion to repeat, and the greater the displacement.

One of the most reflexively-mediated of events during the 1990s, that is to say where television coverage appeared significantly to shape the actions of those concerned, was the live television denial, and later live television admission by a US President, of a sexual relationship with a White House intern. In the year of the scandal the three major US networks devoted a total of more than 32 hours of weeknight news to witness every twist and turn of this story (Gitlin 2001: 167). The real key to the extended televisual presence of the whole affair was the nature of Clinton's denial of having had 'sexual relations' with Monica Lewinsky. On 26 January, 1998, Clinton appealed directly to a live global audience that he 'did not have sexual relations

with that woman, Miss Lewinsky'. Although the definition of 'sexual relations' was later the subject of much political, legal and media analysis, Clinton's tone and body language was unambiguous. In effect, his finger-pointing and appeal to the eye of the camera, was an attempt to compete visually with footage of his and Lewinsky's own non-verbal communication, in a hug and exchange of knowing looks over a rope line at a public event.

This piece of film had been shown repeatedly on television, and stills from it had appeared on newspaper front pages around the globe. The predictable US network news response to Clinton's TV denial was to show repeatedly the Lewinsky hug footage, along with various juxtapositions of the two pieces that emphasized their apparent contradiction of each other. CNN and other news correspondents did not have to say 'we think the President did have an affair with Monica Lewinsky and is lying to the American people', they merely replayed the footage in a seemingly endless loop. CNN researchers even went trawling through their archives, suspecting the existence of other damning images, and another two Clinton-Lewinsky 'private-in-public' scenes were soon added to the weight of televisual evidence used daily to undermine a President.

Thus, Clinton's globally televised retraction of his denial, some months later, had to be even more mediated – even more public – to have any chance of providing new and alternative images to challenge the existing media script. The staging of this televised address, through its mediated build-up, maximized the humiliation for Clinton. And yet, by virtue of its expectant mass audience it was all the more cathartic and humbling, which was the impression Clinton needed to convey in order to survive as President. Given the capacity of television to impose a visual narrative over and above the events themselves, Clinton had little choice but to hope that the medium would enable him, at least, to represent himself as victim of its unforgetting and unforgiving lens.

The use of the Clinton-Lewinsky images on television and in print have come to be used as *media templates* (Boden and Hoskins 1995; Kitzinger 1999; Hoskins 2004). Templates are ways of presenting current events through a visual frame drawn from the past. In other words, a particular interpretation of a news item is conveyed through the showing of a still image, or the running of video or film of images from the past in some way associated with the current story. This is often undertaken through the juxtaposition of images from different times which can *visually contradict* some aspect of the story, often intended to undermine a past statement of one or more of the central characters involved. In this way, news stories are developed and even founded upon simple visual juxtapositions and, in the case of television, montages of visual histories of stories and story genres (for example aircraft catastrophes being shown to frame a story about government claims of improved air travel safety). Templates can also become routinized through the repetition of media flashframes as indicative of not just a news event, but as representative of a whole period of time. It is through this process that the Clinton years, for example, have been and will continue to be historicized by television, with the flashframes of Clinton 'with' Lewinsky indexical of his second term in the White House and imprinted onto the legacy of his Presidency.

Media templates are most powerful and persuasive, however, when they are used reflexively to shape and direct an unfolding news story. In this way, Kitzinger, for example, draws a distinction between a 'frame' and a 'template'. 'Whereas a frame is envisaged as a "map" or "window" which can show different paths and perspectives, the template event implies a more rigid and precisely outlined perspective (which both *operates within*, and *contributes to*, a specific substantive frame') (Kitzinger 1999: 75, original emphasis). From this perspective, templates can shape whole news narratives through literally entering the frame of the story itself. These are not, however, constructed exclusively from 'real' news events and images. In the case of media coverage of the Clinton-Lewinsky affair, American news networks employed a *fictional* template to undermine the President through paralleling his behaviour and the motives for his actions with those of a character in a movie, *Wag the Dog*. This film was newly on release at the height of the Clinton-Lewinsky story and was a wholly fictional depiction of a US President going to war with Albania (just as, it has been alleged, Clinton bombed the Al-Shifa

pharmaceutical factory in Sudan and launched air strikes against Iraq and Afghanistan in 1998) in order to distract public and political attention from a domestic scandal.

The fictional template that became known as the *Wag the Dog scenario* developed when it was employed by journalists to inform questions addressed to Clinton and members of his administration, and to frame a televisual construction of the renewed crisis with Iraq, particularly in respect of Clinton's motives for his then tough line against Saddam Hussein. CNN actually incorporated a comparison between the movie and real events in Washington into a programme as part of a series entitled *Investigating the President*, broadcast two days after Clinton had made his live denial and on the night of the President's State of the Union address. In this film report, CNN parodies itself. One form of visual text (fictional CNN/TV news) is shown within another text (the movie) which is shown within the 'real' news text of CNN. This report self-consciously acknowledges the role of CNN in 'creating' or at least mediating the White House scandal. The multiple narratives – both visual and aural – act to conflate further the fictional and the real storylines. It is not until the report is finished that the viewer is 'brought back' with a degree of certainty into a real-time view with the live audio narrative and visual form of the anchor Bernard Shaw in a Washington studio and a 'CNN LIVE' icon on screen.

Other news organizations also seized upon this template to critique the discourse and actions of Clinton over Iraq and other foreign policy. *ABC Evening News* used the movie on the day of Clinton's televised denial, and *NBC Evening News* of 20 August, 1998, employed it as a template to frame a story on the timing of Clinton's strikes against the alleged 'terrorist bases' in Afghanistan and Sudan. NBC again showed clips from the movie on 16 December, 1998, to illustrate a report on concerns that the latest attacks on Iraq were ordered by Clinton to divert attention from the impeachment hearings.

The various uses of the *Wag the Dog* scenario in news programming demonstrate how American mass culture increasingly involves the turning of history into television and film fiction, and fiction into history. Caldwell, for example, argues that 'television does not try to hide its ontological and textual distinctions. Rather, it flaunts and exploits the distinctions: news versus film, history versus entertainment, and reality versus fiction' (1995: 111). The Clinton-Lewinsky plot was incredible to the point that it often resembled fiction. In this way the *Wag the Dog* contextualization did not appear as remarkable as it may otherwise have done. However, given that the movie possessed the recency almost of a breaking news story itself, it provided a powerful televisual template to frame the news reporting of the Lewinsky scandal. This contrasts with the use of more established fictional templates in TV news (especially in times of war and catastrophe).

In sum, the Clinton-Lewinsky television image constitutes a key twentieth-century flashframe of memory, and the Clinton Presidency has it indelibly printed upon it. The *Wag the Dog* scenario was used to reinforce visually the reported suspicion of Clinton's motives for threatening to take, and also taking, military action in 1998. A key primer of the whole story, however, was the three images of Clinton and Lewinsky taken from footage that had been recorded co-incidentally. Without these, the outcome of the scandal may have been very different. Moreover, there would not now and in the future be an enduring visual template which will function to displace acknowledgement of the merits or otherwise of Clinton's period in office as it displaced many other news stories in 1998–9.

The opening of the twenty-first century witnessed probably the greatest exploitation of the medium of television to date. The terrorists who attacked the United States on September 11th, 2001, sought to cause maximum devastation as well as symbolic destruction of the World Trade Center in New York, and the Pentagon in Washington. Even they, however, could not have foreseen the extent of the global visual exposure, instantaneously and predominantly through television, that their attacks would receive. As a media flashframe the attacks of 9/11 gripped the historiographic space of the television screen, transfixed by the instantly iconic imagery of the planes and the collapse of the Twin Towers. In such circumstances, repetition appears to be the medium's only response. The images of 9/11 became quickly *over*exposed simply because there

was nothing that could be said or shown that could compete with the enormity of the event. Consequently, a stasis set in to television (and also print media) as the event displaced all other news with a glut of images. The footage of the planes colliding and the collapse of the Twin Towers were repeated by news networks, sometimes in slow motion, and even, bizarrely, played backwards on ABC.

The televising of the catastrophic events of 9/11 as the primary 'subliminal point of reference' (Samuel 1994: 27) and hence the site of the *production* of the 'original' memory, affords the medium considerable influence in shaping how it comes to be remembered. Unlike other defining media flashframes in American history, the ubiquitous electronic media of 2001 ensured a multiplicity of views and recordings. In New York, for example, there was a massive concentration of recording media in the locality of the World Trade Center. This included news organizations as well as amateurs with their camcorders and other 'home movie' devices. The resulting panoramic visual record is thus movie-like in its multiple framings, comprised of views from every imaginable angle; people filmed as they ran. After the event, television was able to package (literally) the often highly personal, and personalized, audio-visual records from the many co-present witnesses to the attacks and their aftermath. Using this perspective, one television documentary that assembled contributions from sixteen news organizations and 118 survivors and onlookers into a single narrative, screened to commemorate the first anniversary of 9/11, described it as already 'the most documented event in history'.

Much of the visual documentation of the events in New York on September 11th, 2001, included other spectators shown within the frame as witnesses, and so added another 'layer' of authentication to the event being 'seen'. Christian Delage, for example, argues,

> One knows that placing a third party between the spectator and what is filmed is the basis of our belief in the truth of images . . . We were provided with a space for viewing by the intermediation of indispensable witnesses. Their very presence authenticated the truth of the audiovisual recording and allowed us to share, even from a distance, the sensations of the impact felt at the site. (Delage 2002: 165)

And it is precisely the 'intermediation' of witnesses co-present with the catastrophe that enhances the historicizing function of the televisual gaze. Often, in the repetition of media flashframes spoken witness testimony is added later to television and film footage (and particularly on anniversaries as part of commemorative programming). Although this technique was employed by news networks post-9/11, much of the accompanying commentary was captured simultaneous with the event, provided by horrified and disbelieving onlookers as well as those fleeing the unfolding catastrophe. In this way, 9/11 was powerfully and visually 'scripted' through television.

Network anchors were even moved out of their New York studios, and presented continuous programming as outside broadcasts with the smouldering city skyline as their backdrop. 'Being there' in the television coverage of a major event is important for journalists and other newsworkers so that they can present themselves as on-location (and thus authoritative) witnesses. The increased mobility and thus greater proximity of newsworkers to sites of unfolding events is now a feature, if not a requisite, of contemporary journalism brought about through the use of highly portable and inexpensive equipment (for example the videophone). This has increasingly enabled correspondents to *insert themselves into the televisual frame itself* as both part of and also as bearing witness to the spectacle, as though the familiar sight of the presenters close to sites of the catastrophe was reassuring to viewers. More recently, the 'embedding' of journalists with American and British forces during the 2003 Iraq War enabled a near-continuous presence within the reporting frames (see Hoskins 2004).

In the aftermath of 9/11, CNN not only anchored programming from outside in New York, but also in Washington. On 13th September, with billowing smoke and dust over New York as backdrop, Aaron Brown as anchor hands over to Judy Woodruff, who is also, unusually, seated outside (presumably on a building or raised platform) in Washington, with the White House

and Stars and Stripes fluttering in the wind as backdrop. The anchor, Judy Woodruff, then introduces a film report:

Extract from CNN continuous coverage, 13 September, 2001

Speaker	Commentary	Images
Woodruff:	Bruce Morten is one of our reporters here in Washington who's covered just about every story I can think of in this capital city for at least the last thirty years. Bruce has done some thinking today about the impact of these attacks on the American Government and the American People.	Woodruff seated on 'director's chair' with the White House in the background and various flags flying in the wind also in the frame. Superimposed on the bottom of the screen is a Stars and Stripes graphic, AMERICA'S NEW WAR, and CNN LIVE, which remains throughout the duration of this film report.
Morten:	World War 2 brought Americans together. Most believed that Nazi Germany and Imperial Japan were evil and aggressive. Americans demanded victory: the phrase of the day was 'unconditional surrender'. Korea and Vietnam in contrast divided the country. Vietnam in particular left Americans suspicious, weary of wars, and in the conflicts since the model seems to have been: bomb all you want but we can't stand American casualties. That seems different now.	Black-and-white footage of various troops being paraded and in action in World War 2. Soldiers shooting at a target out-of-shot with mountains as backdrop, presumably taken from the Korean War; sepia-tinged colour film of a marked US helicopter flying overhead and a scene of antiwar protesters. Sharper colour footage of an American jet taking off from an aircraft carrier at sea (presumable from the 1991 Gulf War). Colour shot of coffin draped in Stars and Stripes on airport tarmac. Smoke billowing from WTC.

Woodruff's introduction of Morten draws attention to his experience as a reporter and thus underscores his authority to comment on 'historical' events, emphasizing the sensitivity of the network's reporting of 9/11. On September 11th itself, American commentators and news networks struggled to find adequate historical templates through which to make sense of the enormity of events, although there were numerous references to 'Pearl Harbor' and 'Vietnam'.

Morten's report, however, contains a film montage of key American military engagements from World War 2 through to the 1991 Gulf War. The latter included a direct hit on a target seen through the cross-hairs of the sights from a jet which fired the missile, a view that became synonymous with Coalition bombing raids on Iraq during the Gulf War, and that was replayed endlessly on news networks at the time.

The function of the assembled templates, however, becomes apparent with the last two examples – the move from an image of the arrival of the coffin of a US serviceman to the events of two days earlier, and the burning World Trade Center. Morten's commentary draws directly

upon the visual historical montage to frame a putative shift in American philosophy, from reluctance to sustain casualties in fighting distant wars to acceptance of greater human costs necessary in the fight against terrorism. Television can thus, instantly and powerfully, simplify apparent historical continuities and discontinuities through the juxtaposition of templates over and against new and developing events. In this way, continuous television news programming on and after 9/11 framed shock at the attacks within the visual frame of a 'new war', helping shape public understanding of what the attacks meant, and of what would be an appropriate response.

Journalists have been credited with forging 'the first drafts of history'. Some commentators claim that the speed at which news stories in our real-time news age are assembled and broadcast results in these becoming increasingly 'rough' (Taylor 2001: 176). Furthermore, as I have suggested, the sheer volume of media data appears to overwhelm both history and memory. However, the increased proximity of correspondents to sites of catastrophe and other events enables them more easily to shape and enter stories as they unfold, by placing themselves inside the TV news frame. Increasingly, the testimony of journalists as witnesses is incorporated into the televisual gaze, authenticating the medium's historicizing function. In this way, the medium of television has become increasingly entangled with the events it depicts.

The media flashframe, moreover, increasingly provides the anchor for both journalistic and historical accounts of events. Television, more than any other medium, has visually imploded historical narratives by seizing images and using them to frame unfolding events as well as rescripting those from the past. The political and cultural landscape of the US and beyond has been increasingly influenced by a history that is documented, primarily, by and through television. And although television is only one way in which historical evidence is culturally processed, the extent of its influence remains under-acknowledged and under-explored. Moreover, television provides inauthentic and often enduring visual frames of events that paradoxically feed authentic but often fallible social memory. These are just some of the contradictions inherent in new memory and the role of the visual media in pacing and unsettling history.

Bibliography

An exhaustive bibliography of texts concerned with the broad fields of American visual culture studies would necessitate an additional volume of secondary references. In the annotations, below, we have therefore limited the scope of *indicative* further reading to works that address some of the broader conceptual issues bearing on the emergence of visual culture studies, or that offer indicative introductions to the study of discrete visual modes. For further reading related to the more specific issues and specialisms collected in this book, readers are encouraged to follow citations made in contributors' essays.

For critical anthologies and general introductions to the development of visual cultural studies during the 1990s and 2000s, and for discussion of the intellectual traditions and 'founding' texts out of which visual culture studies has grown, see Bryson *et al.* (1994), Mitchell (1994), Jenks (1995), Burgin (1996), Robins (1996), Walker and Chaplin (1997), Mirzoeff (1998), Stephens (1998), Evans and Hall (1999), Mirzoeff (1999), Smith (1999), Heywood and Sandywell (1999), Barnard (2001), Carson and Pajaczkowska (2001), Jones (2002), Elkins (2003), Howells (2003), Frosh (2003), Rampley (2004), Wright (2005).

Hughes (1997) provides an excellent, if selective, one volume history of American art. On nineteenth-century American landscape painting, Wilton and Barringer (2002) offers a well-illustrated reading of many key paintings: see also Boime (1991), Miller (1993), and Novak (1995). For an introduction to American art and nineteenth-century social change in the US see Lubin (1996). On the relationship between the avant-garde and modernism, see Bürger (1984); and for a collection addressing particular instances of modernist art's impact on American culture and society more generally, see Luddington (2000). For the crucial texts involved in the debates surrounding Abstract Expressionism specifically, see Frascina (2000). An on-the-ground account of the fresh assault on painting during the 1960s and 1970s can be found in Lippard (1997), and for a more historicized account of the ways radicalism impacted on the art world – and vice versa – during the 1960s, see Frascina (1999). For discussion of the eclipse of modernist assumptions about art's relative autonomy by its incorporation within the art-market, see Gablik (1984). On postmodern parameters for art and art criticism, see Wallis *et al.* (1993). For a discussion of the relationship between avant-garde art and theory since the 1960s which traces a retreat from certain 'postmodern' positions on the status of the 'real' in contemporary art, see Foster (1996). For indispensable collections of primary texts see Harrison and Wood (1992), which is an extraordinarily useful compendium of writing by artists, critics, and theorists, and Stiles and Selz (1996), which is more concerned specifically with artists' writings.

For general, if idiosyncratic, texts on the history and theory of photography, Barthes (1993) and Sontag (1977) remain provocative introductions. For an extensive textbook-reader, excerpting from important critical approaches, see Wells (2003), and for single-author introduction see Wells (2000) and Clarke (1997). Trachtenberg (1981) gathers an invaluable and wide-ranging

collection of primary writings, from Niepce and Daguerre, Poe and Baudelaire, to Weston and Abbot. More politically engaged readings can be found in Burgin (1982) and especially in Tagg (1988). Orvell (2003) offers a broad and highly readable survey of key debates, practitioners and critical issues spanning the history of American photography from the daguerreotype to digitization. And, again on American photography in particular, Taft (1964) is an early contribution (originally published in 1938) but remains a useful starting point for the nineteenth century. On the daguerreotype in America, see Wood (1999), Foresta and Wood (1995), and Barger and White (2000). For a social history of American landscape photography in the nineteenth and twentieth centuries, see Jussim and Lindquist-Cock (1985), and on the nineteenth century specifically see Wolf (1983). For a collection of essays on the historicity of nineteenth-century American photography see Sandweiss (1991), and for a still invaluable historicizing of important trends and the work of key practitioners from the mid-nineteenth century through the New Deal see Trachtenberg (1989). On photography and modernism, see Eisinger (1995), Peeler (2001) and Green (1973). For critical histories of American photography from World War 2 through the 1980s, see Turner (1985) and Green (1984). Important texts on documentary photography include Doherty (1976) and Stange (1989). For discussion of documentary photography within other multidisciplinary visual contexts, see Rabinowitz (1994). On 1930s' documentary in particular, see Stryker and Wood (1973), Stott (1973), Curtis (1989), Fisher (1987), Daniel *et al.* (1987), Natanson (1992). On 'political' photography between the New Deal and the Cold War, see Bezner (1999). On a broad drift from social and political engagement in American photography since the 1960s, see Garner (2003); but see also the collection of essays from documentary photographers, editors and curators in Light (2000), which argues that photographers remain committed to social uses of the medium. On the implications of digitization and computer technology for photography, see Mitchell (1992) and Ritchin (1999).

For an introduction to principal theoretical currents and critical approaches in Film Studies, see Hollows *et al.* (2000). For an introduction to key issues in Hollywood and American film, see Hill *et al.* (2000). For broad introductions to Hollywood film see Maltby (2003) and Bordwell and Thompson (2003). On the social, economic and aesthetic contexts of American film to 1907, see Musser (1994). For a history of the silent period from 1907 to WW1, and comment on the formative construction of the star system, see Bowser (1994). On the American film industry between WW1 and the advent of the 'talkies', see Koszarski (1994). Broad, if now quite traditional-looking, introductions to silent-era American film can also be found in Everson (1998) and Slide (1994). On the evolution of early silent-era narrative style, including shot-by-shot case studies of six films, see Keil (2002). For an indispensable introduction to the institutional, economic and aesthetic roots of the Classical era in the silent period, see also the relevant sections in Bordwell *et al.* (1985). On the intersection of silent-era film production and doctrines of American exceptionalism, see Cohen (2001). On the era of Classical Hollywood, Bordwell *et al.* (1985) remains essential introductory reading. On the evolution of Classical style see also Ray (1985). On the interplay between 'creative' and institutional factors in the production of Studio Era film, see Schatz (1998). For essays on diverse legal, regulatory and social pressures motivating Hollywood censorship (and self-censorship) in the Studio Era, see Bernstein (2000) and Prince (2003). For a broad introduction to the shift from 'Classical Hollywood' to New Hollywood, see King (2002). On the early period of New Hollywood as a product of (and part of a backlash against) the cultural politics of the 1960s, see Ryan and Kellner (1988). On continuity between Classical Hollywood and New Hollywood narrative technique, see Thompson (1999). Essays on a wide range of contemporary genre film are included in Neale (2002). For essays offering a wide-ranging introduction to American film in the New Hollywood era, including discussion of 'globalization' and the rise of 'major independent' production/distribution companies, see Neale and Smith (1998). For discussion of contemporary Hollywood grounded in political economy, cultural studies and cultural policy analysis, see Miller *et al.* (2001).

For an introduction to the semiotic construction of meaning in TV, see Fiske and Hartley (1990). For textbook collections offering broad (though not exclusively Americanist)

introductions to key areas in TV studies, including discussion of industrial issues and ownership, audience, genre, production processes and representation, see Allen and Hill (2003) and Geraghty and Lusted (1998). For a collection offering a comparative history of TV technology, institutions, policies, programmes, and audiences in the US and Britain, see Hilmes (2004). For an excellent, more Americanist but older and less wide-ranging introductory collection, see also Mellencamp (1990). For valuable periodized accounts of, respectively, the 1950s and 1960s, see Marling (1996) and Spigel and Curtin (1997). For a consideration of television as an assault on 1960s' radicalism see Gitlin (1980); but for a more optimistic treatment, focusing on TV's relationship with the feminist legacies of the 1960s, see also Dow (1996). For industry insiders' accounts of the diminishing role of public television in the US since the 1950s, see Day (1995) and Engelman (1996). For a highly readable account of the corporate and political factors driving the introduction of digital and high-definition TV in the US, see Brinkley (1998).

For a standard text on the history of electronic media in the US, see Head and Sterling (1996). On economic factors shaping TV news media, see Hamilton (2003). For a political-economy model addressing the influence of US elites on mass media more generally, see Herman and Chomsky (1994). For an ambitious overview of the importance of design and visual form in US print news from the colonial period to the end of the twentieth century, see Barnhurst and Nerone (2001). For essays on the cultural construction of identity by visual stereotyping in the media, see Lester (1996). On electronic media as media 'overload,' see Gitlin (2001). For an overview of existing approaches and proposals for a new ethics of digital aesthetics, see Cubitt (1998). For discussion of the construction of subjectivity by 'new media', see Bolter and Grusin (1999). A broad introduction to cyberculture studies is offered in Gauntlett and Horsley (2004). For sociological and cultural studies approaches to new cyberspace 'communities', and their relationship with communities in the physical world, see Smith and Kollock (1999). On the political disruption and transfiguration of identities by electronic media, see Poster (2001).

For discussion of the broader construction of culture by advertising in the nineteenth century see Lears (1994). On the history of American advertising until 1920, and the shift from advertising product to the construction of consumers, see Laird (1998). For discussion of print ad culture between the World Wars, and its intersection with discourses of American modernity, see Marchand (1985). For a classic account of advertising's institutionalization in the mass society of the 'high Fordist' 1950s, see Packard (1960). For a history of American advertising as demand-management from the nineteenth century to the 1990s, with case studies of advertising campaigns by Coca-Cola, Kellogg's, Wrigley's, Gillette, and Kodak, see Strasser (1995). Ewen (1976) has remained a controversial examination of consumerism and advertising as a displacement of class conflict in the US. Glickman (1999) offers an excellent compendium of critical and theoretical essays that situates advertising within the broader institutions, ideologies and practices of American mass consumption. For an overview of American advertising history grounded in cultural studies methodologies and communications theory, see Berger (2000). For a classic contemporary discussion of advertising and branding, in the broad contexts of the privatiszing of public space and the politics of the anti-globalization movement(s), see Klein (2000).

'A Company of Fair Rebels' (9 August 1862), *Frank Leslie's Illustrated Newspaper* XIV, p. 318.
Abbott, Rev. J. S. C. (1833) *The Mother at Home; or The Principles of Maternal Duty*. New York: American Tract Society. pp. 107–08.
'Abraham Zapruder Film Chronology' *The Sixth Floor Museum at Dealey Plaza*.
 <http://www.jfk.org/Research/Zapruder/Zapruder_Film_Chrono.htm>
'Abraham Zapruder Film Press Conference' *The Sixth Floor Museum at Dealey Plaza*. 6 January, 2000. <http://www.jfk.org/Research/Zapruder/Zapruder_Press_Conference.htm>
Adam, B. (1990) *Time and Social Theory*. Cambridge: Polity Press.
Addison, D. (ed.) (1970 [1894]) *Lucy Larcom: Life, Letters and Diary*. Detroit: Gale Research Co.
Adler, L. and Paterson, T. G. (1970) 'Red Fascism: The Merger of Nazi Germany and Soviet

Russia in the American Image of Totalitarianism, 1930s-1950s', *American Historical Review* 75(4) (April), pp. 1046–64.

Adorno, T. W. (2003) *Aesthetic Theory*. London and New York: Continuum.

Agee, J. and Evans, W. (1941) *Let Us Now Praise Famous Men*. Boston: Houghton Mifflin.

Aglietta, M. (1979) *A Theory of Capitalist Regulation: The US Experience*. London: New Left Books.

Alexander, C. W. (1862) *Pauline of the Potomac; or, General McClellan's Spy*. Philadelphia: Barclay.

Alexander, S. (1998) 'Photographic Institutions and Practices', in M. Frizot (ed.), *A New History of Photography*. Köln: Könemann. pp. 694–707.

Allen, D. and Tallman, W. (eds) (1973) *The Poetics of the New American Poetry*. New York: Grove Press.

Allen, R. C. and Hill, A. (eds) (2003) *The Television Studies Reader*. London: Routledge.

Alison, J. (ed.) (1998) *Native Nations: Journeys in American Photography*. London: Booth-Clibborn Editions for Barbican Art Gallery.

Anderson, B. R. (1991) *Imagined Communities: Reflections on the Origin and Spread of Nationalism*. London and New York: Verso.

Ang, I. (1985) *Watching Dallas: Soap Opera and the Melodramatic Imagination*. London: Methuen.

Anon. (1864) *Dora, The Heroine of the Cumberland; or The American Amazon. A Startling But Authentic Narrative of Innumerable and Dangerous Feats Performed by the Daring Heroine, The Idol of the Loyal Armies*. Philadelphia: Barclay & Co.

Appadurai, A. (1990) 'Disjuncture and Difference in the Global Cultural Economy', *Public Culture* 2(2), pp. 1–24.

Appadurai, A. (ed.) (2001) *Globalization*. Durham and London: Duke University Press.

Appiah, A. (1986) 'The Uncompleted Argument: Du Bois and the Illusion of Race', in H. L. Gates (ed.), '*Race,' Writing, and Difference*, Chicago: University of Chicago Press. pp. 21–37.

Aristotle (1973) *The Poetics*. Cambridge: Harvard University Press.

Arms, C. R. (1999) 'Getting the Picture: Observations from the Library of Congress on Providing Online Access to Pictorial Images', *Library Trends* 48(2) (Fall), pp. 379–409.

Aronowitz, S. and DiFazio, W. (1994) *The Jobless Future*. Minneapolis: University of Minnesota Press.

Arthurs, J. (2003) '*Sex and the City* and Consumer Culture: Remediating Postfeminist Drama', *Feminist Media Studies* 3(1), pp. 83–98.

Ashcroft, B. *et al.* (1989) *The Empire Writes Back: Theory and Practice in Post-Colonial Literature*. London and New York: Routledge.

Ashworth, J. (1995) *Slavery, Capitalism, and Politics in the Antebellum Republic. Volume 1: Commerce and Compromise, 1820–1850*. Cambridge: Cambridge University Press.

Askew, K. and Wilk, R. R. (eds) (2002) *The Anthropology of Media*. New York: Blackwell.

'At long last, a conflict ends for minister decades after napalm bombing, US commander, Vietnamese women make their peace' (1997), *Washington Post*, 20 February, M04.

Attie, J. (1998) *Patriotic Toil: Northern Women and the American Civil War*. Ithaca and London: Cornell University Press.

Austin, M. (1923) *The American Rhythm: Studies and Re-expressions of Amerindian Songs*. Boston: Houghton Mifflin.

Austin, M. and Adams, A. (1977 [1930]) *Taos Pueblo*. Boston: Little, Brown.

Avins, M. (1999) 'Let's Talk about "Sex" – they sure do', *Los Angeles Times*, 5 June, 1.

AWC (1969a) *Open Hearing*. New York: Art Workers Coalition.

AWC (1969b) *Documents 1*. New York: Art Workers Coalition.

Badsey, S. (1998) *The Manchurian Candidate*. Trowbridge: Flicks Books.

Baird, R. (1996) 'Going Indian: discovery, adoption, and renaming toward a "true American," from *Deerslayer* to *Dances with Wolves*', in S. E. Bird (ed.), *Dressing in Feathers: the Construction of the Indian in American Popular Culture*. Boulder: Westview Press. pp. 195–210.

Baker, H. A. (1991) *Workings of the Spirit: The Poetics of Afro-American Women's Writing.* Chicago: University of Chicago Press.

Balio, T. (1998) '"A Major Presence in All the World's Markets": The Globalization of Hollywood in the 1990s', in S. Neale and M. Smith (eds), *Contemporary Hollywood Cinema.* London: Routledge. pp. 58–73.

Ballou, M. M. (1845) *Fanny Campbell, The Female Captain. A Tale of the Revolution.* Boston: F. Gleason.

Baltz, L. (1985) 'American Photography in the 1970s', in P. Turner (ed.), *American Images: Photography 1945–1980.* New York: Penguin. pp. 157–64.

Bancroft, H. H. (1893) *The Book of the Fair.* Chicago and San Francisco: The Bancroft Company.

Banta, M. and Hinsley, C. M. (1986) *From Site to Sight: Anthropology, Photography, and the Power of Imagery.* Cambridge: Peabody Museum Press.

Barger, M. S. and White, W. B. (2000) *The Daguerreotype: Nineteenth-Century Technology and Modern Science.* Baltimore: Johns Hopkins University Press.

Barnard, M. (2001) *Approaches to Understanding Visual Culture.* New York: Palgrave.

Barnet, R. and Cavanagh, J. (1996) 'Electronic Money and the Casino Economy', in J. Mander and E. Goldsmith (eds), *The Case Against the Global Economy.* San Francisco: Sierra Club Books. pp. 360–73.

Barnhurst, K. G. and Nerone, J. C. (2001) *The Form of News: A History.* New York: Guilford Press.

Barnouw, E. (1982) *Tube of Plenty.* New York: Oxford University Press.

Barthes, R. (1957) *Mythologies.* Paris: Seuil.

Barthes, R. (1981) *Camera Lucida: Reflections on Photography.* New York: Hill and Wang.

Barthes, R. (1982a) *Camera Lucida.* London: Jonathan Cape.

Barthes, R. (1982b) 'Le Discours de l'histoire', *Poétique* 49 (February), pp. 13–21.

Barthes, R. (1993) *Camera Lucida.* London: Vintage.

Bartlett, F. C. (1932) *Remembering: A Study in Experimental and Social Psychology.* Cambridge: Cambridge University Press.

Barton, W. E. (1903) *Jesus of Nazareth.* Boston: Pilgrim Press.

Bauman, R. (1989) 'Performance', in *International Encyclopedia of Communication* Vol. 3. New York: Oxford University Press. pp. 262–6.

Bauman, R. and Briggs, C. (1990) 'Poetics and performance as critical perspectives on language and social life', *Annual Review of Anthropology* (19), pp. 59–88.

Baxter, J. (1979) *Science Fiction in the Cinema.* London: The Tantivy Press.

Beam, P. (1979) *Winslow Homer's Magazine Engravings.* New York: Harper and Row.

Begley, A. (1993) 'The Art of Fiction CXXV: Don DeLillo', *Paris Review* 35(128), pp. 274–306.

Bell, D. (1960) *The End of Ideology.* Cambridge: Harvard University Press.

Belton, J. (1994) *American Cinema/American Culture.* New York: McGraw.

Bennett, T. and Woollacott, J. (1987) *Bond and Beyond: The Political Career of a Popular Hero.* Basingstoke: Macmillan.

Berger, A. A. (2000) *Ads, Fads, and Consumer Culture.* Lanham: Rowman & Littlefield.

Berger, J. and Mohr, J. (1982) *Another Way of Telling.* New York: Pantheon.

Berkhofer, R. (1978) *The White Man's Indian: Images of the American Indian from Columbus to the Present.* New York: Vintage.

Berlant, L. (2001) 'Love: A Queer Feeling', in T. Dean and C. Lane (eds), *Homosexuality and Psychoanalysis.* Chicago: Chicago University Press. pp. 432–51.

Bernstein, J. M. (1993) *The Fate of Art.* Cambridge: Polity Press.

Bernstein, J. M. (1996) 'The Death of Sensuous Particulars. Adorno and Abstract Expressionism', *Radical Philosophy* 76 (March–April), pp. 7–18.

Bernstein, M. (ed.) (2000) *Controlling Hollywood: Censorship and Regulation in the Studio Era.* London: Athlone.

Best, G. D. (1991) *Pride, Prejudice, and Politics: Roosevelt versus Recovery, 1933–1938*. New York: Praeger.

Bezner, L. C. (1999) *Photography and Politics in America: From the New Deal into the Cold War*. Baltimore: Johns Hopkins University Press.

Bhabha, H. (1983) 'The Other Question . . .: Homi Bhabha Reconsiders the Stereotype and Colonial Discourse', *Screen* 24(6), pp. 18–36.

Bhabha, H. (1999) 'The Other Question: The Stereotype and Colonial Discourse', in J. Evans and S. Hall (eds), *Visual Culture: The Reader*. London: Sage. pp. 370–78.

Biddle, G. (1939) *An American Artist's Story*. Boston: Little, Brown.

Bird, S. E. (1992) *For Enquiring Minds: A Cultural Study of Supermarket Tabloids*. Knoxville: University of Tennessee Press.

Bird, S. E. (1996) 'Not my fantasy: the persistence of Indian imagery in *Dr. Quinn, Medicine Woman*', in S. E. Bird (ed.), *Dressing in Feathers: the Construction of the Indian in American Popular Culture*. Boulder: Westview Press. pp. 245–62.

Bird, S. E. (1999) 'Gendered construction of American Indians in popular media', *Journal of Communication* 49, pp. 61–83.

'*Birth of a Nation* Run Out of Philadelphia', *Chicago Defender*, 25 September, 1915, p. 1.

Biskind, P. (2000) *Seeing is Believing: How Hollywood Taught Us to Stop Worrying and Love the Fifties*. New York: Henry Holt.

Blair, M. *et al.* (eds) (1995) *Identity and Diversity: Gender and the Experience of Education*. Clevedon: Multilingual Matters in association with The Open University.

Blauvelt, H. (1925) 'When the Modernist Invades Advertising', *Printers' Ink Monthly* (May), pp. 65–6.

Bobo, J. (1995) *Black Women As Cultural Readers*. New York: Columbia University Press.

Boddy, W. (1995) 'The Beginnings of American Television', in A. R. Smith (ed.), *Television: An International History*. Oxford: Oxford University Press. pp. 35–61.

Boden, D. and Hoskins, A. (1995) 'Time, Space and Television'. Paper presented at the 2nd *Theory, Culture & Society* Conference, 'Culture and Identity: City, Nation, World', Berlin, 11 August.

Boime, A. (1991) *The Magisterial Gaze: Manifest Destiny and American Landscape Painting*. Washington: Smithsonian Institution.

Bolter, D. J. and Grusin, R. (1999) *Remediation: Understanding New Media*. Cambridge: MIT Press.

Boorstin, D. (1961) *The Image or What Happened To The American Dream*. New York: Atheneum.

Borde, R. and Chaumeton, E. (1996) 'Towards a Definition of Film Noir', in A. Silver and J. Ursini (eds), *Film Noir Reader*. New York: Limelight Editions.

Bordwell, D. *et al.* (1985) *The Classical Hollywood Cinema: Film Style and Mode of Production to 1960*. New York: Routledge.

Bordwell, D. and Thompson, K. (2003) *Film Art: An Introduction*. New York: McGraw-Hill.

Bourdieu, P. (1977) *Outline of a Theory of Practice*. Cambridge: Cambridge University Press.

Bourdieu, P. (1984) *Distinction: A Social Critique of the Judgement of Taste*. Cambridge: Harvard University Press.

Bourdieu, P. (1993) *The Field of Cultural Production: Essays on Art and Literature*. New York: Columbia University Press.

Bourdieu, P. (1995) *The Rules of Art: Genesis and Structure of the Literary Field*. Stanford: Stanford University Press.

Bourdieu, P. (1998) 'The Essence of Neoliberalism', *Le Monde Diplomatique* online, mondediplo.com/1998/12/08bourdieu

Bowser, E. (1994) *The Transformation of Cinema 1907–1915*. Berkeley: University of California Press.

Bowser, P. and Spence, L. (2000) *Writing Himself Into History: Oscar Micheaux, His Silent Films, and His Audiences*. New Brunswick: Rutgers University Press.

Braverman, H. (1974) *Labor and Monopoly Capital: The Degradation of Work in the Twentieth Century*. New York: Monthly Review Press.

Brecher, J. and Costello, T. (1994) *Global Village or Global Pillage: Economic Reconstruction from the Bottom Up*. Boston: South End Press.

Brinkley, A. (1993) *The Unfinished Nation*. New York: McGraw-Hill.

Brinkley, J. (1998) *Defining Vision: The Battle for the Future of Television*. New York: Harcourt Brace and Co.

Brockett, L. P. and Vaughan, M. C. (1867) *Women's Work in the Civil War: A Record of Heroism, Patriotism and Patience*. Philadelphia: Ziegler, McCurdy & Co.; and Boston: R. H. Curran.

Broderick, M. (1991) *Nuclear Movies*. London: McFarlane, Jefferson.

Brooks, A. (1997) *Postfeminisms: Feminism, Cultural Theory and Cultural Forms*. London: Routledge.

Brown, B. (1996) *The Material Unconscious: American Amusement, Stephen Crane, and the Economies of Play*. Cambridge and London: Harvard University Press.

Brown, D. (1971) *Bury My Heart at Wounded Knee: An Indian History of the American West*. London: Barrie and Jenkins.

Brown, H. G. (1962) *Sex and the Single Girl*. New York: Bernard Geiss.

Brown, H. G. (1964) *Sex in the Office*. New York: Bernard Geiss.

Brown, R. and Kulik, J. (1977) 'Flashbulb Memories', *Cognition* 5, pp. 73–99.

Brunsdon, C. (1997) *Screen Tastes: Soap Opera to Satellite Dishes*. London: Routledge.

Bryson, N. *et al.* (1994) *Visual Culture: Images and Interpretations*. Hanover: Wesleyan University Press.

Buell, H. (1999) *Moments: The Pulitzer Prize Photographs, A Visual Chronicle of Our Times*. New York: Black Dog and Leventhal.

Bürger, P. (1984) *Theory of the Avant-Garde*. Minneapolis: University of Minnesota Press.

Burgin, V. (ed.) (1982) *Thinking Photography*. London: Palgrave Macmillan.

Burgin, V. (1996) *In/Different Spaces: Place and Memory in Visual Culture*. Berkeley: University of California.

Burgoyne, R. (2003) 'Memory, History and Digital Imagery in Contemporary Film', in P. Grainge (ed.), *Memory and Popular Film*. Manchester: Manchester University Press.

Burke, K. (1973) *The Philosophy of Literary Form: Studies in Symbolic Action*. Berkeley: University of California Press.

Burstow, R. (1994) 'On Art and Politics', *Frieze* 18, pp. 33–5.

Burton-Carvajal, J. (1994) '"Surprise Package": Looking Southward with Disney', in E. Smoodin (ed.), *Disney Discourse*. New York: Routledge. pp. 131–47.

Bush, A. L. and Mitchell, L. C. (1994) *The Photograph and the American Indian*. Princeton: Princeton University Press.

Bushnell, H. (1978 [1869]) *Women's Suffrage; the Reform Against Nature*. Washington, D.C.: Zenger.

Butler, J. (1993) *Bodies that Matter: On the Discursive Limits of 'Sex'*. London: Routledge.

Butler, J. (1995) 'Melancholy Gender/Refused Identification', in M. Berger *et al.* (eds), *Constructing Masculinity*. London: Routledge.

Butler, J. (1999) *Gender Trouble, Feminism and the Subversion of Identity*. London: Routledge.

Butler, J. (2004) 'The Force of Fantasy: Feminism, Mapplethorpe and Discursive Excess', in S. Salih (ed.), *The Judith Butler Reader*. Oxford: Blackwell. pp. 183–203.

Butters Jr., G. R. (2002) *Black Manhood on the Silent Screen*. Lawrence: University Press of Kansas.

Cabanas, K. M. 'Ritual and Revolution: Carrie Mae Weems'. Interview by Universes in Universe. *<http://www.universes-in-universe.de/america/us_afro/weems/weems1.htm>*

Caldwell, J. T. (1995) *Televisuality – Style, Crisis, and Authority in American Television*. New Brunswick: Rutgers University Press.

Callinicos, A. (1989) *Against Postmodernism: A Marxist Critique*. Cambridge: Polity.

Campbell, N. (2003) '"The look of hope or the look of sadness": Robert Frank's dialogical vision', *Comparative American Studies* 1(2), pp. 204–11.

Campbell, S. (1928) 'Modern vs. Modernistic Art', *Printers' Ink Monthly* (December), pp. 34–5, 123.

Cándida-Smith, R. (1995) *Utopia and Dissent: Art, Poetry, and Politics in California*. Berkeley and Los Angeles: University of California Press.

Capa, C. (1968) *The Concerned Photographer*. Catalogue. New York: Grossman Publishers.

Caputo, J. (1993) *Against Ethics: Contributions to a Poetics of Obligation with Constant Reference to Deconstruction*. Bloomington: Indiana University.

Carpignano, P. (1997) *Televisuality*. <*www.newschool.edu/mediastudies/tv/*>

Carr, C. K. and Gurney, G. (eds) (1993) *Revisiting the White City: American Art at the 1893 World's Fair*. Hanover: University Press of New Hampshire.

'Carroll Glues St. Louis to its TV Screens; Grand Jury Tries to Link Him to Handbook' (1951), *New York Times*, 23 March, p. 13.

Carson, F. and Pajaczkowska, C. (2001) *Feminist Visual Culture*. London: Routledge.

Carter, J. (1979) *The Crisis of Confidence*. Online. <*www.tamu.edu/scom/pres/speeches/jccrisis.html*>

Cavell, S. (1982) 'The Fact of Television', *Daedalus* 111(4), pp. 75–96.

Chalfen, R. and Pack, S. (1998) 'Why *Krippendorf's Tribe* is good for teaching anthropology', *Visual Anthropology Review* 14, pp. 103–05.

Chang, Y. *et al.* (1999) 'Sex and the Single Girl', *Newsweek* 134(5), 2 February, pp. 60–62.

Chomsky, N. (1992) *What Uncle Sam Really Wants*. Tucson: Odonian Press.

Chong, D. (1999) *The Girl in the Picture: The Story of Kim Phuc, the Photograph, and the Vietnam War*. New York: Viking.

Christ-Janer, A. (1946) *Boardman Robinson*. Chicago: University of Chicago Press.

'Civil Liberties Toting "Storm Center" Separately Classified by Legion' (1956), *Variety* (11 July): BFI Library archive. n.p.

Clarke, G. (1997) *The Photograph*. Oxford: Oxford University Press.

Clark, T. J. (1992) 'The Painting of Modern Life', in F. Frascina and J. Harris (eds), *Art in Modern Culture: An Anthology of Critical Texts*. London: Phaidon. pp. 40–50.

Clark, T. J. (1999) *Farewell to an Idea. Episode from a History of Modernism*. New Haven and London: Yale University Press.

Clay, S. and Phillips, R. (1998) *A Secret Location on the Lower East Side: Adventures in Writing 1960–1980*. New York: The New York Public Library and Granary Books.

Clifford, J. (1988) *The Predicament of Culture*. Cambridge: Harvard University Press.

Clifford, J. and Marcus, G. (eds) (1986) *Writing Culture: The Poetics and Politics of Ethnography*. Berkeley: University of California Press.

Clover, C. (1992) *Men, Women, and Chain Saws: Gender in the Modern Horror Film*. Princeton: Princeton University Press.

Cockcroft, E. (1992) 'Abstract Expressionism, Weapon of the Cold War', in F. Frascina and J. Harris (eds), *Art in Modern Culture: An Anthology of Critical Texts*. London: Phaidon. pp. 82–90.

Cohen, D. A. (1997) *The Female Marine and Related Works: Narratives of Cross-Dressing and Urban Vice in America's Early Republic*. Amherst: University of Massachusetts Press.

Cohen, J. R. (1991) 'The "relevance" of cultural identity in audiences' interpretations of the mass media', *Critical Studies in Mass Communication* 8, pp. 442–54.

Cohen, P. C. (1992) 'Safety and Danger: Women on American Public Transport, 1750–1850', in D. O. Kelly and S. M. Reverby (eds), *Gendered Domains: Rethinking Public and Private in Women's History*. Ithaca, NY: Cornell University Press. pp. 109–22.

Cohen, P. M. (2001) *Silent Film and the Triumph of American Myth*. Oxford: Oxford University Press.

Cole, T. (1974 [1836]) 'Essay on American Scenery', in J. Conron (ed.), *American Landscape: A Critical Anthology of Prose and Poetry*. New York: Oxford University Press. pp. 570–82.

Coleman, A. D. (1979) *Light Readings: A Photography Critic's Writings, 1968–1978*. New York: Oxford University Press.

Coleman, A. D. (1998) *Depth of Field. Essays on Photography, Mass Media, and Lens Culture*. Albuquerque: University of New Mexico Press.

Comella, L. (2003) '(Safe) *Sex and the City*: On Vibrators, Masturbation, and the Myth of "Real" Sex', *Feminist Media Studies* 3(1), pp. 109–12.

Conover, P. J. and Gray, V. (1983) *Feminism and the New Right: Conflict over the American Family*. New York: Praeger.

Conquergood, D. (1991) 'Rethinking Ethnography: Towards a Critical Cultural Politics', *Communication Mongraphs* (58), pp. 179–94.

Cooks, B. R. (1995) 'See Me Now', *Camera Obscura* 36, pp. 67–83.

Coplans, J. (1964) 'Wallace Berman: Art is Love is God', *Artforum* 11(9), pp. 27.

Coplans, J. (1970) 'Early Warhol: The Systematic Evolution of the Impersonal Style', *Artforum* (March), p. 59.

Corliss, R. (1996) 'A SPECIAL DELIVERY: Oscar Nominations Go To the Sweet Italian Film *The Postman* and its Heroic Star, Massimo Troisi', *Time* 147(9) (26 February), p. 9. *<http://www.time.com/time/archive/preview/0,10987,1101960226–135550,00.html>*

Coupland, D. (1993) 'Television View', *New York Times*, 14 November. *<http://membres.lycos.fr/coupland/nyt5.html>*

'Crime Hearing is TV Smash in District, 20 Other Cities' (1951), *Washington Post*, 20 March, p. 1.

Cripps, T. (1971) 'The Reaction of the Negro to the Motion Picture, *Birth of a Nation*', in F. Silva (ed.), *Focus on The Birth of a Nation*. Englewood Cliffs: Prentice-Hall. pp. 111–24.

Cronbach, R. (1972) 'The New Deal Sculpture Projects', in F. V. O'Connor (ed.), *The New Deal Art Projects: An Anthology of Memoirs*. Washington D.C.: Smithsonian Institution Press.

Crow, T. (1985) 'Modernism and Mass Culture in the Visual Arts', in F. Frascina (ed.), *Pollock and After*. New York: Harper & Row. pp. 233–66.

Crow, T. (1996) *Modern Art in the Common Culture*. New Haven: Yale University Press.

Crowther, B. (1956) 'Storm Center', *New York Times* (22 October): BFI Library archive. n.p.

Cubitt, S. (1998) *Digital Aesthetics*. London: Sage.

Current, K. and Current, W. R. (1978) *Photography and the Old West*. New York: Harry N. Abrams.

Currier & Ives: A Catalogue Raisonné. Vol. 1. (1984). Detroit: Gale Research Company.

Curtis, E. S. (1907–1930) *The North American Indian*, 20 vols and 20 portfolios. Cambridge, MA and Norwood, MA: University Press and Plimpton Press.

Curtis, J. (1989) *Mind's Eye, Mind's Truth: FSA Photography Reconsidered*. Philadelphia: Temple University Press.

D'Acci, J. (1997) 'Nobody's Woman? Honey West and the New Sexuality', in L. Spigel and M. Curtin (eds), *The Revolution Wasn't Televised: Sixties Television and Social Conflict*. London: Routledge. pp. 73–94.

Daniel, P. and Smock, R. (1974) *A Talent for Detail: The Photographs of Miss Frances Benjamin Johnston 1889–1910*. New York: Harmony Books.

Daniel, P. *et al.* (1987) *Official Images: New Deal Photography*. Washington: Smithsonian Institution Press.

Daniels, R. (1971) *The Bonus March: An Episode of the Great Depression*. Westport: Greenwood.

Danto, A. C. (1992) 'Playing with the Edge: The Photographic Achievement of Robert Mapplethorpe', in M. Holborn and D. Levas (eds), *Mapplethorpe*. London: Jonathan Cape. pp. 311–40.

Darley, A. (2000) *Visual Digital Culture*. London: Routledge.

Davidov, J. F. (1998) *Women's Camera Work: Self/Body/Other in American Visual Culture*. Durham, NC and London: Duke University Press.

Davidson, B. (1978) *Photographs*. New York: Agrinde Publications Ltd.

Davis, C. C. (1964) 'Companions of Crisis: The Spy Memoir as a Social Document', *Civil War History* 10 (December), pp. 385–400.

Davis, K. F. (1999) *An American Century of Photographs: From Dry-plate to Digital: the Hallmark Photographic Collection*. Kansas City, New York: Hallmark Cards Inc. in association with Harry N. Abrams.

Davis, N. Z. (1978) 'Women on Top: Symbolic Sexual Inversion and Political Disorder in Early Modern Europe', in B. A. Babcock (ed.), *The Reversible World: Symbolic Inversion in Art and Society*. Ithaca, NY, and London: Cornell University Press. pp. 147–90.

Day, J. (1995) *The Vanishing Vision: The Inside Story of Public Television*. Berkeley: University of California Press.

DeCarava, R. and Hughes, L. (1967 [1955]) *The Sweet Flypaper of Life*. New York: Hill and Wang.

Delage, C. (2002) 'A Place for the Spectator', *Television and New Media* 3(2), pp. 163–7.

De Lauretis, T. (1984) *Alice Doesn't: Feminism, Semiotics, Cinema*. Bloomington: Indiana University Press.

Deleuze, G. (1991) *Bergsonism*. New York: Zone Books.

Deleuze, G. (1994) *Difference and Repetition*. New York: Columbia University Press.

Deleuze, G. (1997a) *Cinema 1: The Movement-Image*. Minneapolis: University of Minnesota Press.

Deleuze, G. (1997b) *Cinema 2: The Time-Image*. Minneapolis: University of Minnesota Press.

DeLillo, D. (1997) *Underworld*. London: Picador.

Demaline, J. (2000) 'Mapplethorpe battle changed art world. Ten years later, both sides claim their victories', *Cincinnati Enquirer*, 21 May.
 <http://www.enquirer.com/editions/2000/05/21/loc_mapplethorpe_battle.html>

D'Emilio, J. and Freedman, E. B. (1997) *Intimate Matters: A History of Sexuality in America*. Chicago and London: University of Chicago Press.

Denning, M. (1996) *The Cultural Front: The Laboring of American Culture in the Twentieth Century*. New York: Verso.

Desmond, K. (2002) 'Carrie Mae Weems: The Nelson-Atkins Museum of Art', *New Art Examiner* XXIX(4), p. 75.

'Did Oswald Act Alone? A Matter of Reasonable Doubt' (1966), *Life*, 25 November, pp. 38–53.

di Leonardo, M. (1998) *Exotics at Home: Anthropologies, Others, American Modernity*. Urbana: University of Chicago Press.

DiMaggio, P. J. (1986) 'Cultural Entrepreneurship in Nineteenth-Century Boston', in P. J. DiMaggio (ed.), *Nonprofit Enterprise in the Arts*. New York: Oxford University Press. pp. 41–61.

Dodson, B. (1986 [1974]) *Sex for One: the Joy of Self Loving*. Nevada City: Harmony Books.

Doherty, R. J. (1976) *Social Documentary Photography in the USA*. American Photographic Books.

Doherty, T. (1998) 'Frank Costello's Hands', *Film History* 10(3), pp. 359–74.

Doherty, T. (1999) *Projections of War: Hollywood, American Culture, and World War II*. New York: Columbia University Press.

Doherty, T. (2000) Review of James L. Lorence, *The Suppression of Salt of the Earth: How Hollywood, Big Labor, and Politicians Blacklisted a Movie in Cold War America* (Albuquerque: University of New Mexico Press, 1999), in *Labor History* (August).
 <http://findarticles.com/cf_dls/m03483_41/656.../article.jhtml?term=cold+war+movie>

Doherty, T. (2001) 'The Army-McCarthy Hearings'.
 <www.mbcnet.org/ETV/A/htmlA/army-mccarthy/army-mccarthy.htm>

Dorfman, A. and Mattelart, A. (1975) *How to Read Donald Duck*. New York: International General.

Dorsey, G. A. (1903) *Indians of the Southwest*. Chicago: Atchison, Topeka and Santa Fe Railway System.

Dos Passos, J. (1969 [1920]) *One Man's Initiation: 1917*. Lanham: University Press of America.

Dos Passos, J. (1990 [1921]) *Three Soldiers*. Harmondsworth: Penguin.

Doss, E. (ed.) (2001) *Looking At Life Magazine*. Washington and London: Smithsonian Institution Press.

Doss, E. L. (2002) *Twentieth-Century American Art*. Oxford: Oxford University Press.

Dow, B. J. (1996) *Prime Time Feminism: Television, Media Culture, and the Women's Movement Since 1970*. Philadelphia: University of Pennsylvania Press.

'Draft Manifesto of the John Reed Clubs' (1932), *New Masses* (June), p. 14.

Drummond, L. (1996) *American Dreamtime: A Cultural Analysis of Popular Movies*. New York: Littlefield Adams.

Duchamp, M. (1992) 'The Richard Mutt Case', in C. Harrison and P. Wood (eds), *Art in Theory 1900–1990: An Anthology of Changing Ideas*. Oxford: Blackwell. p. 248.

Duncan, R. (1978) 'Wallace Berman; the Fashioning Spirit', in H. Glicksman (ed.), *Wallace Berman: Retrospective*. Los Angeles: Fellows of Contemporary Art. pp. 19–20.

Dutka, E. and Clark, J. (1997) 'Miramax Finds Success Breeds Admiration, Envy; Movies: The Company Revolutionized the Indie World, But It's Now Accused of Operating Like a Major Studio', *Los Angeles Times*, 30 January: F 1–2.

Dyer, R. (1992) *Only Entertainment*. London: Routledge.

Dyer, R. (1997) *White*. London: Routledge.

Eagleton, T. (1983) *Literary Theory. An Introduction*. Oxford: Basil Blackwell.

Eastman, M. (1915) 'What Is the Matter with Magazine Art', *The Masses* (January), pp. 12–16.

Eco, U. (1992) 'The Currency of the Photograph', in V. Burgin (ed.), *Thinking Photography*. London: Macmillan. pp. 32–9.

Edmonds, S. E. E. (1865) *Nurse and Spy in the Union Army*. Hartford, CT: W. S. Williams & Co.; and Philadelphia: Jones Bros. & Co. 'Making of America' (MOA) digital library, <http://moa.umdl.umich.edu/cgi/sgml/moa-idx?notisid=ABV2963>

Edwards, P. N. (1996) *The Closed World: Computers and the Politics of Disclosure in Cold War America*. Cambridge: MIT Press.

Ehrenreich, B. (1997) *Blood Rites: Origins and History of the Passions of War*. New York: Henry Holt.

Ehrenreich, B. *et al.* (1986) *Re-Making Love: The Feminization of Sex*. New York: Anchor Books.

Eisinger, J. (1995) *Trace and Transformation: American Criticism of Photography in the Modernist Period*. Albuquerque: University of New Mexico Press.

Elkins, J. (2003) *Visual Studies: A Skeptical Introduction*. London: Routledge.

Eller, C. (1995) 'On Screen Chemistry: The Synergy between Unlikely Partners Miramax and Disney Has Surprised Many – Including Miramax and Disney', *Los Angeles Times*, 1 December: D1.

Eller, C. (1997) 'Miramax's Patient Approach', *Los Angeles Times*, 21 March: D4.

Ellison, R. (1965) *Invisible Man*. Harmondsworth: Penguin.

Emerson, R. W. (1982) 'Nature', in R. W. Emerson, *Selected Essays*. Harmondsworth: Penguin. pp. 35–82.

Empen, C. W. (2003) 'Public and Exposed: Imaging the Female Body in American Visual Culture, 1848–1875', Dissertation, Indiana University, Bloomington.

Engelman, R. (1996) *Public Radio and Television in America: A Political History*. Thousand Oaks: Sage.

Epstein, J. and Straub, K. (eds) (1991) *Body Guards: The Cultural Politics of Gender Ambiguity*. New York: Routledge.

Evans, J. and Hall, S. (eds) (1999) *Visual Culture: The Reader*. London: Sage.

Evans, W. (1995 [1938]) *American Photographs*. New York: Museum of Modern Art.

Everson, W. K. (1998) *American Silent Film*. New York: DaCapo.

Ewen, S. (1976) *Captains of Consciousness: Advertising and the Social Roots of Consumer Culture*. New York: McGraw-Hill.

Faas, H. and Page, T. (eds) (1997) *Requiem: By the Photographers Who Died in Vietnam and Indochina*. New York: Random House.

Faludi, S. (1992) *Backlash: The Undeclared War Against Women*. London: Vintage.

Farrell, T. (1993) *Norms of Rhetorical Culture*. New Haven: Yale University Press.

Faust, D. G. (1996) *Mothers of Invention: Women of the Slaveholding South in the American Civil War*. Chapel Hill and London: The University of North Carolina Press.

'FCC Bids Hollywood End Feud with Television or Face Video Bar' (1951) *New York Times*, 30 March, p. 1.

Fearon, P. (1987) *War, Prosperity and Depression: the US Economy, 1917–45*. Deddington: Philip Allan.

'Female Influence and Obligations' No. 226 (1842), in *The Publications of the American Tract Society Vol. 7*. New York: American Tract Society. p. 392.

'Female Soldiers' (17 December 1864) *Frank Leslie's Illustrated Newspaper* XIX, p. 199.

Fender, S. (1989) 'American Landscape and the Figure of Anticipation', in M. Gidley and R. Lawson-Peebles (eds), *Views of American Landscapes*. Cambridge and New York: Cambridge University Press. pp. 51–63.

Films in Review (1956), 7(8), p. 417.

Finlay, Father (1956) Untitled review of *Storm Center*, *The Catholic World* 184(1099) (October), pp. 64–5.

Fisher, A. (1987) *Let Us Now Praise Famous Women: Women Photographers for the US Government 1935 to 1944*. London and New York: Pandora.

Fisher, P. (1999) *Still the New World: American Literature in a Culture of Creative Destruction*. Cambridge, MA, and London: Harvard University Press.

Fiske, J. and Hartley, J. (1990) *Reading Television*. London: Routledge.

Fitzgerald, R. (1973) *Art and Politics: Cartoonists of The Masses and Liberator*. London: Greenwood Press.

Flagg, J. M. (1927) 'The Same Thing – Only Different', *Printers' Ink Monthly* (September), pp. 44, 119.

Fleischhauer, C. and Brannan, B. W. (eds) (1988) *Documenting America, 1935–1943*. Berkeley and London: University of California Press.

Fleming, P. R. and Luskey, J. L. (1986) *The North American Indians in Early Photographs*. New York: Barnes and Noble.

Fleming, P. R. and Luskey, J. L. (1993) *Grand Endeavors of American Indian Photography*. Washington, D.C.: Smithsonian Institution Press.

Fliegelman, J. (1993) *Declaring Independence: Jefferson, Natural Language and the Culture of Performance*. Stanford: Stanford University Press.

Foresta, M. (1984) *Exposed and Developed: Photography Sponsored by the National Endowment for the Arts*. Washington, D.C.: Smithsonian Institution Press.

Foresta, M. A. and Wood, J. (1995) *Secrets of the Dark Chamber: The Art of the American Daguerreotype*. Washington, D.C.: Smithsonian Institution Press.

'For Normal TV Lighting, Optometrist Says Video Does Not Hurt Viewer's Eyes' (1951), *New York Times*, 4 June, p. 36.

Foster, H. (1996) *The Return of the Real: Art and Theory at the End of the Century*. Cambridge: MIT Press.

Foster, H. (1998) *The Anti-Aesthetic: Essays on Postmodern Culture*. New York: New Press.

Frank, R. (1972) *The Lines of My Hand*. Los Angeles: Lustrum Press.

Frank, R. (1987) *Camera Austria* 22, pp. 17–23.

Frank, R. (1993 [1958]) *The Americans*. Manchester: Cornerhouse.

Frank, R. (1994) *Black White and Things*. Washington, D.C.: National Gallery of Art.

Frank, S. M. (1998) *Life with Father: Parenthood and Masculinity in the Nineteenth-Century American North*. Baltimore: The Johns Hopkins University Press.

Franklin, H. B. (1994) 'From Realism to Virtual Reality: Images of America's war', in S. Jeffords and L. Rabinovitz (eds), *Seeing Through the Media: The Persian Gulf War*. New Brunswick: Rutgers University Press. pp. 25–44.

Franzen, M. and Ethiel, N. (1988) *Make Way! 200 Years of American Women in Cartoons*. Chicago: Chicago Review Press.

Frascina, F. (1999) *Art, Politics and Dissent: Aspects of the Art Left in Sixties America*. Manchester and New York: Manchester University Press.

Frascina, F. (ed.) (2000) *Pollock and After: The Critical Debate*, 2nd edn. New York: Routledge.

Frascina, F. and Harris, J. (eds) (1992) *Art in Theory. An Anthology of Critical Texts*. London: Phaidon.

Freidus, M. (1991) *Typologies. Nine Contemporary Photographers*. Newport Beach: Newport Harbor Art Museum.

Freud, S. (1990 [1919]) 'The Uncanny', in *The Penguin Freud Library, Volume 14: Art and Literature*. Penguin: Harmondworth.

Fried, M. (1992) 'Three American Painters', in C. Harrison and P. Wood (eds), *Art in Theory 1900–1990*. Oxford: Blackwell. pp. 769–75.

Friedan, B. (1963) *The Feminine Mystique*. New York: Dell.

Frieden, T. (1998) 'Ownership of Zapruder Film Passes to Government', *CNN* (31 July).

Frosh, P. (2003) *The Image Factory: Consumer Culture, Photography and the Visual Content Industry*. Oxford: Berg.

'Futurism Breaks into Newspaper Advertising Art' (1926) *Printers' Ink*, 18 November, pp. 145–50.

Gabler, N. (1998) *Life the Movie: How Entertainment Conquered Reality*. New York: Knopf.

Gablik, S. (1984) *Has Modernism Failed?* New York: Thames and Hudson.

Gaines, J. (2001) *Fire and Desire: Mixed-Race Movies in the Silent Era*. Chicago: University of Chicago Press.

Gair, C. (2000) 'Whose America? White City and the Shaping of National Identity', in M. Balshaw *et al.* (eds), *City Sites: An Electronic Book*. Birmingham: Birmingham University Press. <http://artsweb.bham.ac.uk/citysites/>

Galbraith, J. (1993) 'Book, Film Tie-In Whetting Appetites for "Chocolate"', *Los Angeles Times*, 29 May: F3.

Galbraith, J. K. (1958) *The Affluent Society*. Harmondsworth: Penguin.

Garner, G. (2003) *Disappearing Witness: Change in Twentieth-Century American Photography*. Baltimore: Johns Hopkins University Press.

Gates, P. (1989) 'American Land Policy', in C. Milner (ed.), *Major Problems in the History of the American West*. Lexington: Heath. pp. 149–63.

Gauchet, M. (1997) *The Disenchantment of The World: A Political History of Religion*. Princeton: Princeton University Press.

Gauntlett, D. and Horsley, S. (2004) *Web Studies*. New York: Edward Arnold.

Gaustad, E. S. (1990) *A Religious History of America*. New York: Harper.

Gay, V. (2002) 'What Makes HBO Tick?', *Cable World* 14(41), 4 November, pp. 16–21.

Geertz, C. (1993) *The Interpretation of Cultures*. London: Fontana.

Geraghty, C. and Lusted, D. (eds) (1998) *The Television Studies Book*. New York: Edward Arnold.

Gibbs, N. (2001) 'If You Want to Humble an Empire', *Time* (supplementary issue 24 September), pp. 33–48.

Gibson, C. and Lennon, E. (2000) 'Historical Census Statistics on the Foreign-born Population of the United States: 1850–1990'. *US Census Bureau*. Updated February 1999. <http://www.census.gov/population/www/documentation/twps0029/twps0029.html>

Gidley, M. (1989) 'The Figure of the Indian in Photographic Landscapes', in M. Gidley and R. Lawson-Peebles (eds), *Views of American Landscapes*. Cambridge and New York: Cambridge University Press. pp. 199–221.

Gidley, M. (ed.) (1992) *Representing Others: White Views of Indigenous Peoples*. Exeter: University of Exeter Press.

Gidley, M. (1998a) *Edward S. Curtis and The North American Indian, Incorporated*. New York and Cambridge: Cambridge University Press.

Gidley, M. (1998b) 'A Hundred Years in the Life of American Indian Photographs', in J. Alison (ed.), *Native Nations: Journeys in American Photography*. London: Booth-Clibborn Editions for Barbican Art Gallery. pp. 152–67.

Gidley, M. (2000) 'Reflecting Cultural Identity in Contemporary American Indian Photography', in T. Claviez and M. Moss (eds), *Mirror Writing: (Re-) Constructions of Native American Identity*. Berlin and Cambridge, MA: Galda and Wilch. pp. 257–82.

Gidley, M. (2003) 'Edward S. Curtis' Photographs for *The North American Indian*: Texts and Contexts', in U. Haselstein *et al.* (eds), *Iconographies of Power: The Politics and Poetics of Visual Representation*. Heidelberg: Winter. pp. 65–85.

Gidley, M. (2004) 'Photography by Native Americans: Creation and Revision', in B. Maeder (ed.), *Representing Realities: Essays on American Literature, Art and Culture*. Tubingen: Gunter Narr. pp. 108–27.

Giles, P. (2000) 'European American Studies and American American Studies', *European Journal of American Culture* 19(1), pp. 12–16.

Gilpin, L. (1968) *The Enduring Navajo*. Austin: University of Texas Press.

Gilroy, P. (1992) *The Black Atlantic: Modernity and Double Consciousness*. Cambridge: Harvard University Press.

Ginsberg, Allen (1973) 'Notes for Howl and Other Poems' and 'When the Mode of the Music Changes the Walls of the City Shake', in D. Allen and W. Tallman (eds), *The Poetics of the New American Poetry*. New York: Grove Press.

Ginsburg, F. (1994) 'Culture and media: A (mild) polemic', *Anthropology Today* 10, pp. 5–15.

Ginzberg, L. D. (1990) *Women and the Work of Benevolence: Morality, Politics, and Class in the Nineteenth-Century United States*. New Haven: Yale University Press.

Gitlin, T. (1980) *The Whole World is Watching – Mass Media in the Making and Unmaking of the New Left*. California: University of California Press.

Gitlin, T. (1995) *The Twilight of Common Dreams: Why America Is Wracked by Culture Wars*. New York: Metropolitan Books.

Gitlin, T. (2001) *Media Unlimited: How the Torrent of Images and Sounds Overwhelms Our Lives*. New York: Metropolitan Books.

Glaser, B. and Strauss, A. (1967) *The Discovery of Grounded Theory: Strategies for Qualitative Research*. Chicago: Aldine.

Glenn, C. W. (2000) 'Frances B. Johnston: The Hampton Album', in V. Paterson *et al.* (eds), *Carrie Mae Weems: The Hampton Project*. New York: Aperture. pp. 62–5.

Glickman, L. B. (ed.) (1999) *Consumer Society in American History: A Reader*. Ithaca, NY: Cornell University Press.

Goldberg, V. (1991) *The Power of Photography: How Photographs Changed Our Lives*. New York: Abbeville.

Golden, T. (1998) 'Some Thoughts on Carrie Mae Weems', in T. Piche *et al.*, *Carrie Mae Weems: Recent Work, 1992–1998*. New York: George Braziller. pp. 29–34.

Goldman, R. *et al.* (1991) 'Commodity Feminism', *Critical Studies in Mass Communication* 8, pp. 333–51.

Gomery, D. (1997) 'Transformation of the Hollywood System', in G. Nowell-Smith (ed.), *The Oxford History of World Cinema*. Oxford: Oxford University Press. pp. 443–51.

Gould, J. (1951) 'Major Issues Seen in Telecasts Now', *New York Times*, 23 March, p. 12.

Gould, J. (1954) 'TV and McCarthy', *New York Times*, 14 March, Section II, p. 18.

Grace, S. (1996) 'Exploration as construction: Robert Flaherty and *Nanook of the North*', *Essays on Canadian Writing* 59, pp. 123–46.

Grainge, P. (2002) *Monochrome Memories: Nostalgia and Style in Retro America*. Westport, CT and London: Praeger.

Grainge, P. (2003) 'Colouring the Past: *Pleasantville* and the Textuality of Media Memory', in P. Grainge (ed.), *Memory and Popular Film*. Manchester: Manchester University Press. pp. 202–19.

Green, J. (ed.) (1973) *Camera Work: A Critical Anthology*. Millerton: Aperture.

Green, J. (1984) *American Photography: A Critical History, 1945 to the Present*. New York: Abrams.

Greenberg, C. (1992a) 'Avant-garde and kitsch', in C. Harrison and P. Wood (eds), *Art in Theory 1900–1990*. Oxford: Blackwell. pp. 529–41.

Greenberg, C. (1992b) 'Modernist Painting', in F. Frascina and J. Harris (eds), *Art in Modern Culture: An Anthology of Critical Texts*. London: Phaidon. pp. 308–14.

Greenberg, C. (1992c) 'The Decline of Cubism', in C. Harrison and P. Wood (eds), *Art in Theory 1900–1990*. Oxford: Blackwell. pp. 569–72.

Greenhough, S. and Brookman, P. (eds) (1994) *Robert Frank: Moving Out*. Washington: National Gallery of Art.

Greider, W. (1997) *One World, Ready or Not: The Manic Logic of Global Capitalism*. New York: Simon and Schuster.

Gridley, D. (1928) 'A Statistical Glass Applied to Modernism', *Printers' Ink Monthly* (December), pp. 44–6, 130, 133.

Griffin, F. J. (1995) *'Who Set You Flowin'?': the African American Migration Narrative*. New York: Oxford University Press.

Griffith, R. (ed.) (1992) *Major Problems in American History since 1945*. Lexington: D.C. Heath.

Griffiths, P. J. (1971) *Vietnam Inc*. New York: Macmillan.

Groseclose, B. (2000) *Nineteenth-Century American Art*. Oxford: Oxford University Press.

Grossberg, L. (1997) *Dancing In Spite of Myself: Essays on Popular Culture*. Durham and London: Duke University Press.

Grover, J. Z. (1984) 'The First Living-Room War: The Civil War in the Illustrated Press', *Afterimage* 11 (February), pp. 8–11.

Grundberg, A. *et al*. (1995) *Tracing Cultures*. San Francisco: The Friends of Photography.

Gubernick, L. (1989) 'We Don't Want to be Walt Disney', *Forbes*, 16 October, p. 109.

Guerrero, E. (1993) *Framing Blackness: The African American Image in Film*. Philadelphia: Temple University Press.

Habermas, J. (1989) *The Structural Transformation of the Public Sphere: An Inquiry Into a Category of Bourgeois Society*. Cambridge: MIT Press.

Haines, G. K. (1977) 'Under the Eagle's Wing: The Franklin Roosevelt Administration Forges An American Hemisphere', *Diplomatic History* 1, pp. 373–88.

Halbwachs, M. (1992) *On Collective Memory*. Chicago: University of Chicago Press.

Hall, G. S. (1917) *Jesus, the Christ, In the Light of Psychology*, 2 vols. Garden City: Doubleday, Page & Co.

Hall, S. (1981) 'The Whites of Their Eyes: Racist Ideologies and the Media', in G. Bridges and R. Brunt (eds), *Silver Linings: Some Strategies for the Eighties*. London: Lawrence and Wishart.

Hall, S. (1995) 'The whites of their eyes: racist ideologies and the media', in G. Dines and J. M. Humez (eds), *Gender, Race and Class in the Media*. Thousand Oaks, CA: Sage. pp. 18–22.

Hallin, D. C. (1986) *The 'Uncensored War': The Media and Vietnam*. New York: Oxford University.

Hamilton, J. T. (2003) *All the News That's Fit to Sell: How the Market Transforms Information into News*. Princeton: Princeton University Press.

Hamilton, P. (1997) 'France and Frenchness in Post-War Humanist Photography', in S. Hall (ed.), *Representations: Cultural Representations and Signifying Practices*. London: Sage. pp. 75–150.

Hanchett, T. W. (1987) 'McClintock Rosenwald school and the Newell Rosenwald school'. <*http://www.cmhpf.org/S&RR/McClintockNewellRosen.htm*>

Hansen, M. (1991) *Babel & Babylon: Spectatorship in American Silent Film*, Cambridge: Harvard University Press.

Hariman, R. (1995) *Political Style: The Artistry of Power*. Chicago: University of Chicago.

Hariman, R. and Lucaites, J. L. (2001) 'Dissent and Emotional Management in a Liberal-Democratic Society: The Kent State Iconic Photograph', *Rhetoric Society Quarterly* (31), pp. 5–32.

Hariman, R. and Lucaites, J. L. (2002) 'Performing Civic Identity: The Iconic Photograph of the Flag Raising on Iwo Jima', *Quarterly Journal of Speech* (88), pp. 363–92.

Harrington, M. (1963) *The Other America: Poverty in the United States*. Baltimore: Penguin.

Harris, J. (1993) 'Modernism and Culture in the USA, 1830–1960', in P. Wood *et al.*, *Modernism in Dispute: Art Since the Forties*. New Haven and London: Yale/The Open University. pp. 3–76.

Harris, J. (1995) *Federal Art and National Culture*. Cambridge: Cambridge University Press.

Harris, N. (1990) *Cultural Excursions*. Chicago: University of Chicago Press.

Harrison, C. and Wood, P. (eds) (1992) *Art in Theory 1900–1990: An Anthology of Changing Ideas*. Oxford: Blackwell.

Hartung, P. T. (1956) 'The Malady Lingers On', *Commonweal* 64(19), 10 August, pp. 466–7.

Harvey, D. (1990) *The Condition of Postmodernity*. Oxford: Blackwell.

Hatch, R. (1956) 'Films', *Nation* (27 October): BFI Library archive. n.p.

HBO Signature, 2003. Online.
 <*http://www.hbo.com/hbosignature/?ntrack_para1=leftnav_other0_1*>

Head, S. W. and Sterling, C. H. (1996) *Broadcasting in America*. Boston: Houghton Mifflin.

Herman, E. S. and Chomsky, N. (1994) *Manufacturing Consent: The Political Economy of the Mass Media*. London: Vintage.

Herman, J. L. (1992) *Trauma and Recovery: The Aftermath of Violence from Domestic Abuse to Political Terror*. New York: Basic.

Heywood, I. and Sandywell, B. (1999) *Interpreting Visual Culture: Explorations in the Hermeneutics of the Visual*. New York: Routledge.

'Hidden Witness: African Americans in Early Photography' (1995) Exhibition Brochure. Los Angeles: Getty Museum.

Hiesinger, U. W. (1994) *Indian Lives: A Photographic Record from the Civil War to Wounded Knee*. Munich and New York: Prestel.

Higham, C. (1981) *Bette: A Biography of Bette Davis*. London: New English Library.

Higham, J. (1992) *Strangers in the Land: Patterns of American Nativism, 1860–1925*. New Brunswick: Rutgers University Press.

Hill, J. *et al.* (eds) (2000) *American Cinema and Hollywood: Critical Approaches*. Oxford: Oxford University Press.

Hill, P. and Cooper, T. J. (1979) *Dialogue with Photography*. New York: Farrar, Straus Giroux.

Hilmes, M. (ed.) (2004) *The Television History Book*. London: BFI.

Hine, L. (1980 [1909]) 'Social Photography. How the Camera May Help in the Social Uplift', in A. Trachtenberg (ed.), *Classic Essays on Photography*. New Haven: Leete's Island Books. pp. 110–13.

Hobsbawm, E. (1994) *Age of Extremes: The Short Twentieth Century, 1914–1991*. London: Michael Joseph.

Hoelscher, S. (2002) Unpublished paper delivered at the US American Studies Association conference, Houston.

Hollinger, K. (1998) *In the Company of Women: Contemporary Female Friendship Films*. Minneapolis: University of Minnesota Press.

Hollows, J. (2000) *Feminism, Femininity and Popular Culture*. Manchester: Manchester University Press.

Hollows, J. *et al.* (eds) (2000) *The Film Studies Reader*. London: Edward Arnold.

Hood, M. (1912) 'Art Impossible Under Capitalism', *The Masses* (March), p. 18.

Horowitz, H. L. (1987) *Campus Life: Undergraduate Culture from the End of the Nineteenth Century to the Present*. New York: Knopf.

Horsman, R. (1981) *Race and Manifest Destiny*. Cambridge: Harvard University Press.

Hoskins, A. (2001) 'New Memory: Mediating History', *The Historical Journal of Film, Radio and Television* 21(4), pp. 191–211.

Hoskins, A. (2004) *Televising War: From Vietnam to Iraq*. London: Continuum.

Howe, H. E. (1940) 'You Have Seen Their Pictures', *Survey Graphic* (1 April), p. 236. Online at *<http://newdeal.feri.org/survey/40b11.htm>*

Howe, L. (1977) *Pink Collar Workers: Inside the World of Women's Work*. New York: Putnam.

Howells, R. (2003) *Visual Culture*. Malden, MA: Blackwell.

Howells, W. D. (1961 [1893–4]) *Letters of An Altrurian Traveller*. Gainesville: Scholars' Facsimiles and Reprints.

Hoxie, F. E. (1989) *A Final Promise: The Campaign to Assimilate the Indians*. Cambridge and New York: Cambridge University Press.

Hoyt, H. (1916) 'In the Art Institute', *The Masses* (August), p. 14.

Hughes, R. (1997) *American Visions: The Epic History of Art in America*. New York: Knopf.

'Humors of the Day' (29 August 1863), *Harper's Weekly*, p. 558.

Huyssen, A. (1995) *Twilight Memories: Marking Time in a Culture of Amnesia*. New York: Routledge.

Huyssen, A. (2001) 'Present Pasts: Media, Politics, Amnesia', in A. Appadurai (ed.), *Globalization*. Durham and London: Duke University Press. pp. 57–77.

'Incidents of the War. A New York Heroine' (19 July 1862), *Frank Leslie's Illustrated Newspaper* XIV, p. 355.

Jacoby, R. (1987) *The Last Intellectuals. American Culture in the Age of Academe*. New York: Basic Books.

Jameson, F. (1989) *The Political Unconscious: Narrative as a Socially Symbolic Act*. London: Routledge.

Jancovich, M. (1996) *Rational Fears: American Horror in the 1950s*. Manchester: Manchester University Press.

Jay, M. (1993) *Downcast Eyes: The Denigration of Vision in Twentieth-Century French Thought*. Berkeley: University of California Press.

Jeffords, S. (1989) *The Remasculinization of America: Gender and the Vietnam War*. Bloomington: Indiana University Press.

Jeffreys, S. (1990) *Anticlimax: A Feminist Perspective on the Sexual Revolution*. London: Women's Press.

Jenks, C. (ed.) (1995) *Visual Culture*. London: Routledge.

Jensen, J. (1990) *Redeeming Modernity: Contradictions in Media Criticism*. Newbury Park, CA: Sage.

Johansen, S. (2001) *Family Men: Middle-Class Fatherhood in Early Industrializing America*. New York: Routledge.

Johnson, J. J. (1980) *Latin America in Caricature*. Austin: University of Texas Press.

Johnson, K. M. (2000) Advertising the Global Economy: Facilitating the Conditions of Reproduction. Unpublished doctoral dissertation, University of Minnesota, Minneapolis.

Johnson, T. (ed.) (1998) *Spirit Capture: Photographs from the National Museum of the American Indian*. Washington, D.C.: Smithsonian Institution Press.

Johnston, F. B. (1966) *The Hampton Album*. New York: The Museum of Modern Art.

Jones, A. (2002) *The Feminism and Visual Culture Reader*. London: Routledge.

Jones, M. A. (1992) *American Immigration*. Chicago: University of Chicago Press.

Jordan, G. and Weedon, C. (1995) *Cultural Politics: Class, Gender, Race and the Postmodern World*. Oxford: Blackwell.

Jussim, E. (1974) *Visual Communication and the Graphic Arts. Photographic Technologies in the Nineteenth Century*. New York: R. R. Bowker.

Jussim, E. and Lindquist-Cock, E. (1985) *Landscape as Photograph*. New Haven: Yale University Press.

Kaplan, E. A. (1997) *Looking for the Other: Feminism, Film, and the Imperial Gaze*. New York: Routledge.

Karp, I. and Levine, S. D. (eds) (1991) *Exhibiting Cultures: The Poetics and Politics of Museum Display*. Washington D.C.: Smithsonian Institution Press.

Kasher, S. (1998) *The Civil Rights Movement: A Photographic History, 1954–68*. New York: Abbeville Press.

Kefauver, E. (1968) *Crime in America*. Westport: Greenwood Press.

Keil, C. (2002) *Early American Cinema in Transition: Story, Style, and Filmmaking, 1907–1913*. Madison: University of Wisconsin Press.

Kellner, D. (1995) *Media Culture*. New York: Routledge.

Kennedy, D. M. (1999) *Freedom from Fear: The American People in Depression and War, 1929–1945*. Oxford: Oxford University Press.

Kenway, J. (1995) 'Feminist Theories of the State: To Be or Not To Be?', in M. Blair *et al.* (eds), *Identity and Diversity: Gender and the Experience of Education*. Clevedon: Multilingual Matters in association with The Open University. pp. 123–41.

Kerouac, J. (1985 [1957]) *On the Road*. Harmondsworth: Penguin.

Kerouac, J. (1993) 'Introduction', in R. Frank *The Americans*. Manchester: Cornerhouse. pp. 5–9.

Kimball, A. (1928) 'Going Modern', *Printers' Ink* (8 November), pp. 17–20.

Kimmel, M. (1996) *Manhood in America: A Cultural History*. New York: The Free Press.

Kim's Story: The Road from Vietnam (1997) First Run/Icarus Films. <http://www.frif.com/new97/kim_s_sto.html>

King, G. (2002) *New Hollywood Cinema: An Introduction*. New York: I.B. Tauris.

Kinnamon, K. and Fabre, M. (eds) (1993) *Conversations with Richard Wright*. Jackson: University Press of Mississippi.

Kinney, K. (2000) *Friendly Fire, American Images of the Vietnam War*. New York: Oxford University Press.

Kinsey, J. L. (1992) *Thomas Moran and the Surveying of the American West*. Washington D.C.: Smithsonian Institution Press.

Kirsch, A. (1994) 'Carrie Mae Weems: Issues in Black, White and Color', in A. Kirsch and S. F. Sterling, *Carrie Mae Weems*. Washington, D.C.: The National Museum of Women in the Arts.

Kirstein, L. (ed.) (1966) *The Hampton Album*. New York: Museum of Modern Art.

Kisselhoff, J. (1995) *The Box: An Oral History of Television, 1920–1961*. New York: Viking.

Kitses, J. (1969) *Horizons West*. London: BFI.

Kitzinger, J. (1999) 'Media Templates: Key Events and the (Re)construction of Meaning', *Media, Culture and Society* 22(1), pp. 61–84.

Klein, M. (1990) 'Historical Memory, Film, and the Vietnam Era', in L. Dittmar and G. Michaud (eds), *From Hanoi to Hollywood: The Vietnam War in American Film*. New Brunswick: Rutgers University Press. pp. 19–40.

Klein, N. (2000) *No Logo*. London: Flamingo.

Knock, T. J. (1992) *To End All Wars: Woodrow Wilson and the Quest for a New World Order*. Princeton: Princeton University Press.

Koedt, A. (1973) 'The Myth of the Vaginal Orgasm', in A. Koedt *et al.* (eds), *The Anthology of Radical Feminism*. New York: Quadrangle Books.

Kolker, R. (2000) *A Cinema of Loneliness: Penn, Stone, Kubrick, Scorsese, Spielberg, Altman*. Oxford: Oxford University Press.

Korten, D. C. (1996) 'The Failures of Bretton Woods', in J. Mander and E. Goldsmith (eds), *The Case Against the Global Economy*. San Francisco: Sierra Club Books. pp. 20–30.

Koszarski, R. (1994) *An Evening's Entertainment: The Age of the Silent Feature, 1915–1928*. Berkeley: University of California Press.

'Kramer may Temporarily Shelve "Circle of Fire"' (1952), *Variety* (21 November) 1952: BFI Library archive. n.p.

Kroll, J. (1993) 'Seeking the "Rotten Core"', *Newsweek* (23 August), p. 52.

Ladd, T. and Mathisen, J. A. (1999) *Muscular Christianity: Evangelical Protestants and the Development of American Sport*. Grand Rapids: Baker Book House.

Lafo, R. R. (2000) 'Expansion and Experimentation', in *Photography in Boston: 1955–1985*. DeCordova Museum and Sculpture Park. pp. 35–52.

LaFollette, S. (1936) 'Review of Federal Art Project at Museum of Modern Art', *The Nation* (October 16).

Laird, P. W. (1998) *Advertising Progress: American Business and the Rise of Consumer Marketing*. Baltimore: Johns Hopkins University Press.

Lange, D. and Taylor, P. S. (1939) *An American Exodus: A Record of Human Erosion*. New York: Reynal & Hitchcock.

Larned, W. L. (1927a) 'Giving the Advertisement a Distinctively New Atmosphere', *Printers' Ink* (21 April), pp. 161–9.

Larned, W. L. (1927b) 'Going the Limit in Newspaper Display', *Printers' Ink Monthly* (January), pp. 43–4.

Larned, W. L. (1927c) 'Putting Futurism into the Border', *Printers' Ink* (7 April), pp. 185–91.

Larned, W. L. (1929a) 'Mingling Modernistic Effects with Conventional Art Techniques', *Printers' Ink* (13 June), pp. 129–36.

Larned, W. L. (1929b) 'Put Your Backgrounds and Borders to Work', *Printers' Ink* (31 January), pp. 125–32.

Larned, W. L. (1929c) 'When the Camera Goes Modern', *Printers' Ink* (29 August), pp. 52–60.

Larrabee, C. B. (1928) 'If We're Going to Be Modern', *Printers' Ink Monthly* (February), pp. 34–5, 163.

Larrabee, C. B. (1929) 'Is Your Product in Step with Modern Design', *Printers' Ink Monthly* (March), pp. 33–5, 138, 140–41.

Lasch, C. (1978) *The Culture of Narcissism: American Life in an Age of Diminishing Expectations*. New York: Norton.

Lasch, C. (1984) *The Minimal Self: Psychic Survival in Troubled Times*. New York: W.W. Norton.

Laumann, E. O. *et al.* (2001) *The Social Organization of Sexuality: Sexual Practices in the United States*. Chicago: University of Chicago Press.

Lears, T. J. J. (1984) 'Some Versions of Fantasy: Toward a Cultural History of American Advertising, 1880–1930', *Prospects 9*, pp. 349–405.

Lears, T. J. J. (1994) *Fables of Abundance: A Cultural History of Advertising in America*. New York: Basic Books.

Leff, M. H. (1984) *The Limits of Symbolic Reform: The New Deal and Taxation, 1933–1939*. Cambridge: Cambridge University Press.

Lenin, V. I. (1996 [1916]) *Imperialism: The Highest Stage of Capitalism*. London: Pluto Press.

Leonard, E. D. (1994) *Yankee Women: Gender Battles in the Civil War*. New York: W.W. Norton.

Leonard, E. D. (1999a) *All the Daring of the Soldier: Women of the Civil War Armies*. New York and London: W.W. Norton and Company.

Leonard, E. D. (1999b) 'Introduction' and 'Notes', in S. E. Edmonds, *Memoirs of a Soldier, Nurse and Spy: A Woman's Adventures in the Union Army*. DeKalb: Northern Illinois Press. pp. xiii–xxviii, 237–58.

Lester, P. M. (1991) *Photojournalism: An Ethical Approach*. Hillsdale, NJ: Lawrence Erlbaum.

Lester, P. M. (1996) *Images That Injure: Pictorial Stereotypes in the Media*. New York: Praeger.

'Letters on Christian Education' No. 197 (1849) *Tracts of the American Tract Society Vol. 3*. New York: American Tract Society. pp. 11–18, 32.

Levine, L. (1988) *Highbrow/Lowbrow: The Emergence of Cultural Hierarchy in America*. Cambridge: Harvard University Press.

Lewis, S. *et al.* (1973) *Photography; Source and Resource*. Rochester, NY: Turnip Press.

Library of Congress (2002) 'Special Collections in the Library of Congress Farm Security Administration/Office of War Information Collection'.

Licht, W. (1995) *Industrializing America: The Nineteenth Century*. Baltimore: The Johns Hopkins University Press.

Light, K. (ed.) (2000) *Witness in Our Time: Working Lives of Documentary Photographers.* Washington D.C.: Smithsonian Institution Press.

'Light with TV Urged to Lessen Eyestrain' (1952) *New York Times*, 21 March, p. 22.

Lincoln, F. (1976) 'The Comeback of the Movies', in T. Balio (ed.), *The American Film Industry.* London: University of Wisconsin Press. pp. 371–86.

Lipietz, A. (1986) 'Behind the Crisis: The Exhaustion of a Regime of Accumulation – A Regulation School Perspective', *Review of Radical Political Economics*, 18, pp. 13–32.

Lipietz, A. (1987) *Mirages and Miracles: The Crises of Global Fordism.* London: Verso.

Lippard, L. R. (1984) 'Trojan Horses: Activist Art and Power', in B. Wallis (ed.), *Art After Modernism: Rethinking Representation.* New York: New Museum of Contemporary Art New York and Godine. pp. 340–58.

Lippard, L. R. (ed.) (1992) *Partial Recall.* New York: New Press.

Lippard, L. R. (1997) *Six Years: The Dematerialization of the Art Object from 1966 to 1972.* Berkeley: University of California Press.

Lippard, L. R. (2000) *Mixed Blessings: New Art in Multicultural America.* New York: New Press.

Lipset, S. M. (1991) 'American Exceptionalism Reaffirmed', in B. E. Shafer (ed.), *Is America Different?* Oxford: Clarendon Press. pp. 1–45.

Livermore, A. A. (1855) 'Gymnastics', *The North American Review* 81(168), pp. 66–7.

Livermore, M. (1889) *My Story of the War.* Hartford, CT: A.D. Worthington.

Livingston, S. (1997) 'Clarifying the CNN Effect: An Examination of Media Effects According to Type of Military Intervention', Research Paper R-18, The Joan Shorenstein Centre, Harvard University.

LoBrutto, V. (1997) *Stanley Kubrick: A Biography.* London: HarperCollins.

Locke, R. (1997) 'Music Lovers, Patrons, and the Sacralization of Culture in America', in R. Locke and C. Barr (eds), *Cultivating Music in America.* Berkeley: University of California Press.

Lown, J. (1995) 'Feminist Perspectives', in M. Blair *et al.* (eds), *Identity and Diversity: Gender and the Experience of Education.* Clevedon: Multilingual Matters in association with The Open University. pp. 107–22.

Lubin, D. M. (1996) *Picturing a Nation: Art and Social Change in Nineteenth-Century America.* New Haven: Yale University Press.

Lucas, S. (1999) *Freedom's War: The US Crusade Against the Soviet Union 1945–56.* Manchester: Manchester University Press.

Lucket, M. (1999) 'A Moral Crisis in Prime Time: *Peyton Place* and the Rise of the Single Girl', in M. B. Haralovich and L. Rabinovitz (eds), *Television, History and American Culture: Feminist Critical Essays.* London: Duke University Press. pp. 75–97.

Luddington, T. (ed.) (2000) *A Modern Mosaic: Art and Modernism in the United States.* Chapel Hill: University of North Carolina Press.

Lupton, E. and Miller, J. A. (1989) 'A Time Line of American Graphic Design', in M. Friedman *et al.*, *Graphic Design in America: A Visual Language History.* Minneapolis: Walker Art Center, and New York: Harry N. Abrams, Inc. pp. 24–65.

Lutz, C. A. and Collins, J. L. (1993) *Reading National Geographic.* Chicago: University of Chicago Press.

Lyon, D. (1992) *Memories of the Southern Civil Rights Movement.* Chapel Hill: University of North Carolina Press.

Lyons, N. (1966) *Contemporary Photographers Toward a Social Landscape.* Rochester, NY: George Eastman House.

Lyotard, J.-F. (1984) *The Postmodern Condition: A Report on Knowledge.* Manchester: Manchester University Press.

MacDougall, D. (1997) 'The visual in anthropology', in M. Banks and H. Morphy (eds), *Rethinking Visual Anthropology.* New Haven: Yale University Press. pp. 276–95.

MacLeish, A. (1977) *Land of the Free.* New York: Da Capo Press.

Magowan, K. (1999) 'Coming Between "The Black Beast" and the White Virgin: The Pressures of Luminality in Thomas Dixon', *Studies in American Fiction* 27(1) (Spring), pp. 77–102.

Maik, T. A. (1994) *The Masses Magazine (1911–1917)*. New York: Garland Publishing.

Mailer, N. (1972 [1957]) 'The White Negro', in N. Mailer, *Advertisements for Myself*. London: Panther.

Malinowski, B. (1922) *Argonauts of the Western Pacific: An Account of Native Enterprise and Adventure in the Archipelagoes of Melanesian New Guinea*. London: G. Routledge and Sons.

Maltby, R. (2003) *Hollywood Cinema*. Oxford: Blackwell.

Mander, J. (1996) 'Facing the Rising Tide', in J. Mander and E. Goldsmith (eds), *The Case Against the Global Economy*. San Francisco: Sierra Club Books. pp. 3–19.

Mapplethorpe, R. (1988) *Mapplethorpe Portraits/Photographs by Robert Mapplethorpe, 1975–87; Twelve Facets of Mapplethorpe by Peter Conrad*. London: National Gallery Publications.

Mapplethorpe, R. (1997) *Lady Lisa Lyon*. New York: St. Martin's Press.

Marchand, R. (1985) *Advertising the American Dream: Making Way for Modernity 1920–1940*. Berkeley: University of California Press.

Marchetti, G. (1993) *Romance and the 'Yellow Peril': Race, Sex, and Discourse Strategies in Hollywood Fiction*. Berkeley: University of California Press.

Margolis, E. (1988) 'Mining Photographs: Unearthing the Meaning of Historical Photos', *Radical History Review* 40, pp. 32–48.

Margolis, E. (1999) 'Class Pictures: Representations of Race, Gender and Ability in a Century of School Photography', *Visual Sociology* 14, pp. 7–38.

Margolis, E. and Romero, M. (1985) 'Tending the Beets: Campesinas and the Great Western Sugar Company', *Revista Mujeres* 2, pp. 17–27.

Margolis, E. and Rowe, J. (2002) 'Manufacturing Assimilation: Photographs of Indian schools in Arizona'. Online at *<http://courses.ed.asu.edu/margolis/paper/paper.htm>*

Marling, K. A. (1996) *As Seen on TV: The Visual Culture of Everyday Life in the 1950s*. Cambridge and London: Harvard University Press.

Marshall, R. (1988) *Robert Mapplethorpe: With Essays by Richard Howard and Ingrid Sischy*. London: Secker and Warburg.

Martínez, E. and García, A. (2002) 'What Is "Neo-liberalism"?' *Corporate Watch*. Online at *<http://www.igc.org/trac/corner/glob/neolib.html>*

'Mary Pickford Hops Out of Stan Kramer's "Fire" Because It Isn't Tinted' (1952), *Variety* (19 September): BFI Library archive. n.p.

Masayesva, V. and Younger, E. (1983) *Hopi Photographers, Hopi Images*. Tucson: Sun Tracks and University of Arizona Press.

Masters, W. and Johnson, V. (1966) *Human Sexual Response*. London: Churchill.

Matthaei, J. (1982) *An Economic History of Women in America: Women's Work, the Sexual Division of Labor, and the Development of Capitalism*. Brighton: Harvester.

Mattingly, C. (1998) *Well-Tempered Women: Nineteenth-Century Temperance Rhetoric*. Carbondale: Southern Illinois University Press.

May, E. T. (1999) *Homeward Bound: American Families in the Cold War Era*. New York: Basic Books.

McCarthy, A. (2003) '"Must See" Queer TV: History and Serial Form in *Ellen*', in M. Jancovich and J. Lyons (eds), *Quality Popular Television: Cult TV, the Industry and Fans*. London: BFI. pp. 80–102.

McCarthy, K. (1991) *Women's Culture*. Chicago: University of Chicago Press.

McClure, M. (1982) *Scratching the Beat Surface*. San Francisco: North Point Press.

McClure, M. (interviewed by E. Lipschutz-Villa) (1992) 'On Semina', in T. Berman *et al.*, *Wallace Berman: Support the Revolution*. Amsterdam, Institute of Contemporary Art. pp. 60–64.

McGilligan, P. (ed.) (1981) *Backstory 2: Interviews with Screenwriters of the 1940s and 1950s*. Oxford: Oxford University Press.

McInnes, M. D. (1999) 'Telling Histories: Installations by Ellen Rothenberg and Carrie Mae

Weems', in Ellen Rothenberg *et al.*, *Telling Histories: Installations by Ellen Rothenberg and Carrie Mae Weems*. Seattle: University of Washington Press. pp. 1–24.

McKinney, J. R. (1928) 'Modern Art vs. Scrambled Art', *Printers' Ink Monthly* (March), p. 88.

McKinney, J. R. (1929) 'What Has Happened to Modern Art in Advertising?', *Printers' Ink Monthly* (November), pp. 38–9, 98, 100, 103.

McKinzie, R. D. (1972) *The New Deal for Artists*. Princeton: Princeton University Press.

McLuhan, M. (1964) *Understanding Media; the Extensions of Man*. New York: McGraw-Hill.

McLuhan, M. (1994) *Understanding Media: The Extensions of Man*. Cambridge: MIT Press.

McLuhan, M. and Fiore, Q. (1967) *The Medium is the Massage*. New York: Random House.

McQuail, D. (1983) *Mass Communication Theory: An Introduction*. London: Sage.

McRobbie, A. (1991) *Feminism and Youth Culture: From 'Jackie' to 'Just Seventeen'*. London: Macmillan.

McRobbie, A. (1996) '*More!*: New Sexualities in Girls' and Women's Magazines', in J. Curran *et al.* (eds), *Cultural Studies and Communication*. London: Edward Arnold. pp. 172–94.

Mellencamp, P. (1990) *Logics of Television: Essays in Cultural Criticism*. London: BFI.

Merritt, R. (1990) 'D. W. Griffith's The Birth of a Nation: Going After Little Sister', in P. Lehman (ed.), *Close Viewings: An Anthology of New Film Criticism*. Tallahassee: Florida State University Press. pp. 215–37.

Meyer, R. (2001) 'Mapplethorpe's Living Room: Photography and the Furnishing of Desire', *Art History* 24(2) (April), pp. 292–322.

Miller, A. L. (1993) *The Empire of the Eye: Landscape Representation and American Cultural Politics*. Ithaca, NY: Cornell University Press.

Miller, J. S. (2000) *Something Completely Different: British Television and American Culture*. Minneapolis: University of Minnesota Press.

Miller, P. (1956) *Errand into the Wilderness*. Cambridge: Harvard University Press.

Miller, T. *et al.* (2001) *Global Hollywood*. London: British Film Institute.

Millett, K. (1970) *Sexual Politics*. New York: Doubleday.

Milner, C. A. *et al.* (eds) (1994) *The Oxford History of the American West*. New York and Oxford: Oxford University Press.

Mirzoeff, N. (ed.) (1998) *The Visual Culture Reader*. London: Routledge.

Mirzoeff, N. (1999) *An Introduction to Visual Culture*. London: Routledge.

Mitchell, W. J. T. (1992) *The Reconfigured Eye: Visual Truth in the Post-Photographic Era*. Cambridge: MIT Press.

Mitchell, W. J. T. (1994) *Picture Theory: Essays on Verbal and Visual Representation*. Chicago: University of Chicago Press.

Modleski, T. (1991) *Feminism Without Women: Culture and Criticism in a 'Postfeminist' Age*. New York: Routledge.

Monroe, J. (1823) 'The Monroe Doctrine'. Online at <*http://campus.northpark.edu/history/WebChron/USA/MonDoc.html*>

Moore, F. (1866) *Women of the War: Their Heroism and Self-Sacrifice*. Hartford, CT: S.S. Scranton.

Morgan, D. (2002) 'Protestant Visual Culture and the Challenges of Urban America during the Progressive Era', in J. M. Giggie and D. Winston (eds), *Faith in the Market: Religion and the Rise of Urban Commercial Culture*. New Brunswick: Rutgers University Press. pp. 37–56.

Morgan, R. (ed.) (1970) *Sisterhood is Powerful: An Anthology of Writings from the Women's Liberation Movement*. New York: Random House.

Morley, D. and Robins, K. (1995) *Spaces of Identity: Global Media, Electronic Communication and Cultural Boundaries*. London: Routledge.

Morphy, H. and Banks, M. (1997) 'Introduction: rethinking visual anthropology', in M. Banks and H. Morphy (eds), *Rethinking Visual Anthropology*. New Haven: Yale University Press. pp. 1–35.

Morris, A. (1984) *The Origins of the Civil Rights Movement: Black Communities Organizing for Change*. New York: Free Press.

Morrow, L. (2001) 'The Case for Rage and Retribution', *Time* (supplementary issue 24 September), p. 49.

Mott, F. L. (1957) *A History of American Magazines*. Cambridge: Harvard University Press.

Mukerji, C. and Schudson, M. (1991) *Rethinking Popular Culture*. Berkeley: University of California Press.

Mulvey, L. (1988) 'Visual Pleasure and Narrative Cinema', in C. Penley (ed.), *Feminism and Film Theory*. New York: Routledge.

Murphy, B. (1972) 'Monster Movies: They Came from Beneath the Fifties', *Journal of Popular Film* 1(1) (Winter), pp. 31–44.

Murphy, B. (1999) *Congressional Theatre: Dramatizing McCarthyism on Stage, Film, and Television*. Cambridge: Cambridge University Press.

Muscio, G. (1997) *Hollywood's New Deal*. Philadelphia: Temple University Press.

Musser, B. (1928) 'Is the Modernist Appeal Dangerous?', *Printers' Ink Monthly* (October), pp. 40–41, 125.

Musser, C. (1994) *The Emergence of Cinema: The American Screen to 1907*. Berkeley: University of California Press.

Nadel, A. (1995) *Containment Culture: American Narratives, Postmodernism, and the Atomic Age*. Durham: Duke University Press.

Naremore, J. (1998) *More Than Night: Film Noir in its Context*. Berkeley: University of California Press.

Nash, R. (1982) *Wilderness and the American Mind*. New Haven: Yale University Press.

Natanson, N. (1992) *The Black Image in the New Deal: The Politics of FSA Photography*. Knoxville: University of Tennessee Press.

Nava, M. (1987) 'Consumerism and Its Contradictions', *Cultural Studies* 1(2) May, pp. 204–10.

Neale, S. (1983) 'Masculinity as Spectacle: Reflections on Men and Mainstream Cinema', *Screen* 24(6), pp. 2–16.

Neale, S. (1985) *Cinema and Technology: Image, Sound, Colour*. London: Macmillan.

Neale, S. (ed.) (2002) *Genre and Contemporary Hollywood*. London: British Film Institute.

Neale, S. and Smith, R. (eds) (1998) *Contemporary Hollywood Cinema*. London: Routledge.

Neely Jr., M. E. and Holzer, H. (2000) *The Union Image: Popular Prints of the Civil War North*. Chapel Hill and London: The University of North Carolina Press.

Neely Jr., M. E. *et al.* (1987) *The Confederate Image: Prints of the Lost Cause*. Chapel Hill and London: The University of North Carolina Press.

Newman, B. (1992) 'The First Man was an Artist', in C. Harrison and P. Wood (eds), *Art in Theory 1900–1990*. Oxford: Blackwell. pp. 566–9.

Nixon, R. (1969) *Vietnamization*. Online at <*www.tamu.edu/scom/pres/speeches/jccrisis.html*>

Noble, L. L. (1964 [1853]) *The Life and Works of Thomas Cole*. Cambridge: Belknap Press.

Noble, P. (1971) 'The Negro in *The Birth of a Nation*', in F. Silva (ed.), *Focus on The Birth of a Nation*. Englewood Cliffs: Prentice-Hall. pp. 125–32.

Noponen, H. *et al.* (eds) (1993) *Trading Industries, Trading Regions: International Trade, American Industry, and Regional Economic Development*. New York: The Guilford Press.

Novak, B. (1995) *Nature and Culture: American Landscape and Painting, 1825–1875*. New York: Oxford University Press.

O'Connor, F. V. (1973) *Art for the Millions: Essays from the 1930s by Artists and Administrators of the WPA Federal Art Project*. Boston: New York Graphic Society.

Oldenburg, A. (1996) 'Miramax Maximized "Postman" Potential', *USA Today* (14 February), D4.

Olson, C. (1966) *Selected Writings*. New York: New Directions.

Olson, L. C. (1991) *Emblems of American Community in the Revolutionary Era: A Study in Rhetorical Iconology*. Washington D.C.: Smithsonian Institution.

'Opened by the President: Mr. Cleveland Presses the Magic Button at Chicago', *New York Times*, 2 May 1893, pp. 1–2.

Orvell, M. (1989) *The Real Thing: Imitation and Authenticity in American Culture 1880–1940*. Chapel Hill: North Carolina University Press.

Orvell, M. (2003) *American Photography*. Oxford: Oxford University Press.

Osborne, P. (2000) *Travelling Light: Photography and Travel*. Manchester: Manchester University Press.

Osgerby, B. and Gough-Yates, A. (eds) (2001) *Action TV: Tough Guys, Smooth Operators and Foxy Chicks*. London: Routledge.

O'Sullivan, J. L. (1839) 'The Great Nation of Futurity', *The United States Democratic Review* 6(23), pp. 426–30.

Oulette, L. (1999) 'Inventing the Cosmo Girl: Class Identity and Girl-Style American Dreams', *Media, Culture and Society* 21, pp. 359–83.

'Pacification's Deadly Price' (1972) *Newsweek* 79 (19 June), p. 42.

Packard, V. (1960 [1957]) *The Hidden Persuaders*. Harmondsworth: Penguin.

Page, H. E. (1997) 'Black male imagery and media containment of African-American men', *American Anthropologist* 99, pp. 99–111.

Parks, G. (1966) *A Choice of Weapons*. New York: Harper.

Parks, G. (1997) *Half Past Autumn: A Retrospective*. Boston: Little, Brown and Company.

Parrish, M. E. (1992) *Anxious Decades: America in Prosperity and Depression, 1920–1941*. New York: Norton.

Parry, E. (1974) *The Image of the Indian and the Black Man in American Art*. New York: Braziller.

Patterson, J. T. (1996) *Grand Expectations: The United States, 1945–1974*. Oxford: Oxford University Press.

Patterson, V. (2000) 'The Hampton Project', in V. Patterson *et al.* (eds), *Carrie Mae Weems: The Hampton Project*. New York: Aperture. pp. 22–37.

Pearce, R. H. (1965) *Savagism and Civilization: A Study of the Indian and the American Mind*. Baltimore: Johns Hopkins University Press.

Peeler, D. (2001) *The Illuminating Mind in American Photography: Stieglitz, Strand, Weston, Adams*. Rochester: University of Rochester Press.

Perlmutter, D. D. (1998) *Photojournalism and Foreign Policy: Icons of Outrage in International Crises*. Westport, CT: Praeger.

Perren, A. H. (1998) *Indie, Inc.: Miramax, Independent Film and the New Hollywood*. Master's Thesis, University of Texas, Austin.

Peters, P. (1998) 'Cuba's Economic Transition and its Implications for US Policy'. Online at <*http://www.adti.net/html_files/cuba/cubatest.html*>

Peterson, M. A. (1991) 'Aliens, ape men and wacky savages', *Anthropology Today* 7, pp. 4–7.

Peterson, T. (2002) 'The Secrets of HBO's Success', *Business Week Online*, <*http://www.businessweek.com/bwdaily/dnflash/aug2002/nf20020820_2495.htm*>

Philips, D. (2000) 'Shopping for Men: The Single Woman Narrative', *Women: A Cultural Review* 11(3) (October), pp. 238–51.

Phillips, L. (1995) *Beat Culture and the New America 1950–1965*. New York: Whitney Museum of American Art.

Piche, T. *et al.* (1998) *Carrie Mae Weems: Recent Work, 1992–1998*. New York: George Braziller.

Pinchot, A. (1917) 'The Commercial Policy of Conscription', *The Masses* (May), pp. 6, 8.

Pirie, D. (1981) *Anatomy of the Movies*. New York: Macmillan.

Poe, G. T. (2001) 'Historical Spectatorship Around and About Stanley Kramer's *On the Beach*', in M. Stokes and R. Maltby (eds), *Hollywood Spectatorship: Changing Perceptions of Cinema Audiences*. London: BFI. pp. 91–102.

Pollock, E. J. (1999) 'Government Plans to Buy Famous Film, But Questions Requests for $30 Million', *Wall Street Journal* (May 20), p. 1.

'Portrait of Kim Phuc, the "napalm girl," 23 years later' (1995) *Life* online, <*http://www.lifemag.com/Life/pictday/wppa04.html.*>

Poster, M. (2001) *The Information Subject*. Amsterdam: Gordon and Breach.

Powell, R. J. (1997) 'Re/Birth of a Nation', in R. J. Powell (ed.), *Rhapsodies in Black: Art of the Harlem Renaissance*. Berkeley: University of California Press. pp. 14–33.

'Praise Pours in on Murrow Show' (1954) *New York Times*, 11 March, p. 19.

Pratt, M. L. (1992) *Imperial Eyes: Studies in Travel Writing and Transculturation*. London: Routledge.

Preston, C. L. (2001) 'Territories of Images, Technologies of Memory', *Visual Sociology* 16, pp. 36–57.

Prince, S. (2003) *Classical Film Violence: Designing and Regulating Brutality in Hollywood Cinema, 1930–1968*. New Brunswick: Rutgers University Press.

Pulver, A. (1997) 'Players in a Reel World: The Weinstein Brothers Brought Their Tough, Hustling Style to the World of Art-House Cinema in America: A Deal with Disney Sees Them Move Into Production', *Guardian*, 17 February: Guardian 2, pp. 2–4.

Pumphrey, M. (1987) 'The Flapper, The Housewife and the Making of Modernity', *Cultural Studies* 1, pp. 179–94.

Putney, C. (2001) *Muscular Christianity Manhood and Sports in Protestant America, 1880–1920*. Cambridge: Harvard University Press.

Rabinowitz, P. (1994) *They Must be Represented: The Policis of Documentary*. London: Verso.

Radner, H. (1999) 'Queering the Girl', in H. Radner and M. Luckett (eds), *Swinging Single: Representing Sexuality in the 1960s*. Minneapolis: University of Minnesota Press. pp. 1–38.

Radner, H. (2001) 'Embodying the Single Girl in the 1960s', in J. Entwistle and E. Wilson (eds), *Body Dressing*. Oxford: Berg. pp. 183–97.

Radway, J. (1984) *Reading the Romance: Women, Patriarchy, and Popular Literature*. Chapel Hill: University of North Carolina Press.

Radway, J. (1999) *A Feeling for Books*. Chapel Hill: University of North Carolina Press.

Rampersad, A. (1988) *The Life of Langston Hughes, Volume II: 1941–1967, I Dream a World*. New York: Oxford University Press.

Rampley, M. (2004) *Exploring Visual Culture*. Edinburgh: Edinburgh University Press.

Ranney, D. C. (1993) *The Evolving Supra-National Policy Arena*. Chicago: University of Illinois at Chicago, Center for Urban Economic Development.

Ray, R. B. (1985) *A Certain Tendency of the Hollywood Cinema*. Princeton: Princeton University Press.

Reed, J. (1966) 'The Trader's War', *The Masses* (September 1914), reproduced in W. L. O'Neill (ed.), *Echoes of Revolt: The Masses 1911–1917*. Chicago: Ivan R Dee. pp. 266–9.

Reed, J. (1977 [1919]) *Ten Days that Shook The World*. Harmondsworth: Penguin.

Reich, C. (1996) *The Life of Nelson A. Rockefeller: Worlds to Conquer, 1908–1958*. New York: Doubleday.

Reich, R. B. (1997) *Locked in the Cabinet*. New York: Alfred A. Knopf.

Reitell, C. (1964 [1924]) 'The New Laborer', in A. Chandler (ed.), *Giant Enterprise: Ford, General Motors and the Automobile Industry*. New York: Harcourt, Brace and World.

Review of *Five* (1951) *Monthly Film Bulletin* (November), p. 356.

Review of *Killers from Outer Space* (1954) *Monthly Film Bulletin* (May), p. 75.

Review of *Storm Center* (1956) *Film Culture* 2(3), p. 25.

Review of *Them!* (1954) *Monthly Film Bulletin* (September), p. 131.

Richard Jr., A. C. (1993) *Censorship and Hollywood's Hispanic Image: An Interpretive Filmography, 1936–1955*. Westport, CT: Greenwood Press.

Richards, H. (2003) '*Sex and the City*: a visible *flaneuse* for the postmodern era?', *Continuum: Journal of Media and Cultural Studies* 17(2), pp. 147–57.

Riechmann, D. (1999) 'Arbitrators to decide value of Zapruder film', *Chronicle* (25 May), <http://www.chron.com/content/chronicle/special/jfk/related/0525zapruder.html>

Riesman, D. (1965) *The Lonely Crowd*. New Haven: Yale University Press.

Riis, J. A. (1971) *How The Other Half Lives: Studies Among the Tenements of New York*. New York: Dover Publications.

Ritchin, F. (1999) *In Our Own Image: The Coming Revolution in Photography*. New York: Aperture.

Robbins, L. S. (2000) *The Dismissal of Miss Ruth Brown: Civil Rights, Censorship, and the American Library*. Norman: Oklahoma University Press.

Robins, K. (1996) *Into the Image: Culture and Politics in the Field of Vision*. New York: Routledge.

Robinson, P. (2002) *The CNN Effect: The Myth of News, Foreign Policy and Intervention*. London: Routledge.

Robson, A. D. (1995) *Prestige, Profit, and Pleasure: The Market for Modern Art in New York in the 1940s and 1950s*. New York and London: Garland.

Rodowick, D. (1997) *Gilles Deleuze's Time Machine*. Durham: Duke University Press.

Rogers, J. C. (1936) 'Art and Freedom', *Art Front* (December), p. 15.

Rogin, M. (1994) '"The Sword Became a Flashing Vision": D. W. Griffith's *The Birth of a Nation*', in R. Lang (ed.), *The Birth of a Nation*. New Brunswick: Rutgers University Press. pp. 250–93.

Roosevelt, T. (1904) 'The Roosevelt Corollary to the Monroe Doctrine'. Online at *<http://www.uiowa.edu/~c030162/Common/Handouts/POTUS/TRoos.html>*

Rosen, D. (1994) 'The Volcano and the Cathedral: Muscular Christianity and the Origins of Primal Manliness', in D. E. Hall (ed.), *Muscular Christianity: Embodying the Victorian Age*. Cambridge, UK: Cambridge University Press. pp. 17–44.

Rosenberg, H. (1952), in *Art News* (December), p. 23.

Rosenberg, H. (1961) *The Tradition of the New*. New York: Grove Press.

Rosenberg, H. (1975) *Art on the Edge*. New York: Macmillan.

Roseneil, S. (2000) *Common Women, Uncommon Practices: The Queer Feminisms of Greenham*. London: Cassell.

Rosenzweig, R. (1983) *Eight Hours for What We Will*. New York: Cambridge University Press.

Rosler, M. (1981) *3 Works*. Halifax, Nova Scotia: Press of the Nova Scotia College of Art and Design.

Roth, M. (1977) 'Some Warners Musicals and the Spirit of the New Deal', *The Velvet Light Trap* 17 (Winter), pp. 1–7.

Roth, M. (1989) 'The Tangled Skein: On Re-Reading Heresies', *Heresies* 24, pp. 84–8.

Rowe, B. (1929) 'There Is No Modern Art in American Advertising', *Printers' Ink Monthly* (February), pp. 47–9, 128, 131–2, 134, 136.

Rowland, D. W. (1947) *History of the Office of the Coordinator of Inter-American Affairs*. Washington D.C.: U.S. Printing Office.

Rubin, J. S. (1992) *The Making of Middlebrow Culture*. Chapel Hill: University of North Carolina Press.

Rupp, L. (1982) 'The Survival of American Feminism: The Women's Movement in the Postwar Period', in R. Bremner and G. Reichard (eds), *Reshaping America: Society and Institutions, 1945–60*. Columbus: Ohio State University Press. pp. 33–65.

Ryan, D. D. (ed.) (1996) *A Yankee Spy in Richmond: The Civil War Diary of 'Crazy Bet' Van Lew*. Mechanicsburg, PA: Stackpole Books.

Ryan, M. P. (1990) *Women in Public: Between Banners and Ballots, 1825–1880*. Baltimore and London: Johns Hopkins University Press.

Ryan, M. P. and Kellner, D. (1988) *Camera Politica: the Politics and Ideology of Contemporary Hollywood Film*. Bloomington: Indiana University Press.

Rydell, R. W. (1993) 'Rediscovering the 1893 World's Columbian Exposition', in C. K. Carr and G. Gurney (eds), *Revisiting the White City: American Art at the 1893 World's Fair*. Hanover, NH: University Press of New Hampshire. pp. 18–61.

Samuel, R. (1994) *Theatres of Memory, Volume 1: Past and Present in Contemporary Culture*. London: Verso.

Sandeen, E. (1995) *Picturing the Exhibition: The Family Of Man*. Albuquerque: University of New Mexico Press.

Sandweiss, M. A. (ed.) (1991) *Photography in Nineteenth-Century America*. New York: Harry N. Abrams.

Sandweiss, M. A. (2002) *Print the Legend: Photography and the American West*. New Haven and London: Yale University Press.

Sass, A. (1998) 'Robert Frank and the Filmic Photograph', *History of Photography* 22(3) (Autumn), pp. 247–53.

Sassen, S. (1996) *Losing Control? Sovereignty in an Age of Globalization*. New York: Columbia University Press.

Sassen, S. (2000) 'The Global City', *American Studies* 41(2/3), pp. 79–95.

Sassen, S. (2001) 'Spatialities and Temporalities of the Global: Elements for a Theorization', in A. Appadurai (ed.), *Globalization*. Durham and London: Duke University Press. pp. 260–78.

Sayre, R. F. (1977) *Thoreau and the Indians*. Princeton: Princeton University Press.

Sayre, N. (1982) *Running Time: Films of the Cold War*. New York: Dial Press.

Scarry, E. (1985) *The Body in Pain: The Making and Unmaking of the World*. New York: Oxford University Press.

Scarry, E. (1999) *On Beauty and Being Just*. Princeton: Princeton University Press.

Schaffer, R. (1991) *America in the Great War: The Rise of the War Welfare State*. New York: Oxford University Press.

Schatz, T. (1995) 'The Structural Influence: New Directions in Film Genre Study', in B. K. Grant, *Film Genre Reader II*. Austin: University of Texas Press. pp. 90–101.

Schatz, T. (1998) *The Genius of the System: Hollywood Film-Making in the Studio Era*. London: Faber and Faber.

Schechner, R. (1985) *Between Theater and Anthropology*. Philadelphia: University of Pennsylvania Press.

Schein, H. (1955) 'The Olympian Cowboy', *American Scholar* 24(3) (Summer).

Scherer, J. C. (1973) *Indians: The Great Photographs that Reveal North American Indian Life, 1847–1929*. New York: Bonanza.

Schlesinger Jr., A. M. (1992) *The Disuniting of America*. New York: Norton.

Schmitz, D. F. (1999) *Thank God They're on Our Side: The United States and Right-Wing Dictatorships, 1921–1965*. Chapel Hill: The University of North Carolina Press.

Scholnick, M. I. (1990) *The New Deal and Anti-Semitism in America*. New York: Garland.

Schudson, M. (1984) *Advertising, the Uneasy Persuasion: Its Dubious Impact on American Society*. New York: Basic.

Schultz, J. E. (1989) 'Women at the Front: Gender and Genre in Literature of the American Civil War', Dissertation, University of Michigan, Ann Arbor, U.M.I.

Schwartz, R. A. (2000) *Cold War Culture: Media and the Arts, 1945–1990*. New York: Checkmark Books.

Sedgwick, E. K. (1993) *Tendencies*. Durham: Duke University Press.

Sekula, A. (1983) 'Photography Between Labor and Capital, in B. H. D. Buchloh and R. Wilkie (eds), *Mining Photographs and Other Pictures: A Selection from the Negative Archives of Shedden Studio, Glace Bay, Cape Breton. 1948–1968*. Halifax, Nova Scotia: The Press of the Nova Scotia College of Art and Design.

Shackleford, M. 'A History of the Zapruder Film'. *JFK Lancer Online Resources* <http://www.jlflancer.com/History-Z.html>

Shain, R. E. (1974) 'Hollywood's Cold War', *Journal of Popular Film* 3(4) (Fall), pp. 334–50, 365–72.

Shank, B. (2001) 'Pierre Bourdieu and the Field of Cultural History', *Intellectual History Newsletter* 23, pp. 96–109.

Shaw, T. (2002) 'Miracles, Martyrs and Martians: Religion and Cold-War Cinematic Propaganda in the 1950s', *Journal of Cold War Studies* 4(3), pp. 5–30.

Shay, J. (1994) *Achilles in Vietnam: Combat Trauma and the Undoing of Character*. New York: Simon and Schuster Touchstone.

Sherman, C. (1998) 'The Path to Peru', *St Petersburg Times* (Special supplement 23 October), pp. 8–9.

Shively, J. (1992) 'Cowboys and Indians: perceptions of Western films among American Indians and Anglos', *American Sociological Review* 57, pp. 725–34.

Shohat, E. and Stam, R. (2002) 'The imperial imaginary', in K. Askew and R. R. Wilk (eds), *The Anthropology of Media*. New York: Blackwell. pp. 117–47.

Silverman, K. (1988) *The Acoustic Mirror*. Bloomington: University of Indiana Press.

Silverman, K. (1992) *Male Subjectivity at the Margins*. New York: Routledge.

Simon, A. (1996) *Dangerous Knowledge: The JFK Assassination in Art and Film*. Philadelphia: Temple University Press.

'Sixtieth Anniversary of *Life*' (1995), *Life* 18 (May), p. 102.

Skármeta, A. (1985) *Ardiente Paciencia*. Hanover, NH: Ediciones del norte.

Skármeta, A. (1987) *The Postman*. New York: Miramax Books.

Slater, D. (1997) *Consumer Culture and Modernity*. Malden, MA: Polity Press.

Slide, A. (1994) *Early American Cinema*. Lanham: Rowman and Littlefield.

Smith, M. A. and Kollock, P. (eds) (1999) *Communities in Cyberspace*. London: Routledge.

Smith, P. (1998) *Complete: Lyrics, Reflections and Notes for the Future*. London: Bloomsbury.

Smith, S. M. (1999) *American Archives: Gender, Race and Class in Visual Culture*. Princeton: Princeton University Press.

Smith, W. (1929) 'Some More about the Modern Trend in Advertising Art', *Printers' Ink Monthly* (December), pp. 44–5, 126.

Söhn, A. (2002) *Sex and the City: Kiss and Tell*. London: Channel 4 Books.

Solnit, R. (1990) *Secret Exhibition: Six California Artists of the Cold War Era*. San Francisco: City Lights Books.

Solomon-Godeau, A. (1991) 'Who is Speaking Thus? Some Questions About Documentary Photography', in A. Solomon-Godeau (ed.), *Photography at the Dock: Essays on Photographic History, Institutions, and Practices*. Minneapolis: University of Minnesota Press. pp. 169–217.

Sontag, S. (1977) *On Photography*. New York: Farrar, Straus Giroux.

Spigel, L. and Curtin, M. (1997) *The Revolution Wasn't Televised: Sixties Television and Social Conflict*. London and New York: Routledge.

Spitulnik, D. (1993) 'Anthropology and mass media', *Annual Review of Anthropology* 22, pp. 293–338.

Spotnitz, F. (1993) 'Money Matters: The End of the Indies: Will Sellouts Follow Buyouts for Maverick Filmmakers?', *Washington Post*, 19 September: G5.

Stange, M. (1989) *Symbols of Ideal Life: Social Documentary Photography in America 1890–1950*. Cambridge: Cambridge University Press.

Stange, M. (2000) '"Illusion Complete within Itself": Roy DeCarava's Photography', in Townsend Ludington (ed.), *A Modern Mosaic: Art and Modernism in the United States*. Chapel Hill: University of North Carolina Press. pp. 279–305.

Stanton, E. C. (1974) *The Original Feminist Attack on the Bible (The Woman's Bible)*. New York: Arno Press.

Stanton, T. and Blatch, H. S. (eds) (1922) *Elizabeth Cady Stanton, As Revealed in Her Letters, Diary, and Reminiscences*, 2 vols. New York: Harper and Brothers.

Starenko, M. (1983) 'What's An Artist to Do? A Short History of Postmodernism and Photography', *Afterimage* 10 (January), pp. 4–5.

States, B. (1996) 'Performance as Metaphor', *Theatre Journal* 48, pp. 1–26.

Steichen, E. (1955 [and 2000]) 'Introduction', in *The Family of Man*. New York: Museum of Modern Art.

Stephens, M. (1998) *The Rise of the Image the Fall of the Word*. Oxford: Oxford University Press.

Stiles, K. and Selz, P. (eds) (1996) *Theories and Documents of Contemporary Art: A Sourcebook of Artists' Writings*. Berkeley: University of California Press.

Stott, W. (1973) *Documentary Expression and Thirties America*. New York: Oxford University Press.

Strasser, S. (1995) *Satisfaction Guaranteed: The Making of the American Mass Market*. New York: Smithsonian Institution Press.

Strauss, A. (1987) *Qualitative Analysis for Social Sciences*. New York and London: Cambridge University Press.

Stryker, R. E. and Wood, N. (1973) *In This Proud Land: America 1935–1943 as seen in the FSA Photographs*. Greenwich, CT: New York Graphic Society Ltd.

Studlar, G. and Dresser, D. (1990) 'Never Having to Say You're Sorry: Rambo's Rewriting of the Vietnam War', in L. Dittmar and G. Michaud (eds), *From Hanoi to Hollywood: The Vietnam War in American Film*. New Brunswick: Rutgers University Press. pp. 101–12.

Sturken, M. (1997) *Tangled Memories: The Vietnam War, the AIDS Epidemic, and the Politics of Remembering*. Berkeley: University of California.

Sturken, M. and Cartwright, L. (2001) *Practices of Looking: An Introduction to Visual Culture*. Oxford: Oxfod University Press.

Susann, J. (1998 [1966]) *Valley of the Dolls*. London: Warner.

Szalay, M. (2000) *New Deal Modernism: American Literature and the Invention of the Welfare State*. Durham: Duke University Press.

Szarkowski, J. (1966) *The Photographer's Eye*. New York: The Museum of Modern Art.

Szarkowski, J. (1975) *William Eggleston's Guide*. New York: The Museum of Modern Art.

Szarkowski, J. (1978) *Mirrors and Windows. American Photography Since 1960*. New York: The Museum of Modern Art.

Szarkowski, J. (1989) *Photography Until Now*. New York: The Museum of Modern Art.

Tabb, W. K. (1997) 'Globalization is *an* issue, the power of capital is *the* issue', *Monthly Review*, 49(2), pp. 20–30.

Taft, R. (1964) *Photography and the American Scene: A Social History, 1839–1889*. New York: Dover.

Tagg, J. (1988) *The Burden of Representation: Essays on Photographies and Histories*. Amherst: University of Massachusetts.

Tallack, D. (1991) *Twentieth Century America*. London: Longman.

Tanner, T. (1990) 'Introduction', in W. D. Howells, *A Hazard of New Fortunes*. Oxford and New York: Oxford University Press. p. x.

'Taradash Says "Library" Will Be More Anti-Red than "Usual"' (1955) *Variety* (6 July): BFI Library archive. n.p.

Taradash, D. (1956) '"Storm Center" Course: Forthcoming Drama Followed Rugged Trail Before Reaching the Screen', *New York Times* (14 October): BFI Library archive. n.p.

Tasker, Y. (1998) *Working Girls: Gender and Sexuality in Popular Cinema*. London: Routledge.

Tatham, D. (1979) 'Winslow Homer at the Front in 1862', *American Art Journal* 11 (July), pp. 86–7.

Taylor, C. F. with Sturtevant, W. C. (eds) (1991) *The Native Americans: The Indigenous People of North America*. London: Salamander.

Taylor, P. M. (2001) 'Television and the Future Historian', in G. Roberts and P. M. Taylor (eds), *The Historian, Television and Television History*. Luton: University of Luton Press. pp. 171–7.

Terkel, S. (1970) *Hard Times*. New York: Pantheon.

'The Beat of Life' (1972) *Life*, 72 (23 June), pp. 4–5.

'The Captive Audience' (1951) *New York Times* (editorial), 21 March, p. 32.

The First 50 Years of Broadcasting: The Running Story of the Fifth Estate, by the editors of Broadcasting Magazine (1982) Washington, D.C.: Broadcasting Publications.

'The Romance of War' (17 August 1861), *Frank Leslie's Illustrated Newspaper*, XII, p. 211.

Thompson, J. B. (1990) *Ideology and Modern Culture*. Stanford: Stanford University Press.

Thompson, J. B. (2000) *Political Scandal: Power and Visibility in the Media Age*. Oxford: Polity.

Thompson, K. (1999) *Storytelling in the New Hollywood*. Cambridge: Harvard University Press.

Thompson, W. F. (1994) *The Image of War: The Pictorial Reporting of the American Civil War*. Baton Rouge and London: Louisiana State University Press.

Tichi, C. (1987) *Shifting Gears: Technology, Literature, Culture in Modernist America*. Chapel Hill: University of North Carolina Press.

'Timothy instructed in the scriptures by Grandmother Lois and Mother Eunice' (1830), *American Tract Magazine* (March), p. 1.

Tocqueville, A. de (1966) *Democracy in America*. New York: HarperPerennial.

Tomaselli, K. G. (1992) 'Myth, racism and opportunism: film and TV representation of the San', in P. I. Crawford and D. Turton (eds), *Film as Ethnography*. Manchester: Manchester University Press. pp. 205–21.

Tomaselli, T. K. (1996) *Appropriating Images: The Semiotics of Visual Representation*. Hojbjerhg, Denmark: Intervention Press.

Tomasulo, F. P. (1996) '"I'll See It When I Believe It": Rodney King and the Prison-house of Video', in V. Sobchack (ed.), *The Persistence of History: Cinema, Television, and the Modern Event*. London: Routledge. pp. 69–88.

Tomlinson, J. (1999) *Globalization and Culture*. Cambridge: Polity Press.

Towne, M. (1926) 'Is Advertising Art Growing Over-Sophisticated?', *Printers' Ink* (25 November), pp. 128–9, 132.

Trachtenberg, A. (ed.) (1981) *Classic Essays on Photography*. New Haven, CT: Leete's Island.

Trachtenberg, A. (1988) 'From Image to Story: Reading the File', in C. and B. W. Brannan (eds), *Documenting America, 1935–1943*. Berkeley, Los Angeles and London: University of California Press. pp. 43–73.

Trachtenberg, A. (1989) *Reading American Photographs: Images as History*. New York: Hill and Wang.

Trachtenberg, A. (1998) 'Wanamaker Indians', *Yale Review* 86 (Spring), pp. 1–24.

Trachtenberg, A. (2004) *Shades of Hiawatha: Staging Indians, Making Americans, 1890–1930*. New York: Hill & Wang.

Treanor, P. (2002) 'Neoliberalism'. Online at
<*web.inter.nl.net/users/Paul.Treanor/neoliberalism.html*>

Tridon, A. (1911) 'What Has Art to do With Socialism?', *The Masses* (October), p. 15.

Truettner, W. H. (ed.) (1991) *The West as America: Reinterpreting Images of the Frontier, 1830–1920*. Washington, D.C.: Smithsonian Institution Press.

Tucker, A. W. and Brookman, P. (1986) *Robert Frank: New York to Nova Scotia*. Boston: Little, Brown and Co.

Turner, P. (ed.) (1985) *American Images: Photography 1945–1980*. New York: Penguin.

Turner, W. B. (2000) *A Genealogy of Queer Theory*. Philadelphia: Temple Press.

UNESCO (1953) *Television: A World Survey*. Paris: UNESCO.

United States Bureau of the Census (1909) *A Century of Population Growth from the First Census of the United Sates to the Twelfth 1790–1900*. Washington, D.C.: Government Printing Office.

'US Senate Historical Minutes: Kefauver Crime Committee Launched' (2001)
<*http://www.senate.gov/learning/min_6cxyc.html*>

Van Gogh, V. (1981) *The Complete Letters of Vincent Van Gogh*, Volume Three. Boston: New York Graphic Society.

Van Lew, E. (1996) 'Occasional Journal', Thursday, 26 June 1862. Reproduced in David D. Ryan (ed.) (1996), *A Yankee Spy in Richmond: The Civil War Diary of 'Crazy Bet' Van Lew*. Mechanicsburg, PA: Stackpole Books. p. 44.

Van Wienen, M. W. (1997) *Partisans and Poets: The Political Work of American Poetry in the Great War*. Cambridge: Cambridge University Press.

Varnadoe, K. and Gopnik, A. (1990a) *High and Low*. New York: Harry N. Abrams.

Varnadoe, K. and Gopnik, A. (1990b) *Readings in Popular Culture*. New York: Harry N. Abrams.

Veblen, T. (1953) *The Theory of the Leisure Class*. New York: Mentor.

'Vets challenge minister's account of napalm attack' (1997), *Washington Post* (19 December), C05.

'Viewers Protest Religion, Clamor for Crime Inquiry' (1951) *New York Times*, 25 March, p. 58.

Volkmer, I. (1999) *News in the Global Sphere: A Study of CNN and its Impact on Global Communication*. Luton: University of Luton Press.

Walby, S. (1992) 'Post-Post-Modernism? Theorizing Social Complexity', in M. Barrett and A. Phillips (eds), *Destabilizing Theory: Contemporary Feminist Debates*. Cambridge: Polity Press.

Walker, J. (ed.) (2001) *Halliwell's Film and Video Guide 2001*. London: HarperCollins.

Walker, J. A. and Chaplin, S. (1997) *Visual Culture: An Introduction*. Manchester: Manchester University Press.

Wallace, M. F. (2003) 'The Good Lynching and *The Birth of a Nation*: Discourses and Aesthetics of Jim Crow', *Cinema Journal* 43(1) (Fall), pp. 85–104.

Wallis, B. (ed.) (1984) *Art After Modernism: Rethinking Representation*. Boston: David R. Godine.

Walsh, R. J. (1927) 'Must Advertising Go Back to Nature?', *Printers' Ink Monthly* (October), pp. 48–9, 113–14.

Walzer, M. (1977) *Just and Unjust Wars*. New York: Basic.

WAR (1971) *A Documentary Herstory of Women Artists in Revolution*. New York: Women Artists in Revolution.

Warhol, A. (1975) *The Philosophy of Andy Warhol: From A to B and Back Again*. New York: Harcourt Brace Jovanovich.

Warren, B. (1986) *Keep Watching the Skies! American Science Fiction Movies of the Fifties*. London: McFarland, Jefferson.

Warren, H. G. (1959) *Herbert Hoover and the Great Depression*. New York: Oxford University Press.

Wasko, J. (2001) 'Is it a Small World, After All?', in J. Wasko *et al.* (eds), *Dazzled by Disney? The Global Audiences Project*. London: Leicester University Press. pp. 3–28.

Weakland, J. H. (1995) 'Feature films as cultural documents', in P. Hockings (ed.), *Principles of Visual Anthropology*. Berlin: Mouton de Gruyter. pp. 45–68.

Weber, S. (1994) *Mass Mediauras: Essays on Form, Technics and Media*. Sidney: Power Institute.

Weed, C. (1994) *Nemesis of Reform: The Republican Party During the New Deal*. New York: Columbia University Press.

Weems, C. M. (1995) *In These Islands: South Carolina, Georgia*. Tuscaloosa: Alabama.

Weems, C. M. (2000) 'Interview', in V. Patterson *et al.* (eds), *Carrie Mae Weems: The Hampton Project*. New York: Aperture. pp. 78–80. Also Exhibition text, pp. 81–3.

Wells, L. (2000) *Photography: A Critical Introduction*. London: Routledge.

Wells, L. (2003) *The Photography Reader*. London: Routledge.

Westerbeck, C. and Meyerowitz, J. (2001) *Bystander: A History of Street Photography*. New York: Little, Brown and Company.

Wexler, L. (2000) Tender Violence: Domestic Visions in an Age of US Imperialism. Chapel Hill: University of North Carolina Press.

'What a Change' (21 June, 1861), *The Well-Spring* 18(25), p. 95.

White, M. (1969) *Mirrors, Messages, Transformations*. New York: Aperture.

Wiebe, R. (1967) *The Search for Order, 1877–1920*. New York: Hill and Wang.

Wild, L. (1989) 'Europeans in America', in M. Friedman *et al.*, *Graphic Design in America: A Visual Language History*. Minneapolis: Walker Art Center, and New York: Harry N. Abrams, Inc. pp. 153–69.

Wilkinson, B. (1997) *The Civil Rights Movement: An Illustrated History*. New York: Crescent Books.

Williams, C. J. (1995) *Freedom and Justice: Four Decades of the Civil Rights Struggle as Seen by a Black Photographer of the Deep South*. Macon: Mercer University Press.

Williams, L. (2001) *Playing the Race Card: Melodramas of Black and White From Uncle Tom to O. J. Simpson*. Princeton: Princeton University Press.

Williams, R. (1977) *Marxism and Literature*. Oxford: Oxford University Press.

Willis-Kennedy, D. (2000) 'Visualizing the "New Negro"', in V. Patterson *et al. Carrie Mae Weems: The Hampton Project*. New York: Aperture. pp. 66–75.

Wills, G. (1997) *John Wayne: The Politics of Celebrity*. London: Faber.

Wilson, E. (1985) *Adorned in Dreams: Fashion and Modernity*. London: Virago.

Wilson, J. (1994) 'Beauty Rites: Towards an Anatomy of Culture in African American Women's Art', *International Review of African American Art* XI(3), pp. 11–17, 47–55.

Wilton, A. and Barringer, T. (2002) *American Sublime: Landscape Painting in the United States 1820–1880*. London: Tate.

Winship, J. (2000) 'Women Outdoors: Advertising, Controversy and Disputing Feminism in the 1990s', *International Journal of Cultural Studies* 3(1), pp. 27–55.

Withers E. C. *et al.* (2000) *Pictures Tell the Story: Ernest C. Withers Reflections in History*. Norfolk, VA: Chrysler Museum of Art.

Wolf, D. (1983) *The American Space: Meaning in Nineteenth Century Landscape Photography*. Middletown: Wesleyan University Press.

Wolfe, T. (1989) *Radical Chic* and *Mau-Mauing the Flak Catchers*. London: Cardinal.

Wolfskill, G. (1962) *The Revolt of the Conservatives: A History of the American Liberty League, 1934–1940*. Boston: Houghton Mifflin.

Woll, A. L. (1977) *The Latin Image in American Film*. Los Angeles: UCLA Latin American Center Publications.

Wood, C. E. S. (1916) 'A Song of Beauty', *The Masses* (June), p. 12.

Wood, J. (ed.) (1999) *America and the Daguerreotype*. Iowa City: University of Iowa Press.

Wood, P. *et al.* (1993) *Modernism in Dispute: Art Since the Forties*. New Haven and London: Yale/The Open University.

Wright, B. *et al.* (1986) *The Hopi Photographs: Kate Cory, 1905–1912*. Albuquerque: University of New Mexico Press.

Wright, R. (1988 [1941]) *12 Million Black Voices: A Folk History of the Negro in the United States*. New York: Thunder's Mouth Press.

Wright, R. (1994 [1937]) 'Blueprint for Negro Writing', in A. Mitchell (ed.), *Within the Circle: An Anthology of African American Literary Criticism from the Harlem Renaissance to the Present*. Durham: Duke University Press. pp. 97–106.

Wright, T. (1992) 'Television narratives and ethnographic film', in P. I. Crawford and D. Turton (eds), *Film as Ethnography*. Manchester: Manchester University Press. pp. 274–82.

Wright, T. (2005) *Visual Impact: Culture and the Meaning of Images*. Oxford: Berg.

Wrone, D. R. (2003) *The Zapruder Film: Reframing JFK's Assassination*. Lawrence: University of Kansas Press.

Wu, H. H. (2000) 'Consuming Tacos and Enchiladas: Gender and the Nation in *Como agua para chocolate*', in C. A. Noriega (ed.), *Visible Nations: Latin American Cinema and Video*. Minneapolis, MN: University of Minnesota Press. pp. 174–92.

Wyatt, J. (1998) 'The Formation of the "Major Independent": Miramax, New Line, and the New Hollywood', in S. Neale and M. Smith (eds), *Contemporary Hollywood Cinema*. London: Routledge. pp. 74–90.

Zeidler, J. (2000) 'A View from Hampton University Museum', in V. Patterson *et al.* (eds), *Carrie Mae Weems: The Hampton Project*. New York: Aperture. pp. 76–77.

Zinn, H. (1980) *A People's History of the United States*. London: Longman.

Zurier, R. (1988) *Art for The Masses: A Radical Magazine and Its Graphics, 1911–1917*. Philadelphia: Temple University Press.

Index

Note: Contributing authors are shown in **bold** type

Abbott, J. S. C. 41
abstract art 68–71, 77–9, 88, 150–7, 163, 176
action films 258
Adam, B. 300
Adams, Ansel 27, 108, 174, 176, 179–80
Adams, Robert 174–5, 180
advertising 20, 65–6, 73–80, 83, 209–10, 214–15, 227–8, 232–40
advice literature 41
African Americans 58–62, 110, 112, 164, 173, 215, 230, 275, 278–82, 290
Agassiz, Louis 278
Albrecht, Chris 292
Alcott, Louisa May 42
Allen, Woody 253
Alley, Norman 118, 123
Allison, J. 109
Altman, Robert 219
Amazons 35–6
American Sunday School Union 41
American Tract Society 41
The Americans 88, 142–8
Anderson, John Alvin 28–9
Andre, Carl 192
Anheuser-Busch (company) 236
anthropology 284–5
Appadurai, Arjun 249, 253
Arbus, Diane 175, 179
Aristotle 203
Armstrong, Samuel Chapman 281
Arnold, Jack 134–5
Arnold, Matthew 152
Art Deco 73

Arthurs, Jane 292–3
Ascom Timeplex (company) 234
Attie, Jeanie 32
Austin, Mary 27
Avalos, David 30
Avedon, Richard 176, 252
Avins, Mimi 291

Baker, Houston 274
Balaban, Burt 135
Baldessari, John 191
Baldwin, James 168, 170
Baltz, Lewis 174–5, 180
Balzac, Honoré de 270
Bancroft, Hubert Howe 49–50, 54
Banks, M. 284
Baril, Tom 270
Barthes, Roland 166, 175, 177, 179, 252
Barton, Bruce 41, 46
Barton, William 45
Batista, Fulgencio 119
Becker, Maurice 69–71
Belafonte, Harry 168, 170
Bell, Clive 150
Bell, Daniel 143
Bender, Pennee 85–6
Benjamin, Walter 154
Bennett, G. H. 26
Bennett, Tony 214
Berger, J. 108–9
Berlant, Lauren 266
Berman, Wallace 190–4, 197–8
Berner, Arthur 220
Bernstein, Jay 155–6

Bewkes, Jeff 292
Biberman, Herbert 136–7
Biddle, George 98
Bierstadt, Albert 14–16
Bird, Elizabeth 230
The Birth of a Nation 19, 56–62
Bischof, Werner 176
Black Enterprise (magazine) 232, 235–6
black and white images 251–6
Blackman, Honor 214
Blake, Linnie 164
Blaustein, Julian 135–40 *passim*
Blauvelt, Hiram 75
Boas, Franz 26
Bodmer, Karl 26
Body and Soul 59–62
Bogart, Humphrey 221
Bond books and films 214
Bonn, Philip 109, 111
Booth, Evangeline 46
Booth, Maud and Ballington 46
Borde, R. 144
Bourdieu, Pierre 99, 180, 243
Bourke-White, Margaret 174, 176
Brecher, J. 233
The Bridge on the River Kwai 136
Brinkley, Alan 89, 97
Britton, Edgar 103
Broderick, Mick 135
Brown, Aaron 303
Brown, Bill 50
Brown, Helen Gurley 211–13
Brown, J. G. 51–2, 55
Brown, Ruth 137–9
Brunsdon, Charlotte 292
Buczak, John 85
Buffalo Bill 22, 27, 217, 219; *see also*
 Cody, Bill
Burgoyne, Robert 250
Burrows, Larry 194
Bushnell, Horace 41, 44–5
Butler, Hugh 122
Butler, Judith 213, 271
Butters, Gerald 58
Byrd, William 218

Cagney, James 219
Cahill, Holger 99–104
Caldwell, J. T. 302
Cameron, James 259
Campbell, Neil 88
Campbell, Stuart 78
Canadair (company) 238

Cándida-Smith, Richard 194
Capa, Cornell 175–6
Capa, Robert 174, 176
Caputo, John 203
Carlson, Richard 134
Carmichael, Stokely 170
Carpignano, Paolo 125
Carr, Carolyn Kinder 52, 54
Carson, Saul 126
Carter, Jimmy 165, 216
Cartier-Bresson, Henri 176–7
cartoons 33–4
Cartwright, Lisa 5–6
Casualties of War 259
Catlin, George 26
Celebrezze, Cat 87, 231
censorship 60–1, 139–40, 271
Central Intelligence Agency (CIA) 134,
 140, 151–2, 196, 261
Chalfen, R. 284
Chalifour, Bruno 88, 162–3
Chamberlain, Kenneth Russell 69
Chambers, Stan 128
Chandler, Raymond 221
Chaney, James Earl 168
Chang, Yahlin 291
Chappell, Walter 176
Chase, William Merritt 53–4
Chaumeton, E. 144
Chiarenza, Carl 176
Chicago, Judy 191
Chicago Tribune 103
Chicago World's Fair (1893) 19, 26, 48–55
Chin, Vincent 257
Chocolat 247
Chomsky, Noam 228
Chong, Denise 205
cinema 56–62, 84–9, 94, 97, 127, 133–4,
 139–40, 216, 242, 245, 247
CIT Group 235
City movies 219–20
civil rights movement 161–74, 257, 275
Civil War, American 31–6, 43–5
Clapp, Thaddeus 101
Clark, J. 242
Clark, Larry 180
Clark, T. J. 155
Cleaver, Eldridge 170
Clifford, James 142
Clinton, Bill 231, 299–302
Clover, Carol 261
CNN 300–3
Coca-Cola 2–3, 146, 251

Cockcroft, Eva 151–5, 197
Cody, Bill 22–3, 28, 217, 219; see also
 Buffalo Bill
Cohn, Harry 137
Cohn, Roy M. 129
Cold War 85–8, 133–40, 142, 151–5,
 161–4, 176, 185, 192, 210, 228–9
Cole, Thomas 14–15, 21–2, 30
Coleman, A. D. 174, 178
collage 193
Collier, John 109–11
Collins, Marjory 110
Columbus, Christopher 51
Communist Party 102
Connally, John 185
Conrad, Peter 267
contemporary art 78, 83, 179
Cooper, Gary 136
Cooper, James Fenimore 218
Coplans, John 193
Cory, Kate 24
Cosmopolitan 209–15, 230, 296
Costello, T. 233
Coughlin, Kevin 138
Coupland, Douglas 183
Coyle, Harry 127–8
Crawford, Joan 218
crayon line drawing 69–71
Cronbach, Robert 101, 103
cross-dressing 35–6
Crove, Cameron 284
Crow, Thomas 4, 163
Cruise, Tom 285
Cubism 76–7, 192
Cugat, Xavier 116
cultural theory 156–7
'culture wars' 227–30
Curtis, Edward 24–5, 27–8, 108, 252, 281
Custer, George Armstrong 219

D'Acci, Julie 214
Daguerre, Louis Mandé 21
Danto, Arthur 270
Darley, Andrew 255
Dater, Judy 180
Daumier, Honore 69
Davidov, Judith Fryer 27, 281
Davidson, Bruce 171–2
Davidson, Jo 68
Davis, Arthur B. 68
Davis, Elmer 135
Davis, Jerry 138
Davis, K. F. 180

Davis, Kristin 296
Davis, Sammy Jr 171
Davis, Stuart 66, 71, 104
Dawes Act (1887) 23
Dawson, Robert 175
The Day the Earth Stood Still 135, 140
Deal, Jo 174–5
Dean, James 139
Debord, Guy 4
DeCarava, Roy 171, 230, 277
The Deer Hunter 260–1
Delage, Christian 303
Delano, Jack 109–10
Deleuze, Gilles 126, 131
DeLillo, Don 183, 186
Dell, Floyd 63
d'Emilio, John 293
Demuth, Charles 66
De Niro, Robert 260–1
De Palma, Brian 259
deregulation policies 233–4
Derrida, Jacques 181
Desmond, K. 280
Dietrich, Marlene 222
digital technology 85, 113, 180, 228, 250,
 255
DiMaggio, Paul 99
diremption 155–6
Disney Corporation 242
Dixon, Joseph Kossuth 27
Dixon, Thomas 56, 58
documentary photography 107–8
Doisneau, Robert 176, 252–3
domino theory 228
Dored, John 118
Dos Passos, John 72
Doughty, Thomas 14
Douglas, Gordon 134
Dow, Bonnie 294
Drummond, L. 285, 290
Du Bois, W. E. B. 60
Duchamp, Marcel 3
'dumbing down' 3
Dunaway, Faye 217
Duncan, Robert 193
Durand, Asher 14
Duryea, Dan 136
Dutka, E. 242
Dwan, Alan 136
Dyer, Richard 249

Eakins, Thomas 54–5
Eastman, Max 63–71 passim

Edison, Thomas 217
Edmonds, Sarah 34–6
Eggleston, William 175, 179–80
Ehrenreich, Barbara 196, 211
Eisenhower, Dwight D. 138
Eisinger, J. 179
Ellison, Ralph 149
Emerson, Ralph Waldo 1, 43
Emery Worldwide (company) 235
Empen, Cynthia Wiedemann 18
escapism 89, 97
Esquivel, Laura 246
Essary, Darlene 137
ethnography 142–3, 285
Eubanks, Jonathan 171
Evans, Terry 175
Evans, Walker 85, 107–8, 146, 174, 176, 275
Ewen, S. 74
expressionism 70, 88, 151–7, 163, 176

Faludi, Susan 291, 297
Family of Man exhibition (1955) 175
Farm Security Administration (FSA) 84–5, 107–14, 174, 275
Farny, Henry 24
Farrow, Mia 214
fathers, role of 39–42
Federal Art Project (FAP) 84–5, 98–104
Federal Bureau of Investigation (FBI) 136
Feininger, Andreas 253
feminism 230, 291–7
Fernandez, Benedict 171
Field, Patricia 296
film noir 220–2
First World War 20, 64, 66
Fiscus, Kathy 128, 130
Fisher, Philip 54–5
Fitzgerald, Richard 69, 71
Five 135
Flagg, James Montgomery 76
Flaherty, Robert 290
Flannery, Denis 229
Fletcher, Bob 171
Flye, Camillus S. 25
Ford, John 217, 220
Fordism 20, 65–71, 83–4, 88, 163–5, 227–8, 233
Foreman, Carl 136
Forman, James 172
Fortune magazine 232–9 *passim*
Foster, Jodie 221
Foucault, Michel 7, 65

Fox, Michael J. 259
Fox Talbot, William Henry 21
Francina, Francis 163
Francis, Anne 214
Frank, Robert 88, 142–9, 177, 280
Frank, Stephen 39
Frankenheimer, John 134
Franklin, Benjamin 50
Franklin, Jack 171
Frascina, Francis 88, 230
Freed, Leonard 171
Freedman, Estelle 293
Freud, Sigmund 267
Fried, Michael 152–6, 191
Friedan, Betty 162, 209–10
Friedlander, Lee 175, 179
Friedman, Milton 243
Friendly, Fred 130
Fry, Roger 150
Futurism 75–6

Gabler, N. 289
Gaines, Jane 57, 60
Gair, Christopher 19
Galbraith, J. K. 143
García, A. 243
Gast, John 14–15
Gates, Bill 186
Gayles, Jonathan 230
Geertz, Clifford 143
Gellert, Hugo 68
Gemini Consulting 235
General Motors 78
George, Dan 217
Geronimo 25
Gershwin, George 253
Getty, J. Paul 279
Gibbs, Nancy 255
Gidley, Mick 16–18
Gilbreth, Frank and Lillian 65
Giles, Paul 8
Gilpin, Laura 27
Gilroy, Paul 274, 278
Ginsberg, Allen 144–8
Ginsburg, F. 284
Gitlin, T. 300
Glintenkamp, Henry 64
globalization 227–8, 232–43, 249, 251, 254
Goldberg, Vicki 166
Gold-Diggers of 1933 84, 89–97
Golden, Thelma 280
Goldenburg, Emmanuel 219

Goldman, Robert 215
'good neighbor policy' 85–6, 116–22
 passim
Gooding, Cuba 285
Goodman, Andrew 168
Gough-Yates, Anna 164, 230
Grabill, John 24
Grace, S. 290
Graham, Billy 134
Grainge, Paul 228, 231
Gramsci, Antonio 278
Grandbois, Dorothy 28, 30
graphic design 73–5
Green, J. 174
Green, Vanita 197
Greenberg, Clement 150–7, 163–4,
 191
Greene, Herbert 135
Greider, W. 234, 238
Gridley, Art 78
Griffin, Farah 274
Griffith, D. W. 19, 56–9, 62
Groden, Robert 186
Groseclose, Barbara 52–3
Gross, Dr 54–5
Grossberg, Lawrence 250
Guccione, Bob 214
Guerrero, Edward 58
Guevara, Che 246
Gulf War (1991) 304
Gunn, Thom 164
Gwathmey, Robert 102–3

Halbwachs, Maurice 299
Hall, G. Stanley 45
Hall, Stuart 4–6
Hamer, Fannie Lou 278
Hamilton, Peter 252–3
Hampton University 281–2
Hanson, David 175
Haraway, Donna 269
Hariman, Robert 164
Harr, Karl 135
Harrington, Michael 111, 143–4,
 147
Harris, Doug 171
Harris, Jonathan 153–7
Hartley, Marsden 66, 71
Harvey, David 233, 239, 252
Hathaway, Henry 133
Hawks, Howard 220
Hayden, Ferdinand Vandiveer 15
HBO 292–3

Hearst, William Randolph 89
Hegel, G. W. F. 1
Heidegger, Martin 155
Heizer, Michael 191–2
Helms, Jesse 229, 270–2
Helmut and Brooks 268–72
Heresies 190–1, 196–8
Heron, Matt 171
Herter, Christian 135
Hickman, R. C. 171
High Noon 136
Hillers, Jack 24
Hine, Lewis 108, 253
Hispanic Business (magazine) 232–9
 passim
Hitler, Adolf 139
Hoffman, Dustin 217–18
Hollinger, K. 294
Hollows, Joanne 291, 294
Holmes, Oliver Wendell 107, 113
Holzer, Jenny 3
Homer, Winslow 32, 52–5
Honda 237–8
Hone, Philip 14
Honey West 214
Hood, Marjorie 68
Hooper, Edward 68
Hoover, Herbert 83, 90
Hopkins, Harry 92, 98, 117
Hopper, Dennis 193, 216
Hopper, Hedda 137
Horner, Harry 134
Hoskins, Andrew 231
Howe, Hartley 107
Howells, William Dean 48–52, 55
Hoyt, Helen 68
Hudson, Henry 51
Hudson River school of painting 13–15,
 21
Hughes, Langston 274, 277
Hughes, Thomas 43
Hull, Cordell 122
human rights 168
Hunter, Kim 138
Hurston, Zora Neale 278
Hussein, Saddam 302
Huyssen, Andreas 228, 250–1

Ickes, Harold 98
iconic photographs 201–8
identity politics 228
IKEA 252–3
immigration into the US 257

interdisciplinarity 8–9
International Monetary Fund 227
Iraq War (2003) 303
It Came from Outer Space 134
Ivey, William 229

Jackson, William Henry 15–18, 24, 26
Jacoby, Russell 180
Janoskowsky, Joseph 112
Jarrico, Paul 137
Jefferson, Thomas 21
Jeffords, Susan 258
Jenkins, William 174
Jenks, Chris 1–2, 7, 9
Jerry Maguire 230, 284–90
Jesus Christ 41–2, 45–6
Joan of Arc 46
John Reed Club 102
Johnson, Frances Benjamin 281
Johnson, Katherine 227–8
Johnson, Lyndon B. 178
Johnson, Steve 186, 188
Johnston, Frances Benjamin 24, 109
Judd, Don 192

Kant, Immanuel 151, 156
Kaplan, Anne 258
Karsh, Yousuf 176
Käsebier, Gertrude 27
Kasher, Steven 172
Keeton, Kathy 214
Kefauver Committee hearings 129–31
Keitel, Harvey 221
Keith, Brian 138
Kellner, Douglas 243
Kelly, Mary 196
Kempf, Jean 88, 162–3
Kennedy, John F. 162–3, 183–5, 188, 193, 216
Kent, Rockwell 101–2
Kepes, Gyorgy 176
Kerouac, Jack 144–5, 194
Ketchum, Robert Glen 175
Kim Phuc 164, 199–206
Kimball, Abbott 76
King, Martin Luther 162, 173
King, Rodney 299
Kirsch, A. 275
Kitses, Jim 219
Kitzinger, J. 301
Klein, William 177
Knock, T. J. 65
Kolker, Robert 221

Kooning, Willem de 191
Korten, D. C. 233–4
Kramer, Stanley 135–7, 140
Krasner, Lee 156
Krippendorf's Tribes 284–5
Kruger, Barbara 180
KTLA 128–31
Ku Klux Klan 19, 57–8, 61–2, 166
Kubrick, Stanley 136

La Cava, Gregory 89
LaFollette, Suzanne 101
Lambert, Douglas 214
Lang, Fritz 220
Lange, Dorothea 30, 85, 107, 109, 112, 174, 252
Larcom, Lucy 31
Larned, W. Livingston 75–6, 79
Larrabee, C. B. 75, 77
Larsen, William Burton 118
Lean, David 136
Lears, Jackson 65–6, 74
Lee, Russell 108–12
Lee, Spike 289
leisure class theory 53–4
Leonardo da Vinci 186
lesbianism 295
Levine, Lawrence 99
Levine, Sherrie 3
Lewinsky, Monica 231, 299–302
Lichtenstein, Roy 252
Life magazine 146, 171, 184–6, 194–5, 199, 246–7, 253
Like Water for Chocolate 244
Lipietz, A. 232, 234
Lippard, Lucy 28, 188, 197
Lippmann, Walter 85
Lipset, Seymour Martin 2
Little Big Man 217–19, 222
Livermore, A. A. 42
Locke, Alain 60
Low, Will 49–51
Lucaite, Hariman 231
Lucaites, John 164
Lucas, George 165
Luce, Henry 85, 146
Lucket, Moya 214
Ludwig, Edward 134
Lumet, Sidney 134
Lupton, Ellen 73
Lyon, Danny 171–3
Lyon, Lisa 270
Lyons, Nathan 175–6

McCarey, Leo 134
McCarthy, Anna 292
McCarthy, Joseph (and McCarthyism) 87–8, 129–39
McClennen, Sophia 228
McClure, Michael 144, 190–3
McComb, Don 20, 88
MacDougall, D. 284
McKinney, J. R. 77–9
McLuhan, Marshal 131
MacMonnies, Mary Fairchild 53–5
Magowan, Kim 58
Maik, T. A. 63–4, 71–2
Mailer, Norman 144
Malcolm X 170, 173, 278, 289
Malinowski, B. 290
Mander, J. 240
Manet, Edouard 151
Manhatta 71
manifest destiny, doctrine of 16–18, 22, 217
Mann, Sally 180
Mapplethorpe, Robert 175, 229, 265–72, 280
The March of Time 121–3
Marcus, G. 142
Margolis, Eric 84–5, 231
Marmon, Lee 28
Marshall, Richard 267
Martin, Mandy 196
Martínez, E. 243
Marx, Karl 1, 84, 151
Marx Brothers 89
masculinity 42–6, 58
The Masses 20, 63–72
Matisse, Henri 70–1, 186–7
Matthaei, Julie 210
May, Elaine Tyler 210
Menzies, Cameron 134
Mercer Management Consulting 239
Merritt, Russell 57–8
Metalious, Grace 214
Meyer, Richard 269, 271
Michals, Duane 180
Micheaux, Oscar 19, 56–62
middle-class consciousness 39–40
Miles, Bert 167
Milius, John 134
Miller, Alfred Jacob 26
Miller, J. Abbott 73
Miller, Wayne 175
Millman, Edward 103
minimalism 192

Minor, Robert 66, 69
Miramax 228, 241–6
Miranda, Carmen 116, 244
Mirzoeff, Nicholas 3, 5, 7–8
miscegenation 58, 60
Misrach, Richard 175
Mitchell, W. J. T. 1
modernity and modernism 73–80, 150–7, 163, 175, 179–80, 254
Modleski, Tania 258
Mohr, J. 108–9
Moll, Elick 137
Moody, Dwight L. 43
Moody, Ken 266–7, 270, 272
Moore, Charles 167, 173
Moran, Edward 51, 70–1
Moran, Thomas 14–16
Morgan, David 18–19
Morgan, Robin 195
Morley, David 249–50
Morphy, H. 284
Morris, Robert 192
Morrow, Lance 254–5
Morten, Bruce 304
Moser, Don 194
multiculturalism 230
multinational corporations 236, 238
Munch, Edvard 8, 202
Muni, Paul 219
Murrow, Edward 130
muscular Christianity 41–6
Muser, Byron 77–8
Muybridge, Eadweard 24–5
My Lai massacre 195, 219
My Man Godfrey 84, 89, 94–7

Naismith, James 44
Naremore, James 253
Nast, Thomas 32
National Endowment for the Arts 178, 229
National Organization of Women 209, 293
Native Americans 21–30, 51, 111, 218–19, 281–2
Nava, Mica 210
neoliberal aesthetics 245
neoliberal economics 228, 243–4
Nero, Shelley 30
New Deal 83–113 *passim*, 163, 275, 253–6
New York World's Fair (1939) 103–4
Newhall, Beaumont 176

Newman, Barnet 88, 150, 153–7, 191
Newman, William 33
newsreels 116–23
Newsweek 199, 232, 235–7
Newtown, Huey 170
Nineteenth Amendment (to US Constitution) 46
Nishime, Leilani 229, 231
Nissan 236
Nixon, Julia 261
Nixon, Nicholas 179
Nixon, Richard 164, 216–17
Noble Peter 57
Noland, Kenneth 191
North, Edmund 135
North American Free Trade Agreement (NAFTA) 228, 243–4
Nourse, Elizabeth 53
Nyby, Christian 134

Obeler, Arch 135
Office for Coordination of Commercial and Cultural Relations 117
Office of the Coordinator of Inter-American Affairs (OCIAA) 85–6, 116–23
Office of War Information (OWI) 85, 107–14 *passim*
Ohana, Claudia 241
O'Keeffe, Georgia 66
Olitski, Jules 191
Olson, Charles 148
Omaha World's Fair (1898) 26
On the Beach 135–6
Osborne, P. 142
Osgerby, Bill 164, 230
O'Sullivan, John L. 13, 87
Oulette, Laurie 213

Pack, S. 284
Page, H. E. 287
pairing of images 265–72
Paley, William 127
Paris International Exposition (1925) 73, 79
Parker, Sarah Jessica 296
Parkins, Barbara 214
Parks, Gordon 167, 170–1, 274
Paths of Glory 136
Paul, St 40
Payne, John 136
Payne, Roz 171
Pearce, Charles Sprague 53
Pearce, Roy Harvey 22

Pearson, Drew 138
Penn, Arthur 216–18, 221
Perine, George E. 35
Perón, Juan Domingo 122
Peyton Place 214
Pfahl, John 175
Photo League 176
'photographing back' 29–30
photography 21, 26–30, 107–10, 162, 166, 170, 174–81
Picasso, Pablo 68
Pickford, Mary 137
Pinchot, Amos 66, 69
Pinochet, Augusto 243
Piper, Adrian 196
Plummer, John 205
Poitier, Sidney 171
Polk, Ozzie and Albert 277
Pollock, Jackson 152–6, 191
Poolaw, Horace 28
Post Wolcott, Marion 109–10, 113
The Postman 245–7
postmodernism 156–7, 162–3, 180, 250
Powell, John Wesley 24
Presley, Elvis 164
Prince, Richard 3
Printers' Ink and *Printers' Ink Monthly* 20, 73–80
Progressive Era 19–20, 64–6, 108
propaganda 117
Pulver, A. 241

queer theory 229, 268–9

Radner, Hilary 211–14
Rambo 228–9, 257–63
Ranney, D. C. 233
Ray, Nicholas 139
Reagan, Ronald 165
Red Planet Mars 134
Redford, Robert 246
Reed, John 64, 66, 72; *see also* John Reed Club
Reed, Luman 14
Reed, Roland 26
Regester, Charlene 19
Reich, Robert 236
Reis, Irving 137
Religious Right in politics 293
Remington, Frederic S. 24, 43
Rennie, Michael 135
Reynolds, Burt 213
RGA (company) 234

Rhoads, Harry Mellon 113
Richardson Fleming, Paula 26
Rickard, Jolene 30
Riesman, David 143–4
Rigg, Diana 214
Riis, Jacob 108
Rivera, Geraldo 186
Robeson, Paul 61–2
Robins, Kevin 249–50
Robinson, Boardman 69
Robinson, Edward G. 219
Robinson, Jackie 171
Rockefeller, Nelson 86, 116–17, 184
Rockwell (company) 238–9
Rocky Mountain school of painting 14–15
Rodowick, David 126
Rogers, Ginger 91
Rogers, John C. 102
Rogin, Michael 58
Romer, John Irving 74
Roosevelt, Eleanor 119, 138
Roosevelt, Franklin 84, 89–93, 96, 116–17
Roosevelt, Theodore 43, 52, 243
Rose, Guy 53
Rosenberg, Harold 103, 153, 176, 191
Rosenwald, Joseph 110
Rosler, Martha 108, 194–7
Rosskam, Edwin 274–5
Roth, Moira 197
Rothstein, Arthur 85, 107–10
Rowe, Brian 78
Rowell, George Presbury 74
Ruby, Jack 193
Ruml, Beardsley 117
Rushdie, Salman 28
Russell, Charles M. 24
Ryan, Michael 84
Rydell, Robert W. 51, 53
Ryle, Gilbert 143

Saab, Joan 84, 88
Salt of the Earth 136–7, 149
Salvation Army 46
Samuel, R. 303
Sandweiss, Martin 26, 28
Santa Fé Railroad 25
Sassen, Saskia 249, 251, 254
Saunders, Richard 167
Sayre, Robert 22
Schapiro, Meyer 191
Schapiro, Miriam 191
Schatz, T. 217
Schein, Harry 136

Schine, G. David 87, 129
Schrader, Paul 216
Schwerner, Michael 168
science fiction 134–5
scientific management 65–6, 69
Scorsese, Martin 216–22 *passim*
Scott, Tony 134
Seale, Bobby 170
Sedgwick, E. K. 268–9
See It Now 130
Sekula, Allan 110
Semina 190–8
September 11th 2001 attacks 254–6, 302–5
Serra, Richard 192
Serrano, Andres 229
Seumptewa, Owen 28
Sex and the City 164, 230, 291–7
Sex and the Single Girl 211, 214
Shaw, Bernard 302
Shaw, Tony 87–8
Shay, Jonathan 204–5
Sheeler, Charles 66, 71
Sheen, Charlie 259
Shepherd, Cybil 221
Sheridan, Philip Henry 22
Sherman, Cindy 175, 179–80
Sherman, Robert 266–7, 270, 272
Shute, Nevil 135
Silver Lode 136
Silverman, Kaja 260–1
Simon, Art 184–5
Simpson, O. J. 250
'single girl' archetype 211–15
Siskind, Aaron 176, 179–80
Sitting Bull 22–3
Skármeta, Antonio 245, 247
Sleet, Moneta 167, 173
Sloan, John 63, 68–9
Smith, Beuford 171
Smith, Henry Holmes 179
Smith, Patti 267, 270
Smith, W. Eugene 174, 176
Smith, Walter 79
Smithson, Robert 191–2
socialization 66–7, 233–5
Society for Photographic Education 177–8
Söhn, A. 294
Solomon-Godeau, Abigail 107–8
Sontag, Susan 175, 179
Soyer, Moses 98
Spero, Nancy 196
Sports Illustrated 232, 236–8

Springsteen, R. G. 133
Stalin, Joseph 153
Stange, Maren 230–1
Stanton, Elizabeth Cady 46
Star Wars 165
Starr, Darren 291
Steichen, Edward 146, 174–5
Stella, Frank 191
Stella, Joseph 66, 71
Stern, Maurice 68
Stevens, May 196
Stevens, Thaddeus 58
Stieglitz, Alfred 66, 174, 178, 187, 252
Stolley, Richard 184
Storm Center 87–8, 134, 137–40
Storrs, John 68
Stott, W. 108
Stowe, Harriet Beecher 58
Strand, Paul 66, 71, 174, 176
Strawberry and Chocolate 246–7
Stryker, Roy 107–8, 111, 113
Sturken, Marita 5–6
Sunday, Billy 45–6
Supreme Court of the US 49, 167
surrealism 142–4, 193
Symbol of the Unconquered 59–62
Symington, Stuart 129
synecdochic fallacy 8
Szarkowski, John 175–9

Tabb, W. K. 240
Tagg, J. 146
Taradash, Daniel 87, 134, 137–9
Tasker, Y. 294
Taxi Driver 220–2
Taylor, Frederick Winslow (and Taylorism)
 65–6, 69, 71
television 86–8, 125–31, 164,
 231, 299–305
'thick description' 143
Thompson, J. B. 233, 300
Thoreau, Henry 71
Till, Emmett 161, 167
Time magazine 250
Tocqueville, Alexis de 2
Tomaselli, T. K. 285
Tomlin, Elaine 171
Tomlinson, John 251
Towne, Milton 75
Trachtenberg, A. 107, 113
Treanor, Paul 243
Tridon, Andre 68
Troisi, Massimo 247

Tron, Nguyen Thi 194
T. Rowe Price (company) 234
Truman, Harry 135
Tsinhnahjinnie, Hulleah 30
Turner, Bill 268
Turner, Frederick Jackson 13
Turner, William Jackson 49–52

Uelsmann, Jerry 180
Uncle Tom's Cabin 58
United Nations 227
Universal Studio 84
Ut, Nick 164, 199–200
utopianism 153–5, 163

Vachon, John 85, 107, 109
Van Gogh, Vincent 70–1, 187
Van Lew, Elizabeth 31
Van Rensselaer, Stephen III 14
Van Voorhis, Westbrook 121
Vanderbilt, Paul 107, 113
Vargas, Getúlio 118, 122
Veblen, Thorstein 53–4
Vidor, King 220
Vietnam War 164, 174, 199, 202–4, 219,
 228–9, 257–63
Vlag, Piet 63, 68, 71
Vroman, Adam Clark 28

Wag the Dog scenario 302
Wagstaff, Sam 270
Wainwright, Loudon 184
Wallace, George 220
Wallace, Michele 58
Walsh, Richard J. 76–7
Walzer, Michael 203
Wanamaker, Rodman 27
Warhol, Andy 2–3, 163, 184–9, 252
Warren, Beth Gates 187–8
Warner Brothers 84, 89
Washington consensus 227
Wayne, John 221
Weakland, J. H. 284
Weaver, Sigourney 272
Weems, Carrie Mae 230, 274–82
Weinstein, Bob and Harvey 241–2
Welsh, Bill 128–9
Westerns 217–22
Weston, Edward 174, 179
Wexler, Laura 27
Whistler, James 150
White, Minor 174–6
Whitman, Richard Ray 30

Whitman, Walt 71
Wider, W. Lee 134
Wiebe, Robert 19, 64–5
Wienen, M. W. van 20
Wild, Lorraine 73
Wilder, Billy 220
Willard, Farnces 46
Williams, Cecil 167
Williams, Linda 58
Williams, R. 239
Willis, Bruce 243
Willis, Deborah 161
Wilson, Elizabeth 296
Wilson, Jackie Napolean 279
Wilson, Judith 275–6
Wilson, Michael 136–7
Wilson, Woodrow 64–5
Winogrand, Garry 175, 179, 280
Wise, Robert 135
Withers, Ernest 167
Within Our Gates 57–62
Witkin Gallery 178–9
Wittick, Ben 28
Wolf, Sylvia Leonard 187
Wolfe, Tom 162
Women's Christian Temperance Union
 (WCTU) 46–7

Wood, Charles Erskine Scott 68
Woodruff, Judy 303–4
Woodward, Ellen 104
Woolacott, Janet 214
Working Woman (magazine) 232, 235,
 238
Works Progress Administration (WPA) 87,
 95, 98–101
World Bank 227
World Trade (magazine) 232–9
World Trade Organization 227
World War 2 85
Wragg, David 88
Wright, Richard 230, 274–81
Wyatt, J. 242

Yeoworth, Irvin S. Jr 134
Young, Art 63, 67, 71
Young Men's Christian Association (YMCA)
 42–3

Zapruder film 163, 183–9
Zealy, J. T. 278, 280
Zeidler, Jeanne 281–2
Zinnermann, Fred 136–7
Zurier, Rebecca 63–4, 67–8, 71–2